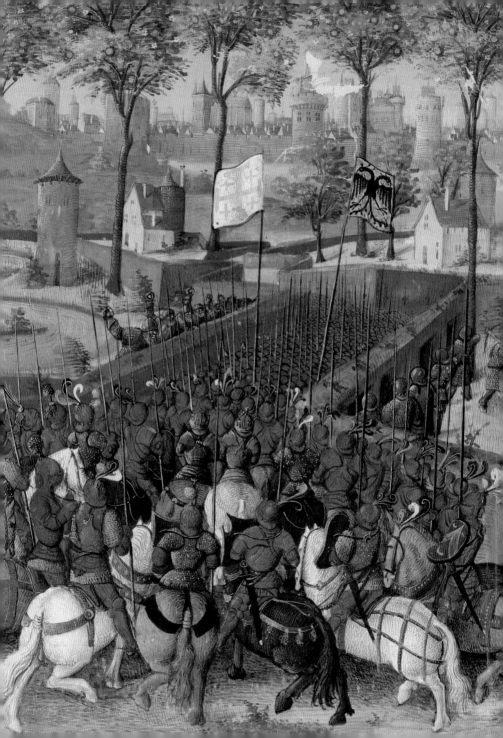

SÉBASTIEN MAMEROT

A CHRONICLE
OF THE CRUSADES

THE EXPEDITIONS TO OUTREMER
AN UNABRIDGED, ANNOTATED EDITION
WITH A COMMENTARY

Thierry Delcourt & Danielle Quéruel
Fabrice Masanès

The copy used for printing the illuminations from *Les Passages d'Outremer*
belongs to the Bibliothèque nationale de France, Paris

TASCHEN
Bibliotheca Universalis

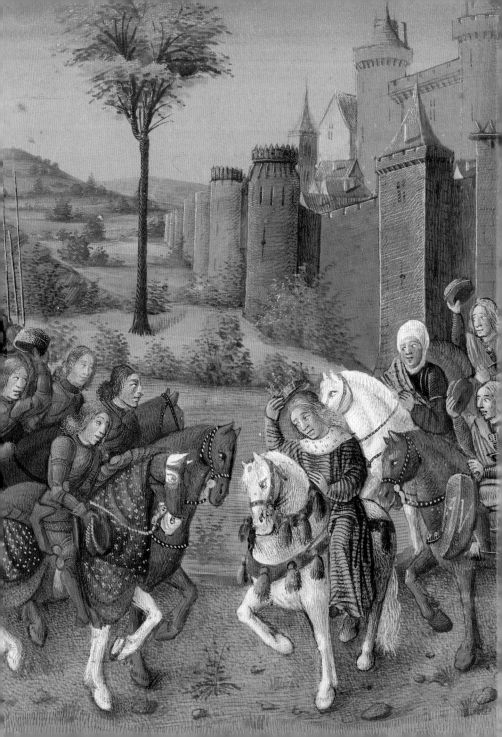

CONTENTS

Thierry Delcourt

Les Passages d'Outremer,
a masterpiece of French
fifteenth-century illumination

p. 6

Thierry Delcourt & Danielle Quéruel

Editors' notes

p. 66

Sébastien Mamerot
THE EXPEDITIONS
TO OUTREMER

English translation of Thierry Delcourt's and Danielle Quéruel's rendition of the original text
by Mary Lawson & Chris Miller
Commentary on the illuminations by Fabrice Masanès

p. 72

Bibliography

p. 754

Thierry Delcourt

LES PASSAGES D'OUTREMER, A MASTERPIECE OF FRENCH FIFTEENTH-CENTURY ILLUMINATION

The magnificent manuscript of *Les Passages d'Outremer,* whose facsimile is preserved in the Department of Manuscripts at the Bibliothèque nationale de France (BnF) in Paris and catalogued as Français (Fr.) 5594, was hand-copied by an anonymous scribe and illustrated under the supervision of one of the great painter-illuminators of the fifteenth century, Jean Colombe, who was active in Bourges from around 1465 to 1493. The 66 miniatures that were produced for the *Passages d'Outremer* are reproduced in the present volume. The book was commissioned by one of the great figures of the period, Louis de Laval-Châtillon, a member of the inner circle of Louis XI of France. Laval lived from 1411 to 1489 and thus experienced the latter stages of the Hundred Years' War and the renaissance of the kingdom of France in the wake of Charles VII's definitive defeat of the English in 1453.

The text in this manuscript is entitled *Les Passages d'Outremer.* It is a history of the crusades written by Louis de Laval's secretary and chaplain, Sébastien Mamerot, who penned it from 1472 to 1474 at his patron's request. The manuscript reproduced here was probably made very shortly after Mamerot had completed his text, for the rather dry style of the illuminations suggests that they were produced quite early in the career of Jean Colombe, during the 1470s.

Book production in the late Middle Ages

The popular image of medieval manuscript production – monks copying and illuminating texts in monasteries – holds true until about 1250. Thereafter, the only books still hand-copied in monasteries were exemplars used for meditation or teaching in situ. The true intellectual centres were now secular and it was from the universities

that the pioneering thinkers tended to emerge. Consequently, from the thirteenth century onwards, lay workshops called *librairies* ("bookshops", in modern French) arose that were effectively craft enterprises specialised in the production of books. They arose in the great university cities of Europe and near the centres of power, for princes liked to create their own private libraries. Thus, the books made by the *librairies* were not confined to the subjects taught in universities. A new class of collector of variable means emerged and books for private use soon came to be produced for them. Alongside the magnificent volumes illuminated for great bibliophiles such as the uncles of Charles VI – John, duke of Berry, Philip the Bold of Burgundy, Louis of Orleans and, somewhat later, Jacques of Armagnac, duke of Nemours – these studios produced more commonplace works for a wider public consisting of the middle and lower ranks of the aristocracy and the mercantile bourgeoisie. These were literary or historical texts and religious works. Many of the latter were books specifying the prayers for the "hours of the day" over the course of the calendar year; these were called *livres d'heures*, or "books of hours". The highly developed cultural life at the courts also led books to include pieces of music, chivalric tales, courtly poetry as well as literary and philosophical texts, which were aimed to appeal to the rich and leisured.

It is generally assumed that the three stages of manuscript production – that is, copying the text, embellishing it with illuminations and binding the book – took place in swift succession. In fact, they were mostly independent. A book might be made to order for a professional *libraire*, who could then keep it a while before selling it; it might also be commissioned privately from a *libraire*, a copyist or an illuminator. The text of a book of hours, for example, was often copied by a professional scribe who lived close

1.
Louis de Laval's Book of Hours,
c. 1470–1475 and c. 1480
The Creation
Illumination by Jean Colombe,
24.3 x 17.2 cm (9½ x 6¾ in.)
Paris, Bibliothèque nationale de France

to the patron or *libraire* who commissioned the book. In such cases, the copyist could refer to local saints and take into account local liturgical practices. The space required for the illuminations would be left blank. Marginal decoration, such as borders and small ornamental capitals, might be the work of a single painter and only the precious large-scale illuminations – and not necessarily all of these – would be commissioned from a famous artist.

In a different genre, that of chivalric romances, we know that Jacques of Armagnac, duke of Nemours, had manuscripts copied on his own premises by clerics working for him. The manuscripts were then sent to Paris, where they were illuminated by painters such as Maître François. But when the duke retired to his castle at Carlat, in the Limousin, he entrusted illuminations to an artist from Cologne who worked directly for him: Evrard d'Espingues. The sale of such works was the business of the *libraires*, who might or might not be able to provide all the stages of production. *Libraires* sometimes acted as intermediaries between the patron and the copyist or illuminator. But they might also risk commissioning books at their own expense, which they would sell at their stalls. This was the standard procedure for more commonplace books, such as books of hours, which the purchaser could subsequently have personalised (or customised, as we might say). They might add an illumination showing them kneeling before a saint whom they particularly venerated; they might simply have their coats of arms illuminated in areas left blank for that purpose. This would seem to be the case with a book of hours copied in the workshop of a *libraire* from Lyons and almost entirely illuminated by Jean Colombe. Only the last miniature, representing its owner, Jean Molé de Troyes, is the work of a different artist, Maître de Guillaume Lambert, who was

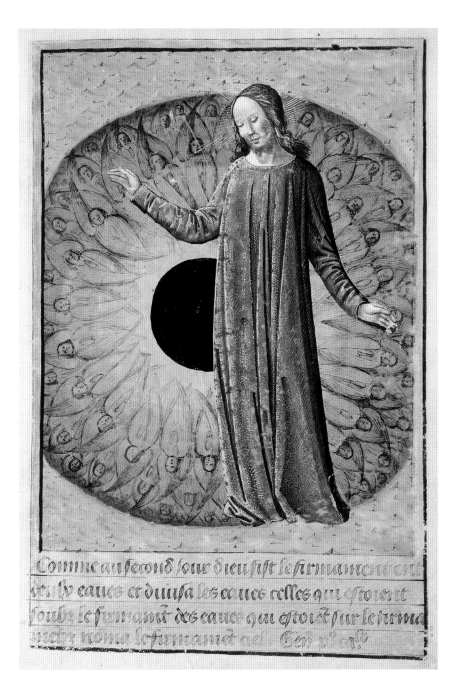

Comme au second iour dieu fist le firmament entre
les caues et diuisa les eaues celles qui estoient
soubz le firmament des eaues qui estoit sur le firma-
ment: nōma le firmamēt ciel. Gen̄ p̄ cn̄

9

active in Lyons in the 1480s. It seems very likely that it was included at the request of the purchaser after the completion of the rest of the manuscript.[1]

The art of bookmaking in France had undergone a first flowering between the reign of Louis IX (1214–1270) and the early fifteenth century. It came to an end around 1415–1420, a period that witnessed the defeat of the French chivalry at Agincourt in 1415, and the death of both the most magnificent and munificent bibliophile, the duke of Berry, and his favourite painters, the Limbourg brothers (1416). The English grip on France was tightening; the situation culminated in 1420 with the signing of the Treaty of Troyes, by which Charles VI disinherited the Dauphin (the future Charles VII) and recognised the king of England as heir to the French throne. After two long decades of recession, manuscript production in France began to revive in the 1440s. Now, though the capital continued to play an important role, Paris was no longer the only centre of production. Many provincial centres sprang up, particularly in the valley of the Loire. In the wake of Charles VII, many French kings chose to reside in the Loire region, which became the centre of French power. Great princes, such as the king of France, the duke of Burgundy, the duke of Anjou (known as "Good King René"), the count of Nevers, Jacques V of Armagnac and the duke of Savoy, continued to play an active role as patrons, but a new and much wider clientele for the *librairies* emerged. It was formed by the new class of royal functionaries and the higher clerical orders; the latter recruited both from the old aristocracy, which had often suffered financially in the wars, and the rich mercantile and financial bourgeoisie.

Jean Colombe was a prolific artist. His clients included the queen of France, the duke of Savoy, senior functionaries at the royal court and the rich merchants of Troyes,

2.
Louis de Laval's Book of Hours,
c. 1470–1475 and c. 1480
Louis de Laval Kneeling before
the Virgin and Child
Illumination by Jean Colombe,
24 x 17 cm (9½ x 6¾ in.)
Paris, Bibliothèque nationale de France

and he is a perfect representative of the new style of bookmaking that arose in the late
Middle Ages. Like most artists of his day, Colombe was often on the move: he first
established himself at Tours, where he learned his trade through contact with manu-
scripts illuminated by the great painter Jean Fouquet, then moved to Savoy, where he
became the official illuminator of the duke. His reputation extended as far as Champagne,
no doubt thanks to the links between Louis de Laval, then governor of the region, and
the bourgeoisie of the regional capital, Troyes. But he almost never worked on his own:
we often find his hand in manuscripts on which other artists also worked, either because
their illumination was undertaken in several stages (on a number of occasions he was
asked to complete the illuminations of an unfinished book, notably of *Les Très Riches
Heures du duc de Berry*) or because the work was from the outset shared out among a
number of illuminators. Moreover, he could never have illuminated the multitude of
manuscripts attributed to him today – to these we must, of course, add all those, no
doubt still more numerous, that have been lost or destroyed. Consequently, he was
surrounded by assistants, some of whom we know by name, such as Colombe's son
Philibert or Jean de Montluçon. It is often not possible to assess the part the master
played in the realisation of a given illumination, though the most splendid pages are
certainly by his hand.

The patron: Louis de Laval

Louis de Laval belonged to one of the oldest aristocratic families in the kingdom
of France.[2] His ancestor Guy I had been granted the county of Laval in the early elev-
enth century by the count of Maine, Herbert Eveillechien, who was himself a vassal of

the count of Anjou, Fulk Nerra. Another of his ancestors, Guy IV, had taken part in the First Crusade, in 1096.

Louis himself was the third son of Jean de Montfort, lord of Kergolay (1385–1414), and Anne de Montmorency-Laval (1385–1466), the heir of Guy XII. Anne was the daughter of Jeanne de Laval, whose first husband had been Bertrand du Guesclin (*c.* 1320–1380); the latter had helped Charles V to liberate most of the French kingdom from English occupation.

After the death of Guy XII, in 1413, Jean de Montfort became lord of Laval under the name Guy XIII. His premature death – he died of the plague at Rhodes in 1414 while returning from a pilgrimage to the Holy Land – marked the beginning of a particularly troubled period for the lords of Laval. The kingdom of France was gradually coming under English control thanks to the defeat at Agincourt (1415) and the madness of King Charles VI. The town of Laval was captured by English troops in 1428 despite the resistance of Guy XIV's brother, André de Lohéac, but soon retaken by the French in 1429.

Jean de Montfort (Guy XIII) and Anne had five children: two daughters, Jeanne and Catherine, and three sons, Guy XIV (1406–1486), André de Lohéac (1408–1486) and Louis de Laval-Châtillon (1411–1489). At the death of Guy XIII in 1414, his son Guy XIV was only eight years old, so his mother, Anne, took over the regency. Indeed, she shared power with her son until her death in 1466. Guy XIV distinguished himself by taking part alongside Joan of Arc in the Loire campaign against the English in 1429. In gratitude for his services, Charles VII, by royal order, raised the lordship of Laval to the rank of county. Guy XIV married a daughter of the duke of Brittany and often acted

as a mediator between the monarchy and the duke. In his status as honorary "cousin du roi", he was one of the six peers of the realm who took part in the coronation of Charles VII at Rheims in 1429.

The esteem in which he was held by a succession of French kings was further attested by a series of late honours: Guy XIV was made lieutenant-general of Brittany in 1472 and became Grand Master of France (head of the king's household) shortly before his death.

The youngest of the three brothers, Louis, was born in 1411, as we know from a note by Jean Robertet, secretary to Louis XI, at the end of his Book of Hours (ill. 1, 2).[3] Laval's grandmother, Jeanne de Laval-Châtillon, bequeathed to him the lordship of Châtillon-en-Vendelais, in Brittany (today in Ille-et-Vilaine, near Vitré), in consequence of which he was commonly known as the "lord of Châtillon", though he possessed other lordships in Brittany and Aquitaine. Louis XI further bestowed on him the lordship of Vierzon, though on a non-hereditary basis; however, from 1479 on, this was contested by Louis of Bourbon.

Louis de Laval began his career in the service of the John V of Brittany, whose court he frequented at least until 1437. Between 1441 and 1443, he took part in the military operations conducted by Charles VII and the Dauphin (the future Louis XI) to liberate the French territory still occupied by the English; this included the siege of Pontoise (1441), the campaign to relieve the citadel of Tartas in Aquitaine (June 1442) and the siege of Dieppe (August 1442). He thus showed himself a faithful servant of the Dauphin, whom he accompanied on his expedition against Duke John IV of Armagnac (1443). When Charles VII exiled his son to the Dauphiné, after the failure of Louis's

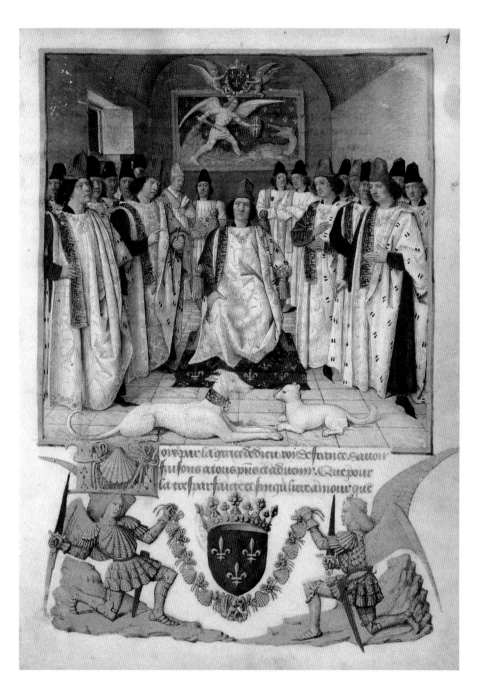

3.
Statuts de l'ordre de Saint Michel, 1470
Louis XI Presiding over a Chapter
of the Order of Saint Michael
Illumination by Jean Fouquet,
20.5 x 15 cm (8⅛ x 5⅞ in.)
Paris, Bibliothèque nationale de France

revolt, Louis de Laval followed him into exile. The Dauphin then made him governor of the Dauphiné (1448).

He seems, however, to have drawn closer to Charles VII when Louis, constantly in revolt against his father, was forced to seek refuge in the court of Burgundy (1456); the Dauphin then relieved Louis de Laval of his governorship of the Dauphiné, replacing him with John V of Armagnac in January 1457. However, in April of that year, Charles VII placed the Dauphiné under direct royal rule and restored Louis de Laval, who then governed in the king's name.

Soon after, he was made governor of the city of Genoa, a function he combined with his governorship of Champagne. Alfonso V of Aragon had just seized the kingdom of Naples; faced with Alfonso's hostility, the doge of Genoa sought a rapprochement with Charles VII and the republic of Genoa placed itself under the protection of the French king in 1456. The first lieutenant of Charles VII at Genoa was René of Anjou's son, John of Calabria, but John was succeeded as governor of Genoa and the Ligurian coast by Louis de Laval, perhaps as early as 1458 and certainly by September 1459.

In the prologue to the *Histoire des neuf preux (Story of the Nine Worthies)*, which he authored in 1460, Sébastien Mamerot refers to Louis de Laval as "lord of Chastillon en Vendelois and of Gael, and governor of the Dauphiné and of the city and lordship of Genoa", but later notes that he began the story of Arthur in "1463 in Provence". Louis de Laval had gone to Provence from the city of Saonne (today's Romans, in the Drôme), where he stayed after leaving Genoa. Almost immediately after his appointment, he had found himself embroiled in a Genoese revolt, which had been fomented by the dukes of Milan; on 10 March 1461, he was forced to take refuge in the citadel of the

4.
David Aubert, Chroniques de Jérusalem, c. 1455
Departure of the Crusaders in 1096
Illumination by the Master of the
Girart de Roussillon (attributed),
28.2 x 54 cm (11 ⅛ x 21 ¼ in.)
Vienna, Österreichische Nationalbibliothek

city and then to retreat westward along the coast to Savona. By 1462, this city, too, was under threat from Milanese and Genoese troops, and he owed his life to the arrival of a rescue expedition sent by Louis XI under the command of the count of Dunois.

A letter signed by him in Romans and dated 29 October 1463 shows that Louis had returned to France by that time, before indeed Savona was definitively handed over by the French to Francesco Sforza, duke of Milan, in February 1464.

Mamerot twice recounted the story of his patron's time in Genoa. He speaks of the first part of Laval's governorship in the King Arthur chapter of the *Nine Worthies* and gives a complete, if tendentious, account of the whole episode at the end of *Les Passages d'Outremer*. In neither case has the history of the Genoese expedition anything to do with the subject of the book.

The death of Charles VII and the coming to power of the Dauphin as King Louis XI in 1461 proved no impediment to Louis de Laval's career. By January 1465 at the latest, he was a member of the king's council and was appointed "lieutenant-general and governor of Champagne" in that same year, probably in April, with the considerable annual income of 6,000 Tours livres. The appointment was made at a critical moment in the struggle between Louis XI and his powerful neighbour, the duke of Burgundy. On his accession to the throne, the new duke, Charles the Bold (r. 1467–1477), set about making himself wholly independent of the throne of France and uniting the dispersed territories that he owned in Burgundy, the Franche-Comté and the Netherlands by conquering Lorraine.

Champagne lay at the frontier between the royal domain and the Burgundian territories and was therefore of the highest strategic importance. Louis de Laval, as gover-

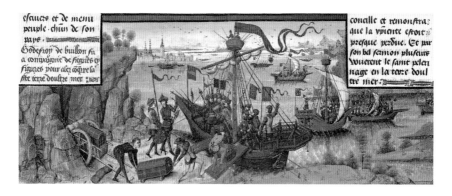

nor and lieutenant-general, was invested with substantial military, political and administrative powers. In Troyes, the regional capital, his second-in-command was another member of the royal entourage and a descendant of an old local family: Michel Jouvenel des Ursins, who twice occupied the post of *bailli*, or steward (in 1457–1461 and 1464–1470). The city was under direct threat from Charles the Bold. Thus, in late 1470, he ordered the confiscation of supplies sent from Troyes. Louis de Laval had to organise the defence of the town and won important victories against the Burgundian troops in 1471.

Though replaced as governor in 1473 by Charles d'Amboise, lord of Chaumont, Louis de Laval enjoyed ever-increasing royal favour throughout the reign of Louis XI. He was appointed "grand master, registrar and reformer general of the waters and forests of France" in 1466; this was not a purely honorific function and it carried an annual income of 12,000 livres along with various privileges. He seems to have continued in this post until his death, since he was confirmed in it by Charles VIII in 1485. When, in 1469, the king founded the Order of Saint Michael, modelling it on the Burgundian Order of the Golden Fleece, Louis de Laval and his brother André de Lohéac were among the first group invited to become members. At its inception, the order comprised only thirty-six members, half of them chosen by the king and the other half by cooptation for their military prowess and fidelity. Jean Fouquet painted the meeting of the chapter or assembly (ill. 3). By the side of the king, we see the secretary of the order (the king's secretary, Jean Robertet) and its chancellor, Guy Bernard, bishop of Langres (whose diocese covered much of Burgundy). They are surrounded by the other members of the chapter, including Louis de Laval, but Fouquet's stereotypical faces make identification almost impossible.

5.
Martin de Troppau, *Chronicon
pontificum et imperatorum*, c. 1395–1400
The Opening Page of the Chroniques Martiniennes
Illuminated page, 38.5 x 25 cm (15 ⅛ x 9 ⅞ in.)
Paris, Bibliothèque nationale de France

Finally, in October 1470, Louis XI entrusted Louis de Laval with the relatively delicate mission of accompanying the queen of England, Margaret of Anjou (the daughter of King René) and her daughter-in-law, the princess of Wales, when they came visit Paris.

We know little about the latter stages of Louis de Laval's life. He ended his career in the service of Charles VIII (r. 1483–1498), who named him *bailli* and governor of Touraine in 1483. We know that he strongly encouraged the king to marry the Duchess Anne of Brittany in order to ensure that the duchy formed part of the royal domain. His fidelity to the French throne was shown even in his death, when he bequeathed to Anne of Beaujeu, daughter to Louis XI, the book that he must surely have loved most: his magnificent Book of Hours. The rest of his library was probably inherited by his most direct descendant, his nephew Pierre de Laval, to whom he bequeathed the family castle at Montjean, which he had received from his brother André some years before. Indeed, the image of Louis de Laval that has come down to posterity is principally that of a literary patron and a passionate bibliophile.[4]

The author: Sébastien Mamerot

It was not uncommon in the Middle Ages for an author to work directly for a rich and powerful patron such as Louis de Laval. In the mid-twelfth century, Benoît de Sainte-Maure, author of the *Roman de Troie*, and Wace, author of the *Roman de Brut* and the *Roman de Rou*, wrote for the English king, whereas from 1170 to 1180, Chrétien de Troyes wrote his chivalric tales at the behest of such powerful patrons as Countess Marie of Champagne, for whom he penned the *Chevalier de la charrette (Lancelot du Lac)*, and

Philip of Alsace, count of Flanders, to whom he dedicated his *Conte du Graal (Perceval)*. Examples of this kind can be found throughout western Europe. In the fifteenth century, the dukes of Burgundy surrounded themselves with a team of professional writers that included Jean Miélot, Olivier de La Marche and David Aubert (ill. 4), educated men who also played a role in the administration of the duchy. The fortunes of Sébastien Mamerot were not dissimilar. He was secretary to Louis de Laval, who bestowed on him an income by appointing him canon of the collegiate church of Saint Stephen in Troyes, and he seems to have accompanied his protector wherever he went, writing exclusively for Laval as and when he was asked. Mamerot was a translator and compiler rather than an author in the modern sense and, as such, perfectly embodies the figure of the professional writer in the late Middle Ages.

By now we know a considerable amount about the life and personality of Mamerot.[5] He was born in Soissons (he regularly refers to himself in his works as "the Soissonais") and was probably the son of Jacques and Jeanne Mamerot: in March 1439, Jeanne claimed the inheritance of her late husband in the name of her son "Bastien", then still a minor. Since the age of majority was fixed at twenty-one, following Parisian custom, we can deduce that Sébastien Mamerot was born in 1418 at the earliest. Another Mamerot, Jaquin, son of Gilles Mamerot, applied for a degree in 1444. Since the name Mamerot is extremely rare, he was probably from the same family. But no trace of the name Sébastien Mamerot has yet been found in the records of the University of Paris. For the moment, then, we can say nothing about his education. Moreover, where his name appears in the registers of the collegiate church of Saint Stephen, no university qualification is cited; he is simply referred to as "canon".

Mamerot's career depended almost entirely on his protector Louis de Laval. He was already in Laval's service by 1458, becoming his chaplain by 1460. We do not know whether he followed his master to Genoa in 1462, when Laval was appointed governor there, but we know that he was with Laval in Provence in 1463 and in Troyes in 1468, since he began the story of Arthur in his *Histoire des neuf preux* in Provence and finished it in Troyes on those dates. It is therefore likely that he accompanied his master to Troyes when the latter was made governor of Champagne by Louis XI in 1466. Thanks to Louis de Laval's patronage, he was also appointed canon at the collegiate church of Saint Stephen in Troyes in 1472.

The chapter of Saint Stephen had been founded in 1157 by Henry I, count of Champagne, known as Henry the Liberal. In Mamerot's time, it was among the richest and most powerful of the realm, with an exceptionally large number of canons: seventy-two. Moreover, it was frequently at odds with the bishop and the cathedral chapter over matters of precedence, independence and revenues. The archives show that Mamerot had the use of a canon's residence near the church and that he attended most of the annual meetings of the chapter, at least until 1477. But he probably did not live all year in Troyes, since Louis de Laval was replaced as governor of Champagne in 1473. Moreover, Mamerot notes that he finished *Les Passages d'Outremer* at Vierzon on 19 April 1474.

We know that the canon's residence was sold on 13 August 1478, the date at which we lose all trace of Mamerot in the archives of Troyes. He may have returned to his master's side or simply have died soon afterwards; *Les Passages d'Outremer* was his last work. His literary output is well known. All of it is dedicated to Louis de Laval and it

dates from a relatively short period: from 1458 to 1474. In the Middle Ages works were often composed somewhat earlier than the date of the manuscripts in which they have been preserved; the manuscripts themselves can often be dated precisely, either because the copyist specified the year in the text or on account of the style of the illuminations. Though we do not know when Mamerot died and cannot therefore definitively claim that he had no part in copying or illuminating the surviving manuscripts, there is no evidence that he was involved in this capacity.

In 1458, Mamerot translated the universal chronicle written in Latin by Martin de Troppau for Louis de Laval, giving it the title *Chroniques martiniennes* (*Martinian Chronicles*; ill. 5). Troppau's text covers the period up to 1277 and was continued by Werner de Liège, who covered the period 1277–1370. A further anonymous text brought the chronicle up to the date of 1424. This was not, in fact, a translation so much as a complete rewrite. Mamerot "completed" Troppau's text with extracts – some of them very long – from a variety of sources, including the books of the Old Testament, histories from classical antiquity and medieval chronicles.

The latter included the *Histoire de la destruction de Troie* (*The Story of the Destruction of Troy*) after the Latin work by Guido delle Colonne and the *Alexandreis* by Walter of Châtillon, a work commissioned by Henry the Liberal of Champagne that recounts the adventures of Alexander the Great in a manner part-epic, part-historical chronicle. Mamerot demonstrates considerable discrimination and independence of judgement, comparing sources and discussing their content and sometimes recording his own conclusions. This relatively new way of approaching history is also found in *Les Passages d'Outremer*.

6.
Benvenuto da Imola, translation
by Sébastien Mamerot, *Romuleon*, c. 1490
Rape of Lucretia
Illumination by Jean Colombe,
44 x 31 cm (17 ⅜ x 12 ¼ in.)
Paris, Bibliothèque nationale de France

The *Chroniques martiniennes* proved to be a considerable success. In 1907, Pierre Champion identified five manuscripts,[6] one of which in all likelihood belonged to Louis de Laval and, around 1504–07, the great Parisian printer Antoine Vérard published an edition that included an abridgement of the *Chronique scandaleuse* by Jean de Roye, which brought the chronicle forward to the year 1503.

Shortly after the completion of the *Chroniques martiniennes*, in 1460, Louis de Laval commissioned from the man now described as his "chaplain" a *Histoire des neuf preux (History of the Nine Worthies)*, which recounts the life and deeds of three heroes from the Old Testament (Joshua, David and Judas Maccabeus; ill. 7), three from classical antiquity (Hector, Alexander and Caesar) and three from the Christian era (Arthur, Charlemagne and Godfrey of Bouillon). In his prologue, Mamerot announced a forth-coming *Vie de Bertrand du Guesclin (Life of Bertrand du Guesclin)*, since the first husband of Louis de Laval's grandmother deserved, in his view, the status of the tenth worthy. However, this *Life* does not appear in the sole surviving manuscript of his *Nine Worthies*. The theme of the *Nine Worthies* appeared for the first time in a sequel to the *Roman d'Alexandre (Alexander Romance)*, called *Les Vœux du Paon (The Vows of the Peacock)*; written by Jacques de Longuyon from 1312 to 1313, it attained considerable popularity. We find it in murals (e.g. in the Castello della Manta, near Saluzzo, in Piedmont, Italy, and the Château de la Valère, near Sion, in the Valais, Switzerland), decorated objects, wood engravings, stained-glass windows and in the *Livre du chevalier errant* by the Italian lord Thomas of Saluzzo (1395; Paris, BnF, Ms. Fr. 12559). The greatest princes of the day possessed tapestries of the *Nine Worthies*: Louis of Anjou (1364), Charles V of France (1379), Philip the Bold, duke of Burgundy (1394), while Louis, duke of

e roy tarquin qui lors eſ
tout aſſe veux comme dit
titus liuius ou premier liure de
la fondacion de la cite aſſiega
vne cite de toſcane nommee ar
dee ſoubz eſperance de la pillier
et les ieunes filz du roy maioient
en comun ſouuent enſemble. Si
aduint vne foiz comme ilz ſoup
poient en loſtel de ſextus tarqui
le maiſne et ſouppaſt auecqz
eulx collatinus tarquin filz de

egenius qui naſquit apres la
mort de ſon pere qui eſtout frere
de luchumon depuis dit tarqui
le vieil qui entrauint mencion
des femmes car chun deulx loit
la ſaenne par merueilleuſe ma
mer. la noiſe enflamma dit
collatinus quil neſtoit neceſ
ſaire faire tant de parolles car
en peu dheures pouoit eſtre ſeu
de quant ſurmontoit ſa lucreſſe
toutes les autres dames ilz eſtoiet

23

Orléans, had each of the nine towers of his castle at Pierrefonds decorated with a statue of one of the Worthies. It is, therefore, no wonder that the subject also attracted Louis de Laval.

The *Histoire des neuf preux* comprises an extraordinarily long text covering 486 folios in the only surviving manuscript, a copy lavishly illuminated by Jean Colombe and dated 1472.[7] Mamerot began to write the text in 1460, and it seems likely that it was completed by 1468.[8]

In 1461, Louis de Laval asked Mamerot to add the *Histoire des neuf preuses (History of the Nine Female Worthies)* to his Nine Male Worthies. The Female Worthies occupy the end of the Vienna manuscript, but their story is much shorter, comprising only 51 folios. The theme of the Nine Female Worthies had been made popular by the poets Eustache Deschamps and Christine de Pisan, the latter in her *Cité des Dames*, in the late fourteenth and early fifteenth century. Thomas of Saluzzo cites both sets of Nine Worthies in his *Livre du chevalier errant*. The list of Female Worthies varies from author to author. Boccaccio and Thomas of Saluzzo cite nine heroines from the ancient world (Semiramis, Lampeto, Sinope, Delphile, Argea or Melanippe, Hippolyta, Penthesilea, Thamyris and Theuca) and to these Mamerot intended to add Joan of Arc, among whose companions-at-arms Louis de Laval's two brothers were numbered. But this text, like that of his life of Bertrand du Guesclin, if it ever came into being, has disappeared.

Meanwhile, in 1466, Mamerot had begun to write a new book, likewise commissioned by Louis de Laval. It was a translation of a history of Rome written in Latin from 1361 to 1364 by an Italian, Benvenuto da Imola: the *Romuleon* (ill. 6). This text

was so famous in the fifteenth century that two translations were made of it simultane-ously. One was commissioned from Jean Miélot by Philip the Good, duke of Burgundy (1460), the other from Mamerot by Louis de Laval. The objective was to make avail-able to a readership not familiar with Latin a more precise account of Roman history; the *Romuleon* was better adapted to the taste of the day than such medieval compilations as *L'Histoire ancienne jusqu'à César (Ancient History until Caesar)* and *Les Faits des Romains (The Deeds of the Romans)*.

There are three manuscripts of the *Romuleon* in Mamerot's translation.[9] The first two are *de luxe* productions, copied onto fine parchment in a meticulous bastard hand and illuminated. The more famous of the two is undoubtedly Ms. Paris, BnF, Fr. 364 (ill. 8). It includes 126 large illustrations and the page layout is similar to that of the manuscript of *Les Passages d'Outremer,* Ms. Paris, BnF, Fr. 5594; it was illuminated by Jean Colombe in his final period of activity (*c.* 1490). Several illuminations use motifs that the artist can only have discovered in *Les Très Riches Heures du duc de Berry*, whose unfinished illuminations he had completed several years before at Chambéry at the request of the duke of Savoy.

This famous manuscript of *Romuleon* was commissioned by the Admiral of France, Louis Malet de Graville (1444–1516), who believed that he was descended from Julius Caesar and therefore felt that he had a family interest in Roman history. The manuscript had entered the Bibliothèque du Roi (Royal Library) in the Château de Blois by 1518.

A second manuscript of the *Romuleon* (BnF, Fr. 365–367, *c.* 1493) comprises three volumes and dates slightly later, though the style of illumination is directly influenced

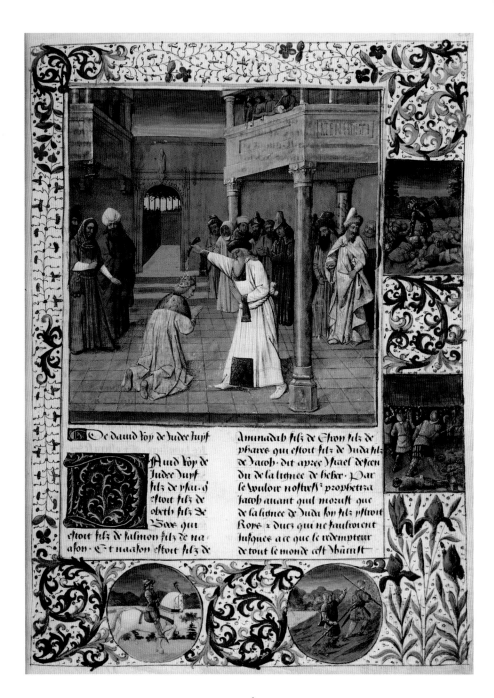

ℭ De dauid roy de Judee huft

Aud roy de
Judee durst
filz de psau. q̃
estoit filz de
obeth filz de
Booz qui
estoit filz de salmon filz de na
afon · Et naason estoit filz de

Aminadab filz de Chon filz de
phaux qui estoit filz de Juda filz
de Jacob · dit apxes Israel descen
du de la lignee de heber · Par
le wulow nostres prophettza
Jacob auant quil mozust que
de la lignee de Juda son filz pstoit
Roye z ducz qui ne fauldroient
Jusques a ce que le redempteur
de tout le monde cest xhamst

7.
Sébastien Mamerot, *Histoire et faits*
des neuf preux et des neuf preuses, c. 1472
The Unction of David by the Prophet Samuel
Illumination by the Master of the Yale Missal,
32.8 x 24.5 cm (12 ⁷/₈ x 9 ⁵/₈ in.)
Vienna, Österreichische Nationalbibliothek

by Jean Colombe since it is the work of his son and grandson, Philibert and François Colombe, and of the studio of another painter from Berry, Jacquelin de Montluçon. The manuscript, whose binding bears the monogram of Henry II of France, belonged to Louis XIV's great minister Jean-Baptiste Colbert, before entering the Bibliothèque du Roi in the eighteenth century.

The third manuscript of Mamerot's *Romuleon* is in the Department of Prints and Drawings at the Staatliche Museen zu Berlin, Stiftung Preussischer Kulturbesitz (Ms. 78 D 10). It is a less sumptuous copy, on paper, featuring 128 pen-and-ink drawings. The governor of Berry, André de Chauvigny, bestowed it on a notable from Lyons, Philippe du Moulin, in 1498.[10]

Another work has only recently been attributed to Mamerot and we do not know when it was written. This is a short treatise on the deeds of Alexander the Great, Pompey and Charlemagne entitled *Les Trois Grands* (*The Three Great Men*; ill. 9). It was obviously close in inspiration to the *Histoire des neuf preux*, since two of the "three" are common to both texts. Two copies of this text are known today. One of these was included in the manuscript of *Les Passages d'Outremer*, Ms. Paris, BnF, Fr. 5594 (fol. 277–281v); the other is in a collection that includes a treatise on heraldry. The interest of the latter is that it was made around 1500–1510 for an eminent member of the Troyes bourgeoisie, Claude Molé, mayor of the city in 1511 and 1512.[11] The presence in Troyes of the secretary of Louis de Laval had clearly not been forgotten in the early sixteenth century.

Les Passages d'Outremer

When and where *Les Passages d'Outremer* was written – surely the most famous of Mamerot's texts after the *Chroniques martiniennes* – is known: at folio 5, the author notes that he began it on 14 January 1472 at the behest of his patron, Louis de Laval, then governor of Champagne under Louis XI (ill. page 81). In the colophon, he states that he completed it at Vierzon on 19 April 1474, shortly after Easter. The chronology of the French kings that follows *Les Passages d'Outremer* in manuscript BnF, Fr. 5594 (fol. 282–284), bears the very same date.

The three manuscripts through which the text has come down to us can all be dated to the end of the fifteenth century, but none of them reveals any information about their making. The most famous exemplar is manuscript Fr. 5594 of the Biblio-thèque nationale de France. It is a sturdy volume comprising 293 large (32 x 23 cm; 12 ½ x 9 in.) folios of the kind of high-quality parchment known as vellum. These are the characteristics of a *de luxe* volume. In addition to *Les Passages d'Outremer*, it contains a number of other texts: on the flyleaves, we find the transcription and translation into French of a letter (ill. page 71) sent by the Ottoman sultan Bayezid II to the French king Charles VIII on 4 July 1488 (fol. 3v–4) – this is clearly an addition that was made after the rest of the manuscript had been completed; Mamerot's *Les Trois Grands* (fol. 277–281v); a short chronology of the kings of France dated 19 April 1474 and entitled *L'ordre des regnes et regnans en France (The Order of the Reigns and Rulers in France)*, which is also the work of Sébastian Mamerot (fol. 282); and finally, a letter from the writer Georges Chastellain to a Benedictine named Castel, with the latter's reply (fol. 284–285).[12]

The binding bears the monogram of Henry II of France (r. 1547–1559) and of his nurse and mistress, Diane of Poitiers, to whom the manuscript no doubt belonged. It then entered the library of the Clermont-Tonnerre family before reaching the collection of Cardinal Mazarin, who was minister to the regent, Anne of Austria, in the early part of the reign of Louis XIV. This manuscript entered the Bibliothèque du Roi in 1668 along with a considerable number of other books in the cardinal's possession.

It was made by at least two copyists; we know this from the differences in writing but also from certain graphic variations (such as the alternation between *–oient* and *–oyent* endings for the third person plural of the imperfect). The rubricator – the scribe who made the rubrics that introduce each chapter – is a further contributor and not to be identified with either of the two scribes. This specialisation was common practice at the time and is the source of further graphic differences from the body of the text in this volume.

The two other manuscripts known to us (Paris, BnF, Fr. 2626, and BnF, Fr. 4769) are also illuminated but they are of an inferior quality. Though both are copied onto parchment rather than paper, the writing was executed hastily. Clearly these were more commonplace productions and ordered by a *libraire* for general sale rather than commissioned by a wealthy patron. In 1868, Achille Chéreau published the late fifteenth-century inventory of a *libraire* whose shop stood "opposite the Dunois town-house" in the affluent quarter of Tours.[13] The 267 items comprised 146 printed books and 121 manuscripts, the latter no doubt produced by the *libraire*'s own workshop. Among them is cited a manuscript volume of *Les Passages d'Outremer*. This may refer not to the *de luxe* exemplar reproduced here but to one of the two other copies now in the Biblio-

8.
Benvenuto da Imola, translation
by Sébastien Mamerot, Romuleon, c. 1490
Some Gauls Preparing an Ambush
Illumination by Jean Colombe,
45 x 32.5 cm (17¾ x 12¾ in.)
Paris, Bibliothèque nationale de France

thèque nationale de France. We should add that, in his *Histoire de Sablé* (*History of Sablé*, 1583; the city of Sablé is now in Sarthe), the local historian Ménage notes that he made use of a manuscript of *Les Passages d'Outremer* that we are now unable to identify.

There is also a printed version dated 1518, which was sold in Paris by the printer-bookseller Michel Lenoir.[14] This volume in fact brings together four different texts. The first is a Paris-Jerusalem itinerary of unknown source. The second is the beginning of *Les Passages d'Outremer*. The third is a description of the Holy Land taken directly from *Sainctes peregrinations de Jherusalem et des lieux prochains, du mont Synaÿ et de la glorieuse Caterine* (*Holy Pilgrimages in Jerusalem and nearby places, Mount Sinai and the glorious St Catherine*), written in 1488 by a Carmelite monk from Pont-Audemer, Nicole Le Huen, and previously published in Lyons and later Paris. After that comes the rest of *Les Passages d'Outremer* with some additional chapters. The presence in this volume of an account of a journey to the Holy Land has led people to suppose that Mamerot made the pilgrimage himself in 1488, but there is no evidence of this contention.

Few copies of this very rare edition exist in libraries[15] and very few were sold during the twentieth century. The other editions sometimes attributed by bibliographies and catalogues (notably that of the Bibliothèque nationale de France) to Sébastien Mamerot have nothing to do with our author. They are editions of *Les passages d'outremer du noble Godefroy de Bouillon, qui fut roy de Hierusalem, du bon sainct Loÿs et de plusieurs vertueux princes qui se sont croiséz pour augmenter et soustenir la foy crestienne*, which begins with the story of Godfrey of Bouillon, and was published by the printer François Regnault in 1517 and 1525. We do not know the author of this work.

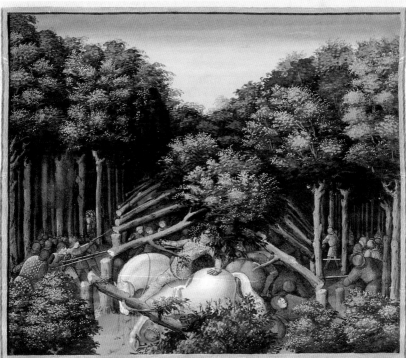

le seruice du temple. Au regard de
la proie elle fut autant grande aux
gaulloys que la victoire. Car com
bien que grant partie des bestes feus
ourisset par le tresbuschement du
bois. Toutesfoys les autres choses
furent trouuees saulues. Ceste descó
fiture nonce a Romme. fut tant
grant que en la cite quils clourent
toutes les stacons cest les boutiques
et escluyes et ouurirent pour quoy
le Senat commist aux dix quils

alassent par la cite et feissent ou
urir les stacons et ostassent ainsi
de la cite la semblance de tristesse
publicque. Titus Sempronius có
sul eust assembler le senat et con
forta et encouraga les Senateurs
afinque eulx qui nestoient pas
rompue pour la desconfiture de
Cannense nencheminassent leurs com
ges aux mendres miseres. Et aus en
tendissent aux aduersaires Cartha
giens et a semblal. Et que la ghi

The history of the crusades

Les Passages d'Outremer tells the story of the crusades, from Charlemagne's mythical expedition to deliver Jerusalem from Arab conquest to one of the last major Christian offensives against the Turks, the defeat at Nicopolis in 1396. His narrative therefore combines legendary elements with historical fact.

The crusades formed one of the principal episodes in the long-running struggle between the Christian and Islam worlds in the Middle Ages. When, in October 732, Charles Martel defeated the Arab armies at Poitiers, Western Christians first became conscious of their unity in the face of the Islamic threat. Then, for several centuries the two worlds paid little attention to each other, though Charlemagne exchanged ambassadors with the caliph of Baghdad, Harun al-Rashid, and local contacts were established in Spain and Sicily. By contrast, the Byzantine world maintained frequent contact with its Arab neighbours; the relations were complex, governed by mutual respect, mistrust and constant commercial and cultural exchanges.

The geopolitical, cultural and religious order of the medieval world underwent seismic changes during the eleventh century. In the West, the structures inherited from the Carolingian Empire disintegrated; Germany was by then made up of rival principalities over which the emperors found it very difficult to impose their authority; Italy had established itself as an urban civilisation in which commerce played a major role; in France, a seigniorial society had formed around the fortresses in which lived free men who performed their military service on horseback and were called knights *(chevaliers)*; and finally the Church of Rome sought to impose its moral, religious and even political authority throughout the West by finally putting an end to the abuses that had

9.
Sébastien Mamerot,
***Les Trois Grands,* c. 1500–1510**
The Emperor Charlemagne
Illumination by the Master of the Entrées
Royales, 16.2 x 11.5 cm (6⅜ x 4½ in.)
Paris, Bibliothèque Sainte-Geneviève

discredited it. The radiant influence of Cluny Abbey (founded in 909) became a symbol of this religious reform, which was also evinced in the long contest between the papacy and the Germanic empire for the right to appoint priests and bishops: the Investiture Quarrel reached a climax when, in 1077, Pope Gregory VII forced Henry IV to beg for forgiveness by presenting himself barefoot at Canossa Castle in Tuscany.

Meanwhile, Byzantine Christianity had reached a high point under the reign of Basil II (963–1025). The empire had retaken the Balkans and dominated all of Asia Minor as far as Mesopotamia, Armenia and the gates of Palestine. It had acquired a solid foothold in southern Italy and still had nominal authority over Venice. The rupture between the patriarch of Constantinople, Michael Cerularius, and the Pope, which occurred in 1054, concerned the question of authority and only much later took on the character of schism. But the formidable Byzantine Empire collapsed in a matter of years under the assault of the Seljuk Turks. Their chief, Tugrul-Beg, captured Persia in 1051 and Baghdad in 1055. In 1071, his nephew Alp Arslan (r. 1063–1072) inflicted a severe defeat on the Byzantine emperor Romanus IV Diogenes outside the Armenian town of Manzikert. Within a few years, Alp Arslan's son Malik Shah I (r. 1072–1092) had conquered almost all of Byzantine Anatolia and captured Antioch (1084), after wresting Jerusalem from the hands of the Arab tribes in 1078. He then established his capital at Nicaea, a mere hundred kilometres from Constantinople. At the same time, the Norman Robert Guiscard seized southern Italy and a new wave of barbarians from the steppes, the Petchenegs, threatened the Danube frontier of Byzantium. When he took power in 1081, the new emperor, Alexius I Comnenus, found his dominions threatened on every side.

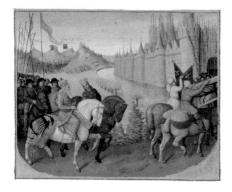

10.
Grandes Chroniques de France,
c. 1455–1460
*Arrival of Louis VII and the Emperor
Frederick at Constantinople*
Illumination by Jean Fouquet,
46 x 35 cm (18 ⅛ x 13 ¾ in.)
Paris, Bibliothèque nationale de France

The First Crusade

The Turkish conquest of the Holy Places in 1078 sent shockwaves through the West. In late 1094, Pope Urban II dispatched an ambassador to Constantinople to improve relations between Rome and the Eastern Church. Though we now know that Alexius Comnenus never appealed to the Pope and Western princes to launch a crusade, he did indeed ask for help and sought to recruit mercenaries to fight the Turks. Urban II, seeking to impose his authority on the Christian West, summoned bishops and abbots to the Council of Clermont (27 November 1095) and called upon them to deliver the Holy Sepulchre under the protection of a cross-shaped emblem that would be their safe-conduct.

Messengers were sent the length and breadth of France and southern Italy to communicate the Pope's speech to the nobility. At the same time, a throng of serfs, peasants, monks and nuns set out in utter disorder under the leadership of a monk from Picardy, Peter the Hermit. All kinds of people joined the throng as it crossed France, Germany and Hungary. The "People's Crusade" finally reached Constantinople in August 1096, its path across Europe strewn with crimes. It was almost entirely destroyed by the Turks in a battle near Nicaea.

While the people were on the march, the barons' crusade was being organised. Godfrey of Bouillon and his brothers, Eustace and Baldwin of Boulogne travelled overland through Germany, Austria, Hungary, the Danube and the Byzantine provinces of Bulgaria and Thrace. The count of Toulouse, Raymond of Saint-Gilles, went by land to the great Byzantine port on the Adriatic, Dyrrhachium (today's Durrës, Albania), where he joined forces with the French barons and the Normans from southern Italy,

the latter led by Bohemond of Taranto. Though they were recalcitrant and attempted to resist, these princes were all forced to pay homage to Alexius Comnenus and to promise to restore to his authority all former Byzantine possessions. The capture of Nicaea in 1097 was the first victory won by the Franks and it opened up the route across Asia Minor to the Holy Land.

The crusaders now divided into two groups. Bohemond met a surprise attack by the Turks at Dorylaeum but was reinforced by Raymond of Saint-Gilles. The Frankish victory in that battle shook the throne of Sultan Kilij Arslan and allowed the crusaders to cross central Anatolia unopposed, though heat and lack of water proved formidable enemies. Baldwin of Boulogne parted company with the main body of the army to conquer the distant city of Edessa, and the other barons reached Antioch in October 1907. The great city was protected by a curtain wall bearing more than 400 towers and was reputed to be impregnable. Over the city stood the huge citadel, in which defenders could take refuge if the curtain wall had been breached. After months of arduous siege, in which many crusaders fell, Bohemond managed to enter the city (2 June 1098), having bribed an Armenian inhabitant named Firouz. But the crusaders were now caught between the Turkish garrison of the citadel and the regent of Mosul, Kerbogha. Alexius I Comnenus, marching to relieve the Christians, was informed that the city had fallen and returned to Constantinople. For the Frankish barons, this was an act of treachery and freed them from the oaths of loyalty that they had taken.

As morale fell in the besieging army, one Peter Bartholomew had an opportune vision, in which it was revealed to him where the Holy Lance – the spear that had pierced the side of Christ on the Cross – was buried. This discovery, made on 15 June,

restored the courage of the crusaders. On 28 June 1098, Bohemond drove Kerbogha back and forced the Turkish garrison of the citadel to surrender. Some days later, he was proclaimed prince of Antioch.

In January 1099, the Frankish barons decided to set out for Jerusalem. The army was now notably thin on the ground (1,500 knights and 12,000 foot soldiers at the most) and arrived in sight of Jerusalem on 7 June. The heat and lack of water made an immediate assault imperative. On 13 June, a first attempt to storm the city failed, but the arrival of ship-borne reinforcements enabled the crusaders to construct siege-engines. On 15 July, two knights from Lorraine first entered the Holy City, followed by the armies of Tancred of Hauteville, Godfrey of Bouillon and Raymond of Saint-Gilles. There followed a dreadful massacre of the Muslim and Jewish inhabitants of the city, which was captured in a matter of hours. Godfrey was elected king on 22 July; on 12 August, at Ascalon, he routed an Egyptian army that had come to reinforce the city. The Franks were now well established in Palestine. Many years went by before their conquest of Palestine was complete, but by the end of 1099, they were masters of most of the Holy Land, Lebanon (gradually conquered by Raymond, who had become count of Tripoli) and the Syrian coast. The Christian states extended from Edessa and Cilicia in the north to the Red Sea.

The Second Crusade

At the death of Godfrey of Bouillon (1100), his brother Baldwin of Edessa succeeded to the throne. His reign and that of his successors saw the consolidation of the Frankish states in Palestine. As conquest was completed, an unprecedented society arose, in which

11.
Vincent of Beauvais, *Miroir historial*, c. 1455
Vincent of Beauvais Reading
Illumination, 7.5 x 8 cm (3 x 3 ⅛ in.)
Paris, Bibliothèque nationale de France

elements of feudal, Byzantine and Arabic traditions found their place. The foundation of the military monastic orders (Hospitallers, Templars, Teutonic Knights) improved the security of pilgrims and contributed to the defence of the new realms.

The rise of Zengi, who became the regent of Aleppo in 1128, brought to an end the relative equilibrium in relations between Christians and Muslims. The Byzantine emperor John II Comnenus (r. 1118–1143) attempted to impose his own authority over Antioch; exploiting the situation created by John's death and the election of the child Baldwin III as king of Jerusalem, Zengi captured Edessa on 24 December 1144. This event had considerable impact in the West and Bernard of Clairvaux decided to preach a new crusade at Vézélay on 31 March 1146. Hearing his inflammatory words, the crowd was filled with enthusiasm.

This time not only great barons but the leading princes of the West took the cross. They included the German King, Conrad III, the duke of Swabia, the duke of Bavaria, King Roger II of Sicily and the King of France, Louis VII, accompanied by his wife Eleanor of Aquitaine. The emperor Manuel I Comnenus (r. 1143–1180) measured out his aid as the crusaders made their way across Asia Minor. But the expedition achieved little more than a brief and unsuccessful campaign against Damascus in July 1148: Edessa remained in Islamic hands, Zengi's son Nur ed-Din had restored the unity of the Turkish principalities under his command and most of the principality of Antioch was also lost. For some years, a fragile peace made up of successive skirmishes and truces prevailed between Christians and Muslims.

But now a series of events revolutionised this situation. Baldwin IV of Jerusalem (r. 1174–85) was afflicted with leprosy; Manuel I Comnenus was defeated by the Seljuks

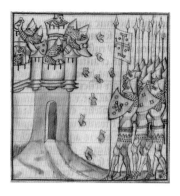

12.
Vincent of Beauvais, *Miroir historial*, 1396
Siege of Jerusalem (1187)
Illumination, 8.5 x 8 cm (3 ⅜ x 3 ⅛ in.)
Paris, Bibliothèque nationale de France

at the battle of Myriocephalum (1176); and Egypt and the Baghdad caliphate were united under the authority of the Kurdish Salah ed-Din (Saladin). The Frankish states were imperilled and, on 3 July 1187, Saladin crushed the Frankish troops at the Horns of Hattin, near Tiberias. On 10 July, the port of Acre capitulated and on 2 October, Jerusalem in its turn fell after a fortnight's siege. The Holy Land was overrun and only Tyre, Antioch, Tripoli and a few isolated fortresses remained in Christian hands.

The Third and Fourth Crusades

News of the loss of Jerusalem was no sooner known in the West than the princes of Europe mobilised to recapture it. The German emperor, Frederick I Barbarossa, took the cross in 1189, followed in 1190 by Philip II Augustus of France and Richard I (the Lionheart) of England.

Frederick left Germany on 11 May 1189, but drowned in the river Saleph (now Göksu) in Cilicia on 10 June 1190. Many of the German knights decided to return home as soon as they arrived in Palestine and only a small number of them came to help Guy of Lusignan, the king of Jerusalem, in his siege of Acre.

On 11 June 1191, Richard the Lionheart arrived at Acre, which surrendered on 12 July. But on 20 August of that year, Philip II, having fallen ill, returned to France. Richard led the crusaders along the coast to Jaffa and on 7 September won a handsome victory over Saladin at Arsuf. After indecisive military operations, a truce was made between Richard and Saladin on 2 September 1192; the Franks were granted possession of the coast of Palestine from Tyre to Jaffa, along with the city of Antioch. These successes were promising rather than satisfactory, and the death of Saladin in 1193 prompted

Pope Innocent III to organise a Fourth Crusade. After the death of the count of Champagne, Tibald III, it was placed under the command of Marquis Boniface of Montferrat. The crusade was set to leave Venice on 29 June 1202. However, they did not have the means to pay for their transport and were therefore requested to recapture the city of Zara (now Zadar), which had revolted against the Serenissima; the campaign began on 11 November. The crusaders then agreed to help Alexius IV, son of the dethroned Byzantine emperor Isaac II Angelus, replace his father on the throne. Constantinople was taken for the first time on 17 July 1203 after fierce fighting. But Alexius IV proved unable to fulfil his promises of financing the crusade, and the Byzantine populace rebelled against the crusaders and overthrew the emperor that they had imposed. The city was therefore again attacked and captured on 9 April 1204. After the wealth of the city had been savagely pillaged, the Byzantine Empire was shared out between Frankish barons.

Most of the crusaders' contemporaries viewed the result of the Fourth Crusade with astonishment and dismay; the massacre of other Christians, even if they were schismatic, was unacceptable. Moreover, some of the troops sent to the assistance of the Holy Land were deployed in Greece, where the pickings were deemed to be richer. However, the Frankish states in the Levant continued to resist the Turkish threat for a further century.

13.
Vies et miracles de Monseigneur
Saint Louis, 1450–1500
Departure of Saint Louis for the Crusade/Meeting
with the Pope at Lyons/Demolition of the Fortress
of Roche du Clin
Illumination, 37 x 26.5 cm (14 ½ x 10 ⅜ in.)
Paris, Bibliothèque nationale de France

The Last Crusades

The crusading aspiration was not extinguished by the disastrous capture of Constantinople. Many pilgrims, some of them soldiers, continued to embark on journeys to the Holy Land. The "children's crusades" in 1212 and 1223 brought together millions of men, women and children in Germany and France but most of them were simply sold into slavery.

In 1213, Pope Innocent III issued a new appeal. Philip II was at war with the English king, John Lackland (who was allied with the German emperor), and the Fifth Crusade consequently mobilised the knights of central rather than western Europe. Its spiritual leader was Francis of Assisi but its temporal leaders were Andrew II of Hungary and Leopold VI, duke of Austria. This was the first crusade whose target was Egypt, now considered the centre of Muslim power. However, it achieved little beyond briefly capturing the Egyptian port of Damietta, in 1219.

The Sixth Crusade was the work of Emperor Frederick II of Hohenstaufen, who in 1225 married the heiress to the throne of Jerusalem. Frederick arrived in Acre on 7 September 1228 and on 18 February 1229 arranged a ten-year truce with the sultan of Cairo, al-Kamil. By this treaty, the Franks recovered Jerusalem, Bethlehem and Nazareth, though the Islamic holy places were left in Muslim hands. Having made a triumphal entry into Jerusalem on 17 March, Frederick left the Holy Land on 1 May. Jerusalem was retaken by the Turks when the truce ended in 1239. The poet Tibald IV of Champagne recaptured the Holy City briefly in 1240–44, but its fate had by now ceased to concern the West.

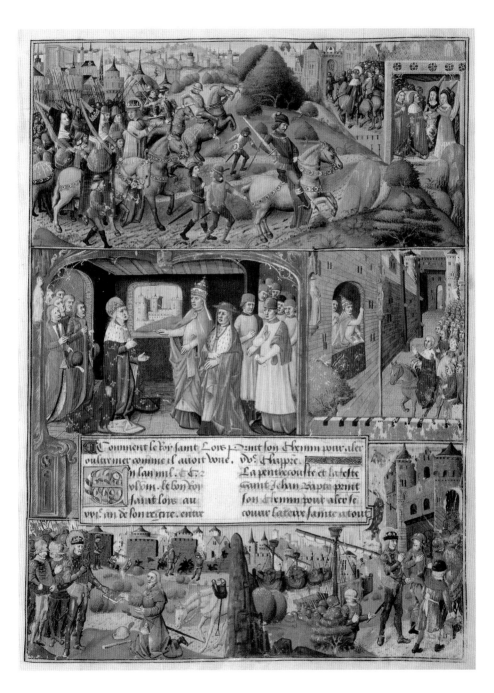

Comment le Roy saint Lois print son Chemin pour aler
oultre mer comme il auoit voue. ꝑꝰ Chappie.

En lan mil. ꝉ. & z
lviij. le bon Roy
saint lois au
vij. an de son regne. entra

La pentecouste et la feste
saint Jehan Bapta print
son Chemin pour aler se
couure la terre sainte a tout

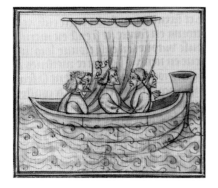

14.
Vincent of Beauvais,
Miroir historial, 1396
Assembled Crusaders
Illumination, 7 x 8 cm (2 ¾ x 3 ⅛ in.)
Paris, Bibliothèque nationale
de France

The Crusades of Louis IX

News of the fall of Jerusalem nevertheless incited Innocent IV to call for a Seventh Crusade, in 1245. Only the pious French king Louis IX (r. 1226–1270) responded to his appeal. He embarked at Aigues-Mortes in August 1248 with all the dignitaries of his kingdom and set out to attack Egypt. He won an initial victory at Damietta (June 1249) and rejected the sultan's offer of a peace settlement that included the restitution of all the lands conquered by the Muslims since 1244; this would have included Jerusalem. Unable to advance beyond the fortress of Mansourah, Louis was taken prisoner on 5 April 1250. He was ransomed for a huge sum and then set about organising the defence of the last remaining Christian strongholds of Outremer before returning to France in April 1254. But by 1263, the dissension among the Frankish barons offered favourable conditions for the Mameluk offensive led by Sultan Baibars. Most of the coastal cities and the last inland strongholds fell one after another. Louis IX therefore renewed his crusading vows in 1267 and headed an expedition against Tunis in the hope of converting the emir and leading him on a joint invasion of Egypt. But this eighth and last crusade failed almost completely: Louis died of the plague under the walls of Tunis on 25 August 1270.

The fate of the Frankish states in Palestine was now sealed. Tripoli fell in 1289 and Acre was wrested from the Templars after a fierce battle in May 1291. During the summer of 1291, the last Christian strongholds fell into Baibars's hands. The adventure of the crusades was at an end. Later expeditions, such as the Nicopolis "crusade" of 1396, no longer sought to obtain a Christian state in the Holy Land but merely to ensure the defence of the Byzantine Empire, which was now surrounded by the Ottoman Turks.

The content of *Les Passages d'Outremer*

By the time Stéphane Mamerot began writing *Les Passages d'Outremer*, the crusades were only a distant memory. The last substantial military expedition involving French knights had ended in disaster at Nicopolis (1396). The battle of Varna in Eastern Bulgaria (1444), another heavy defeat inflicted by the Turks, principally involved the Hungarian king, John Hunyadi, the despot of Serbia, Durad Brankoviç, and the king of Poland, Władysław III. Constantinople fell into the hands of the Ottomans in 1453, the Byzantine Despotate of Morea (which more or less encompassed the Peloponnese) in 1460 and the little Greek empire of Trebizond in 1461. Mamerot alludes to the fall of Trebizond in his prologue, perhaps because the memory still lingered in the French court of the ambassadors sent by Emperor David Comnenus to implore Charles VII to provide aid against the Turks. Of the Latin holdings in the East, only Rhodes survived (governed by the Knights Hospitaller of St John of Jerusalem), a few Venetian possessions in the Aegean and the kingdom of Cyprus, which had remained in the hands of the Lusignan family.

However, the crusades had not entirely faded from memory in the 1470s. "Good King" René of Anjou, the putative sovereign of a kingdom of Jerusalem that had long since vanished (and of a kingdom of Naples now definitively lost to the Aragonese), entertained chimerical dreams of reconquering the Holy Land. When news came of the fall of the Byzantine Empire, the Burgundian nobility unanimously resolved to undertake a new crusade at the sumptuous "Feast of the Pheasant" (1454).[16] They were, of course, never called upon to fulfil their promise. We are therefore reduced to hypothesis in explaining why Louis de Laval became interested in the crusades.

It might be thought that Mamerot's mission was to record the family history of his protector; Guy IV had taken an active, if modest, part in the First Crusade and Guy XIII had died in Rhodes in 1414 while returning from a pilgrimage to the Holy Land. Among Louis de Laval's ancestors, Robert I of Vitré (d. 1090) and André II de Laval (d. 1211) had also made the pilgrimage, while André III of Vitré died in Egypt while fighting alongside Louis IX at the battle of Mansourah on 8 February 1250. But the supposition is incorrect. These names are, strangely enough, absent from *Les Passages d'Outremer* and Mamerot never even cites the lordship of Laval. Indeed, Louis de Laval had been able to acquaint himself with certain of these events in the *Chroniques martiniennes* translated and adapted by Mamerot in 1458. Moreover, both Charlemagne's mythical expedition to Jerusalem and the First Crusade featured in the *Histoire des neuf preux* that Mamerot had written in 1460 at his master's request: Charlemagne and Godfrey of Bouillon were among the three Christian Worthies.[17]

Mamerot's narrative follows a relatively simple chronological line, as we can see from the detailed résumé below. He begins with the fictive expedition supposedly led by Charlemagne to the Holy Land to rescue Jerusalem from the Saracens. The story goes that Charlemagne was asked to undertake this crusade by the Byzantine emperor Constantine V and his son, the future Leo IV (ch. I–V). The legend first appears in the tenth century in the *Chronicon* by Benoît de Saint-André de Mont Soracte; the *Chanson de Roland*, too, seems to allude to it. In his universal chronicle, written around 1420, Guy of Bazoches states that Godfrey of Bouillon's crusade is considered the second because Charlemagne had led the First Crusade. The legend was popularised by Pierre de Beauvais, who, in the early thirteenth century, wrote a Latin history of the transla-

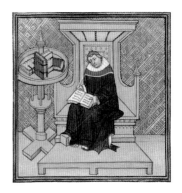

15.
Grandes Chroniques de France,
14th century
Einhard Writing
Illumination, 45 x 32.5 cm
(17 ¾ x 12 ¾ in.)
Paris, Bibliothèque nationale de France

tion of the relics of Saint Denis, which were thought to have been obtained in the wake of Charlemagne's victorious crusade (Beauvais's authority for this is the *Pseudo-Turpin Chronicle*). This narrative was then incorporated into the *Grandes Chroniques de France* (ill. 16) written in the abbey of Saint Denis and subsequently into the *Miroir historial (Speculum historiale; Mirror of History)* by the Dominican Vincent of Beauvais (the only source that Mamerot cites for the beginning of his history; ill. 11).[18] A French version of the *Miroir historial* exists in manuscript form in the Bibliothèque de l'Arsenal.[19] The legend was also popularised by the *chanson de geste* entitled *Galien le Restoré (Galien Restored)*.

A historian as scrupulous as Sébastien Mamerot can never have given the least credibility to this myth. Jerusalem was conquered by the Arabs in 638, while Constantine V reigned from 741 to 775. Yet, Mamerot clearly favoured the myth over historical truth. His narrative continues with a long account of the events of the First Crusade, from the council held in Clermont by Pope Urban II (1095; ill. 16) to the foundation of the kingdom of Jerusalem and the election of Godfrey of Bouillon as king in 1099 (ch. VI–XXXV). The reigns of Baldwin I, Baldwin II, Fulk and Baldwin III are more succinctly dealt with, taking us up to the capture of Edessa by Zengi in 1144 (ch. XXXVI–XLII). The Second Crusade, preached by Saint Bernard of Clairvaux and led by the German King Conrad III of Hohenstaufen and the French king, Louis VII (ill. 10), is described at some length (1147–1149; ch. XLIII–XLVIII). What follows is the complex history of the alliances and conflicts between the Latins and the Byzantines under Emperor Manuel Comnenus, the growing power of Nur ed-Din and Saladin and the tensions within the kingdom of Jerusalem (ch. XLIX–LIX).

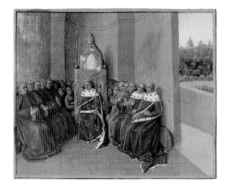

16.
Grandes Chroniques de France,
c. 1455–1460
Preaching the First Crusade
Illumination by Jean Fouquet,
46 x 35 cm (18⅛ x 13¾ in.)
Paris, Bibliothèque nationale de France

Saladin's defeat of the Franks at Hattin (1187), his capture of Jerusalem and the Third Crusade (1189–1192) led by Frederick Barbarossa, Philip II Augustus of France and Richard I of England occupy chapters LX–LXVI. There follows a short account of the Fourth Crusade, in which Mamerot foregrounds the usurping role of the Byzantine emperors Andronicus I Comnenus and Isaac II Angelus in order to justify the Latin conquest of Constantinople (1204; ch. LIX and LXVIII). Mamerot sketches in the Sixth Crusade led by Emperor Frederick II (1228–29) and the abortive expedition of Tibald IV of Champagne in 1240 (ch. LXIX–LXXII). He tells in greater detail of the expeditions led by Louis IX of France to Egypt and Tunis (1248–1254 and 1270; ch. LXXIII–LXXX; ill. 13).

Having taken the view that the subsequent overseas expeditions were not really crusades, Mamerot resumes his narrative again in 1388 to recount a small expedition led by Charles VI to bring help to the Genoese holdings in the Levant (ch. LXXXI–LXXXII). Finally, he tells of the disastrous crusade defeated at Nicopolis (1396) and the assistance brought by Marshal Boucicaut to Emperor Manuel II Paleologus when the latter was besieged in Constantinople by the Turks. *Les Passages d'Outremer* ends with events in Genoa, where first Marshal Boucicaut, and later Louis de Laval, governed in the name of the French king (ch. LXXXIV–LXXXVIII).

There are some surprising choices among the events that Mamerot included in his chronicle. The internal history of the Latin states is given scant treatment and no mention at all is made of the Fifth Crusade, no doubt because no French knights took part in it. He similarly fails to mention the fall of Acre and of the last Christian holdings in the Holy Land (1291). His account of the conquest of the Byzantine Empire is confined

to the capture of Constantinople. Mamerot does not cite the creation of the Frankish principalities in Greece, despite the fact that French knights – and notably those from Champagne – were prominent in their conquest. The efforts to organise new expeditions after the fall of Jerusalem are passed over in silence until Charles VI's rather insignificant campaign on behalf of Genoa. The only justification for the inclusion of this minor episode is the fact that Louis de Laval became governor of Genoa several decades after that campaign. Mamerot's objective seems in fact to be that of recounting the major trans-Mediterranean expeditions by the French knights and barons (and by extension, those of other western European countries) and not at all that of writing a story of the crusader states.

A detailed study of the sources of *Les Passages d'Outremer* has not yet been undertaken. Mamerot himself indicates certain of them: first and foremost, the *Miroir historial* by Vincent of Beauvais (ill. 12, 14), a widely disseminated text of which Louis de Laval, as we have seen, possessed a manuscript copy dating from the fourteenth century (ch. XXVI);[20] then William of Tyre's *Historia rerum in partis transmarinis gestarum* (*History of Deeds Done Beyond the Sea*; see ch. LII and ill. 19);[21] and finally the *Livre de Boucicaut*, which he sometimes cites verbatim (ch. LXXXIII).[22] Mamerot is guilty of certain chronological and topographical errors, but this is not surprising; he had never been to the Holy Land and was working entirely from secondary sources – manuscript sources that were particularly vulnerable to errors of transcription.

As the notes to the text suggest, Mamerot's history is underpinned by a very strong aristocratic ideology that undoubtedly reflects the views of his protector. He believed that the prime mover in the crusades was the nobility, while the plebeian foot-soldiers

were incapable of understanding the issues and were prone to falling prey to irrational emotions. At the end of chapter VIII, he explains the failure of the People's Crusade thus: "And thus was annihilated and lost that great army, through the pride and outrage of the common people, who would not obey the knights and other nobles, captains and chiefs who were experts in the art of war. This shows how dangerous it is to entrust the adventure of combat to those who know nothing of it." And at the end of chapter XXIV, he praises the wisdom of the princes: "And the common people would have lost all hope had it not been for the great wisdom, prudence and steadfastness of the princes and great barons."

Feats of arms and exploits of extraordinary courage, the political and military strategy of the Frankish barons, siege operations and battles are all described in detail, particularly with regard to the First Crusade, which is recounted at much greater length than the later expeditions.

Mamerot presents the Byzantines in an extremely unfavourable light; in doing so, he follows a tradition deriving from the earliest chronicles of the First Crusade. Only John II and Manuel I Comnenus are considered at all respectable, while Alexius I Comnenus is viewed as treacherous, duplicitous and cruel; he is no ally, but instead the enemy of the crusaders, a man eager to seek any pretext for reneging on his promises to them.

Though Mamerot never so much as mentions the part played by his patron's ancestors in the crusades, he frequently cites the counts of Champagne, Henry I the Liberal (1152–1181), Henry II (1181–1197, king of Jerusalem after 1192), Tibald III (1197–1201) and Tibald IV (1201–1253), and more than once refers to the fact that

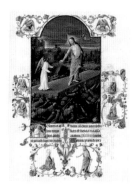

17.
Les Très Riches Heures du duc de Berry, c. 1483–1485
The Resurrection
Illumination by Jean Colombe,
29 x 21 cm (11 ⅜ x 8 ¼ in.)
Chantilly, Musée Condé

Henry I founded the collegiate church of Saint Stephen in Troyes (e. g. in chapters XLIII and LVI). He also emphasises the Champenois origins of several lords: Guy of Possesse, Hugh of Payens, the founder of the Order of the Temple in 1119, and Miles of Plancy. These references testify to his interest in Troyes and Champagne.

The illuminator: Jean Colombe

During the fifteenth century, Bourges was an important centre of illumination. The initial impulse for this activity came from the presence in the town of John, duke of Berry (1340–1416). The brother of Charles V and uncle of Charles VI of France, John was one of the key figures in the kingdom when Charles VI succumbed to madness. A lavish patron of the arts and bibliophile, he possessed one of the finest collections of illuminated books of his time. When the Dauphin Charles, the future Charles VII, was disinherited by the Treaty of Troyes (1420), he in his turn moved to Bourges. Subsequently, the artistic life of the city continued under the patronage of the financier Jacques Cœur.

The second period of Bourges illumination began in the 1460s and centred on the figure of Jean Colombe. Thanks to the proximity of Tours and the palaces of the Loire valley – the favourite residences of Louis XI, Charles VIII and Louis XII – several artistic centres arose in the region. Court commissions allied to several other factors favoured their growth. The university in Bourges – which had been founded at the behest of Louis XI and as a result of Louis de Laval's commitment to the cause between 1467 and 1470 – no doubt played a role in the rise of the local *libraires*. But behind the growth of illumination in Bourges, there lay a broader tendency, favoured by the economic

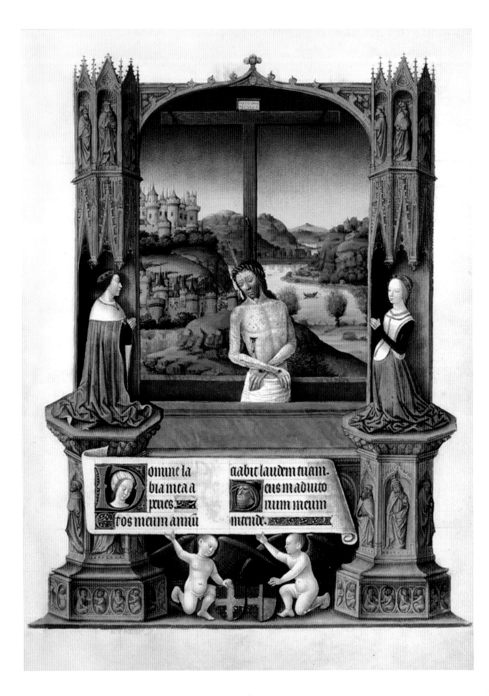

18.
*Les Très Riches Heures du duc
de Berry*, c. 1483–1485
Man of Sorrows
Illumination by Jean Colombe,
29 x 21 cm (11 ⅜ x 8 ¼ in.)
Chantilly, Musée Condé

recovery of the French kingdom after the end of the Hundred Years' War in 1453. The aristocracy, senior figures in the church and the financial and mercantile bourgeoisie (then in the ascendant) were creating libraries and therefore commissioning manuscripts, many of them lavishly illuminated, from local artists or those established in the main centres of production, primarily Paris and the Loire valley. The introduction of printing in the 1460s did not eliminate this industry, which came to an end only later, in the 1520s. For many years, the custom continued of embellishing certain printed works with ornamental capitals or illuminations, just as if they had been manuscripts.

Though the production of illuminated manuscripts in Bourges was not confined to Colombe's studio,[23] there was no other illuminator of comparable importance in the city.[24] Now considered one of the most important French painters of the late fifteenth century, he was rescued from anonymity as late as the early twentieth century, when Paul Durrieu wrote about him in his study of *Les Très Riches Heures du duc de Berry* (1904).[25]

Jean Colombe was born in Bourges, it would seem around 1430–1435, to Philippe and Guillemette Colombe. His elder brother was the sculptor Michel Colombe. His activity as an illuminator began around 1463, at which time he was living in the house of a copyist named Clément Thibault. The following year, he married a woman named Colette and set up house opposite his mother's home. He made sufficiently rapid progress in his career to be able to buy a house in 1467. There, he lived until his death, which was probably in 1493. At all events, he was no longer alive by 10 November 1498, when a house that he had bought in 1483 was sold and the deed described him as "the late Colombe".

Colombe initially drew his inspiration from the work of two great illuminators of the previous generation, both of whom had been active in the Loire valley: Barthélémy d'Eyck and – above all – Jean Fouquet. Colombe then came to the attention of Louis XI's wife, Queen Charlotte of Savoy, for whom he illuminated at least two manuscripts: *Les Douze Périls d'Enfer (The Twelve Perils of Hell)*[26] and a *De Vita Christi (On the Life of Christ)*.[27] It was probably at the request of Charlotte that he painted a book of hours for her daughter, Anne of France, the future Anne of Beaujeu (*c.* 1470–1480).[28] In a letter written sometime between 1469 and 1479, Queen Charlotte asked Louis XI's councillor, Imbert de Bastarnay, to exempt Jean Colombe, "a poor illuminator in Bourges", from tax and from his obligations as a constable of the watch.

Charlotte was no doubt responsible for the fact that Colombe next worked for her brother, Duke Charles I of Savoy and his wife, Blanche of Montferrat. We know that the need to find new outlets for their art often forced artists to move from city to city or even take up permanent residence far from their native towns. In 1485, Colombe completed the illumination of one of the most famous Gothic manuscripts, *Les Très Riches Heures du Duc de Berry* (ill. 17, 18), which at that time belonged to the House of Savoy.[29] It had been left incomplete in 1416 by the death not only of the duke of Berry, who had commissioned it, but of its illuminators, the Limbourg brothers. Colombe next completed an *Apocalypse* (*c.* 1489)[30] for the House of Savoy, receiving payment of 400 florins the following year. The favour in which he was held at the Savoy court in Chambéry was demonstrated in 1486 by the title of official illuminator to Duke Charles I and subsequently of *familier* (member of the household) with a salary of 100 florins a year. Towards the end of his career, Colombe illuminated a *Histoire de Merlin (Story of*

Merlin) and a *Histoire du Graal (Story of the Grail)* for another member of the ducal family, Jean-Louis of Savoy, bishop of Geneva.[31]

The influence exerted on Colombe by the *Très Riches Heures* was considerable. He subsequently reused many of its motifs in his own compositions, a fact that allows us to date his compositions with some precision. Colombe also obtained numerous commissions from members of the royal entourage. Among them, we should note the king's secretary, Jean Robertet, who around 1470 asked Colombe to complete the illumination of a little book of hours begun by Jean Fouquet for Antoine Raguier (ill. 22, 23);[32] Geoffroy de Victorines, head of the king's household;[33] the bastard Louis of Bourbon, count of Roussillon, for whom he illustrated a *Vie du Christ (Life of Christ)* in three volumes;[34] the duke of Orleans, the future King Louis XII, around 1490;[35] and, of course, Louis de Châtillon-Laval, who was to become one of his most loyal patrons.

Laval commissioned from Jean Colombe an extraordinary book of hours (Paris, BnF, Ms. Lat. 920). The first stage of illumination, dating around 1470–1475, had been commissioned from another artist, born, like Fouquet, in Tours, who is known to us merely as the Master of the Yale Missal. Colombe completed this first stage, which comprised full-page illuminations and illustrations of the upper register of the manuscript. Then, during the 1480s, he undertook the rest on his own: this involved a cycle of illuminations illustrating the Old Testament in the bottom margin of the pages.

Louis de Laval also had illuminated a *Histoire des neuf preux*,[36] dated 1472, in which the Master of the Yale Missal played a part, and *Les Passages d'Outremer* (the manuscript reproduced here, BnF Fr. 5594, *c.* 1475). The superb manuscripts of *La Fleur des histoires (The Flower of Histories)* by Jean Mansel and of Mamerot's translation of *Romuleon*,[37]

both made for Admiral Louis Malet de Graville, belong to the last phase of Colombe's career and date from after 1485, as shown by the numerous quotations from *Les Très Riches Heures du duc de Berry*. The *Romuleon* manuscript is undoubtedly a copy of one made for Louis de Laval and now lost. A manuscript of *Le Gouvernement des princes* (*The Government of Princes*; Paris, BnF, Bibliothèque de l'Arsenal, Ms. 5062) illuminated by Jean Colombe and at one time in the possession of Béraud Stuart, lord of Aubigny, may originally have been intended for Louis de Laval; the frontispiece miniature is a portrait of Laval, whom we immediately recognise in the broad, sleeveless red surcoat that he is so often depicted wearing.[38]

Colombe worked not only for the aristocracy close to the royal court, but for members of the bourgeoisie. A rich Bourges merchant, Jean I Lallemant, almost certainly commissioned a book of hours (Bourges use) now in New York.[39] The presence of Louis de Laval in Troyes when he was governor of Champagne (1465–1474) surely has to do with the fact that Colombe illuminated a number of manuscripts for important families from that city. Thus, his studio illuminated a modest book of hours mentioning saints particularly venerated at Troyes (Savinian, Mastidia, Loup, Syre).[40] Three manuscripts incorporating the arms of the Troyes family Le Peley would seem to be from Colombe's hand. The most important of these is undoubtedly the magnificent book of hours acquired in 2005 by the Médiathèque de l'Agglomération Troyenne (ill. 21).[41] Its exceptionally ambitious programme of illuminations follows an iconographic model and a layout very close to that of Louis de Laval's Book of Hours. There are no quotations from the *Très Riches Heures*, which suggests a date relatively early in the 1480s. It was made for Guyot II Le Peley and his wife, Nicole Hennequin.[42]

19.
William of Tyre, *Historia rerum*
in partis transmarinis gestarum,
12th–13th century
Philip Augustus and Richard I
the Lionheart
Illumination, 40 x 29 cm
(15 ¾ x 11 ⅜ in.)
Paris, Bibliothèque nationale de France

Colombe's studio was extremely prolific. Its activity spanned a period of some thirty years, from around 1465 to 1493 (the presumed year of his death). Countless manuscripts were produced, many of them containing a multitude of miniatures. Louis de Laval's Book of Hours contains no less than 1,234 miniatures. The book of hours for that lesser personage Guyot II Le Peley was somewhat smaller in format but nevertheless contained 571 miniatures. Colombe began his career in a notably competitive milieu and he no doubt benefited from his association with the *écrivain de forme* (manuscript calligrapher) Clément Thibault. Success seems to have come early, despite his being described as "poor" by Charlotte of Savoy, given that he was quickly able to buy his own house.

Among the manuscripts produced by Colombe's studio, there were – as one might expect of the period – a large number of books of hours[43] and missals,[44] but also more ambitious projects, such as chronicle histories,[45] chivalric romances,[46] religious treatises and works of moral edification.[47] These manuscripts often use closely related decorative motifs, characters and compositions, whose combination allows us to define a readily recognisable "Jean Colombe style" despite the changes visible over the course of his career.[48] Indeed, at times that style is almost stereotypical, particularly in the minor productions of the studio, to which the master no doubt added a few last-minute "final touches".

From the outset, Colombe seems to have worked very economically, developing a set of formulae that allowed him to fulfil the numerous commissions that he received as quickly as possible. Compositions were simplified. He used tricks, such as representing crowds from an overhead perspective, so that only skulls, haloes and skull-caps

20.
Guido delle Colonne, *Histoire de*
***la destruction de Troie*, c. 1495–1500**
Paris Leaving Troy
Illumination from the studio of Jean Colombe,
49.5 x 33 cm (19 ½ x 13 in.)
Paris, Bibliothèque nationale de France

were depicted (e.g., fol. 109, 205, 235, 248v, 263v). In the backgrounds, which border on the naive, light blues and greens predominate. The angular – almost square – faces of the male figures contrast with the idealised oval visages of the female figures, whose pale flesh tones are subtly highlighted with pink at the cheeks and whose eyes are modestly lowered beneath their high, shapely brows.

The full-page paintings often boast architectural frames, generally Gothic in inspiration (ogee arches, polygonal pilasters on bases) rather than Renaissance (columns incrusted with precious stones and pearls, semicircular arches). The niches in the columns – which are sometimes quite considerable in number – contain statues of prophets, apostles and Biblical personages, which are always related to the principal scene. The friezes are adorned with putti or bear inscriptions, often in the form of an *incipit* (the first words) of a prayer. The constant presence in his illuminations of representations in bas-relief has led certain commentators to wonder whether "the Colombe illumination studio was not strongly influenced by the work of the sculptor Michel Colombe".[49]

Later in his career, Colombe became a master of interior decoration on a miniature scale and often painted walls covered with frescoes or grisaille bas-reliefs, their scenes commenting on the principal subject of the painting. He still liked group scenes, but now rendered them as a mass of faces in serried ranks. His horses are squat and often seen from behind or in three-quarter profile. The peaceful landscapes have grown ever more complex and rock excrescences of improbable and distorted forms now emerge from them (see fol. 140v, 143v, 197). He became a specialist in realistic urban backgrounds, with half-timbered houses evocative of the streets of Bourges and other French cities. Examples in the manuscript in the Bibliothèque nationale de France include

facsimile include folios 11 and 274v; at folio 8, the image of Paris is easily recognisable thanks to the towers of Notre-Dame.

Like Fouquet before him, Colombe showed particular skill in representing richly ornamented monuments (e.g., fol. 76, 97v, 118, 202v), cathedral portals and Gothic palaces; among the latter, we often recognise the favourite residence of the duke of Berry, Mehun-sur-Yèvre, near Bourges, which also appears in the *Très Riches Heures*. In this and a number of other manuscripts, there are many paintings of large and mighty warships (fol. 112, 211, 217, 269v).

In his less luxurious productions, Colombe uses monochrome abstract forms that can be quickly painted, but to which a master can add details that evoke volume or depth. He therefore makes undeniably effective use of gold to pick out the folds of clothing. The manuscripts whose illumination remains unfinished (e.g., BnF, Fr. 91) or in which the underlying drawing can be seen beneath the worn paint, allow us to perceive how lively Colombe's compositions were: the protagonists are rapidly sketched with an impulsive line that vividly renders movement and narration. The subsequent painting phase allowed the artist to complete the image with picturesque details and decorative elements designed to satisfy the patron who had commissioned the work.

Comparison of representations of the same scene from manuscripts made for different patrons shows that Colombe also varied his representations to suit his clients' expectations. For the famous scene in which David sees Bathsheba bathing, he produced chaste illuminations in which Bathsheba dips her legs in the waters with her skirts rolled up (ill. 24)[50] and others in which a brazen and even seductive Bathsheba stands stark-naked and full-frontal.[51]

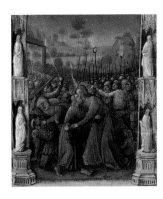

21.
Guyot Le Peley's Book of Hours,
c. 1475–1480
The Arrest of Christ
Illumination by Jean Colombe,
13 x 9.4 cm (5 ⅛ x 3 ¾ in.)
Troyes, Médiathèque de l'Agglomération
Troyenne

The influence of Jean Colombe continued after his retirement and death. His son Philibert and his grandson François continued to illuminate until the early sixteenth century, adopting certain of the iconographic models established by Jean Colombe. We also have manuscripts illuminated by another painter who worked with him, Jacquelin de Montluçon, and which are, as it were, continuous with Colombe's work. We might say the same of the anonymous artist known as the Master of Spencer 6, who can perhaps be identified with the illuminator Laurent Boiron, active in Bourges from 1490 to around 1510. Among the manuscripts decorated by this master, we can count a beautiful book of hours,[52] certain pages of the *Histoire de la destruction de Troie la grand* (ill. 20),[53] an interesting book of hours according to the use in Rome,[54] a faithful copy of the manuscript (belonging to Louis XII) of Claude Seyssel's translation of Xenophon's *Anabasis*, which was commissioned from the master by Duke Charles I of Savoy,[55] and a fairly large number of more modest books of hours, made for women of the bourgeoisie and the petty nobility.

The illuminations of manuscript BnF Fr. 5594

As we have seen, Louis de Laval had several manuscripts illuminated by Jean Colombe while the latter was based in Bourges. Before *Les Passages d'Outremer*, he had commissioned the decoration of his magnificent Book of Hours,[56] which was illuminated in two stages (in the early 1470s and the 1480s), and *L'Histoire des neuf preux et des neuf preuses* (1472).[57] It seems likely that he also possessed a manuscript, very probably illuminated by Jean Colombe, of Mamerot's translation of *Romuleon*, the exemplar from which Louis Malet de Graville's manuscript of that work was copied.[58]

22.
Jean Robertet's Book of Hours, 1460–1470
Saint Luke
Illumination by Jean Fouquet,
10.8 x 8 cm (4 ¼ x 3 ⅛ in.)
New York, Pierpont Morgan Library

The style of the miniatures, still a little dry and with very bright colours, places the work on *Les Passages d'Outremer* early in Colombe's career, in the 1470s. The beautiful scene on folio 5 (ill. p. 81) shows the author handing his patron, Louis de Laval, the work that the latter had commissioned. Laval is easily recognised from his "signature" red surcoat with split sleeves, which is also seen in his Book of Hours[59] and in the Louis Malet de Graville manuscript of the *Romuleon*.[60] Though, in the lower part of the scene, his coat of arms has been scratched out – no doubt by some subsequent owner – it remains intact at folios 19 and 176v. Everything suggests that this was the dedicatory exemplar and that it must have been copied and illuminated shortly after Mamerot had completed his text, probably as early as 1474–75.

There are sixty-six paintings in our manuscript of *Les Passages d'Outremer*; this may be insignificant compared to the 126 in the *Romuleon* and the much larger number in Louis de Laval's Book of Hours, but it is quite sufficient for Colombe to have needed a team of assistants. Among these we recognise the style of another Bourges-based illuminator, Jean de Montluçon, whose reputation was at its highest in the 1480s and who may have been starting his career when he worked on *Les Passages d'Outremer*. The distinctive grimacing expressions and delicate colours of his figures mark them out from the more stereotypical personages painted by Jean Colombe, whose manner was still rather dry and lacking in expression. Jean de Montluçon had a hand in folio 148 and in the impressive scenes relating to the bloody seizure of power by Isaac II Ange-lus and the humiliation of Andronicus I Comnenus (fol. 193v).

This was the first time that Colombe had chosen to use the entire surface of the folio. The page is divided into three parts: the principal image occupies the upper two-

thirds of the surface available. In the lower third, we find two columns of text within a zone of images shaped like a set square. In most cases, this contains a single image, but it may contain two images, one horizontal, one vertical in format, or a smaller rectangular image occupying half the base of the page and a second image occupying the remaining "L" shape.

The first two illuminated pages are exceptions to this rule. The dedication scene (fol. 5; ill. p. 81) is surrounded by an architectural frame in which several grisaille images are depicted in the shape of medallions. The opening page of the main text (fol. 6; ill. p. 85) is divided by rounded arches borne on torsade columns whose capitals are decorated with statues of soldiers. Under the gaze of Charlemagne, who wears full armour and carries a shield emblazoned with the cross, it affords a résumé of the first chapter. The main image, showing the capture of Jerusalem by the Saracens, is surrounded by vignettes evoking the main episodes described in the chapter: the vision of Constantine V, the appeal of the ambassadors to Charlemagne, the council held by Charlemagne and the king setting off on his mythical crusade.[61]

The manuscript of *Les Passages d'Outremer* is undoubtedly Jean Colombe's masterpiece; prolific as he was, his production is uneven, but here he gave his best. It is also fascinating testimony to the complex relations that, in the late Middle Ages, bound the great patrons who commissioned manuscripts, the authors who worked for them and the craftsmen who made their books (copyists, illuminators and *libraires*). It is particularly informative concerning the personality of one of the great bibliophiles and patrons of the late fifteenth century, Louis de Laval, whose name is now better remembered for the magnificent manuscripts that he left than for his career under the French kings

23.
Jean Robertet's *Book of Hours*, 1460–1470
The Arrest of Saint John the Baptist
Illumination by Jean Colombe,
10.8 x 8 cm (4 ¼ x 3 ⅛ in.)
New York, Pierpont Morgan Library

Louis XI and Charles VIII. The text contained in this modern manuscript has never before been published in the modern era. It bears witness to the interest of the French aristocracy in a period of history by then relatively remote, though still present in the form of prose *chansons de geste* and chronicles. But it also shows us the way in which a contemporary author worked, compromising with his sources and with the need to foreground the martial deeds of his patron and the aristocratic ideology to which that master subscribed, but maintaining a critical distance nevertheless.

Sébastien Mamerot is not, perhaps, the most faithful historian of the crusades. The chroniclers who were present, such as William of Tyre, Geoffrey of Villehardouin, Robert of Clary and John of Joinville, give a more reliable account of the events that they relate. But, though they pretended to objectivity, they no less than Mamerot were restricted in their outlook and ideology; theirs was a time when the critical theory of history had not yet come into being. Like their works, *Les Passages d'Outremer* offers us a clear insight into the way that the men of the late Middle Ages perceived the past. This volume further affords the rare pleasure of dwelling on some of the most beautiful images ever created in the last flowering of French Gothic illumination, just before the Renaissance overthrew the conventions that had governed their making.

Notes

1 Rodez (Aveyron), Société des lettres, sciences et arts de l'Aveyron, Ms. 1. The portrait is on fol. 169v.

2 There are no biographies of Louis de Laval. The most recent and complete information on his life is to be found in Frédéric Duval, *La traduction du* Romuleon *par Sébastien Mamerot, étude sur la diffusion de l'histoire romaine en langue vernaculaire à la fin du Moyen Âge* (Geneva, 2001), pp. 217–239.

3 "These hours were commissioned by Louis de Laval, lord of Chastillon and Comper, knight of the king's order and grand master of the waters and forests of France, who died at Laval on 21 August 1489 at the age of seventy-eight. By his will, he bequeathed them to Mme Anne of France, daughter of King Louis XI" (Paris, BnF, Lat. 920, fol. 342v).

4 We know only a small number of manuscripts from what must have been a very extensive library. They include his famous Book of Hours, which almost certainly contains more illuminations than any other medieval manuscript (Paris, BnF, Lat. 920); a fourteenth-century manuscript of the *Miroir Historial (Mirror of History)* by Vincent of Beauvais, in French (Paris, BnF, Fr. 316); and a fourteenth-century manuscript of the *Mariage Nostre Dame* (Paris, BnF, Fr. 409). The great scholar Léopold Delisle further attributed a three-volume manuscript of the *Chroniques* of Jean Froissart (Paris, BnF, Fr. 2652–2654) to the Laval library, though without compelling proof (see *Le Cabinet des manuscrits de la Bibliothèque nationale*, Paris, 1874, vol. II, pp. 376–377). It is also possible that Louis de Laval owned a manuscript of Guillaume de Coquillart's translation of the *The Jewish War* by Flavius Josephus (Vienna, Österreichische National Bibliothek = ÖNB, Cod. 2538), though this may have belonged to his nephew Pierre de Laval (see Duval, *The Translation of* Romuleon [note 2], pp. 223–224). The following manuscripts, containing the works of Sébastien Mamerot, certainly belonged to Louis de Laval: (as Frédéric Duval has recently shown) one of the manuscripts of the *Chroniques martiniennes* (Rome, Biblioteca Vaticana, Reg. 1898); the *Histoire des neuf preux et des neuf preuses* (Vienna, ÖNB, Cod. 2577–2578); and *Les Passages d'Outremer* (Paris, BnF, Fr. 5594). The exemplar belonging to Louis de Laval from which the *Romuleon* in the possession of Admiral de Graville was copied (Paris, BnF, Fr. 364) has since been lost.

5 This section on the life and work of Mamerot derives in large part from the recent publications of Frédéric Duval, particularly from his *La traduction du* Romuleon *par Sébastien Mamerot* (see note 2).

6 Paris, BnF, fr. 6360; Paris, BnF, fr. 9684 (one folio missing); London, British Library, Add. 25 105; Rome, Biblioteca Vaticana, Reg. 1898 (see Duval, *La Traduction du* Romuleon [note 2], pp. 233–234) has demonstrated that this manuscript was commissioned by Louis de Laval); Toulouse, Bibliothèque Municipale, Ms. 453. This list is no doubt incomplete and should be revised.

7 Vienna, ÖNB, Cod. 2577–2578. The copy of the manuscript was completed in Troyes in 1472 by a scribe who calls himself "Robert Bryart (or Briart) of the diocese of Bayeux" (Ms. 2578, fol. 271) and says he was a "servant of the redoubtable lord, Monseigneur of Chastillon" (ibid., fol. 97), which suggests that he was in the permanent employment of Louis de Laval.

8 There is no modern edition of Mamerot's *Histoire des neuf preux*, therefore, only parts of it have been studied. The part devoted to Arthur is very substantial. Mamerot here transposed not only the English historian Geoffrey of Monmouth's *Historia Regium Britanniae (History of the Kings of Britain; c.* 1130), but the chapter in *De casibus virorum illustrium (On the Fates of Famous Men; c.* 1375) devoted to Arthur and the Round Table by the Italian humanist Boccaccio. For the latter, Mamerot undoubtedly relied on the early fifteenth-century French translation by Laurent de Premierfait. Though his text is full of battles and speeches, Mamerot substantially abridges his sources and, in a spirit of rationalism, rejects legends such as that according to which Arthur is not dead but sleeping on the isle of Avalon, waiting to return and deliver the Britons from Saxon domination. He is nevertheless happy to claim Arthur as an ancestor of Louis de Laval, whose martial exploits while governor in Genoa in 1462 he recounts in complete defiance of context, as he was to do again in *Les Passages d'Outremer*. The chapter of "Les Neuf Preux" on Caesar is almost entirely abridged from the medieval compilation *Les Faits des Romains (The Deeds of the Romans)*.

9 See C. Schaefer, "Die *Romuleon* Handschrift des Berliner Kupferstichkabinett", in *Jahrbuch der Berliner Museen*, 1981, vol. XXIII, pp. 142–143.

10 This manuscript figures in the catalogue of the sale of the Chancellor D'Aguesseau's collection in 1785 and subsequently, at an unknown date, entered the collection of the duke of Hamilton. The latter collection was then bought by the Prussian State in 1882. It is impossible to be sure of the links between the three manuscripts. The illumination of the Berlin manuscript would seem to derive directly from Fr. 365–367, but the text does not. We are at least certain that none of the three is the original source. In all probability, there was a dedicated manuscript, illuminated by Jean Colombe for Louis de Laval. There is no other explanation for the fact that Ms. BnF Fr. 364, which was commissioned by Admiral de Graville (as we have seen), opens with a scene in which Mamerot is handing the book to Louis de Laval, who is readily recognised in his red surcoat, in which he appears in all his portraits. It is presumed that Graville commissioned Jean Colombe to make an exact copy of Laval's dedicatory manuscript, which has since been lost. Graville and Laval were close friends.

11 Paris, Bibliothèque Sainte-Geneviève, Ms. 3005, illuminated by the Parisian painter called the Master of the Entrées Royales. The text of *Les Trois Grands* is at fol. 19–24v.

12 Georges Chastellain (1415–1475) was a poet and writer from Hainault (now in Belgium). His works notably include a chronicle of the court of Burgundy.

13 Achille Chéreau, *Catalogue d'un marchand libraire du XVe siècle tenant boutique à Tours …* with explanatory notes (Paris: Académie de Bibliophiles, 1868). This inventory is now in the Department of Manuscripts at the BnF.

14 Antoine Du Verdier, in his *Bibliothèques françoises*, repeating the conjectures of his predecessor Bernard de La Monnoye, describes this edition. He notes that it must date from 1518 and not 1528, as La Croix du Maine believed.

15 Bibliothèque municipale, Lyons (Rés. 105 176 CGA); Bibliothèque d'Amiens-Métropole (Lescalopier 4944, Rés. 336 C); BnF (Réserve, LA9–2, LA9–2 Alpha et LA9–2 Béta; Arsenal 4H 5169, 5170 et FOL H 3069); New York Public Library; British Library, London; and Koninklijke Bibliotheek, The Hague.

16 At the end of the banquet, a Saracen giant appeared; he led an elephant bearing a tower in which a beautiful woman was imprisoned, symbolising the Christian faith oppressed by the

Turks. Then all the lords present swore on a pheasant borne by the *roi d'armes* of the order of the Toison d'Or to take up the cross.

17 It should be noted that, some years before, in 1466, Louis de Laval had commissioned a translation of *Romuleon* from Mamerot, when Jean Miélot had just finished a translation of the same work for the duke of Burgundy. Now, when Mamerot began *Les Passages d'Outremer*, the subject had just been evoked by a number of writers working for the Burgundian court. Between 1420 and 1438, a servant of Philip the Good of Burgundy (r. 1419–1467), Emmanuel Piloti, had written for the duke a *Traité sur le passage en Terre Sainte (Treatise on Expeditions to the Holy Land)*. This text has been translated into modern French and presented by Danielle Régnier-Bohler in *Croisades et pèlerinages: Récits, chroniques et voyages en Terre Sainte, XIIe–XVIe siècle* (Paris, 1997), pp. 1227–1228. In 1439, the duke commissioned a translation of Jean Terzelo's *Advis sur la conqueste de la Grèce et de la Terre Sainte* from Bertrandon de la Broquière. Finally, in 1458, Jean Aubert had completed his *Chroniques et conquêtes de Charlemagne*, which made use of many *chansons de geste*. Given the military, political and cultural rivalry between the king of France and the duke of Burgundy, we might easily suppose that Louis de Laval had sought, with *Les Passages d'Outremer*, to renew French competition with the literary and historical works on which the Burgundian court so prided itself, for the greater glory of his king. The dukes of Burgundy were very active patrons of the arts and letters. They commissioned prose versions of the *chansons de geste* and romances of the Round Table alongside chronicles and new works. The taste for illumination exhibited by successive dukes of Burgundy is demonstrated by the magnificent manuscripts of the Librairie de Bourgogne, which are today for the most part in the collection of the Bibliothèque royale de Belgique in Brussels (some are also in the BnF, Paris).

18 Book XXV, ch. 3, 4 and 5.

19 Paris, BnF, Bibliothèque de l'Arsenal, Ms. 283. The text of the chapters on Charlemagne's crusade was published by Louis Milland, "Charlemagne à Constantinople et à Jérusalem", *Revue archéologique*, n. s., 2nd year, III (1861), pp. 37–50. The sequence of episodes that it contains is very similar to that in *Les Passages d'Outremer*.

20 Vincent of Beauvais (d. 1264) was the author of an encyclopaedia entitled *Speculum maius (The Great Mirror)*, completed around 1258. Its historical part, the *Speculum historiale*, was widely disseminated throughout Europe, notably in the French translation by Jean de Vignay, the *Miroir historial* (1333). The story of the crusade occupies book XXVI, ch. 96–105.

21 William of Tyre's history, written in Latin, covers the history of the Latin states in the Levant from the conquest till 1184. It was widely known in the West. Taking up the thread from earlier chronicles, it helped spread the views of the Norman dynasty of Antioch, in particular as regards Frankish relations with Byzantium.

22 The *Livre des faits de Jean le Meingre dit Boucicaut (Book of Deeds of Jean le Meingre, known as Boucicaut)* was written from 1406 to 1409 by an anonymous author, whom some have suspected (without any proof) to be the marshal himself.

23 A large number of books of hours in the Bourges use, many of them modest, bear witness to this fact. We know little about the people who bought or commissioned them. We also know of important manuscripts made for families of the Scottish nobility who had settled in Berry at the suggestion of Charles

VII. One of these is the *Moneypenny Breviary*, illuminated in part by Jacquelin de Montluçon, *c.* 1485–1490, now in a private collection.

24 I am very grateful to François Avril, honorary Curator General at the Department of Manuscripts at the BnF, for his aid and advice in this section, which is based primarily on the description of the activity of Jean Colombe that he wrote with Nicole Reynaud in *Les manuscrits à peintures en France, 1440–1520* (Paris, 1993), pp. 325–338.

25 Thanks to the discoveries made by Jean-Yves Ribault, archivist for the Cher *département*, who completed the earlier research of Paul Chenu, Alfred Gandilhon and Maurice de Laugardière, the life of Jean Colombe is well documented. For a résumé of the information amassed by J.-Y. Ribault, see Claude Schaefer, "Œuvres du début de la carrière de l'enlumineur Jean Colombe", in *Cahiers d'archéologie et d'histoire de Berry*, no. 35 (December 1973), 45.

26 Paris, BnF, Fr. 449.

27 Paris, BnF, Fr. 407.

28 New York, Pierpont Morgan Library, M. 677.

29 Chantilly, Musée Condé, Ms. 65.

30 Biblioteca de El Escorial, E. Vit. 5.

31 Paris, BnF, Fr. 91, and Brussels, Bibliothèque royale de Belgique, Ms. 9426.

32 New York, Pierpont Morgan Library, M. 834.

33 His Book of Hours, *c.* 1470, is now in the Philadelphia Museum of Art, Philip S. Collins Collection, 1945–65–15.

34 Paris, BnF, Fr. 177–179.

35 *Book of Hours*, St Petersburg, Russian National Library, Ms. Lat. Q. V. I. 126.

36 Vienna, ÖNB, cod. 2577–2578.

37 Respectively Paris, BnF, Fr. 53 and Fr. 364.

38 Nicole Reynaud asserts that Béraud Stuart commissioned this manuscript, see Avril and Reynaud, *Les manuscrits à peintures* (note 24), p. 325. But this theory has been contested. See Duval, *La traduction du* Romuleon (note 2), p. 232.

39 New York Public Library, MA 113.

40 New York Public Library, MA 51.

41 Troyes (Aube), Médiathèque, Ms. 3901.

42 Another book of hours, in the collection of the Biblioteca Laurentiana, Florence (Ms. Pal. 241), and a manuscript of the *Histoire de Jules César* (Paris, BnF, Fr. 22 540), both later than the Médiathèque's manuscript, were probably made for Guyot II Le Peley's son. Finally, a book of hours (Troyes use), made for one of Guyot II's half-brothers, Jean Molé (Rodez, Société des lettres, sciences et arts de l'Aveyron, no. 1), belongs to a later phase of Colombe's production, since it was copied and illuminated in Lyons, where the artist almost certainly made the great majority of the paintings produced while he was in the service of Duke Charles I of nearby Savoy.

43 In addition to those already mentioned, we might cite the following books of hours (among a host of others): New York, Pierpont Morgan Library, Ms. M 430 (1460s), M 248 (*c.* 1470 for the Colombe illuminations), M 330 (*c.* 1480); Paris, BnF, nal 3181; Moulins, Bibliothèque municipale (hereafter BM), Ms. 80; Besançon, BM, Ms. 148; Laon, BM, Ms. 243–3; Geneva, Bibliothèque Publique et Universitaire, Ms. Lat. 35; Florence, Biblioteca Laurentiana, Ms. Med. Pal. 240; Oxford, Keble College, Ms. 42; Baltimore, MD, Walters Art Gallery, Ms. W 213 and Ms. W 445; New Haven, CT, Yale University, Beinecke Library, Ms. 425; *Heures dites de Jules II*, Chantilly, Musée Condé, Ms. 78; the former Donaueschingen Ms. 335 and the *Heures*

Bureau, from the former collection of Maurice Loncle (both now in private hands).

44 Among his earliest works are the Pontifical of the archbishop of Bourges, Jean Cœur (New York, Pierpont Morgan Library, Ms. Glazier 49). We also know of a French missal to which the Master of the Yale Missal also contributed (New Haven, CT, Yale University, Beinecke Library, Ms. 425) and a much later Franciscan missal probably dating from Colombe's residence in Lyons (Lyons, BM, Ms. 514).

45 These have already been described: they include the works of Mamerot, Jean Mansel's *Fleur des histoires* (Paris, BnF, Fr. 53) and the manuscript of the *Faits des Romains* made for Jean Le Peley of Troyes (Paris, BnF, Fr. 22 540).

46 There is a *Tristan en prose* in the Pierpont Morgan Library, New York (Ms. M 41, copied 15 April 1468). Later, *L'Histoire du Graal* and the *Merlin* made for Jean-Louis of Savoy, cited above.

47 For example, the five fragments of the *Mortifiement de vaine plaisance*, whose illuminations, left incomplete by Barthélémy d'Eyck, illuminator to King René of Anjou, were completed by Jean Colombe (Metz, BM, Ms. 1468) and another complete exemplar of the same text (Cologny-Geneva, Fondation Bodmer, Fr. 44); an exemplar of *Breviloquium de virtutibus antiquorum principum et philosophorum* by Jean de Galles (New York, Public Library, Spencer 76); *L'Orloge de sapience* (Glasgow, University Library, Hunter 420); a collection comprising *La Vie de Nostre benoît Sauveur Jésus Christ, La Sainte Vie de Nostre Dame, L'Exposition du Miserere mei Deus* (Paris, BnF, Fr. 992); and an exemplar of Boethius's *De Consolatione Philosophiae*, copied by the Bourges scribe associated with Colombe, André Roussel (London, British Library, Harley 4335–4339).

48 The earliest work of Colombe is dryer and presents more emphatic colours than his later productions, in which he moved away from the Tours style represented by Jean Fouquet. The impact of the style of work of the Limbourg brothers in the *Très Riches Heures*, whose illumination he completed, may account partly for this change, but it no doubt also owes something to the new Italian and Flemish models that were beginning to circulate.

49 *Cahiers d'archéologie et d'histoire du Berry*, no. 35 (December 1973), 4.

50 Among many other examples, see the two manuscripts made for high-ranking individuals, Anne of France's Book of Hours (New York, Pierpont Morgan Library, M. 677, fol. 211) and Louis de Laval's Book of Hours (Paris, BnF, Lat. 920, fol. 158).

51 Rome-use hours, Oxford, Keble College, Ms. 42, fol. 50; detached folio of Guyot II Le Peley's Book of Hours, now in private hands; Besançon, BM, Ms. 148, fol. 150; Florence, Biblioteca Laurentiana, Pal. 24; Jean Molé's Book of Hours (Rodez, Société des lettres, sciences et arts de l'Aveyron, Ms. 1, fol. 98v).

52 New York Public Library, Spencer 6.

53 Paris, BnF, naf 24 920.

54 Paris, BnF, Lat. 1375.

55 Paris, BnF, Fr. 701.

56 Paris, BnF, Lat. 920.

57 Vienna, ÖNB, Cod. 2577–2678.

58 Paris, BnF, Fr. 364.

59 Paris, BnF, Lat. 920, fol. 51.

60 Paris, BnF, Fr. 364, fol. 14.

61 This system presents analogies with the layout of several other important manuscripts illuminated by Jean Colombe. He uses a variant of it in manuscripts of smaller format, but contemporary with *Les Passages d'Outremer*, such as the *Mortifiement de vaine plaisance* (Cologny-Geneva, Fondation Bodmer, Ms. 44) or the *De Consolatione Philosophiae* (London, British Library, Harley 4335–4339) – the copying of which was done by André Roussel, who collaborated with Colombe on at least three occasions – and is dated 1 February 1476 (1477 according to today's calendar). But in the latter, the text becomes a *trompe-l'œil* sign held up by two angels, a model that probably derives from Jean Fouquet's *Heures Robertet*. Still closer are the *Romuleon* illuminated for Admiral Louis Malet de Graville (Paris, BnF, Fr. 364) and the opening pages of the copy of *Faits des Romains* made for Jean Le Peley of Troyes (Paris, BnF, Fr. 22 540). The manuscript of *Les Faits des Romains* is much more modest than that of the *Romuleon*, no doubt because its patron was much less wealthy than such powerful figures as Louis de Laval or Louis Malet de Graville. Indeed, it has only thirty-six miniatures and a single full-page illumination, which represents the triumph of Caesar after his victory over the Gauls (fol. 1). But as Marie Jacob has shown in her article "*Les Faits des Romains*, un autre manuscript aux armes Le Peley enluminé par Jean Colombe" (*L'Art de l'enluminure*, no. 21 [2007], pp. 62–67), it is more or less a copy of the same scene in the *Romuleon* manuscript (fol. 81). This, in turn, was inspired by the triumph of Metellus in the manuscript of Boccaccio's *Cas des nobles hommes et femmes*, which was illuminated by an emulator of Jean Fouquet active in Tours around 1465 (Munich, Staatsbibliothek, Cod. Gall. 6, fol. 189v). But in the *Romuleon* and *Faits des Romains*, the image in the lower register is systematically divided into a main image, which occupies the lower part of the page, and an intermediary vignette. Colombe applied the same principle – maximum use of free space – in the 1480s, during the second stage of illustrating Louis de Laval's Book of Hours (Paris, BnF, Lat. 920). There he filled the bottom margin of the manuscript with an iconographic cycle representing the principal episodes of the Old Testament. He used an identical form of composition in the little book of hours made for Guyot II Le Peley (Troyes, Médiathèque, Ms. 3901).

EDITORS' NOTES

The edition of the text

The manuscript Fr. 5594, hereafter A, poses no major problems of readability: abbreviations are relatively rare and the letter "i" is generally written in a way that distinguishes it from the down-strokes of the letters "u", "n" or "m". However, it is not always easy to tell "c" and "t" apart, even when they are isolated, and is notably difficult in double letters. We have chosen to transcribe "ct" only when the manuscript makes such a reading possible and when this form matches the etymology ("faicte" or "dicte" but "mettent") – fifteenth century copyists tended to use written forms inspired by Latin. The long "s" preceding an "f" is often similar to an "f"; there, too, we have tried to stay as close to the manuscript as possible in our reading and to respect etymology ("deffendre" but "toutesfois"). But it is important to note that for the copyists and readers of the late Middle Ages, these issues were trivial, and the double letters "ct" or "tt", "sf" or "ff" were considered equivalent and even interchangeable; the evidence for this is clear where a double-letter is split at the end of a line. The text contains a number of mistakes: some words are omitted, and confusion regarding singular and plural, past participles and the infinitive form of –er verbs, etc., often arises as a result of the inconsistent spelling. Immediately after its production, the manuscript itself was reread and corrected here and there; missing words were added in the margin (e. g., fol. 23v, 28v, 31, 44, 47, 104), and certain repetitions were expunctuated (fol. 87) or scratched out (fol. 105, 113). But this was a superficial rereading and errors remained. Manuscript A is, however, easy to correct using another contemporary control, a manuscript without illumination: Paris, BnF, Fr. 4769 (manuscript B). This second manuscript is not, however, faultless either; it includes certain errors of its own that are not found in A.

We should further note that certain readings, confirmed by both manuscripts, remain

incomprehensible, for example the mention, early in Mamerot's account of the Third Crusade (fol. 137v), of the bishop of "Versailles"; Versailles was then a small village and did not have its own bishop until the nineteenth century. There is no reason to suppose that Mamerot would have heard of Versailles and we know of no source in which a papal legate is mentioned who was bishop of a city of a similar name. Yet this is undoubtedly the word that appears in both manuscripts. It is presumably an erroneous spelling of "Vézelay". The third manuscript (BnF, Fr. 2626), which dates from slightly later, and the sixteenth-century edition, will be used in a forthcoming scholarly edition.

The minor errors of the text in A are surprising given that this was the dedication exemplar, illuminated by Colombe for Louis de Laval, the author's patron and protector. If it was copied directly from Mamerot's original text, this must have been done somewhat hastily and in a slipshod manner, and it seems unlikely that the author corrected the copy. The manuscript was very likely illuminated by Colombe shortly after the text was completed, while Mamerot was still alive and more often resident in Berry, where he had completed the composition of *Les Passages*, than in Troyes.

Notes on the translation

There is, as yet, no modern translation of *Les Passages*. Like many other authors of the intermediary period known as Middle French, Mamerot has been long neglected. If we exclude the very few references in theses and nineteenth-century works, it was only in the 1990s that scholars began to take an interest in his work. We would therefore ask the reader to forgive any errors that may have arisen in this edition, for which only two of the three surviving manuscripts were consulted; the printed edition of 1518 had to be put aside for later study. Similarly, certain place-names of secondary importance have not been identified, though this is no obstacle to understanding the text as a whole.

It is always a delicate matter to translate a fifteenth-century text into modern French. Middle French is no longer the language of medieval France; indeed the syntax and morphology are very close to modern-day French, but the vocabulary is very different, both because it refers to objects (such as arms or siege-machines) and notions (feudal relations) no longer current and because, less rich than the language of today, it is less precise. Moreover, the literary language of the fifteenth century abounds in repetition and stock phrases; it tends toward long, periodic sentences featuring confused sequences of relative and interpolated clauses or propositions dependent on the present participle. Indeed, repeated use of the imperfect subjunctive posed no problems for the fifteenth century, but is no longer idiomatic today.

24.
Louis de Laval's Book of Hours,
c. 1470–1475 and c. 1480
Bathsheba bathing
Illumination by Jean Colombe,
24.3 x 17.2 cm (9½ x 6¾ in.)
Paris, Bibliothèque nationale de France

Translation must therefore avoid two pitfalls, each of them equally detrimental: an excessive modernisation of the language, which would remove all dross from the text, and an excessively medieval style, which would form a barrier between today's readers and the writing of Sébastien Mamerot. We have sought to avoid both of these errors by simplifying sentence construction wherever possible, eliminating pointless repetition and explicating obsolete vocabulary. We have also chosen to give place-names as they are widely found in the literature of the crusades.

Since the work of translation into French was divided between two translators, some superficial differences of style will no doubt transpire. We hope that they will not stand in the way of the reader's pleasure in a text of supreme historic and literary interest and whose sumptuous manuscript – as reproduced in this volume – would in itself be sufficient justification for the work to be made accessible to all.

Thierry Delcourt (1959–2011), former Chief Librarian and Director
of the Department of Manuscripts, Bibliothèque nationale de France

Danielle Quéruel, Professor of Medieval Literature
at the Université de Reims Champagne-Ardenne

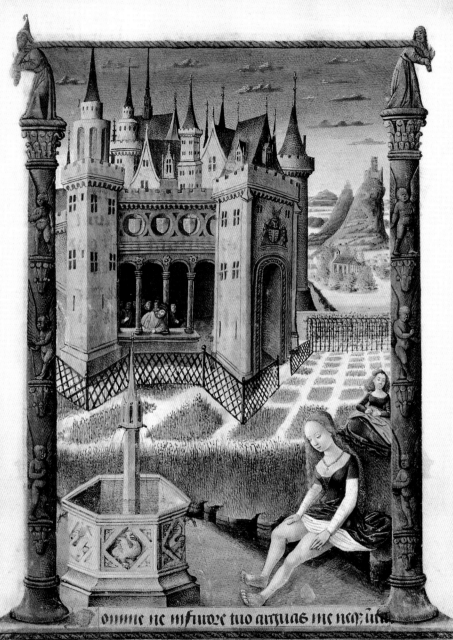

omine ne in furore tuo arguas me neq; in

DOMINE NE IN FVRORE TVO ARGVAS ME NEQVE IRA

LETTER TO SULTAN BAYEZID

The letter below, written by the Turk to the king partly in Italian and partly in Latin, reads as follows:

"Sultan Bayezid,[1] by the grace of God sovereign emperor of Asia, Greece, etc. to the very excellent and most serene Charles, king of France,[2] etc., you very dear brother, greetings and fraternal friendship.

Most dear King, we are sending to your majesty our man Anthoine of Rericho, who will tell you certain things as ordered to by ourselves. Give him your confidence as a trustworthy man sent by us, for everything that he will tell you is in our own very words. Given in Constantinople on the fourth day of July, the year of our holy prophet 893 and the year of holy Christ 1488" and addressed to "the very excellent and renowned Lord Charles, king of France, our dear brother".

It is to be noted that the original letter is written on double paper glued together and smooth as a playing card, but much less thick. And it is folded lengthways and across as it is represented in the middle of the next page. And there were three points at which it was sealed with carefully diluted paste and stuck like glue at the two ends and the centre of the letter. And on each there was an imprint of the signet of the Turk, like the one at the head of the letter. And there was no address on it. Then there was a cover of similar smooth glued paper, closed and sealed in three places like the letter. And on this cover was the address of the letter. And the golden seal is the seal of the Turk's own hand. Similarly, the size of the original letter is such as it is represented here, with no additions, as can be seen.

Serenissimo et excellentissimo dño Carulo francie Regi ʒ̃
fratri nr̃o Carissimo

Sultambaiasit dei gratia maximo Imperatore asie grenez̃
serenissime et excellentissimo dño Carulo Regi francie et̃
fratello nr̃o carissimo salutem et fraternam amicitiam
Serenissime rex mandamo al serenita Vostra el nr̃o homo
Anthomo Rericho. el qualle referira alcune chose che ly
aueme cõmesso. Date ly fede, come a persona fedata mandate
de noy. Et tuto quello. chelly dira. sono parolle nostre. Ex
constantinopoli die quarta mensis Jully Anno dñi nostri
prophete. 893. Et anno dñi christi. 1458.

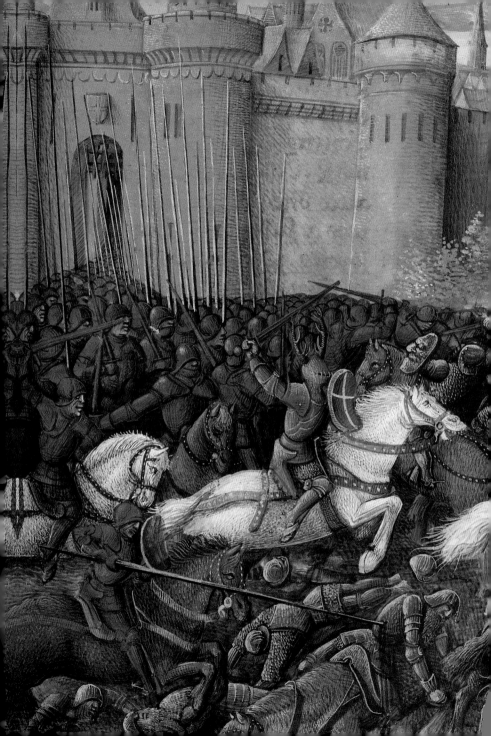

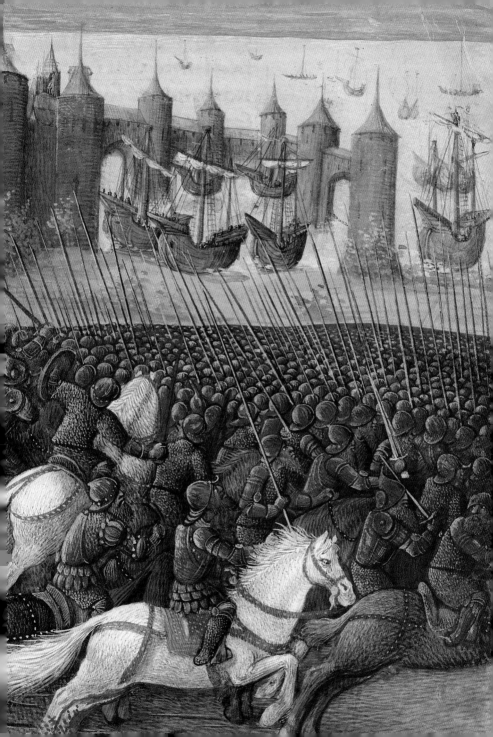

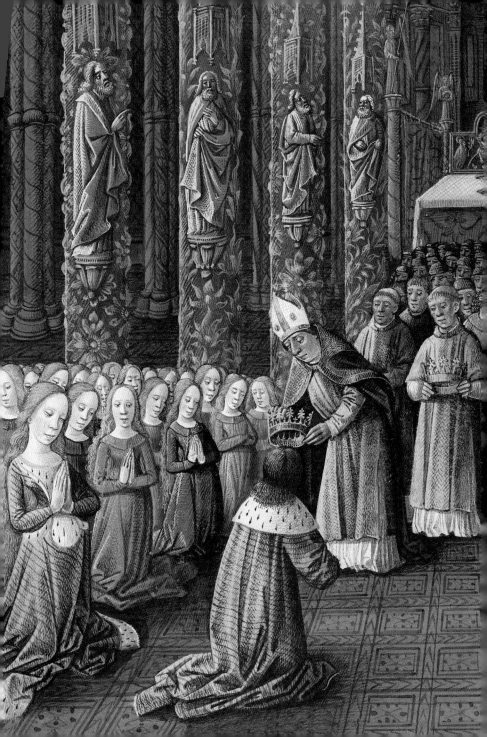

Sébastien Mamerot

THE EXPEDITIONS MADE TO OUTREMER BY THE FRENCH AGAINST THE TURKS FROM CHARLEMAGNE TO 1462

The Expeditions Made to Outremer by the Kings of France and Other French Princes and Lords against the Turks and other Saracens and Moors in Outremer.

I. How the Holy City of Jerusalem was taken from the Christians by the Saracens.

II. How the ambassadors and legates of the emperor of Constantinople and the patriarch of Jerusalem arrived in Paris at the court of Charlemagne.

III. How Charlemagne arrived in Constantinople and of the great honours bestowed upon him there by the emperor Constantine and his son Leo.

IV. How the emperor Constantine prepared a great abundance of gold, silver, silk cloth and other valuables.

V. How the Holy Relics of the Passion of Our Lord were found in Constantinople.

VI. How Pope Urban, the second of this name, came to France. Chapte.

VII. How Walter the Penniless, who led a great company of pilgrims through various lands, passed through Hungary.

VIII. How the two armies of Peter the Hermit and Walter the Penniless were almost entirely destroyed.

IX. How a German priest preached the crusade in Germany.

X. How Godfrey, duke of Lorraine, and subsequently king of Jerusalem, assembled a great army in order to set forth and reconquer the city of Jerusalem.

XI. How the emperor Alexius sought to imprison Godfrey of Bouillon and his army on the pretext of doing them charity.

XII. Of the departure of Bohemond, prince of Taranto, and Tancred, his nephew, who were of such high renown.

XIII. Of the departure of Raymond, count of Toulouse, and Adhemar, bishop of Le Puy.

XIV. Of the nature, situation and fortifications of the city of Nicaea.

XV. How Suleiman thought to surprise Bohemond and Tancred when they were separated from the main army.

XVI. How Duke Godfrey slew a bear, which grievously wounded him.

Contents

XVII. How the great army of pilgrims came before Antioch.

XVIII. How our men quickly made a great bridge of ships over the river.

XIX. How the disloyal Greek Taticius secretly fled from the siege of Antioch.

XX. How the Turks of Halkia, Shaizar, Hama and divers other cities and countries, attempting to raise the siege of Antioch, were routed.

XXI. How a citizen of Antioch wished to deliver the city to the Christians for the love of Bohemond.

XXII. How Firouz killed his own brother, that he might deliver Antioch more easily to the Christians.

XXIII. How the pilgrims failed to take the keep of Antioch when they seized the city.

XXIV. Of the poor pilgrims whom Kerbogha mocked and sent to the sultan of Persia out of contempt.

XXV. How Bohemond caused several parts of the city of Antioch to be burned down.

XXVI. The great battle of Antioch, as admirable a battle as there has ever been.

XXVII. How Hugh the Younger and Baldwin, count of Hainault, sent by the princes of Antioch as envoys to the emperor in Constantinople, were surprised en route.

XXVIII. How the count of Toulouse captured the city of Albara.

XXIX. How the count of Toulouse, leading a great army, departed from Maarat.

XXX. Of the messengers of the caliph of Egypt and of the emperor of Constantinople.

XXXI. Of the nature, situation and shape of the Holy City of Jerusalem.

XXXII. How the princes and the other pilgrim crusaders laid siege to Jerusalem.

XXXIII. Of the devotional processions held by the pilgrims before Jerusalem.

XXXIV. How Godfrey, duke of Lorraine, was elected and crowned king of Jerusalem.

XXXV. How Bohemond and Baldwin, count of Edessa, came to Jerusalem.

XXXVI. The first expedition undertaken by the French after the conquest of Jerusalem.

XXXVII. How a further army sent by the caliph of Egypt was almost entirely destroyed.

XXXVIII. Of the expedition undertaken by the brother of the king of Norway, whose reign lies beyond England.

XXXIX. How Baldwin of Le Bourg was elected and crowned king of Jerusalem.

XL. How the Venetians dispatched a great army, which defeated the caliph of Egypt's fleet.

XLI. How Fulk, count of Anjou, became king of Jerusalem.

XLII. How Baldwin III was made king of Jerusalem.

XLIII. The Third Great Crusade, which was led by the emperor Conrad.

XLIV. How Emperor Conrad and King Louis the Younger parted company after crossing the strait of Saint George.

XLV. How the French defeated an army of Turks.

XLVI. How King Louis the Younger was received in triumph at Antioch.

XLVII. Of the land in which Damascus lies.

XLVIII. Of the various interpretations of the betrayal before Damascus.

XLIX. Of other feats in Outremer, and how Nur ed-Din conquered and slew the most valiant prince Raymond.

L. Of the siege of Ascalon and the various machines constructed and assaults and sorties made.

LI. How the emperor Manuel broke the promises that he had made to the prince of Antioch.

LII. Of King Amalric and the question that he posed concerning eternal punishment and glory.

LIII. How King Amalric went to the aid of Egypt for a second time.

LIV. How King Amalric returned to Egypt.

LV. The crowning of King Baldwin IV.

LVI. How King Baldwin IV was defeated and many of his men killed.

LVII. How King Baldwin IV once defeated Saladin.

LVIII. How Guy of Lusignan, count of Jaffa, was made governor of the kingdom of Jerusalem.

LIX. Of the malice of Andronicus, emperor of Constantinople, and of his shameful death.

LX. How the king and the count of Tripoli were reconciled.

LXI. How Saladin took many cities and castles in Syria.

LXII. How King Guy, by surrendering Ascalon, was saved along with a tenth of the knights therein besieged.

LXIII. How Saladin besieged the city of Tyre.

LXIV. How the crusaders King Philip II Augustus and King Richard undertook to go to the succour of the Holy Land.

LXV. How King Philip set sail once more.

LXVI. How King Richard had the prisoners of Acre cruelly put to death.

LXVII. A brief account of certain expeditions to Outremer made by the emperor Henry.

LXVIII. How the pilgrim crusaders renounced their chief intent.

LXIX. How Damietta was captured by the king of Acre and the French pilgrims.

LXX. The overseas journey taken by the disloyal emperor Frederick, who was excommunicated.

LXXI. A further crusade initiated in France, led by Tibald, count of Champagne and king of Navarre.

LXXII. How the king, Saint Louis of France, fell gravely ill and was suddenly cured.

LXXIII. How Saint Louis left France for the first time to cross the sea.

LXXIV. How the sultan of Egypt fortified Jerusalem.

LXXV. Of the quarrel that arose between the viscount of Châteaudun and his sailors.

LXXVI. How Saint Louis led his army out of Damietta.

LXXVII. Of the mad uprising of the shepherds and how it was suppressed.

LXXVIII. How Saint Louis undertook a second expedition to Outremer.

LXXIX. Of the Saracen who came to surrender to the Christians.

LXXX. Of the defeat inflicted on the Saracens by King Charles of Sicily.

LXXXI. Of the overseas expedition made by Duke Louis of Bourbon.

LXXXII. Of the great army of Moors that came to the aid of the city of Carthage.

LXXXIII. The expedition into Hungary made by the French to assist the Hungarians.

LXXXIV. The arrangement of the forces in the dreadful battle of Hungary.

LXXXV. How news of this dreadful defeat came to be known in France.

LXXXVI. How the emperor Manuel of Constantinople enlisted the help of the French.

LXXXVII. How the army of Boucicaut, joining that of the Greeks, made great raids on the Turks.

LXXXVIII. How the emperor Manuel came to France and the return of Boucicaut.

End of the chapters of the expeditions to Outremer.

Short treatise entitled "The Expeditions Made to Outremer by the Kings of France and Other French Princes and Lords against the Turks and Other Saracens and Moors in Outremer".

Because, during the truces that prevail in this year of 1472, there have come to our ears new complaints on the subject of the grave enterprises, exactions and conquests made in the Holy Land and in Christian lands by Mehmed, the enemy of all Christendom, also known as the Great Turk, who, not content with his great conquests and having seized the very excellent cities of Constantinople and Trebizond[3] and several other provinces, cities, towns, castles and parts of Greece, which he has already overrun in great number, seeks every day to root out the name and glory of the Christians by continually assembling great armies, in order to lead new attacks on the Christian people, as those do testify who were acquainted with his conduct during his former conquests; therefore, my much revered Lord Louis de Laval, lord of Châtillon in Vendelais and of Gaël, lieutenant-general of King Louis XI now reigning, and governor of Champagne to the aforesaid king, requests and desires that I, Sébastien Mamerot of Soissons, cantor and canon of the church of Saint Stephen in Troyes, his chaplain and domestic servant, should bring together in a full treatise and volume the expeditions to Outremer made by the very excellent and very Christian king of France and the emperor of the Romans, Charles the Great, otherwise and most commonly known as Charlemagne, and by other kings, princes, barons, knights and peoples of divers kingdoms, undertaken of their own accord, from the holy conquest of Jerusalem accomplished by the very excellent conqueror Charlemagne to the expeditions of today.

To please my redoubtable lord, I began the present volume in the city of Troyes in the year indicated above, on Thursday, the fourteenth of January, hoping thus to occupy his mind as he commanded, for the glory of God, for the honour and profit of the French and all other Christians who shall hereafter cross the seas, by telling them of the misfortunes, perils and injuries that came to those who have in former times made this Holy Journey, and more especially concerning the Holy Sepulchre and Jerusalem, by invoking the grace of Our Lord God Jesus Christ and with his help in this matter.

DEDICATION SCENE

"I hereby bring to an end my account of the expeditions to Outremer,
praising Our Lord Jesus Christ, by the grace of whom I, Sébastien Mamerot,
a priest native of Soissons and cantor of Saint Stephen's in Troyes,
completed this treatise at Vierzon this Tuesday, the nineteenth of April, 1474,
shortly after Easter."

(FOL. 277VA)

Often, particularly in the latter centuries of the Middle Ages, illuminated manuscripts commissioned by a dignitary opened with a picture of the author or the copyist presenting the finished book to his patron. Mamerot's manuscript is no exception. The cleric Sébastien Mamerot, canon of the collegiate church of Saint Stephen in Troyes and secretary to Louis de Laval, is here portrayed in the centre of the scene, kneeling before the great nobleman in whose employ he was. With his distinctive tonsure and his monk's habit, he holds out a closed book, covered with a red binding and adorned with golden clasps, to the dedicatee Louis de Laval, who is receiving the manuscript. Laval can be identified by the same red surcoat that he wears in all his portraits, for example, in the picture that shows him kneeling before the Virgin and Child in his *Book of Hours* (ill. 2, p. 11) or in the *Romuleon*. The coat of arms of the dedicatee at the bottom of the picture has been effaced, but it appears carved above the gate behind Laval, at upper left, as well as in the illuminations in folios 19 and 176v. In the background, Jean Colombe has portrayed an elegant fortified residence on the bank of a river, recalling one of the châteaux of Louis de Laval. Behind the dignitary stands a group of elegantly clad nobles. For this page, the artist has provided a magnificent frame of small pictures showing what the crusades were really like: wars, encounters, assemblies, reconciliations, peace treaties, conquests and a camel and its rider. These medallions contain monochrome pictures in alternate shades of blue, red and brown, which reappear throughout the manuscript. With this frame, the artist has created the illusion of a costly book cover bearing gems and ivory carvings set in engraved gold leaf. The historiated letter at the beginning of the prologue portrays a clerk writing, another allusion to Mamerot's work.

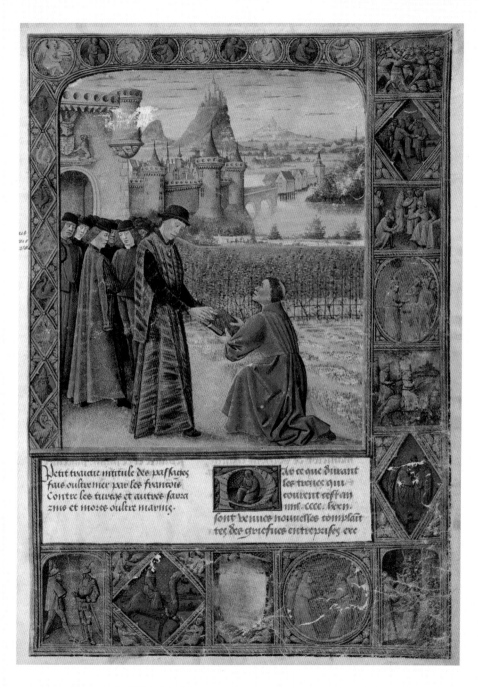

Petit traicte intitule des passiges
faiz oultre mer par les francois
Contre les turcs et autres sarra
zins et moete oultre marins.

Au ce que durant
les treues qui
couvent restan
ane cccc lxxi
sont venues nouuelles complait
tes des griefues entrepaises cre

Chapter I.
How the Holy City of Jerusalem was taken from the Christians by the Saracens, the flight of the patriarch of Jerusalem and the vision of Constantine, emperor of Constantinople, and how ambassadors were sent to Charlemagne in France.

When the holy King Charles the Great, commonly called Charlemagne, was reigning in France, it happened that the Saracens captured the Holy City of Jerusalem by force and there made a cruel massacre of the Christians, who had held it since the emperor Heraclius had retaken it from Chosroes, king of Persia. The latter had captured the city shortly before and taken from it the Holy and True Cross of Our Lord Jesus Christ,[4] as I have written at greater length in the translation and enlargement that I made of the *Chroniques martiniennes* fifteen years ago.

Therefore, John, the patriarch of Jerusalem, a man of great holiness, and a number of knights and other Christians of various estates who were present and living in Jerusalem at the time of its capture, contriving to flee that city, took refuge in the cities of Acre, Antioch and other such cities, towns and castles of Syria as were held and garrisoned by Christians. And shortly thereafter, the patriarch left the land of Syria, taking with him John, bishop of Naples (though some claim that he was only a priest), and David, archpriest of Jerusalem. He quickly arrived in Constantinople and approached the emperor Constantine, the fifth of this name, and his son Leo IV, who was also subsequently emperor and husband of the empress Irene, by whom he had Constantine VI. The latter was afterwards blinded by Irene, his mother, in the seventh year of his rule.[5] After this she reigned alone for four years, till she was at last exiled by Nicephorus,[6] who thus usurped and held the empire of Constantinople for eight years, to his own great misfortune and that of the empire, which was long governed by tyrants thereafter. But I shall say no more about him at present, since he does not concern my little treatise, to which I now return.

When the emperor Constantine V saw the patriarch of Jerusalem, he received him with great honours, humility and joy. But when he learned from the patriarch that the Saracens had suddenly seized Jerusalem, killing the majority of the Christians who lived there, and desecrated the church of the Holy Sepulchre and other Holy Places, and

that they had strengthened its fortifications because they hoped to keep it and by this means effect a military conquest of the entire land of Syria, he was greatly saddened. And he and his princes and his other people, both those of the Church and the lay people of Constantinople, when they heard of these misfortunes, cried out again and again in grief and pain. But they desisted more quickly than they would otherwise have done, for they feared a worsening of the situation if the Saracens and their other enemies learned of their pain and were on this account emboldened to go further in their conquests and even to cross the sea in great haste and attempt to surprise them while they were still afflicted with grief. And the other reason was the evident peril in which they saw the other cities and Christians of Syria, who now remained, as it were, without commanders or defenders. For which reason, the emperor Constantine put an end to his grief and called a halt to these cries and lamentations, commanding that all the princes, knights, councillors and military commanders present in Constantinople and the neighbouring regions should assemble in the palace of Blachernae[7] in Constantinople, on the third day after the service in memory of the dead and the martyrs, so that they might deliberate in council about what should be done to prevent the enterprises of the Saracens and to recover the Holy City of Jerusalem. The Greeks willingly obeyed this order.

But the night before this third day, the emperor Constantine, when he was lying in his bed and thinking how he might come to the aid of the Holy Land, attack the Saracens and recover Jerusalem, prayed to Our Lord to send him counsel and succour on this subject. There he was overtaken by sleep. And, rapt between sleeping and waking, he had a sudden vision, before his bed, of a very handsome young man, who, raising him a little as if to wake him and let him hear what he wished to say, calling upon him gently to reassure him, said: "Constantine, you prayed and begged Our Lord to come to your aid. This he has done. Summon Charles the Great, king of Gaul and France, who is the defender and combatant of the Church of God." Then he said to him: "Raise your eyes and look to the heavens". And when Constantine obeyed, he saw high in the air a knight armed with a coat of mail and leg-armour, wearing at his collar an escutcheon and a red-handled sword hanging from his belt. And he carried in his hand a white spear, from whose point ever and again came burning fiery flames. And he held in his hand a helmet of gold. And as the emperor Constantine gazed attentively at this horseman, he found him very handsome, of great stature, already old, with a long, thick beard, his head very white and hoary and his eyes aflame and sparkling like twin stars. And he was astonished by the horseman's beauty and his gaze.

CAPTURE OF JERUSALEM BY THE SARACENS (AD 638). DREAM OF CONSTANTINE V

"When the holy King Charles the Great, commonly called Charlemagne, was reigning in France, it happened that the Saracens captured the Holy City of Jerusalem by force and there made a cruel massacre of the Christians."

(FOL. 6B)

The opening page of the first chapter of *Les Passages d'Outremer* is sumptuously decorated. To the right and at the bottom of the principal illumination, the frame is adorned with architectural elements, such as round arches resting on pillars and featuring delicate cable moulding; these are crowned with capitals decorated with statues of men in armour. Each scene depicted here recalls an important episode related in the lines that follow: the appearance of an angel to Emperor Constantine V in his sleep, together with the vision of a splendid knight in armour with a white beard and holding a shield bearing the image of a white cross on a red ground, proclaiming the arrival of Charlemagne; the embassy sent to the emperor of the West to ask him to come to the aid of Constantine; and Charlemagne's journey to Constantinople. The principal scene displays the composition most often used by Jean Colombe in this manuscript. In the foreground, we see a battle scene, which recalls an important event narrated in the text; behind this appears a scene composed of buildings, perhaps

a town or a fortress, as a reminder of the dangers that threaten the lands of Outremer; and, finally, in the background, the picture extends into a landscape comprising meadows, rocks and sea inlets. In the foreground of this picture, Colombe depicts a mêlée in which the Saracens are falling upon the Christians, who can be identified by the anachronistic crosses worn on their armour. Dead bodies scattered on the ground attest to the violence of the combat. The reference here is to the capture of Jerusalem by the Saracens and the city is portrayed as a massive fortress with the enemy armies pouring in. For Sébastien Mamerot, it was the capture of Jerusalem in AD 638 by the Arabs that marked the beginning of the long conflict that led the nobles of the West to set out on crusade to regain the Holy Places. Of course these scenes have very little in common with the historical facts: the capture of Jerusalem took place more than a century before the reign of Constantine V, who himself died before Charlemagne came to the imperial throne.

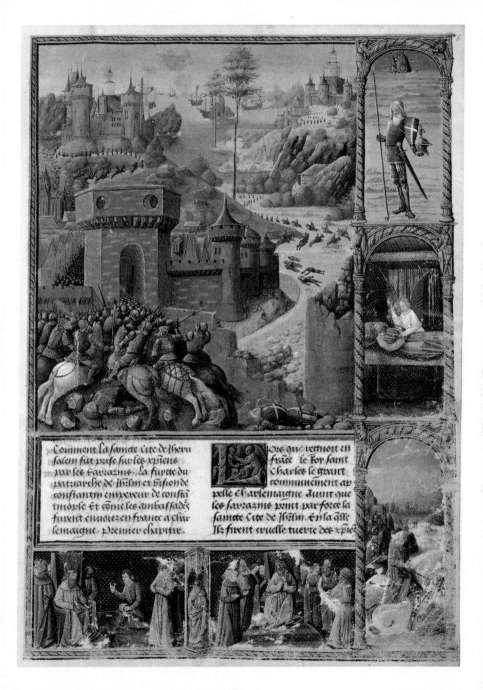

Comment la sainte cite de jheru
salem fut prise sur les xpiens
par les saraszins. La fuyte du
patriarche de jhrlm et division de
constantin empereur de consta-
tinople et comme les ambassades
furent envoiez en france a char-
lemaigne. Premier chapitre.

ors que regnoit en
france le roy saint
Charles le grant
communement ap-
pelle Charlemaigne. Avint que
les saraszins prent par force la
sainte cite de jhrlm. En la qlle
ilz firent cruelle tuerie des xpiēs

The angel vanished and Constantine woke, sad that he had departed, but remembering the vision in its entirety. Then, he got up and, having heard mass, entered the great hall, where the patriarch of Jerusalem and most of the Greek princes, knights, councillors and military commanders were assembled. In their presence, after they had discussed divers ways of recovering Jerusalem, according to what each amongst them thought best, he recounted his entire vision and asked them for their advice, declaring, moreover, that the fame, strength, valour and victories of Charles the Great exceeded all others in the East and the West. And this a number of knights present in the council and who had been in France and seen Charlemagne and certain of his battles, immediately confirmed; they told him that he was of the same size and build as the horseman that the emperor told them he had seen, and that he should, therefore, invoke his aid. And to corroborate his vision, they began to recount the great exploits of, the reputation of valour of and the conquests already won in great abundance by King Charlemagne. So much did they say on this subject that the emperor, knowing from his vision that they were telling the truth, and that Charlemagne exceeded in the renown of his valour all other princes, so that he was in consequence feared and loved throughout the West, decided that he must follow their advice. And, following their counsel and opinion and that of all the others, he wrote a most authentic letter, in the form of an epistle sealed with his great seal, writing it and signing it in his own hand so that it should be sent to the great King Charlemagne. The patriarch did the same, writing another such letter, also in his own hand, which he signed with his seal, in order that this, too, should be sent.

In each of these epistles were set down the events that had occurred in Jerusalem and the vision of Constantine, with no other difference than the titles of those who conveyed them and the different way either had of ordering them in his writing, for each of them begged King Charlemagne, both in the epistles and through their ambassadors, in one and the same concluding sentence, that he come to the aid of the Holy Land and the city of Jerusalem and help avenge the outrage inflicted on Our Lord Jesus Christ and his Christian people, and above all other things the opprobrium inflicted by the Saracens on the holy patriarch by expelling him from the holy seat of Jerusalem, where Saint James the Less had been the first bishop following the arrangements made by Our Lord and his apostles. And the emperor most especially bade him believe that this vision came from Our Lord, and that he should never once think that he had invented it in order to enjoy his aid and assistance, but that he declared that he had, indeed, seen it in obedience to Our Lord, and that he did not write to him for lack of

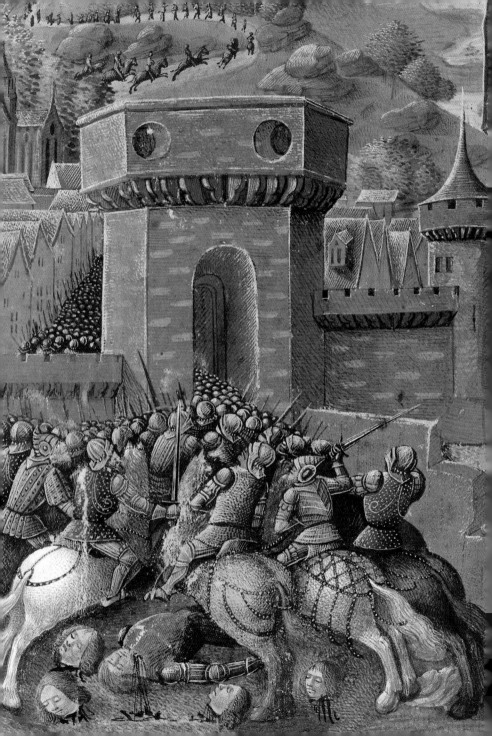

courage, nor did he request his help because he lacked men or knights, for he had on earlier occasions carried the day against the pagans with fewer men than he now had, and that he had seven times driven them out of Jerusalem when they had three times as many men as he did, and he had, nevertheless, seven times defeated them on the battlefield.[8] It was, therefore, clear that he appealed to him in order to obey Our Lord and the vision that he had shown him. These things considered, let him hasten to come and obey the orders of Our Lord, in order that he should not disobey the Lord's command and be at fault in tarrying too long.

When these epistles and requests were thus written and arranged, the emperor and the patriarch chose four principal ambassadors and messengers, two Latin and two Hebrew. The Latins were John, bishop of Naples, and David, the above-named arch-priest, and Samuel and Isaac were the Hebrews. Having the epistles and well versed in what they must say and do by order of the emperor and the patriarch, they set off as quickly and directly as they could to France to find King Charlemagne.

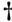

Chapter II.

How the ambassadors and legates of the emperor of Constantinople and the patriarch of Jerusalem arrived in Paris at the court of Charlemagne, who received them with great honours. The great sorrow that he felt for the loss of Jerusalem. The edict that he issued for its aid. The great army that he assembled and how he lost his way and miraculously rediscovered it.

Having passed through Germany, the first French city to which the legates and ambassadors of the emperor Constantine and the patriarch of Jerusalem came was Rheims, where they had been told while they were still in Germany that they would find King Charles the Great. This was not so, for he had left the city shortly before, leading part of his army in great haste into Auvergne against certain princes of this region who had rebelled against him and disobeyed his orders. The ambassadors would, therefore, have followed him, but were unable to do so because of pains in the head and stomach that so afflicted John, bishop of Naples, that they were obliged to stay two days in Rheims. At the end of these two days, Bishop John being again able to bear further travel, they set out, not directly following Charlemagne, not only because he was now very far away but also because of the illness and weakness of Bishop John.

For his sake, they travelled only part of the day and reached Saint-Denis peacefully, praying there, piously visiting the relics and the abbey, and there remaining till it was reported that Charlemagne had captured the castle where his adversaries had taken refuge – the adversaries against whom he had marched with part of his army – and that he was making his way back and would soon return to Paris. The ambassadors and legates rejoiced at this news.

Therefore, having stayed three days in Saint-Denis, they departed and came before the king, whom they encountered as he was entering Paris. Kneeling before him they gave him the highest salutation in the name of the emperor and the patriarch of Jerusalem and then presented their two epistles. Charlemagne, hearing their salutations and learning whence they came, gave them a most honourable welcome, wishing them all honour and joy. And in their presence, he straightway opened the epistles and read them word by word, silently and at length. Then tears began to flow from his eyes and he felt at once great joy and great sorrow: joy that the renown of his deeds, valour and glorious victories and triumphs should have spread as far as Greece and Jerusalem and throughout the Orient; and sorrow because the Holy City of Jerusalem and the Holy Sepulchre had been desecrated and sullied by the cruel and inhuman enemies of the holy Catholic faith.

He then began to weep for pity and gave the epistles to Turpin, archbishop of Rheims, whom he called forth, commanding that he translate the letters into French before the assembled company. This, the Archbishop Turpin did forthwith, translating them very clearly, so that when the princes, prelates, barons, knights, gentlemen, warriors, councillors and all the other French people who were near the king had heard the letters concerning the sad news and painful events of the Holy City of Jerusalem, they were filled with immense anger and a desire for vengeance, and all began as one man loudly proclaimed: "Sire, if you believe us too weary to suffer the hardships of so long a road, we swear and promise to God that, if you, our earthly sovereign lord, refuse to lead us or come with us, and do not want to help us accomplish the aid and vengeance that God has commanded us to perform, we shall leave fully armed tomorrow morning with the ambassadors and legates who have been sent to you to enhance your most exultant reputation. For it seems to us – nay, it is true – that nothing can harm us, since God wishes to lead us."

And when King Charlemagne, who wanted with all his heart to fulfil the request of the emperor Constantine and the patriarch, understood that the views, encouragement, promises and requests of the all the princes, prelates, councillors and warriors

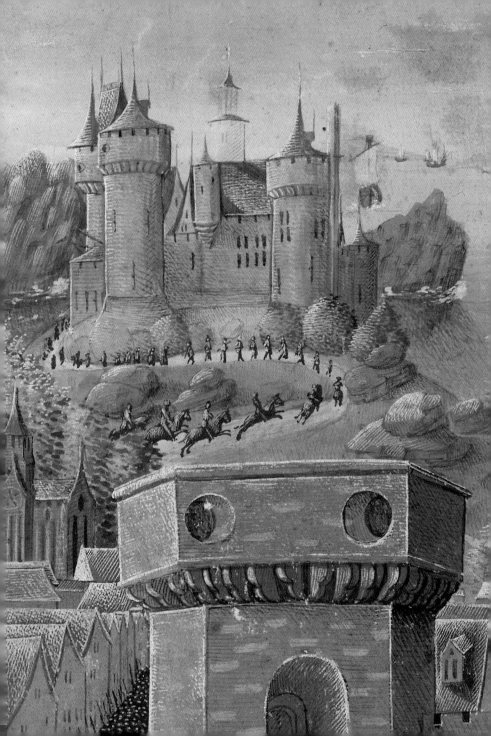

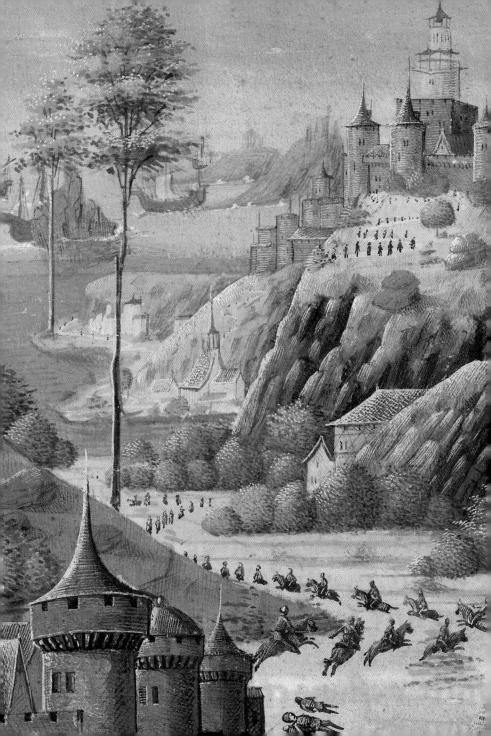

CHARLEMAGNE AND THE ENVOYS OF CONSTANTINE V BEFORE PARIS.
PREPARATION OF THE ARMY

"And as the emperor Constantine gazed attentively
at this horseman, he found him very handsome, of great stature,
already old, with a long, thick beard, his head very white
and hoary and his eyes aflame and sparkling like twin stars."

(FOL. 7B)

This is the first page showing the illustrations arranged in the manner that is typical of this manuscript: a large principal scene takes up the whole of the upper register, while one or two secondary, smaller scenes are placed in the lower register. After Constantine V's dream, in which Charlemagne figured as the man of Providence, the Byzantine emperor sent four emissaries, two Latin and two Hebrew, to inform the princes of the West of the capture of Jerusalem. They encountered Charlemagne with his army as he was entering Paris. Jean Colombe has taken particular care over the depiction of the cathedral of Notre-Dame, which is easily recognised by its two tall towers rising above the roofs of the city. In the centre of the scene, Charlemagne appears in armour on horseback; he is shown, as tradition has it, as an old man with a white beard. His office and title are indicated by the sumptuous mantle around his shoulders and by his horse's caparison, which is decorated with the *fleurs-de-lis*. Before him kneel the Byzantine envoys, led by a cleric who is possibly John, bishop of Naples. He appears to be handing Charlemagne the letter begging for his support in liberating the Holy Land. The lower miniature shows the Frankish king reviewing his troops, as a graphic illustration of his power and authority. The picture in the lower left-hand corner is damaged and difficult to make out.

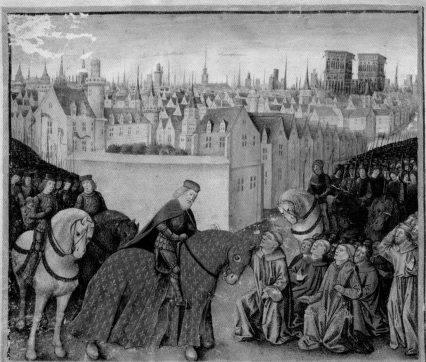

Comment les ambassadeurs et le
gatz de lempereur de constantino
ple et du patriarche de Iherin avi
nerent a paris deuers Charlemai
gne qui les recuist moult honnou
rablement. La grant compassion
quil eust de la perdition de Iherin
Ledict quil fit pour la secourir.
La grant armee quil assembla.
Et comment il perdit son chemin
et se trouua miraculeusement.
Second chapitre.

Ces legatz et am
bassadeurs de lem
pereur constantin
et du patriarche de
Iherin passerent par alemaigne
Et la premiere cite de france ou
ilz arriuerent fut Rains. En la
quelle on leur auoit dict en pas
sant eulx estans encores en ale
maigne quilz trouueroient le
Roy Charles le grant Ce quilz
ne furent obstant quil sen estoit

93

were wholly in accord with his own wish, and they were all united in the desire to do what he wished, he put aside all his grief and, thanking them from the bottom of his heart, made an edict that he immediately had announced and published throughout his realm, that any man who owed him obeisance, young or old, who could bear arms, should furnish themselves with the arms that they needed and follow him in this expedition without any excuse, and that all those who did not follow him and disobeyed his new edict and his command, would every year pay four deniers of silver as bondservice and all their heirs after them in perpetuity.

When this edict was known and understood in the kingdom of France, so great an army sprang up that none had ever been so powerful and so great nor, indeed, so courageous and ardent. Therefore, the much renowned King Charlemagne decided to lead his army as far as he might by land. He set out for Constantinople, passing through Germany, Hungary, Bulgaria and the other lands, kingdoms and countries beyond the river Danube.[9] And in all those kingdoms and countries, neither here nor there did he find any king, prince or people who dared prevent his advance or oppose him; on the contrary, they all came forward to meet him with great reverence and esteem, and very willingly supplied to him and his great army all kinds of victuals and all that he needed.

So much was this true that he was able to lead his entire army to Constantinople without obstacle, with this exception only, that one night he lost his way when crossing a great forest that was at least two days' travel across and perhaps more, though he thought that it could be crossed in a single day. In this forest, there were many cruel beasts that devoured men; in particular, there were gryphons, bears, lions, tigers and many other beasts horrible both to the sight and to the ear.

Thus, when the army had marched so long that it was now pitch dark, it began to rain so hard and so long that those who led them could not find the roads and paths and no longer knew which way to turn. This they announced to Charlemagne, who, perceiving that his men were each and everyone of them soaked and exhausted and that, given the darkness of the night, it was not possible to find the right way by means of the stars or in any other fashion, gave the order that everyone should hasten to put up their pavilions and tents and should rest and take their ease insofar as they might. But he himself, after his tent was erected, went apart in orison and prayed to Our Lord, reciting psalms from the book of Psalms. Thus, he spent much of the night without sleeping.

And Our Lord, seeing his fervent devotion and the great expedition that he was undertaking for love of Him, sought to help him find his way again. For at the point

when he had reached the psalm of the psalm-book that says, "Deduc me Domine in semitam mandatorum tuorum quia ipsam volui", which means, "Make me to go in the path of thy commandments; for therein do I delight" – and he recited the whole psalm – the voice of a bird native to this land was heard, which replied to him so loudly that those who were sleeping before him in his tent all woke at once, terrified and dumbfounded. They saw in it the sign that some great prodigy should occur because these birds spoke a human language.

And when Charlemagne had finished the psalm, he added to his orisons and prayers what follows: "Educ Domine de carcere animam mean ut confieatur nomini tuo", that is, "Bring my soul out of prison, that I may praise thy name". The bird began to cry even louder and more vehemently than before and said, "Frenchman, what say you?" And though it is said that the Greeks often teach certain birds to acclaim the emperor by saying "Cheire Basileos anithos", which means in Latin "Salut Cesar inclitissime" and thus "Most victorious emperor, God be with you", the natives of the country said that they had never heard any bird speak in so comprehensible a manner. And it must be believed that this bird then replied in Latin to Charlemagne, that being a language not much spoken in this region.[10]

And it must be confessed that it spoke miraculously and that it was sent by God to restore Charlemagne, who had erred from the right path, he and his army, to the proper road. Thus, indeed, it turned out, for Charlemagne ordered the entire army to follow a little path that the bird had taken and, by following it, the next day, a little after the break of day, they rediscovered the broader road that they had been following. And there exist to this very day in that region birds of this kind that habitually sing such words, if we are to believe the pilgrims who have passed through that region on their way to Jerusalem. And Our Lord not only restored Charlemagne to the right path, but also took care that neither he nor his men sustained any injuries from the wild animals in this forest. This was, indeed, a rare thing for those who sought to cross that forest.

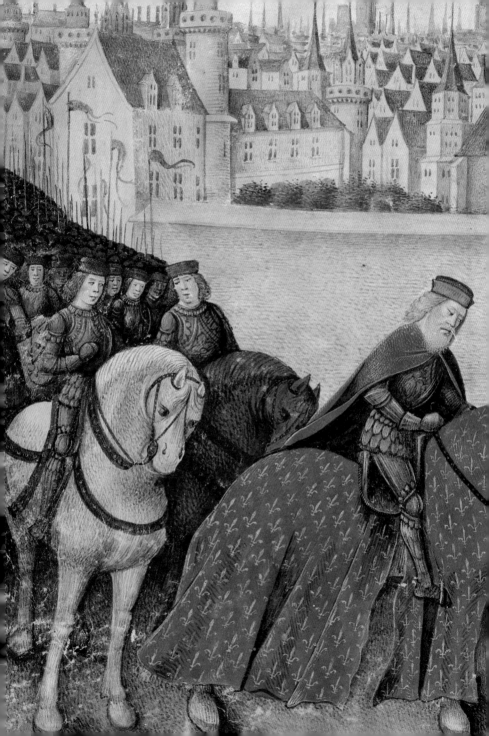

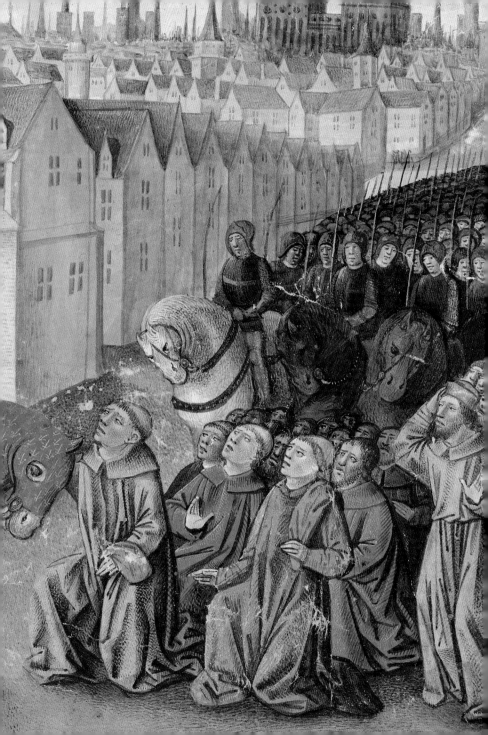

Chapter III.
How Charlemagne arrived in Constantinople and of the great honours bestowed upon him there by the emperor Constantine and his son Leo. And how, together, they went into the kingdom of Syria and there reconquered the Holy City of Jerusalem and drove out the Saracens from the city by force of arms, the very same Saracens who had previously captured it from the Christians.

When they were approaching the city of Constantinople, Charlemagne made his advance known to the emperor. Therefore, as soon as Constantine and his son Leo IV had been informed that he was within seven leagues of Constantinople, they went out to meet him with a very handsome and noble company of princes, prelates, nobles and burghers of the city. And do not ask about the many great honours that the emperor conferred on the very noble and valorous Charlemagne and the great joys that they mutually bestowed on each other, for this would be too long in the telling. The Greeks gazed upon Charlemagne and contemplated him with admiration and could not have enough of him, his arms and his stature. And the emperor Constantine above all, who gazed upon him attentively and realised that it was, indeed, Charlemagne whom he had seen in his vision, wept so fervently with joy that, though he attempted to express with gestures and words before the Greek, French and German nobles, princes and prelates, the patriarch of Jerusalem and the other princes and prelates of Syria, Persia and divers other nations assembled, it was a long time before he was able to gather breath and actually do so, because of the constant sighs that his joy brought forth.

Despite these sighs, he finally recounted his vision loudly and clearly, and, again and again embracing Charlemagne, stated and affirmed that he was the horseman that he had seen in his vision, armed, clothed and carrying lance, arms and sword, of just such stature and visage: that is, he whom Our Lord had announced would be the man to reconquer the Holy City of Jerusalem from the pagans. Therefore, he and all the others conducted the very noble Charlemagne into Constantinople crying "Huzzah" at the top of their voices and expressing the utmost joy. The clergy and all the burghers and their wives and the citizens came towards him, all richly dressed as became their rank. And they led him to the main church, known as Haghia Sophia, where the

cantors were singing "Te Deum" with innumerable instruments that resounded and rang out most melodiously. And when orison had been made by King Charlemagne, Emperor Constantine and his son Leo IV came amongst them and led them with great honour and amidst the sounds of very melodious instruments into the Great Palace and into the halls and chambers that had been prepared and furnished for them. They welcomed the king and his entourage and gave him lodging and had served to him wines and various dishes of meat in great abundance, to him and to his followers, just as each of them desired. They were in great need of this because of the great pains and suffering that they had endured during the long voyage that they had just made.

However, the following morning, after Charlemagne had heard mass as he customarily did every day, he declared to the emperor Constantine that he and his army were ready to depart and set out to accomplish the expedition and the pilgrimage that they had undertaken at his demand. Constantine was much astonished at this and could not, he felt, too much extol the renown, valour and power of so mighty and noble a king, who was not fatigued nor broken by so long a route, but who wished to set off again immediately without asking for a day of rest, instead of taking his ease. He came to explain this to Charlemagne, begging him to wait and stay for eight or ten days, as much for his own repose as for that of his men. To which Charlemagne replied – and it was the truth – that he had promised and sworn, when still in France and wishing to set out, having heard of the misfortunes in the Holy Land, that nowhere would he stay more than three days without absolute necessity compelling him to, till he saw the Holy City of Jerusalem. He, therefore, begged the emperor to be content to see him depart and accomplish that which he desired.

Constantine understood this desire and dared not oppose Charlemagne; so he ordered that his army, which had long been held in readiness while he awaited Charlemagne's arrival and was informed of his coming, should set off and take the vanguard, for his men knew the terrain and regions through which they must pass. This order having been given and published, the two armies at once set off in handsome order. And Our Lord extended his grace to the Christians, to such an extent that no writing can be found recording any conflict either on the outward or the return journey, between the armies, nor even amongst individuals over the sharing out of spoils, great as these were after their victory, yet innumerable discords and disputes had often occurred in the past (and were to do so again thereafter) when several nations were thus allied. Yet these nations were often smaller, both in the number of their men and in the diversity of their customs, morals and languages, and many of them perished, some

ARRIVAL OF CHARLEMAGNE IN CONSTANTINOPLE.
CHARLEMAGNE AT THE PALACE OF CONSTANTINE

*"To which Charlemagne replied – and it was the truth – that
he had promised and sworn, when still in France and wishing to set out,
having heard of the misfortunes in the Holy Land, that nowhere
would he stay more than three days without absolute necessity compelling him to,
till he saw the Holy City of Jerusalem."*

(FOL. 12A)

On this page, Jean Colombe portrays the arrival of Charlemagne at Constantinople, where he is welcomed at the gates of the city by Constantine V and his son, the future Leo IV, at the head of a triumphal procession. The jubilation of the capital of the Byzantine Empire is underlined by the noble ladies and prelates who have come out of the city in a procession to meet the emperor and the elegant citizens who have gathered to pay homage to him. In the lower register, the two emperors and their retinues are in an immense room in the palace, lighted by windows through which can be seen a maritime landscape. A cloth laid over the great table and the presence of a squire carving meat suggests that there has been a banquet in honour of Charlemagne. To the right, although the painting is damaged, it is possible to make out a religious service that is taking place in a church, which is undoubtedly that of Hagia Sophia.

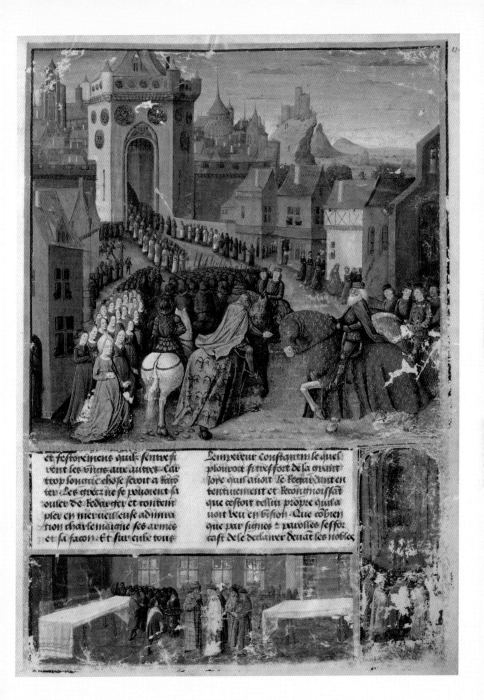

et festoierent quilz sentirent les vngs aux autres. Car trop longue chose seroit a raconter. Les grecz ne se pouoient fi ouler de regarder et contem pler en merueilleuse admira tion charlemaigne ses armes et sa facon. Et sur eulx tous

Lempereur constantin lequel plouroit si tresfort de la grant ioye quil auoit le regardant en tendrement et kcongnoissoit que cestoit vestir propre quila uoit leu en vision. Que cobien que par signes ⁊ parolles sesfor cast de le declarer deuant les nobles

of them to the last man, when they travelled to and remained in the lands that they wished to conquer, or had already all but conquered through their pains and great efforts, or again when they returned from those lands.

In short, the two emperors and their two armies, in good health and undiminished, reached the Holy City of Jerusalem, which they besieged and encircled, and attacked it so fiercely and continuously that they took it by storm, despite the multitude of Saracens and pagans of various nations that were within its walls and had, shortly before, as I have already related, captured it from the Christians by force of arms, and had so fortified, victualled and equipped it that they thought they could hold it against the rest of the world. But they were mistaken, for they were all put to the sword or killed with various tortures in order to avenge the cruel acts and inhuman treatments that they had previously inflicted when they had killed a great number of the Christians who lived in the city and desecrated and despoiled the church of the Holy Sepulchre of Our Lord God Jesus Christ and the other churches and Holy Places of the city of Jerusalem. When once this great massacre of Saracens and heathens had been accomplished, the king and the emperor led their armies back through the kingdom of Syria and Jerusalem and, within a short time, they had reconquered all the cities, towns and fortresses that were occupied by the pagans, every one of whom they put to the sword as they found them in the places that they took. This conquest completed, they returned to the city of Jerusalem, which they had repaired and reinforced so that it was stronger than it had ever been before, and they restored the patriarch John to his seat and all the other people of the church to their dignities and benefices and the nobles and lay people to their heritages and lordships.

When they had done all this, when the churches had been reconstructed and they had re-endowed them and visited them weeping and praying most devoutly, they set off again with their two armies, going directly to Constantinople, where they arrived shortly afterwards safe and sound and were received with great joy, honour and jollity.

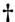

Chapter IV.

How the emperor set out a great abundance of gold and silver, silk cloth and other valuables and wanted Charlemagne and his men to take whatever they wanted from this store. But Charlemagne, who refused all such and was compelled by the emperor Constantine to take some gifts for the love of God, asked for relics of the Passion of Our Lord, which the emperor granted him.

Constantine, thinking that he would feast Charlemagne and long detain him so that he and his army would stay in Constantinople, everywhere brought together from all sides anything that he thought would give him pleasure. And he was extremely joyful to have in his capital so excellent and powerful a prince and thought that it would be an excessive honour to him wherever it was known that he had feasted, honoured and loved this excellent conqueror. But his joy was nevertheless short-lived, for, but a few days afterwards, King Charlemagne ordered the princes and principal commanders of his army to announce their departure in due form, saying that each must take care of his affairs immediately, and that he intended to set off on the day that he announced and to return to Germany and France. On the eve of the day when he wished to depart, after the emperor had, with the patriarch of Jerusalem, held a great feast for him, he told them his intention and sought to take his leave of them in order that he might set out on his return as he had decided.

The emperor and the patriarch were saddened by this, putting it to him that his men had made a great expedition and this justified a long stay before taking so long a road back, in which they would have to pass through divers lands and countries that were foreign and extremely formidable because of the wild animals that lived there, not to speak of the very dangerous rivers and perilous places that they would encounter before they came to their own lands and countries. And by these protestations and similar prayers and requests, the emperor Constantine and the patriarch of Jerusalem attempted again to detain Charlemagne in Constantinople, hoping to entertain him even more richly than they had before. But he made it so entirely clear to them what business and necessities might and would have arisen amongst the people of his lands and kingdoms due to civil dissension while he had been so long absent that they no longer dared ask him anything more nor counsel him to remain, even though the

CHARLEMAGNE ANNOUNCING HIS DEPARTURE TO CONSTANTINE V.
COUNCIL PRESIDED OVER BY CHARLEMAGNE. CHARLEMAGNE DECLINING
THE GIFTS OF THE EMPEROR BUT ACCEPTING THE HOLY RELICS

*"When Charlemagne heard him speak of Holy Relics, he was
overjoyed and, very willingly thanking the emperor Constantine, he told him
that he deemed Our Lord Himself to have offered them to him."*

(FOL. 14B)

The depiction of certain celebrated structures and other architecture of the city occupies an important place on this page, as is often the case in the paintings of Jean Colombe. The eye is drawn to the huge and imposing city gate of Constantinople, which fills the whole left side of the principal picture. The gate is sumptuously decorated: there are statues housed in niches against a multi-coloured ground, friezes formed of coloured medallions like jewels set into the stonework, a great round arch marking the entry beneath the gate and walls and ceilings covered with reliefs beneath the vaulting. The street leading to this gate is lined with half-timbered houses resembling those of Western cities of the fifteenth century, all decorated in honour of Charlemagne with brilliantly coloured hangings. The picture accurately illustrates the passage in the text where Constantine has laid out magnificent gifts all along the streets in the hope of detaining Charlemagne. In the foreground, the two emperors' white mounts brighten the scene. Charlemagne would appear to refuse the gifts of Constantine and makes a gesture of farewell. As proof that the emperor has decided to depart, his horse already makes to leave, while his troops are marching towards the other gate. In the lower left-hand register, the two emperors are shown in the palace once again; Charlemagne has agreed to delay his departure in order to see the Holy Relics, which are kept in the treasury. To the right, in a room with walls of green marble and a coffered ceiling, Charlemagne is seated in a chair and appears to be listening attentively to a young man who is speaking to him of the relics.

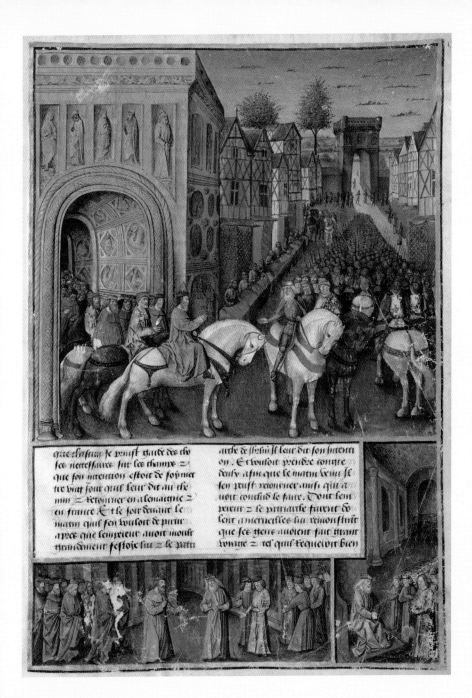

que chascun se preist garde des cho-
ses necessaires sur ses champs z
que son intention estoit de sojour-
ner viet jour quil leur dit au che-
min z retourner en alemaigne z
en france. Et le soir devant le
matin quil sen vouloit de partir
apres que lempereur auoit moult
grandement festoje lui z le pati-

arche de ihrlm si leur dit son intenti-
on. Et vouloit prendre congie
deulx afin que le matin bien se
sen preist retourner ainsi quil a-
uoit conclud le faire. Dont sem-
pereur z le patriarche furent do-
lent a merueilles lui remonstrit
que ses gens auoient fait grant
voyage z tel quil requeroit bien

emperor asked him to remain for the following day. Charlemagne, thinking that the emperor had need of him again in secret matters, accepted and said that he was content to delay his departure till the third day and longer again if need were.

The emperor Constantine asked him for this delay in order to honour him and his men with great and rich gifts. In this he was as good as his word, for that night and the following day, he had brought before the outer gate of Constantinople and arrayed along the streets down which Charlemagne and his men must pass a great quantity of treasures, such as coursers, palfreys, sacred objects, falcons, cloth of gold and silk of various sorts and colours and other jewels and superb gifts. When the third day came, Charlemagne was warned that the emperor had had these treasures prepared and hoped to give them to him. But he himself wanted no such gifts. Fearing, however, that he would commit the sin of pride if he refused the emperor's presents, he summoned a number of his prelates, princes and councillors and asked them what he should do, saying that he would follow their advice. And all of them together replied that he should receive no gifts from anyone for a task that he had undertaken solely for the love of God. And that, if his men accepted these gifts, it might be thought that they had come to the aid of and delivered the Holy Land and the Holy City of Jerusalem through covetousness and avarice and not through piety and pilgrimage. Charlemagne, understanding that his princes and prelates were of the same opinion as he was and that they were advising him to do that which he wished to do, let it be known to his men that they were forbidden to take or keep the presents prepared for them or even to cast their eyes on them.

Thus, it came about that on the third day, when Charlemagne wished to take leave of the emperor, his son Leo IV, the patriarch and the other Greek princes and prelates, the latter told him that they would escort him to the outer gate. And this they did, despite all his protests. When they came to the place where all these treasures were set out, the emperor Constantine generously begged him to choose as many as he and his men would like, for that was why he had had them assembled there. But Charlemagne replied that he and his army had come to acquire heavenly and not worldly gains and they had willingly endured the hardships and the voyage in quest of the grace of Our Lord and temporal glory. The emperor, hearing these replies, told him that he should take some jewels, not as payment for his pains, but to show the people of his own lands and countries as testimony of the grace and mercy of Our Lord and of his having been in the regions of Jerusalem, Antioch and Constantinople.

But Charlemagne would by no means agree to that. So Constantine, seeing that he would not give way and accept worldly treasures, very affectionately begged him and obliged him by oath and as if by conjuration, requiring that, at the very least, for the love and honour of God, he should agree to stay a few days more so that he could choose from the Holy Relics that he, the emperor, had in his treasury.

When Charlemagne heard him speak of Holy Relics, he was overjoyed and, very willingly thanking the emperor Constantine, he told him that he deemed Our Lord Himself to have offered them to him. And he told him what, that very day, he had thought concerning the great gifts that the emperor wished to make to him; that he had longed to ask him for the gift of a reliquary, which would be an example of piety and devotion for the Western peoples. And on this occasion, he would willingly, therefore, grant his request if his own were heard, and would choose something that he might honestly and with dignity take back with him. Constantine was overjoyed and agreed that he might ask for whatever he wished and that it would be given to him. Then Charlemagne said to him: "I, therefore, ask you to give me one of the reliquaries of the Passion of Our Lord Jesus Christ, containing things that caused His Passion and His death, so that those of my kingdom, who cannot come here, should have a memento of those things." And Constantine very generously granted him this. Charlemagne, therefore, went back within the gates of Constantinople, and all his men with him, and they were lodged as before.

Chapter V.

How the Holy Relics of the Passion of Our Lord, which had been in Constantinople, were found, and of those that were given to Charlemagne and the miracles that occurred when they were given to him in Constantinople. How he departed. The miracles that Our Lord performed for them on their way. How he deposited them in Aix-la-Chapelle in Germany, and the miracles that occurred there.

Since the era of the holy emperor Constantine the Great and his empress mother, Saint Helena – who by Our Lord's special grace was deemed worthy to find and to take the True and Holy Cross of Our Lord Jesus Christ, and the Crown of Thorns and the Holy Nails with which He was crowned and crucified on the day of His holy Passion,

when He, according to His human nature, died for our redemption – the Holy Relics that she carried to Constantinople had not been shown to the people, and in particular the Holy Crown and the Holy Nails. As for the True Cross, this empress saint wished to leave it and did leave it in Jerusalem, although later the emperor Heraclius, after he had conquered and killed Chosroes, king of Persia, and his son, took from them the True and Holy Cross, which they had carried away when they had destroyed Jerusalem and took it back to Jerusalem and there had it cut straight through the middle; one half he left in Jerusalem and the other he carried to Constantinople. And he had caused it to be sawn in two such that in each of the two cities there was a cross identical in length and in breadth, for he did not dismember it but only split or sawed it through the middle.[11]

And so it came to be that when Constantine V heard and knew the will of Charlemagne, he gathered together the patriarch and the prelates, the princes and the clergy of Constantinople, because he did not know the exact place where the Holy Relics were. And few others knew it, except certain treasurers and guardians of the relics of their people, by whom he was informed of a most secret place in which they should be, according to certain inventories and certain words of men of old. That is why he chose seven from amongst them – very old and renowned for their great saintliness and religion – whom he commanded to open the holy treasury and to take out one part for Charlemagne, in his presence. But it was commanded that, before all else, the chosen seven and the emperor Charlemagne and all those who wished to see the relics, and most particularly all the French, should fast for three days continuously and should confess themselves most devoutly, and this they did accordingly.

And when the three days had passed, the emperor and Charlemagne entered the holy place where the Holy Relics were and there they confessed themselves straightway to a saintly archbishop whose name was Hebroin. And Charlemagne commanded also those of his people who had entered with him to confess themselves, and they obeyed him most gladly and with good heart. The patriarchs, the prelates and the other members of the clergy who had also entered began to sing psalms and litanies. And during this time, the seven holy men opened the secret place, which had hitherto long been hidden save to a small number of people, and they took out the casket in which reposed the Holy Crown of Thorns with which Our Lord Jesus Christ had been crowned in scorn. And Damel, bishop of Naples, held it in his hands and took it out of the casket.

As it was opened, at the very moment when he drew out the Holy Crown, there came forth a great and most sweet smell that spread over all those who were present,

CHARLEMAGNE WORSHIPPING THE HOLY RELICS.
THE BISHOP OF NAPLES SHOWING THE CROWN OF THORNS TO CHARLEMAGNE

"And when they had long given thanks and praise most joyfully,
the Emperor Constantine caused to be given to King Charlemagne the Crown
of Thorns with which Our Lord had been crowned on the day of His Passion,
the Holy Nail with which he had been nailed that same day to the cross,
a piece of wood from the Holy Cross, the Shroud of Our Lord, the Gown of
Our Lady, which she had worn when she bore Him, the Tie [...] and
the arm of Saint Symeon, with which he had received Our Lord Jesus Christ
on the day when he had gone up to the Temple in Jerusalem."

(FOL. 17VA)

The principal scene takes place in the church at Constantinople, where the emperor has assembled the prelates and clergy to present in solemn fashion the Holy Relics of Christ to Charlemagne. There is a reliquary in the form of a church placed on the altar; from this Damel, bishop of Naples, has taken out the Holy Crown of Thorns with which Christ was crowned in mockery at the moment of his Passion and Crucifixion. Charlemagne and Constantine, together with all those present, are kneeling in prayer to Our Lord. The cult of relics, which was so important throughout the Middle Ages, here assumes prominence. According to legend, St Helena, during a pilgrimage to Palestine, discovered a num-ber of relics of the Passion of Christ, which were later dispersed to different cities of Christendom. The surroundings are sol-emn: the side chapels of the church depicted in the background of the prin-cipal illumination display a refined Gothic style – vaulting with lancet arches, tall pillars crowned with capitals, sculptures housed in niches, stained-glass windows lighting the church, all bearing witness to the splendour of the place. Just like Jean Fouquet, Jean Colombe takes pleasure in depicting the celebrated buildings and architectural art of his day. In the lower register, the faithful kneel in prayer, their hands joined, while Charlemagne receives the relics, which he will take back with him to the West.

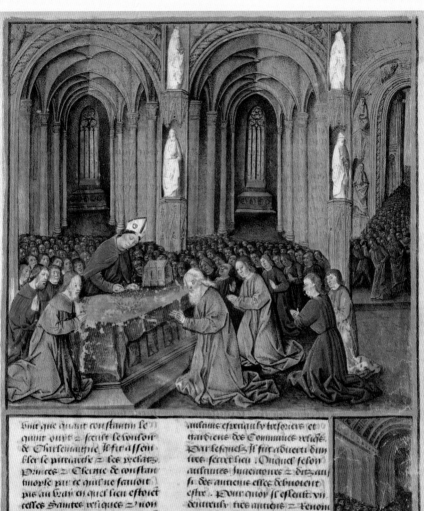

Sur que durant constantin le
gnint ouyt z seruit le wndour
de Christenaume il fit assem
bler le pitriarche z les prelats
Princes z Clerise de constan
tinoble par ce quil ne sauoit
pas au bray en quel lieu estoient
celles Saintes resiques z non
faisoient gaires dinistres si no

visame espirituel ly tresoriers et
gardiens des Communes reliques
Par lesquels il fut aduerti dun
tres secret lieu Onquel selon
aultunes Inuentoure z dits au
si des auncienne esse debuoient
estre Pour quoy il esploit vn
deuoreulx tres auncien z renom
me de saint sanctite z resigi

in such a way that they believed themselves to be in paradise on earth. And Charlemagne, rapt with joy, knelt straightway on the ground and, with great devotion and faith, humbly begged of and prayed to Our Lord for His goodness to perform a miracle, so that if there were any who disbelieved or who doubted that this Holy Crown was that which He had borne on his precious and most worthy head, they should henceforth doubt no longer. Our Lord God Jesus Christ heard his love, his faith, his devotion and his prayer, for when his prayer was not yet finished, there descended suddenly from Heaven a dew, which in the sight of all miraculously watered the wood of the Holy Crown in such a way that the thorns straightway flowered and gave forth a smell so great and sweet that no language exists that can describe it. And, to briefly speak in His praise, all those who were inside the holy church were so nourished and so filled with this sweet and pleasant smell that they prayed most lovingly to Our Lord that they might remain for ever in this blessed state. And there was a brightness so great and so resplendent that each one believed that he had been clothed from Heaven.

While these smells and these splendours spread around, the sick who were present felt pain and grief no more, as they had done hitherto. After a long moment, Charlemagne rose from his prayer and began to recite a psalm from the psaltery, beginning with "Exaudi Domine vocem meam quia clamavi ad te", and several others right to the end. And all this while the patriarchs, the prelates and the clergy were singing with great devotion "Te Deum laudamus". Our Lord God wished once more to prove yet more completely that this was the True Holy Crown, so that none could ever again doubt that this was the very one that Jesus Christ had worn during His Passion. For when the aforementioned Damel, bishop of Naples (whom I believe to be that John whose surname, according to some, was Damel by reason of the bishopric of Naples, which he held hereafter and who had been sent as a messenger to Charlemagne by the Patriarch of Jerusalem), cut the Holy Crown with a knife to splice it in two, the wood, and most particularly the two cut ends, appeared as green by the grace of the Holy Dew descended from Heaven as they had been the very day that they were cut from the living, verdant tree when the Holy Crown had been made. And, what is more, Our Lord made it blossom anew, as prolifically as if it were still rooted in the earth.

And at that moment King Charlemagne, who throughout that day had knelt so often and so long, bare knees to the ground, that the skin was almost stripped from them and from his elbows, too, seeing this new miracle and fearing that the fresh flowers would fall to the ground and be trampled by the crowd, cut a piece of red cloth that he had prepared in which to place the Holy Relics, and plucked those holy flowers

and, wrapping them in the piece of cloth, put them in his right glove. And preparing himself to receive the other Holy Relics, he held out his hand to give the glove and the flowers to Archbishop Hebroin and, believing that he was about to take the glove, let it go. But both he and the archbishop were weeping so profusely that they could see nothing, and Charlemagne did not realise that the archbishop was not expecting to receive the glove and the archbishop did not understand that Charlemagne intended to give it to him. And so the glove remained between the two of them, in the air, with no human help whatsoever. And then Our Lord, heaping miracle upon miracle, acted in such wise that the glove remained a long while in the air, until Charlemagne took one part of the Holy Thorns, held them against himself and, his eyes clear once again, turned to the archbishop to ask for his glove. And he saw it still hanging in the air, which grieved him deeply. And he began to weep again, believing that he had displeased the Lord by putting the flowers in his glove. However, when the archbishop assured him that he had not seen him hold the glove out to him, he was comforted and, thanking Our Lord most humbly, took the glove and unfolded the cloth, where he found the flowers changed into manna, which filled him with great joy. And he began to recite with David: "Quam magnificata sunt opera tua Domine", which means: "Lord God, how splendid and how glorious are your works". And this manna, which he wrapped anew in the cloth, is to this day preserved with great honour in the church of Saint-Denis in France, along with another part of the manna, which Our Lord gave to the children of Israel when they were in the desert.

When these things happened, the people of Constantinople and of other races and nations were gathered together at the doors of the church, pushing against each other to see the miracles and marvels and to know what was happening and whence came this pleasant smell, which filled the whole city. And they went in through the doors, which were in part open and in part broken, and around these doors was a throng of people unbelievably great. And all the while, all were singing with great devotion, giving thanks to Our Lord and reciting: "Hec dies quam fecit Dominus, exultemus et letemus in ea", "This is the day that the Lord has made, let us rejoice in it; today is truly the day of the holy resurrection". And all were filled with profound joy, and most particularly Charlemagne, who sang with them: "Cantate Domino canticum novum quia mirabilia fecit". And beside this psalm, he sang several other psalms from the psaltery with the prelates and the clergy.

And after they had finished these with great praise and joyfulness, they departed thence and went, still singing, as far as the place where the other bishops were. From

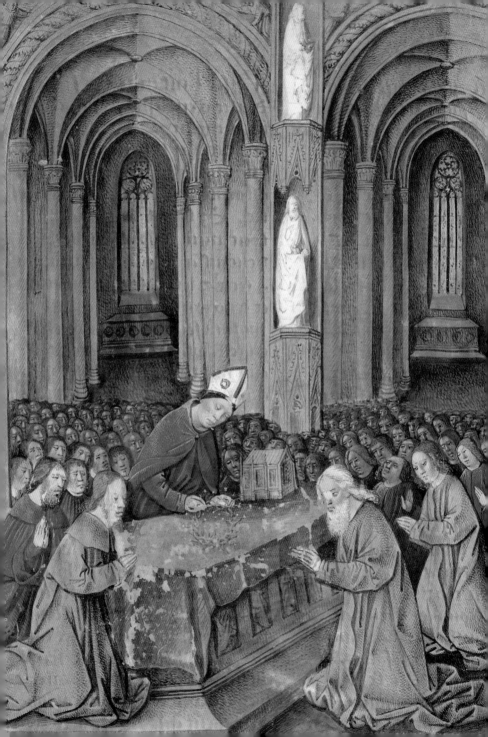

there, Bishop Damel of Naples took out the Holy Nail and carried it and presented it with great honour to Charlemagne. Whereupon there occurred another most wonderful and most marvellous miracle, and indeed there were several others, for in the same way that there had come the sweet smell when the Holy Thorns had flowered, likewise, when the Holy Nail was taken from the casket by Bishop Damel, a great, marvellous and pleasant smell filled the place and the church where it was, but none could find words adequate to describe it. And a like miracle spread throughout the city on men of various standing who were in that place, and so great was it that, thanks to the great healing power of this smell, three hundred and one who were sick with divers illnesses were cured at that very moment.

All together and individually they swore under oath that they had recovered their health at the same time. Amongst them was one who had languished eighteen years with three afflictions, blind, deaf and mute. And he said that he had first recovered his sight, then his hearing and finally his speech. And he said that this had happened to him on account of the three miracles and divine mysteries that had been proven. For when the Holy Crown of Thorns was found and removed, he recovered his sight. When it was cut, he recovered his hearing. And when it flowered, he recovered his speech. After they had heard his words in stillness and in silence, all the prelates and the clergy gave humble thanks to Our Lord and sang devoutly "Suscepimus Deus memoriam tuam in medio templi tui", and "Omnes gentes plaudite minibus, etc.".

And after they had finished these two psalms, there came running into the church a child whose right hand and all his right side had been withered since birth. And he declared before them all, loudly and clearly, how Our Lord had cured him, and he said: "I was lying on my bed when, towards the hour of nones, I seemed to see before me an old, white-haired smith who drew a lance and an iron nail out from the middle of my foot and from my right hand. And at that same moment, I was in perfect health, and I am come running to give thanks to Our Lord for his great kindness and mercy."

And because of this, the prelates, the princes and the clergy, ever more joyful, began once again to praise Our Lord and to give thanks to Him and to sing. And they sang most devoutly "Te Deum laudamus" and all this time the most victorious King Charlemagne was singing "Manus tue Domine fecerunt me et plasmaverunt me. Da michi intellectum ut discam mandata tua", and many other psalms from the psaltery. And when they had long given thanks and praise most joyfully, the Emperor Constantine caused to be given to King Charlemagne the Crown of Thorns with which Our Lord had been crowned on the day of His Passion, the Holy Nail with which he had been

nailed that same day to the cross, a piece of wood from the Holy Cross, the Shroud of Our Lord, the Gown of Our Lady, which she had worn when she bore Him, the Tie (which is a type of belt or long narrow strip of cloth with which Our Lady had bound Our Lord when she had swaddled him and laid him in the cradle) and the arm of Saint Symeon, with which he had received Our Lord Jesus Christ on the day when he had gone up to the Temple in Jerusalem. King Charlemagne had each of these Holy Relics wrapped in divers silk cloths, and then he had them placed all together in a sack of buffalo hide. Thereafter, whenever he went out, he carried it, always hanging around his neck, until he had come into his own chapel of Our Lady at Aix-la-Chapelle in Germany. And out of respect for Our Lord and for his Holy Relics, and to please the Emperor Constantine, he stayed all that day and several others in Constantinople.

Then he took his leave of the emperor and of his son, Leo IV, and also of the patriarchs of Jerusalem and Constantinople, and of all the other Greek princes and prelates, who grieved deeply at his departure. And he took the road once again to return to France with his army, and having passed through a number of lands and countries without incident, he came to the castle of Lymecon, and here, after he had been to church, he stayed for six months and a day, as much to allow his people to rest as by reason of the great multitude of people who came to see him because of the great miracles that Our Lord performed on all those who came there to honour the Holy Relics that he carried.

And amongst others, the magistrate of that castle, called Galatiel, and his wife, whose name was Mara, had one son who was troubled with divers afflictions, for he had lost the use of his eyes through weakness in the head, his nose was large and swollen, he was hunchbacked and he suffered besides from gout in his hands and feet. In short, he was daily so tormented and he suffered so much that the pain had made him lose his wits, and for that reason men said that he was mad. But when his father and his mother knew that Charlemagne was come and heard tell of the great miracles that Our Lord had performed, thanks to the relics that the king was carrying, in Naples and in many other places, they brought their child to him. And the child died as soon as he had been placed before him and the Holy Relics. Their grief thereat was terrible, because they had no other child, and they most humbly begged Charlemagne to help them and to come close to the corpse with the Holy Relics. This he did most gladly. And then Our Lord performed a marvellous miracle because, no sooner had Charlemagne raised the arm with which he held the sack wherein were the Holy Relics and its shadow alone touched the dead body, than the body gave off an unbearable stench,

and yet they were still some distance from it. Finally, Archbishop Hebroin, a man of great saintliness, the Archdeacon Gilbert, a man of great religion, Does, bishop of Serence, and Gerase, subdeacon of Greece, who were amongst the greatest nobles of Thebes, begged Charlemagne to go closer to the corpse. And this Gerase went down and took the casket from the hands of the emperor and ran towards the body of the dead child. And while he was hastening to take the relics out, he supported the casket on the bier where the corpse lay. And straightway by this touch, the child, who was called Thomas, was restored to life and got upon his feet, healthy and cured of all his afflictions. Besides this miracle, fifty men and women, hitherto sick with divers illnesses, were cured before the Holy Relics while Charlemagne was staying there.

After the passage of six months and a day, Charlemagne departed and journeyed such that he arrived with his army and the Holy Relics in the city of Aix-la-Chapelle in Germany. And he assembled and placed the Holy Relics that he had brought from Constantinople in the church in that city, which he had founded in honour of Our Lady. And yet more, on the very day when he arrived and on the following days, a dead man was restored to life and twelve men were delivered from the devils that possessed them, while eight who were paralysed, fifteen who were lame, forty who had only one arm, thirty who were hunchbacked, fifty-two who suffered from the falling sickness, fifty-five who had goitres and the innumerable blind and fever-ridden, all from that neighbourhood, were cured before these relics.

To authorise the translation of these Holy Relics, Charlemagne gathered together a great council, which was held in that city of Aix on the second Wednesday in June, which was the fourth day after Pentecost. To this council came Pope Leo; Archbishop Turpin; Achilles, bishop of Alexandria; Theophilus, patriarch of Antioch; and many other bishops and abbots. They all accorded an indulgence to all those who might visit these Holy Relics each year in a state of grace, and they decreed that each year, on that Wednesday, there should be celebrated the translation of the Holy Relics, of which most were thereafter conveyed, with the fair of Lendit, to the abbey of Saint-Denis in France by the king and emperor Charles the Bald. And they are there to this day, kept with great honour, and they bear witness evermore that the holy king and emperor-saint Charles the Great, otherwise known as Charlemagne, went to Jerusalem and reconquered it by force of arms,[12] as it is revealed in the tale of his journey, which I shall now bring to a close, praise be to Our Lord Jesus Christ.

✝

Chapter VI.
How Pope Urban, the second of this name, came to France. Of the councils that he convened there. How he preached the reconquest of the Holy Sepulchre and the city of Jerusalem, and made and gave the first cross and badge of the crusade, which was worn on the journey to Outremer; and of the princes and prelates, barons and nobles and others who came together by reason of his preaching, and principally of Peter the Hermit.

In the year of grace of Our Lord 1095, Henry IV, king of Germany and Holy Roman Emperor, was in the fortieth year of his reign and the seventh of his empire, and Philip,[13] the first indeed of that name and son of King Henry, son of King Robert, who was son of King Hugh Capet, reigned in France. Pope Urban, the second of that name, was constrained by the tyranny exercised by Henry IV against the holy apostolic seat to take refuge in France, where he was received with many honours by King Philip. With his aid, he caused to assemble that same year three times three councils in different places in the kingdom, of all the bishops and prelates who were on that side of the mountains as far as England. The first of these councils was celebrated by him in the abbey of Vézelay; the second in the city of Our Lady of Le Puy; and the third at Clermont in Auvergne. In these councils, amongst other things, after he had made a number of most notable reforms and new constitutions, he set forth most powerfully how the pagans, the Saracens and other infidels, almost as long ago now as forty-five years, had taken and continued to hold and to treat in the most wretched servitude and shame the Holy City of Jerusalem, the Holy Sepulchre of Our Lord and the other Holy Places that lay round about it, together with the Christians who lived and sojourned there. And how, after having killed the others in a most tyrannical and inhuman manner, these they had reduced to a life of misery, that they might continue to exercise their insatiable cruelty on them because of the opprobrium they bore with the holy name of Christian. And how they held them in the most shameful captivity and serfdom, a thing that was most dishonourable and disgraceful to all Christians.

He concluded, by setting forth most plainly with divers reasons, that the holy Christian people ought no longer to suffer and endure that these Holy Places and the people of Jerusalem and the places round about it should be treated thus, but that each

one, according to his power and his faculties, should use his body and his possessions to remedy these things quickly by force of arms, and admonished and entreated them all in the name of Our Lord that each should make peace or a long truce where there was war and discord, that they might undertake this journey in safety. The better to achieve and accomplish this, he gave with all his authority full pardon and remission of all sins, with regard both to penance and penitence, to all those who would follow his preaching and undertake the journey and who would wear the cross on their right shoulder.[14]

And Our Lord planted these exhortations and these most praiseworthy indulgences and pardons so firmly in the hearts of the princes, prelates, barons, knights, gentlemen, burghers, merchants and other Frenchmen, that the greater part of them came before the Pope and before the bishops who, thereafter and at his commandment, preached this crusade in their bishoprics. And they took and received from their hands the Holy Cross, and swore that they would undertake and make the Holy Journey with all their strength and with all their power, on that occasion or in a particular movement. There took the cross, then and shortly thereafter, so infinite a number of princes, prelates, barons, knights and others, from divers sects of Christianity, that never again, before or since, has there been any record of so great and so praiseworthy an assemblage of princes, prelates and Christian people.

Foremost amongst those who took the cross from France, England and Germany were the venerable Adhemar,[15] bishop of Le Puy, who was papal legate, and William, bishop of Orange, both of them men of great knowledge and saintliness; Hugh the Younger, thus named because he was a younger brother of King Philip of France and was then known by that name although later he was called Hugh the Tall, and he was the father of Ralph, count of Vermandois;[16] Robert, duke of Normandy, second son of King William the Bastard,[17] who conquered the kingdom of England; and the most wise and powerful and glorious prince Raymond,[18] count of Toulouse, who spent great sums and performed great exploits during this journey; the most renowned and victorious prince Godfrey of Bouillon, duke of Lorraine, and thereafter created king of Jerusalem by the pilgrims who had taken the cross[19]; and his two brothers, Baldwin, who was king of Jerusalem after him, and Eustace, count of Boulogne; Baldwin of Le Bourg, son of Hugh, count of Rethel, their cousin, third king of Jerusalem of that line and second of the name of Baldwin, for he succeeded to the kingdom after King Baldwin, the brother of King Godfrey; Robert, count of Flanders; Stephen, count of Blois and Chartres, father of the old count Tibald, who lies buried at Lagny-sur-Marne and

URBAN II PREACHING THE FIRST CRUSADE (1095).
THE ASSEMBLY OF THE CRUSADERS AND THE CARDINALS

*"A host of people took the cross through the preaching of Pope Urban
and that movement brought about chiefly by a knight called Peter the Hermit,
a native of the Beauvais region, who had been on pilgrimage to the
Holy Sepulchre the year before and had reported to the Pope, in France
and in the other aforementioned lands, the wretched condition of the Holy Places
and of the Christians in that holy land of Jerusalem."*

(FOL. 20VA)

In 1095, Pope Urban II, who had taken refuge in France, called three successive councils to launch an appeal to go on crusade – in Vézelay, in Notre-Dame du Puy and in Clermont. The preaching scene is here shown as taking place inside a vast church whose nave rises in two stages. Tall, pale sculptures stand out in clear relief against pillars carved in an ochre-coloured stone. The assembly listens attentively to the Pope. Jean Colombe excels in suggesting crowds; his strength lies in the way in which he places his subjects, some of whom, seen from the back, are reduced to nothing more than their hats, while others surround them seated in a circle. Colombe's depiction of Urban II's appeal contrasts with that of the same event presented by Fouquet in the *Grandes Chroniques de France* (ill. 16, p. 46). Unlike Fouquet, the master of Bourges has not attempted to portray the Pope and the important dignitaries who surround him, but rather to show the impact of Urban's words on the crowd that has gathered; Fouquet, for his part, chose not to show the crowd. In the lower register, Colombe portrays men in armour, doubtless the knights who are getting ready to take part in the First Crusade and who stand opposite the prelates and cardinals who represent the Church.

et auſtres ſains lieux la cuiron.
Et les vpiens y habitans & demou
rans. & que les auſtres par eulx
tyranniquement & inhumaine
ment tues. ſls auoient reſerue
en ſubiuguſe vie a fin que ſur
eulx en opprobre du ſaint nom
vpien puſſent continuer plus
ſonguement leurs Inſuſtables

ſuruitutes. Et comment ſls
les tenoient en troy opprobrieuſe
captuute & ſeruitute. ou tresgrant
deſhonneur & opprobre de tous
les vpiens. Conſiderant & non
ſtant par diuerſes raiſons tres
euidentes que le ſaint peuple
vpien ne debuoit plus ſouffrir
ne durer que ſes ſains ſieulx

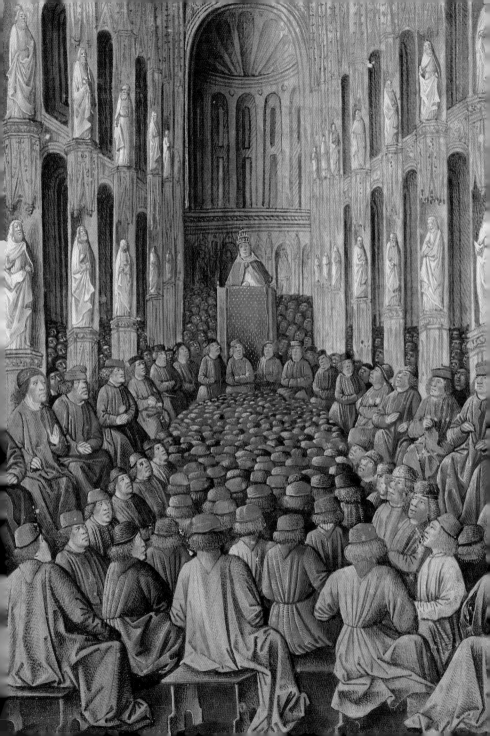

who had as son the most fortunate Henry, of blessed memory, the first to bear the name and the arms of the county of Champagne and who founded with his own means eight collegiate churches and eight hospitals, and most particularly the collegiate church of Saint Stephen in Troyes, where his body rests;[20] Baldwin, count of Hainault; Hugh, count of Saint-Pol; Enguerrand, his son; Baldwin of Mons; Isoard, count of Die; Rambald, count of Orange; William, count of Forez; Stephen, count of Aumale; Rotrou, count of Le Perche; Rainald, count of Toul, and Peter, his brother; Warner, count of Gray; Alan Fergant and Conin, two mighty barons of Britanny; and many other barons, knights and squires of France and of other kingdoms and countries who were not counts but who were nonetheless lords of great baronies and lordships, and very powerful and famed for their valour, such as Ralph of Beaugency; Drago of Nesle; Evrard of Le Puiset; Guy of Guerlande, seneschal of France (whom I believe to have been at that time a sort of constable because the name of that office had not yet acquired the same high honour in the kingdom as it bears at present); Anselm of Ribemont; Thomas of La Fère; Clarambald of Vendeuil; William the Carpenter; Roger of Barneville; Cunes of Montaigu; Do of Cons; Guy of Possesse; Gales of Chaumont; Gerard of Cerisy; Henry of Hasque and Godfrey, his brother; Gaston of Béarn; William Amancy; Gaston of Beziers; William of Montpellier; Gerard of Roussillon; Gilbert of Montcler and Walter the Penniless.

Amongst the Italians and those from across the mountains there assembled, too, the most wise and valiant Bohemond, prince of Taranto, son of Robert Guiscard, duke of Apulia, descendants of the dukes of Normandy and of the former counts of Blois,[21] and Tancred, his nephew, the son of his sister; Richard of the Principate, son of William Strongarm, brother of Robert Guiscard; Raymond, his brother; Robert of Eaule; Herman of Carni; Robert of Sourdeval; Richard, count of Rossignuolo; Boel of Chartres; Humphrey of Montigneux and many other great barons, knights and squires, not counting the common people from each of the countries named above, from France, England and Germany as well as from beyond the mountains.

A host of people took the cross through the preaching of Pope Urban and that movement brought about chiefly by a knight called Peter the Hermit, a native of the Beauvais region, who had been on pilgrimage to the Holy Sepulchre the year before and had reported to the Pope, in France and in the other aforementioned lands, the wretched condition of the Holy Places and of the Christians in that holy land of Jerusalem. The greater part of the pilgrims took with them their wives and children, certain even had with them all the people in their household. They undertook with great

courage and strong will this crusade and Holy Journey, which was the first during which, by order of the Pope, the pilgrims of the Holy Sepulchre began to wear the cross on their right shoulder and on their breast, as a sign of true brotherhood and recognition, that they might easily recognise each other, love each other, and help and succour each other despite the diversity of their languages. But after having sworn and promised true faith and companionship, some by word of mouth, some by their presence and the last ones by letter, they did not all meet together again until they laid siege before the city of Nicaea, beyond Constantinople. But they went their ways to divers seaports and divers lands at divers times and passed through divers dangers, some more so than others, and they met with injuries or pleasures, as will be recounted in detail hereafter.

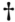

Chapter VII.

How Walter the Penniless, who led a great company of pilgrims through various lands, passed through Hungary. Of the outrage that was committed on certain of his companions at Malavilla in Hungary, and thereafter at Belgrade in Bulgaria. Of Peter the Hermit and of the loss of his treasury in Bulgaria because of the cruelty of the Bulgars; and how he suffered much harsh treatment in those regions and a number of his men were killed, and how he arrived with the rest of his troop at Constantinople before the emperor.

Walter the Penniless, who some call Walter the Unlearned, who was a most wise and valiant knight and under whose leadership there had assembled a very great number of people of divers nations and languages, although there were few knights amongst them, was the first of all the pilgrims to set off on the path of the Holy Journey of the First Crusade. And although the preaching of the crusade had begun as early as the month of November 1095, the general departure was delayed, partly because of the great preparations that were necessary for an undertaking so dangerous and of such magnitude, but also because of the preaching.

But this Walter the Penniless and his men, who were the first, as I have said, set off from the place where they had agreed to assemble on the eighth day of the month of March before Easter in the year 1095 – as counted after the blessing of the Holy Candle, as it is done in the parliament of Paris. They passed through Germany and

made their way to the kingdom of Hungary, which is completely enclosed and surrounded by great rivers, marshes and deep bogs, such that one may neither enter there nor come out except through certain places and narrow entrances, which are like gates into the country. At that time there reigned there a very valiant king called Coloman,[22] who, when he heard of the coming of Walter and his men, and was informed of the Holy Journey to Outremer, rejoiced at it and caused to be carried and presented to them food and other things necessary in great abundance and cheaply wherever they passed in his kingdom. And thus, they crossed the whole kingdom most peacefully until the greater part of them had crossed over the great river Maros, which forms the eastern limit of Hungary, but a few pilgrims had remained on the other side of the river unknown to Walter the Penniless. And they went to buy meat and other things of which they had need at a nearby castle, called Malavilla.[23] But some Hungarians, filled with ill will and realising that they were few in number, rushed upon them and took away by force all their armour and their money, and they stripped them and beat them violently. And they treated them most shamefully and left them to walk away naked. And that is why, after they had crossed over the river Maros and told Walter and their companions of the atrocities to which they were subjected, and explained in what condition they had been sent away, although they had done no wrong, the others were deeply grieved. But yet, because they saw that to go back across the river would be too dangerous and would risk delaying or even preventing their journey, they left their vengeance to the Lord, that they might undertake the journey, and set off again, so that they arrived in Belgrade, which is the chief city of Bulgaria.

But Nicetas, who was its duke, would never suffer Walter and his men to come into the city, nor that any should give or sell them food or any other thing in exchange for their money, although Walter requested these things from him most respectfully. This being so, because the army of pilgrims lacked food, Walter could never prevent certain pilgrims from going forth to pillage the country. And it so happened that they were bringing back a great number of cattle when the men of that country gathered together in great number and took them by surprise, killing the greater part of them and recovering the booty. And, worse still, they burned down a church in that place, with around one hundred and forty pilgrims who had sought refuge inside. That is why, when Walter saw the cruelty of the Bulgars and the atrocities committed by certain of his own men who were not prepared to obey him, he took the road with those who were agreed to place their trust in him, and passed peacefully through the forests of Bulgaria, and came to the city of Stralice, in the kingdom of Denmark.[24]

THE EXPEDITION OF WALTER THE PENNILESS.
CRUSADERS BEING DESPOILED BY THE HUNGARIANS

*"They passed through Germany and made their way to the kingdom of Hungary,
which is completely enclosed and surrounded by great rivers, marshes and deep bogs,
such that one may neither enter there nor come out except through certain places
and narrow entrances, which are like gates into the country."*

(FOL. 21A–21VA)

The first crusaders departed following the appeal of Urban II. Walter the Penniless set out with his men and passed through Hungary. There, beside the river Morava, the Hungarians attacked them and stripped them of their armour. This is the scene that is represented in the principal picture. Jean Colombe paints a landscape in which the countryside blends with outlines of towns towards which the crusaders are making their way after their defeat. Two other episodes in their journey are recalled below: at left, the crusaders, denied entry to the city of Belgrade, attempt to enter it by force, while at right, the Germans are setting fire to a small town near Sur because of a quarrel that broke out with the merchants. The painter must have read the entire chapter with rapt attention when selecting the scenes that he wished to depict, for his pictures convey the dramatic nature of the narration.

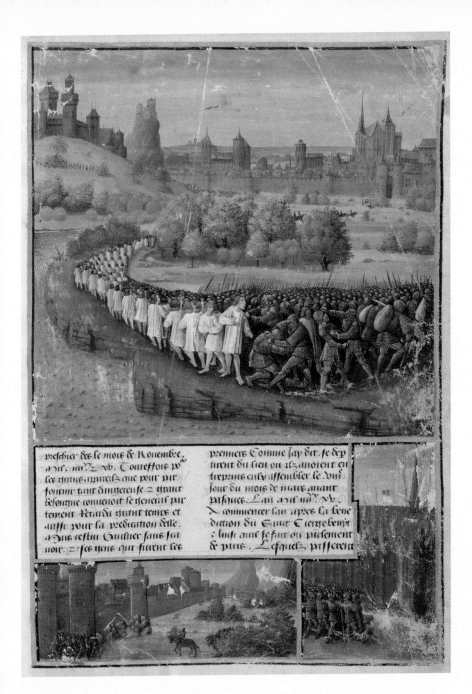

mescher des le mois de Nouembre
mil. iiii.c. vb. Touteffoie pᵒ
lee choze apᵣez que pour pᵣ
fournir tant dangereuse ⁊ quant
befoingne connueoit se sheueaf par
tement ⁊etandu quant tempe et
aussi pour sa pᵣedieation delle.
⁊Dne cestui Guultier sans sa
uoir. ⁊ fee gene qui furent lee

pᵣennere Comme say dit. se dep
turnt du sieu ou ilz auoient en
tepᵣine eulx affembler se Dns
sour du mois de nuns auant
pasques. Lan iiii mᵒ. vb.
⁊ commencer sau apᵣez la bene
diction du Saint Cierge benist
⁊ ainsi auet se sait on puisement
⁊ plus. Lefquelz passerent

In that city there was a most wise duke who, knowing their holy undertaking, received them most amiably and caused to be sold and presented to them cheaply all that they wished to have. And he performed a number of great kindnesses for them and had a great part of what had been taken from them in Belgrade given back to them. And he had them conducted in safety as far as Constantinople, where, when they had arrived, Alexius, who was the Greek emperor (most rich and powerful and who distributed great and rich gifts but was nonetheless cunning and cruel and who harboured a mortal hatred for the Latins, as shall be plain to see hereafter) immediately summoned Walter the Penniless to come before him. And after he had come and told him that he intended to wait for Peter the Hermit, by whose command he had led one part of his troops this far, the emperor paid him great honour and welcomed him lavishly, and assigned to him a handsome lodging outside the city, for him and for his troops, and he commanded that they should have food and everything of which they had need cheaply.

Now it was only a short while before that Peter the Hermit had departed from his country of Beauvais with at least forty thousand men and, passing through Lorraine, Bavaria and Austria, approached Hungary. He sent certain of his wisest knights and companions before the king, that he might authorise the army of Our Lord to pass in peace through his country and permit them to have food and other necessities cheaply. And the king of Hungary accorded them a safe conduct and commanded that they should be given what they asked for in exchange for payment. And they passed in peace through all of Hungary as far as Malavilla, which they attacked, because some of them had been warned of the outrage that had been committed on their companions, the marks of which were still to be seen, and they used such force that they took and killed all the inhabitants, except those who, thinking to save themselves in the river, threw themselves in and were drowned: those killed were to the number of four thousand but only around a hundred died on the side of Peter the Hermit.

When Nicetas, duke of Belgrade, heard of the terrible vengeance that had just been wreaked on the people of Malavilla, he feared that the same thing might happen to his city because of the offence that had been done to Walter. For that reason, he had all the goods and all the inhabitants removed, and the greater part of them retreated with their possessions into the depths of the forests, while he himself and certain of his companions took refuge in a mighty castle and made ready to defend it against Peter the Hermit if this should be necessary.

After staying for five days at Malavilla, because of the great abundance of goods and riches that the crusaders found there, and hearing that the king of Hungary, who

had been informed of the destruction of Malavilla, was coming with a great army to take his revenge, Peter the Hermit made haste to reassemble his ships, small boats and other craft, and he crossed the river as swiftly as possible with all his army. Having crossed the river, the crusaders took the road to Belgrade, which they found empty. And thence they went through forests and wooded farmland for eight long days until they arrived before the city of Sur, whose lord had fortified it and closed the gates because of their coming, after having taken hostages from Peter the Hermit. When they asked for food, he had it given to them for a reasonable price, and so it was for their other needs, so that they were very well served and lodged for that night. But on the next day, around a hundred Thiois (in other words, Germans) who were under Peter the Hermit's command stayed behind. And when the whole army had crossed the river and the bridge, they set fire to the mills and to a small unfortified village next to the walls, and these they burned by reason of a dispute they had the evening before with a merchant of that city, without gathering up what they had got.

However, as soon as the lord of the city, who had received them so generously, saw the destruction and the evil recompense that the Thiois had made him, he was blind with rage and fury and, caring not that only certain deserved punishment, determined to have his revenge upon all. And for that reason, he gathered together all those in the city who could bear arms, and they were many, and exhorted them to take revenge, and he found certain of the evildoers who had not yet followed the others. Then he and his men struck them down, and killed them all and cut them into pieces. And, their anger not yet assuaged, they caught up with a part of the baggage carts and the rearguard, where were the aged, the women, the children and the sick, and they put them all cruelly to death. And they returned to their city with the goods, the carts and the ploughs that they had taken. Peter the Hermit and his men returned before the city, hoping to take it and destroy it. But when certain wise knights sent as envoys to the lord of the city told them of the outrage committed by the Thiois, they were content to regain what they had lost and the prisoners, that they might pursue their journey.

Although all was thus resolved between the two sides, a number of the common people became so agitated that, in spite of the messengers whom he sent to them and although he personally forbade them to take action as being in breach of their vows, Peter the Hermit could not prevent a thousand of them from hurling themselves upon the city to take revenge for the atrocites that had been committed against them. Seeing this and knowing how small in number they were, the inhabitants, being under the impression that the rest of the pilgrims would not come to their aid, came out in

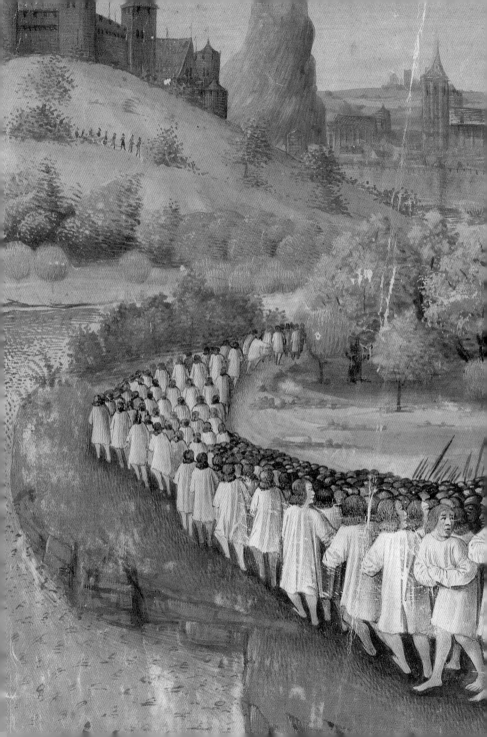

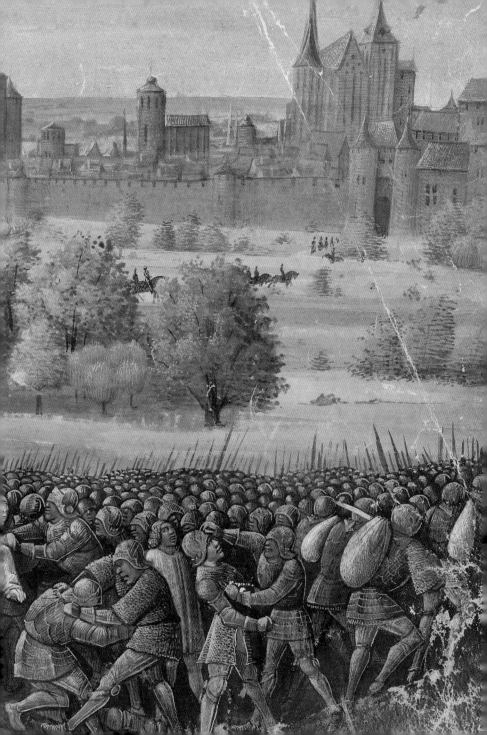

a crowd from the city walls and came as far as the bridge, where they found around five hundred pilgrims, all of whom they killed or drowned. That is why, when those in the great army saw their cruelty, they set off to the aid of their companions. And thus, little by little, began the battle in which the pilgrims on foot who had started the conflict again were soon beaten, and those from the city then attacked the nobles and the knights. And the soldiers from the city repaid the outrage inflicted upon them by the actions of the foot followers, for, in the end, the whole army was beaten and they fled, hither and thither, in divers places, through the wooded farmland and the valleys, leaving more than ten thousand of their companions dead and killed, and having lost all their harness and their baggage, and in particular a cart loaded with money that had been given to Peter the Hermit in France to provide for the army.

However, during the night that followed this cruel defeat and for three days thereafter, the pilgrims reassembled in a tumult to the sound of the horns and trumpets, and on the fourth day around thirty thousand men were on a high mound around Peter the Hermit, bewailing their losses, for many had lost money and armour. And yet they did not wish to renounce their journey, but took the road again, making for Constantinople by the most direct way. The emperor Alexius sent messengers to meet them, who reproached them for having the reputation of attacking everyone, despite the great shame this brought upon them. And he would not suffer such things in his empire, but however, he would be content that they should come to him at Constantinople by the most direct road and as early as possible, and if they came through his lands, he would had food delivered to them everywhere cheaply.

Peter and the wise counsellors in his army, greatly pleased with the emperor's offers and making their excuses as best they could, gave heartfelt thanks to the messengers for this great generosity, since they suffered sorely from lack of food. They set off and followed the messengers as far as Constantinople, where they found Walter the Penniless and his men, who rejoiced at their arrival. The emperor Alexius likewise feigned pleasure and he desired to see Peter the Hermit, whom he welcomed warmly. But he and his Greeks were astonished that within so small a man as Peter there could be so much intelligence, according to what they had heard and as they realised for themselves from his fine and wise replies. And some days later, Peter the Hermit and his men and the men of Walter the Penniless departed on the order of the emperor, and went into Bithynia, which is the first region in Asia. And they set up camp beside the sea, near a ruined castle called Civetot, to stay there and rest until the arrival of the great army of princes.

Chapter VIII.
How the two armies of Peter the Hermit and Walter the Penniless were almost entirely destroyed by Suleiman, the lord of Nicaea.[25] And how Walter the Penniless was lost because the greater part of them would not accept his counsel and would not obey their commander.

Peter the Hermit, Walter the Penniless and their two armies, united into one, took their ease in the marches of Bithynia, for they were provided with cheap food from all the outlying areas. But as it often happens that people find peace and quiet insupportable, so it was that those of the common people, who found themselves wearied of repose and who knew from the inhabitants of that land that they were near the lands of the pagans, could not resist going forth to pillage, and they brought back a most great quantity of food from all their pillaging forays, because they positioned themselves along the main highways, where they were very often found to the number of more than ten thousand. And although they were warned, from Constantinople and from elsewhere, that they should remain together and not disperse hither and thither on these forays before their own great army was arrived, because a multitude of their powerful adversaries from all regions were assembled around them bearing arms, neither Peter the Hermit nor anyone else was able to keep them together, without their constantly going out to pillage. And amongst other forays, they made one, on a day when Peter the Hermit had gone to Constantinople to seek a remedy for the rising price of food, on which seven thousand men on foot and three hundred on horseback gathered together and went swiftly before the great city of Nicaea, where they took much booty, which they carried back to the army, and they returned safe and sound without any loss.

Seeing this, the Thiois, that is to say the Germans, a people who are quickly roused, envied them greatly. For that reason, almost three thousand of their language assembled and went directly towards Nicaea. And at four leagues from that city, they attacked a castle inhabited by pagans, which was situated on a high mound,[26] and they took it by storm, killing all whom they found therein – men, women and children – sparing none. And when they saw that the area around was fertile with food crops and that the castle was strong and handsome, they decided that they would keep it and await the

great army there. But this was their downfall, for Suleiman, lord of Nicaea, who was lately returned from the eastern marches and had brought thence, by dint of prayers and money, a great number of Turks and other Saracens bearing arms to prevent, as he thought, the pilgrims from France, whose reputation had reached his ears, from passing through his lands, was already armed and in the field. He was drawn up in the woods, so close to the castle that he knew straightway that it had been taken. And for that reason, he made all haste towards it, and laid siege to the castle, leading assaults so violent and so incessant that he took it yet more rapidly than the Thiois had done. And he put them all to the sword.

The news of the death of the Thiois was soon known in the army, and there arose a great murmur, and most particularly on the part of the common people, who shouted loud and clear that they should straightway move against Suleiman and his army, to avenge the deaths of their brothers and companions. And because the barons, knights and other wise captains advised against moving so rapidly, explaining that they should rather take heed of the counsel of the emperor Alexius, who advised them to wait for the great princes, who were on the point of arriving and that, when they were come, they could take their revenge, the common people all began to shout publicly against them, saying that they were false and wrong.

And because of the exhortations of a captain called Burel, who inflamed them all and incited them to this foolish undertaking, the barons, knights, captains and nobles were constrained to obey them and to take to the field with them, where they were in all around twenty-five thousand on foot and five hundred on horseback, drawn up as best they could, on account of the urgency and the obstinate will of the people. And thus, they made their way as directly as possible to Suleiman, who lay in ambush in the wood to take them by surprise in the camp where he had been told they were lying. But when he realised that they were arriving, because of the noise they were making, and understood that they would have to pass through a plain close to the wood where he was, intending to go to the castle that he had just recaptured, he let them pass and led his men discreetly from the cover of the wood right along the plain, so that our men, who had neither seen nor heard him and did not think to find him so close (and for that reason they were not drawn up in good order) were utterly surprised and overcome with horror when they heard them and saw them in their midst. However, they attacked them again with extraordinary courage and valour, emboldened by the great anger and thirst for vengeance inspired in them by the death of their companions. And on the other side, the Saracens, who saw that fine words would not suffice and that

they would be dead if they did not strive their utmost against them, received them with all their might.

And so began that cruel combat, which lasted a great while and where many were killed on both sides, so that, in the end, the pilgrims were routed utterly, for Suleiman had so many more men, all on horseback, that the pilgrims on foot could no longer withstand them. And they, all of them, began to flee to the fields, thinking to save themselves. But that availed them little, for Suleiman and his men followed them and pursued them so closely and for so long that they were almost all killed or taken captive, because of the foolish and impetuous will of the common people. And many knights of valour and renown were killed there, amongst others the most valiant Walter the Penniless, Renaut of Broies and Fulk of Orleans, who were most excellent and valiant knights, and so many other nobles and common people that of the twenty-five thousand men on foot and the five hundred on horseback, there would not have been found more than three together.

And what redoubled and made yet worse the grief and the loss of the Christians: Suleiman, when he saw the great slaughter and the rout of our forces, rose up in such great pride that he came right up to the camp with his army. And there he had his will, for there were only the sick and the aged there, and he killed them all without pity, save for the children and certain maidens, whom he kept to take into slavery. When he heard that nearly three thousand pilgrims had retreated when they had heard his sudden onrush, and that they had fortified, very close by, with great boulders and pickets, a fortress that master Vincent of Beauvais[27] says was the castle of Civetot,[28] ruined or perhaps deserted as a trick by the Turks, who had dismantled it long ago and abandoned it with no gates or windows, he led his men that way and launched lengthy assaults. And, indeed, he would have taken the fortress but that the pilgrims, who had no hope of mercy if they surrendered, defended themselves with such great valour that, during that time, Peter the Hermit, who was still at Constantinople, learned that the others had been routed and that these were under siege.

Grieved beyond measure but acting in most timely fashion, he went in all haste before the emperor and explained to him the dire straits in which our men found themselves, and besought him so affectingly to bear aid straightway to the besieged that the emperor, who loved him greatly, complied with his prayers and sent messengers as swiftly as possible to Suleiman and to the other Turks and pagans, and demanded that they should launch no more assaults against our men who were in the castle. And Suleiman obeyed him, but he took away the prisoners, maidens and other children,

BATTLE BETWEEN THE CRUSADERS AND THE HUNGARIANS (1096).
GOTTSCHALK PREACHING THE CRUSADE

"While these things were happening to Peter the Hermit in Bithynia,
a German priest called Gottschalk, who had preached in Germany in his language just
as Peter the Hermit had done in France, also took the road to follow him."

(FOL. 26A)

The scene in the lower register shows the German priest Gottschalk preaching the crusade in Germany. From there, he led his army of nearly 15,000 men as far as Hungary, where a bloody battle took place between the troops of the king of Hungary and the German crusaders, whose ill renown had preceded them. The battle scene shown in the upper register is exceptionally brutal. Dead bodies are strewn across the earth, which is red with the blood of the slain: the vast scale of the conflict is conveyed here by the piles of helmets and armour. In the foreground, three knights on galloping white horses are seen charging each other. In the distance, hazy blue hills stand out against the sky, softening the brutality of the scene.

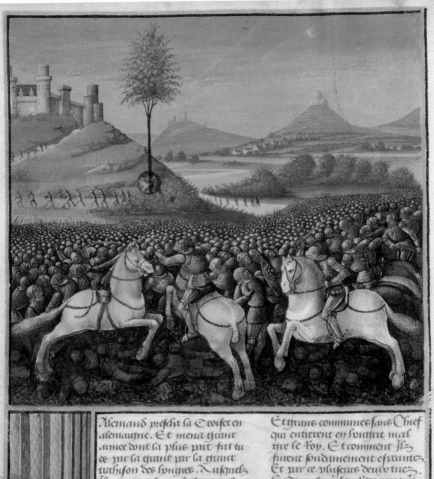

Alemand prescha la Croisée en
alemaigne. Et mena maint
armée dont la plus part fut tu
ée par sa maint par la grant
trahison des hongres. Duquelz
Ilz auoient fait plusieurs oultra
ges. Et ses aultres sen retournè
rent en sainte terre paisi. De
plusieurs Cheualiers de france

Et trans communes sans Chief
qui entrerent en souffrit mal
tre le Roy. Et comment Ilz
furent soudainement espoante
Et par ce plusieurs deulx tuez.
Et de ceulx q sen retournerent.
Et des aultres qui a chreuerêt
seurs beuz par aultres passa
ges. IV.

and all the booty that he had seized. And thus was annihilated and lost that great army, through the pride and outrage of the common people, who would not obey the knights and other nobles, captains and chiefs who were experts in the art of war. This shows how dangerous it is to entrust the adventure of combat to those who know nothing of it.[29]

<div align="center">✝</div>

Chapter IX.

How a German priest preached the crusade in Germany and led a great army, of which the greater part was killed through the treachery of the Bulgars, against whom they had committed a number of atrocities, and how the others returned to their own country. Of a number of French knights and of the great crowds on foot who succeeded in entering Hungary in spite of the king. And of how they were suddenly overcome with horror and a number of them killed for that reason. And of those who turned back and of others who accomplished their vows by going on another way.

While these things were happening to Peter the Hermit in Bithynia, a German priest called Gottschalk,[30] who had preached in Germany in his language just as Peter the Hermit had done in France, also took the road to follow him. He was at the head of a good fifteen thousand Germans who, while they were passing through Hungary, where on the order of the king they were being generously supplied with wine, food and all other necessary goods for a reasonable price, started to get drunk and, emboldened by wine, became overweening. Such was their presumption and malice that they stole the food brought to them by the merchants and labourers. And, worse yet, they took their women and beat their husbands. And none in the army had the power to stop them.

And this is why, when the king of Hungary heard the reports of their evil deeds, he had a great army from his kingdom assembled posthaste, and he pursued them with such haste that he came up with them near Belgrade. But when they knew that the king of Hungary was leading a great army against them, they gathered together and, all of one mind, drew up in order of battle. And they determined to await the Hungarians to fight and conquer them or to die in combat, selling their lives dearly. For they knew well that they needed to pass that way, and that they would never find mercy

or friendship at the hands of the Hungarians, by reason of the great evils that they had caused them to suffer.

When the king and the Hungarians saw that they were stubbornly determined to die in combat or to have the victory, they considered that it would not be easy to vanquish so great a number of men who had no hope of obtaining pardon, and that they could not conquer them without heavy losses on the Hungarian side. So for that reason, they used instead of force disputation and treachery, for the king of Hungary sent ambassadors to them, and reproached them with honeyed words for their ingratitude, at the same time saying that he knew well that not all were guilty and he wished only to punish the evildoers, and warning them that, for their common safety, they should lay down their arms and surrender themselves to his mercy. They might hope for a pardon from the king with which they could not but be pleased. Gottschalk and the noble knights of the army, who were greatly displeased by the outrage committed by the others, rejoiced at the offer of the king, because they had confidence in his great nobility. And they succeeded by their counsels in persuading all their companions to lay down their arms and to leave them there, not without it being both said and shown to them that no good would come from thus submitting and giving themselves up to people as untrustworthy as the Hungarians.

And assuredly no good came of it, for the Hungarians, as soon as they saw that they had laid down their arms, after they had given up both their arms and long staves, fell suddenly upon them, and killed all those whom they could reach, with no thought of seeking out who was good or who was evil. And they made a slaughter so terrible that, on the field where they treacherously killed them, the blood rose to the middle of a man's leg, although a small number of them, who had hidden amongst the dead, were able to escape thence and return to their own country, where they urged the other pilgrims to take vengeance for the treachery and cruelty of the Hungarians.

In spite of this misfortune, a short time after, a very great army of pilgrims set out, principally composed of common people who came from divers parts and regions of France. There were a good two hundred thousand men on foot and three thousand on horseback, without a commander-in-chief or a captain, although there were amongst them knights and squires of renown, such as Thomas of La Fère, Clarambald of Vendeuil, William the Carpenter and other noble and valiant men. But the common people refused to obey them in anything, and placed no faith in their advice. This army thus having gathered together and gone through Germany, those of the common people caused many disorders of evil nature, both on the roads and in the enclosed settlements,

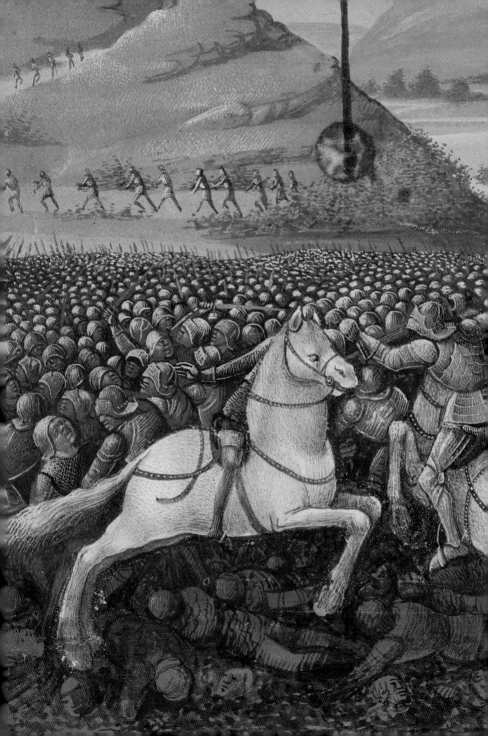

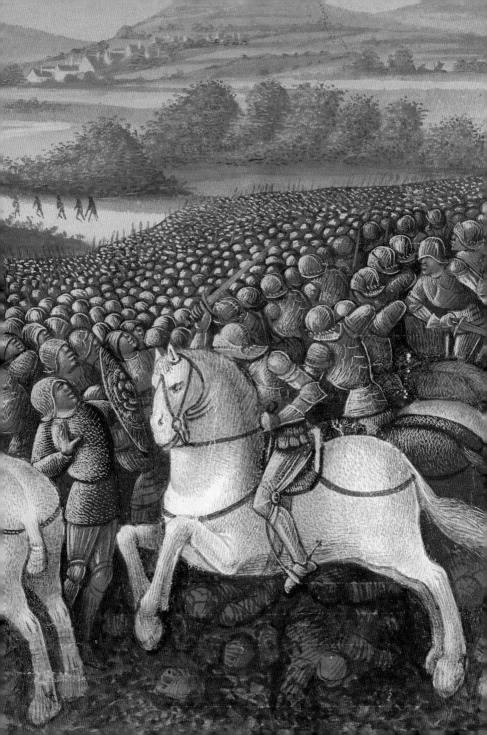

and most particularly, they killed all the Jews whom they could find, even inside the towns and cities. And continuing thus from bad to worse, they came to the great river Luitans,[31] which is the entry into Hungary. They meant to cross over on the bridge that spans it, but the king would not accept this, in spite of their prayers and the messengers they sent him, fearing that by reason of their great number they would wish to take vengeance for the treachery that he had committed against the army of Gottschalk. For this reason, the pilgrims, who were utterly enraged by his refusal and rebelled at having to retrace their steps and abandon the journey for which they had made considerable sacrifices, decided with one accord to burn and destroy all the land of the king of Hungary that lay on that side of the river, and that they would gain the bridge and cross the whole length of the kingdom by force, in spite of the king and the Hungarians. And indeed, they burned and destroyed a number of nearby towns, and a hundred Hungarian knights were sent to forbid them entry into a fortified passage. But they attacked them so valiantly that they killed them all, except for a small number who left the passage open to the pilgrims and saved themselves by taking shelter in the tall reeds that grew in the great marshes nearby.

Thus, the pilgrims passed through and, heedless of the consequences, attacked a town that was at the end of the bridge, against whose walls they set up all their scaling ladders. And they had so many of these that the inhabitants lost all hope of defending themselves, and were simply awaiting death, when the pilgrims were struck with a fear so terrible that those who had almost gained entry to the town, by the ladders or by the holes that they had made in the walls, let themselves at that instant fall to the ground from the top of the ladders and also from the bridges, gates and walls. And they took flight like people who saw death pursuing them. Not one of them knew why he was fleeing, and the Hungarians could not believe that they were fleeing in good earnest, because they could see no reason for their flight. But finally, these very men who had lost the courage and the will to defend themselves opened their gates and came down from the walls, and they pursued the pilgrims, of whom they killed a very great number meeting no resistance, for the greater part of them sought nothing else but a place in which to hide.

And thus was destroyed and utterly ruined that great army, for a German count called Emich, who had been the foremost to urge the pilgrims to their evil deeds, came back thence into his own country leading a great part of the vanquished, although Thomas of La Fère, Clarambald of Vendeuil and the other barons and noble Frenchmen who were in that great army wished to continue their pilgrimage. For that reason,

they went a different way, through Lombardy, Rome and Naples. When they arrived there, they were informed that a number of princes and noble Frenchmen had set sail from those parts and had reached Dyrrhachium[32] and had gone thence into Greece, and they set sail after them and found them and joined the great army.

Chapter X.
How Godfrey, duke of Lorraine, and subsequently king of Jerusalem, assembled a great army in order to set forth and reconquer the city of Jerusalem. Of the honours that the king of Hungary accorded him, and how Godfrey waged war and so forced the emperor of Constantinople to surrender to him Hugh the Younger and the other great lords whom he had taken through treachery.

Godfrey of Bouillon, duke of Lorraine, was at that time the prince who was the most renowned for his strength and valour. It is in his honour that chronicles of Outremer were given his name and that some call this Holy Journey the "Conquest of Godfrey of Bouillon", both because he completed the Holy Journey and in its course performed a very great number of noble and praiseworthy deeds and also because, when the city of Jerusalem had been conquered by him and by the other princes, prelates and barons, they elected him sovereign of all the kingdom, by true election and with one voice. He departed from the marches of Lorraine on the fifteenth day of August in the year 1096, with a great army wherein were many great princes and rich and valiant barons, not counting the men on foot and other men of divers estates. Those of the greatest renown and the most powerful were Baldwin, his brother, who was king of Jerusalem after him; Baldwin, count of Hainault; Hugh, count of Saint-Pol; Enguerrand, his son, who was a young but most valiant knight; Warner, count of Gray; Rainald, count of Toul;[33] Peter, his brother; Baldwin of Le Bourg, who was the third king of Jerusalem after the conquest, and who was the cousin of Duke Godfrey and the son of Hugh, count of Rethel; Henry of Hasque and Baldwin, his brother;[34] Do of Cons; Cunes of Montaigu; and a number of other great lords and other high-born gentlemen. Some of them were married and brought with them their wives and children.

Each loving the other and obeying each other according to their rank and renown, they arrived on the twentieth day of the following September in Austria, and camped

inside and around a town of that country called Toilembourg,[35] before which runs the great river of Luitans,[36] which separates the empire of Germany from the kingdom of Hungary. There they rested for several days. From the time that they had left their own country, they had heard tell many times all along the way of the great cruelty and treachery committed against the armies of Peter the Hermit and of Gottschalk by the king of Hungary. And for that reason they assembled in council and determined, in order that they might pass in peace through Hungary, which was their best way and the most direct, to have him expiate these wrongs and take vengeance for the outrage that the king had committed on them, that they might find means to pass through his country in peace.

And so they sent wise knights, and foremost amongst them was Godfrey, the brother of Henry of Hasque, both because he knew the language and because he was very close to the king. And after they had found the king of Hungary, who did them great honour and most particularly to Godfrey of Hasque, they set forth to him at great length, by explanations and by threats, the cruel acts that he had committed against the army of Our Lord, and how the army that accompanied Godfrey wished to stop in his country to destroy it by force, that they might have revenge for a cruelty so execrable. But then the king made excuses and did his utmost, by excellent and sweet reasons, to show how he had been surprised by the others before he had had the least intention of displeasing them, but on the contrary had offered them freely all that they wanted in his lands. He explained to them that they had caused him too great a destruction through their ingratitude and their wicked actions, which were unworthy of Christians. He requested that Godfrey of Hasque ask Godfrey of Bouillon to be at a castle called Ciperon,[37] where it was his intention to go straightway, that they might become friends if he agreed to come there.

And Godfrey, after he had agreed to this request, returned and obtained Duke Godfrey of Bouillon's agreement that he would choose three hundred men on horseback, and he went to the castle of Ciperon before the king, who received him there with great celebration. And when he left him, the duke gave as hostages his brother Baldwin, his wife and a number of high-born gentlemen, which should guarantee that his army would commit no evil actions in Hungary. And it was on this condition that the duke and all those of his army passed through all the kingdom of Hungary, where they found all the goods of which they had need at a fair price. And they committed no wrong-doing there, because the duke had it announced as they entered the kingdom that no person amongst his men or in the army should commit any violence, excess or injury

upon pain of hanging. Moreover, the king of Hungary went always alongside them on the right side, to ensure that all those things that they required should be brought to them and to keep the peace in the disputes that are likely to arise in such a case.

And when they came to Malavilla, of which we have already spoken at length, the duke first had one thousand well-armed men cross to the other side of the river to guard the bank, that the others might cross over in safety and comfortably. And when they had all crossed over, the king came up to the duke and the other barons, and returned to them the hostages who were in his train, and when they parted from each other, he gave them great gifts. They took their leave of him, thanking him for his gifts, and then they took the road once more, in fine and handsome array, and after they had passed through the city of Sus[38] arrived in Stralice. While they were staying there, they learned that Emperor Alexius of Constantinople was holding prisoner Hugh the Younger and a number of great barons of France, who had set out long before from their own countries, and had passed through Lombardy and Apulia, that they might reach Constantinople sooner, and had set sail thence. And afterwards they had landed at Dyrrhachium, in Greece, where they had stayed, thinking themselves safe since this town belonged to the emperor of Constantinople, and there they awaited their other companions, not suspecting anyone.

But the magistrate of that land had seized Hugh the Younger and all the other barons and had sent them in chains to the disloyal emperor Alexius, who had kept them in prison ever since and would not deliver them, but was keeping them and hoped to hold them a long time. And the other pilgrims only approached with all their armies that they might force him through fear to deliver them. And this is what came about and it cost his country dear, for, when Duke Godfrey and his men were warned of his disloyalty, they demanded of him in all haste, beseeching and admonishing him, to deliver to them without delay this royal prince, Hugh the Younger, whom they considered as their lord, brother and companion in this Holy Journey, with all those of his company. And they said that his exercise of his power and his will was so much the worse in that he had not acted honestly, by taking and by holding so noble a prince when he had done no harm whatsoever to him.

In spite of all the prayers and all the requests made by the messengers of the duke and of the other princes and barons of his company, the emperor Alexius would not deliver the Frenchmen. And for this reason, they resolved together to destroy by fire and by other acts of war all the land from Stralice as far as Constantinople, and so they gave free rein to their army, who within a short time burned a number of towns and

villages, and destroyed so many lands that complaints thereof came often and in great number to the emperor Alexius. The latter, knowing that he would not be able to resist them and fearing the worst, demanded of the duke and the barons that they have their men come in peace, and he would give up to them willingly Hugh the Younger and the other barons whom he was holding prisoner. This is why they ceased making war and led their army before the city of Constantinople, where they made camp as if to lay siege to it. But Hugh the Younger, Drago of Nesle, William the Carpenter and Clarambald of Vendeuil, whom the emperor had lately released from prison, that he might send them back to them, soon came out from the city and came to meet them, at which the duke and the other barons rejoiced greatly, and they received them with great jubilation.

<div align="center">✝</div>

Chapter XI.
How the emperor Alexius sought to imprison Godfrey of Bouillon and his army on the pretext of doing them charity. Of the site of the city of Constantinople. Of the country and the sea that surrounds it. How the emperor made an attack on the army of Godfrey, and of his great valour and that of his men, and of how they made their way out of the narrow place in which the emperor had confined them. Of the letter of Bohemond warning against Alexius, and how Alexius honoured Godfrey thereafter and gave him great and rich gifts, to him and to the other princes and barons of his company.

While Hugh the Younger and his companions, who had been freed, were telling Duke Godfrey and the princes and barons of his army how they had been imprisoned, the messengers of the emperor Alexius arrived, and begged him, in the name of their lord, to be pleased to come to him, with but few followers, at Constantinople. And Duke Godfrey, who did nothing without taking counsel, learned that the princes and barons were of the opinion that he should not go there, nor put himself in the position of being in the power of so untrustworthy a prince. This is why he replied to the messengers that he was presently not able to go. When he heard this answer, the emperor Alexius was seized with such bitter anger that he forbade his men everywhere to sell them food or any other thing. And the princes and barons, to remedy this interdiction, sent out a great number of their people to loot, and they brought back food in abundance

for all, both rich and poor. And when the emperor saw that they were thus destroying his land, he was afraid that they might do yet worse, and for this reason he commanded the merchants to bear all their goods to the pilgrims as before, and they obeyed him.

In the meantime came Christmas Day, on which occasion the duke and the princes commanded and proclaimed throughout the army that none was to do wrong or violence to anyone, that day and on the four days following. During this time, the messengers of the emperor came to speak most peaceably with the duke and the other princes and barons, and besought them to cross the bridge and to take up quarters near a palace that is called Blachernaes and where all their army could be lodged in the many houses that lay along the strait of Saint George.[39] And although the emperor made this offer under pretext of charity, and as if to show that he had pity on the French nobles and their army, his intention was quite the contrary, for he did it (as appears hereafter) to enclose and confine our men in a narrow space, that he might prevent them from ranging freely over his land as they had been doing. However, the princes and barons, complying with their request, received them gladly because the winter was very harsh, by reason of the cold, rain and snow, to such a degree that the tents were rotting and could no longer withstand so great a quantity of rain and snow, and the poor men and horses could find no shelter or bedding in the dry.

And the better to understand how the emperor thought to grip and as if besiege our men through cunning and malice, know that the city of Constantinople is situated and girt about in the following manner: that same sea on which stands Venice comes to thirty miles from Constantinople, and thence one arm of the sea branches off, which is full of sweet water and extends for two hundred and thirty miles to the south. But its breadth is not always the same, for in such a place it is only a mile wide, while in such another it is thirty miles or more across. This strait flows between two ancient cities, Scyton and Abydos, of which one is in Asia and the other in Europe, for this arm is the separation and the limit of these two parts of the world. Constantinople is in Europe, and Nicaea, which is on the other side of the strait, is in Asia. This is the sea on which the great king of Persia had a bridge of boats built, to go across. And this strait opens into another sea, on which is founded the city of Acre.[40] At the place where it is widest, it forms a little bay, where stands the port, which men say is the best and the most calm in all the seas, and the city of Constantinople, which is in the shape of a triangle and is situated nearby.

The first side of the triangle is between the port and this strait, and it is there that stands the church of Saint George, which gives to this sea the name of the "strait

ALEXIUS I COMNENUS AND GODFREY OF BOUILLON

"Godfrey of Bouillon, duke of Lorraine, was at that time the prince
who was the most renowned for his strength and valour. It is in his honour
that chronicles of Outremer were given his name and that some call
this Holy Journey the 'Conquest of Godfrey of Bouillon', both because
he completed the Holy Journey and in its course performed a very great
number of noble and praiseworthy deeds and also because, when the city
of Jerusalem had been conquered by him and by the other princes,
prelates and barons, they elected him sovereign of all the kingdom,
by true election and with one voice."

(FOL. 27VA)

The miniatures on this page focus on the confrontations that arose between the leaders of the crusade and Emperor Alexius I Comnenus in the winter of 1096–97. Not without good reason, the latter suspected that the crusaders' intention was not just to help him recapture former Byzantine areas, but also to set up kingdoms of their own in the East; he therefore required of the leaders of the crusade to swear an oath of allegiance to him, a request that some of them, including Godfrey of Bouillon, at first refused to comply with. In the first scene, at lower right, Godfrey of Bouillon receives a message from Bohemond warning him of the evil intentions of Alexius.

Armed conflicts between the crusaders and the Byzantines are shown in the scene at left. Alexius finally convinces the leaders of the crusade to visit him in his palace. The reconciliation takes place in the principal scene: the emperor takes off his crown to greet Godfrey of Bouillon, while in the background, his throne remains empty, adorned with a cloth of gold on which can be seen the two-headed eagle of the Byzantine coat of arms. Here, heralds in the gallery play a trumpet fanfare to underline the solemnity of the occasion. This scene is described with great precision by Sébastien Mamerot, and Jean Colombe is faithful to the text.

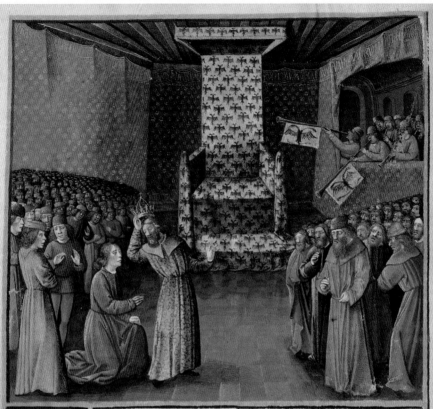

venice z buons. Et leur priect
quilz passassent le roie. Et se
uuissent sauer empres buit mi
lais qui a nom Blaquerne.
Et que sil se pouroit sauer
toute leur armee en traint mul
titude de maison selon le bras
Saint George. Et combien q
Lempereur feist fuire celle of

fre soubz umbre de Christe. Et
comme demoustrant quil auoit
pitie des nobles fumeire z de
leur armee. Son entention estoit
toute contraire. Car sil se fu
sont ainsi que de puis aprent
peu enchore z tout noz gens
a lesteivit. A fin quilz nessent
pas tel abandon de courir par

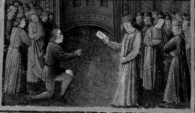

of Saint George", and this side goes the full length of the port as far as the new palace of Blachernaes. The other side of the city stretches from the church of Saint George as far as the Golden Gate.⁴¹ And the third side stretches thence as far as the palace of Blachernaes. This noble city of Constantinople is tightly girt with walls and moats, with towers and barbicans, and most particularly in front of the open country and into its port there comes down a river of sweet water that is small in the summer but swollen in the winter because of the rains. And on this river there is a bridge over which our men passed, and they thus found themselves trapped between the open sea and the strait, along the length of the port, where they were lodged in houses that had been built there long ago.⁴² And while they rested there, awaiting the arrival of the other princes and barons, the emperor Alexius often sent messengers to Duke Godfrey, to ask him to come to speak with him. But the duke, who feared his disloyalty greatly, did not wish to go to him. But, that he might satisfy the emperor and lest he be reproached because he would not go to him, he sent him three wise and valiant knights, Cunes of Montaigu, Baldwin of Le Bourg and Henry of Hasque, through whom he made excuses for himself and explained to him that the council held with the other princes and barons of his army had concluded that he should refrain from going before the emperor until the arrival of the great army of the other princes.

Thereupon the emperor knew such bitter rage that he straightway forbade food to be carried to our men and, what is more, he sent one morning a number of boats full of archers, who arrived suddenly before the place where Duke Godfrey was lodged, and shot so many arrows that they killed many of our men who were on the sea, and wounded many others through the windows of the houses. This is why the duke and the other princes and barons, gathered together in council because of this new treachery, and lest they should be surprised and besieged there where they were confined, sent Baldwin, his brother, with five hundred knights and other valiant men on horseback, to take and guard the bridge, which he did.

And seeing the people of Constantinople advancing bearing arms, to rush down upon them and to kill them sparing none, the duke and all his men set fire to the houses where they were lodged and to others in the neighbourhood, stretching over a good six or seven miles, so that a number of the houses even of the emperor were burned with those of the people. When this was done, they ordered the trumpets to be sounded and made their way all in order towards the bridge, fearing lest the people of the city should have come there to prevent them from crossing over. But Count Baldwin, the brother of Godfrey, had already conquered it from the Greeks, whom he had chased

with force a great distance away. And when the army and all its baggage had thus passed peacefully over with them, they stopped, in good order, in a very beautiful plain that was nearby. The men of the city came out shortly thereafter in force, and our men made a number of great skirmishes against them near the church of Saint Cosmos and Saint Damian, which is today called the palace of Bohemond, and near the palace of Blachernaes.

And when eventide came, there were many killed from the city, and few from amongst our men, so that the Greeks could no longer withstand our men and took flight. The pilgrims chased them, killing and pushing back all those they caught, forcing them to return to Constantinople. And then our men went back into the plain and camped there as best they could, placing a permanent watch to avoid any sudden attack by the Greeks. And these, when they had gone back into their city, considering that they had lost many people and that our men had wrought great destruction on them, were so filled with anger and great rage that they began to gather together across the town and to urge their people on, that they might launch a fresh attack with greater force than before.

But night fell, which caused them to change their minds. Day had no sooner dawned on the following day than the duke and the other pilgrim barons and princes had it announced that each man should be armed and ready for combat. And this done, they chose a party of captains to go out to loot, and the rest of the army was drawn up to guard the tents and the camp, for they were certain that the emperor would do his worst against them. During the six days when those who had gone out looting remained afar, the messengers that Bohemond had sent arrived in great haste before Duke Godfrey and the other princes, when he had learned that they were coming close to Constantinople, to warn them of the evil intentions of the emperor Alexius. And they presented them with a letter from Bohemond, where was found amongst other things: "Know, Sire, that you have to deal with a most disloyal man, who ever sets his heart and purpose on deceiving those who have confidence in him, and who hates most particularly our men and does his utmost to harm them. If you have not already understood this, you will know it: he will delay hardly at all before acting as I write to you, for I know well the malice of the Greeks and most particularly the deceitfulness of their emperor. For this reason, I beg you to retreat from Constantinople and to go back with your men to the plains of Andrianople[43] or of Philippopolis,[44] and to winter there, where there is an abundance of good things. And if it please God, as soon as the mild weather returns, I shall hasten to depart hence and to join my army with

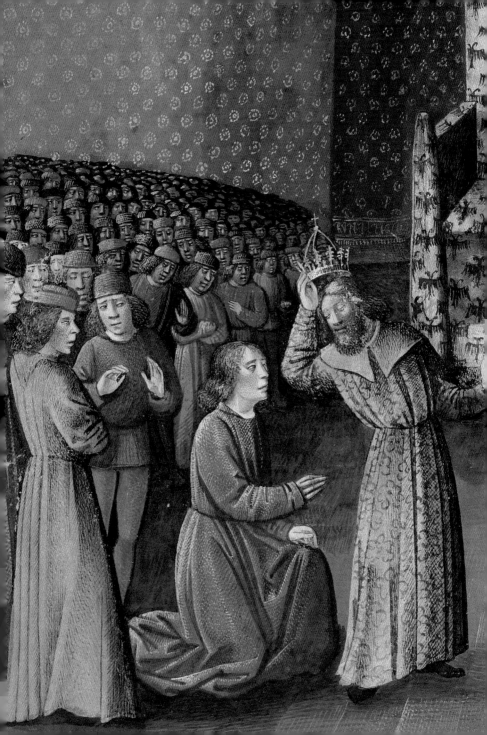

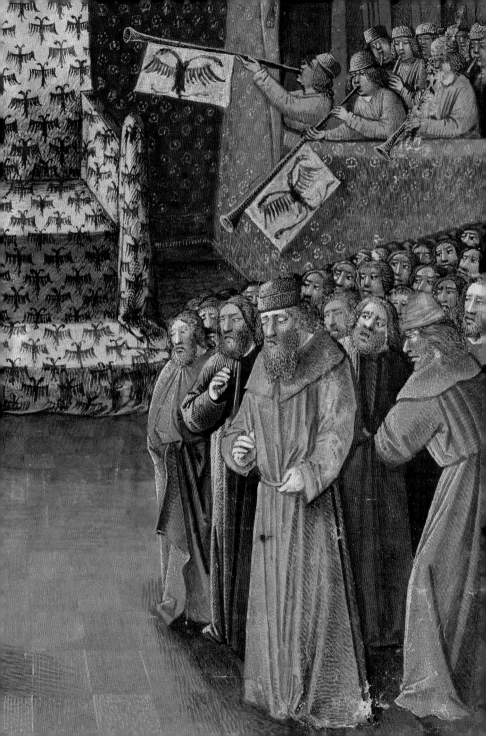

yours. I will help you as my lord and my friend against this disloyal prince Alexius, who seeks to do the greatest possible evil to true Christians."[45]

When the duke had caused the letter from Bohemond to be read aloud before the princes and barons, he had another one written, which he sent to him, wherein was one clause that said: "The princes of this army and I give you heartfelt thanks for your love and your loyalty. And know that we have already found out but too well that which you suspect of the prince and the people of the Greeks. We well know that it is your good sense and your loyalty that inspire your counsels, but we do not have enough trust in the arms that we have here to fight against the heathen, to convert and transform them into Christians like us. That is why we all await you and desire your coming. And when you have come, we will do all that you command." Now, those who had gone out to loot had gone as far as sixty miles distant, taking and pillaging by force all the towns that they found in their path. And they brought back thence so great a quantity of corn, wine, cattle and other riches, with which this land was overflowing, that they could scarcely carry them. And God knows with what joy they were received by the army, and also what grief and chagrin were felt by the Greeks, when they saw them returning thus laden with riches at the end of six days.

And more than any other, the emperor Alexius was filled with anguish: considering the high valour of the duke, the French and the other pilgrims, being advised of the arrival of the messengers of Bohemond, who would shortly arrive himself, and fearing to be totally destroyed by the duke and his men, he pondered at length how he might make peace with him. And to that end, he finally sent messengers to them, and besought them, him and the other princes, to be pleased to come to speak with him, and if they were fearful that he intended some harm to them, that he was content to send them as hostage his oldest son, John, until they should return. This is why the duke and the other princes, who took counsel about this matter, decided to comply with his request and they sent to him Cunes of Montaigu and Baldwin of Le Bourg to receive this hostage.

When they had returned with the son of the emperor, Duke Godfrey and the other princes went to him in Constantinople, where they were joyfully received by all the Greeks, whatever they might be thinking. The emperor himself, to do them honour, embraced them all and asked the name and title of each one, the better to honour them, speaking most courteously to all, as much to individuals as to all in general, a thing he knew well how to do. The other Greeks, too, did not cease to marvel at the proud and noble steadfastness of the French princes. Finally, when the emperor was sitting in his palace on a throne covered and surrounded by draperies in gold and in richly

worked silk, from top to bottom and on all sides, surrounded by his princes and barons, he spoke these words to the duke: "We have heard it said a number of times in this land that you are of high lineage and of great power in your own country, that you are a good and loyal knight and that, to increase the faith in Our Lord Jesus Christ, you have undertaken to fight against those who do not fear him and who cause suffering to his people. This is why we admire you and love you with all our hearts, and we wish to honour you with the highest honour possible, for you are truly worthy of it. And for this reason, it pleases us, according to the counsel and with the agreement of our princes and barons, to appoint you and choose you, and to place our empire in your hands, that you may keep it in good state, as our son, in perfect love." And when he had thus spoken, he forthwith had Duke Godfrey clothed in an imperial robe, and made him sit beside him. And then the barons of Greece prepared for him a great and solemn feast, as it was the custom to do in that country for such things.[46]

And thus was peace concluded, sworn and confirmed between the emperor and the pilgrim princes. And the emperor caused his treasury to be opened, and from this he gave and presented an admirable quantity of gifts to the duke and his companions: of gold and silver, precious stones, lengths of gold cloth and many-hued silks, vessels of gold and silver and of divers materials and styles, which were distributed by the emperor Alexius in abundance. And although they were both without number in quantity and beyond all price, the emperor did not cease to give each week to Duke Godfrey, from Epiphany to Ascensiontide, as many precious stones and gold and silver as two strong men could carry, and ten measures of the brass money that was used then in that country. But the duke shared all these things with those in the army whom he thought to be in most need of them.

A short time afterwards, the duke and the other princes and barons took leave of the emperor and returned to their army. And when they were arrived, they straight-way sent back most honourably John, the eldest son of the emperor, whom they had kept as a hostage. And the emperor had it announced that, on pain of death, none should do wrong to the pilgrims, and that they should sell them all victuals at a fair price. And the duke also had it cried in his army that each one, if he loved life, should take care to do no violence or wrong to the people of the country. And thus they passed the rest of the time in peace, until the month of March.

Duke Godfrey – who knew that the other princes and barons were coming with their great armies, that the wish of the emperor was to have him cross over with his men to the other side of the strait of Saint George before the arrival of the other

Clashes between crusaders and the troops of Alexius.
Bohemond I interrogating prisoners

*"And so the prisoners were taken before Bohemond
and questioned, to know who had urged them to launch
themselves in such a way against our men."*

(FOL. 33VA–33VB)

Once again, Colombe depicts a battle between the crusaders and the army of Alexius. The Norman Bohemond of Taranto has crossed the Adriatic Sea with an army in order to join the crusade. After they have crossed the river Vardar, the Christians are attacked by the soldiers of Alexius. This is the battle in which the Christians are led by Tancred, who can be seen in the foreground. In the lower register, the prisoners are led before Bohemond, who is interrogating them. He wants to know who has ordered them to attack his army and they admit that they are in the emperor's service.

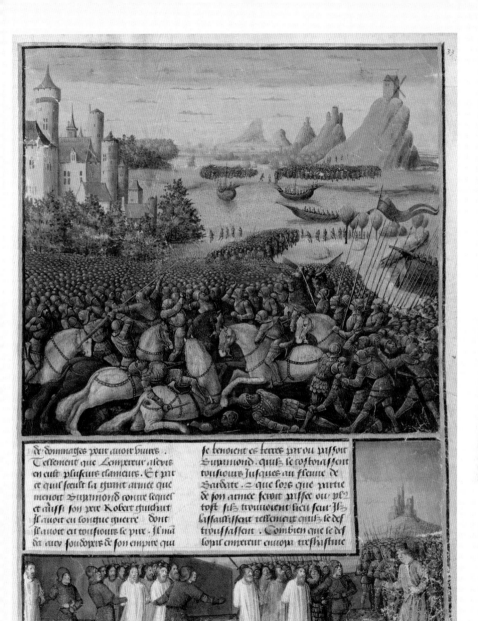

de dommages pour auoir hurrs .
Tellement que Lempereur alevit
en eulx plusieurs clameurs. Et pur
ce quil sceust la tyanit armee que
menoit Sigismond contre lequel
et aussi son pere Robert thachut
il auoit eu longue guerre dont
il auoit eu toussiours le pire . Il ma
da eulx souldoyers de son empire qui

se tenoient es terres pur ou passoit
Sigismond . quilz se tostorassent
toussiours susques au fleuue de
Saidate . et que lors que partie
de son armee seroit passee ou plu
tost silz trouuoient lieu seur Ilz
lassaillissent tellement quilz se des
trouuassent . Combien que le des
loyal empereur entoru treshastiue

157

princes and that this was also the wish of the princes and barons of France – said to the emperor that he wished to cross over, feigning, however, not to know what the emperor desired. At this the emperor was most joyful, and made ready for him so great a fleet that the army crossed over in a short time to the other side of the strait of Saint George, and landed in the country on that side, which is in Asia and is called Bithynia.

When they had crossed over, Godfrey and his army were lodged in the city of Chalcedon on the strait of Saint George, where they were housed most comfortably. For this city is so close to Constantinople that there is only the strait between the two, and it is so narrow at this place that any who have business in the city of Constantinople can go there two or three times in a day. And in like manner as the emperor had the duke and his men to cross over, so he also had the other pilgrim princes and barons do when they arrived, because he did not wish the two pilgrim armies to be lodged together on the Constantinople side, lest they should be too strong for him.

Chapter XII.

Of the departure of Bohemond, prince of Taranto, and Tancred, his nephew, who were of such high renown. Of the disloyalty and treachery that the emperor thought to commit against them. How Tancred defeated the Greek mercenaries. Of the feast that the emperor held for Bohemond, and of the journey of the count of Flanders.

Bohemond, prince of Taranto, son of Robert Guiscard, had already left Apulia and arrived at Dyrrhachium before the winter, and he had brought with him his nephew Tancred, the son of his sister, and a number of great lords and noble barons, knights and squires, foremost amongst whom were Richard of the Principate, son of William Strongarm, brother of Robert Guiscard, and Raymond, his brother (all of them descendants, as I have already described, of the line of Rollo, first duke of Normandy, and of the counts of Blois); Robert of Ansa; Herman of Carni; Robert of Sourdeval; Richard, count of Rossignuolo; Hoyaux of Chartres; Humphrey of Montgueux; and a number of others, without counting the men on foot, who with one accord had chosen as commander the noble Bohemond.

In spite of the winter, Bohemond took the road and his army passed through Castoria, where he celebrated Christmas. But because the men of that country did not

wish to supply them with food, considering them as their enemies, Bohemond sent a party of his men out to loot, and obtained a great quantity of food by force of arms. Thence, he went to Pelagonia, where he had to wreak great destruction to obtain food, of which the emperor Alexius was informed. And, having had knowledge of the great army led by Bohemond, against whom he had conducted a long war in which he had always been worsted, as likewise against his father Robert Guiscard,[47] he ordered the mercenaries of his empire who were stationed in the regions through which Bohemond was passing, to accompany him constantly as far as the river Bardate[48] and, when part of his army should have passed over or, indeed, earlier if they found a safe place, to attack and rob him.

The disloyal emperor sent in all haste a number of great Greek lords before Bohemond and, on the pretext of the great honour that he meant to do him, he made known to him after a number of pleasant words that he rejoiced greatly at his coming, and asked him to make haste to come to Constantinople, where it was his intention to feast and honour him as was fitting for a prince such as he, and most particularly out of respect for the great journey that he was undertaking with such courage. But when Bohemond heard these messengers, he took but scant account of their promises, for he knew his treachery.[49] However, concealing his resolution, he did them honour and feasted them splendidly, but always remaining on his guard. And in truth, he had need to do so, for, when one part of his army had crossed over this river Bardate, the mercenaries and the army of Constantinople, who had ever kept pace with him and believed that they had reached a place where they might defeat him utterly, made a sudden assault on the rest of the army. But when Tancred, who was leading the vanguard, heard the noise, he crossed back in haste with two thousand of the most valiant men. They fell upon the Greeks with such force that they killed and took captive a great number of them, and the rest took flight.

And so the prisoners were taken before Bohemond and questioned, to know who had urged them to launch themselves in such a way against our men, in view of the offer that the emperor had made to him, and they confessed and acknowledged most readily that it was the emperor who had secretly demanded that they do this thing. And despite this, Bohemond pretended to believe that the emperor had not caused this thing to be done, which greatly displeased a number of the members of his company, who were not as skilled at pretence as he. But they obeyed him until he had led his army across Macedonia as far as the neighbourhood of Constantinople. The emperor sent out once more a number of great barons to meet him, asking him to leave his army

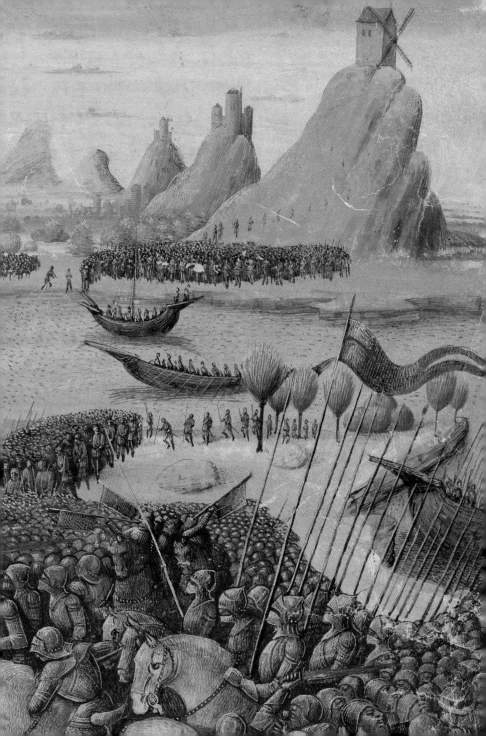

and come straightway to him, with but few of his men, to Constantinople. After which, since Bohemond could not determine whether he should go or not, since he feared to incense the emperor or to fall into the toils of his falseness and treachery, Duke Godfrey determined to go to him, and he arrived on Maundy Thursday. And later, when they had feasted each other and told of their adventures, Bohemond departed, as Duke Godfrey besought him, and came to Constantinople before the emperor, who feasted him and honoured him greatly for a number of days.

During this time, Tancred did not dare to go before the emperor, but he passed with his army into the country of Bithynia, on the other side of the strait of Saint George. Hearing this, the emperor was greatly angered, but he concealed his thoughts by giving many rich gifts to the duke and Bohemond. He gave them authority to cross to the other side of the strait with their armies. Shortly thereafter, Robert, count of Flanders, set out in his turn. He had crossed the sea to Dyrrhachium, where he had wintered, and went to Constantinople with his army. The messengers of the emperor came out to meet him, as they had done for the others and, having been warned by them, he went on to Constantinople with a much smaller company. And after the emperor had embraced him and feasted him, he paid homage to him, in like manner as the other princes and barons before him, except for Tancred and those men of the army whom he had led across unknown to the emperor. When he had paid homage, Robert, count of Flanders, took leave of the emperor, who gave him handsome gifts. And he crossed over with the Flemish to the other side of the strait of Saint George, where he found his companions, the other princes and barons who had already crossed over, who expressed their joy at seeing him arrive.

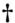

Chapter XIII.

Of the departure of Raymond, count of Toulouse, and Adhemar, bishop of Le Puy. Of the great perils they faced in Hungary, Dalmatia and the marches in those countries. How the emperor caused the men of the count to be attacked while he was feasting him at Constantinople, and how Count Raymond worked with skill against the wiles of the emperor, in the end paid homage to him, and crossed over the strait with the other princes. The journey of Robert, duke of Normandy, and Stephen, count of Blois and Chartres.

Raymond, count of Toulouse, who was one of the most rich and powerful princes of France, and one of the three who performed the most deeds worthy of renown during this Holy Journey, and the very venerable Adhemar, bishop of Le Puy, whom Pope Urban had chosen as legate, when he had determined on the First Crusade to go in his place, took the road with a considerable army, where there were to be found, with them and under their command, William, bishop of Orange; Rambald, count of Orange; Gaston of Beziers; Gerard of Roussillon; William of Montpellier; Raymond Pilet; Gaston of Béarn; William Amancy; and a number of other most noble and valiant barons, knights and squires, well and richly mounted, armed and decked out, in very great number, without counting the foot soldiers, all of whom left their rich lands to accomplish the Holy Journey in the company of their leader, the good Count Raymond. He led his army across Lombardy and the other regions of Italy, and thence he entered the land of Istria and Dalmatia, which lies between the Adriatic sea and Hungary. Therein are four archbishoprics: Zara, Spalato, Antibare and Raguse,[50] which are inhabited by cruel people who have the habit of robbing and killing. And it is easy for them to do this to those who pass that way, for this land is full of mountains, forests and deep and fast-flowing rivers, and also of marshes, so that there is little land that can be ploughed. But there is an abundance of cattle, upon which they live in divers ways, speaking several languages and clothed differently, for those who live along the shore and close by speak French[51] and a Slav tongue.

In crossing these lands and these regions, the army of the count of Toulouse endured a number of great dangers and losses, as much by reason of the severity of the winter as lack of food, all the more so because the people of that country had deserted their

The passage through Dalmatia.
Crusaders crossing the Bosphorus

*"Raymond, count of Toulouse, who was one of the most rich
and powerful princes of France, and one of the three who performed
the most deeds worthy of renown during this Holy Journey,
and the very venerable Adhemar, bishop of Le Puy, whom Pope Urban
had chosen as legate, when he had determined on the First Crusade
to go in his place, took the road with a considerable army."*

(FOL. 34B)

Raymond IV of Toulouse was one of the main leaders of the First Crusade. He set off with Adhemar of Monteil, bishop of Le Puy. The principal scene shows the march through Dalmatia of the southern French crusader army led by Raymond. On this march, the crusaders were constantly harassed and attacked by their enemies, who are seen here lurking in the bushes, waiting to ambush them. A succession of mountains, forests and rivers evokes a wild and inhospitable setting. In Colombe's workshop, exotic landscapes often took the form of rocky hills with typically distorted shapes. These hills help to structure the composition of the miniatures; in addition to a colour perspective, they lend further depth to the landscape. The Byzantine emperor is shown in the lower left picture receiving Raymond of Toulouse, who greets him. The miniature in the lower register at right shows the crusader troops crossing the Bosphorus.

tes armes z guerre en tresgrant
nombre sans ceulx de pict . Qui tous
laissecent leur riche terre z pays
pour acomplir le saint voyage . auec
et en sa compaignie z souls sa co̅
duite du bon Conte raymond .
Lequel mena son armee par son
hardie z aultres pays dytalie dont
se entra en la terre disae . z de du
mage qui est entre sa mer adri̅
ne z hougrie . La ou a Quatre

archeueschie . sadee . Spilete . Am
tibure . z Ragule . peuplees de nuy
rice aues . z entretins a labor et
tics . z bien en ont saauance sur
ceulx qui par la passent . Car
ceste terre est plaine de montaigne
de forestz z de riuiere prsonde
et couaite fort . et auisi de maise
tellement quil ni voit de terre sa
soumilee . s que de lestau va
mant sibondlice dont se z buit

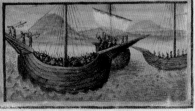

towns for fear of the pilgrims and had retreated into the forests, the caves and their strongholds. And it was there that they had gathered together all their food and other possessions, and it was for this reason that the pilgrims had great difficulty in providing their army with food. And again, they suffered great harm, because the Slavs and the Dalmatians, who knew the fortified and dangerous places, often left the places where they were hidden. And when they were able to surprise any pilgrims who had been separated or fell behind, or who were feeble or sick, they robbed, pillaged and killed them without mercy.

When Count Raymond, who was one of the wisest princes of his age, knew of their sorties, he was grieved beyond measure and put his army on their guard and pursued the Slavs, to such effect that they never dared to return, for he had the arms and the legs cut off a number of prisoners who had been brought to him alive, and he left them thus, living, on the roads, to serve as an example and to terrify the others; fearing so cruel a death and the watch that had been set up against them, they gave up their sorties entirely. Thus the army passed on somewhat more easily, but still with great difficulty, for, apart from these troubles, the air in that land was filled with a fine rain so dense that those at the back could scarcely follow those ahead.

At the end of three weeks, they arrived at a castle called Skodra,[52] where the king of Slavonia was. The count of Toulouse went before him and, thinking to gain his love for himself and his men, he gave him a number of great gifts, that he might command his people to let the pilgrims pass in peace, and to supply them with food in exchange for their money. But this served no purpose, for they did not cease their cruel deeds, which the pilgrims had to suffer as far as Dyrrhachium, which they reached at the end of six days' travelling across these lands, and as far as their arrival in Skodra and thereafter. In this town of Dyrrhachium, the emperor Alexius sent a number of great Greek lords to Count Raymond, for he had long feared his coming, because he had heard of the reputation of this powerful and most wise prince. The count received the letter and the messengers most honourably, and he and all those of his army rejoiced greatly that the emperor should offer to supply them with food, and a safe passage through the lands of the empire, as far as Constantinople. They thanked him most warmly, by a letter and by messengers whom the count sent to him, who straightway hastened his army onwards, in such wise that they reached Pelagonia, where the bishop of Le Puy, who had encamped some distance from the army in a beautiful place that he had found, was attacked and carried away by night by Bulgarian bandits. While one of them thought to save him in the hope of obtaining money from him, and his companions were argu-

ing against this, men from the pilgrim army picked a quarrel with them and rescued the good Adhemar, bishop of Le Puy, and all his possessions.

On the following day, the army took the road again and, passing through Salonica[53] and Macedonia, they came, after a number of days and great difficulty and great toil, to within four days' journey of Constantinople, to a great river called Redosto,[54] which flows into the strait of Saint George. There, messengers from the emperor came again before Count Raymond, and besought him to present himself before him, at Constantinople, with a smaller company. And there arrived likewise messengers sent by the princes and barons who were on the other side of the strait, asking him to do what the emperor wished. Count Raymond obeyed them and, leaving his army under the guard of the other barons, he came to Constantinople and went before the emperor, who welcomed him most honourably. And then he asked him to pay homage to him in like manner as his companions had done, to confirm their true alliance and friendship. But the count replied straightway that he would do no such thing. The emperor felt such great rage and bitterness thereat that, concealing his cruel will, he secretly commanded his captains of war to gather the greatest possible number of men-at-arms and to withdraw the boats that were carrying food to the pilgrims on the other side of the strait, that they might deprive them of these, and to leave not one on the other bank, so that they might not cross over again to this side. And this done, he commanded them to attack the army of Count Raymond by night and by surprise, and to kill and wound all those whom they were able to take by surprise.

And that is what they did; when night was fallen and the pilgrims of the count were sleeping, believing themselves to be in a safe place and amongst friends, because of the fine promises of the emperor, they were suddenly attacked by the Greeks. The latter killed a number of them and had already put the greater part of them to flight in their sudden night assault, when the valiant knights who were there, hearing the noise and the cries of the slaughter, armed themselves with their companions, and ran in all haste to where the Greeks were, so that, hearing their prayers and their requests, those fleeing turned back into the camp and chased the Greeks from it by force of arms, and the rest took flight. And although our pilgrims had the victory, a great part of them, and not only amongst those on foot but also amongst the greatest, on the day after, forgetting their vows and promises, would have abandoned the great journey through bitterness at the treachery of the Greeks had it not been for the wise counsel and explanations of the venerable bishops of Le Puy and of Orange, who, by their most praiseworthy preaching and other prayers and entreaties, reconfirmed them in their

first desire.[55] When the count of Toulouse knew of the treachery and harm that his army had suffered, he was deeply grieved, and asked most plainly and forcefully of the princes and barons who were on the other side of the strait of Saint George, and most particularly of those who had entreated him to come to Constantinople, that they should help him to avenge the outrage committed by the Greeks, setting forth to them clear reasons why they ought to do so, in like manner as he had sworn.

But when the emperor heard of this and understood that he had acted wrongly, once his anger had abated, he secretly asked Bohemond and the count of Flanders to come before him at Constantinople, that they might appease the wrath of the count. Which thing, in a word, they did, explaining to him, amongst other things, that they should not delay the accomplishment of their vows to undertake such an act of vengeance, which in any case they had not the power to perform, but that they ought rather to keep this in their hearts until another time. And the emperor, to excuse himself, swore, in the presence of the count of Toulouse and a number of other princes and barons, that he was without all knowledge of the deeds of his captains. Thus, was concluded the peace between the emperor and the count, who paid homage to him in like manner as his companions had done.[56] And the emperor then gave him most valuable presents, and he gave likewise new gifts to the others, who had made the peace. Then they returned to the other side of the strait, where, when they were arrived, while Count Raymond had his army pass through and go into Bithynia, Duke Godfrey; Bohemond; Robert, count of Flanders; and the bishop of Le Puy and all their men set up camp in their place, and determined to lay siege to the city of Nicaea. They arrived there and began their siege on the fifteenth day of May in the year 1097. And while they were besieging the city, there arrived Robert, duke of Normandy, second son of King William the Bastard, who had conquered England. This Robert had with him a very handsome and great army, and a number of noble and valiant princes and barons, who were his companions and allies on this journey: amongst others Stephen, count of Chartres and of Blois, father of the old count Tibald who founded Lagny-sur-Marne, where he lies buried, and who had for a son the most fortunate, renowned, generous and praiseworthy prince Henry, first count of Champagne, who, amongst a number of great and praiseworthy foundations, founded, as I have already said, the canonical church of his eminence Saint Stephen in Troyes, where he rests.

With the duke of Normandy there was also Eustace, brother of Duke Godfrey, who was sent by them before the emperor and the other princes and barons to announce their arrival. In that army were also to be found Stephen, count of Aumale; Alan Fergant

and Conan, who were two mighty barons of Brittany; Rotrou, count of Le Perche; and Roger of Barneville, who had all gone as far as Naples with Hugh the Younger when he crossed over to Dyrrhachium. But because of the great numbers and the winter, they stayed in Apulia and in Calabria, which are very fertile lands.

And when the spring was come, they took the road and, after having passed through Dyrrhachium, Macedonia and Thrace, they arrived at Constantinople before the emperor Alexius, who gave them a fine welcome. And they, too, paid homage to him, in like manner – for they had been forewarned – as the other princes and barons had done. With his authority, and after he had made them a number of great presents, they crossed with their armies to the other side of the strait, and made their way with all haste to the siege of Nicaea. And although the emperor had already shown well enough in divers ways that he bore a mortal hatred to the French, a thing that he thought to hide by his great gifts and his welcome, he wished all the more to deceive them. For on their departure, under the pretence of alliance and perfect friendship, he sent with them to lead them and guide them one of his Greek knights called Taticius, one of his counsellors and his familiar, who, in like manner to his master, was the most disloyal, cruel and inhuman traitor who ever lived. And he had, indeed, the appearance of a felon, for his nose was deeply sunk and his nostrils were broad and wide open. And the emperor advised them to trust him everywhere and in everything, affirming and swearing that there was not a man in the world who knew better the roads and the paths that they would have to follow and who could lead them better, and that he was sending him with them because of the love that he bore them, something that he would never otherwise have done, because hehad always taken counsel of him, and had profited from this, and that he did so still day after day.

And the emperor spoke many other great praises of this traitor Taticius, whom he commanded secretly to do all he could to lead them and settle them in a place where they could quickly be beaten by the Turks and the other enemies of the Christians, because he knew that he bore a mortal hatred to the Latins and knew more about treachery than any other Greek, at the same time saying to each of the princes that they would be able to know his wishes through this guide, for he would be writing to him at all times. And he besought them to make request to him to know and to have anything that they wished from Constantinople. And the traitor Taticius made all haste towards the siege of Nicaea, where all the pilgrims were to be found for the first time together: they were reckoned at six hundred thousand men on foot bearing arms and a hundred thousand knights and other men on horseback.

BATTLE OF NICAEA (1097).
ALEXIUS I COMNENUS AND THE ENVOYS FROM NICAEA

*"This noble city of Nicaea, thus distinguished by these
two holy councils, is situated on a plain, but there are mountains
nearby, which almost completely surround it.
The land round about is very beautiful and very fertile."*

(FOL. 37B)

The battle of Nicaea took place on 19 June 1097. The crusaders can be seen engaging the troops of Suleiman. In the foreground, the opposing troops are shown slaughtering each other in a fearsome mêlée. Fallen horses and men are in their death throes on the ground. In the distance, an immense army marches out of the town of Nicaea. The fortress gives the impression of power: its castle is protected by gates, towers and crenellated walls, while a lake lying right along the city walls makes it possible for the town to be resupplied by boat. In the lower register is shown the episode in which envoys sent by the citizens of Nicaea come to surrender to Emperor Alexius, who receives them seated on a throne. A final scene shows the foot soldiers engaged in merciless combat.

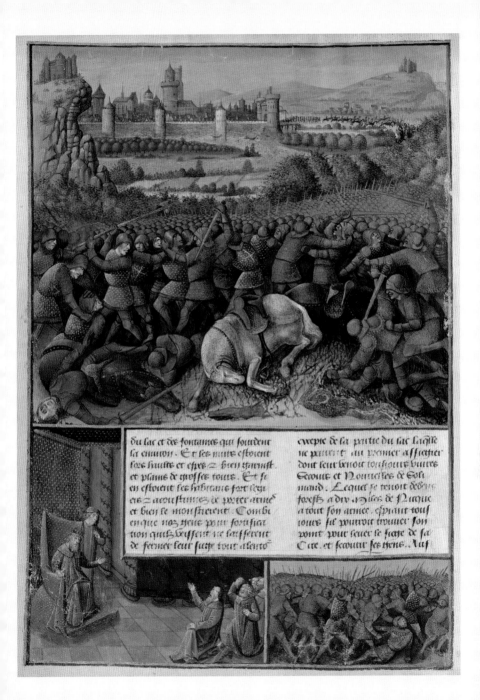

du lac et des fontaines qui sourdent
la enuiron . Et ses murs estoient
fors haults et espes ⁊ bien garnis.
et plains de grosses tours . Et se
en estoient ses habitans fort sub-
tils ⁊ acoustumés de porter armes
et bien se monstrerent . Combi
enque noz gens pour fortifica-
tion quilz feissent ne laisserent
de fermer leur siege tout a lentou

excepte de la partie du lac laqlle
ne peurent au premier assieger
dont leur venoit tousiours vitres
Secours et Nouuelles de Gosi
mund . Lequel se tenoit dedens
forest a dix lieues de Nique
a tout son armee . espiant tous
iours sil pourroit trouuer son
point pour seurer le siege de sa
Cite . et secourir ses gens . Aus

Chapter XIV.

**Of the nature, situation and fortifications of the city of Nicaea. How Sulei-
man, who was its lord, thinking to raise the siege, was defeated by the divers
tactics practised against those in the city. And how, with great expense and
difficulty, Taticius through cunning convinced the citizens, who had realised
that they would be taken by force, that they should surrender to the emperor,
and how the princes were content with this and asked the emperor to send
men to safeguard it.**

Nicaea was formerly no more than a bishopric, but the holy emperor Constantine
the Great had it elevated to the title of archiepiscopal see and removed it from the
archbishopric of Nicomedia, under whose authority it had always been, because the
first of the four great councils had been held there in the time of this Constantine and
of Saint Sylvester.[57] And it was in this same place that was held thereafter the seventh
council,[58] which was convened and celebrated in the time of Pope Adrian and Emperor
Constantine, who was the son of Irene. This noble city of Nicaea, thus distinguished
by these two holy councils, is situated on a plain, but there are mountains nearby,
which almost completely surround it. The land round about is very beautiful and very
fertile. To the west, close to the city, lies a very broad and long lake, over which are
borne into the city all manner of victuals and merchandise. Its waves beat with great
force against the walls of the city whenever the wind blows. On the other side there
are moats, broad and deep, filled with water from the lake and the springs that well up from
the ground thereabouts. And the walls at that time were high and thick and well defended,
filled with sturdy towers, and the inhabitants felt they were secure, and they were
accustomed to bear arms, as they well showed, even though our men, although they
could see the fortifications, did not fail to make the siege tight all around, except on the
side of the lake, where they were not able to make the siege tight at first. It was always
from that side that there came to them food, help and tidings of Suleiman, who was
ten miles from Nicaea with his army, keeping to the forests and always spying out the
land to see if he could find occasion to raise the siege of the city and rescue its people.

Suleiman sent them two of his privy chamberlains, by whom, amongst other things,
he made known to them that he had all confidence in them, and that he trusted

in them because of their great valour, for they would not suffer themselves to submit to people come from distant parts of the West and who were half dead, as much because of their long journey as from the lack of comfort and changes of air, to which they were not accustomed. They must remain on their guard and be ready to launch themselves against the besieging forces, because he would attack the Christians the next day before the hour of nones. And he had not the slightest doubt that he would chase them away and vanquish them utterly.

But, with the aid of Our Lord, things did not fall out as he had thought because, when some of our men caught sight of Suleiman's messengers on the lake, and saw that they had landed at some distance from the city, wandering and looking hither and thither to see where they might enter most easily, they pursued them in such haste that the first they killed there and then and the other they led straightway to the princes of the army. And by questioning him under torture, they discovered what Suleiman would do. For that reason, they straightway made known to the count of Toulouse and to the bishop of Le Puy, who had not yet arrived at the siege, that they should make haste to arrive there as early as possible in the morning, which thing they did.

When they were arrived, they made ready in such earnest that, when Suleiman came the next day, thinking to have ten thousand of his men make entry on the side where was the gate that the pilgrims had not secured the evening before, his men found there the count of Toulouse, who met them with courage. And thus began the battle, but it lasted but a short while, for the count of Toulouse and his men soon forced them to fall back as far as Suleiman, who rallied his men against the count of Toulouse. And they would have been hard put to it, had not Duke Godfrey and Bohemond soon thereafter added their troops to those of the count. And then they made a horrible massacre of the Turks and other Saracens of Suleiman, who were forced to take flight, although our men were scarcely able to pursue them, because the forests and the nearby mountains served them as refuge. Tancred, Guy of Guerlande, Guy of Possesse and Roger of Barneville were the worthiest in this battle, which lasted an hour.

And when the princes and barons saw that the army that Suleiman had led from his distant lands was routed, they determined to take the city of Nicaea by assault. They had divers siege-machines strike the walls and the towers. When these machines were completed and had caused great damage to the city walls, they launched two assaults, which brought them little gain, but where they lost, amongst a number of their men, four valiant knights: one called Baldwin Chaulderon of Berry and the other Baldwin of Ghent were killed during the first assault, one being struck by a stone and the other

by an arrow; and during the second assault William, count of Forez, and Galles of L'Ile were also struck by arrows and killed while they were attacking boldly. And on the same day, Guy of Possesse, knight of Champagne, most generous and of great renown, died of sickness. Shortly thereafter, it happened also that Count Hermann, who was German, and Henry of Hasque had made a castle of wood, where twenty knights were shielded. But the knights and the men-at-arms whom they had placed there were all killed, because the Turks in the city, who had made a number of machines to hurl stones, hurled so great a quantity without cease that one strike demolished the castle completely. And thus were killed all those who were inside, so that not one man escaped. Our men were deeply afflicted by this, but nevertheless they continued their siege.

And seeing that food and other goods often came into the city by the lake, they sent knights and other men before the emperor at Constantinople. At their demand, the latter had sent to them sea boats of divers kinds, both large and small. When our men came to where the boats were, they transported some of them dismantled and the others on three or four carts yoked together. They did this with such zeal that they brought them in one night from the sea, overland, right down to the lake, although there were at least seven miles between the two. And they fortified them with strong bars and filled them with men-at-arms. The people in the city were terrified in the morning, when they realised that they could no longer receive help from the sea. And again, our men made a number of other assaults, in one of which Duke Godfrey killed with one strike from his crossbow a great Turk who had from time to time come out from the protection of the city wall and inflicted great harm on our men.

Finally, a Lombard constructed in a few days an engine of wood, so solid and so well fortified that neither fire nor stones were able to destroy it. And in spite of the Turks, he pulled it up against the city walls, filled with men-at-arms and engineers. In spite of the people in the city, who hurled stones against the engine without being able to destroy it, our men in the machine pulled out so many stones, both large and small, from a great tower, that they were able to put in wooden props. And then they set fire to it, which in a very short time consumed the props, so that the tower fell, making so great a din that the wife of Suleiman, who was in the city, thought that it had been taken by assault when she heard the noise and the sound of the trumpets, which our men caused to ring out in jubilation. For that reason, on that same night, she put out in a boat on the lake with her two sons, and our watchmen seized the boat, and led her before the princes with her two sons. They kept them until the end of the siege, which lasted seven weeks and three days, so that, in the end, the citizens, seeing

that the tower as it fell had caused a great section of the city wall to collapse and that they could hold out no longer before being taken by assault, demanded a truce in which to parley and surrender, which was accorded them.

During this truce, the disloyal Greek Taticius spoke in secret to the most important citizens, and made them understand that the pilgrims, who were all cruel and inhuman barbarians, would kill them and destroy them all if they surrendered to them, because they coveted their possessions and wished to go onwards. And this is why he counselled them to surrender to the emperor Alexius, who was their neighbour; they would pay honour to him and he would treat them as his own people. Listening to this counsel and this suggestion, the people of Nicaea made it known to the princes and barons that they would willingly put themselves in the hands of the emperor, if this suited them. And the princes and barons were content, for they believed that the emperor would distribute amongst the army the booty that they would capture throughout his empire, as he had promised to them at Constantinople. And the citizens agreed that they would first of all had brought to the siege and set free all the prisoners of Peter the Hermit that Suleiman had taken at Civetot, and all those who had been taken during the siege. For, whatever the pain and whatever the fatigue they had suffered while laying siege to the town, they were still desirous above all of going onwards, and they sent messengers to the emperor. And these demanded for their part that he would send men-at-arms to guard the city of Nicaea, which they would surrender to him. And the emperor, greatly rejoiced, sent letters and individual presents to each of the noble princes and barons in the army, and he also sent men-at-arms to seize the town and to guard it.[59]

One party of these returned to him and brought the prisoners to him at Constantinople, while the others stayed in Nicaea, where they had the towers and walls rebuilt. But they took all the armour, food and riches of Nicaea to the profit of the emperor, to the great displeasure of the common people, who murmured because they had had no booty. They were pacified by the princes and barons, who explained to them that, even if the emperor was, indeed, failing to keep his promises, they must needs support him, lest they put at risk their vows and promises. And further, as soon as the emperor had the wife and the two sons of Suleiman, he made celebration for them a number of days in Constantinople, then sent them back speedily free of all obligation, that he might gain the love of the Turks and that, by common accord, he and they might do more harm to our men.[60] He hoped also that, when the pilgrims tightened their grip around another city, its inhabitants would prefer to surrender to him. And in such a manner was the

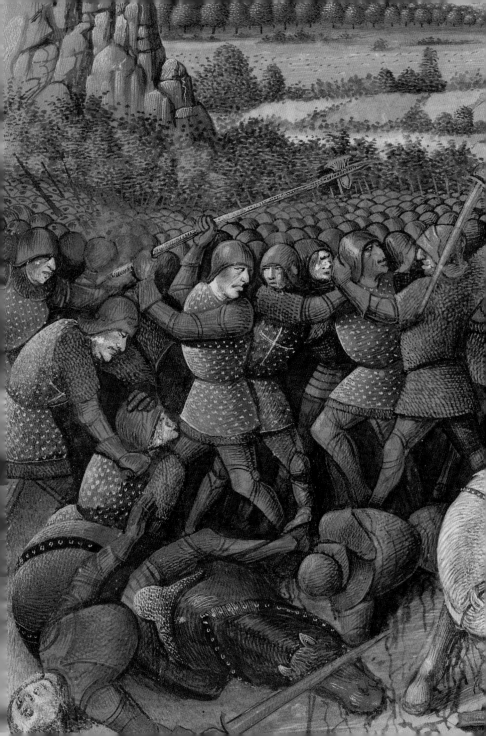

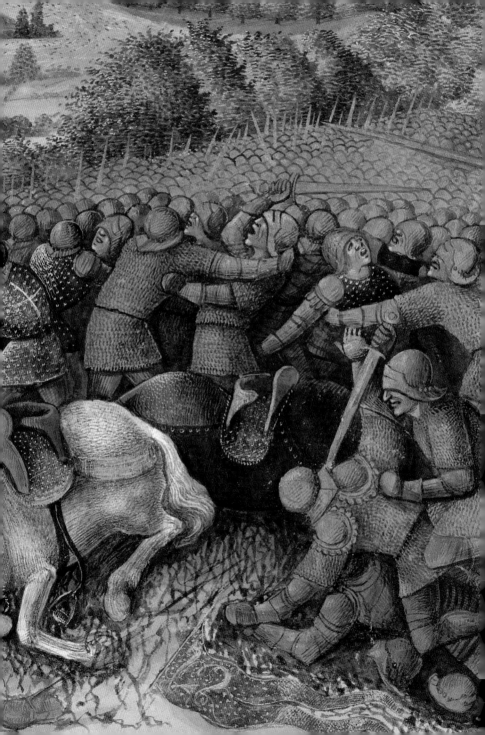

city of Nicaea taken and surrendered to the pilgrims and to the emperor Alexius on the twentieth day of the month of June in the year 1097.

Chapter XV.

How Suleiman thought to surprise Bohemond and Tancred when they were separated from the main army. Of the great crowd and of the skirmishes with the Turks. How Bohemond was rescued and the Turks beaten. Of the great gain that our men made there. Of the great difficulties they had. Of the great thirst they suffered for lack of water.

Three days before the end of June, the army of pilgrims took the road again, after the emperor Alexius had received the city of Nicaea, taken by their conquest. But, because there was a great fog and it was still not light when they left their camp, or perhaps that they might better be able to find fresh food supplies, they divided themselves then into two parts, not equal in size, for in one part were only Bohemond, the duke of Normandy, Count Stephen of Chartres and of Blois, Tancred and the count of Saint-Pol and their men, who took a road to the right, which led them down into a valley called Gorgon, where they camped at around the hour of nones, near a river with a great abundance of water.

And they slept there the following night in perfect peace, although, in spite of everything, they had a most close guard and watch kept in the army. And all the other pilgrims took the road to the right and journeyed the whole day through most beautiful places. And at eventide they camped in a great meadow near the water, two miles distant from Bohemond and those who had taken the other road. But when Suleiman, who was most aggrieved at the loss of his city and who was keeping pace, concealed, always in proximity to our men, that he might seek a means of harming them, knew with certainty from his spies that they had separated, he set off at daybreak towards the army of Bohemond, thinking to find them sleeping. But this was not the case, for the good watch caused the pilgrims to arm rapidly, so that they were all remarkably well drawn up before their enemies, who were a good two hundred thousand men, all on horseback, had reached them. They had already placed the sick and the aged, the women, children and others who could not bear arms in the middle of the deep waters of a great marsh. They had besides encircled them with a great

quantity of carts, so that none could reach them on any side. And, from the very beginning, they had made known their misadventure to the other princes and barons, demanding that they come to their aid without delay.

And things being thus done and ordered, Suleiman sent at the hour of prime a party of his archers, who fired an extraordinary quantity of arrows. And after this first attack, he sent out another party, who fired arrows as the others had done. Seeing that they were losing many of their horses and that a great number amongst their men were wounded, those on horseback galloped out on both sides against the Turks, to give combat with lance and sword. But these fell back into the midst of their great army, so that our men could find none against whom to fight. And when the pilgrims retreated and reformed with the foot soldiers, the Turks returned to launch their arrows against them, so that there were a good two thousand pilgrims killed, both foot soldiers and horsemen.[61] And amongst others were killed there two most valiant knights, one called Robert of Paris and the other William, who was the brother of Tancred. To avenge the death of his brother, Tancred hurled himself, as if maddened, into the midst of the Turks, and made an extraordinary massacre amongst them. Bohemond had even to go and pull him back by force, cleaving a way through the press of men, because he did not wish to come back.

To be brief, our men had so many killed and wounded that they were dumbstruck. When the Turks saw this, they hung their bows on the pommels of their saddles and, taking their swords and their knives, fell upon our men with such sudden force that they caused them to fall back as far as the carts that they had used to encircle those who were not armed, before the assault of the Turks. There they defended themselves against them with great valour, despite the great number of their enemies. And Our Lord, who saw the straits in which they were, filled the hearts and bodies of those in the main army with so high a courage and such strength, diligence and valour that they arrived in time to rescue them. For Duke Godfrey and his two brothers, Baldwin and Eustace, the count of Toulouse, Hugh the Younger and as many as forty thousand other valiant barons, knights and other men on horseback, leaving those who were badly mounted with the rest of the main army, came up to them at full gallop and in good order, sounding their horns and trumpets, until they could see the Turks, who were dismounting that they might tighten their horses' girths.

When Bohemond and his companions realised this, they rejoiced greatly and fell upon the Turks. And in accordance with the advice of the good Adhemar, bishop of Le Puy, who urged them on with pleasant words to avenge the deaths of their brothers who were killed there, they gathered their forces and killed in a short time so great

a number of the enemy that the others no longer dared to hold their position, but fled to save their lives. And our men followed them and pursued them closely, killing and slaughtering more than four thousand of them, sparing none, and they rescued a number of our men who had been taken prisoner previously. And then they turned aside into the tents of Suleiman and the other Turks, and they found them full of great riches, not counting the food, pavilions and horses, to such a degree that all found themselves rich. Indeed, one may well believe that there was rich booty, after the rout of two hundred thousand men on horseback, of whom they found near twenty-three thousand dead. But on the side of the Christian dead, there were around four thousand men on foot and but few on horseback.

Our men rested for three days in the place of the battle,[62] which had lasted from the hour of prime until the hour of nones, for both the sick and the wounded and also for the beauty and pleasant aspect of the country. And they determined to keep together and closely united thenceforward, until they knew the country better. And they took the road again at the end of three days, and went right across Bithynia and entered a country called Pisidia. By seeking the most direct road, they found themselves in regions so dry that more than five hundred of them died of thirst, and great suffering caused many women to be brought to bed before term, because of the heat and the absence of water. And it was most pitiful to see them, and the beasts and birds as well. When they came to a great lake, many of the men and the beasts drank to excess, to such a degree that they died there and then.

However, having passed through great dangers, they arrived in the land of Antioch Minor,[63] where there were beautiful rivers, springs and woods in abundance. They camped there along a beautiful river and they chose their campsites well. Baldwin, brother of Godfrey, and with him Rainald, count of Toul, Peter of Escadenois, Baldwin of Le Bourg and Gilbert of Montcler, and at least seven hundred men on horseback, without counting the men on foot who were following them, separated from the main company because it was difficult to find food, and journeyed throughout the land seeking adventures. Tancred did likewise, taking with him Richard of the Principate, Robert of Ansa and a number of other knights and men on horseback, as many as five hundred without counting the men on foot, who were greater in number than those on horseback. The main intention of these two young princes was to travel over all the country that surrounded the army. And if they found any perils, dangerous passages or a great number of people desirous of doing harm to the main army, to make this known to the army and, depending on what they might come across, continue on their way.

Chapter XVI.

How Duke Godfrey slew a bear, which grievously wounded him. Of the adventures of Baldwin, his brother, and Tancred, and of the two outrages that Baldwin committed against Tancred, and Tancred, in turn, against Baldwin. The peace made between the two of them, and how Baldwin was made count of Edessa.[64]

Godfrey and the other princes, who had stayed in the camp and who wished to take their ease for a while after their great efforts, because they were in pleasant and agreeable places, went out one day to hunt in the forests nearby. Now it happened that the duke took one path and the others did likewise, each going their own way as is usual in such cases. But he had gone only a little distance when he heard a great cry, in which direction he hastened with all possible speed. And he saw then a poor man from the army who had gone out to look for wood in the forest and who was fleeing in great terror because of a huge and horrible bear that was pursuing him. Therefore, he spurred on his horse in that direction and provoked the bear by his cries. Leaving the poor man, the bear came right up to the duke and, with one stroke, bit and pulled at the horse, bringing both it and the duke down; rearing up on its hind legs, it wounded him deeply in the thigh and, even worse, went towards him again to attack him with its two front paws, thinking to knock him over and snap at him with its gaping mouth.

Realising this, the duke gripped it by the scruff of its neck with one hand and, dragging its head backwards, with the other pierced it side to side by driving his sword into its body right up to the hilt, and he flung it dead upon the ground. But, weakened from the loss of blood from his wounds, he had perforce to sit down straightway upon the ground, for he was wounded to the point where, greatly afflicted, he could stand no longer. The poor man whom he had delivered ran back to the army to tell this news, at which the barons and all those in the army lamented dolefully. They straightway rushed to the place and bore him on a litter into the camp. There they dressed the wound carefully, for all the princes had good doctors. And besides, the most valiant count of Toulouse was seized by a sickness so serious that all expected him to die and the bishop of Orange administered Extreme Unction to him and recited the prayers for the dead and all the other usual services except for the mass. While these two princes were thus

GODFREY OF BOUILLON SLAYING A BEAR.
THE CRUSADERS BEING INFORMED OF GODFREY'S EXPLOIT.
GODFREY OF BOUILLON AND RAYMOND IV ON THEIR SICKBEDS

*"The duke gripped it by the scruff of its neck with one hand
and, dragging its head backwards, with the other pierced it side to side
by driving his sword into its body right up to the hilt, and he
flung it dead upon the ground. But, weakened from the loss of blood
from his wounds, he had perforce to sit down straightway
upon the ground, for he was wounded to the point where, greatly
afflicted, he could stand no longer."*

(FOL. 42A)

The principal scene shows the valiant Godfrey of Bouillon fighting a huge bear reared up on its hind legs. Although the bear has wounded him, he succeeds in plunging his sword into the animal's body. The duke's horse has fallen to the ground. Some way off, the man attacked by the bear and whom Godfrey has saved looks on. This is a magnificent composition in which forest and clearing alternate, with a maritime landscape in the distance serving as the setting for the adventure. In the lower register, the man saved by the duke is alerting the crusaders in their camp to what has happened. The final miniature is divided by a column into an outer room, where pilgrims are praying for the life of their lords, and an inner chamber, where the wounded Godfrey is seen lying in bed; Raymond of Toulouse, who was gravely ill, can be seen on another bed in the background. At the head of the chapter (fol. 41), the initial capital is adorned with the portrait of a man who may be Godfrey.

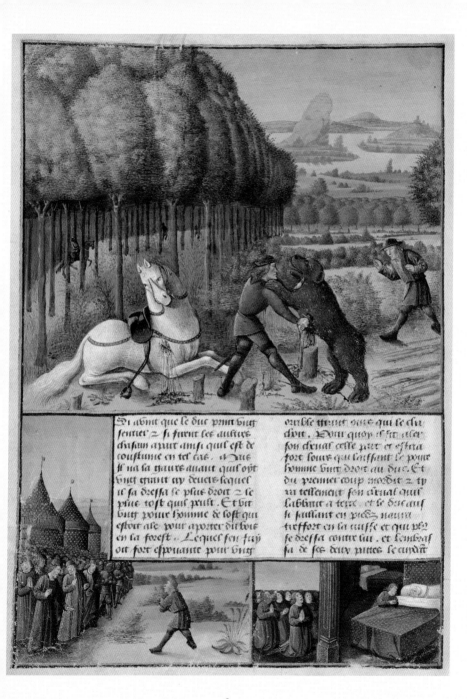

Si aduint que le duc print bñ
sentier z si furent les aultres
disant ayant ainsi quil est de
coustume en tel cas . a dire
Il na sa nature auant quil oyt
bñf criant ay ducis sequel
il sa dressa le plus droit z le
plus tost quil peut . Et dit
bñf poure homme de lost qui
estoit ale pour apoter du bois
en la forest . Lequel son fup
ot fort espouante pour bñf

oualse trent sage qui se chir
doit . Pour quop il sit aler
son cheual celle part et estria
fore sours qui laissant le poure
homme bint droit au duc. Et
du premier coup moidit z ty
ra tellement son cheual quil
sablitit a terre . et se duc auf
se saillant en piecs naura
treffort en sa cuisse et qui peñ
se dressa contre lui . et lembras
sa de ses deux pittes se cuidit

sick, all those in the camp bewailed their lot and grieved beyond measure and finally turned once more to Our Lord and besought him so earnestly to save their two chief leaders and defenders that he cured them in a very little time. They gave thanks to him most humbly and, following their counsel, raised camp and took the road again. When they had passed through all of Pisidia, they arrived in Lycaonia, in a city called Iconium,[65] which they found empty of people and victuals, for the Turks had withdrawn into the mountains and the strongholds, and had left it thus bare that they might oblige our men to pass through more quickly and not to stop there, for they would find no food.

And they had perforce to do this and pass through in haste, for they had great need of food. Thence they passed through another city called Heraclea[66] and then went on to another called Caesarea Mazacha, where they stayed for three days. There the wife of Baldwin, the brother of Godfrey, whom he had left in the care of his two brothers, died and was buried with all honour. She was deeply mourned, for she was an excellent woman, and wise, and descended from a great English family. In the meantime, Tancred entered the land of Cilicia, which borders on Syria on the eastern side, and another land called Isauria, with the great mountain of Taurus to the north and the sea to the south. He led his men before the city of Tarsus, which is an archiepiscopal see and which was founded, according to some, by Tarsis, the son of Janus, the son of Japheth, the third son of Noah, although Solon says that it was Perseus who founded it. One can reconcile these two accounts by saying that Tarsis founded it and that Perseus enlarged it. It was in this city that was born monsignor Saint Paul the apostle.

When the citizens of Tarsus saw that they were besieged, observing the strength of Tancred and listening to his fine words, they agreed to place his banner on the highest tower and promised to surrender to Bohemond when the great army passed that way. And Tancred promised that he would defend them and safeguard them against all and that they would lose nothing. But he could do no such thing for, shortly thereafter, Baldwin and his army came up and, seeing the tents, took them for Turks. Tancred and his men also came out straightway because they believed in like manner that these were Turks who had gathered to raise the siege. But they recognised each other and made great show of friendship. But this friendship was but short-lived when, on the following morning, Baldwin and his men, who had been well lodged and tended by Tancred, beheld his banner on the high tower. This aroused extraordinary emotion amongst them, for, said they, there was no reason that Tancred's men should enjoy such honour in preference to men who were greater in number and more powerful than they. The matter rose to such heights that a mortal hatred then arose between

Baldwin and Tancred, who had ever before been as two brothers. And they thought to call their men to arms and launch them into combat after a number of wicked words that Baldwin had said to Tancred. To avoid a war that would risk distracting them from the great journey, Tancred in the end let Baldwin do as he would, and he laid siege to the city. And the citizens had perforce to surrender the city to him when they saw that Tancred could not defend them.

And receiving Baldwin into the city by his order, they threw Tancred's banner down from the top of the tower. He, concealing his wrath, was meanwhile departed, and arrived two days later before the city of Mamistra,[67] which was the richest city of that land, the most strongly girt about with walls and towers and the best defended by the Turks. But Tancred took it by assault after attacking it for three days continuously. That is why he caused all the Turks to be killed and the food and wealth to be shared out amongst his men, who were in great need. And each one of them had so much of these things that they were all rich. As matters went thus forward, it happened that the news of the capture of Tarsus by Tancred caused three hundred men on foot from the great army of Bohemond to follow him, for they thought that he was still there. But when they came up to the gates, Baldwin, who knew that they were seeking Tancred, refused to let them come into the city, thus at night, when they were resting, tired, outside the city, the Turks who were in the castle and the towers that they had not yet surrendered, made a sortie with their wives, children and all their goods, and took flight. But, wishing to leave a cruel memory of their departure, they killed almost all the pilgrims on foot whom they found asleep outside the gates. On the following day, this event aroused such murmurings and so great an agitation amongst Baldwin's men that the pilgrims on foot rose up against the nobles and the knights, because, in spite of their entreaties, they had refused to open the gate to the pilgrims on foot from Bohemond's army. They would have cut all their throats had they not taken refuge in the towers, for there were many more of them. However, after they became somewhat calmer, the knights begged them to accept the public apology of Baldwin and with this they were satisfied. He swore and declared in their presence that he had only refused them entry because he had given his word to those in the city that he would let none other than his own men enter before the arrival of the great army, and the other barons also spoke most mildly of this agreement to the men on foot. Some days later, leaving one part of his men to guard the city, he took the other part, along with a seafaring corsair called Guynemer, a native of Boulogne-sur-Mer (who, repenting of his misdeeds, had gathered together a great number of his stout ships and

had arrived by sea but a short time ago near Tarsus, where Baldwin had recognised him), and set off once more in search of adventures, which he found much nearer at hand than he had thought. For he arrived before Mamistra,[68] where he did not demand entry, knowing the outrage that he had done to Tancred. But he made camp in the gardens while waiting to continue on his way.

It was then that Tancred, who had not forgotten the outrage that he had done him at Tarsus, launched his archers against Baldwin's men and killed a number of them, because they had not distrusted them. Thus began the battle, which lasted but a short time, for Baldwin's men were far greater in number than Tancred's. The latter thought to make the best of the situation by withdrawing his men into the city, but in this he did not succeed, for they had to pass back over a bridge, beneath which ran a great river where many were drowned. Besides, the others pursued them so closely that a great number were killed before they had reached safety. When Tancred's men were returned into the city and realised the great loss that they had suffered, they wished once more to sally forth to have their revenge, but they were prevented from doing so by the coming of night. However, on the following day, both sides exchanged emissaries to recover their prisoners, for, on Tancred's side, Richard of the Principate and Robert of Ansa, who had led the sortie, had been taken and on Baldwin's side, a great lord called Gilbert of Montcler.

In the end, thanks to the efforts of wise barons and knights, all the prisoners were returned. And, with Our Lord's help, Baldwin and Tancred were reconciled and once again became friends and brothers as before, so that Baldwin, through true affection, when he went to see his brother Godfrey after learning that he had been grievously wounded, left Guynemer and his ships with Tancred, who then led his army into Cilicia, where he conquered all the castles and killed all the Turks who held them, for the natives, who were Armenian Christians, had no strongholds. And for that reason, there was such dread of him that the Turks who lived in the mountains, when they heard tell and saw that he had conquered all the plain, fearing that he might wish to seize them by force, sent to him to appease him great gifts of gold and silver, precious stones, lengths of cloth of gold and silk, and other rich presents besides. Thus, he gained profit and honour for himself and for the pilgrims wherever he went. Baldwin, in like manner, had been to the great army and, in accordance with the counsel of his brother Godfrey, whom he had found in good health, had acknowledged, that he might appease him, before Bohemond and all the nobles, the act of folly that he had committed against Tancred. Thus, peace was made between them.

He returned to Tarsus with a new army, which he had gathered together with great difficulty because of the outrage he had done to the pilgrims on foot, of which many of them were mindful. He set out on campaign at the urging of a valiant Armenian knight called Bagrat, who had escaped from the prisons of the emperor Alexius and had joined Baldwin at the siege of Nicaea. And he went towards the land that surrounds the great city of Edessa,[69] which had always been truly Christian from the time of the preaching of Saint Simon and Saint Jude. The good Abgar was once its king; he reigned in the time when Our Lord Jesus Christ preached in Judea, and his worth was such that he had a letter in Our Lord's own hand, according to common belief.

And there, after Baldwin had gained all this land against the Turks, the city was given to him by the citizens, for they killed the duke,[70] who was Greek and who had caused them to suffer many hardships. This duke had but shortly before adopted Baldwin, whom he had made his heir because he had no child, even if thereafter he sought ceaselessly the means to remain sole lord and to disinherit Baldwin. When his fellow citizens understood that they risked losing Baldwin, they attacked him in his palace and finally killed him. Thus, Baldwin remained their lord, of that city, county and all the lordship, too, which was most extensive and rich. Thereafter he bore always the name and the title, up to the day of his accession to the throne of Jerusalem.

Chapter XVII.
How the great army of pilgrims came before Antioch and how the city was besieged. Of the situation and the might of this city.

Antioch was formerly a most noble city, occupying the third place in dignity amongst the patriarchates after the Church of Rome. In ancient times, it was called Reblata, and its lands, Hama. And it was in this city that, as it is written in the fourth Book of Kings in the twenty-fourth chapter, Zedekiah, king of Jerusalem and of Judea, was led before Nebuchadnezzar, king of Assyria and of Babylon, who, after reproaching him with his ingratitude and causing his son to be killed in his presence, had his eyes put out and had him led away in this state, bound with iron chains, into Babylon. And he made this city of Antioch into a kingdom, whose first king was one of the princes of the great Alexander, king of Macedon, whose name was Antiochus. He added to it towers and walls and other rich buildings, so that there were two hundred

ARRIVAL OF THE CRUSADERS AT ANTIOCH

"Antioch was formerly a most noble city,
occupying the third place in dignity amongst the
patriarchates after the Church of Rome."

(FOL. 44B)

On 21 October 1097, after a long march across the Anatolian wastes and the inhospitable, mountainous countryside of Cilicia, the crusaders arrived before the gates of Antioch. The splendour of the city and the great size of the fortifications catch the eye immediately, thanks to the skill with which Jean Colombe places them in the principal picture on this page. The massive walls and countless towers described by Sébastien Mamerot date from the period of Antiochus, one of the princes of the Macedonian king Alexander. The city had converted to Christianity, and the artist represents its many churches. The situation of Antioch, which Mamerot writes at length about in the text, is suggested here by mountains and the river Orontes flowing close to the city. The crusader army is shown in the foreground. Three commanders in armour are riding between the foot soldiers and the cavalry – these are perhaps Godfrey of Bouillon, the count of Toulouse and another nobleman. The picture in the lower register provides details of the everyday life of the crusaders, as they move from one place to the next and transport their supplies. The army travels across country with wagons and baggage; a team of horses, escorted by armed men, is drawing a cart laden with barrels.

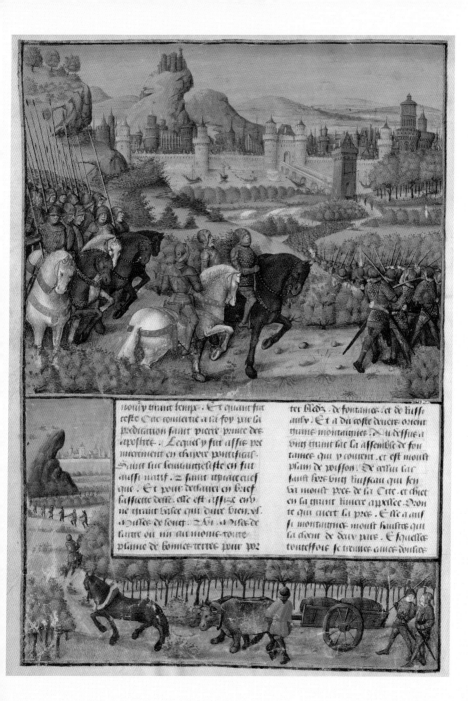

and fifty towers right along the walls, and he had it called Antioch, with all the surrounding country, in memory of his own name. After him there reigned four and eighty kings. And it was there also that was held the first council of those who believed in Jesus Christ after his resurrection, where it was laid down and decreed that they should be called "Christians", after "Christ", for they had previously been called "Nazarenes", after the city of Nazareth, where Our Lord Jesus Christ had long been raised.

And this city was converted to the faith by the preaching of Saint Peter, the prince of the apostles, who was the first to occupy the papal throne. Saint Luke the Evangelist was born there also and Saint Ignatius was its bishop. And to describe its situation briefly, it sits in a great valley that stretches a good forty miles in length and is six miles wide, at least, in the middle, filled with good cornland, springs and streams. On the east side, there are great mountains, above a great lake that is fed by the springs that flow into it and that is rich in fish. From this lake there runs out a stream that flows very close to the city, and falls into the great river called Orontes, which flows nearby.

The city is enclosed on two sides by very high mountains, where one finds nevertheless sweet water and good ploughland. The mountain that is towards the south is called Orontes, after the name of the river, for as Saint Jerome says, "Antioch sits between the river Orontes and mount Orontes". Many have believed that this mountain, which goes right down to the sea, was that Parnassus so often spoken of, but Parnassus is in Thessaly. The walls of Antioch begin in the mountain that is towards the south, and they go right down to the river. There is as well a great open space inside the walls, for they encircle two mountains crowned with a castle and a keep so strong that men say they are impregnable, except through famine. And between these two mountains, whose sides are very steep, there is a narrow valley where flows a most rapid and noisy torrent. This renders good service to the dwellers in the city, where are also to be found a number of beautiful and good springs. A river flows from the side of the rising sun, so near that the bridge by which one passes over, to enter into the city on that side, touches the walls. It goes on to flow into the sea seven miles away.

This city so noble, so rich and so strong that it was a good two or three miles long, had as lord a powerful Turk called Yaghi-Siyan, one of the princes of the army of another powerful Turk named Malik Shah, the great sultan of Persia, who had conquered this city of Antioch, that of Nicaea and all the other towns, castles and cities of these marches and almost all of Syria fourteen years before.[71] On his return to Persia, he had given the city of Nicaea to Suleiman, his nephew, and Damascus to Duqaq, his other nephew, desiring that each of them should bear the name of sultan. And

to enable them to maintain their state, he gave them the greatest lands and the greatest countries, that they might ensure their renown and their power. And the flourishing city of Aleppo and this city of Antioch he gave to two princes and knights who were close to him: Aleppo to one named Aq Sunqur al-Hajib, who was the father of Zengi and the forefather of Nur ed-Din, of whom you will hear tell hereafter, and Antioch to this Yaghi-Siyan.

When he was informed of the taking of Nicaea and of the defeats of Suleiman, and when he knew that these powerful pilgrims wished to pass through his lands, thinking to prevent them, he had sent letters and messengers to all the princes who professed the law of Mohammed as he did, and he had admonished, begged and required them to unite their efforts with his own to resist these most powerful men who had left their own lands that they might raise high the Christian faith and destroy that of Mohammed.

And he had succeeded so well, through his letters and his messages and also by his words, that he had led a very great number of pagans, Turks and other Saracens, both through religious fervour and as mercenaries, to Antioch, where he had strengthened by the greatest means possible the defences of all the entrances and narrow passages through which the pilgrims had perforce to pass to get there. Yet in spite of this, he had so greatly alarmed and terrified all those of his sect that the great sultan of Persia, who was the most powerful in the East and the sovereign of them all, had promised him that he would send in all haste to his aid one of his chief princes, called Kerbogha,[72] and men without number bearing arms. And this he did, as we shall tell it hereafter. But although the rumour of this spread straightway, our men, that is to say Duke Godfrey, the count of Toulouse, Hugh the Younger, Behemond and the other princes and barons of the great army, did not renounce their intent to take the road to accomplish their holy pilgrimage.

After they were well rested and Duke Godfrey and the count of Toulouse had completely recovered their health, they led their army by the best and most direct road towards Antioch, but they sent Count Robert of Flanders, Robert of Rosoy and Joscelin, son of Cunes of Montaigu, and a number of other nobles and men on horseback and on foot before a strong and rich city that was held by the Turks, called Artah,[73] situated fifteen miles from Antioch. Its inhabitants, who were Christians, seeing that the Turks, who had done them such great wrongs and who held them in most shameful subjection, were fleeing to find refuge in the strongholds and towers of the city for fear of the Christians, rose up in arms and ran after them so suddenly that they killed them all before they could retire into the strongholds. And having done this, they threw

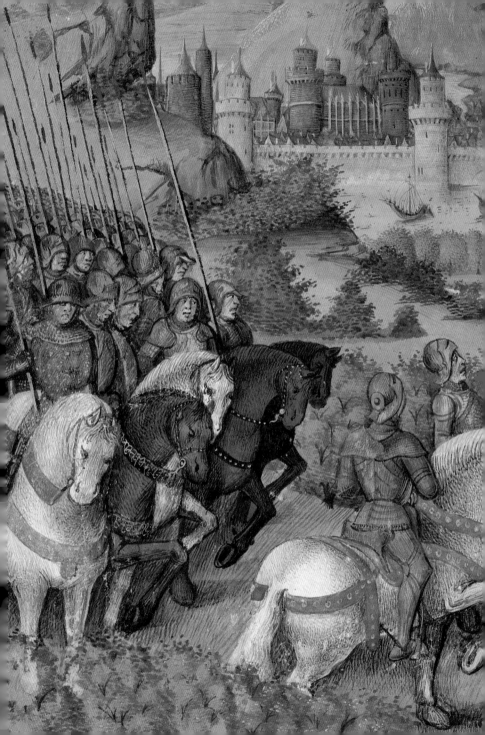

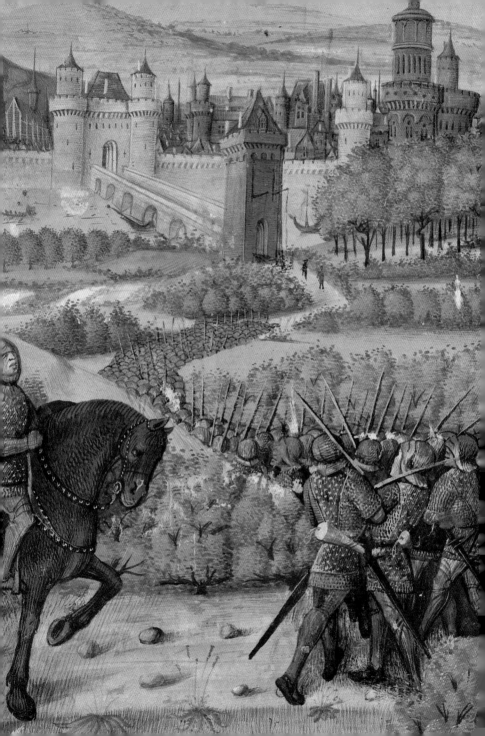

their heads over the walls to our men, for it was through their confidence in them that they had done this thing, and they opened the gates to them and received them with great joy into their city, where they found great riches and great abundance of food.

When this capture was known in Antioch, the Turks chose five thousand armed men and sent them to see if they could recover the city. One party lay in ambush near Artah, and the others went running ahead as if to pillage, and they lured certain of our men outside and succeeded in encircling them between themselves and the men in ambush. When those who were still in the city realised this, they made all haste to go out and all were drawn up together in combat formation. Thus, in spite of all the Turks, our men were able to return into their city without any loss, although the Turks laid siege to them and attacked them. These lost many of their men there without gaining anything. Shortly thereafter, when they heard the news of the arrival of the great army that was on its way, they raised the siege and returned to Antioch, on the very same day that they had departed thence. Thus departed this life Joscelin of Montaigu, who was honourably buried in this city. Shortly thereafter, those of the great army sent one thousand five hundred men on horseback there to raise the siege and, if it was already raised, to fortify the city with strong defences and armed defenders.

And soon the princes, who were all gathered together, except Baldwin, who was at Edessa, sent Robert, duke of Normandy, Evrard of Le Puiset, Roger of Barneville and a number of other barons, with a great army, that they might take, near Antioch, a bridge over the river Iron or, called by some, Caesar.[74] They found that people from the city had strongly fortified two large towers that were at the entrance to the bridge in front of the pilgrims, and that they had sent seven thousand men on horseback to defend the banks of the river before Antioch. They, therefore, launched themselves against the towers, which were soon taken, for those who were defending them both inside and outside took flight when they learned that the great army was approaching. And a number of the pilgrims, desirous of accomplishing feats of arms and who had no room to pass because of the narrowness of the bridge, searched along the banks of the river until they found a place to cross, there where the inhabitants of the country had never perceived one. They passed over so quickly that they drove off the seven thousand men who were on the bank on the other side and it was there that the whole army crossed over, with their carts and their possessions, and made camp six miles from Antioch.

On the following day, they went forward between the mountains and this river and camped a mile from the city. And once they were close enough to observe it at their ease, the princes, prelates, barons and knights gathered together in council, for

some counselled delaying the siege until the spring, both because of the coming of winter, which would make sleeping in the open most difficult, and also because many members of the great army, scattered through divers lands, had not yet returned and could not be easily assembled again before the summer. They maintained that the emperor Alexius would surely send them a great army and that reinforcements should also come to them from beyond the sea, which would be necessary to lay siege to a city so great, strong and well fortified. In the meantime, men and horses could stay and rest in the country round about, which would allow them to be fresher and fiercer when this should be needful. But the others maintained that it would be better to begin the siege straightway, explaining that, if they delayed, the other side could fortify the city while they were resting and could bring in greater supplies of men, arms, victuals and other goods than they now had, and finally, that those of our men who should be coming would be the more diligent if they knew that the city was under siege. This last opinion carried the day, so that the princes and barons divided their men into several sieges around the city, as seemed best to them, on the seventeeth day of the month of October in the year 1097.

But although our people numbered three hundred thousand men bearing arms, without counting the women, the children and the other unarmed people, they could not encircle the whole city for, apart from the mountains, where it is not possible to lay a siege, there was a great part of the wall, from the foot of the mound to as far as the river, which was situated on the plain, but where there were no besiegers. The arrival of our men caused a terrible uproar, as much because of the noise of the trumpets and the other instruments as of the great number of carts and the neighing of horses. But the people of Antioch remained peaceful and silent as if the city were empty, whereas it was filled with an immense multitude of people and of other armed men. There were five gates in that city: that facing east was called Saint Paul's Gate, because it was opposite the mound in front of the church of Saint Paul; the other, which faced west, was called Saint George's Gate because it was in front of the church of Saint George. The greater part of the city is situated between these two gates. On the north side there were three gates, which all gave onto the river: the upper gate was called the Dog's Gate and in front of it there was a long bridge that straddled a marsh skirting the city wall on that side. The second of these three gates has since been called the Duke's Gate, because it was before this gate that Duke Godfrey laid siege; the river flowed a mile away from these two gates. And the third was called the Bridge Gate, because it was there that was found the bridge on which one crosses the river. For between the Duke's Gate, which

was the middle of the three bridges, and the Bridge Gate, which was the last one on this side, the river comes so close to the city that it flowed beside the walls. But it so happened that our men could not lay siege to this gate, nor to that of Saint George, because they could not get there without crossing the river.

Bohemond laid siege to the upper gate with those of his company. After him, going down the length of the valley, there took up positions Robert, duke of Normandy; Robert, count of Flanders; Stephen, count of Blois; and Hugh the Younger, who together all laid siege to the city from Bohemond's camp as far as the Dog's Gate, for the French, Normans and Bretons were with them. In front of the Dog's Gate were placed the count of Toulouse and the bishop of Le Puy with all their men, who were great in number, for there were men from Burgundy, Provence and Gascony. They held all the space as far as the other gate, before which were placed Duke Godfrey; Eustace, his brother; Baldwin, count of Hainault; Rainald, count of Toul; Cunes of Montaigu; and, in their company, other barons and a great number of divers men, for along that line were men from Lorraine and from Hainault, with Saxons, Bavarians and Franconians, in such great numbers that they all but occupied the whole space as far as the Bridge Gate, and they commanded the river that flowed there. In these parts outside the city, there were great numbers of apple, fig and other fruit trees, all of which our men cut down to take up their positions.

It was astonishing to see the great preparations that each one made for himself, according to his power, both in the matter of tents, encampments and fortifications as well as in seeking a way to get close to the walls and to attack the city. All the inhabitants were so terrified that a number of them, considering that a people so powerful and so set upon their destruction would never be turned aside from their aim unless they suffered great losses, wished to have been long dead that they might not behold their own loss, that of their wives and of their children, and that of their city to boot, which they feared would soon be upon them.

Chapter XVIII.
How our men quickly made a great bridge of ships over the river and lake. Of the wooden castle made by the count of Toulouse. How it was burned. Of divers sorties made by those in the city, and how, on divers occasions, they robbed and killed certain pilgrims who were pillaging. Of the great cost of food and the great mortality in the army from the very beginning and how Bohemond and the count of Flanders set off to pillage.

Siege having thus been laid to Antioch, the pilgrims had from the very first great need of pasture and other things in their encampments for their horses. Men and horses had thus perforce to swim across the river to range over all the country, which they did for a long time without the Turks seeming troubled thereby. But finally these caused a number of their men to cross over, almost every day, by the bridge, some secretly and some in full daylight, and these went all over the country and killed many pilgrims when they found them scattered. And they ran no risk, for our men could not return to the siege but by the river, and could not receive help from the great army. For this reason, the princes sent out to search for a number of boats, which they found on the lake and on the river, both upstream and downstream, and they joined them together and covered them with hurdles and other things, so that three or four men abreast could cross over in safety, which did them much good, for they would cross to and fro by this means, both to go out to pillage and to go down to the sea, where they had perforce to go each day to fetch those things that were needful.

This bridge of boats was near the camp of Duke Godfrey, up against the gate that he was guarding, whence was distant a good mile the other bridge of stone. And they inflicted great harm on Duke Godfrey's men through this gate, and on the count of Toulouse's men through the other gate, called the Dog's Gate, for there was there another stone bridge to cross over the marsh, across which the Turks often passed and made very great sorties, both day and night, against the count of Toulouse's men. They shot their arrows in serried ranks into the encampments, killing and wounding many, and then returned at their ease across the bridge into the town, for our men could not follow them save by crossing the bridge. And on this occasion, the count, the bishop of Le Puy and the chief leaders of their siege brought up great hammers and crowbars,

BURNING OF THE WOODEN FORTRESS BEFORE THE BRIDGE GATE.
ARMED CONFLICT ON THE BRIDGE OF BOATS (1097)

"It was astonishing to see the great preparations that each one
made for himself, according to his power, both in the matter of tents,
encampments and fortifications as well as in seeking a way to get close
to the walls and to attack the city."

(FOL. 47A–47B)

Miniatures showing the siege and conquest of Antioch appear in several chapters. Here Jean Colombe, in his depiction of certain episodes, is faithful to Sébastien Mamerot's narrative: the lower register shows the temporary bridge of boats, which allowed the crusaders to sally forth and gather fresh supplies on the opposite bank of the river. The principal scene shows the wooden castle vis-à-vis the Bridge Gate, a kind of fortress, known as La Mahomerie, which had been built on the orders of count Raymond of Toulouse. When the crusaders took flight following the first sortie of the Turkish garrison of Antioch, the latter took advantage of this and set fire to the wooden castle. Familiar elements of Colombe's art can be found here: the depiction of troop movements and the way in which the crusaders flee to their camp. In the background stands the city of Antioch, with its inhabitants coming out to attack the crusaders.

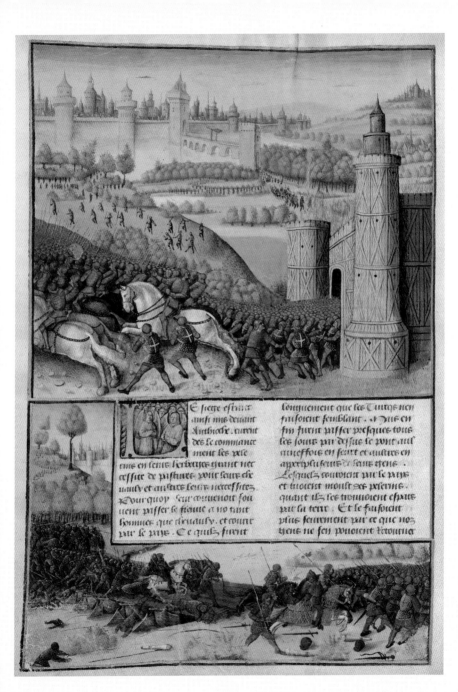

E siege estant
ainsi mis deuant
Anthioche. eurent
des le comme
ment ses prie
ens en sens heroiques quant net
cessite de pistures pour seure che
uauls et austres seurs necessites.
Pourquoy seur conuenoit sou
uent passer se fioute a no tant
hommes que cheuauls. et count
par le prise. Ce quils furent

sonquement que les Turds nen
faisoient semblant. A Dus en
fin furent passer presques tous
les sours par dessus se pont auf
nutessois en seurt et auistres en
aperpsu seuis de saute etene.
Lesquels conuoient par le prise
et troient moult ses priseme.
quant ils ses trouuoient espars
par sa terr. Et se faisoient
plus seurement par ce que noz
tens ne sen pouoient retourner

203

thinking to break down the entrance to the bridge in front of them. But the stones were so great and so well laid, and those in the town shot so many arrows down at them from the city walls and towers, that they could not finish the task. And after a number of their people had been killed or wounded, they were constrained to abandon their labours. Seeing this, the princes had built before the entrance of the gate a strong wooden castle, in which the count of Toulouse placed his men. And thence they hurled stones from catapults all along the bridge, so that none dared cross there any more.

One day, those in the town succeeded in driving the army of the count away from the wooden castle, and they came out from their gates in such great number that those in the wooden castle, observing their great power, came down and took flight with all haste into the middle of their encampments, and left their castle undefended. Those from the town burned it completely and went back thence into the city manifesting great jubilation. When they saw their castle burned, our men straightway assembled three catapults and hurled stones all along the bridge and against the gate. But because they had realised that the Turks would let none pass save when they were hurling stones, they caused great rocks to be brought up, so huge and so heavy that a good hundred men were needed to carry one. And they dressed the rocks and fitted them together and closed the gate of the bridge with them, in spite of all the citizens, who could not prevent this because the great army of the count had come out from its camp to guard the masons and the workmen. The gate was thus covered up, so that hence-forward that entry always left our men in safety and in peace. It happened besides that three hundred pilgrims, who were in the habit of watching others crossing the bridge of boats and then going out pillaging, went over one day and ranged hither and thither, scattered, fearing nothing. Those from the town came out in great number across the bridge over the river and pursued them across the fields. Our men then thought to take refuge in the middle of their great army by crossing the bridge of boats, as they had been accustomed to do hitherto, but they could not do this because another party of Turks came there before them. And thus, they were enclosed. To rescue them, a number of men from the great army crossed over and found the Turks, who had already killed and vanquished our men. They pursued them, killing them as they went, as far as the bridge of stone, over which others from the city came out in force, so that they once more drove off our men as far as the bridge of boats. There, because the passage was so narrow, were killed and drowned a number of pilgrims on foot and some on horseback, whom the great army was unable to rescue.

The Christians thus found themselves more besieged than were those in Antioch.

And what is more, there was a great number of Turks in the woods and in the passages, whence they often came out to range over the country. And when they found certain of our men who had gone out marauding far from the camps, they killed them if they were few in number. They followed them so closely that they scarcely dared go out pillaging any longer, nor make any sorties out of the camp, where they were not secure, for the rumour ran that all the Turks from the marches round about were assembling to attack them one day in such great numbers that one might not count them. In the third month, too, the food began to be costly beyond all measure: in the beginning they had gathered together so great a quantity, both for the men and for the animals, that they had wasted the greater part of it foolishly and without reason. Three or four hundred of them had perforce to join together under oath to scour the country; they would make a sortie and often bring back what would supply the army for a few days, for they went far away and thus found towns that were rich and well stocked. But when the Turks from the city and those from the country around saw this, they laid such great ambushes for them and killed so many of them, either going out or returning, that often not one person came back to tell the tale. From this fact, the high prices in the army were such that a cow cost four silver marks that in the beginning had cost five sous, and a lamb or a kid cost six sous that in the beginning had cost three or four deniers. And fodder for a horse cost eight sous for the night. And for this reason, there died so great a number of horses, of hunger and of cold, that of the seventy thousand that men reckoned were with the army in the beginning there remained not twelve thousand, who were so thin and so tired that one could scarcely hope they could be of use. Besides, it rained so hard and so often that the tents and the pavilions could not keep out the water. Thus, those who were beneath the greater part of them were so wet that their shirts rotted on their backs, because they had no place where they might dry them.

The deaths through cold and hunger were so many that there arose a great and mortal epidemic in the army and at the siege, to such a degree that it was hard to find a place to bury the dead. Some who were still in good health and who feared the epidemic went away to Count Baldwin at Edessa and into the other cities of Cilicia that were held by our men, so that there remained at the siege not the half of those who were there in the beginning.

The princes, seeing these troubles in the army, decided in general council that the count of Toulouse and Hugh the Younger should watch over the army, for Duke Godfrey was gravely ill, and that Bohemond and the count of Flanders should take a large number of men and range in great force far away deep inside the lands of the pagans

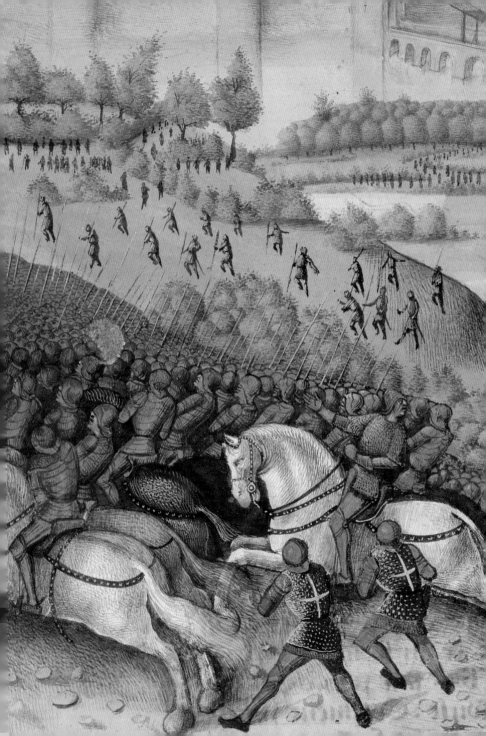

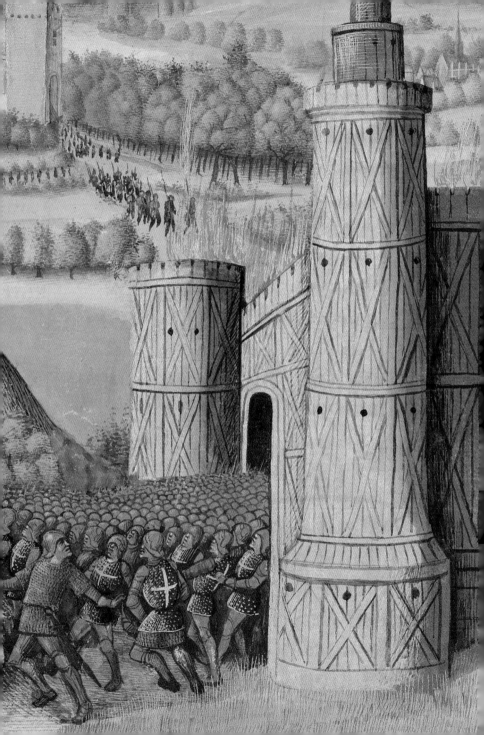

and the Turks, that they might bring back food and whatever else they should find, and this they did. But while they remained afar, the Turks of Antioch, who knew of their absence and, therefore, reckoned the less of the others, attempted a number of great sorties against the army. And most particularly they made one such on a day when they were gathered together in very great number: they opened the Bridge Gate and rushed out suddenly, spurring on their horses and crossing both through the river and over the bridge towards the camp of our men. Those who had been watching them and who were all forewarned of these attacks came out themselves and went to meet them so boldly that they began by killing two Turks who were amongst the most powerful in the city, who had advanced ahead of the others. The others from the city, seeing this, took flight to return into the city. But while they were fleeing, utterly vanquished, certain of our men, who belonged to the common folk and who had followed them thinking to gain booty, saw returning one part of the pilgrims who had driven them back and thought that they had been beaten. And they began to flee in great disorder. The Turks, seeing this, turned back and crossed over the bridge in all haste, and fell upon our men who were fleeing and killed a good twenty men on horseback and yet more of those on foot. Thus, they returned once more, filled with pride, into their city.

In the meantime, the count of Flanders and Bohemond, who had advanced most deeply into the marches of Cilicia and had brought back thence a great quantity of booty, were warned by their spies (and most particularly Bohemond, who always had a number of them in divers places) that a great number of Turks were lying in ambush for them. The count of Flanders wished, then, to take the vanguard, that he might lure them out of their ambush, and Bohemond came after. But he did not know straightway that the count of Flanders and the Flemish had been beaten and were being pursued, and that they had lost many men and a great quantity of goods, which had been carried away by the Turks, who were superior in number. Nevertheless, they soon knew, by another spy of Bohemond and the count, that a number of other Turks were lying in wait for them in another ambush. The count of Flanders wished most particularly to ride against them, but taking more men than he had done during the previous skirmish. And Bohemond followed him. Once the battle began, the Turks were driven into a valley and pressed so tightly that they could not use their arrows and lead their attacks as they were accustomed to do, so that, in the end, they were vanquished.

And our men followed them and pursued them so hard that they killed many of them, and won there a great quantity of armour and robes, and many rich horses and mules, which they led away into the army with their other prizes. And God knows that

they were received there with great joy! But this was soon abated, because they heard, and it was confirmed to them shortly thereafter, that Svend, son of the king of Denmark, and a fine army that his father had gathered together to follow and to help the pilgrims, had been taken by surprise after the city of Nicaea and all, except for two or three, had been killed by the Turks who had spied them and pursued them suddenly between two cities, one called Philomelium[75] and the other Terma. For although they were in the marches of their enemies, they had not kept watch as they ought to have done. And great pity was it, for the young prince was very valiant, as likewise were all of his men, who sold their lives dearly when they saw themselves enclosed in the midst of their enemies.

Chapter XIX.
How the disloyal Greek Taticius secretly fled from the siege of Antioch and a number of great princes and barons followed his example. Of the second famine and the mortality suffered by the army. And how Bohemond terrified the spies by causing men to be roasted and feigning that he wished to eat them.

Taticius, that inhuman Greek whom, as I have said, the emperor Alexius had sent with our men as his accomplice in malice and spite that he might commit all the harmful acts that he could, was turning over in his heart both the great toils and difficulties in which were the pilgrims at the siege of Antioch and also that he had exercised his spite wherever he had the power, as much in counselling them badly as in revealing all that he had been able to find out that would harm them: he dreaded and feared, for he was the most cowardly of men, that the people of Antioch might come out some day or some night suddenly and in force against our men and slaughter them all and him with them. And for this reason, he counselled each day now one, now the other of the princes and barons, in the guise of warning them, to raise the siege and to withdraw until the spring into the cities and the towns of this region that took their side, saying that during this time they could rest and refresh themselves, and that they would escape the mortality and the bad air: he was sure that as soon as the grass had grown again, the emperor Alexius, who was gathering together a very marvellous and a very great army, would order it to set out to come to their aid.[76] Thus, they would be able to lay siege afresh around all the city of Antioch, which could scarce withstand so formidable a power as that which they would then muster.

HARLOTS BEING DRIVEN OUT OF THE CRUSADERS' CAMP.
BOHEMOND I CUTTING THE PRISONERS' THROATS AND BURNING THEM

"The venerable bishop of Le Puy and the other prelates and holy priests
besought the princes and barons to organise fasting and prayers for three days
continuously, that Our Lord might come to the aid of his people, against
whom he was perchance angered. So it was done, amidst tears and weeping,
and the princes ordered that all the harlots be driven from the army and that any
found in the act of fornication should have his head cut off. Drinking bouts
in the taverns, gaming and loose oaths were also forbidden and chastised
with corporeal punishments, which were inflicted upon those who did not respect
the new orders, while the others were given warning of what they risked."

(FOL. 51A)

In the course of a harsh winter, famine and pestilence broke out in the camp of the crusaders. Believing that this calamitous situation was the result of God's wrath against the conduct of the Christians, the princes, prelates and monks commanded that all should fast and pray and forbade all immoral conduct – drunkenness, gambling and relations with women of easy virtue. On the recommendation of the bishop, Adhemar of Monteil, the princes ordered all harlots to be driven out of the camp. The men are shown kneeling in prayer. The town of Antioch rises in the background, its fortifications towering above the sea. In the lower register, Bohemond can be seen standing before his tent, overseeing the torture of the Turkish prisoners suspected of spying. Some have their throats slit by the butchers and are hung up and disembowelled like animals, whereas others are roasted on spits. This scene is particularly brutal and realistically depicted.

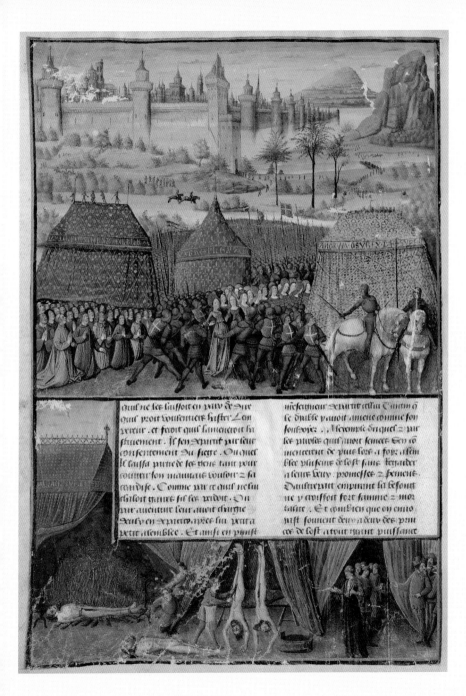

qui ne les laissoit en paix de Sire qui pentt souscennier hister. Con recrut . et fait qu'il sauneroit sa finement . Il sen departit par leur conscentement du siege . Du quel Il laissa partie de ses biens tant pour courbir son mautiais coustoir 2 sa coutdise . Comme par ce qu'il ne sui estoit venuz si les prodoit . On puir auentuer leur auoit cheune Deny en departir apres sur petit a petit àssemblee . Et ainsi en prient

ne seigneur departit celui tantin q se diable auoit amene comme son souscroye . . Accomple du quel 2 par les pruvies qu'il auoit semees Sen co mienceront de puis soes a fois assem blee pluseurs de lost sans lenganter a leur sceu . promesses 2 semens . Daustrepart empung sa besongne y croissoit fort samme 2 mor talite . Et combien que en enni past souvent deux a deux des prin ces de lost atout grant puissance

But this devilish schemer did not succeed in turning aside the princes and barons from their undertaking, for a number of them had already tried him enough to be acquainted with his cruelty and to know that he sought any occasion to flee. However, concealing their feelings, both that they might be free of such a disloyal traitor and also because he did not cease to say that he would willingly go to urge haste on the emperor and to cause him to come posthaste, he left the siege with their authority. And he left with them some of his men, as much to hide his evil intentions and his cowardice as because it mattered little to him to lose them, unless, indeed, it was that he had charged them to come after him, a few at a time, in secret. So it was that Our Lord undertook to get rid of this Taticius, whom the Devil had brought there as his mercenary.

Following his example, and because of the words that he had sown, a number of members of the army began then to take flight in secret, heedless of their vows, promises and oaths. And besides, what made matters worse, the famine and mortality grew without cease. And although the princes of the army were often sent out, two by two, into the lands of their enemies with a considerable and well-armed company, and although they killed many of them as they found them, yet they brought back no food, or very little, for the Turks had carried it all back into the mountains and strongholds. The venerable bishop of Le Puy and the other prelates and holy priests besought the princes and barons to organise fasting and prayers for three days continuously, that Our Lord might come to the aid of his people, against whom he was perchance angered. So it was done, amidst tears and weeping, and the princes ordered that all the harlots be driven from the army and that any found in the act of fornication should have his head cut off. Drinking bouts in the taverns, gaming and loose oaths were also forbidden and chastised with corporeal punishments, which were inflicted upon those who did not respect the new orders, while the others were given warning of what they risked.

And Our Lord vouchsafed his mercy on his people who were conducting the siege, for Duke Godfrey, who was, one might say, the guarantor and the standard of the army and who had been grievously sick after he had been wounded by the bear, recovered his health at a stroke: the pilgrims believed that this was the result of a miracle wrought by Our Lord and they all took strength and courage once more.

Shortly thereafter, the princes and barons gathered together in council, because they could scarcely do or say anything without it being known in all the lands of the Turks, both near and far, because of the spies that they sent into the army wearing

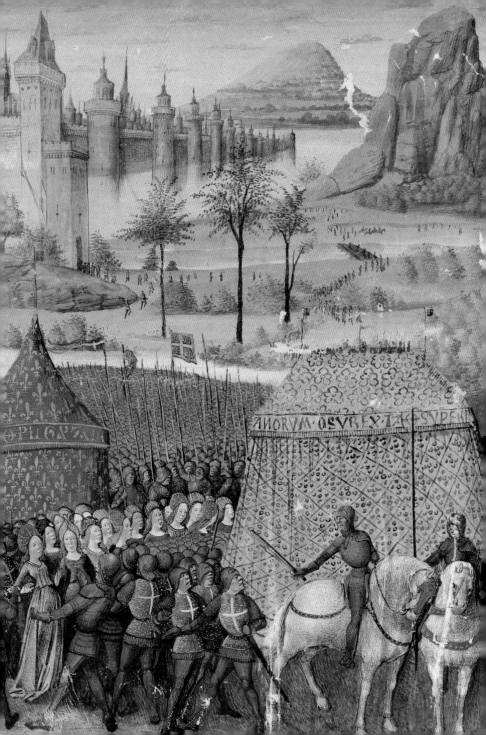

Greek, Syrian or Armenian dress, many of whom knew these tongues, for members of these countries came often to the siege. Bohemond begged the council to let him make an end of this matter, and when he had come into his tent on that evening, he caused his butchers to come to him and had delivered to them some Turks, for he held a number of them prisoner, and ordered that their throats be cut and then that they be prepared and roasted on spits as if they were to be eaten. And when certain of his men, amazed at this novelty, asked him what he intended to do with them, he answered them that the princes and barons had sworn an oath to roast and eat in this fashion all the spies that they found at the siege. And these words, which ran from one to the other, reached the spies, who went into Bohemond's tent with the throng of people to see this great prodigy. Beholding them roasted, they were so horrified that they left the camp in all haste for fear of suffering the same treatment, so that, on the morrow, it was clearly seen that there was lacking a crowd of people whom the men were accustomed to see.

The princes and barons were most happy at this and they approved of Bohemond's great prudence. It was all the more profitable to them in that the spies who had fled to their lords, filled with fear and admiration of the pilgrims, told in all the lands that they passed through that the men who were laying siege to Antioch could bear greater hardships and were more enduring than rock or iron, and that they surpassed the bear and the lion in cruelty, for the animals ate people raw while those laying siege to Antioch roasted them first and then ate them. This is why the sultan and the great emirs could no longer find any who were ready to become their spies against our men. The people of Antioch themselves were all horror-struck at this, and the councils and the matters of the army remained more secret than was usual. At that time, messengers from the caliph of Egypt also came into the army.[77] They brought great presents to the princes and barons from the caliph, to thank them for the war that they had waged against Suleiman and that they were waging against Antioch, and they besought them to pursue the siege. They promised to help and succour them both with food and in fighting men, for their master and the great sultan of Persia, who was sovereign of these lands but a short while before, opposed each other on the law of Mohammed and were mortal enemies.[78] And the princes received and feasted these messengers with great honours, and made them remain a long while with them.

Chapter XX.

How the Turks of Aleppo, Shaizar, Hama and divers other cities and countries, attempting to raise the siege of Antioch, were routed. The fortress that our men had built. How the count of Blois, feigning to be sick, left the siege with at least four thousand men from his force. Of the destruction that our men suffered when they went to sea. How they were avenged, and of the stronghold maintained by the count of Toulouse.

Yaghi-Siyan and the great lords of Antioch, who knew well the hardships that our men were suffering because of hunger and other things, and saw that they did not look likely to raise the siege, in spite of all they were suffering, but were the more steadfast and the more desirous to continue, were more and more terrified. This is why Yaghi-Siyan, following their counsel, sent certain of his close chamberlains with letters to the princes and to the cities round about, beseeching and urging them on their honour to help him to save the city and to raise the siege, in a way that would cost them little and that he would explain to them. He asked them to lay in ambush one day, secretly, near Antioch, letting it be known in the city, and to launch skirmishes against our men to lure them out of their camps towards the bridge.

For then he and his people would launch themselves out of Antioch against them and would engage them in combat until those who were in ambush found occasion to launch themselves upon them and to encircle them from the rear. And thus, they would rout and kill them all most easily, for which they would be rich and honoured for ever. Urged on by his entreaties and by his assurances of victory and gain, Turks without number from the cities of Aleppo, Shaizar, Hama and other cities and lands around, gathered together and came bearing arms as far as the castle of Harenc,[79] which is fourteen miles from Antioch, thinking to make their ambush on the morrow and to surprise our men. These were warned of their intentions by Armenian and Syrian Christians, who, by giving them like warnings, had already protected them, then and thereafter, from a number of great perils.

That is why the princes, gathered together in council, secretly ordered all those who might have a mount to take it and form into order of battle as soon as night fell and to leave the siege making no noise, and they ordered the men on foot who would remain in

the camps to hold themselves armed and ready to defend them if need should be. And thus it was done. When night fell, our men went out into the fields across the bridge of boats and moved on as far as a place situated between the lake and the river Iron, which are about a mile distant the one from the other, and they rested there. Their enemies, who knew nothing of them, had also passed over by the bridge that crosses this river Iron.

But with the coming of morning, they were warned by their scouts that our men were coming to meet them. So they lined up in combat formation and sent out first two detachments, who began a dense fire of arrows, but not for long, for our men spurred their horses hard and fell upon them with such force that they broke their ranks and caused them to fall back into the body of their army. There was a fierce battle in that place, so that the Turks, whose skill in warfare had from the outset deserted them, could not long withstand the onslaught and the power of the Christians, and took flight to Harenc. Our men pursued them, killing a very great number of them, so many, indeed, that those in the castle, when they saw their disarray, set fire to it and then took flight themselves also without waiting for our men, who ran inside the castle. The Armenians, who had remained there and who had put out the fire after the Turks had departed, welcomed them with jubilation. Our men, who were returning with a great booty of Turks on horseback, occupied the whole castle, leaving behind them more than twenty-eight thousand dead and having gained more than a thousand light and heavy horses, of which they had great need. And our men numbered no more than seven thousand horsemen all told.

The inhabitants of Antioch made a fearsome sortie and attacked the encampments just at the moment when those on watch signalled them to return because the other pilgrims were returning victorious and in jubilation. So they gave up the assault and returned into their city, into which our men hurled the heads of two hundred Turks as soon as they arrived, for they had brought with them five hundred heads to terrify the inhabitants of Antioch. And they caused the other three hundred to be stuck on stakes before the city walls, and set people to guard them, that their companions might always have them before their eyes if they came out to skirmish. After this defeat, which took place on the seventh day of the month of February in the year 1098,[80] the barons, gathered together in council, had a mighty fortress built on a raised mound that stood on Bohemond's land. They garrisoned it with doughty soldiers who advanced against the Turks when they attempted sorties against our army, as was their wont. Thus, the army found itself as safe as if it had been inside the strong walls of a city, for there was a garrison on the east side, and on the south side the city walls and the marsh that lay

alongside them, while the river, flowing towards the sea, protected them from the west side and towards the north.

But few days passed after the building of this fortress before the count of Toulouse, Bohemond, Adhemar of Le Puiset and Warner, count of Gray, were chosen, with certain of their men, to conduct the messengers of the caliph as far as the sea, and to bring back thence new pilgrims, who had just arrived in the port aboard a Genoese ship. When those in Antioch saw this, they sent four thousand of their most valiant knights and men on horseback to lie in wait for our men when they returned. On the fourth day, when Bohemond and his companions were bringing back a crowd of unarmed men from the sea, with no thought of the Turks, they came suddenly out of their hiding place and surprised the pilgrims in mid passage. When they heard the shouts and the din, the count of Toulouse, who was with the vanguard, and Bohemond, who was following him, joined forces and explained as best they could to those on foot how to hold together to resist. But these were so terrified that they began without thinking to run into the hedges and the woods and the bushes to hide themselves. Seeing this, the princes, knights, other nobles and horsemen made their way back to return to their camps. More than three hundred amongst those who could not follow them soon came upon their death. When this news reached the siege, where it was even said that the count, Bohemond and those who had gone with them to the sea were all killed or taken, there arose an immense lamentation. However, Duke Godfrey concealed his profound grief and gave the order to take up arms, for he had the charge of the army, forbidding any, no matter whom, to stay out of such a fight, on pain of death.

Doing as he desired, they crossed over the bridge of boats and, gathered together there, they formed five battalions. The first was led by Robert, duke of Normandy, the second by Robert, count of Flanders, the third by Hugh the Younger, the fourth by Eustace, brother of the duke, and the duke himself led the fifth. Seeing his battalions drawn up in good order, he stood on rising ground and, calling the pilgrims around him, said to them: "My brothers and my companions, the news is abroad that the treacherous Turks, those dogs, have thus killed very many valiant and wise men, our brothers and our companions whom you had sent down to the sea to bring back those who had just arrived, and the others who had gone down to speak with them there. I see only two possibilities: either we shall die with them like good Christians, in great honour and certain to receive our recompense from Jesus Christ, whom we serve unto death; or, if Our Lord desires that we should continue to serve Him, we will have vengeance on those curs who have caused such great harm to Christendom by killing so many noble

*"On that evening, Duke Godfrey did a thing that stunned and terrified
the Turks, and that added greatly to his renown, power and valour, for there
was a great Turk on horseback who resisted as long as possible before
the bridge, that the others might pass over. Seeing this, the duke hastened towards
him and struck him with his sword across the middle of his body with
so great a stroke that he cut him clean in two, although he was clad in a good
stout hauberk, and his breast, arms and head fell to the ground while his horse
carried his legs and the rest of his body into the city across the bridge."*

(FOL. 54B–54VA)

In spite of their suffering and the famine, the Christians did not abandon the siege of Antioch. The principal picture shows their camp and the troops drawn up in battle order; at a little distance can be seen the Saracen army, also prepared for combat. Beneath the city walls, Jean Colombe depicts many heads. Dense ranks of soldiers hold up as a deterrent the heads of their enemies on the end of their spears. This might be an allusion to the incident recounted by Sébastien Mamerot, when the Turks pushed forward in such a mass as the city gates were opened that many of them fell into the water and were drowned. In the lower register, three Christian noblemen stand in the middle of a battlefield, which is strewn with enemy corpses. The Saracen army is fleeing to the mountains.

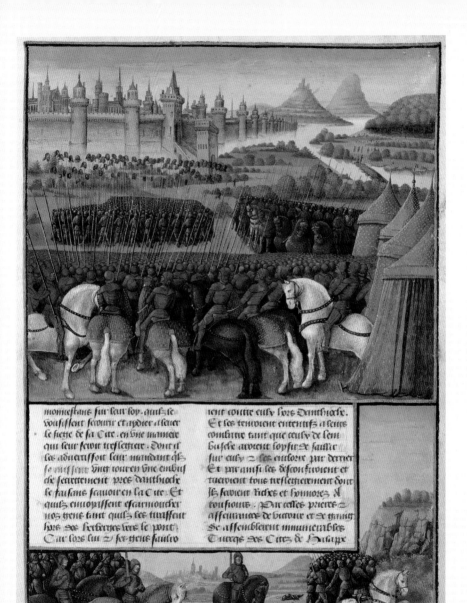

monnestans sur leur loy quilz se
voulsissent sconir et aydier asener
le sietie de sa Cite en vne maniere
qui leur seroit tresseciete. Dont il
les aduertissoit leur mandant qilz
se mussent vnet souren vne embus
che secretement prez dantlioche
le saisans scauoir en la Cite. Et
quilz enuoyassent escarmoucher
nos gens tant quilz les tiraissent
hors des serenes lors le pont
Car lors lui et ses gens saillo-

rent contre eulx lors Dantlioche.
Et les tenoient ententifz a leurs
combatre tant que ceulx de seur
bagere aroient loy sur se saillir
sur eulx et les enclorre par derrier
Et par ainsi les desconsuoient et
tueroient tous tresseciettement dont
ilz seroient riches et honnores A
tousiours. Par telles prieres
asseurances de scauoir et de tramy
Se assemblerent innumerables
Turcqs des Cites de Halappe

and valiant warriors. And as for myself, I swear to you on my soul that never shall I love life, in whatever guise, so much as I would love death, as long as they wait to be avenged. Listen, if it please you, to what I shall say to you: it seems to me that, if the Turks have carried the victory against our men as people are saying, they will be so filled with pride that they will wish to come to incense us with their arrogance, by bringing their victims and their spoils before us into their city. And you will see that they will not keep their order of combat, for when warriors have performed great feats of arms, it is bad for them. That is why my counsel, if it please you, is that we stay here in good order, ready to fulfil the service of Our Lord, for whose sake we have left our countries and our lands and are come hither. Let us have good hope in Him, for He will repay his soldiers in full. When his enemies reach us, we will receive them boldly! Let each one of you remember in his heart the wrong and the shame that they have done to Our Lord and to us all." These words pleased them so greatly that they began to ask and entreat each the other to be good and valiant and to hold themselves ready to meet their enemies.

But shortly thereafter arrived Bohemond, and then the count of Toulouse, and God knows what joy was theirs! They made scarce any noise, but they told them the counsel of Duke Godfrey, and Bohemond and the count said that it was excellent. They sent certain of their men to divers places to spy on the convoy of Turks. On the other side, Yaghi-Siyan realised from the behaviour of our men that those whom he had sent into ambush had robbed our men. Fearing that those in the great army might vanquish them before they could retreat into the city, he had the trumpets sounded and ordered out all those who could bear arms and had them drawn up before the bridge, to rescue them if need be. But this availed them little, for our men commended themselves to Our Lord when their spies knew that the other Turks were approaching as they returned with their victims, and they moved out before them and rushed upon them. They attacked them with such force and boldness and made so great a slaughter in so short a time, that the others thought to beat a retreat by urging on their horses that they might save themselves across the bridge of stone. But this they could not do, for Duke Godfrey, who from the beginning had suspected that they might try to escape that way, had led his men onto a small mound before the bridge, whence he repulsed or killed all those who thought to pass that way. And those who turned back on their tracks were killed by those in the great army.

That is why Yaghi-Siyan, seeing that his men were being massacred, ordered the gates of Antioch to be closed, that none of those whom he had ordered out might get in again if they did not gain the victory. He himself came across the bridge with his

army to make sure that the fight was joined with our men, but these met them and attacked them with such speed that they straightway turned back thinking to save their lives. They left behind them piles of dead so great that it was horrible to behold. Seeing that he could withstand no longer, Yaghi-Siyan ordered that the gates be opened to take back into the city those few of his people who still remained, for he knew, because he had tried it, that he had caused the death of a very great number of them by closing them. But when the gates were opened, there was so great a press to get in because of the force with which our men were cramming them together, that a very great number of the Turks fell into the water and were drowned.

On that evening, Duke Godfrey did a thing that stunned and terrified the Turks, and that added greatly to his renown, power and valour, for there was a great Turk on horseback who resisted as long as possible before the bridge, that the others might pass over. Seeing this, the duke hastened towards him and struck him with his sword across the middle of his body with so great a stroke that he cut him clean in two, although he was clad in a good stout hauberk, and his breast, arms and head fell to the ground while his horse carried his legs and the rest of his body into the city across the bridge. The Turks were truly terrified and felt a great dread, and not without reason. More than two thousand Turks were killed in this brigandry. And had the night not fallen so early, those in the city would have lost so great a number of people that they could scarce have defended it. It was but too evident that there had been a great massacre, for all the river ran red right to the sea. And in particular, as was told by certain Christians who escaped from the city to our men, seven great emirs were killed in this defeat.

On the morrow, the pilgrims gathered together and gave humble thanks to Our Lord for his aid. Then they held council, wherein it was decided that another fortress should be built before the Bridge Gate, in a mosque where those in the city had buried most richly the night before the greater part of those who had been killed in combat on the previous day. That is why certain of the common people, when they knew the will of the barons, ran into the mosque, and they dismembered the corpses and dragged them across the fields that they might take the rich things with which they were decked, to the great mourning and the great displeasure of those in the city. They found that those in the city had lost many of their men, for fifteen hundred of them had been buried there, without counting those who had been drowned in the river and those who had been buried inside the city. The princes ordered three hundred heads to be cut off the Turks who had been dug up and had them taken to our men who were at the seaport, with whom there were still the messengers of the caliph of Egypt. These

were joyful at the death of their enemies, but feared lest our men might not do likewise to them in the future.

When this news was known, a number of our men who had fled and hidden in the woods and in the mountains came back and rejoined those at the siege, who bravely built a fortress with stones pulled out in part from the tombs that had been there before. And since each one of the princes and barons refused to fortify it and to ensure its defence because of the great expense that would be needful thereto, the count of Toulouse offered to do so, and this he did, which the pilgrims acknowledged gratefully. He gained yet greater renown, for he put five hundred silver marks into the hands of the bishop of Le Puy and the other wise men, to help to recompense the poor men-at-arms for the horses that had been lost in the battle. They gained thereafter yet greater boldness against their enemies, and all the pilgrims called the count of Toulouse the "father who safeguards the army". He also placed five hundred knights and other most strongly armed men in his new fortress. And since this passage was defended against the people of the city, our men went out into the surrounding lands in safety, for the Turks could not go out save by the Bridge Gate to the west, which was between the foot of the mountain and the river Iron. And this way out could do but little harm to our men, for all their encampments were on the other side of the river.

Nevertheless, there was not complete famine in the city, because there was this way whereby fresh food could reach them. The princes and barons gathered together and took counsel to know how they might deprive them of this, and in the end, decided that they must build a tower there. But none wished to undertake this, although a number of them said that Tancred could do it, but this thing he refused, alleging that he had not the means to cover so great an expense. The count of Toulouse, accepting his explanation, gave him a hundred silver marks and ordered that he should have forty marks each month drawn from the men's money. So Tancred accepted this charge and had the tower built, fortified and garrisoned, keeping it unscathed to the very end.

And a few days thereafter, certain pilgrims learned that those in Antioch had sent out a great part of their riders into a very beautiful place full of pasture and grass, three or four miles distant from the city, because they had not enough pasture within the city. This is why a great number of our knights and our men on horseback[81] gathered together and went out that way, not directly but by narrow passages and secretly, so that they surprised and killed those who were guarding the horses. Our men gained there two thousand sturdy horses who might carry armed men, not counting the mules and the hinnies, of which there were more than two hundred. They led them all to the

siege, where they were met with a most joyful welcome, for it was of horses that they had the greatest need in the army, for they had lost many of their own in battle and a number of them were dying each day of hunger and sickness.

Chapter XXI.
How a citizen of Antioch wished to deliver the city to the Christians for the love of Bohemond, on condition that the princes would consent that it should belong entirely to Bohemond, and the count of Toulouse would not agree to this. Of the great terror they felt at the coming of Kerbogha. Of the counsel of Bohemond, and how Baldwin of Edessa, brother of the duke, allowed our men to take Antioch, for he safeguarded Edessa against the siege of Kerbogha.

Baldwin, brother of Duke Godfrey, did much good for all those in the army, great and small, and he often sent them great presents according to the rank of each one. And it was to the duke above all that his aid was profitable, for he gave him fifty thousand silver besants in coins and all the revenues of the dependencies of Edessa that lay on this side of the great river Euphrates and that furnished food in great abundance. And he also made himself much loved by the great Armenian lords who lived around the city of Edessa.

For his honour and for his love, one of them, who was most powerful and who was called Nicusus, sent to Duke Godfrey a ceremonial tent, the richest that ever was seen, of an astonishing size and fashioned with divers skills. But it was not presented to the duke straightway, for Bagrat, of whom I have spoken and who had caused Baldwin to come into the marches of Edessa, when he was told of this gift, mounted an ambush and took it from those who were bearing it, and he had it presented to Bohemond in his name. But shortly thereafter, the messengers of Nicusus came before him and told the duke of the outrage that had been committed against him. For this reason, the duke demanded what was rightfully his from Bohemond, who parted with the tent with very bad grace. However, when he saw that the duke had so strong a desire to have it, he was generous and courteous enough to surrender it to him. Many were greatly astonished thereat, for it seemed to them that so small a matter ought not to cause so ill-tempered an outburst as this which the duke showed against so noble a prince. But some excused him, alleging that flattery had caused him to do this thing,

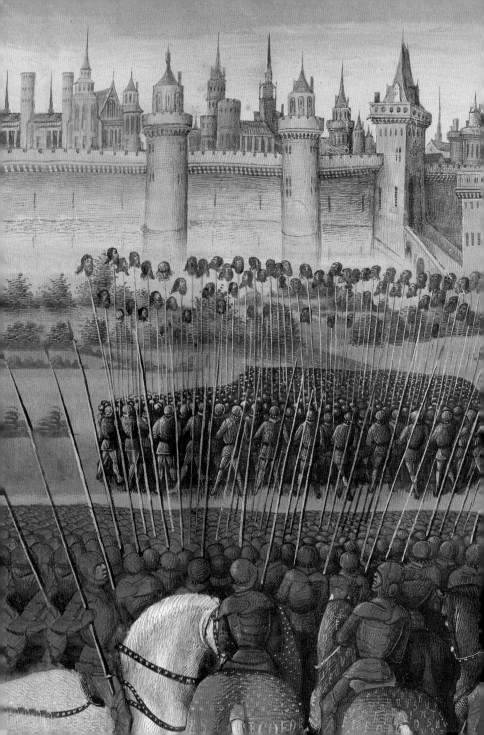

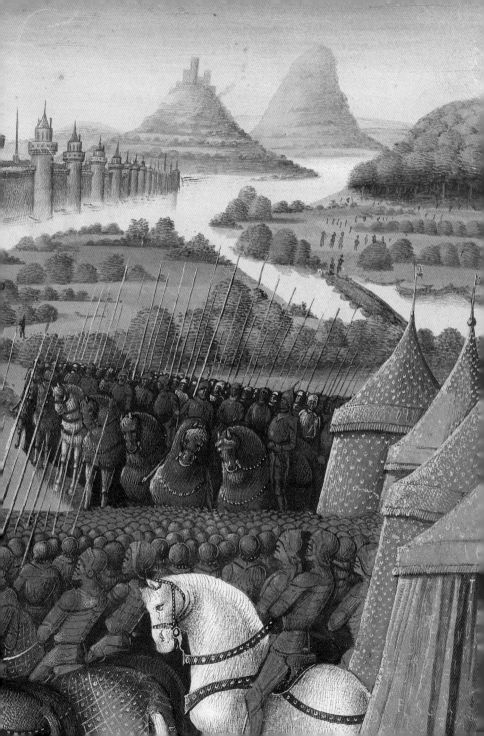

while others said that men were considering his honour too little and that he would have been humiliated if he had not been paid this courtesy and others, too, in great number.

The great prudence and the great valour of Bohemond made him admired both near and far, amongst his friends but also amongst his enemies, to such a degree that an Armenian Christian made contact with him by a secret messenger and became his friend. This was a rich and powerful citizen of Antioch called Firouz, so called because his forefathers had begun life as workmen who made hauberks.[82] For Firouz means, in our tongue, "he who makes hauberks". They were at that time so many that there was no family in Antioch that counted so great a number of members, or was as powerful, as that of which he and his only brother were heads. After the city had been besieged for seven months, it seemed to this Firouz that he would render a great service to Our Lord if he could enable the Christians to enter Antioch before Kerbogha (who, men said, was leading an army of Turks without number) had come to besiege them, which was likely to cause their loss. And he considered at the same time that he would have revenge, and all of Christendom with him, for the most cruel deeds and other tortures that the Turks had done to them and continued to do, by holding him and his kinsmen in Antioch like captives. And besides, men would praise him for ever for having rendered so great a service to the Christians and, what is more, Bohemond (whom he wished to see remaining as their lord) would love him, with all his kinsmen and his heirs after him, in perpetuity.

That is why he sent him one of his sons, who was accustomed to make known his wishes to him, to warn him of the coming of Kerbogha, who was already close to that land, and to explain to him the danger he and those laying siege were in, if they did not take Antioch before his arrival. He said to him as well that he had hope of delivering the city to him before Kerbogha could arrive there, through the help of Our Lord and if he was assured by all the princes that the Christians in the city would suffer no pillage, and also that Antioch would belong in perpetuity to Bohemond and his heirs. Happy with this offer, Bohemond sought discreetly and indirectly to know the will of the princes. When he knew that one part of them would not readily consent, he deferred until a more favourable time. Finally, he drew to one side Hugh the Younger, Robert, duke of Normandy, and the count of Flanders, and said to them that he trusted in God and that, if they were ready to give him their share of Antioch, like all the other princes and barons, he would put the city in their power within but a few days.

They were most joyful at this, because they admired and greatly approved of his wisdom, and counselled that he should speak of this with the count of Toulouse. But

the count refused to renounce his share, despite all their prayers and exhortations. And so for a while the matter rested thus, for Bohemond replied that he knew that he who was ready to deliver the city would never do so, unless it remained solely his. And it went badly with our men because of this, for Kerbogha had already come close enough with his great army to lay a counter-siege and to revictual and rescue Antioch during that time when Bohemond was delaying his decision because of the refusal of the count of Toulouse, all the while concealing these things from his friend Firouz. But, thanks to Our Lord, the Turks from the neighbourhood of Edessa counselled Kerbogha to besiege that city and take it before pursuing his road, for the Christians who held it once more had subjected them to hardships without number and had pillaged and burned their lands. Kerbogha, who believed that he would easily succeed in this affair, began there, although it would prove to his great shame, loss and dishonour. For Baldwin, the brother of the duke, who knew that he was coming, had fortified the city to forestall all danger, and he had garrisoned it well with doughty soldiers, food and munitions, and he defended it with valour. During the three weeks that the siege lasted, he killed so great a number of Turks that the emirs and the other wise men of Kerbogha counselled him to depart from the siege and to go straightway to raise the siege of Antioch, as the great sultan caliph of Persia had commanded him, and that he could quickly take Edessa on the way back. For this reason, he departed shamefully, leaving a great number of dead from his men and without inflicting any harm on Edessa or the men of the garrison, and he went by the most direct road possible to Antioch.[83]

When his coming was known to the princes and barons, they sent, to ride out against him and to know who came with him, Rainald, count of Toul, Drago of Nesle, Clarambald of Vendeuil and Gerard of Cerisy, with other knights who were tried and tested in arms. Advancing under cover and observing the Turks from afar, they reckoned that they were there in extraordinary numbers, which were continually increased as fresh soldiers arrived, one after the other, like rivers and springs running down to the sea. This they told in secret to the princes and barons alone, forbidding them to make known the great power of their enemies to whomsoever it might be, lest the people at the siege should take fright and flee. And they gathered together in council to discuss what they should do. When they were assembled, some of them counselled that they should leave the siege and, both on foot and horseback, advance until they were two or three miles in front of the Turks, who were coming on in great disorder and most rashly. They would then beg mercy of Our Lord, that he might help them, and thereafter they would join combat. The others said that it would be wrong if all those at the siege

departed, and they suggested that one part should remain, that they might prevent those in the city from joining the others, and that the finest and the best mounted of the army, leading a great part of those on foot, should go out against Kerbogha to do combat. When Bohemond saw at last that there was great doubt and that they knew not which way to decide, he called Hugh the Younger, the duke of Normandy and the count of Flanders, and said to them: "I see you in great doubt, and it is not surprising that you should fear the coming of so powerful a lord, who comes against us leading so great a number of our enemies, and also that you should not be agreed upon the manner in which you should meet him nor on how resolute you may be when he arrives. To be frank, all things considered, I have not yet heard you utter one thing that is likely to be of service to us, for whether we all leave our camps and go out against him, as some of you counsel, or whether one part stays in the camps and the other goes, as the others counsel, we will have wasted all our pains and all that we have already spent during the siege of this city. For there is not the slightest doubt that, as soon as the half or the whole of our forces leave here, those coming will send a great quantity of men, arms and fresh food into the city. If not one of us remains here, they will do this with ease; if only one part of us remains here, the same will befall, for there will not be enough of those who stay to cause them to abandon their undertaking, considering that even when we are all here together, it is only with great difficulty that we can keep those in the city shut up within its walls. And it would be impossible for those who remained and who would be but few in number to resist both those on the inside and those on the outside. That is why it seems to me that it would be better to find some way of getting into the city before the arrival of help. And if you ask me how such a thing could be, I tell you that it will be simple and swift with the help of Our Lord, for I have a friend in this city, loyal and wise as it seems to me, who has promised me, against certain privileges that I must ensure for him and his kinsmen, to deliver up to me a very strong tower that he holds and that is well garrisoned. And we will get into the city by means of this tower, for it includes walls to both the inside and the outside of the city. But he wishes that the city should be made over and given to me in its entirety, by you and by all others. If you consent, we shall have the city. If not, and if one of you can obtain its surrender, I agree to relinquish my share to him from this moment on, for we cannot have it through the intermediacy of my friend without it being given to me in its entirety. Declare then what you think and I shall make known your decision to him."

Listening to these words and to these promises, all the princes granted to Bohemond the whole share that each one of them might have had in the city with a good

will, giving thanks to Our Lord and heartily approving of Bohemond, except for the count of Toulouse, who never wished to give him the share that might fall to him, in spite of the entreaties of the other princes.[84] These promised Bohemond that they would help him to obtain the whole city, on condition that he kept this undertaking most secret, and they besought him to accomplish wisely that which he had undertaken. The council members having separated, Bohemond then made known to his friend Firouz that the princes had accorded him the whole of the lordship of Antioch, which delighted him greatly.

Now to cut this story short, it happened that the son of Firouz, whom he had sent to his dwelling because he could not go there, to accomplish certain tasks for Yaghi-Siyan, of whom he was the personal notary, found there a great Turkish emir in bed with his mother. It is certainly not surprising that he was enraged, but he did not dare to touch him and he went back to his father, to whom he told this thing secretly. And his father, who was wise, hid his grief and his intentions, and pacified his son by laying before him the other outrages that the Turks had done to them, saying that he would do his utmost to increase their strength swiftly, with the help of Our Lord Jesus Christ.

He sent him back secretly to Bohemond and asked him to keep on the watch towards his tower, for he would have him enter there on the following night. But he thought to be prevented from doing so, because those who had the guard of the city began to have their suspicions and to foresee that the city would be betrayed, even if they did not know on what occasion, nor by whom, nor how this would come about, because they could guess nothing of all this; nevertheless, when the chief men of Antioch were speaking of this together, they were of the certain opinion that this thing must happen. And they spoke so much of it that they gathered together before Yaghi-Siyan and told him that the men of the city who were his subjects had this fear, and not without reason, for the Christians who dwelt therein like them loved better those on the outside, because they were of the same faith. Most particularly this Firouz, in whom he had all confidence, was so intelligent, secretive and powerful in the city, that great harm for all the city was to be feared through the fault of the Christians and even of this man.

Hearing their remonstrances and fearing lest Firouz be guilty of that which they suspected, Yaghi-Siyan summoned him before him and told him all that they had said to him, and because he considered him a wise man, he besought him to counsel him as to what he should do. Firouz, who was wise and wily, understood well that Yaghi-Siyan was hiding his true thought and wished to sound him out.

CAPTURE OF ANTIOCH (1098).
MASSACRE OF THE TURKISH GARRISON (1098)

*"The Syrians, the Armenians and the other Christians, inhabitants and
citizens of Antioch, when they, too, knew that our men were masters, seized
their arms and began to search the houses and the streets and they put to death
all the Turks whom they found. And they took great pleasure in this,
taking revenge for the great cruelty that they had suffered at the Turks' hands:
they spared neither young nor old, neither woman nor child in this slaughter.
And in truth, it was horrible to see these people of divers ages and ranks lying
dead on the ground with their blood flowing everywhere along the streets."*

(FOL. 60VB)

The city of Antioch, shown here in the foreground, occupies nearly the entire picture. Jean Colombe has drawn the towers and the crenellated walls, as well as the houses and the principal buildings, in a way that gives the impression of a mighty and invincible city. The crusader armies are at the foot of the ramparts, awaiting the opportunity to enter Antioch. Bohemond, followed by a handful of nobles, is scaling the walls; he is the first to climb up the ladder to the top of the tower, where Emir Firouz, who has determined to deliver the city to him, is waiting. The banners and standards flying in the wind mark the end of the siege and victory for the Christians. The scene depicted in the lower register paints a graphic picture of the atrocities of war. In a bloody massacre, the inhabitants are being dragged out of their houses and their throats are being cut. Some attempt flight by throwing themselves out of the windows, but in front of the doors and in the streets below, the merciless Frankish soldiers await them.

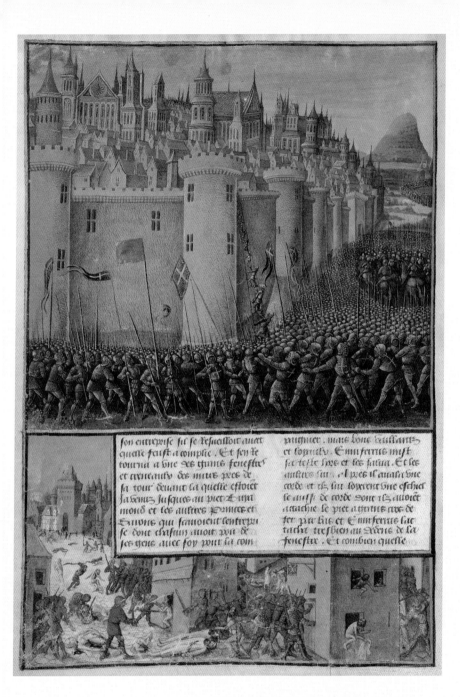

son entreprise si se reueilloit auec
quelle feust a complie. Et sen de
tourna a vne des tirans fenestres
et creneaulx des murs pres de
sa tour deuant la quelle estoit
sa kemis Iusques au piet Et ay
mond et les aultres / omicet et
Simons qui sauoient sentrepri
se dont chascun auoit vun de
ses gens auec soy pour sa com

puignier . mais lone leuissans
et copuelx Emil ferrius mist
sa teste hors et les salua . Et les
autres sint . Et pres il auast vne
corde et els sint soyrent vne eschiel
le aussi de corde dont ils alloit
attache se piet a haultis cire de
fer par kis et Emil ferrius sat
tacha tresbien au nerue de la
fenestre . Et combien quelle

For this reason, he replied in his presence to the Turk who had made this suggestion that he might remove his suspicions: "Sire, you are a great and wise lord, and all those in the city must acknowledge you as such, and most particularly the lord whose treachery you fear, for we must certainly fear all that might befall by lack of vigilance over all those things that you have in your care. Now that we risk losing our lives, our liberty, our wives, our children, our country, our city, our patrimony and all our other goods, which are the things over which we must take care to watch, and although the peril is great, it seems to me that it is simple to avoid all possible treachery, so that, if there were one who was miserly and cruel enough to wish to betray the city and to destroy us and his country at the same time, he would have neither the power nor the opportunity to do such a thing. The reason for this is that such a thing cannot be undertaken but by those to whom is entrusted the guard of the towers. Therefore, it would be best, if you suspect them, that you should often change their place. For this betrayal cannot be desired and accomplished unless you allow it to happen. By changing their place so often that those who have been in one tower for one night will be posted on the day after in another tower, the which they will not know beforehand, you will remove from them any possibility and any time to accomplish their treachery."When Yaghi-Siyan, the other emirs and the great Turkish citizens had heard the words and the counsel of Firouz, they lost all their suspicion of him, and would have followed his counsel that very night, but it was already so late that they could not make the change that was needful. And for that reason, they decided to do it, but they would delay until the following day. Yaghi-Siyan bade them take their leave and commanded them to attend full well to those things that were in his charge.

When Firouz was gone back into his house, knowing that he would never be able to accomplish this undertaking unless he did so on the coming night, he began to speak with his younger brother and to try him discreetly to see if he was of his opinion. He bewailed bitterly before him the great peril in which the poor pilgrims found themselves, who had come from lands afar to increase the holy faith of Our Lord Jesus Christ. But his brother replied unmoved: "The pity you feel is most unreasonable, and I am warning you of this great folly. To tell the truth, it would please me greatly if the Turks had already cut down all those whom you see down there at the siege, with all the others of their sect. For since they have come into our land, we have had not a single good day nor a single good night, but we have been forced to endure many wrongs because of their coming. I cannot then love them and, on the contrary, I wish that they might make a bad ending, and as soon as possible!" Firouz knew from this answer that he must

distrust his brother as much as Yaghi-Siyan. This is why he hid his intention from him and changed the subject, pondering inwardly all the while how he might deliver himself from him. Now although the wise Firouz might be accused of betrayal by some, because he delivered his city to the enemies of Yaghi-Siyan, who loved him and trusted him, men should in no wise so accuse him, for he gave it to true Christians, who else would all have been in great danger of being put to death by the enemies of Our Lord Jesus Christ. What is more, eight days before, the Turks of Antioch had wished to kill Firouz and the other Christians dwelling there, and indeed, they would have accomplished this cruel act there and then, had it not been for a great Turkish emir, who was a close friend of the Christians, and who had delayed the matter for eight days and had said to them, in the secret council when they had thus spoken of killing them: "I counsel you not to do yet more wrong to the Christians who dwell in this city, for it may be that those who are besieging us will go away before the eight days are over and will raise the siege for fear of the coming of Kerbogha. And if they should thus go away, why should we kill our Christians, for if they do not go, you may just as well accomplish what you are talking of whenever you wish."

Pity and the counsel of this emir alone delayed the massacre of our men: on that day, which was the eighth, the order had been given to those whose charge it was to kill, on that very night, all the Christians in their homes. But Our Lord would not allow this thing, and retribution was brought upon them for this damnable iniquity by Firouz – and I believe, too, that they were in part delayed in doing it, and that they did not begin that night, because on that very day the princes had had it proclaimed throughout the army of pilgrims that all those who had horses should be armed by the hour of nones, and should place themselves each one in the body of fighting men to which they belonged, to do whatsoever the captains should command. Bohemond counselled that these commands should be made and known only by the first and the principal barons, who should pretend to depart and to raise their siege. And they did, indeed, depart at the hour of nones, but they went no further than a valley close by. But when those in Antioch saw them in arms, they thought that they had departed to confront Kerbogha, and so they were in no great haste to kill the Christians as they had undertaken to do. Our men went back the same way on that very night and returned in secret into their tents at around dawn.

Chapter XXII.
How Firouz killed his own brother, that he might deliver Antioch more easily to the Christians. And how the city was taken, and how Yaghi-Siyan and the other Turks were killed or taken.

While Firouz was on the watch in his tower,[85] waiting for news from Bohemond, his messenger came to him around midnight. He made him wait a short time in a secret place, until the nightwatchmen who were then approaching the tower should have gone. For they would go three or four times each night, on top of the walls, right along the city wall, to check that the watch and all other things were in good order. For this reason, the captain of the nightwatch, when he came to the tower with a great number of men, and found there Firouz who was keeping the defences that were in his charge in good order, saluted him and passed on, to finish his round.

When he had thus passed by, Firouz straightway sent back the messenger to Bohemond, asking him to make all haste to come up before the tower with a good company in whom he could trust. When he had said this, he let the messenger go down and went into his tower, where he found his brother sound asleep. He ran him through from side to side with his sword and killed him, lest he prevent his undertaking if he should awake before it was carried out. He returned to one of the great windows and to one of the crenellations in the wall near his tower, at the foot of which Bohemond and the other princes and barons who knew of the undertaking were already arrived. Each one of them had with him to accompany him a small number of his own men, truly good, valiant and loyal companions. Firouz put out his head and greeted them and they greeted him in return. Then he let down a rope and they threw up to him a ladder, also of rope, whose base they had attached to great iron hooks, and Firouz attached it firmly to the inside of the window. And although this ladder was made in a most artful manner and was stretched most taut, none dared go forward to climb it. So Bohemond climbed up the ladder first and reached the crenellation and the window where his faithful friend Firouz awaited him, who recognised him and held him by the arm and kissed his hand and said: "God keep this hand!" Bohemond climbed up onto the walls and kissed his friend, thanking him most tenderly for the service that he had rendered him. Thence he led him into the tower and said to him, as he showed him

the corpse of his brother: "Behold what I have done for God and for you! This man whom you see here dead was my brother, and I have killed him because I could not obtain his accord for the worthy task that we are engaged upon."

Thereupon Bohemond was exceedingly joyful, for he knew that Firouz was most trustworthy. He returned in all haste to the crenellation, called his people and demanded that they climb up the ladder. But still none of them dared climb up, for fear there were some trickery, until Bohemond himself, who was most agile, strong and courageous, went swiftly down again, right to the foot of the ladder, and said to those of his company: "You stay too long! There is no doubt, for know that this worthy man has shown me his own brother, whom he has killed for love of us." When they heard this news, each one of them hastened to be the first, or amongst the earliest possible, to get up onto the wall by this ladder. So enough of them climbed up in a short time onto the wall to keep watch, lest anyone prevent the rest from climbing up. When the count of Flanders and Tancred had climbed up, they explained to the others what they should do and sent them to the neighbouring towers, having stoutly garrisoned the first tower. They had the other towers garrisoned and killed the Turks who were assigned to the watch there.

When the other princes and barons who had remained behind to lead the army saw that there were already enough men on the walls to garrison a number of towers, they ran in all haste to their camps to call their men to arms and to lead them all along the walls, that they might be nearer at hand to get into the city when those on the walls gave the signal. And so it was done. As for our men on the walls, they were not idle, but were so valiant and so bold that they took ten towers, one after the other, in a very short time, and killed all those whom they had found inside. Although they made a great din, the city had not yet stirred and was not wakeful, for the people thought that it was but the dying Christians who were being killed, as had been ordered and for that reason they did not rise from their beds. But they soon knew to the contrary, for in that part where our men had climbed up, there was a postern down which a number of our men went. They broke off its locks and its bolts and they opened the gates to the rest of our men, who entered then in a crowd.

They went away to the Bridge Gate, and wrested it from the watchmen, whom they killed to a man. At that moment a squire bore the banner of Bohemond, his master, onto the highest tower, which was situated on a mound near the keep. Then, when our men that were in the city saw that day was approaching and that dawn was already appearing in the sky, they commanded the trumpets and horns to be sounded to call all those in the army. When the princes and barons at the siege heard the signal, they spurred on

their horses hard and came into the city through the gates, which they found open. Those on foot who stayed at the siege, and who knew nothing of this undertaking, were all astonished in the morning when they awoke to see that their tents were empty. But they learned that the city had been captured from the sound of the trumpets and the shouts of the people, and they rushed then in all haste upon the booty. There followed a horrible massacre, because the Turks, who had remained until then in their houses, thought that their people were killing the Christians. But seeing the banners, and the armed men in their streets, they understood the plight they were in and took their wives and children and began to flee from the houses. But no sooner had they escaped and fled before one of our forces than another greater came upon them and slaughtered them all.

The Syrians, the Armenians and the other Christians, inhabitants and citizens of Antioch, when they, too, knew that our men were masters, seized their arms and began to search the houses and the streets and they put to death all the Turks whom they found. And they took great pleasure in this, taking revenge for the great cruelty that they had suffered at the Turks' hands: they spared neither young nor old, neither woman nor child in this slaughter. And in truth, it was horrible to see these people of divers ages and ranks lying dead on the ground with their blood flowing everywhere along the streets. When Yaghi-Siyan, the lord of the city, saw from his keep that his people were being slaughtered and that his city had been taken, he thought that he could not stay there in safety. He, therefore, fled furtively by a hidden gate and went away into the country, as one drunk with rage. But he had not gone far when he was met by Christian Armenians from that land. Realising that he was fleeing, these men approached him, pretending that they wished to honour him in like manner as was their wont. And they seized him and flung him to the ground, and then they cut off his head and bore it into the city and there they presented it to the princes and barons before all the people.

Not all the Turks who were at that time in Antioch were originally from the city, for they were from a number of races and countries; some had come there at Yaghi-Siyan's bidding, partly through loyalty and partly as mercenaries, while others had come to fight and win fame through arms. Some who had good horses and who were not well acquainted with the byways of the city mounted their horses when they heard the din and began to gallop towards the keep. It so happened that a great company of our men who were searching the city came in their direction and ran after them with great ardour. So the Turks, thinking to escape them, fled uphill, beating their horses so violently that they hurled themselves off the top of the mountain, which was so high

and so steep that they were all broken into pieces, horses and men, before they reached the bottom of the valley. There died in this wise more than three hundred. There were also other Turks, natives of the city, who mounted their horses when they realised in the morning that they were taken by surprise and got out into the country through the gates that our men had opened, and they galloped towards the mountains. One part of them escaped in this manner and the rest were pursued so closely by our men that they took them prisoner back into the city. After the princes and barons had planted their standards and banners on the towers and at the gates, and after the great slaughter had ceased, each one began to seize the great riches that were found there in abundance, as chance offered, so that all were rich and laden, even if they found but little food. They gained there five hundred fine warhorses, who were nonetheless so thin that they could scarce stand up. Thus, it was that the first pilgrim crusaders took the mighty city of Antioch on the third day of the month of June in the year 1097.

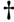

Chapter XXIII.

How the pilgrims failed to take the keep of Antioch when they took the city. Of the first outriders of Kerbogha, who killed Roger of Barneville in an ambush. Of the first coming of Kerbogha before Antioch and of the harm he did to our men because of the keep. And how a number of pilgrims took flight secretly over the walls of Antioch.

When the princes and barons learned that Kerbogha was approaching with an immense army, they gathered in council on the very same day that they entered Antioch, that they might act in such a manner that the keep, which dominated the city inside the city walls, might be taken before his arrival. And they decided that, after having placed guards on the gates, the towers and the walls, they would lead out the rest of the army posthaste to attack the keep. But when they had come close enough to look at it at their ease, they acknowledged that it was impregnable, save by starving it out, and that it could not be taken quickly by assault. So they built a fortress and made a great wall of lime and sand before the entance to the gate and the common road by which men descended from the keep to the castle, and they garrisoned it with valiant men and with a number of catapults to prevent those in the keep from coming down by surprise upon our men in the city. And they were warned on that same day

that Kerbogha had entered the lands of Antioch. So they sent one of the barons down to the sea, that he might tell those from the army who had gone there to attend to their own affairs to return straightway and to make all haste to carry into the city all the food that they might find. But of food they found little, even though the labourers of our faith who dwelt around Antioch, when they heard tell that the city had been conquered by our men, brought in most joyfully all the food that they had hidden, for the great siege had caused the city and the country to be emptied.

Our men, who were busied in fortifying their new fortress and garrisoning the city, had scarce time to search for food, for on the second day after the capture of Antioch it happened that three hundred Turks from the great army of Kerbogha took up position in the fields near Antioch that they might try a daring exploit, and they secretly made an ambush and then sent out thirty of their men who were the best mounted to ride as far as the space close by the gates. When Roger of Barneville, a knight of Normandy who was very valiant and had conducted himself most nobly in the army, saw the Turks who were riding without protection so close to the gates, he took fifteen knights of his company and went out to meet them. But they feigned fear and began slowly to flee, that they might lure our men into their ambush. And this is what happened. Then Roger, knowing that they were too many and all better mounted than he, rallied his fifteen knights and thought to retreat towards the city, defending himself as he went. But he could not succeed in this, because they encircled him and cut off his head, to the great grief of all the pilgrims, but most particularly of the princes, who had his body borne in and buried most honourably under the porch of the church of Saint Peter.

And on the next day, which was the third day after the capture of the city, this great prince Kerbogha came from the direction of the rising sun to lay siege to the city.[86] His army was of such size in the diversity of men and baggage, both in numbers of men and of animals, that it was not possible to count them. He took up his position between the lake and the river Iron, which are around a mile distant the one from the other. Then, approaching closer in accordance with the counsel of his people, he made his camp on the side where the keep was, that he might launch his men against the gate that came down from this keep into the city and penetrate into the midst of our men whensoever it pleased him. When all his people had taken their positions, he held all that part of the city that is situated on the south side, from the West Gate as far as the East Gate. As there was, close to this East Gate, a fortress that our men had built and fortified before the siege and that they had given to Bohemond to guard and thereafter to Duke Godfrey, after the capture of the city, the Turks who had taken up position nearby began to

attack it with all their strength. When Godfrey, who was at the City Gate, saw that his men were suffering greatly, although they were defending themselves most valiantly, he went out into the fields with a great company of well-mounted men and fell upon the Turkish assailants. But he was forced to retreat back into Antioch, because of the arrival of a great multitude of Turks who charged his men so closely that they left there a good two hundred, dead or prisoners: it must be said that there were ten Turks fighting against every one Christian. When the Turks had inflicted such great harm on our men, for they knew that Godfrey of Bouillon was their leader, they became so overweening that they clambered up the mountain, got into the city by the keep gate, surprised some of our men who had not suspected their coming and killed them. But the pilgrims gathered together and straightway pushed the Turks back into the keep. However, these made a number of like sorties, where they often inflicted harm on our men, for they knew another road than that on the mound where our men had built the wall and the fortress. That is why the princes and barons, gathered in council to counteract this danger, determined that Bohemond and the count of Toulouse should make a deep and broad ditch between the city and the flank of the mountain, and also a fortress. Which thing they did, and they garrisoned it with a great number of doughty soldiers, whom the Turks attacked with ardour, leaving them no rest, for they would come most often from the fields into the keep, coming up and going down by hidden paths.

Most particularly, there came down on them one day a multitude without number: if the outcry that arose throughout the city had not brought the other knights in the city to their rescue, they would have taken or killed Bohemond, Adhemar of Le Puiset, Ralph of Fontaine, Rambald Creton and a number of others who were all knights and great lords and who had taken their place in the new fortress to defend it. But Hugh the Younger and the count of Flanders rode there in all haste with their men, in numbers enough to drive off the Turks and to kill a number of them and to capture others before they could go back into the keep.

Those who had been able to escape came before Kerbogha and told him that those who were inside Antioch were valiant, bold and courageous beyond measure, so that it seemed they feared not death when they were fighting. So Kerbogha, knowing that he was losing time on the mountain, ordered his army to descend into the valley and, crossing over the river Iron by the ford, he positioned his men down there.[87] Some got down from their horses close up against the walls and fired against our men at the first opportunity. Seeing this, Tancred came out by the gate facing east and encircled them, killing six of them before the others might remount, and he had their heads carried

back into the city to comfort the pilgrims for the death of Roger of Barneville. While these things were happening and our men were thus besieged in the city of Antioch, where they endured great suffering and ran great risks, most particularly because of the sorties that those in the keep often made into the city, there were a large number of them who were so terrified that they let themselves down the whole height of the walls by night, in baskets, on ropes or by other means, and fled towards the sea, thinking to escape, so that a number of them were killed or made prisoner by the Turks, who found them in the fields. And those who were able to escape and to reach the port told the merchants and the other pilgrims who had arrived there to weigh anchor and hold themselves ready to flee, for the great prince Kerbogha, who had a very great army, had recaptured Antioch from our men and had put them all to the sword, and that they themselves had escaped thence amidst great danger and fearful adventures. Now they told these lies to the seamen and the merchants that they might embark on their boats and leave, for fear of being killed by the Turks if they should come.

A number of men of divers estates departed in this fashion, amongst whom were William of Grant-Mesnil, a rich lord of Normandy who owned great estates in Apulia and whose wife was the sister of Bohemond; Aubrey, his brother; William the Carpenter; Guy Trousseau; and Lambert the Poor,[88] who were all rich and powerful lords. And some did an even worse thing, for the anguish of hunger and the fear of being killed pushed them to surrender to the Turks and to deny the faith of Our Lord Jesus Christ. Such men did great wrong to those of our men who stayed in Antioch, for they told the Turks of the true state of the misfortune and of the danger in which those in the city found themselves. And many of those who stayed in the city would most willingly have departed, had not Godfrey, the count of Toulouse, the count of Flanders, Tancred and Bohemond persisted in their resolve. Following the counsel of the bishop of Le Puy, Bohemond set guards on all the gates and on all the walls, that they might keep watch by day as well as by night. These swore that they would not depart until the very end and then only on the order of Bohemond, who went each night through all the city with a great number of men and with bright lights to seek out any betrayal.

There were as well four fortresses to guard: the first was located on the little mound by the keep, the second had been built a little lower down by the ditch to counter the sorties of those in the keep, the third was outside the East Gate (this had been built to safeguard the army before the city had been taken) and the fourth was at the end of the bridge. It was by this gate that the city was finally besieged and encircled, and the count of Toulouse held it at the outset. But once the city had been taken, he left it to enter the

city, and it was the count of Flanders who took it and garrisoned it with five hundred knights and other well-armed men, for he thought that if the Turks gained it, our men could no longer go out across the bridge, and their situation would be far worse: nevertheless, a few days later, he set fire to it and abandoned it. When Kerbogha realised that our men would be able to launch themselves from that side along the bridge, he sent there a thousand Turks clad in hauberks, who attacked the tower violently, but were not able to seize it on that day. On the very evening that the count had it burned down, Kerbogha had decided to send there on the morrow two thousand soldiers at least, a number so great that they could have taken it and there would have been no means to prevent this.

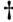

Chapter XXIV.
Of the poor pilgrims whom Kerbogha, out of mockery and contempt, sent to the sultan of Persia. Of the great famine that they suffered in the city, which was almost recaptured by surprise. Of the seamen and other Christians who were surprised and killed by the Turks. And of the number of great lords who took flight on the pretext of going to seek help and who caused the emperor Alexius to turn back as he was leading a great army to rescue those in Antioch.

But a few days after this fortress had burned, it happened that a number of Turks who were ranging the land around Antioch found there certain poor pilgrims who were searching for food, and they captured them and took them to the siege, before Kerbogha. Seeing that they had no arms but frail wooden bows and swords that were all rusted and, what was more, old clothes that were rotting away, he reckoned them of little worth and said scornfully: "Do these people here look like men who could wrest his empire from the sultan of Persia and conquer the land of the Orient? Why, we can see that they would be but too happy to find a crust to eat in a pigsty! Their bows are not strong enough to kill a sparrow! I shall tell you what you shall do: take them all, in the state that they are in, to his excellency the sultan who has sent me here, and tell him that he need have little anxiety about these people who are come here, for he may see that it is with people like these that we have undertaken to make war. Let him then leave to me the whole charge of this task, for it will not take long before I wipe them out utterly, so that none will ever speak of them again, as if they had never existed." So he thus entrusted them to his men and they led them away.

He thought to gain great honours by these vainglorious words and by his boastful-ness, but they would thereafter cause him shame, for he believed that he would conquer the Christians without difficulty at a time when he had not yet tried them in combat. But he acted speedily to lay siege to the city from all sides and caused the ways in and out to be so well guarded that men might no longer use them to bring in food. There set in then so great a famine that the good Christians who were besieged had perforce to eat camels, donkeys, horses and many other meats that were yet more unpleasant: if any found a dead dog or a dead cat, it was straightway eaten as a delicacy, for it is said, and truly, that the starving stomach cares not what fills it.

The important gentlefolk, who were used to receiving great honours, had no shame in coming unbidden to any place where people were eating and in sitting down and eating with the rest, but they often met with a refusal and were turned away. The ladies, noblewomen and young girls were so hungry that they were pale, thin and wan, and they were often reduced to begging for a morsel to keep themselves alive, to their great shame. None could have had so hard a heart as not to feel pity for them. Men and women of high courage, as befitted their birth, hid themselves away in their houses to await death rather than beg at the doors. Certain of those who had food, knowing that they were there, gave to them out of charity, but despite this many died. One might see knights and other men, hitherto so strong and so valiant in all that they undertook, rendered so feeble through hunger that they went through the streets leaning on a stick, their heads sunk, begging for bread in the name of God. One might also see mothers, who had nothing left with which to feed themselves, abandoning in the streets the little children they were suckling that others might care for them. To tell you briefly of their sufferings, it was well-nigh impossible to find in the whole population one single man who had quantity enough of that which he needed to live, for even if there were a man who had gold or silver, it availed him nought, for he could find nothing for sale with which to feed himself. The barons and great lords, who were accustomed to hold fine courts and to feed in ample quantity great numbers of people, hid themselves in the end that men might not find them in the act of eating. They knew then, in their hearts, greater anguish through this famine than the poor people, for they met all day long with their knights and people from their own estates who were dying of hunger and to whom they had nothing to give.[89]

It would take too long to tell of all the calamities people suffered in Antioch during this ordeal. All one can say is that it is rare to find, in a history as true as this, that such high-born princes and so great an army should ever have suffered such torments, nor

such terrible hunger. And even worse, the Turks, who well knew the situation of our men and that they were weakened and had for the most part lost the heart to defend themselves through lack of food, attacked ceaselessly right up to the city walls throughout the day. Most particularly, those in the keep and those who came down through the gate tried sorties against the fortresses inside Antioch. They had already exhausted our men by attacking them at length each day and knew full well that they were defecting and that they were abandoning hope of defending themselves and of keeping the city, alas, and not without reason, for when they had wearied themselves all day in withstanding heavy assaults, they could find nothing to eat at night. The Turks, knowing this, approached one night and secretly placed their ladders against a tower where there was neither watch nor guard, as they had well observed, and this was a tower close to that by which our men had got in. At the beginning of the night, thirty Turks climbed up onto the walls that way and they were already moving off to enter the tower when the master of the nightwatch, who was making his round in that quarter, saw them on the walls and shouted: "Treachery! Treachery!", calling those in the other towers and those who were on watch close by. These awoke and ran in all haste when they heard the clamour. Amongst the first came running Henry of Hasque and two of his cousins, one called Franko and the other Soyemères, both born in the city of Mézières on the river Meuse. All three fell upon the thirty Turks and they killed four of them at the first clash. Those from the towers followed them, but not straightway. The twenty-six Turks that remained put up a resistance, but it was slight, for they were hurled down so violently from the top of the walls that they had all their limbs broken.

While these Turks were thus killed or maimed, the valiant Soyemères died also, pierced by a sword in the belly, and Franko was borne off most grievously wounded. Although Antioch was completely besieged, famine pushed certain pilgrims who were in the city to take the risk of going by night to the port, where the boats of the merchants were. One part of them would buy food and bear it into Antioch to make a profit, and they earned in this wise much money when they succeeded in their undertaking. But the other part returned no more, for they feared to be shut up in the midst of the famine, the more so because a great number both of the one and the other part were killed by the Turks who came upon them. When Kerbogha knew that food was from time to time reaching those in Antioch from the sea, he sent a great number of his Turks, who killed all the Christians – merchants and others – whom they found at the port and burned the boats that were not anchored offshore, for these took flight. And so those in Antioch lost all hope of getting food, for the maritime islands like Cyprus,

Rhodes and the others situated along the coastline of Cilicia, Isauria, Pamphilia and the other neighbouring regions dared no longer bring their boats into the port, which worsened most grievously the situation of the besieged pilgrims, for the merchants had hitherto often brought them help from that direction.

When the Turks returned from the sea where they had made this great slaughter, they found the pilgrims who surrendered there, but they killed them all except for a small number who saved themselves by hiding in the hedges and the bushes. These tidings caused extreme concern amongst those in the city, who were so dumbstruck that they could scarce any longer ensure their defence and, what is worse, they no longer wished to obey the barons who could do nothing to help them. And elsewhere, there befell also a most great difficulty, which was a cause of despair, for William of Grant-Mesnil and those who had fled with him went to Alexandria,[90] where they found Count Stephen of Chartres and of Blois. They had been awaiting his arrival from day to day in Antioch, for the princes, barons and all the other pilgrims who were besieged there hoped that he would keep the promise that he had made to them when he left, that he would return as soon as he was somewhat restored from a sickness from which he gave out that he was suffering. But when this William and those of his following had told him of the great famine and of the close siege of Antioch, and (although, indeed, the situation was most grave) had described matters as being worse than they were, that they might excuse their shameful flight and their wicked cowardice, it was simple to hold him back, for he had no great wish to return. They, therefore, determined with one accord that they should flee further, and they set sail and returned by the most direct route to Constantinople.

Some days later, when they had put into one of the cities on the coast to rest, they heard that the emperor Alexius had set out from Constantinople with a great army and that he was approaching Antioch to rescue the pilgrims, as he had promised them. And this was, indeed, the truth, for he was already in the city of Philomelium[91] with an army without number, made up of Greeks and more than forty thousand pilgrims, those who were sick and had remained in his lands together with those but newly arrived, come from the provinces of France, and who arrived continually as long as the great journey lasted. This is why the count and his cowardly companions presented themselves to him. And the emperor, who knew that the count was of wise counsel and a great prince, received him with joy and feasted him splendidly and asked him attentively what was the mood of the other princes and barons. And he answered him, that he might conceal his shameful flight: "Sire, your liegemen, the princes and barons of our lands who passed through your empire and whom you welcomed so courteously and with such great

*"Confessing their sins and asking forgiveness of Our Lord with tears and
sincere repentance, they dug down deep in the place that the cleric showed them,
and there they found the Lance of which he had spoken to them. And God
knows that each one of them was then as joyful as if he had gained all that
he desired. So they sounded the bells and the news ran straightway through the city,
so that all came running, great and small, and they all gazed with attention,
great humility and devotion upon this sacred relic newly come out of the earth."*

(FOL. 69A)

In 1098, after the capture of the city of Antioch, the Turkish army of Kerbogha continued to harass the Christians. Bohemond was charged with the guard and defence of the city, and he wanted the inhabitants to help him in its defence. When he was unable to get them to come out of their houses, he ordered his men to set fire to a number of places in the city. It is this incident that is depicted in the lower register of the page. A half-timbered house is consumed by flames and the inhabitants finally come out of their houses and join the armed men in the streets. Starved, sick, terrified by the thought that the Turks might slit their throats, the Christians lose confidence in God. The principal picture shows how a cleric, Peter Bartholomew of Provence, who had had a vision of Saint Andrew while he slept, told the bishop of Le Puy and the count of Toulouse that the Holy Lance that had pierced Christ's side was buried under the church of Saint Peter. The artist depicts the soil that has been dug out in the church, with the spades lying on the ground; the bishop holds the lance and shows it to the faithful, who are all kneeling in prayer.

Or sachès qui a
uoit sceu commēt
L'empereur ℈ Co
stantinoble lenoit
atout trestgrant
Armee pour leuer le siege Dan
thioche et secourir les pelerins a
uoit moult doubte sa venue par
ce que c'estoit grant chose Du
renom et de la puissance de son

pere. Et puis de plus a cestene
quil sen estoit retourne. En
moult grant soye et en monta
en tel orgueil quil tenoit desla
tous mors et prins les princes
estans en Anthioche. Et pur
ce les faisoit assaillir plus con
tinuelment et trop plus aspre
ment que deuant. Et pur le
contraire ilz estoient tellement

honours, laid siege, but a few days after their departure, to the city of Nicaea, which they took and which they surrendered to you. Then they laid siege to the city of Antioch, which they have taken, at the cost of great hardships, pain and suffering, after more than nine months. But they could not take an impregnable keep, which the Turks still hold and that is situated on a high mound inside the walls of the city. And when they had taken this city, they thought that they had made an end of the matter, but they suffered great losses and fell into fresh pains, perils and even greater misfortunes than before, for, on the third day following their entry, there arrived a most powerful pagan prince from out of Persia, who is called Kerbogha. He was at the head of so many men that the country was covered with them, and he laid siege to our men inside, so that they could neither go in nor come out. They are suffering inside from a famine, which is not to be endured and that has so weakened them that they can scarce defend themselves. And to make matters even worse, this Kerbogha has sent a party of Turks from his army down to the seaport near Antioch, and they have killed all the merchants who used constantly to carry food and other things from divers parts of your empire there and who brought some help to those in Antioch. And besides they have killed the pilgrims who used to go there and return secretly by night to revictual those under siege, and they have burned all the boats that were in the port, and they have killed the seamen, so that none dare bring either food or boats there any more: thus, the besieged have lost all succour with regard to food. And what causes them the greatest harm of all is that the Turks of the keep, who can go out into the fields and return into the city at will, make continual assaults against them, day and night, and allow them no rest.

This is why I, and these valiant lords who have come with me who are most wise and prudent, when we saw that this was how things were going and knew that what they did could not end well, warned them many times that they should not seek to conquer this country and this land against the will of Our Lord Jesus Christ, but that they should instead depart taking as little risk as possible, and conduct those people who were following them and lead them to a place where they would not be delivered to their death. Many a time and most pleasantly have we spoken and repeated these warnings to them, but they did not wish to believe us: hardened in their headstrong will, they did not wish to stir from the city. And, to be sure, there are amongst them a goodly number who are somewhat lacking in sense. That is why, when we saw and understood that, if we remained there longer, we should be put to death like them and would in no wise profit Our Lord thereby, we departed and commended them to God, that he might counsel and safeguard them, for indeed, they have need of this!

Moreover, because I am your liegeman, I invite you in good faith to take counsel from your people before you go further, for even if it is true that you are the greatest prince in the world, nevertheless, you do not have at present as many men as Kerbogha has Turks around Antioch, for there are seven Turks against one of your men. And that is why I counsel you for my part, and if the others are in accord, that you should turn back on your road before putting all your people into so great a danger. And, to tell the truth, if you should go further, they are hopeful of having already achieved the conquest of the city and you will find them much closer than you think. And if they should come on, your retreat will be all the more shameful to you the closer you are to them. And the valiant men who are here with me know well that these matters are as I have told them. And you may also know a great part of them from that prudent man called Taticius, who is most wise and most loyal, and your personal friend whom you have given to us. He has left our men because of the many and great failings that he discerned in them."

When Count Stephen of Blois and Chartres had thus finished these comments before the emperor, to his great dishonour and reproach (had it not been that he returned thereafter to the pilgrims with a great army, and that he brought aid and succour to them in the Holy Land of Jerusalem and the land around, where he died on the battlefield), one of the brothers of Bohemond called Guy,[92] who had remained with the emperor, was greatly troubled and angered thereat and said, loud and clear, that the count and the others had not told the truth and that they had departed like cowards. And there were other harsh words, but William of Grant-Mesnil, who was a most noble lord and of a great family, but not of great courage, and who had as his wife the sister of Guy, made him hold his peace and took him away because he spoke thus violently against the count of Blois.

At his demand, the emperor gathered his council together and there it was decided that he should rather return whence he had come and lead his men without harm and without peril into their own country, than risk fighting against Kerbogha and stirring up all the lands of Orient against him. Believing the count and fearing lest the Turks had already slaughtered our men in Antioch and were preparing to take the road to recapture the land of Bithynia, which our men had already conquered for him, the emperor took the road back. And to safeguard himself against the coming of the Turks and that they might lack food if they wished to pursue him, he burned and destroyed, to left and to right, all the land from Iconium as far as Nicaea.

And so it befell that the emperor turned back again because of the words of so great a prince who had deserted his companions so shamefully, and that the Christians of Antioch lost his help and that of his great army, of which they had great need, for,

had he continued, he would have entirely delivered them. But all things considered, even if the count spoke wrongly and with bad intent that he might conceal his flight, their turning back was the work of God, for if the emperor, who came with so great a number of new and fresh men, had raised the siege or beaten the Turks, Our Lord would not have been so greatly lauded or thanked for it as he was hereafter, nor the princes, barons and pilgrims achieved such great renown as they did. On the contrary, the emperor and his Greeks would have plucked in fame and in victory the fruit of the great hardships, suffering and toil that our men had endured, and for which they would not have been rewarded. But the last to come would have obtained all things for ever, that which Our Lord would not allow, for he desired that the matter should be accomplished to the honour, glory and benefit of the princes and other Christians of Antioch.[93] And not without reason, for they endured there hardships and evils without number, and they were thrown once more into a state of well-nigh extreme grief when they knew how the emperor and his army had turned back because of the words of the count of Blois and of William of Grant-Mesnil. And the common people would have lost all hope had it not been for the great wisdom, prudence and steadfastness of the princes and great barons.[94]

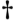

Chapter XXV.
How Bohemond caused several parts of the city of Antioch to be burned down, because otherwise he could not have forced men out of their houses to fight against the assault of the Turks. Of the sermon preached by the bishop of Le Puy. And how the Lance of Our Lord was found in Antioch, which restored strength and courage to all the pilgrims, who determined to go out to fight Kerbogha and who challenged him.

Kerbogha, who had learned that the emperor of Constantinople had come with an immense army to raise the siege of Antioch and to rescue the pilgrims, was sorely afraid of his coming, because the renown and the power of the empire were considerable. But when it was certain that he had turned back, he was exceedingly joyful thereat and was so overweening that he already took all the Christians who were in Antioch for dead and imprisoned. For this reason, he caused them to be attacked more continually and yet more violently than before. And they, on the other hand, were so

disheartened, both through stupefaction and because they were weakened by famine, that many thought that Our Lord had forgotten them. And they let themselves fall into despair and would no longer endure any hardship that they might defend the city, and they all hid themselves in their houses.

Now it happened on a day when Bohemond, who had the principal charge of guarding and defending the city in the name of all the princes and barons, and who had authority over all, had positioned men against the assaults from without and the sorties from within, that he ordered everyone to come forth. But none came, and so he sent his men to seek them out and to warn them in their houses. But they could not make them come out, which stupefied him, but he thought of a new ruse and finally ordered his men to set fire to a number of places in the city, and fear then caused them all to come out in a crowd into the middle of the streets. And when he saw them, he told them what he wished them to do and they obeyed him. However, a new trouble and a new astonishment arose shortly thereafter, for there ran through the city the rumour that a number of the knights, princes and even barons had determined amongst themselves, in secret council, to go out of the city by night and to leave the people to escape as best they might, and to go off to the port to set out to sea. Duke Godfrey of Bouillon, who was told of this, then had the bishop of Le Puy come to him and told him of it. And then he had come to him as well all the princes and some of the barons and knights, and he knelt before them and begged and besought them never, for the love of God, to have such a thought, setting forth to them in most gentle words that if it should befall that Our Lord detested them so greatly that he allowed them to commit such an offence, then they would lose their souls like men who would lose all hope of divine grace and they would fail in the service due to Our Lord. And besides, they would lose all honour in this world, for they would be dishonoured, and all their descendants, who would be blameless, would likewise be shamed thereby and have the finger pointed at them for ever and, what is more, they would be the less esteemed for it as long as the world should last.

And he spoke at such length to them that those who had this desire lost it by reason of these words and through the fine preaching of the bishop of Le Puy. Nevertheless, all began to weaken from hunger and sickness throughout the city, to such a degree that they waited for nothing other than the mercy of Our Lord or death. They remembered most often the riches, honours and contentment that they had left behind in their own lands for the service of Our Lord. And yet He was repaying them here with such board and thanks that they were dying daily of hunger and sickness, and

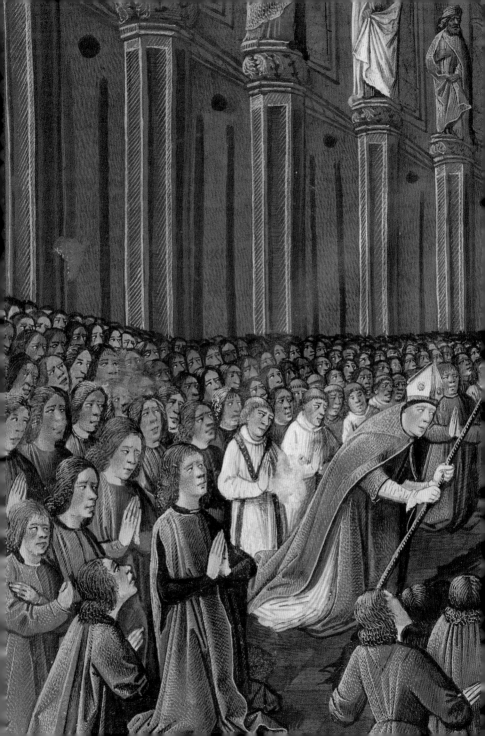

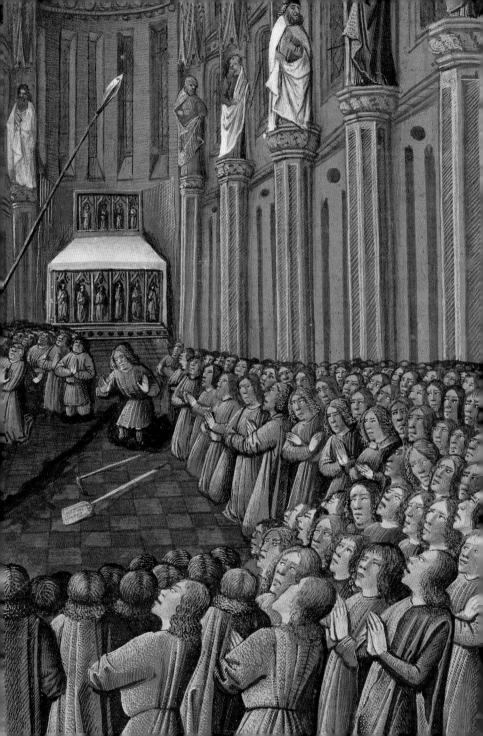

greatly feared that they would all be killed by the Turks, at a moment as yet unknown, to the shame of Our Lord and of His Christian faith.

And so it was that some amongst them wished often to heap reproaches on Our Lord, like men who knew neither what to do nor what to say. And, in truth, to show more fully the suffering that the plain gentlemen and those of the common people must endure, Count Hermann, who was a very great lord of Germany, was so poor that Duke Godfrey had pity on him and delivered to him each day a loaf, and not a large one: the duke could not be more generous to him, because he had not the means, and yet Count Hermann still reckoned this a large ration. And Henry of Hasque, who was one of the finest knights in the army, was likewise reduced to such an extremity and such great poverty that he was dying of hunger. When Duke Godfrey knew this, he had men seek him out and he said to him that he wished him to eat at his table and that he would share the half of his own poor ration with him.

And to speak briefly, it would take too long to tell of all their sickness and many causes of anguish, but Our Lord, who cannot forget mercy in all his works, sent to them a very great comfort, for a cleric called Peter, born in Provence,[95] came one day to the bishop of Le Puy and the count of Toulouse and said to them, overwhelmed with fear, that monsignor Saint Andrew had appeared to him three times at night in his sleep, and had commanded him to go before the barons and to tell them that the Lance that had pierced Our Lord's side on the Cross was hidden under the earth, in the church of monsignor Saint Peter in the city, and he had shown him most surely the place where it was. And he affirmed that he would never have dared to reveal this vision if Saint Andrew had not threatened him at the third time that misfortune would befall him if he did not do so.

It was not astonishing that the cleric feared to say a thing like this, for he was a poor man of humble family who could barely read. But the bishop of Le Puy and the count of Toulouse nevertheless caused the other princes and barons to gather together and ordered the cleric to tell of his vision in their presence. They rejoiced greatly thereat, and believing and taking as true what the cleric said, they all went straightway to the church of monsignor Saint Peter. Confessing their sins and asking forgiveness of Our Lord with tears and sincere repentance, they dug down deep in the place that the cleric showed them, and there they found the Lance of which he had spoken to them.[96] And God knows that each one of them was then as joyful as if he had gained all that he desired. So they sounded the bells and the news ran straightway through the city, so that all came running, great and small, and they all gazed with attention, great humil-

ity and devotion upon this sacred relic newly come out of the earth. The sight of it comforted them all, great and small, rich and poor, as much; it seemed to them, as if they had seen Our Lord. A number of other good people amongst them said and affirmed that to them, too, there had appeared visions of angels and apostles.

Thanks to these happenings, all the people forgot the greater part of their sufferings. The bishop of Le Puy and the other holy prelates who were of the company spoke then to all the pilgrims, and said and explained to them that Our Lord was showing them his help and counsel. And they gave them explanations so convincing that all, both great and small, took courage and strength again, and they swore on the Holy Evangelists and the relics that, if Our Lord brought them forth from the peril wherein they were and gave them victory over their enemies, they would not leave this holy company until they had conquered Jerusalem, with His help, and delivered the Holy Sepulchre from the Turks and the other pagans who held it in their power.

The people of Our Lord having thus received comfort for the great sufferings and the famine they had endured for twenty-five days, all, both great and small, began to beseech one another and to say that it would be good to put an end to their suffering and to wait no longer. And they determined with one accord to fight against the Turks who had besieged them and that, if Our Lord wished to cause them to die at the hands of the Turks, it would be better to die in combat defending the city that they had conquered for the honour and the benefit of the Christians, rather than to faint and languish within it, without having tried to discover if Our Lord wished to come to their aid.

From these words was born such a clamour, and such was the desire to fight in the hearts of the common people, that each time that they saw one of the princes or one of the principal barons, they all said to him that they were delaying too long. When this opinion came thus from the mouths of the common people, the princes trusted that it must come from God, who had put into their hearts the desire to accomplish so noble an undertaking, and they were most happy to accomplish what they demanded. That is why they sent to Kerbogha Peter the Hermit, who was a holy man, wise and knowing how to speak eloquently, and they gave him as companion another valiant man, called Heloyn,[97] who was also wise and courageous, loyal and of great prudence, and who well knew how to speak the language of the Saracens, and most especially the language of Persia. These two having demanded a truce that they might speak to Kerbogha, they went out from the city and were led by the Turks, on his orders, into his tent, where he sat enthroned with his rich men and his great lords. Peter, who was the spokesman, said to him, by way of accomplishing that with which

the princes had charged him, but without greeting him or paying him respect or bow-
ing to him: "The blessed company of princes, barons and the people of Our Lord Jesus
Christ that is inside this city demands of you that you abandon this siege and attack it
no longer, but that you let them hold in peace the city that Our Lord God Jesus Christ
has given up to them that they might preserve His faith and serve Him. For monsignor
Saint Peter, the prince of the apostles, converted it in the first place by his words and
by the miracles that Our Lord wrought through him, even if the men of your religion
conquered it by force from our people no more than fifteen years ago. But now we
have recovered it through the will of Our Lord and we have come into our own again.
This is why you must let us enjoy our heritage and go back into your country. And if
you do not wish to do this thing, know that this dispute must be resolved by combat
before three days have passed. And that you should not complain that we sought the
death of so great a number of men in combat, they propose a wager to you: if you are
ready to engage in single combat, they are ready to send out against you a man as great
as you, that you may fight with him. He of the two who is victorious will win the quar-
rel for ever, without contestation. And if this solution does not please you, choose
a certain number of your men, ten or twelve or whatever number pleases you, and our
pilgrims will send out the same number, and the quarrel will be resolved through them
and no other person may interfere. And those who are victorious in combat will have
won the argument for ever."

When he had heard Peter the Hermit speak thus, Kerbogha was greatly provoked,
and he turned towards him with scorn and said to him: "Peter, it seems to me that those
who have sent you here are in no state to propose a wager to me, nor that
I should be constrained to choose amongst their plans. On the contrary, they have been
reduced by my strength and power so that they are no longer able to do as they wish.
But I shall do just as I please with them. Go away, and tell these jesters who have caused
you to come here that they are so mad that they cannot even understand the dire straits
they are in, for if I had so desired, I could have broken and taken this city long since and
I could have put my men inside by force, so that all whom we found there would have
been put to the sword. But I wish that you should die a far less noble death and that
you should languish with hunger like dogs. And when it pleases me, I shall enter the
city, where I shall take the men and the women I shall find of suitable age and lead them
all to his excellency, the great sultan of Persia, to serve him, and they will be his slaves.
And all the others I shall put to the sword like rotten trees that cannot bear fruit."

Having heard this response, Peter returned with his companion to Antioch, and

he wished to say what Kerbogha had replied to him before them all, both great and small. But Duke Godfrey, who was most prudent, drew him aside, calling to him the princes and the principal barons, and caused him to say to them what he had learned. And when he heard the violent words and the great threats of Kerbogha, the duke forbade Peter the Hermit to tell the men that Kerbogha and his Turks were demanding battle against us, lest they take fright, which Peter did most sagely. But when the common people heard this news, they all cried out with joy in a loud voice: "We want battle, in the name of Our Lord". And to look at them, it seemed, indeed, that they had within their hearts a great desire to fight, to such an extent that they forgot the sufferings to which they had been subjected because they had great hope of victory.

When the princes and barons saw the mood of the common people, they rejoiced greatly and had great confidence in them. For this reason, with one common counsel and accord, they announced to them that the battle would take place on the morrow, whereat they rejoiced extremely and went back into their houses with joyful hearts. You could have seen the armour being examined, the hauberks being unrolled, the helmets being reburnished and the swords and knives being reshaped. None in the city either slept or took rest thereafter, nor the following night; those who had horses were busied about them, attending to all those things that were needful for them. And before night fell, it was commanded that, before sunrise, each man should arm himself to the best of his ability to do combat and that they should make their way to the appointed place, following the banners of their captains.

When dawn appeared, the priests were robed in the churches and sang masses, and all those who were to go to the combat confessed themselves there and received the precious body of Our Lord God Jesus Christ, which gave them perfect security of both body and soul. And each pardoned the other all his resentment and his anger, for they wished to perform in perfect charity the service of Him, who says in the Gospel: "And all will know that ye are my disciples if ye love one another". When all were thus prepared, Our Lord God Jesus Christ sent them his grace, which gave them so great a strength and such great boldness that those who had been listless and thin on the day before and could not stand upright, became so strong and lithe that it seemed to them that their weapons no longer weighed anything. They were so bold and so vigorous that even the smallest had the will to perform great feats in the battle if the chance should arise. The bishop of Le Puy and all the priests wore vestments as if to intone the mass, and they held the cross and the relics, with which they blessed the pilgrims and commended them to God, and they granted them forgiveness for all their sins if

CRUSADERS DRAWING UP THEIR TROOPS IN BATTLE ORDER

*"When dawn appeared, the priests were robed in the churches
and sang masses, and all those who were to go to the combat confessed
themselves there and received the precious body of Our Lord God Jesus Christ,
which gave them perfect security of both body and soul."*

(FOL. 70VA)

The armies are seen preparing for a fresh battle. In the principal picture, Jean Colombe shows the crusaders drawn up in battle order in the open countryside. Following Sébastien Mamerot's text, he depicts clerks and prelates wearing cassocks and surplices together with the soldiers. This fine composition is painstakingly depicted and bears witness to a high degree of artistic skill: the placing of the horsemen in the foreground, the thin tree in the middle of the plain that marks the vanishing point, the line of the horizon revealing glimpses of mountain ranges and the city of Antioch hazy blue in the distance. As always, Colombe has taken great pains to depict the horses. In the lower register, the huge mêlée that was to be a particular feature of this battle is depicted. The victory was won by the Christians.

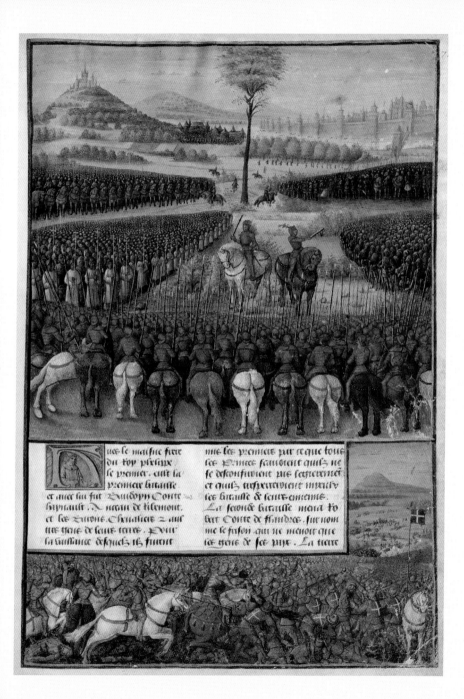

ues le maisne frere
du roy pieux
le premier. eust la
premier bataille
et auec lui fut Bauduyn Conte
haynault. Auram de tiremont
et les autres Cheualiers et aul
tre gens de seule terre. Pour
la suistance desquelz ilz furent

mie les premiers pur ce que tous
les princes sauoient quilz ne
se desconfiuoient pie sectretnet
et quilz tresperceuoient murdre
les bitaille de seul enuemie.
La seconde bitaille mena ro
bert Conte de flandres. sur nom
me le frisbon cui ne menoit que
les gens de ses puys. La tierce

they died in the service of Our Lord God Jesus Christ. And more than all the others, the bishop of Le Puy preached to them and he spoke most particularly to the princes and barons and entreated them to commit themselves most fully in their hearts to avenge the shame that the Turks and the other Saracens had long wished to visit on Our Lord Jesus Christ in the Holy Land. And finally, he blessed them gently with his hand and commended them to God.

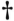

Chapter XXVI.
The great battle of Antioch, as admirable a battle as there has ever been. The way the men were drawn up on the Christian side. Of the rain and of the grace sent by Our Lord to our men's comfort. Of their great boldness. How they helped one another. Of the flight of Kerbogha. Of the defeat of his men and of the great riches our men gained there.

Hugh the Younger, brother of King Philip I, led out the first body of troops: with him were Baldwin, count of Hainault, Anselm of Ribemont and the barons, knights and others of the people of their lands. It was because of their valour that they were put in the vanguard, because all the princes knew that they would not easily be vanquished and that they would cut through the enemy troops the best. The second battalion was led by Robert, count of Flanders, whose second name was Friesian, who led out none but men from his own country. The third was led by Robert, duke of Normandy, who had with him his nephew, Peter, count of Aumale, and all those from his country. The fourth body was entrusted to the bishop of Le Puy, who had taken off his habit and was well armed, mounted on a fine warhorse and bearing the Holy Lance with which Our Lord God Jesus Christ was pierced in the side on the day of his most holy and most beneficial Passion: and he led out the men of the count of Toulouse, who remained behind because he was gravely ill. So the princes left him in the city to prevent those in the keep from attempting a sortie during the battle, that they might get into the city and there kill the sick and the old, which they might most easily have done if he had not been on guard. And they left another two hundred men in the fortress that they had built on the smallest mound inside the city as soon as they had taken it, which they left well defended with catapults to block the passage of the men from the keep. Rainald, count of Toul, led out the fifth body: he had with him his brother, Peter

of Escadenois; Warner, count of Gray; Henry of Hasque; Rouar of Ammellac; and Walter of Domedarc. The sixth body of troops was led by Rambald, count of Orange, Louis of Moccoub; and Lambert, son of Cunes of Montaigu. The most excellent knight Godfrey, duke of Lorraine, led out the seventh body: with him was Eustace, his brother, and those men whom he had brought with him. The eighth was conducted and led out by the valiant, wise and most courtly knight Tancred. The count of Saint-Pol led the ninth, with Enguerrand, his son; Thomas of La Fère; Baldwin of Le Bourg; Robert, son of Gerard; Renaut of Beauvais; and Gales of Chaumont. The tenth was led by the count of Le Perche, who had with him Evrard of Le Puiset; Dreux of Mont; Ralph, son of Godfrey; and Conan the Breton. The eleventh body was led by Isaord, count of Die, who had with him Raymond Pilet; Gaston of Beziers; Gerard of Roussillon; William of Montpellier; and William Amancy. The twelfth was the last, and there were to be found there the greatest number of men: it was entrusted to Bohemond and it was commanded that he should go last that he might bring aid to those bodies that had the greatest need of it. In each of these twelve bodies of troops there were foot soldiers, and it was also commanded that these should go in front and that the knights and men on horseback who came after should guard them and defend them. And proclamation was made throughout the city, forbidding the armies to leave Antioch before Our Lord God Jesus Christ had given them the victory, and ordering that none should be so rash as to think of pillage as long as there remained one single Turk to defend himself. For when Our Lord had put their enemies to flight, then they could come back and gather the spoils without danger.

Kerbogha, too, who from the very beginning of the siege had feared to see our men launch themselves suddenly upon his army, and particularly since Peter the Hermit had been sent to him as a messenger, had commanded those in the keep to sound the horns and to display a banner if they saw that the pilgrims thought to make a sortie. When they were warned by these two drum signals, before the hour of primes, that the pilgrims were preparing to make a sortie, they sent in all haste two thousand mounted archers to guard the entrance to the bridge before they should have passed through the gates. When they came before the bridge, they dismounted straightway, although our men soon forced them back, for Hugh the Younger, who went out the first from the city, led his men to the other side of the bridge that they might cross over and, most particularly, he ordered his archers to fire and launched his foot soldiers against those of the Turks. Seeing that his men were not able to cross over this way at the first assault, he set spurs to his horse and flung himself into the midst of the Turk-

ish archers, and struck so hard to the left and to the right (as, too, did his men, who followed him when they saw his great boldness) that he delayed the Turkish archers from remounting and taking flight, shooting all the while and defending themselves as they fell back, as was their wont. Anselm of Ribemont wrought wondrously there, for he plunged a number of times, quite alone, deep into the midst of the Turks, and opened up a wide space to his men, who often thought to have lost him, but when he got there he did, indeed, open this large space around him. And Hugh the Younger, too, won great renown in this first sortie, in which our men made a glorious beginning.

The count of Flanders, the duke of Normandy and the count of Hainault were also heartily praised and lauded during this initial reversal. And to speak truly, few of the Turkish archers escaped from this, and our men drove them back into their refuges and into their great armies. There befell on that very day a thing that should not be forgotten: when their archers were thus beaten and all our troops were come out of the city as had been commanded before, there began to fall a rain so soft and gentle that one never saw a sweeter dew, so that it seemed to them that it was the benediction of Our Lord God Jesus Christ and the grace of Heaven that descended upon them. And we may, indeed, believe that it was so, for they were all as fresh, strong and lithe as if they had endured no suffering whatsoever.

And this refreshing dew brought well-being not to the men alone, but to the beasts as well, for all the horses of our men, which before were pitifully thin, tired and stricken by hunger, were as fresh, strong and lithe as if they had ever been well treated. And this thing was well known and proved on that same day, for, although for a number of days they had eaten nought save leaves and bark from the trees, they were tougher, more agile and stronger to bear their discomfort during this combat than the horses of the Turks, who had always been fed enough and more.

When all the troops had gone out of the city, the princes and principal barons determined with one accord to make their way towards the mountains, which were almost two miles distant from the city, for if the Turks, whose troops were without number, had gone towards that side and had placed themselves between our men and the city, they would have encircled our people, so that those who might have been fatigued or wounded would have been killed or taken prisoner if they had thought to withdraw that way. And so it was that the troops of pilgrims went out into the open country, without one troop touching the other. When they saw them thus skilfully drawn up and in such great numbers, the Turks were greatly astonished thereat, for hitherto they had thought that they were but a small number of men shut up in the

city, but by a miracle of Our Lord, it seemed to them at that moment that their numbers were as great as their own. Our men, who were thus armed and drawn up in bodies of troops on the fields, had with them as well a number of priests, clerics and men of the Church, clothed in albs, stoles and surplices, each one of whom carried in his hand the sign of the cross. And those who had remained on the city walls were dressed in the same manner, all of them weeping and offering up orisons, and they cried for mercy to Our Lord God Jesus Christ, praying to him devoutly and most humbly to have pity on his people and to save them that day, and not to suffer the infidels and the heathens to cast disgrace upon His name and upon His faith.

On the other side, Kerbogha, who had been warned by a number of people and, indeed, by the vanquished archers that our men were come out of the city and were coming towards him to give combat, gave thought thereupon to their renown, which the Turks had hitherto always scorned and mocked. And so he took counsel of his barons and drew up his troops in all haste, in accordance with the counsels of his wisest men, and particularly of certain natives of Antioch, of whom he had a number with him. And he formed a great body of troops from his finest and his boldest knights, and he entrusted this to Suleiman of Nicaea, of whom we have spoken already, and he commanded him to lead those troops towards the sea before our men had occupied the whole plain between the mountains and the city. He commanded that this great body of troops might come in front of our men when they were vanquished and wished to retreat towards the sea from the city, so that they would then be crushed as if between two millstones.

And as for his other troops, he took his time to draw them up and placed them, some before and some behind, as one who is well versed in the art of war, explaining to his captains that they must carry themselves like great barons and good knights, and that they should not fear our men who were no more, to judge from what he said, than dogs and people dying of hunger, ill mounted, poorly armed and all broken by the long suffering they had borne. Despite what Kerbogha commanded or did, our men reached the mountains and the sea. So then the French, the Normans, the Flemish and the men of Hainault, who made up the three first bodies of troops, moved off somewhat before the others and threw themselves with such speed, force and boldness into the midst of the leading Turkish troops that they broke their formation and opened a space for their companions. A great many Turks were killed there, but there came up to help them so great a multitude of other Turks that all our other troops had to join ranks with the three first bodies, except for that of Bohemond. And horrible it was then to hear those that remained there, for although the Turks were fresh and well nourished, our men cut

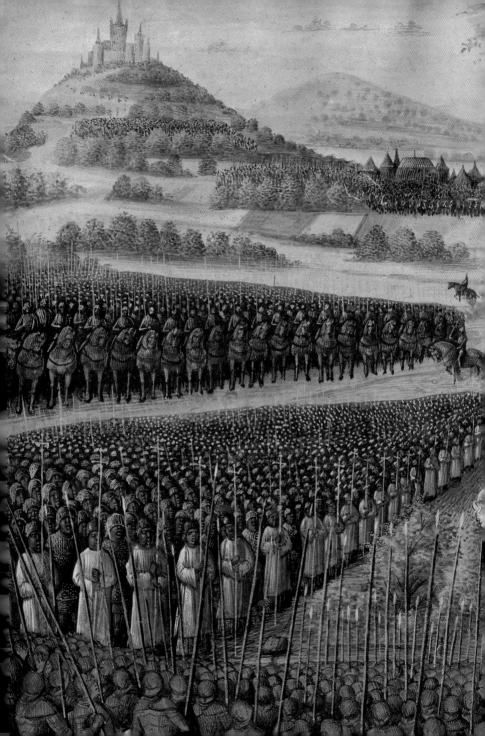

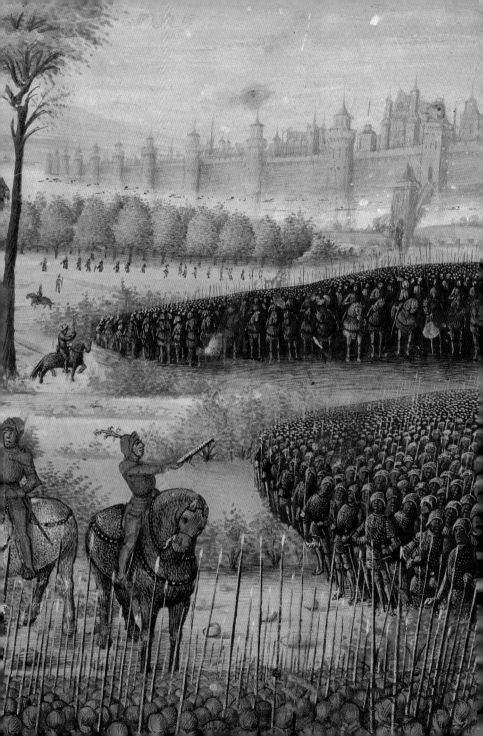

them in two in great numbers. Nevertheless, the Turks succeeded in containing them, thanks to the troops who came unceasingly to their aid. Duke Godfrey observed one of these troops, the greatest of all, which he saw arriving, full of pride, from his window, and thought that, with this troop vanquished, the others could scarce resist. This is why he led his men and his troop as directly and swiftly as he could to meet them.

He forced his way in with such vigour and, no sooner within, he and the men who had followed him performed great feats of arms, maiming and killing so many Turks that the earth was strewn with their bodies and the survivors could no longer resist the might and courage of Godfrey and his men, but took flight in order to save their lives. Suleiman, as we have said, had near him the main body of the army, and when he saw the rout of his companions, advanced. Seeing that Bohemond's troops were not with the others, he now led his men towards Bohemond's contingent and set on his archers. But that tactic was short-lived, for they quickly hung their bows over their saddle-bows, exchanging them for clubs and swords, and so violently assailed Bohemond's men that they all but forced them to retreat, for they could not withstand so great, vigorous and ferocious an attack by so great a multitude. Godfrey realised this from afar and went to their rescue. Tancred, perceiving the straits in which his uncle Bohemond found himself, did the same. So that when they arrived, Suleiman and his Turks were immediately overcome and forced to take to their heels; but having had time to prepare Greek fire,[98] they threw it down on the grass of the fields where they were. The grass was high and tinder dry, the fire took quickly and our men could not pursue the Turks but were forced to retreat because of the violent flames and thick black smoke. The Turks, seeing our knights had retired, now rode down on the infantry still caught in the midst of the smoke and killed numbers of them. But when the pilgrim horsemen heard the cries of their foot soldiers, they straightway braved the fire and the smoke, returning in all haste to where the smoke was densest and there killed and put to flight all the Turks who had entered it. Chasing them down, they killed a great number of them before they reached the main army of the Turks, which had already been defeated.

In the place where this rout took place, there was a little valley in which, when rain fell, a sounding torrent ran, for so people call streams that do not arise from a spring or streambeds in which water does not flow all year round. Those of the fleeing Turks who were able had climbed as far as this valley and there regrouped on a small mound, to the sound of war trumpets, horns and drums. But that was of little assistance to them, for Hugh the Younger, the count of Flanders, Bohemond and Tancred and their men followed so close on their heels, storming up the streambed with such hardihood and

vigour, that they drove in those assembled on the mound and defeated them, forcing them to take flight down into the valley to save their skins. So effective was this that the Turks abandoned all hope of again gaining ground and every man fled in hope of saving himself, however vain.[99]

Kerbogha himself, the prince of the Turkish army, having gauged the danger well enough from the first, had retired to a high and distant hill in order to see which way the battle went and from there frequently sent horsemen to find out how his men conducted themselves. When friends and relatives at his side saw his men in flight, they advised that he, too, should flee. And he was overcome with such fear that, abandoning the rest of his men, without once stopping he changed horses again and again till he had gained the further bank of the Euphrates. When they knew of his flight and found themselves leaderless, the others then began to take to their heels without thought of return. And they had time to escape, because our pilgrims, knowing that their horses were exhausted, did not long follow the Turks for fear of riding their horses to death. Only Tancred pursued some four thousand of them with a small company, killing and striking down all that they could. So filled with fear were their Turkish hearts that ten of our men pursued five hundred or more!

This was a glorious and celebrated victory and no clearer proof could be asked that against the Lord none may ever prevail! No, He does not abandon those who place their hopes in Him, for here a small number, poor, dying of starvation and having come from distant lands, were able to defeat and, indeed, to rout the power of the orientals in their very own country, with the help of the Lord, though the Turkish host was beyond number, had eaten their fill and had all the supplies that they needed. The battle being thus at an end, our victorious men could, on their return, enter the Turkish camp without striking a blow. There they found infinite quantities of gold, silver, precious stones, vessels, carpets and cloth of gold, silver and silk. And there were so many oxen, cows and sheep and so much wheat and flour that the pilgrims were loaded down with their plunder. Thanks to this victory, they gained many fine, well-rested horses; indeed, they wondered that any army could have so many. They also acquired a great quantity of tents and very richly ornamented pavilions – and of these they were in great need, for their own were all rotting. At this great victory, infinite riches of all kinds fell to our men.

But the princes, barons and men hastened to the camp principally to see the marvellous opulence and craftsmanship of Kerbogha's tent. Like a city in shape, with towers and battlements small and large, it was made of fine silk, while narrow covered

streets resembling those of a great city went from the main palace to the other tents and pavilions. The length and breadth of the great hall were such that two thousand men could be seated there in comfort. In short, their tents were so rich and our men found in them such goods and wealth as it would be tedious to tell. And the same is true of the great number of harlots and little Turkish children who had remained inside the camp and whom the pilgrims conveyed to the city of Antioch as soon as they could. Thither they returned in their extreme joy and rendering thanks and praises to Our Lord for the great, renowned and most profitable victory that He had granted them that day, which was the day after the feast of the glorious apostles Saint Peter and Saint Paul, the twenty-eighth day of June 1098.

And the Turks of the keep, who had seen the defeat of their men, immediately asked the princes to let them leave the keep and take with them their wives, children and belongings and leave in safety. This request was granted. So they went forth and abandoned the place, on which were placed the banners of the princes and barons. Great are the works of the Lord, and rightly rewarded they who trust in Him! For the morning before this battle, the pilgrims were so poor and in such dire straits that Duke Godfrey, who had spent almost all his wealth helping poor gentlemen and other folk, no longer had so much as a horse to ride, having to borrow one from the count of Toulouse, a boon granted only reluctantly and after long pleading. And many knights and other great lords, who had reached the army as wealthy men, had by now been reduced to such indigence that they rode that day on asses and mares. Indeed, there were many knights and other very noble lords who found no other recourse but to go into battle on foot alongside the soldiers of the people, which they did with great courage and boldness, exhorting the foot soldiers and advising how they might do most damage to their adversaries. It was never known for certain how many of the enemy had been killed, but there were so many Turks slayed that the power of Persia was much reduced for a considerable time and the Christians (and particularly the French) were thereby greatly honoured, enriched and raised in everyone's esteem.

When thanksgiving had been made by the pilgrims to Our Lord Jesus Christ, to the very glorious Virgin Mary, His worthy mother, and to all the saints in Paradise, on the advice of the bishop of Le Puy, they ordered that the church of Saint Peter, which was the main church of the city, and all the other churches of the city, too, should be swept clean of the sullying marks of idolatry left by the Turks and that they should again be blessed and dedicated as required. And they assigned to each priest, canons and other dignities and offices, on whom they bestowed rents and revenues,

enriching and clothing them magnificently, so that they might do holy service. For this purpose they spent and employed huge sums of gold and silver. For, according to master Vincent of Beauvais in his *Miroir historial*, there were three hundred and forty churches in the city of Antioch.

They were reluctant to dismiss the incumbent patriarch of Antioch, but he himself resigned of his own free will shortly after their arrival because he was Greek and could not understand the pilgrims. So the pilgrims appointed in his place a Latin named Bernard, who was born in Valence in France. He had come with the bishop of Le Puy as his chaplain; the bishop had shortly before made him bishop of Artah. They raised Bohemond to the rank of lord of Antioch, as they had all agreed and promised with the exception of the count of Toulouse, who opposed this.[100] He for some time retained control of the Bridge Gate and certain other nearby towers that he had garrisoned, claiming them as his share of the city. Bohemond was, however, considered from that point on by the inhabitants of the city as their lord and called prince of Antioch and the greatest of all the lords aforementioned, because those of his own land had always called him prince, and for this reason, the name remained for ever attached to the city of Antioch and the lordship of the city, and thus to those who came thereafter to be lords of that city.

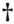

Chapter XXVII.
How Hugh the Younger and Baldwin, count of Hainault, were sent by the princes of Antioch to Constantinople. How they were surprised en route. The death or capture of Count Baldwin. The return to France of Hugh. The terrible sickness abroad in Antioch. The death of the bishop of Le Puy. Why the barons set out into divers regions. Of the great conquests of Duke Godfrey and how the inhabitants of Edessa and Balak attempted to betray Baldwin of Edessa.

When they had taken the necessary measures at Antioch, the princes and barons met in council to decide what they should do. They finally resolved to send messengers to Constantinople, to the emperor Alexius, asking him as a pledge of his loyalty and in fulfilment of his promise to come in person with a large army and join them as soon as possible so that they could complete the great expedition that he had enjoined them to undertake and more especially assist them to conquer Jerusalem. They also wished to inform him that, should he not respect his promise and come in person without

further delay, they would no longer be bound by the promises that they had made him, and rightly so, if he was not honouring his own. To make this journey, they chose Hugh the Younger and Baldwin, count of Hainault. These two were caught en route by a Turkish ambush, by which they were suddenly assailed and carried off to lands so remote that nothing further was heard of them. But Hugh the Younger contrived to escape safe and sound and, arriving in Constantinople, came before the emperor. Having been entertained for several days, he took his leave and returned to France, to his great dishonour, without regard for those who had sent him or for his great lineage or his vows and promises, and this though he had proved himself till then very noble, courteous and courageous.[101]

What is more, a few days later there arose in Antioch an epidemic so fatal that no day passed without thirty or forty coffins being seen in the churches and the number of the dead grew such that no pilgrim expected anything but death. Almost fifty thousand men, women and children died during this epidemic. And amongst their number was the very wise, renowned and reverend father, Monseigneur Adhemar, the bishop of Le Puy, whose wisdom in counsel had made him the very backbone of the army. His death caused great lamentations and grief amongst the pilgrims in the city. His body was buried in the church of Saint Peter, at the very place where they had found the Lance that pierced the side of Our Lord. Another of those who perished was Renaut of Ameillac, a knight of great valour and high birth, whose body was interred beneath the porch of the church of Saint Peter. Henry of Hasque died, too, at the castle of Turbessel,[102] where he had gone to rest. He was buried there amidst lamentations, tears and regrets. According to some doctors, the cause of this epidemic was the corruption of the air; for others, it arose because our men had suffered too great a hunger and when abundance returned, ate excessively. And this latter opinion seemed the more truthful, for those who ate least recovered their health easily.

When the princes and barons saw that the epidemic was continuing and that the common people were beginning to demand that they leave for Jerusalem, they met in council. Their views were various: some said that it was best to go as directly and quickly as possible to Jerusalem, since the people incessantly demanded this and everyone was anyway honour-bound to do so; others that the weather did not favour this enterprise, the heat being too great and the drought such that they would need much water; also that the army would not find enough wheat for the men nor pasture enough for the horses; for these reasons, it was best to wait until the feast of Saint Remigius, when the weather would be more temperate. Meanwhile, the horses could be rested and new horses

sought; the people, too, would be refreshed and the sick and the weak could regain their health and strength. All agreed this last course was best, but the princes and barons decided to leave Antioch both in order to avoid its pestiferous air and to find cheaper provisions. Bohemond went down into Cilicia, where he took and garrisoned with his men Tarsus, Adana, Mamistra and Anazarbus, so that the entire region was subject to him. Others went far from the main body of the army into neighbouring cities in order to seek rest for themselves and their horses. But many knights and foot soldiers crossed the Euphrates and went to Baldwin at Edessa, where he welcomed them with great joy.

During their stay, he gave them provisions in abundance and bestowed handsome and rich presents on them when they wanted to depart. During this time, it happened that Ridwan, the lord of Aleppo, decided to seize a fortress of these marches, a castle called Azaz.[103] It is there that the game of chance was invented, or so it is said. While thus besieged, the lord of the castle, realising that he was not powerful enough to resist the siege and that he would have no help from the Turks of his religion (since they lived in fear of the power of Ridwan), secretly sent messengers to Duke Godfrey, whose courage was so renowned, sending him his son as a pledge that he would acknowledge Godfrey's suzerainty over himself, his castle and all his goods. Godfrey decided to attempt the affair and asked his brother Baldwin to bring as many men as possible, telling him that he intended to raise the siege of Azaz. And he immediately set off with his army, taking as direct a route as possible and making long marches.

When they saw that help was coming, the messengers of Azaz took two pigeons that they had brought for this purpose – the siege of the castle preventing anyone from entering – and tied their feet together. When he saw this, the lord of Azaz understood that help was coming. This gave him the courage to attack Ridwan's army, which hitherto had so terrified him that he had not so much as shown himself at the battlements. Baldwin, too, did everything he could and arrived with three thousand horsemen to join his brother, the duke, one day's march from Azaz. On Baldwin's advice, Duke Godfrey sent to ask the other princes and barons who had remained behind in Antioch to come to his aid, along with his friends and companions, in order that he should succeed in his undertaking. He had already, before his departure, with the greatest consideration requested the help of Bohemond and the count of Toulouse, but they were nettled that the Turkish lord of Azaz had preferred to appeal to Duke Godfrey and, therefore, refused to accompany him. But when he again petitioned them, it seemed that they could no longer remain behind without great dishonour. Therefore, they quickly put their armies in fighting order and followed him. There were then nearly

*"Almost fifty thousand men, women and children died during this epidemic.
And amongst their number was the very wise, renowned and reverend father,
Monseigneur Adhemar, the bishop of Le Puy, whose wisdom in
counsel had made him the very backbone of the army. His death caused
great lamentations and grief amongst the pilgrims in the city. His body
was buried in the church of Saint Peter, at the very place where they had found
the Lance that pierced the side of Our Lord."*

(FOL. 75VB–76A)

The death of the bishop of Le Puy, Adhemar of Monteil, on 1 August 1098, like the death of Godfrey two years later, is one of the most tragic events of the First Crusade. Adhemar was one of the most important figures in this crusade; not only was he the legate and representative of the Pope, but for the crusaders, he was the supreme authority, and he was mourned by all the Christians. The upper miniature shows the funeral procession of Adhemar, who was buried in the church of Saint Peter in Antioch. A throng of monks accompanies his body. The church's façade, with its three monumental porches richly adorned with statues, provides a sumptuous setting for the scene. In the lower register, Jean Colombe has painted a group of elegantly dressed young horsemen, wearing caps decorated with white plumes. These may be crusaders who have paid a visit to Baldwin at Edessa and are returning laden with gifts.

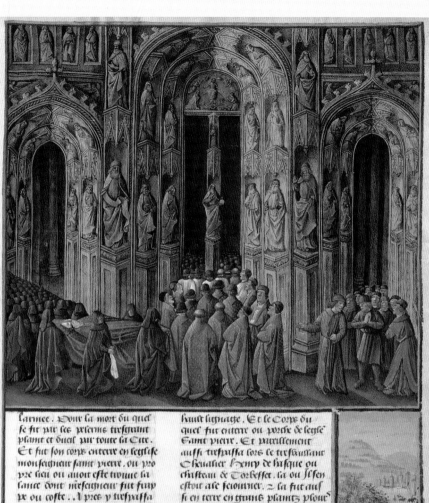

larinee . Dont la mort du quel
se fir pur ses psalmes tresgrant
plaint et dueil pur toute la Cite .
Et fut son corps enterre en leglise
monseigneur saint pierre . ou pro
pre lieu ou auoit este trouue la
saincte dont nresseigneur fut serp
pe ou coste . Apres y trespassa
Reynault de ameillac Cheualier
de moult grant vaillance z de

haut lignage . Et le corps du
quel fut enterre ou porche de leglise
Saint pierre . Et pareillement
aussi trespassa lors le tresvaillant
Cheualier Henry de busque ou
chasteau de Torbesset . la ou il sen
estoit ale seiourner . z la fut auf
si en terre en grans plaintz plours
et Regretz . Loccasion de celle mor
talite disoient les aulcuns medecins

thirty thousand men bearing arms around Godfrey. Ridwan was warned by his spies and conceived such a fear of them that he dared not abide their arrival, though he himself commanded forty thousand Turks. So he returned to Aleppo.

Godfrey as yet knew nothing of all that but was still at the head of his army when he learned that around five thousand of Ridwan's Turks had surprised pilgrims coming from Antioch to assist him and had killed some of them in situ and carried away others to their castles and fortresses. He, therefore, turned back and made such haste towards them, reaching them by a short-cut shown to him by locals and charging them down before they could take refuge in their castles. And so hard did he press them that almost all of them were killed or taken and the Christian prisoners freed. Very few Turks survived. This was a great disaster for Ridwan, for they were the best and most courageous of his entire army.

The duke then turned his army back towards the castle of Azaz and on his way encountered the lord of Azaz, who had anticipated his coming and met him with three hundred horsemen. Dismounting, the lord knelt and humbly thanked him, first Godfrey himself and then all the other princes and barons, for the help they had brought him when he was in dire need. And he swore that, as long as he lived, he would remain loyal to them and the other Christians. He would seek whatever was good and profitable and honourable for them and would protect them in all that he might against any harm. The duke, the princes and barons slept that night at the castle and Count Baldwin returned the following day to Edessa and the others to Antioch, with the exception of Count Godfrey. A few days later, ceding to the request of his brother Baldwin, who wanted him to go to Edessa, where he might see him more often, Godfrey set off towards the castles of Turbessel, Hatap and Ravendel with the poorest of his army and subjected all the land thereabout. He often came to see his brother Baldwin, who only just escaped death at the hands of the inhabitants of Edessa. For when certain amongst them saw that he was no longer as affable as he had been at the outset and that the multitude of pilgrims coming to his court at Edessa and remaining there with him because of the great gifts that he bestowed on them, had swollen his pride, they organised a plot against him and decided to have the Turks kill him, the Turks being very happy to hear of this enterprise. But one of the conspirators was a friend of Baldwin's and informed him. He, therefore, ordered an investigation, seized the principal malefactors and inflicted severe punishment. Some were blinded, others – less guilty – were exiled and their goods forfeited. He let others remain, but confiscated most of their possessions, an amount that came to twenty thousand bezants.[104] This he very generously shared out amongst

the pilgrims who had helped him take castles and strongholds and cities in the vicinity of Edessa. And he gave such great gifts, undertook such great enterprises and made such conquests that none of his neighbours any longer dared oppose him, though the great lords of the region would have liked to find some means to be rid of him.

Now there was in these marches a great Turk named Balak, lord of the city of Saruj[105] before it was conquered by our men. Seeing that Baldwin no longer counselled him as he had done before nor showed him so favourable a countenance, intending treachery he one day took him aside and told him that he wished to bring his wife, children and all his worldly goods to Edessa. He wished, he said, to hand his castle to Baldwin, since the Turks and the other members of his family hated him and sought to do him harm because of his acquaintance with the Christians and the love that he showed them. Baldwin saw no harm in this and, on the day agreed with Balak, went with two hundred horsemen to take possession of the place. The latter had secretly brought within the walls great numbers of armed Turks so that they might capture the count as soon as he entered the city. Thus, when Baldwin reached Saruj, Balak invited him to go up onto the walls of the city to see how well fortified it was. But he should bring only a few of his men, lest his belongings, still scattered outside the castle, be stolen. Baldwin trusted him and was about to comply. But certain wiser comrades dissuaded him, fearing the treachery of this Turk, whom they knew to be malevolent. Baldwin, following their advice, first sent twelve valiant and well-armed men into the tower to see if there was anything amiss, whereupon the Turks ran out from their concealment and pursued and seized the twelve.

When the uproar came to Baldwin's ears and he understood that he was betrayed, he took up a position close to the tower and, saddened, called to Balak, demanding of him on the oath of allegiance that he had sworn to restore the captured men to him or at least let them be ransomed, since he would pay a great deal for them. Balak replied that he would have not a single man until he had restored to him his city of Saruj. So the count, hearing this reply and seeing the power and the great garrison of the castle, returned to Edessa in great dudgeon. But some days later, it happened that a valiant knight called Robert of Chartres, to whom Baldwin had entrusted the safety of Saruj, having heard of the treachery of Barak, left Edessa with a hundred horsemen. One night he placed himself in ambush near the fortress where the twelve prisoners were kept and the next day galloped past the city, in order that the enemy should come forth. Many men from the garrison were provoked by this and chased after him, thus falling into the ambush; a number of the men of Saruj were killed. The others returned

to the fortress, whence six of the prisoners were delivered in exchange. Shortly afterwards, four of the prisoners escaped. Meanwhile, Baldwin had another great Turk beheaded.[106] The man often came to meet him in Edessa, promising to hand over his castle to Baldwin; but when Baldwin asked him to deliver the castle, the Turk asked him for more time and became evasive. Following these events, Baldwin avoided an alliance with all Turks, not merely with those with whom he had already had dealings and but with others, too.

Chapter XXVIII.
How the count of Toulouse captured the city of Albara and how the great army left the marches of Antioch to go to Jerusalem. The taking of Maarat. The debate about Maarat between the count of Toulouse and Bohemond. Another epidemic afflicting our men. And the great attacks and gains made by the count of Toulouse at the outset.

Raymond, count of Toulouse, vexed at having been so inactive in the taking of Antioch, gathered his men and took a large number of the pilgrims still in the city and went to besiege the city of Albara, which was two days' march from Antioch. Though it was defended, he forced the citizens to surrender the city. Based in this city, he commanded the entire region, and thanked the Lord for it. He asked the patriarch of Antioch to assign to Albara a good and true man named Peter, a native of Narbonne, who had come with Raymond from France, and to make him archbishop of Albara. But the epidemic was still raging in Antioch; indeed, a goodly number of Germans, having just arrived from their own country and staying in Antioch, died of the epidemic almost to a man. This plague raged for three entire months, in which time there died at least five hundred knights and a quantity of mounted nobles and of common people so great that their numbers could never be known. By the first day of November, all the princes and barons who had left Antioch because of the epidemic had returned, as they had promised. And they decided to go and besiege the stronghold of Maarat, which was just eight miles from Albara, since they would not otherwise be able to control the common people, who ardently desired to continue on to Jerusalem. And on the day agreed, the count of Toulouse; Duke Godfrey; Eustace, his brother; the count of Flanders; Tancred, duke of Normandy; and their men set out to lay siege to Maarat.

The inhabitants of this city were very rich and proud and particularly despised the pilgrims at the outset because they had, earlier that year, taken arms against certain of our men in a minor battle and killed some of the best of them. All the prouder, therefore, they raised crosses on their walls and spat on them under the eyes of the pilgrims to show their derision of our faith. Moreover, they shouted many insults. And consequently, the princes and barons, incensed at this, commanded an attack, which was carried forward with such vigour that they would have taken the city on their very first assault, having only arrived the day before, had they had ladders. Bohemond arrived on the third day. He established his men on the side of the walls where there were no besiegers. And our men then made hurdles[107] and ladders and set up catapults that filled in the moats. Then they set to mining the walls and, though the inhabitants defended themselves with great ferocity, throwing a great many kinds of missiles and other objects down on the attackers, they failed to wound any of our men – God be thanked, who ensured their safety and gave them the strength and courage to take the city by storm, which they would have done but for the fall of darkness. But before dawn, the inhabitants, having lost all hope of surviving the siege, carefully concealed themselves and a part of their wealth, and descended to deep cellars and caves. Unaware of the inhabitants' fear, the princes had the gates and city carefully guarded so that none might escape and had a watch set over the siege.

But some of the common people, seeing no one on the walls and hearing no sound from within the city, crept out of the siege-camp and easily made their way into the city with ladders, for they found no one on the walls or, indeed, in the city. And therefore, they doubtless took whatever they found. This they did out of great need, for they had suffered hunger and penury. And when morning came, the princes and other nobles entered the city, but found little there, for the first of the common people to enter had taken everything there was to take. But they discovered soon after where the Turks were hidden and starved them out. And a great number were killed at that point and the survivors made prisoners.

Thus, the city of Maarat was taken. There the very religious and venerable William, bishop of Orange, died of illness, a man who greatly loved Our Lord. A fortnight after the capture of the city, the duke of Lorraine and the count of Flanders returned to Antioch. After their departure, a great debate arose over the city of Maarat between the count of Toulouse, who wished to give the land to the archbishop of Albara, and Bohemond, who was unwilling to part with his share if the count would not surrender the towers that he held in Antioch, which the count refused to do. Therefore, Bohemond

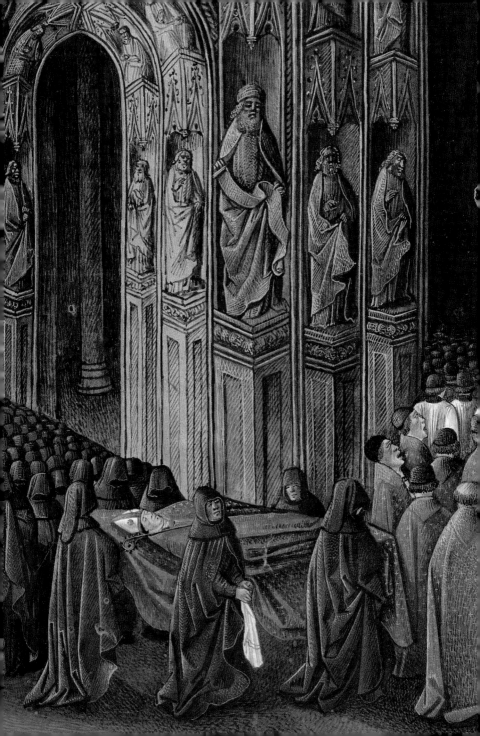

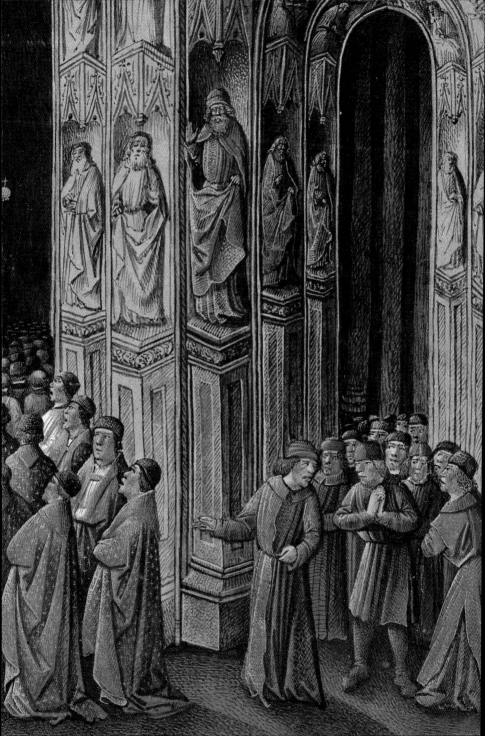

left Maarat in high dudgeon and, on his arrival at Antioch, attacked the towers belonging to the count with such violence that their garrison, perceiving that they could not hold out against this assault, quickly surrendered. During this time, the count, seeing that he was now alone in Maarat, gave the city to the archbishop of Albara. But a few days later, he joined the other princes and barons at the city of Rugia, which is midway between Antioch and Maarat, and held a council to determine the route that they should take to go to Jerusalem. Angry at the strife between the two princes on the subject of Maarat and sorry that men should be taken from their great army in order to garrison this and other cities, the common people assembled and by common agreement demolished the walls and towers of this city in spite of the archbishop, to whom they were violently opposed, for they did not want the count any longer to stay in this region because of Maarat. When he saw this, the count, on his return, was extremely angry. But he realised that it was beyond remedy and so concealed his fury.

The common people now came together in a mob, endlessly crying out to the princes that they should lead them to Jerusalem and that, if they would not do so, they the people would themselves choose a knight and follow him to the Holy City so that they might fulfil their vows and complete their pilgrimage. And, if the truth be told, during the three and a half months in which they had occupied Maarat, the pilgrims had suffered a terrible famine, from which many died. The famine was such that many ate human flesh and other things that were neither good nor fitting food. The result was a great loss of men, for the famine that they had endured during the siege of Maarat had killed many of them; others died in action or of illness. Amongst those who died was the very valiant young knight Enguerrand, son of Hugh, count of Saint-Pol, who was much lamented by the army. When the count of Toulouse saw the great fury of the common people and understood the dangers that they had endured, being anyway through true compassion inclined to satisfy their requests and their humble petitions, he informed them, contrary to the word of the other princes, that they would leave for Jerusalem a fortnight from that day. Moreover, to alleviate their ordeal and particularly their hunger, he took a part of his cavalry and foot soldiers, the strongest and most able of his men and, leaving the rest in the city, led them out into the territory of his enemies. There he took by force and demolished towns, castles and strongholds and brought back a great quantity of cattle and other victuals, which he divided up equitably at Maarat amongst those who had and those who had not accompanied him. In this way, they were all enriched with gold and silver and well provided with victuals.

Chapter XXIX.

How the count of Toulouse departed from Maarat with his great army, burned down the city, and set off for Jerusalem. Of the other lords who followed him. Of several towns that they took, the inhabitants of which fled when they heard of the arrival of the army. How the count of Toulouse received a present from a Turk and raised the siege of Jebeil to his own dishonour. Of the death of Anselm of Ribemont.

At the request of the count of Toulouse, the archbishop of Albara appointed a guardian and a captain in his city and set off towards Jerusalem with the count. When the day came for the expedition to continue, the count, wholly unable to hold back the common people, left Maarat, which he had had burned to the ground, and led the great army of pilgrims forth. By now, however, there were only around five thousand men, amongst whom only three hundred were mounted. After his departure, the duke of Normany and Tancred immediately followed and joined him. And though they had been so numerous in the beginning, each of these princes now had in his company scarcely more than forty mounted men, though there were great numbers of foot soldiers. The army thus assembled found abundant provisions en route, for they went through Shaizar, Hama and Homs,[108] whose lords willingly made them great gifts of gold and silver and presented them with oxen, cows, sheep and other provisions at reasonable prices. Moreover, each guided them across his own territory. Thus, the army increased and its situation improved day by day, and everywhere the pilgrims found easy passage and good horses, which they had sorely lacked. Finally, they had over a thousand mounted men, even before the arrival of the other princes.

Since leaving Maarat, they had been marching far from the coast and had gone in peace, save the attacks of a few thieving and pillaging Turks who followed the army or marched beside it through woods and hidden paths. Thence they sprang out in surprise attacks and struck suddenly, attacking the weak and the sick who remained behind the army. The count of Toulouse, therefore, set an ambush for them with some of the strongest and best-mounted pilgrims. The Turks suspected nothing and threw themselves, as was their wont, upon a few poor pilgrims on foot who had cunningly been allowed to straggle behind the army. The count with his ambush caught the Turks

between his men and the main army and pressed them so hard that he cut them to pieces excepting only a few, whom they made prisoner. In this way, the count gained many horses and many suits of armour, which delighted the army on his return. This prevented such banditry thereafter. Moreover, the castles and cities on their route, on either side, made them liberal provision of victuals. For there was no lord who did not make them great presents in order to avoid being plundered. And they had victuals of all kinds delivered to the army very cheaply, save the garrison of a castle so powerful that they never so much as deigned to send presents to our men, but came down from their stronghold in an attempt to stop them passing.[109]

But our men attacked them with such violence that they were almost all killed or made prisoner. Then, knowing that the garrison of the castle had been eliminated, they climbed the mountains and took possession of the castle, which they demolished, setting fire to the houses after they had taken what in them was worth taking. They brought from this city a great number of horses that they found grazing in the nearby pastures. And the messengers of the great lords of the cities and towns of the regions nearby, who had come to our men bringing presents in order to persuade them not to attempt their destruction and also to spy out how they did things, when they saw how strong they were, how valiant and how sensible their actions, and that wherever they went they did exactly as they wished and no one could prevent them, they returned to their lords and told them that the pilgrims were very proud and courageous men. And the result of this report was that more presents and provisions were brought from all sides to the army, without payment, so widely feared were the pilgrims.

The princes then hastened forward and crossed the entire region in very few days, arriving in the land of Phoenicia, where they established their men in the plain, near a very large and strong city called Arqa,[110] which lies at the foot of mount Lebanon, on a steep, high hill, four miles from the sea. This city is very old, for it was founded and named after himself by the Arkite, son of Canaan, son of Ham, son of Noah. Six miles from this city was the very rich and powerful city of Tripoli.[111] In each of these cities – but also in other cities, towns and castles – there were great numbers of pilgrim prisoners, who had been brought there by the Turks and even by some Christians. For it must be said that during the siege of Antioch and after its conquest, many of them had gone hither and thither in the most haphazard way to look for food, and for this reason, the inhabitants of the regions in which they made their raids had pursued them and, killing some and often capturing many, kept them in prison in the hope of obtaining money or exchanging them for their own prisoners if necessary.

The city of Tortosa[112] was also nearby and so two hundred pilgrims who had chosen as their captain Raymond Pilet[113] left the siege and camp before Arqa and launched an attack on Tortosa. The following day they forced their way into the city and laid hands on great riches and goods, which they found without defence because the Turks had fled during the night and, taking only their wives and children, retreated into the mountains that surrounded their city. Moreover, when the month of March had come, the people who had remained in Antioch appealed tirelessly to Duke Godfrey and the count of Flanders to set off after the others, the news of whose great successes filled the region. The two princes and the other barons and pilgrims from Antioch set off as soon as they could and came to Lattakieh in Syria, where they numbered twenty-five thousand men, all well armed, relative to their rank. Bohemond accompanied them so far and then took his leave and returned weeping and regretful (though with their consent) to Antioch, which he was to guard. And this was, indeed, necessary, for it had only recently been conquered.

In the city of Lattakieh, Guynemer, the sea-rover born in Boulogne, who had been captured by the inhabitants during an attack he had attempted at the outset, before the capture of Antioch, was held captive. Godfrey asked that he be freed and they released him and his galleys. The duke had him take his boats and go back on board his galleys and thus accompany the army along the coast. Seven miles from Tortosa lay Jebeil,[114] which Godfrey and his men straightway besieged. A magistrate of the caliph of Egypt, who held the city in the name of the caliph because it is the first city under his suzerainty on the Egyptian side, came out and spoke to Count Godfrey, offering him six thousand bezants and several other large presents if he were willing to raise the siege. But the duke replied that Our Lord would never permit such a betrayal and that he wished to hear no more of it. The magistrate then sent a messenger to the count of Toulouse, who was besieging Arqa. And the count, taking the money, invented a story and told the duke and the count of Flanders that the great sultan of Persia, having been informed of the defeat of Kerbogha, was sending a still greater army against the pilgrims. And he asked that they might all, for this reason, abandon the siege and march towards him so that they should all be together. The duke and the count, having heard and believed this news, immediately lifted their siege and set off as quickly as they could.

Passing before the city of Banyas, which lies beneath the castle of Margat,[115] they came to Marqiye, the first city of Phoenicia on the north side. From there they came to Tortosa and left their fleet for some days moored by a neighbouring island. Then

they came in all haste to the city of Arqa. Tancred came out to meet them, leaving the siege and revealing to them the imposture of the count of Toulouse. They were so angry that they were unwilling to camp near the count, but withdrew far from him. When the count learned this, he sent them messengers with great gifts; they made excuses for him with fine words and appeased all the princes and barons except Tancred, who could never agree with him and accused him of all kinds of things. At all events, prior to the arrival of Godfrey, the count's men, showing themselves incompetent in their assaults on Arqa, had suffered such losses that some said that Our Lord must have withdrawn his aid because of their sins. Amongst others, the very valiant and renowned knight Anselm of Ribemont was killed there by a stone during an attack, he who had done so much good in the army. As he was dying, he three times very devoutly said "Deus, adjuva me", which is "God, help me". And when he had said this for the last time, he gave up the ghost. And I believe his soul is in glory, for he had been very Catholic and very devoted to the bishop Saint Quentin during his earthly life. There, too, another knight, a great lord and close friend of the count of Toulouse, by the name of Pons of Baladur, was killed by a stone.

During this siege, a great dispute arose amongst many members of the army; some said that the Lance found in Antioch was that which had pierced the side of Our Lord, others that it was not. There the cleric to whom the revelation had been vouchsafed offered to walk through a great fire.[116] And, at the demand of many, he entered the fire and emerged unscathed, but died only a few days later. This increased the murmuring in the army, though those of his party claimed – which may well have been true – that he died only because he was crushed by the press of those who had rushed to embrace and congratulate him, testifying to their wonder at seeing him come forth safe and sound or again because Our Lord thus permitted him to die, having clearly approved his revelation by a miracle.

Chapter XXX.
Of the messengers from the caliph of Egypt and of the emperor of Constantinople and the defeat of the Tripolitans. How the siege of Arqa was abandoned. Of several cities through which the pilgrims passed. Of the Christians of Jerusalem and how the city of Bethlehem was surrendered to Duke Godfrey.

During the siege of Arqa, the messengers that the pilgrims had sent to Antioch arrived at the same time as those from the caliph of Egypt, the caliph having detained them by force and by trickery for nearly a year. With them he sent some of his own messengers, who brought offers very different from those that he had made at Antioch. Then he had told them that, if they turned their might valiantly against the sultan of Persia, they would have considerable assistance from him in men, money and provisions. But via these last messengers, he informed them that he would do great things for them, he believed, if they agreed to go to Jerusalem in parties of only two or three hundred pilgrims and without arms; in this way they might all return safe and sound after making their prayers. When they heard these words, the princes and barons were greatly angered and began to hold the caliph in profound contempt. So they told the Egyptians to return to their master and tell him from them that they would never go unarmed to Jerusalem with his authorisation and one after another, but they would all go there together, with the aid of Our Lord Jesus Christ, with their troops in battle order and their banners raised.

Their reason for refusing the caliph's offer was this: since our men had defeated Kerbogha, the sultan of Persia had been so weakened that his neighbours no longer feared him, whereas before none would have dared stand up to him. And since then his position had steadily deteriorated. Of particular note was the fact that a high constable of the caliph of Egypt named Emirey[117] had very recently taken Jerusalem from the sultan of Persia, in whose hands it had been for thirty-eight years. The caliph's pride had been so swollen by this event that he no longer feared any power at all and thought that nothing could harm him. At the same time there came messengers from the emperor Alexius, who complained bitterly of Bohemond and the other pilgrims, declaring that all the princes and barons had become liege-lords of the emperor and that they had sworn to him, indeed, promised on the holy evangels, to take no profit from any of the

"Besides, those in the great army slept not the whole of that night,
so great was their longing to see the Holy City, which they knew that they
would most surely see on the morrow, for it was to visit this place that
each one of them, according to his rank, had left his country and the place
of his birth and had endured countless hardships and great grief and sickness."

(FOL. 85VA–85VB)

On 7 June 1099, about a year after the conquest of Antioch, the crusader army arrived at the gates of Jerusalem – their final destination. Sébastien Mamerot gives a lengthy description of the city of Jerusalem in this chapter. The upper scene shows the crusaders' first view of the Holy City. Colombe has depicted it in the foreground in an idyllic Arcadian setting with shepherds peacefully playing a recorder and a bagpipe. A little further back, he conveys, by means of huge rocks that tower up on each side of the picture, an impression of the deep valleys that surround the city. Finally, the great height of the city itself is revealed: gates, towers, ramparts, monumental buildings and shrines are massed together. It is impossible to identify for certain the places represented, but the artist suggests the great number of Holy Places and churches in the city: Jerusalem, the scene of the Passion of Christ, had been a place of pilgrimage since the fourth century. The principal picture shows a group of admiring visitors who appear to be exploring the city. In the lower register, the same visitors are gazing at the craftsmen – masons and stone carvers – who are working on the fortifications of a tower.

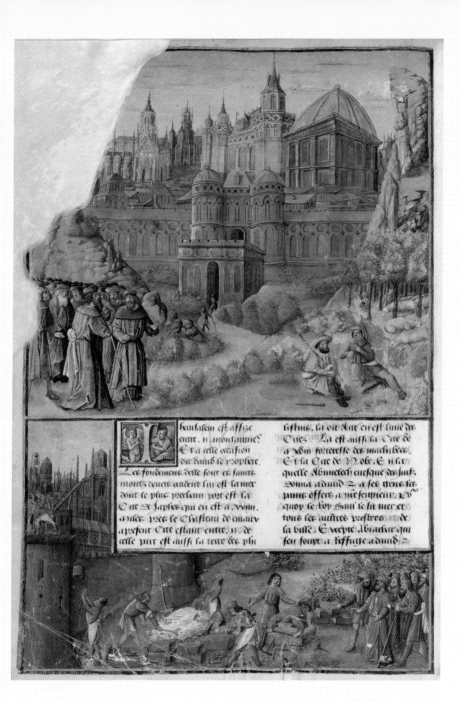

erufalem eſt aſſize
entre .ıɪ. montaignes.
Et a celle occaſion
dıt dauid ſe propbete.
Les fondemens delle ſont es ſamts
mons deuaıt ardent luı eſt ſa mer
dont le plus prechaın port eſt la
Cıte de Iappes quı en eſt a .xviiı.
mıles. pres le Chıſteau de emaus
a preſent Cıte eſtant entre. en
celle part eſt auſſi ſa terre des phı

lıſtıns. la ou Nar en eſt luie de
Cıtes. La eſt auſſi ſa Cıte de
a Nom forterefſe de machabees.
Et la Cıte de Nobe. E nſi
quelle Abnmelech euefque des ſaıt
donna a dauıd .z. a ſes troıs ſer
uaıs offert a nre ſeıgneur. pou
quoy ſe roy Saul le fıſt tuer et
tous ſes aultres preſtres. de
ſa uılle. Excepte Abıathar quı
ſen fouyt a refſuge a dauıd .z.

287

cities, towns and castles that had previously belonged to the emperor of Constantinople and to restore them to him as soon as they were taken, and that this promise included Jerusalem. And nevertheless, he alleged, Bohemond and many others had acted in breach of this agreement and their promises. He complained of this and demanded to know the reason.

When they heard these petitions, the princes and barons made reply that the emperor, too, had sworn, when they made the agreements cited, that he would come and follow them as soon as he could with the power of his empire to help them capture towns, cities, castles and countries, and indeed, that he would come with them as a true crusader and pilgrim of the Holy Sepulchre; that he would have delivered to them by sea a great quantity of provisions and other necessities, which they would pay for, and that the price would not be high. But he had done none of this, though they had often asked him to. And since there was no law obliging men to keep terms with one who broke them, they had abandoned their alliance with him and had rightly granted to Bohemond and other princes and barons the city of Antioch and the cities, towns and castles that they had conquered and which they now wanted to keep against all-comers, for themselves and their heirs in perpetuity.[118]

When the messengers of the emperor were informed of the resolute decision of the princes, they begged them at least to wait and go no further, so that the emperor, who was, they said, due to arrive very soon with an immense army, could share with them in the conquest of Jerusalem. And if they were willing to wait, he would be most grateful, and would make great and valuable presents to the princes and barons and salary the foot soldiers. At this the count of Toulouse rose to advise them that they should wait for the emperor. But the others thought that he said this merely in order to maintain the siege of Arqa and countered him, recalling the delays they had experienced with the emperor and the little help that they could expect from the Greeks. There arose amongst the princes a fierce dispute on this subject, with the result that the magistrate of Tripoli, who was under the command of the caliph of Egypt and had shortly before offered a great sum of money if they would raise the siege of Arqa and spare Tripoli and its territory, would no longer hear of a treaty, but said that he would fight our men.

Hearing this proud declaration and having deliberated on the question, they left the archbishop of Albara in command of the camp and the siege and, with their troops in battle order, they set off for Tripoli. The magistrate and the lord of Tripoli had left before them and had already put their men in battle order to face our army, for which

they had little enough respect, given that the count of Toulouse had already besieged Arqa for two months without effect. But as the two armies came together, our men threw themselves upon the enemy with such vigour that they immediately fled to their city. And when they entered the citadel, they were pressed so hard that seven hundred of them lay dead on the field while amongst our army barely four men were killed. There the pilgrims of the army celebrated the feast and solemnities of Easter, which fell on the tenth day of April. Then they returned to the camp and siege of Arqa, which Duke Godfrey, the duke of Normandy, the count of Flanders and Tancred now left, by reason of the great complaints and demands of the men, who wanted to go to Jerusalem. Nor would they ever agree to remain, despite the entreaties of the count of Toulouse. He followed them immediately afterwards in great sadness.

The army of pilgrims was resting under camp five miles from Tripoli when the lord of that city sent to them; he abandoned all pride and humbly besought them to take his possessions and to move on from his territory. And the princes, to please the men who wanted to go to Jerusalem as soon as possible, promised to do no further harm to the three cities that he held: Arqa, Tripoli and Ibelin.[119] Moreover, he handed over more than fifteen thousand bezants and surrendered those of our men who had been kept prisoners. He further bestowed great gifts and rich presents, horses and mules, silk cloth and vessels of various kinds. And he sent them a great quantity of oxen, cows and sheep in order that they should not pillage the towns around the three cities. There came to the army at that place good and noble Syrians of our religion, who lived high on mount Lebanon near these three cities, on the eastern side. The princes received them with great joy and, following their advice, deemed it best to lead the army along the coast, for several reasons, in particular because their fleet could accompany them and thus bring them security and comfort; for, in addition to Guynemer, there were ships from Genoa, Venice, Cyprus, Rhodes and other Greek islands, laden with provisions and goods, which were rendering great service to the army.

The Syrians departed first, to lead the army following the safest route as far as Jerusalem, and the magistrate of Tripoli sent to accompany them certain of his men who knew the road well. Our men were thus conducted in safety, so that, following the shore and leaving mount Lebanon to their left, they passed the city of Ibelin and, that they might await those who lagged behind, made camp by what is called the Dog River.[120] Having rested there a day, they departed thence and came before the city of Beirut, and made camp again close by, along the banks of another river. The magistrate of this city gave them much money and supplied them with food enough and cheaply,

that they might spare the trees and the corn on his lands. On the morrow, they came to another river and stopped there, before the city of Sidon,[121] whose magistrate and captain would not suffer food to be brought to them, but sent some of their Turks out to skirmish against them. But the pilgrims caused them to beat a retreat in all haste back inside their walls, after a number of them were left dead in the fields and right in front of their gates. They attempted no more sorties and our men remained there in peace throughout that day and the day following to rest, sending marauders out to pillage the land round about, whence they brought back countless booty of food of every sort, and they all returned together, save for one knight called Walter of Ver, and they knew not what befell him.

And on the following day, they passed along a very steep road and went down through defiles into the plain, leaving on their right the ancient city of Sarepte, where Elisha the prophet came and multiplied, through the grace of Our Lord, the food and possessions of the good widow woman. They crossed a river that runs between Sidon and the great and strong city of Sur, formerly called Tyre, and stopped nearby before those most noble springs that are so renowned in the Scriptures and were called the Fountain of the Gardens and thereafter the Well of the Living Waters, and there they rested for a night in delicious gardens. And when day broke, they took the road again and passed through a most dangerous defile that lies between the mountains and the sea,[122] and came down into the plain of the city of Acre,[123] near which they set up their tents and pavilions along a river. He who had charge of the town had enough food brought to them at a fair price, and he struck a bargain with the princes and barons, whereby he promised that, if they could take the city of Jerusalem and remain for twenty days following in the kingdom without being thrown out by force, or if they could conquer Egypt on the battlefield, he would surrender the city of Acre to them without a blow being struck. Thence the pilgrims left Galilee to their left and, passing between mount Carmel and the sea, they came to Caesarea, which is the second archiepiscopal see in the land of Palestine, and set up camp two miles from that city, on a stream that descends from a marsh nearby. And there they celebrated Pentecost, which was that year on the twenty-ninth day of May.

On the third day, they took the road again, leaving the city of Jaffa[124] on the right, and travelled through a plain to the town of Lydda,[125] where rests the body of the glorious martyr and knight monsignor Saint George, in whose memory the emperor Justinian once had built a most beautiful and wealthy church, which the Turks had utterly destroyed when they heard of the coming of our men.[126] Learning that the noble

city of Ramleh[127] was nearby, they sent there the count of Flanders with five hundred knights to discover what would be the bearing of the inhabitants towards them, but they found that they had all fled, the night before, into the mountains with their women and children. The princes, informed of this news by the count, led in the rest of the army of pilgrims, who found the town well stocked with every sort of food. They, therefore, remained there three days and, after they had made their offerings and their orisons to the glorious martyr, they had elected as bishop thereof a Norman called Robert, native of the archiepiscopal see of Rouen, and gave him for ever these two cities of Lydda and Ramleh, together with the towns round about, for they wished to offer to monsignor Saint George their first acquisition in this land.

Whilst our men were approaching, the Turks learned of this and were informed that the chief intent of the pilgrims was to come to the Holy City, that city for whose sake they had departed in such great numbers and with such panoply from their lands and countries, that is to say, that they might see the Holy Sepulchre and deliver it from the hands of the heathen. They toiled ceaselessly, day after day, to fortify this Holy City with all things that were needful to its defence and its safeguard: and most particularly the caliph of Egypt, who had conquered it but a short time before with great pains and expense and difficulty, sent people of his there as soon as he knew that our men were approaching so close to it, and he had it garrisoned and strengthened afresh, with towers, walls and other fortifications and things needful to the defence of besieged towns. Further, he demanded then by messengers sent purposely to those in the Holy City, that they should remain steadfast under his subjection and his lordship, saying that he freed them for ever from all the Frankish obligations due to him, which made them yet more desirous of protecting themselves and defending themselves to the death.

And on that occasion, they had all the strong and young men from the neighbouring towns enter their city. And when they saw that they were thus reinforced, they gathered together before the Temple, which is very great, and proffered there divers advice: some wished to slaughter all the Christians who lived in that Holy City, to destroy the church and to seal off the Holy Sepulchre, that no Christian might ever again come there on pilgrimage nor pray there, while others alleged that, by so doing, the pilgrims would detest them yet more and would, therefore, attack them with greater ferocity and all the more stubbornly. And finally, this last opinion carried the day, so that they ransomed the patriarch and all the Christians who dwelt there for the sum of fourteen thousand bezants; and that he might pay it, the patriarch had to go to

Cyprus to beg the Christians there to help him to find this sum for the love and honour of God, for, if they did not do so, the Turks would destroy the churches of Jerusalem and slaughter the men of our faith who dwelt there. And in the meantime, when the Turks of Jerusalem had taken all their money, they threw them all outside, save for the women and children, that they had to hide themselves in the small towns thereabouts for fear of being killed by the other Turks in that region.

And elsewhere, when our men had stayed for three days at Lydda, they departed thence and, leaving some amongst them in the strongest part of that city to defend it against pillagers, they moved off together as far as the city of Nicopolis,[128] which is in Palestine and which is the place that Saint Luke the Evangelist calls Emmaus. There well up from the ground there springs, where many men are healed of divers maladies. And they say that Jesus Christ came to these springs with his disciples and washed their feet there, and it is for this reason that this water has always been thus sanctified. Our men found there all that of which they had need. And the Christians of the city of Bethlehem, the very place where Our Lord God Jesus Christ was born, came to Duke Godfrey and besought him, and the other princes and barons likewise, to send men to guard them, for the Turks coming from the cities, towns and castles of the land round about were assembling to garrison Jerusalem, and for that reason they feared greatly that they might see them come into their city of Bethlehem and destroy the church that they had redeemed often from their enemies.

When the princes heard their request, they were deeply moved to aid them, and they gave them a hundred men on horseback, valiant and well mounted, with Tancred as their captain. And the messengers conducted them such that, very early on the morrow, they entered the city of Bethlehem, where they were welcomed by a fine and joyful procession of all the citizens, both men of the church and lay people. They led them into the church that is built on the place where Our Lady bore Our Lord God Jesus Christ, and they gazed upon the crib wherein He was laid straightway after His birth.

Besides, those in the great army slept not the whole of that night, so great was their longing to see the Holy City, which they knew that they would most surely see on the morrow, for it was to visit this place that each one of them, according to his rank, had left his country and the place of his birth and had endured countless hardships and great grief and sickness. And they longed so ardently that the day might dawn that they might take the road, that it seemed to them that that night, which was, indeed, one of the shortest in the year, lasted longer than two of the longest! And then, because it had been announced in the army during the night that Duke Godfrey had received

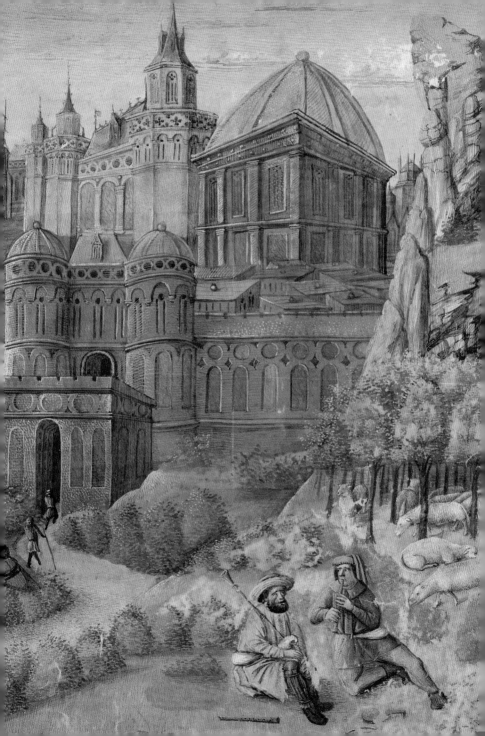

the messengers from Bethlehem the day before and that he had already sent certain of his men there, the pilgrims on foot could no longer be prevented from calling to each other and begging each other to go to Jerusalem, that they took the road before daybreak. Seeing this, the valiant knight Gaston of Beziers, filled with pity for them and fearing to see them fall into some ambush of the Turks where they could be killed or taken captive, for they had no captain or chief, mounted his horse straightway with thirty companions and followed until he came up with them and could marshal them in order as best he could.

And thereafter, to explore the country, he rode on till he was just short of Jerusalem, whence he was bringing back an enormous head of livestock as booty, but he had to let them go, because the strongest and most valiant Turks from that Holy City burst out in a crowd to come to rescue them. Gaston, seeing that he could not resist them, was constrained to withdraw with his men to a nearby hill, whence he spied, shortly thereafter, far off in a valley, Tancred and a hundred men on horseback who were returning from Bethlehem to the great army, and he knew that they were Christians. That is why he moved off towards them and told Tancred of his adventure, urging him to go towards the Turks, who were still at no great distance. And this they did, so that they defeated them without difficulty, killing a good number of them and the others taking flight and returning inside Jerusalem, greatly frightened by their first sortie. Our men then led back unhindered into their encampments and the army the livestock that they had recovered, to the great joy of the other pilgrims. Hearing that this livestock had been captured before the very gates of Jerusalem and that they were so close to the city, they all began to weep with joy and fell on their knees. And, amidst great sighs, they returned humble thanks to Our Lord, because his love to them was so great that they would shortly see the object of their pilgrimage, the Holy City that Our Lord so loved that it was there that he wished, by his death, to save the whole world, that is to say all those who had believed and obeyed Him and His laws, faith and commandments.

It was pitiful to see and hear the tears, cries and sighs of these good and noble pilgrims, who straightway set off to gaze upon that which they had so long desired to visit. And they saw soon the towers and walls of the city, and that is why they all took off their shoes and kissed the earth, so humbly and so devoutly and with such great dignity that the hardest heart could not have forborne to weep at the sight of them. But this vision rejoiced their hearts so greatly and gave them such increase of strength and courage that the road henceforth weighed as nothing to them, but they

went along without difficulty and lightly, all moved by a single will, until they arrived before the walls and the gates of Jerusalem. And they all encamped there in accordance with the orders of the princes and barons, as shall rapidly be told hereafter.

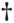

Chapter XXXI.
Of the nature, situation and shape of the Holy City of Jerusalem. Of the Holy Places that lie round about it. Of the divers names by which it has been called, and of its rebuilding and new sites. Of the aspect of the Temple and of the divers names of the land and kingdom of Jerusalem.

Jerusalem is situated between two mountains, and it is for this reason that David the prophet says: "Her foundations are in the holy mountains". On the west side is the sea, where the nearest port is the city of Jaffa, which is about twenty-four miles distant, near the castle of Emmaus (the present-day city), which lies between the two of them. It is also on that side that is to be found the land of the Philistines, of which Nare is one of the cities. There also is found the city of Modin, the fortress of the Maccabees, and the city of Nobé, in which Abimelech, high priest of the Jews, gave to David and his people the bread offered to Our Lord. This is why King Saul caused him to be killed along with all the other priests in the city, save Abiathar, who took refuge with David and was high priest right up to the reign of King Solomon. That is where Lydda is to be found, where Saint Peter healed a paralysed man called Aeneas (and he also brought to life again a woman called Thabida in the city of Jaffa referred to above); he lodged there in the house of Simon the cordwainer, who sounded the brass when he received the message from the centurion Cornelius.

On the east side flows the river Jordan, and the desert is hard by, where the sons of the prophets were wont to gather together. In that part lies the wild valley called the Dead Sea, which was once a paradise of gardens, but the Lord God ravaged it with fire from Heaven and tipped into the abyss Sodom, Gomorrah and three other cities, along with their inhabitants, because they persisted obstinately in unnatural sins, and their people descended living into Hell, according to some. On the other side of the river Jordan stands the city of Jericho, where Joshua, who led the people of Israel, wrought greater destruction through prayer than through battle; it was in this same city that Our Lord God Jesus Christ restored sight to a blind man.

On the south side, Jerusalem owns the city of Bethlehem and the city of Tecua, where the prophets Amos and Habakkuk were born, and also Hebron, where the patriarchs were buried. And on the north side, this Holy City of Jerusalem owns the city of Gabaon, where Our Lord God by a miracle caused the sun to stand still, that Joshua might win a yet more glorious victory over his enemies. To the north also was once found Sychar, where Our Lord spoke with the woman from Samaria, and also that Bethel on which the people worshipped the golden calves in the lifetime of Jereboam, king of Israel, and for a number of years after his death. There, too, is Sebasta, which is called Saint John of the Sabbath, where the tomb of Saint John the Baptist is, in which were buried before him the prophets Heliseus and Abdias. This city was once called Samaria because of the mount of Somer that is there, and all that land is still called Samaria. There also is situated the city of Nablus, in ancient times called Sichen, that Symeon and Levi, the sons of Jacob, burned down after they had slaughtered all the inhabitants thereof, that they might avenge the rape of their sister Dinah by the son of the lord there.

This Holy City of Jerusalem, which is situated in a place where there is to be found neither river nor stream nor spring nearby, has nevertheless long been and is still the capital of the land on which it is built; it was in the beginning called Salem, and Melchizedek was her king in the time of Abraham. After him, it was called Jebus, because of the Jebusites who dwelt there and possessed it, but King David drove them out and made it the capital of his kingdom after he had greatly augmented it with walls, towers, gates and buildings, and he called it Jerusalem. And because David had earlier captured the Tower of Sion, it was called thereafter the "city of David". Solomon, the son of David, who reigned after his father, had the Temple of the Lord and a number of other excellent buildings erected and he changed the name from Jerusalem to Jerosolima, which means Jerusalem of Solomon.

But all that which he and his predecessors built there was, during the captivity and the exile of the Jews in Babylon, pulled down and destroyed by Nabuzadim, prince of the fellowship of knights of the great King Nebuchadnezzar, king of Assyria and Babylon, although the city and the Temple were rebuilt thereafter by Nehemiah and Jerozababel under Cyrus and Darius when they were kings in Babylon. But they were yet again destroyed, forty years or so after the resurrection of Our Lord, by the emperor Titus, son of the emperor Vespasian, whom he succeeded, only to be rebuilt once again by the fourth emperor after them, whose name was Helios Hadrian and who called the city Helis after his own name. But he did not have it rebuilt on the slope of the mountain, as it had been before, for he had all the stones and the buildings borne to the top

of the mountain, so that the place where Our Lord Jesus Christ was crucified and the place of His Holy Sepulchre were enclosed therein, whereas before they had been outside the walls. And this Hadrian, through malice, caused a temple of Venus to be built on the spot where Jesus Christ was placed on the cross, so that if any Christian went there to worship Our Lord, it seemed that he was worshipping Venus, and for this reason, no Christian dared go there any more. And this place had been almost forgotten when the blessed Queen Helena found there the Holy Cross.

This Holy City, which is neither too great nor too small, neither too narrow nor too broad, but made up of four squares, is surrounded on three sides by deep valleys. On the east side is the vale of Jehoshaphat, in which is to be found a most noble church in the place where Our Lady was buried and where her tomb is still to be seen today; below it flows the torrent of Kedron,[129] which Our Lord God Jesus Christ, as Saint John the Evangelist tells us, crossed over on that holy Thursday after the Last Supper, as he went to the garden where Judas would betray him and deliver him up to the Jews. To the south is to be found a vale called Gehenna.[130] Thence can be shown the field of Aceldamh, which was bought with the thirty pieces of silver that Judas received for betraying Our Lord. When he gave these back to them, the Jews, knowing his treachery and not wishing to make use of the silver within the Temple fabric, for it was blood money, bought this land and transformed it into a burial ground for the pilgrims. On the west side is to be found a part of the valley where an old pool is that was of great importance in the time of the kings of Judaea, and it stretches as far as the upper cistern that is today called the lake of the Patriarch; near it is the old cemetery, which is called the Lion's Cave. On the north side, it is possible to climb straight up from the plain to the city, and it is there that is shown the spot where monsignor Saint Stephen, the glorious protomatryr and my patron, was stoned.

And, as is known, because I have already spoken of it, there are within the walls of Jerusalem two mountains, which form a valley between them, and this divides the city almost exactly in the middle. One of these mountains is on the west side and it is on its summit that is situated the church called Sion, and near it is the Tower of David, which is the keep of the town, formed of very strong towers, walls and curtain walls that can be seen towering above the whole city. There, too, on the east slope, is situated the church of the Holy Sepulchre, which is round in shape, and since it is on the slope, the summit of the mountain, which is higher than the church, renders it dim, for it is most close by. The church is built in the form of a crown open at the top, and it is through here that light falls into the interior, and under this opening is the Sepul-

SIEGE OF JERUSALEM (1099).
CRUSADERS BUILDING SIEGE-MACHINES

"In the year of grace of Our Lord God Jesus Christ 1099,
the seventh day of the month of May, the Holy City of Jerusalem was besieged
by the first pilgrim crusaders, chief amongst whom were Godfrey,
duke of Lorraine; Robert, duke of Normandy; Raymond, count of Toulouse;
Robert, count of Flanders; and Tancred, the nephew of Bohemond."

(FOL. 87VB–88A)

The siege of Jerusalem lasted about five weeks. In the upper register, Colombe shows the bustling activity in the crusaders' camp before the city. The women and children help by fetching water. Soldiers pour out of the tents, while the archers before the fortress are already loosing their arrows. The walls were repeatedly attacked during the siege. Following an unsuccessful assault on the city on 13 June, siege-machines were built with the aid of the Genoese: stone throwers, catapults, battering rams, siege towers, ladders and shields. In the lower register, carpenters are constructing various siege-machines, towers and ladders under the supervision of the crusaders.

la sainte Cite de ihrlm . par les
premiers pelerins auisies . Des
ques estoient les principaulx
Godefroy duc de lorraine . Robert
duc de normendie . Raymod
conte de Thoulouse . Robert
conte de flandres . z Tancre
nepueu Buemond . Et com
bien que en la principale armee
de cestin voyage se trouuassent
ou siege de Nique . Cent.

.xl. hommes a cheual . z .vi.
.xl. auec tous portans armes
sans les femmes . enfans et brief
les gens non armes . Toutesfois
en cestui iour que la sainte Cite
fut assiegee non tout le temps
que dura le siege . les opiens
ne se trouuerent en tout tant
hommes que femmes que .xx.
.vii. mil deffensables . Desquelz
nauoit encores que . xviii. a dr

chre of Our Lord God Jesus Christ. It is true that, before the arrival of our men in this land, there were certain kinds of small chapel, most narrow, on the mount of Calvary, the place where Our Lord Jesus Christ was crucified, where stood the True and Holy Cross and where His most precious body was taken down from the cross, anointed and buried. But after our men assumed the lordship, it seemed to them that the place and the space and the church itself were too mean, having regard for their sanctity, and they raised there a new outer wall and a fine and high enclosure, of most elaborate workmanship, which encompassed and contained the first church and the sacred places of the mount of Calvary of which we have already spoken.

The other mountain, which is called Moriah, is on the eastern side and on its slope, looking towards the south, is the Temple, which the laymen call the Temple of the Lord. And it is this place that David bought wherein to place the ark of the Lord, and there Solomon, and after him Nehemiah, Esdras and Zerubbabel, built the first Temple. And since that time, some say that Omar, son of Catap, erected the building that was still there when our men took the city.[131] The shape of this Temple is as follows: it is surrounded by a square courtyard, two bowshots long and of like width, enclosed with sturdy walls of middle height. To the west, there are two gates by which one enters: one is called the Beautiful Gate, and it is there that Saint Peter cured the man who had been lame from his mother's womb, and the other has no name. To the north, there is also a gate, and another towards the east, which is called the Golden Gate; to the south is situated the Royal House, which is called the Temple of Solomon. Over each of these gates and in the angles there are high towers, into which the Saracen priests were accustomed to mount at certain hours to call the people to prayer.[132] Some still remain while the rest have fallen. None dared to dwell within this enclosure, and none was permitted to enter unless their feet were bare and well washed, for the Saracens placed doorkeepers there to keep watch.

In the middle of this place, which was thus enclosed, there was another, higher place, square in form and with the four sides of equal length, where one mounted by two stairways on the west side and on the south likewise, but on that side one could not gain entry save through the middle. In each of the angles was an oratory where the Saracens made their orisons, and of these certain still exist whilst the others have been destroyed. In the middle of this place is the Temple, which is formed of eight squares with as many sides; both inside and out, the walls are clad in marble slabs richly adorned with gold, while the roof, which is perfectly round, is of lead. Each one of these two places, both the upper and the lower, is paved with the finest white stone that, when

it rains in winter, all the water that falls in abundance from the Temple descends, clean and clear, into the cisterns that are placed inside the enclosure.

In the middle of this Temple, inside the pillars, there is a rock, quite high, and below it a pit, and there are those who say that it was on this rock that the angel alighted when he killed the people because of the sin committed by David, when he called his people to be counted. And the angel did not cease killing those amongst the people of Israel until Our Lord commanded him to put his sword back in its scabbard, and it was at that time that David set up there an altar to God. This rock was all bare and uncovered when our men entered Jerusalem on this journey, and for at least fifteen years thereafter it remained thus, but when they had become lords of Jerusalem once more, they clad it again with fine white marble and set up an altar there, on which thereafter the priests celebrated divine service as long as the Christians had the power to do so.

This land and kingdom of Jerusalem bore the name of Judaea after ten of the tribes of the Jews separated themselves from the lordship of that son of Solomon who was called Rehoboam. Hearkening to the opinions of the youths who had been raised with him, and heedless of the council of the old men when his people begged him to lighten the most heavy charges that had been laid upon them by his father, Rehoboam answered that he was more powerful than ever his father had been, and that he would for this reason treat them yet more harshly than he had. Now, the two other lines, those of Benjamin and Judah, remained with Rehoboam in Jerusalem, and it was by reason of this line of Judah that, according to some, for long thereafter, Judaea was thus called, while others called it Palestine, which means "land of the Philistines".

This Holy City is thus, as it were, the centre and navel of the Promised Land, in accordance with the terms spoken by Joshua, who said when he spoke to the children of Israel: "Your boundaries will be from the desert to the mount of Lebanon and from the great river Euphrates as far as the western sea". One finds in certain writings that there were springs outside the city whose streams flowed to the interior, but that they were stopped up during the wars, so that all the land round about has since then remained so dry that the city cannot have water, save from the winter rains. During that season, when it generally rains most often and heavily, people collect water in all the country in cisterns, of which there are great numbers in the city and in the region round about.

Sion is today a place situated within the city, to the south, inside the vale of Gehenna, where was founded a church in honour of the martyr Saint Procopius; it is there that Solomon received the royal unction, as it is written in the third Book of Kings. One finds springs two or three miles distant from the city, but they are few and they give

but little water. On the south side, in the place where the two valleys join, there is a most celebrated spring, which is called Siloam. Our Lord commanded the blind man who had never seen, that he might be healed, that he should wash in this spring and that he would see. This spring, which is about a mile distant from the Holy City, is small and seems to boil in its depths, and it does not always flow, but people say that the water returns every three days. And this is sufficient for the description of the Holy City and of the Holy Places that adorn it.[133]

When the Turks, as it has already been said, were sure of the arrival of our men, they stopped up all the springs and cisterns that were at a distance of five miles from the city, for they wished to prevent the pilgrims from maintaining a siege through lack of water. And in truth, they would, indeed, suffer through this, as you will hear, while those in the city had then and always had water in abundance, both from their cisterns and from the water that came to them from the springs outside, which flowed down through conduits into two very great pools situated near the Temple. One of these pools is still there today and is called the Probatic Pool, and it was there that they were wont to wash the flesh of sacrificial beasts. The Evangelist says that this pool had five small porches and that the angel would descend there to move the water and that any man who descended there straightway thereafter was healed. And this is the very pool where Our Lord cured the paralysed man.

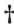

Chapter XXXII.
How the princes and the other pilgrim crusaders laid siege to Jerusalem, which would have been taken at the first assault if they had had ladders. Of the great machine in wood, and of the other small ones, which were made in a very short time by our men. Of their great thirst and how they had water. Of the ships of the Genoese that came into Jaffa. Of the defeat of certain Turks and how the ships of Egypt thought to surprise the Genoese.

In the year of grace of Our Lord God Jesus Christ 1099, the seventh day of the month of May, the Holy City of Jerusalem was besieged by the first pilgrim crusaders, chief amongst whom were Godfrey, duke of Lorraine; Robert, duke of Normandy; Raymond, count of Toulouse; Robert, count of Flanders; and Tancred, the nephew of Bohemond. Now at the siege of Nicaea there had been in the main army of this

expedition a hundred thousand men on horseback and six hundred thousand on foot, all bearing arms, without counting the women, children and old men who were not armed; on this day, however, when they laid siege to the Holy City, and throughout the whole siege thereafter, the Christians numbered no more, all told – both men and women – than twenty thousand soldiers, of whom but one thousand five hundred were on horseback and eighteen thousand five hundred on foot,[134] for all the others were but the old, the infirm, the sick and the women. And all things considered, one could well have seen and understood the high valour of men who were so few in number and who were laying siege to so mighty a city that had but recently been newly fortified. And, what was more, there were within forty thousand Saracens and other Turks, all chosen to bear arms, for those who guarded the city in the name of the caliph of Egypt had caused to come there, from the towns and castles of the land around, all the Turks and other pagans who were the strongest, most agile and best built to defend the city.

Nevertheless, when the Christian princes and barons had thus settled their men, they had come into their council the chief Christians from the neighbouring country and asked counsel of them, that they might know on which side it would be best to attack. Finding that there was but very little risk from the east side, nor yet to the south, because of the deep valleys that lay there, they decided to close the siege to the north.[135] All the princes, barons and other pilgrims were, therefore, placed in encampments on the west side, starting at the Gate of David: Duke Godfrey occupied the first position; the second was the count of Flanders; the third the duke of Normandy; the fourth Tancred, close by the Tower of the Angel, which has long been called Tancred's Tower in his honour; and the count of Toulouse took and occupied the position that ran from this tower as far as the West Gate. But Tancred, seeing that this tower, which dominated the encampments and that part of the valley that was nearby, defended the gate beneath full well and, observing that he could gain no advantage by attacking on that side, moved his men, in accordance with the counsel of wise knights and others who knew well the way the city was laid out, and went off to the mound on which the tower stood. And he took up his position there, between the city and the church called the church of Sion, which is outside the walls, at about a bowshot's distance, that he might inflict greater harm on the Turks and prevent them from attacking this church, in which Our Lord God Jesus Christ celebrated the Last Supper on the day of Holy Thursday, and gave his own body to his disciples, and washed their feet; and it is there that the Holy Spirit descended in tongues of flame upon the disciples of Our Lord, on the day of Pentecost. It is there, also, that Our Lady departed this world and where is to be found the sepulchre of monsignor Saint Stephen, the pro-

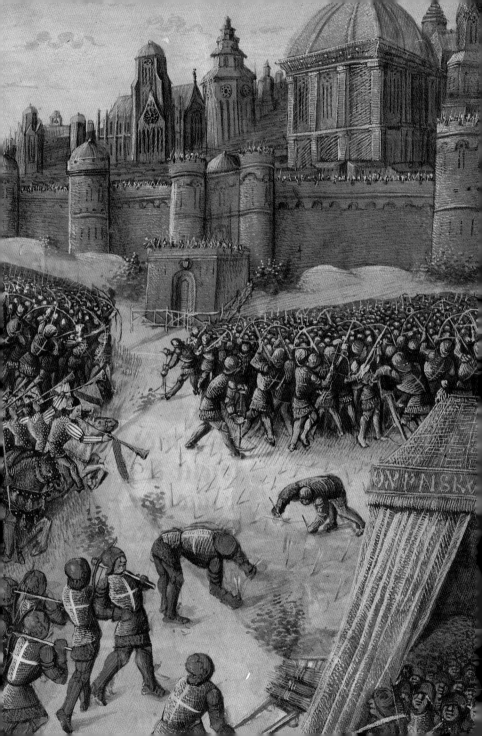

tomartyr, my patron. When the princes and barons had thus positioned their men and closed the siege from the Gate of the Angel, which is located above the vale of Jehoshaphat, as far as to the other corner of the city, which is on the slope of that valley to the south, scarce one half of the city was besieged, for from that place as far as the gate on the south side, which is called the mount of Sion, all the city was free of besiegers.

And yet they chose the fifth day of the siege to have it announced in the encampments that all should arm themselves the very best they could to move out for the assault, which they did straightway. And they began to attack the city in divers places with extraordinary courage and with such headlong force that it seemed that they feared no harm, for they wished most ardently to serve Our Lord, so that they took by assault at the very first attack all the outer walls with their walkways, and pushed the Turks violently back inside the great city walls, so frightened and terrified by the strength, valour and boldness of our men that they lost all hope that they might defend the city against them. And, as it was known thereafter, if our men had had ladders or wooden castles to climb up on the walls, they could have gone inside from that very moment and taken the city in one single assault. But, when their attack had lasted from the hour of primes until just after midday, they knew that they could do nothing without ladders or other siege-machines and retreated into their encampments, not without a deep desire to return when their siege-machines should be built.

And shortly thereafter, the princes and barons gathered together in council[136] to decide on the manner whereby they might get wood to build the machines. For that reason, a powerful man of that country who was present pointed out to them certain valleys that were six miles distant, where they would find a sufficiency, and they, therefore, sent there, guarded and accompanied by the barons and their men, carpenters who might cut down the wood and bring it back. They applied themselves with such diligence that in very few days they had had a great quantity of wood borne back into the army on wagons and carts. The princes and barons then had come to them all those in the army who knew how to make machines that might batter down towers and walls, such as stone throwers, catapults, castles,[137] covered galleries mounted on wheels and covered ways, of which they had a very great quantity made in a short time. For the pilgrims who were craftsmen took no wages if they could manage without, and the others who had no money were paid out of the army's common fund; and it was, indeed, most needful to proceed thus, for there was no prince or baron rich enough to pay for these works out of his own privy purse unaided. And they also caused money to be given to certain knights who had spent their all. Elsewhere, while the princes and

barons were having these great machines set up, the other knights and the common people were ranging amongst the hedges and bushes to seek out hazel and other switches to make hurdles, for none wished to be idle in this matter. No matter what thing was called for, so that it served a useful purpose, none felt shame at doing it, saying that all the hardships and toil they had suffered and the expenses they had made on the journey were of no value if they could not take the Holy City.

Matters being at this pass, they began but a few days after to have great need of water in the army, and the pilgrims knew extreme suffering through thirst, because the wells, springs and cisterns had been stopped up and filled in by the Turks before the arrival of our men, as has already been told. But the citizens of Bethlehem and Tecua, who knew the country round about, pointed out to them springs, cisterns, wells and brooks, and at all of them there were great disputes because of the crowds who thronged around them. For when the poor labourers, those who carried the heavy burdens, and the others were able to carry back their barrels and other containers full of that cloudy, thick water into the army, they sold it dear, and the agony of thirst grew ceaselessly because of the heat and dust, which got into men's mouths and their chests, and for this reason, they spread out throughout the land seeking water. And when two or three amongst them had found a brook or a spring, all the others came running, so that the water lasted scarce any time, and so it was only with great pains that they found a sufficient amount. For this reason, certain of them let their horses and their other beasts wander where they would, for they had not the means to water them, and because of this a great number of them died in the fields, which corrupted the air. In short, the anguish that the people felt here because of thirst was scarce less than that which they had suffered before Antioch through hunger! Certain of those who had horses left the encampments and went through the small towns round about to seek pasture and food.

Seeing this, the Turks of Jerusalem often made sorties from that part of the city that was not besieged and went to spy on them and to take them by surprise in the fields, so that they killed a number of them together and took their horses into the city. And those who could escape them turned back and fled into their encampments, where the numbers of pilgrims were dwindling, because of these forays but also because of the sickness and infirmities that persisted there. And on the contrary, those in the city grew and multiplied from day to day, both in men and in food, for they could enter at their ease across the plain, which was not besieged. And although our men were most diligent in constructing divers assault-machines, the enemy also were most attentive in observing how they made them, and they strove to make like machines or, even better, to defend themselves. And

this they could well do, for they had at their disposal more wood of all kinds than had our men; and they had, for throwing and defending themselves, stones in abundance, for they had laid in good stock of them from the very beginning.

Matters being thus, the princes asked the count of Toulouse, who was the richest, to send one of his knights, called Valdemar Carymelle, with thirty men on horseback and fifty men on foot as far as Jaffa, to conduct back thence some Genoese who had just arrived by sea and who had asked that men might go to meet them. But the princes reproached him thereafter for sending too few men and for that reason he sent there after them Raymond Pilet and William of Sabran[138] with fifty men on horseback. Although these made haste, the Turks, who were six hundred on horseback, had attacked those who had gone ahead in the plain that lies between Lydda and Ramleh, and had already killed four knights and yet more of those on foot, although Valdemar had gathered the rest around him and was valiantly resisting the Turks. These were swiftly routed after two hundred of their companions had been killed by two knights and their men, who had galloped there and fallen upon them with headlong force. Nevertheless, two of our brave knights were finally both killed there also, who were deeply mourned, one called Gilbert of Trêves and the other Achard of Montmerle.

When our men had won this victory, they went on to Jaffa, where they were received most joyfully. But while they were waiting there to unload their ships before returning to the army, the Egyptian fleet, which had lain concealed in the port of Ascalon, saw a chance to do harm to our men, and that is why the fleet set sail in all haste by night and came by surprise before Jaffa. So our men and the Genoese went down as swiftly as possible to the port and tried to defend their ships against the Egyptians. Seeing that they would not be able to resist them, they removed all that they could of the sails and other accessories, which they carried away with them into the fort of this city of Jaffa, for the rest of the city was utterly bare and without fortifications. They left their ships to the mercy of the Egyptians, who thought to seize a Genoese ship but newly arrived after a pillaging expedition, whence it was returning all laden with booty, but those who commanded it understood from afar what was happening and succeeded in escaping into the city with their possessions.

And some days thereafter, their other companions and those who had come to meet them at Jaffa went back safely to the army, where all the pilgrims welcomed them most joyfully, for the Genoese seamen were for the most part good carpenters, and most skilful in the construction of catapults and other machines of war, so that, after their arrival, the work begun by the princes was swiftly accomplished and in the best fashion. But the

work was already well advanced because Duke Godfrey, the duke of Normandy and the count of Flanders had so earnestly besought that most valiant knight Gaston of Béarn that, to please them, he assume the charge of overseeing the workmen, which he did most diligently. The princes and barons had also led out from the army the common people and the other pilgrims, that they might send them to search for boughs and branches to make the hurdles that would be needful to cover the machines, and even to cut down great trunks and to carry them to the workmen in the army, and they had them spread out the skins of dead beasts over the machines to protect them from fire.

And to speak truthfully, each of the princes was most diligent in the building of machines, as befitted his means, but above all the count of Toulouse, for he was the wealthiest and so had more workmen. It was to him that the Genoese workmen went straightway, and they had as their chief a most excellent workman called William Embriaco. They had all worked in this manner for a whole month in the army, to design and to build the machines, so that each man had accomplished and achieved what he had undertaken. So the princes gathered together in council and determined on what day they should make the assault, but because there was bitter resentment between the count of Toulouse and Tancred, and because a number of the barons and knights loathed each other, the princes and barons, after being rebuked by the bishops, wished to make their peace on all these matters and to forgive each other all their bad intentions. In this way, they would be more ready to come to the aid of Our Lord if this should be needful and, if they had to die, then they would await death with greater tranquillity. And thus was concluded a true accord between them all, with the help of Our Lord Jesus Christ.

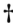

Chapter XXXIII.
Of the devotional processions held by the pilgrims before Jerusalem. How Duke Godfrey changed his encampment on the night of the greatest assault. Of the marvellous castles and other machines of war. Of the second assault of the catapult, which killed the enchantress, and of the boldness of the princes and barons. Of the unknown knight, and how the Holy City was taken by assault. Of divers visions, and also of the great massacre of the Turks.

At the demand of the prelates, it was commanded that all should walk in procession bearing the Holy Relics, of which there were a number in the army, and that each one

PETER THE HERMIT PREACHING.
PROCESSION FOR THE CAPTURE OF JERUSALEM (1099)

*"During this procession, the sermons were pronounced by Peter the Hermit
and Arnulf, the chaplain of the duke of Normandy, who was a great cleric but
a man of evil life and too inclined towards spiteful actions. These two
exhorted the pilgrims most particularly, using most sweet words, to undertake
this heavy task for Our Lord with great strength and courage, explaining
by most clear tokens that it was more worthy to die there than to live."*

(FOL. 91B)

All forces were now mobilised to achieve victory. On 8 July 1099, one week before the storming of the city, a procession was held in which the crusaders walked barefoot around the city: this was modelled on the taking of Jericho by Joshua. The procession is depicted by Jean Colombe in the lower register. It is headed by Peter the Hermit, Arnulf of Chocques and others, who are carrying the relics. They are leading the procession to the mount of Olives, the place where Jesus gathered his disciples on the day of the Ascension before rising to heaven before their eyes. The scene in the upper register shows Peter in a vast chapel delivering a sermon in which he encourages the crusaders and prepares them for the coming battle and for death. Some crusaders can be seen confessing their sins before going to take up arms. The many people who are present all assume an attitude of devotion. Great care has been taken over the architectural features: the artist has conferred a remarkable height and spaciousness to the chapel in his depiction of tall columns in vibrant colours of green, blue and pink, crowned with statues.

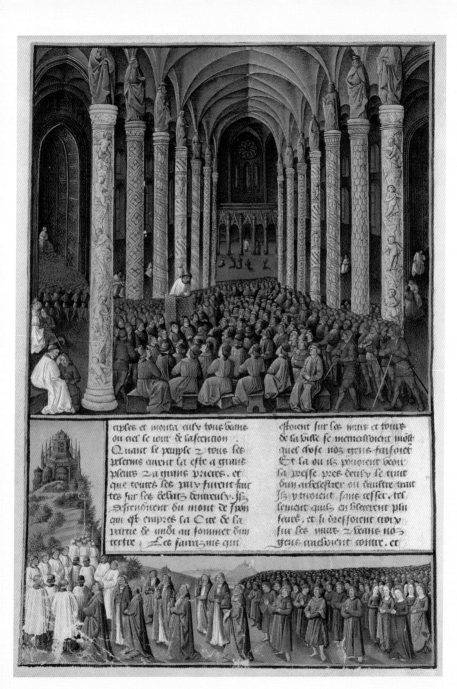

aples et monta euls tout beaue
ou ciel le iour de lascention
Quant le puple z tous ses
pseaus eurent la este a grant
pleurs za grans prieres. et
que toutes ses pluy furent fur
tes fur ses celrz doulourenr. Ils
descendoient du mont de Syon
qui est empres la Cite de la
partie de midi au sommet dun
tertre. Les saintzme qui

estoient fur les murs et toures
de la ville se mervestoient most
quel chose noz gens faysoient
Et la ou ils pouoient veoir
la presse pres deulz se tout
bun arbalestres ou daultre tout
Ils y tiroient sans cesser. tel
lement quils en blecerent plu
seurs. et si dressoient cruy
sur ses murs z traioit noz
gens trachoient contre. et

should go barefoot to the mount of Olives, and that he should fast for that day,[139] and should confess himself and make most humble orisons to Our Lord, that he might have pity on his Christian people gathered together there, that he might accept their service and that he might be content that his heritage should be recovered thanks to them. During this procession, the sermons were pronounced by Peter the Hermit and Arnulf, the chaplain of the duke of Normandy, who was a great cleric but a man of evil life and too inclined towards spiteful actions.[140] These two exhorted the pilgrims most particularly, using most sweet words, to undertake this heavy task for Our Lord with great strength and courage, explaining by most clear tokens that it was more worthy to die there than to live. The mount of Olives is distant about a mile from Jerusalem on the east side, for the vale of Jehoshaphat lies between the two, and it is there that Our Lord gathered together his disciples and ascended into Heaven before their eyes on the day of Ascension.

When the people and all the pilgrims had been to that place, tearfully and in prayer, and when peace had been made in their disputes, they came down from the mount of Sion, which is situated near the city on the south side, on the top of a height. The Saracens who were on the walls and towers of the city were greatly astonished at what our men did, and when they saw this crowd at the distance of a crossbow shot or of a bowshot, they loosed their arrows ceaselessly, wounding a number of our men. And they set up crosses on the walls and spat upon them under the eyes of our men, and they did or said to the pilgrims many a shameful thing besides, which is not to be spoken of. Thereupon, the strength and courage of the pilgrims did but increase the more from rage and from the desire to avenge the outrage that the Turks thought to do to Our Lord. When the divine service had come to an end in the church, they returned to their encampment, announcing the day when they would attack the Holy City, that each one should make ready most diligently, for his part, all that would be needful to him to accomplish this great work.

On the day before the assault, Duke Godfrey, the duke of Normandy and the count of Flanders saw that the part of the city that they had besieged was defended with all kinds of machines and garrisoned with Turkish defenders. And since they were less secure on that side than the others (and for that reason they could scarce do any damage to the city on that side), they determined on, and did indeed accomplish, a most considerable undertaking, for they worked throughout the night to transport all their heavy machines, whose parts had not yet been put together, and set them up on the side that is between the Gate of Saint Stephen and the Tower of the Angel, that is to say, to the north, the side of the city that had not yet been besieged. And all was achieved before sunrise,

a thing that was not accomplished without great difficulty, because there was a good half mile between that place and the place where they had first been positioned.

When morning came, the Turks, who had asked themselves with great astonishment what our men could be doing, there where they heard such an uproar, saw that the machines and the men of the three lords were no more in the place where they had been before. They were, therefore, greatly afraid, and even more so when they set out to make their round of the city upon the city walls and saw where our machines had been placed, and how our men had set up and mounted their machines so close to the city walls, which would not protect those inside from a great and strong wooden castle; indeed, so close was it that those inside it could all but touch the Turks who were in a small tower at the place where the wall was lowest. The Turks then feared them even more than they had done in the beginning.

The other princes and barons of the army had worked so manfully throughout that night on their sides that they had set up their machines before daybreak around the other sides of the town, and most particularly the count of Toulouse had brought up close to the walls a castle that he had caused to be made with great pain, between the church of the mount of Sion and the city. And Tancred and the others had also set up another, very tall and very solid, near the Tower of the Angel, which is called Tancred's Tower. And these three castles were built in the same fashion, for they were all square and the sides facing north were double, so that the outer section could be let down onto the wall and so formed, as it were, a bridge; and yet that side would not be open, for there remained the inner section to defend those who were in the castle.

On the day that had been appointed for the assault, all the pilgrims were ready early in the morning, all showing the same holy courage, to begin the attack when the signal should be given and to continue until they took the Holy City with the aid of Our Lord, or to die in his service during the attack. They thus began the assault, invoking the grace of Our Lord, and from the very first moment, all worked together and did their utmost – men, women, children, old men, the sick and the infirm – to push the castles forward near the walls, that the men might fight hand to hand with the Turks. For there was not one pilgrim who did not do his utmost to be seen to be accomplishing some action that would deliver the Holy Places from the hands of the Turks.

The Turks, in the meantime, were ceaselessly shooting a great quantity of arrows and bolts[141] and hurling great stones with their machines and bare hands, both against our men and our machines, thinking to push the good and valiant pilgrims back from their walls. But no matter what the Turks threw, our men were so ardent and so com-

mitted to this undertaking, that they feared neither to die nor to be killed in accomplishing it. But they kept moving forward as far as they could, sheltering behind shields and bucklers, and indeed, there were even a number who bore before them doors and windows, that they might protect themselves against the blows from the stones and arrows. Those who had been placed in the wooden castles did not cease to loose their arrows against the Turks who were in the crenellations of the walls and towers, and a large part of our men had also a great quantity of levers and ropes with which they did their utmost to pull the castles nearer to the walls. And those who hurled the stones and worked the catapults often provided the others with large numbers of huge stones and machines to hurl them, while there were also others with slings, who sent them flying continuously. In short, all our men were most diligent according to their task. But those who wished to move their castle forward could not do so, because there was a broad and deep pit before the outer wall, so that they could not well bring their machines closer. And nor did the shots from the catapults and the mechanical stone throwers do any great harm to the walls, for the Turks had suspended from them on ropes sacks filled with hay and straw, mattresses, great bales filled with cotton, coarse woollen cloth and thick carpets, so that when the stones from the machines struck them, their blows were futile.

Elsewhere, the Turks in the city had more, and stronger, machines set up on the inside, and a much greater number of bows and crossbows than had our men on the outside, and with these they killed many a pilgrim. And the others could not help but be terrified, and so it was that the assault was most ardent and most dangerous from the morning until vespers, for never was there an assault where the volleys of stones and arrows flew as thickly as in this one, from the moment when they poured out from three places, that is to say in three different parts of the city. Although our men attacked with amazing force, the Turks defended themselves likewise, and amongst other things, they very often pierced our castles with their machines, and they threw flaming objects at them with such force that they were burning in all parts, although our men were provided with water and with vinegar with which to put out the fire, together with hurdles and other things with which to stop up the holes. This terrible assault was not finished before darkness fell, which forced our men to withdraw into their encampments to eat and to take some rest, leaving a large number of people on watch and a guard to watch over the moveable castles and machines.

Those in the city also exerted themselves to the utmost to guard their walls, for they feared greatly lest they should see our men, whom they had seen attacking with such vigour, climb up by night on ladders and get into the city. Neither did the hearts of the

pilgrims who were in their encampments and in their lodgings rest easy, for they were remembering the assault that had just taken place; each one of them remembered what he had done, and to each one of them it seemed that he had failed to do many of those things that he ought to have done. They were all desirous of returning to their places, and for the moment when they could display their valour, and they longed most ardently that the night should be over and the day come again. To look at them, it seemed that they had taken not the slightest harm from the sufferings and pain that they had endured on the previous day, for in their hearts they had the clear hope of winning the day with the help of Our Lord, as soon as they should have departed together once more to the assault. And this confidence engendered more pain in their hearts, because the night lasted too long for their liking, than the pain that their bodies had suffered during the assault.

As soon as dawn broke, each one returned in all haste to the place and task that were assigned him, despite the countless volleys of stones that those in the city hurled at them from divers machines. And there happened then a thing most worthy of the telling, for our men had a huge stone thrower called a *châble*, so solid and so well made that it threw immense stones and did great damage in those places that it hit. For this reason, the Turks, when they saw that the stones from their machines could not reach the stone thrower, called up onto their walls, on that side, two old enchantresses who had brought with them three young girls to cast a spell on the machine and who should help them to accomplish the spell, but they stayed so long on the wall that the stone thrower hurled a stone directly at them and caused all five to fall to the ground dead. Our men, who had previously been greatly troubled as to their intentions, then gave an immense shout of joy, and this well-timed hit refreshed them and gave them greater strength, whereas those in the city, on the contrary, were greatly amazed and terrified, for it seemed to them that the death of these two old women would bring the enemy great good fortune.

Yet they defended themselves in an astonishing manner, so that the assault lasted until just after midday without anyone well knowing who had the upper hand. Our men began to tire, and the capture of the city to weigh heavy on them, for they were overwhelmed with their exertions and yet matters had scarcely advanced. That is why they fell into despair and wished to abandon the wooden castle, which was almost completely demolished and broken by the stone throwers and catapults, and they wished to draw back the other machines, which were already smoking from the fire that the Turks had hurled at them. This being so, they had perforce to abandon the assault until the following day and this is what they wished to do. Their enemies, who saw this clearly, were thereupon so overweening that they mocked and said vile words

to them, and defended themselves against them yet more ardently than before and did great damage to their machines.

In truth, the situation of our men had not been good, were it not for the generosity of Our Lord God Jesus Christ, who comforted them by a miracle. For monsignor Saint George appeared to them from the mount of Olives, mounted on a great white charger, armed like a knight, covered with rich white cloth and bearing a silver buckler, on which there shone resplendent a great red cross. This knight had never before been seen in the army (and would never again be seen thereafter), save for one other time when he had appeared to a priest of the army as the pilgrims were arriving at Jerusalem to besiege it; and he had said to him then that he was Saint George, the chief of the army, and demanded of him that he bear certain of his relics to Jerusalem and said that he would always come to their aid. So he began to wave his buckler, which was clear and flaming, and signalled to those of our men who were already retreating and who dared no longer to mount the ladders, to return to the assault.

It happened then that Duke Godfrey and Eustace, his brother, were on the top level of the castle, that thence they might better determine what they should do and also that they might safeguard the belfry, which was very solid. And when the duke saw the signal that the knight made, he straightway believed that he had been sent by God and that it was monsignor Saint George who was fulfilling that which he had before revealed to the priest, and so he began to call back the pilgrims who were departing and abandoning the assault, and to cry out to them that the city would be taken if they would come back. When Our Lord thus intervened miraculously inside the city just as before he had done outside, all the pilgrims regained strength and courage, so that they immediately returned in all haste to the assault, with as much joy, and valour, and boldness as if each one of them had been sure of victory, and by divine grace all were refreshed as if they had suffered no pain at all during that day.

There then occurred a most clear miracle, for those who were most grievously wounded and remained lying sick in their beds, leapt from them, strong and fresh, taking up their arms again and beginning the assault once more with the others. The barons, too, who were the chiefs of the people, were always at the forefront, for one could find the greatest lords of the army there where the greatest danger was, to set a good example for the others, which made yet more bold those of the common people. The women, who could not bear arms, ran in the midst of the army with pitchers full of water and gave it to drink to all those who were wearied from attacking, and they encouraged them most sweetly and did their utmost to serve Our Lord Jesus Christ. In short, all our people had

such joy in their hearts that that which they did seemed to cost them nothing, so that in the space of an hour, they had filled in the ditch and taken a most strong outer wall, and had pulled the castle right up to the walls, against which the Turks had hung, as I have already said, a number of great pieces of wood and other things that might reinforce them against the blows of the machines. But those in the wooden castle cut the ropes of two great beams, which those of our men who were down below took hold of at great risk and danger to themselves, and they fixed them that they might support and reinforce the bridge of the castle when it was lowered onto the city walls. And indeed, there was need of this, for the bridge was of wood that was so thin that if these two beams had not been thus placed to reinforce it, the armed men would not have been able to cross over it.

Elsewhere, while Godfrey of Bouillon and his companions who were on the north side were thus busied, the count of Toulouse and his men were attacking the city most violently from the south side. They had toiled so hard for two whole days that they had filled in the ditch in front of them and had brought up their wooden castle so close to the city wall that those who were on the upper level might easily strike with their spears the Turks who were defending a small tower nearby. None could find words to describe the ardour and the stubborn persistence that each one of the Christians had in his heart to do his very best during the assault, so certain were they, in their opinion, that they would accomplish their vows and promises on that day, both because of all those things that we have just told and because a good hermit who dwelt on the mount of Olives had affirmed to them that the Holy City would be taken on that very day. With all the pilgrims engaging so ardently in the assault, the men of Duke Godfrey and the other barons who were accompanying them strove with great ferocity to drive back their enemies, for they had risked reinforcing their assault in so dangerous a fashion that the Turks were greatly wearied thereby and were defending themselves but feebly. And our men had pushed themselves so far that they had filled in the ditch and taken the outer walls, that they were advancing without hindrance as far as the towers.

And because those on the inside scarce troubled any longer to draw their bows, nor to throw stones, whether through the arrow slits or from the top of the walls, the duke commanded those in the wooden castle to set fire to the mattresses stuffed with cotton and the sacks full of straw that hung from the walls; there arose then a smoke so black and dense that not a thing could be seen, and it happened that a gusty wind from the north blew this smoke onto those who were defending the walls and the turrets and troubled them so greatly that they could open neither their mouths nor their eyes, but were compelled to abandon the places that they were defending and had to guard. Duke

Godfrey, who was watching constantly how they were faring, was the first to realise this, and commanded his men to pull up without delay to the top of the moveable castle the two great beams that had been dropped from the walls, and he had them laid across to the city walls from the wooden castle, and had the bridge from the castle mounted on the city walls. With the bridge thus strengthened with the wood of the enemy, Duke Godfrey climbed onto it, and he entered first into the Holy City of Jerusalem; after him Eustace, his brother, climbed on and entered also, followed by two other knights who were also brothers and most valiant, one called Litold[142] and the other Gilbert, natives of Tournai, and after them, there climbed on as many knights as the bridge could support. And when the Turks saw the banner of the duke on the walls and observed that our men were on the inside, they abandoned the towers and went down into the city and positioned themselves in the narrow streets to defend themselves. When our men who were still on the outside, watching the duke, saw that some knights were already in the city and had taken certain towers, they waited for no orders but began to raise the ladders and to climb up onto the walls in all haste. And thus there were, within a very short time, many of our men in the Holy City, and they had no difficulty in entering, for they found not the slightest resistance and had ladders enough, for the knights of the army had before been commanded to have one ladder for every two men.

The duke ran along the top of the walls, and as he went along he placed his men in the towers, and he made haste to take the fortress. And soon there entered also into the Holy City the duke of Normandy, the count of Flanders; Tancred the valiant; Hugh, the old count of Saint-Pol; Baldwin of Le Bourg; Gaston of Béarn; Gaston of Beziers; Thomas of La Fère; Gerard of Roussillon; Louis of Mocton; Rambald, count of Orange; Cunes of Montaigu; Lambert, his son; and a number of other knights whose names cannot all be told. When the duke learned that these had gone in, he called them to him and sent certain of them to open the Gate of Saint Stephen, where, when it was opened, the people entered in crowds, so that within but very little time the whole army was on the inside. And thus was taken the Holy City, towards the hour of nones on Friday, the fifteenth day of July, in the year of grace of Our Lord Jesus Christ 1099. And when Godfrey and the princes, barons, knights and men on foot saw that the gate was open, they came down from the walls and, with drawn sword and spear in hand, they went through the streets killing all the Turks whom they met, sparing neither the women nor the children, for it was bootless to cry for mercy.

They committed so dreadful a massacre in so short a time that there were in the streets great heaps of heads cut off and necks chopped through, so that one could not

pass through save by straddling the corpses. Those on foot, who made the greatest slaughter, moved on in a crowd through the other parts of the city, bearing axes and great hammers, and they killed and slaughtered all whom they met, both men and women, save for the poor Christian inhabitants whom they spared, for these had swiftly made themselves crosses when they had heard the tidings of the capture of the city, and some of them wore them on their clothing and others bore them in their hands. While the common people had thus already reached right to the middle of the city, the count of Toulouse and those of his party were still continuing their assault around the mount of Sion. But when the Turks who were resisting them there heard the cries and saw the banners of the others in the city, they abandoned their towers and walls and took flight as swiftly as they could to the keep that was close by, which was the most strongly fortified part of the city, and those who were able to go in (and not all could) closed its gates. The count of Toulouse, seeing that there were no defenders on the walls, set up the draw-bridge of his wooden castle against them and, climbing upon it, he entered the city, followed by Iseard, count of Die,[143] and Raymond Pilet, William of Sabran and the other knights, together with all their men, both by the castle and the ladders; all of them thought that they were the first to enter, and, leaping from the walls, they slaughtered all the Turks that they found in the streets. So many dead were there that it was most horrifying, and also to see the human blood spreading and running in great streams through the streets, for those who escaped from the men of the count of Toulouse fell into the hands of those of Duke Godfrey. A very great number of Turks had taken refuge inside the walls of the temple enclosure, which were exceedingly strong, but our men forced their way in and slaughtered them all, and it is reckoned that people to the number of ten thousand were killed there. The common people searched the cellars and hiding places and when they found any Turks concealed there, they put them to death. And because the princes and barons had determined and decreed together, previously, that each one should own that house in the city (with its ancillary buildings) that he had seized, the barons set up their banners on those which they had won. The knights of lesser rank hung up their shields there, and those on foot placed their hats or their swords there as a sign that the house was taken, that they might prevent others from going in.

When this Holy City had been taken, so that the Turks whom they had found therein had been killed, princes and barons gathered together before laying down their arms and appointed those men who should guard the towers and gates, that they might prevent those outside from entering without authorisation, until choice had been made, with one accord, of a lord of the city who should possess it entirely. There was, indeed, nothing

remarkable in the fact that they were anxious, for the country round about was still full of Saracens who could perchance have gathered together and attacked the city suddenly by surprise. The princes and barons then parted from each other and they went to take off their armour in their residences, and there they washed their faces, hands and bodies, which were covered in blood, and put on fresh robes. And all the other pilgrims began to go along with them, barefoot, weeping and sighing, saying prayers and returning most humble and devoted thanks, that they might visit the Holy Places of the city where Our Lord and Redeemer Jesus Christ had lived in human form, and they kissed most devoutly the places where his feet had trodden. The clergy and the people of the Christians who dwelt in that Holy City and who had dwelt there always under the Turks, who had them endure divers hardships, grief and suffering, came there also before them in procession, bearing the Holy Relics, and led them into the church of the Holy Sepulchre, singing and giving thanks to Our Lord. It was a thing most sweet to see and most pitiful to hear, how the princes, barons, knights and all the men with them wept for joy and pity, and how they prostrated themselves in the form of the cross before the Sepulchre of Our Lord, for each one believed that he saw, dead and lying before him, the precious body of our most Holy Redeemer Jesus Christ. There was such quantity of tears and sighs that none could describe it, and there was likewise such quantity of cries and tears in the other churches that it seemed that this would last for ever.

And when they came into one of the Holy Places, they could not have brought themselves to depart had it not been for their desire to go into the other places, so joyful were their hearts at the honour that Our Lord had done them in vouchsafing that they should see the day when the Holy City was delivered, thanks to them, from her slavery to the enemies of their faith, and the rest of their lives seemed then of little import to them. They gave so liberally of their goods to the churches and to the poor, and further, they made a vow to distribute such great gifts in their own countries, that it seemed that they attached no importance to the things of this world. And to speak truthfully, they felt that they were at the gates of Paradise, and indeed, they were, for there cannot enter into the heart of anyone in this world a joy so great as was in theirs, and they could not tire of going to all those Holy Places where Our Lord Jesus Christ had been. And besides, the bishops, prelates, priests and other members of the clergy could not leave the church of the Holy Sepulchre, where they prayed earnestly for the people, thanking our Redeemer Jesus Christ most devoutly for his holy help. When the pilgrims had become quiet, there were amongst them a number of noteworthy people, who were certainly to be believed, who affirmed that they had seen during the assault the most venerable Adhemar, bishop

GODFREY OF BOUILLON BEING LED TO THE CHURCH
OF THE HOLY SEPULCHRE. COUNCIL OF THE CRUSADERS

*"They found the greatest number of praiseworthy things in respect
of the noble Duke Godfrey, amongst all the other princes, even if those
who wished to find fault with him affirmed that he had a most tedious habit.
For when he was in a church where he had heard mass and all the divine service,
he never wished to depart before he had demanded at length of the priests
and clerics to explain what was depicted in the paintings and the stained-glass
windows and what was their meaning. And again, he would listen so readily
and so attentively to the stories and the lives of the saints that this
displeased his companions, and his repast was often spoiled for this reason."*

(FOL. 98A–98B)

Once the city was taken, the time was come to elect a king for Jerusalem and its kingdom. The barons came together in an assembly that is shown in the lower register. Jean Colombe's depiction remains faithful to the account of the incident given by Sébastien Mamerot: the clerics present themselves at the door of the council chamber and demand that first of all a spiritual leader, or patriarch, should be elected. Nevertheless, the council continued and it was the popular Godfrey of Bouillon, an excellent Christian, who was preferred to his rival Raymond of Toulouse; the former declined, however, to be crowned as king. The upper scene shows the ceremonial entry of Godfrey of Bouillon into the church of the Holy Sepulchre. It cannot be denied that the church building resembles the Gothic cathedrals in France, for instance that in Bourges, the artist's hometown: a façade adorned with statues, finely wrought pinnacles and a porch all bear witness to the care with which the artist took over his range of colours. The church of the Holy Sepulchre in Jerusalem was on the putative site of Christ's tomb.

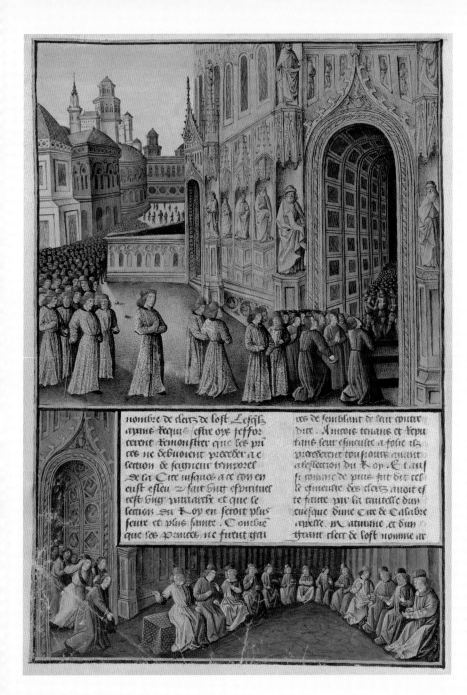

nombre de clers de l'oft. Lesqlz
apms requis estre oyz s'effor
cerent remonstrer que les pri
ces ne debuoient preceder a e
section de seigneur temporel
de la Cite iusques a ce corē en
euft esteu et sait bng espirituel
cest bng rutilarele et que le
lection du Roy en seroit plus
seure et plus saine. Combie
que les pances ne furēt gai

res de semblant de leur contre
dire. Ancois tenans et repu
tans leur esmeute a folie ilz
procederent tousiours auant
atestation du Roy. Et tauf
si comme de puis fut dit cel
le esmeute des clers auoit es
te saite par la cautelle dun
euesque dune Cite de Calabre
appelle. r̄ atume. et dun
trant clerc de l'oft nomme ar

of Le Puy, climb up the first onto the walls of the city, calling out to the others and beseeching them to follow him; and many other pilgrims, who were also holy men and who had died during the Holy Journey, also appeared to a number of people on the day when they visited the Holy Places. It is thus most plain to see that Our Lord loved this city more than any other, and that this was the greatest pilgrimage that could be, when the dead were brought to life by the will of Our Lord, that they might accomplish their vows and finish their pilgrimage.

And when the princes, prelates, barons and knights had finished their orisons and had visited the holy churches, they gathered together in council and, considering that it would be too dangerous not to empty the city of the corpses that lay therein, they appointed men to do this. And they commanded besides that, on the third day, there should be held a general market. And meanwhile, the Turks who had withdrawn into the tower and keep of David surrendered these to the count of Toulouse, who let every one of them depart and caused them to be conducted in safety as far as the city of Ascalon, with their women, children and all their possessions.[144]

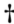

Chapter XXXIV.
How Godfrey, duke of Lorraine, was elected and crowned king of Jerusalem. Of the constable of Egypt and the great army that he led thence to reconquer Jerusalem, and how he returned thence in shame. Of the return of the duke of Normandy and the count of Flanders to their own lands, and of the death of the duke of Normandy.

On the eighth day after the taking of the Holy City, the princes and barons convened to elect from amongst them a king of this Holy City and its lands. And after they had made their orisons and prayers, they invoked the grace of the Holy Spirit, that he would vouchsafe that they should elect the best king and lord who might safeguard the Holy City and the kingdom of Jerusalem, and they assembled away from the others. But while they were pondering this election, a great number of clerics from the army came to the door of the council. Having demanded to be heard, they did their utmost to prove that the princes ought not to proceed to the election of the temporal lord of the city until there had been elected a spiritual lord, in other words a patriarch, and that the election of the king would be made thereby more sure and more holy. The princes, without appearing

to contradict them, considered nevertheless that this uproar was a folly, and continued with the business of the election of the king. Besides, as it was said thereafter, this uproar of the clerics had been fomented by a bishop of a city in Calabria called Marturano[145] and by a great cleric from the army called Arnulf, the chaplain and familiar of Duke Robert of Normandy, and these two men of the church were accomplices in all their ruses.

Finally, because the princes and barons wished to know more of the station and life of each one of them, and most particularly of the one whom they should elect, they appointed certain men of good principles and repute to seek out the truth discreetly, and these prudent men, who were most loyal and discreet, conducted their enquiry with much good sense, hiding all that it was needful to conceal. After they had made their enquiries, under oath, of all those whom it was needful to question to know the truth, they found the greatest number of praiseworthy things in respect of the noble Duke Godfrey, amongst all the other princes, even if those who wished to find fault with him affirmed that he had a most tedious habit. For when he was in a church where he had heard mass and all the divine service, he never wished to depart before he had demanded at length of the priests and clerics to explain what was depicted in the paintings and the stained-glass windows and what was their meaning. And again, he would listen so readily and so attentively to the stories and the lives of the saints that this displeased his companions, and his repast was often spoiled for this reason.

When this report and the others were made before the other princes and barons, they pondered long before going on to elect the king. There was amongst them a large party who would have agreed on the count of Toulouse, had it not been for those of his lands, who were his closest companions, who thought that if he were elected king of Jerusalem, he would remain there and people from his own country would go to him there, whereas on the contrary if he were not made king, he would return swiftly to his lands in France, where he had been born, which they earnestly hoped for. And so they knowingly perjured themselves, or so it was thought thereafter, and said that there were many faults in him, of which, indeed, he was in no way guilty, but they wasted their time in this manner, as it appeared thereafter, he had not the slightest desire to leave the Holy City. When the princes and barons had discussed this matter at length amongst themselves, they were all, with one accord, of one mind and elected with none dissenting the good Duke Godfrey as king of the Holy City and the kingdom of Jerusalem.

And so they conducted him, with all the people, showing the most extreme joy, into the church of the Holy Sepulchre, and they presented him there to Our Lord. Their jubilation was immense, and they showed all signs of rejoicing, for he was the

prince best loved of all, both great and small. But when they wished to crown him king, he refused, beseeching the princes and barons not to do so, for it was enough that he had the crown that Our Lord God Jesus Christ had worn in the Holy City on the day of His Passion. And so Duke Godfrey was never crowned, although he was then and ever afterwards the true king of Jerusalem.[146]

But a few days after his election, he gathered together in council all the princes and barons, and he begged the count of Toulouse to give him the keep, that is to say, the Tower of David, as of right. But the count refused, making the excuse that he had conquered the tower and that it was his for that reason; yet he said that he meant to return rapidly to his lands in France and that he would keep the tower only till that time and then he would give it up to him. As King Godfrey was not content with this, explaining that he did not wish to be king of a city wherein the strongest place should belong to someone other than himself, and that if the keep were not given up to him, he did not wish to accept his election, the princes obtained the accord of the count of Toulouse that he would hand over the tower to the archbishop of Albara. The archbishop gave it up straightway to King Godfrey, and when certain of them asked him why he had surrendered it so quickly, he replied that he had been forced, although, be that as it may, none has ever known for certain if he was forced to do so. But meanwhile, the count of Toulouse was so embittered at this that he determined to return to France, for he was of the opinion that the princes and barons had not behaved towards him as they ought to have done, for he had rendered them during the journey most great services that they did not remember, according to what certain of his men said.[147]

Having determined to turn his back on their council, he went to bathe in the river Jordan and arranged his affairs that he might rapidly take the homeward road. But he did not do that which he had determined upon: but few days thereafter, the bishop of Marturano, with the support of the duke of Normandy, chose his companion Arnulf as patriarch of Jerusalem, and he caused him to be enthroned in an iniquitous manner on the seat of the true patriarch. The latter had gone to Cyprus but a short while before the arrival of the pilgrims, to seek help for himself and the other Christians of Jerusalem, and also for the church of the Holy Sepulchre, which the Turks wished to destroy unless they obtained a great sum of money, which the Christians had perforce to pay them, so that they might redeem the church. It was then that was found also a great part of the True and Holy Cross, which was in a silver reliquary buried deep inside the church of the Holy Sepulchre, and it was an old Syrian who revealed its presence, for he alone knew that it had been buried there in the past by the Christians, lest it be taken from them by the Turks. It was

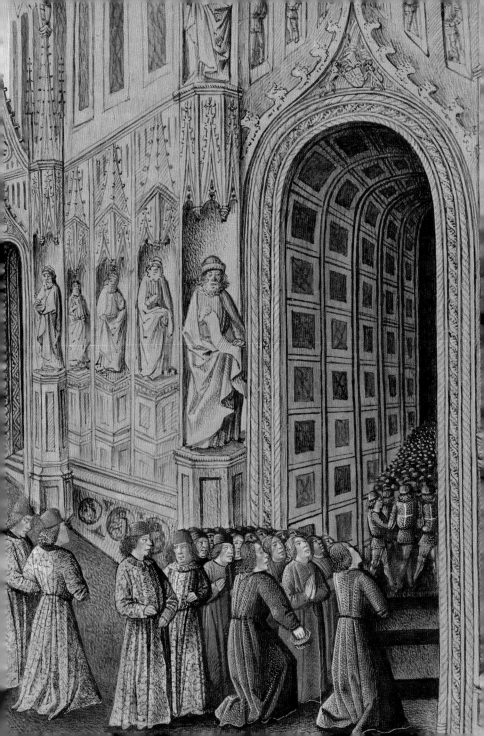

borne thence in procession as far as the Temple, and all the pilgrims felt themselves greatly comforted by this venerable reliquary that Our Lord had caused them to find.

However, but few days thereafter, they received news and were warned that a very great army from the caliph of Egypt had left Egypt, both by sea and by land (and, most particularly, one of his constables called Emireus, who had been a Christian but who had renounced his Christian faith and had placed himself at the service of the caliph, through avarice and a taste for sensual pleasures, and who had conquered the Holy City for him from the sultan of Persia after the defeat of Kerbogha).[148] And this army was coming to retake Jerusalem from our people, which this constable thought to do most easily, thanks to the great army and the multitude of men whom he had at his disposal. But Our Lord changed Emireus's scheme, for our men knew but a few days thereafter through their spies that he had come with his army before the city of Ascalon, and that there had joined him there other Saracens and Turks, from Damascus and Araby, who were in great number in these regions and who, before the arrival of our men, had heartily detested each other: most particularly, the Egyptians constantly feared the waxing power of the Arabs.

But, whatever might be their feeling towards each other, their common hatred of our people gave them the firm intent to come straightway before Jerusalem and to retake it, for they could not believe that the princes and barons who were inside would dare to come out onto the battlefield. Our men determined, by common accord of the bishops and princes, that there should be processions of all the men, barefoot and wearing shirts, into the church of the Holy Sepulchre, humbly beseeching Our Lord Jesus Christ, amidst tears and sighs, that he would maintain his watch over his people, whom he had hitherto defended until this day, and that he would not suffer the Holy City to fall once again into the hands of the heathen. Thence they conducted the procession as far as the Temple, where the bishops and priests celebrated divine service most devoutly.

When the service was finished and the bishops had given their benediction before all the people, King Godfrey gathered together the princes and barons, and appointed, in accordance with their council and advice, those barons and knights who would guard the city. Then he left the city with the count of Flanders[149] and they came to the plain of Ramleh. The other princes stayed in Jerusalem, save for Eustace, the brother of the king, and Tancred, whom the citizens of Nablus in Syria had sent for, that they might hold and guard their city: this they had done on the order of the king, for at that time they knew nothing of the Egyptians. But the king now sent men to look for them, and they came in all haste with the other princes and barons, who were still armed and ready, waiting for the answer from the king and the count of Flanders. These latter, who were

already in Ramleh, being forewarned of the great power of the constable Emireus, commanded that all those in Jerusalem should leave the city in haste, save for those whose duty it was to guard it, and to bring all the people of Jerusalem to fight against the great multitude of their enemies. This is why the count of Toulouse and the other princes and barons left Jerusalem in fine formation, and came in haste into the plain of a place that is today called Ibelin, where were the king and the count of Flanders.

And when they had been there for a day, they saw at nightfall, far off, a vast horde that covered a great part of the plains. And because our men thought that these must be their enemies, being in any case amazed at their late arrival, the princes sent out in that direction two hundred men on horseback, well mounted, that they might see near at hand who they were and how many they might be. When they came closer to them, they found that they were bullocks, cows and livestock, in numbers so great that one could scarce believe that there were so many in the whole region, and they were guarded by men on horseback, that they might protect the shepherds and at the same time discourage rustlers. When the outriders had returned to the princes and had told them what they had seen, they sent certain of their men-at-arms, who seized all the livestock and certain of the guards, through whom they received news of their enemies and how they were encamped seven miles distant from that place, with the intention of coming upon them and slaughtering them all. For that reason, our men formed themselves into nine bodies of troops, and it was commanded that three of them should go on ahead on the flanks, for the plain was great, three should hold the middle position and three should bring up the rear. As for the Saracens, none could ever tell their numbers, so vast was their multitude, which was increased day by day as all those from the land round about came hastening to them one after the other.

And when the sun was up in the morning,[150] it was announced on the command of King Godfrey that all must arm themselves and that each one should take up position in his fighting formation. This being done, and having a firm hope in Our Lord Jesus Christ, for to him it is but a simple thing to cause the lesser to vanquish the greater, they marched off to that place where they knew their enemies were, and these were advancing in great disarray until the moment when they saw our men on the plain. But when they understood that they did not mean to flee, but that they were coming to provoke and attack them, they began to fear them more. But they were yet more terrified to see that the men in our army covered a most considerable area of land, thanks to the great head of livestock that they were driving before them as a ruse and that kept coming on when they themselves were not moving. They truly believed that they were armed men!

DAGOBERT SETTING OFF FOR JERUSALEM WITH BOHEMOND,
BALDWIN AND THEIR FOLLOWERS

"And but a short while after they had visited most devoutly
the Holy Places, when all the members of the clergy were gathered together,
Arnulf, who had usurped the patriarchate, was deposed, and then,
by common accord, the venerable pastor Daimbert was elected patriarch
of Jerusalem and confirmed by all."

(FOL. 102A–102VA)

In the lower register, Jean Colombe shows Dagobert, archbishop of Pisa, travelling to Jerusalem with Bohemond of Taranto, Baldwin of Edessa and their followers. In the principal scene, he illustrates the episode in which Godfrey of Bouillon pays homage to Dagobert after he has been elected patriarch. With a portico supported by columns covered with cable moulding, triumphal arch and high walls decorated with sculptures, the setting is reminiscent of an ancient city.

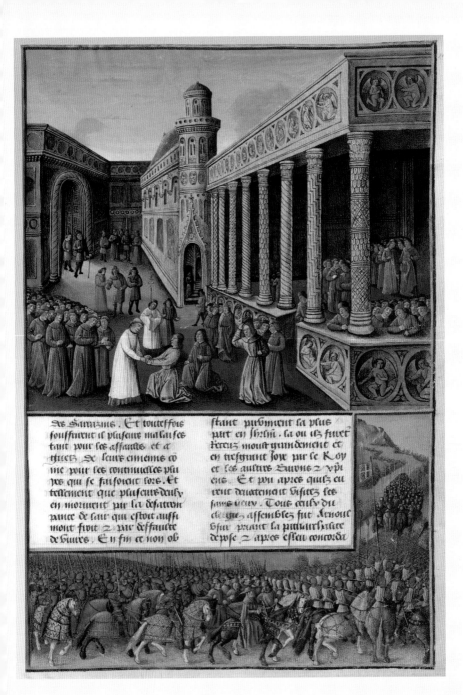

de Sarazins. Et touteffois
souffirent il plusieurs malaises
tant pour les assaultz et a
ttucz de leurs ennemis cõ
me pour les continuelles plu
yes qui se faisoient lors. Et
tellement que plusieurs deulx
en moururent par la desatou
rance de leur qui estoit aussi
mont fait ⁊ par deffaulte
de Vivres. Et en fin et non ob

stant publiement sa plus
part en Sbrslin. la ou ilz furet
recueilliz mout grandement et
en treshaunte Joye par le Roy
et ses aultres Suivis ⁊ vpi
ens. Et peu apres quilz eu
rent devotement visitez les
sains lieux. Tous ceulx du
cleargie assemblez fut Arnoul
esleu prant la pluralite des
voise ⁊ apres esleu concordi

And the greatest lords, those who might have been thought best able to cope with combat, began to withdraw as secretly as they could, little by little, and to take flight, leaving their troops, one after the other, and concealing themselves. And for this reason, when the lesser knights and common people observed this, they said to each other that there would be no shame if they also took flight. And this they did, for they spurred on their horses hard and all began to flee, as hastily as they could, towards those places where they thought to find refuge, abandoning their tents that were most richly stocked. And the Christian princes and pilgrims, when they saw that Our Lord had fought on their side by filling the hearts of the Saracens with so terrible and great a fear that they had taken flight without striking a single blow, rejoiced exceedingly and gave thanks to Him most devoutly.

And, taking council amongst themselves, they concluded that they should not follow them in disarray through the country, because their numbers were too great in comparison to their own and, if the chance should offer, they could still do them harm if perchance they rallied. And for this reason, they moved off in fine formation to the tents of the Saracens, wherein they found great abundance of gold, silver, robes and vessels of divers kinds, and other rich things, which they took and divided amongst themselves without dispute. And thus, each one of them rich and laden with possessions according to his station, they returned, praising Our Lord, and entered in great triumph the Holy City of Jerusalem.

But few days thereafter, those two valiant princes Robert, duke of Normandy, and Robert, count of Flanders, left Jerusalem. And taking leave of King Godfrey and the other princes and barons, they took the road that they might return to their own countries, passing through Constantinople, where they were richly feasted by the emperor Alexius. Taking their leave also of him, they set off once more and arrived in their own countries, meeting there with different fortunes, for the count of Flanders was warmly welcomed by his subjects, but Duke Robert of Normandy found matters greatly changed, for during the time that he was on the holy pilgrimage, his oldest brother, called William, who was king of England, died with no direct heir. After his passing, although the kingdom should have reverted by right to this Robert, duke of Normandy, their third brother, the youngest of the three, called Henry, had caused the princes and lords of England to believe that Duke Robert, his brother, had been elected king of Jerusalem, and that he wished to die there and never to return, nor ever to possess his English lands again. So they had crowned him king and, after they had paid him homage and sworn their oath of fealty to him, he had vested their lands in them again as their true king and lord.

Knowing this, Duke Robert, when he had arrived in Normandy and been received with honour by the Normans as their true and natural lord, commanded his brother through his legates to renounce his title to the Crown and the kingdom of England, and to surrender them to him as both reason and the law demanded. King Henry having refused to do so, Duke Robert assembled a great army in Normandy and other places and, crossing the sea, came into England, and King Henry, his brother, came to meet him with the power of the land. But when the two bodies of troops stood facing each other, all ready and drawn up in battle array, certain princes and lords from each of the two parties, believing that there could befall great loss and great harm if it should come to battle, succeeded in causing the two brothers to come to an accord, whereby King Henry should remain king for ever, but should pay each year three thousand pounds in gold to Duke Robert of Normandy.

And thus was made peace, but it lasted scarce any time, for good Duke Robert, once he had returned to Normandy, was desirous of holding in full franchise certain towns and castles in the Cotentin that he had given in pledge to King Henry his brother long before this last agreement, which Henry would neither agree to nor suffer. And that is why Duke Robert laid siege to them and took them by force, and for this reason, their disaccord grew so great that King Henry, crossing the sea, arrived in Normandy with a great army. When Duke Robert led his men into battle against them, he was betrayed and sold by certain of those whom he held to be most faithful to him, such that he was taken by his brother King Henry, and his army was routed before Tinchebrai, and he was taken away captive into England. There he died in prison, surrendering a glorious life to Our Lord, for whom he had endured many a great hardship during the pilgrimmage called "Godfrey of Bouillon's journey". And so Henry remained in peace king of England and duke of Normandy.

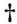

Chapter XXXV.

How Bohemond and Baldwin of Edessa came to Jerusalem. Of the election of the patriarch and how Godfrey was confirmed king. Of the capture of Bohemond. Of the death of King Godfrey of Bouillon and of the election of Baldwin, his brother, as king of Jerusalem, and how Tancred left the city and went to govern Antioch.

Raymond, count of Toulouse, left Jerusalem also but a short while later, and he came as far as Lattakieh and thence, leaving behind the countess, his wife, journeyed on to Constantinople. And although he had said when he departed that he would return speedily, the emperor retained him long, being desirous of celebrating his presence with splendour, and giving him rich gifts, so that two whole years were passed ere he returned to Jerusalem. For part of this time, and as long as King Godfrey lived, the most valiant Tancred remained with him, governing in great state Tiberias,[151] Nazareth and the principality of Galilee that the king had given him. He founded there a number of churches, and endowed them with rich jewels, rents and revenues, and most particularly he did much good to the churches of Nazareth, Tiberias and mount Tabor, leaving them all in a most excellent state when he no longer wished to retain the lordship, for in these churches and in those of the principality of Antioch that he governed long after, he showed plainly that he was most intelligent, rich and valiant, and most devout towards Our Lord God Jesus Christ and his most glorious mother, the most worthy Virgin Mary.

Elsewhere, Baldwin, count of Edessa, brother to King Godfrey, and Bohemond, prince of Antioch, also left their lands and took the road with a fine company of men-at-arms to visit the Holy City of Jerusalem. But before they arrived there, they encountered on the road a most notable prelate of saintly life called Daimbert, archbishop of Pisa,[152] together with a number of other Italians, so that, when their two companies were joined together, they were a good thirty-five thousand men all told, both on foot and on horseback, which conferred much greater safety on them for their passage through the lands of the Saracens. But yet they suffered many a difficulty, both by reason of the attacks and ambushes of their enemies and also of the continual rains that there were then, so that many of them died thereof, through the dampness of the air, which was also most cold, and through

lack of food. At last, however, the greater part of them reached Jerusalem,[153] and there they were well and most joyfully received by the king and the other Christian barons.

And but a short while after they had visited most devoutly the Holy Places, when all the members of the clergy were gathered together, Arnulf, who had usurped the patriarchate, was deposed, and then, by common accord, the venerable pastor Daimbert was elected patriarch of Jerusalem and confirmed by all.[154] When he had acceded to the pontificate, there came and knelt before him King Godfrey of Bouillon, who besought him to invest him with the kingdom of Jerusalem and to confirm him as king, and Bohemond, who besought him likewise to confirm him in his office of prince of the principality of Antioch; this thing he did most willingly after they had done homage to him, for he wished thus to honour him who had given them these offices, that is to say, Our Lord Jesus Christ, for it was considered that Daimbert was Christ's vicar in that region. There was then great feasting and celebration in Jerusalem, during which the king, princes and all the nobles assigned to the patriarch all the rents and revenues that the Greek patriarch had possessed formerly, and a great number of others, too. Once these things were accomplished, Count Baldwin and Bohemond took their leave of the patriarch and king, and after they had been, out of devotion, to bathe themselves in the waters of the Jordan, where Our Lord God Jesus Christ was baptised by Saint John the Baptist, they went back safe and sound, each one to his own lands.

But Bohemond left Antioch but a few days after his return, for he wished to take under his control the city of Melitene,[155] a city that is situated on the far side of the river Euphrates and whose Armenian Christian lord, whose name was Gabriel, had appealed to him that he might give the city into his safe keeping, lest he should be dispossessed of it by the Turks. But a Turk named Danisman,[156] who had been warned of the coming of prince Bohemond, gathered together Turks in greater number than the Christians, and he rushed upon them suddenly at a fortified crossing, so that he killed all those who tried to defend themselves, except for prince Bohemond, whom he carried away as captive most strongly bound.[157]

And he came with all speed before the city of Melitene, hoping that he would take it without difficulty by laying siege to it. This thing he did not do, however, for certain Christians, who had escaped from the rout, went in all haste to Edessa, where they announced to Count Baldwin the capture of Bohemond and the siege of Melitene. This is why he gathered together with all speed a most great army and, having gone out into the open country, he led this army directly to Melitene, which was three long days' journey from Edessa. He went most rapidly, so that the Turk, learning of his arrival,

had not the time to complete his undertaking, but, fearing he be encircled by him and not daring to await his coming, abandoned the siege and retreated, taking flight into his own lands and castles, keeping Bohemond captive and most strongly bound. And Count Baldwin, who was already near the city, pursued him constantly for three days until he saw that he could not catch up with him, when he returned to the city of Melitene, where Gabriel received him with great joy and, returning the city to him in accordance with the conditions that he had promised to Bohemond, Count Baldwin returned but a few days after to his lands of Edessa.

There arose also at that time a discord in Jerusalem because the patriarch demanded the Tower of David, that is to say, the keep, and one-quarter of the city of Jaffa, saying that they belonged to him, although the pilgrims had given them to King Godfrey after the conquest of the Holy City and the kingdom of Jerusalem. On the feast of the Candle,[158] before the clergy and all the people, the king surrendered for ever, through generosity, one-quarter of the city of Jaffa to the patriarch, for him and for his church. And when Easter Day[159] was come, before all those who had come to the solemn celebrations, he left also in the hands of the patriarch one-quarter of the city of Jerusalem, and the Tower of David, and all their dependencies, provided, however, that the duke should hold the cities and the tower and the lands until such time as, with the help of Our Lord, he should have conquered from the Turks two other cities, which would increase his kingdom; he further provided that, if he should die in the meantime, then all should come without contestation into the hands of the patriarch and his church on the day that he departed this life.

One may be surprised that the patriarch, who was a holy man, should dare to impose such conditions upon King Godfrey, seeing that he was to all intents alone and surrounded by all his enemies, for there remained in the city at that moment not one of the princes and great barons who had been there until the holy conquest of Jerusalem, except for himself and the most valiant Tancred, who, from all their powerful men bearing arms, could have thrown into battle no more than around three hundred men on horseback and two thousand on foot. These were but few considering the multitude of their enemies that were in the lands beyond their own, for the cities that had been conquered by our men did not lie close to each other and could not bring succour to each other unless they passed through the dangerous lands of the Turks, at very great peril to themselves. Even in the villages around the cities that were held by the Christians, there dwelt none save Saracens, who more than all others loathed our people, and would rather, through contempt, endure the most great hardships than till those lands of which the rents would be paid to the Christians. And they did many an evil thing to them through treachery, and

there were besides so few of our people in the cities that the bandits who got in at night broke open their houses most often to kill or rob them.

And so it was that many Christians abandoned their properties in the cities and returned in secret to their own lands, for they feared greatly lest one day they should see the Turks who lived round about gather together, seize their towns and cities by force and slaughter them and wipe them out, even to their names. And it was for this reason that certain of them took flight, before returning once more when the war was over to the neighbourhood of their houses and were desirous of assuming possession once more of their goods and of driving off those who had been within and had safe-guarded the cities and towns, and this thing gave rise to great lawsuits and disputes. And for this reason, that they might chastise those who went away in this fashion, a law was decreed, which was observed inviolate, first in the kingdom of Jerusalem and thereafter in the principality of Antioch and the county of Edessa. And in accordance with this law, any man who retained his property peaceably during a year and a day should never need to answer for his right, but should retain the property for ever, no matter by what title or by what means he had obtained it.

When things were at this pass in Outremer, there arose a new and most grievous sorrow, for when he was returned from those parts of Araby that were beyond the river Jordan[160] and had brought back thence to Jerusalem a vast booty of livestock and other rich goods, of which he and his people had very great need, King Godfrey had dwelt there but a most brief time when he was struck down by sickness. The doctors of the kingdom, who were assembled, could not cure him, and when he was told this with certainty, most devoutly, and when he had received the blessed sacrament from the altar and the other sacraments, in the midst of weeping and of great show of devotion, following the wish of all good Christians, he surrendered his glorious soul to Our Lord God Jesus Christ on the twentieth day of July[161] in the year of grace of the incarnation of Our Lord Jesus Christ 1100. And his body was buried with great magnificence amidst the most great lamentations and weeping of all the people in the church of the Holy Sepulchre, beneath the mount of Calvary. And it is in this church that henceforth all those kings of Jerusalem who died there have always been buried.

And so departed this life King Godfrey of Bouillon, first Latin king of Jerusalem, who accomplished during his life many a deed most worthy of memory. After the death of him who reigned but one short year, this kingdom remained three months without a king, so that finally the barons sent for Baldwin of Edessa, brother to King Godfrey, who, as some men asserted, had counselled on his deathbed that he should be chosen.

And when Count Baldwin, who was at that time in the city of Melitene, heard of the death of his brother, he took with him, at the request of the barons, two hundred men on horseback and eight hundred men on foot, and leaving his county of Edessa and his other lands in the hands and under the safeguarding of one of his cousins, called Baldwin of Le Bourg (who succeeded to the county of Edessa after him and thereafter to the kingdom), he came in a few days to Antioch, where he put his wife[162] and her retinue on board a ship and gave orders that they be brought to Jaffa, which was the sole city under Christian control on the whole Syrian seaboard. He freed himself of these ladies in this fashion, for he knew that they would hinder him in his passage through the lands and under the eyes of the Turks, whom he expected only too well to encounter (as, indeed, he did), although he followed the coast from Lattakieh and passed before the cities of Jabala, Valenia, Marqiye,[163] Tortosa and Arqa as far as Tripoli, whose lord, knowing that he had set up camp in the fields, sent him great gifts of food and rich presents of gold and silver. And he made known to him for certain that Duqaq, king of Damascus, was spying on him to do him harm if it should be within his power.

The count thanked the lord of Tripoli and moved on through Jabala and came to the Dog River, where there was a most perilous crossing, for on one side the mountains are most high, the rocks are sheer and the road is steep, while on the other side the sea is of great depth and constantly throws up great waves. And although this road was no more than a toise in width, it was a good quarter of a league long. Besides, the people from that land and even certain Turks had come there from afar on the orders of the king of Damascus and they had fortified this passage to defend it against our men. But when the count sent there certain of his men who were amongst the best mounted to discover how he might pass through, they saw that their enemies had come down from the mountains into the plain and for that reason they feared there should be some ambush behind them. This they made known to the count who, when he had drawn his men up, went forth to attack them with such reckless speed that a great number of them were slain, and the others fled, leaving on the plain their pavilions and their tents. The count and his men made camp there, yet they had very little rest, for the Turks hurled missiles at them ceaselessly throughout the night, both from the mountains and also from the boats that came constantly in fresh numbers by sea from the cities of Jabala and Beirut. A number of them were killed and wounded and they had scarce any space wherein to water their horses at the river, which flowed nearby.

And on the morrow Count Baldwin, calling his men together in council, ordered them to load up the baggage and retrace their steps, that they might deceive their

BALDWIN I ATTACKING A TURKISH CAMP.
BALDWIN I GIVING ORDERS TO ASSIST THE WIFE OF A NOBLEMAN
DURING THE BIRTH OF HER CHILD

"But, on the road, the pangs of childbirth seized the wife of a great Turkish lord,
whom they were carrying away on horseback. The king, when he was told of this,
turned back to her and caused her to be gently taken down, and he had made up for
her a bed with mattress and curtains, as decently as could well be, and had her laid
thereon. As there was no covering for her, he took off a great and rich mantel
of squirrel fur that he was wearing over his armour, with which he covered her."

(FOL. 106VA)

Once he became king, Baldwin I devoted himself chiefly to enlarging the kingdom of Jerusalem. From 1100 to 1118, he led a number of expeditions to take possession of the coastal towns and built numerous fortresses. In Sébastien Mamerot's account of the episode illustrated here, the king captured a Turkish camp; those who were in the camp fled and the Christians seized their possessions. The women and children were spared, including the heavily pregnant wife of a nobleman, whom Baldwin released together with her attendants so that she was able to deliver her child safely on the wayside. Jean Colombe takes pains to indicate the intimate details of this scene, showing how the king ordered a rich mantle to be taken to the lady so that she could be kept warm. His behaviour on this occasion increased Baldwin's renown amongst his adversaries.

audoyn le pre
mier de cestui
nom Roy
de Jhrlm tenãt
son royaulme
en demourer paisible par lespa
ce de .iij. mois depuis son cou
ronnement voult resuscitier ses
ennemis anciens de la foy .
Car il se et assembla une pe
tite armee tant de ceulx du

Royaulme. comme de ceulx quil
auoit amenez de Rohne. Et em
uopnt ses espies deuant. passa
le fleuue de souldam tant seur
tement que aucun deulx ne se
apperceut de son armee iusques
a ce quil fut bien auant es desez
dumbe. en vng lieu selon ce que
ses espies lui auoient nomme
Il surprint entour mynupt vne
grant assemblee de Turcqs q̃

enemies. This thing they did, placing the beasts of burden and the weaker men to the fore, while the count and the strongest men, those who were the best mounted and the boldest, formed the rearguard, that they might ensure their defence ahead, to the right and to the left.

Those to the fore made show of being fearful, but they did this only because of the defiles where the Saracens were, whom they wished to draw out, that they might fight them in the open, which came about. For the Saracens, seeing that the Christians were retracing their steps, believed that they were truly taking flight, and their arrogance thereat was so great that they came down from the mountains and the fortified places in all haste and they came on in a disorderly crowd and approached our rearguard, firing their javelins and arrows in a dense mass. The Turks and the Saracens who were in the boats nearest to our men leapt onto the shore and ran after their companions, that they might have a share in the pillage, believing that their side had already carried the day.

But when Count Baldwin knew that the Saracens had moved far away from the mountains and the boats, he ordered his standard bearer to turn his horse's head, that they might throw themselves upon those who were pursuing them. He himself was the first to enter the fray, followed by all those of his own battle corps, with such reckless speed that they killed and slaughtered so great a number of Saracens from the moment of their first assault that the rest were so terrified that they could no longer defend themselves, but took flight into the mountains and to the boats, which availed them little, for the people in the boats were encircled between a party of our men and the sea. And the others could not all return to the mountains because our men pursued them so closely, striking and killing them, that but few of them could escape and take refuge in the mountains. The greater part of them were so terrified that they sprang down from the top of the rocks, thinking that they might flee higher and farther if they did not follow the road or the path, and they killed themselves most wretchedly by falling headlong, either onto the rocks or into the sea.

When Count Baldwin of Edessa had thus gained this victory over his enemies with the help of Our Lord, and when they had returned thanksgiving and praise, he returned most joyfully with his men to the place where he had left his baggage. Setting out thence once more, they went to another place hard by that was called Juniye,[164] and there they shared out their great booty of horses, armour, beasts of burden and other rich things. On the morrow in the morning, the count took a number of his men, the most valiant and the best mounted, for he wished to visit the passage to find whether it was quiet. And when he was sure that there was no defence there, he sent for the

rest of his men, and when they had joined him once more, he took the road. His army passed before the city of Beirut and, going on its way, held close to the region by the shore. After they had passed close by the cities of Sidon, Tyre and Acre, they came to the city of Haifa,[165] whose inhabitants delivered to them with great pleasure food at a fair price, and gave them splendid gifts. But Baldwin did not go in, nor would he suffer any of his men to go in, for the city belonged to Tancred and he had no wish to displease him, by reason of the outrage he had done him at Tarsus in Cilicia.

And he followed the most direct road through Jaffa until he reached Jerusalem, where he was welcomed with great joy by the clergy and the people as their king and their lord.[166] But the patriarch Daimbert did not come before him, because he had been warned that Count Baldwin had great love for Arnulf (who had been deposed from that dignity of patriarch that he had for a moment usurped), he feared lest the king might treat him with disrespect, at the instigation of this disloyal familiar. And he had, therefore, retreated outside the city and taken refuge in the church of the mount of Sion, where he passed his time in study and prayer, at which the count was much displeased. Nevertheless, certain wise men succeeded in reconciling them.

And on Christmas Day of the year 1100, Count Baldwin was consecrated, anointed and crowned king of Jerusalem by the patriarch before all the other prelates and barons, and before all the people, too, in the church of Bethlehem. And it was then that Tancred, who had not forgotten the outrage that Count Baldwin had done to him at Tarsus and who had no love for him, and who for that reason did not wish to be his man, came before him and gave back into his hands the cities of Tiberias and Haifa that King Godfrey had given him; and having taken his leave of them, he departed to Antioch, which much displeased the barons, who were greatly angered that the king should let him thus depart. But he made scarce any effort to retain him and, to speak truthfully, the people of Antioch had on a number of occasions asked Tancred, by divers messengers, if he would of his goodness come to safeguard and govern the city and principality, until such time as Our Lord should have caused his uncle, Bohemond, their prince, to be freed from his prison. And he acceded to their requests: after they had welcomed him into the city and the other places, he governed them so well and he safeguarded and defended them so valiantly, constantly increasing the lordship by new conquests from the Saracens and causing a good and true justice to prevail, that the clergy, nobles and all the people called him, by reason of his excellence, their father and their lord. And besides, King Baldwin, the first of that name, gave the cities and the lands that Tancred had possessed in the kingdom of Jerusalem to a great lord, a most valiant and a good knight, called Hugh of

Saint-Omer. And thus was accomplished "Godfrey's journey", the second of the great expeditions to Outremer made under the leadership and at the instigation of the French.

✝

Chapter XXXVI.
The first expedition undertaken by the French after the conquest of Jerusalem, and the Second Great Crusade, in which there took part the duke of Aquitaine, the count of Poitiers, Hugh the Younger, the duke of Burgundy, Stephen, count of Blois, the count of Vendôme and the brother of the count of Toulouse.[167] Of the treachery of Alexius and of the death of Hugh the Younger, the return of the count of Poitiers and the death of the count of Blois. Of the defeat of King Baldwin, of his victory thereafter and of the deliverance of Bohemond and the death of Count Raymond.

Baldwin, the first of that name, king of Jerusalem, seeing that his kingdom had remained peaceful for four months after his coronation, wished to arouse the old enemies of the faith, for he formed and gathered together a small army, composed both of those from the kingdom and those whom he had brought with him from Edessa. After he had sent his spies out as scouts, he crossed over the river Jordan in secret, such that none observed his army until he was far inside the deserts of Araby. In a place that his spies had shown him, he took by surprise, towards midnight, a great gathering of Turks, who were settled in their pavilions and great tents, with their women and children, horses, livestock and many rich things. There were there a number of great lords of their religion who all, hearing far off the uproar our men were making, mounted their horses in great haste and took flight, leaving the other Turks, women and children in their tents. The king and his men went inside and found that all was theirs for the taking, and so they killed the Turks who had remained and carried off the women, children and rich things without any resistance.

But, on the road, the pangs of childbirth seized the wife of a great Turkish lord, whom they were carrying away on horseback. The king, when he was told of this, turned back to her and caused her to be gently taken down, and he had made up for her a bed with mattress and curtains, as decently as could well be, and had her laid thereon. As there was no covering for her, he took off a great and rich mantel of squirrel fur that he was wearing over his armour, with which he covered her. He left her beside women to attend her and an exceeding great quantity of wine and other foods, which would there-

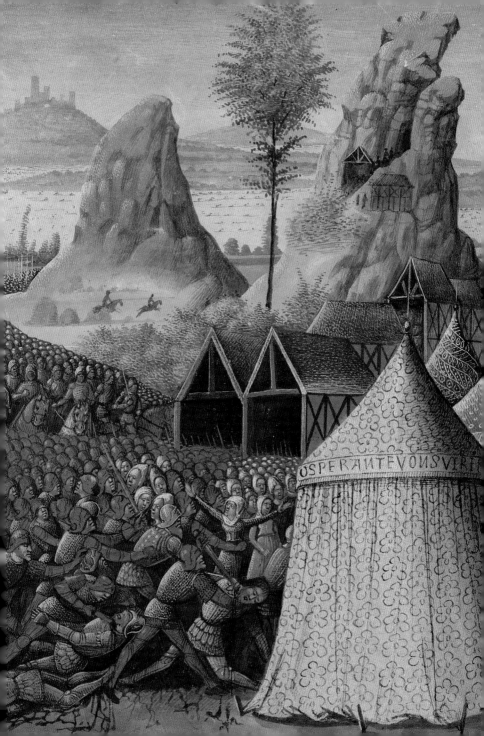

after save for him his honour, his goods and life, for the lord who was her husband returned later, secretly and from afar and, having found her, learned from her lips of the respect that the king had paid her. Thereafter he loved all Christians and, most particularly, the king and all the people of France. And long afterwards he himself freed the king, from a place where he had been surrounded in the midst of his enemies and whence he could in no wise have escaped without dying or being taken prisoner.[168]

At that time, there spread throughout France the great tidings and the worthy fame of the high feats accomplished by the first pilgrim crusaders, and of the great succour and help that Our Lord had often brought them, both during the conquest of Antioch and that of the Holy City of Jerusalem and other places. That is why the holy crusade began again, with yet more splendour, that crusade that we could and should call the second, for although there was neither emperor nor king, there were to be found there nonetheless a number of noble and excellent princes. Amongst those who took the cross this time were William, duke of Aquitaine and count of Poitiers, who was the most rich and powerful of them all; Hugh the Younger, count of Vermandois and brother to King Philip I; Stephen, count of Chartres and of Blois (both of whom had departed, one after the other, from Antioch, as has already been told); and Stephen, duke of Burgundy,[169] with many counts, barons, knights, gentlemen and other men of divers estates in exceeding great numbers, who formed a most powerful army. All of them following the road taken by the first pilgrims, they came to Constantinople, where they found the emperor Alexius and Count Raymond, who had come there to seek the aid and succour of the emperor, for he wished to conquer one of the cities of Syria from the Turks and to retain it for his whole life, never to return to his lands in France. And God knows the joy that the pilgrims felt when they saw him, for it was their hope that he would be the best leader of their army.

After the emperor Alexius had feasted them splendidly and given them rich gifts, they took their leave of him, which he appeared to accept most willingly, but this was through treachery, as they would know only too well thereafter. For he, and the greater part of the other Greeks likewise, were jealous of the honour and renown that was noised abroad in praise of the French, by reason of the great and rich conquests that they had made thanks to their strength and valour. So the Greeks (and this was most particularly true of the treacherous emperor Alexius) continually warned, by letters and messengers, the Turks and other Saracens and pagans who dwelt in those lands through which our men must pass and in the lands round about, that they might gather together to attack them in divers ambushes and in open and sudden battle. At the very least they must not suffer all the Christians to pass through, lest they should gain such power that

they would destroy all the peoples of the Orient, and would conquer all of Africa and Asia, and would annihilate the religion of Mohammed.[170]

It was at his instigation and because of his urging that they called upon mercenaries and other armed men. The Turks and other Saracens, forewarned of the route that our men would follow, took them easily by surprise, both because of the treachery of the Greeks, whom the Christians trusted when they swore to them that they need fear nothing at the hands of their enemies and that no army was being made ready against them, and because they divided and did not move on together as the first crusaders had done. Thus, the Turks, forewarned by the Greeks and their spies that they had separated, ran after them so suddenly that they seized all their beasts of burden and their baggage and slaughtered in one single day at least fifty thousand men, women and children. And those who escaped the slaughter fled all naked and poor, for they lost all their riches in this defeat. And finally, fleeing and hiding themselves amongst the mountains and valleys, and woods, hedges and bushes, they came, one after the other, to Cilicia and withdrew together into the chief city of that land, which is called Tarsus, and there Hugh the Younger died of sickness, hunger, cold, thirst and all the sufferings he had borne during his flight. His body was buried in the church of monsignor Saint Paul in the city where he was born.[171]

When the pilgrims had stayed for five days in Tarsus, they took the road again and reached Antioch, where they were welcomed with honour and splendidly feasted by Tancred, who gave them great gifts, and most particularly to the count of Poitiers, who had lost the most. They set off again thereafter, one party going by land and one party by sea, and they all came together again before a city on the coast called Tortosa, which, following the council of the count of Toulouse, they attacked and took by force, killing or taking captive all the pagans, Turks and other Saracens who were therein. And our men won there a great quantity of arms, food and other rich things, of which they had likewise great need. When they were ready to depart, they gave the city to the count of Toulouse, which they deeply regretted thereafter, for the count did not wish to depart from the city nor to conduct them as far as Jerusalem, no matter how they entreated him;[172] nevertheless, they took the road again to make their way thither. During this time there put into Jaffa a fleet of Genoese, who beached their ships and came to Jerusalem on Easter Day. The king, knowing that they were come to gain money and to celebrate the faith, agreed, at their demand, that he would maintain them, and if he won a town, city or castle from their enemies with their help, would give them a third part of all the moveable possessions and, further, would give to the Genoese for ever one of the finest streets in each of the cities they had conquered. These accords

SECOND BATTLE OF RAMLEH (1102).
ARRIVAL OF BALDWIN I IN JAFFA

"At that time, there spread throughout France the great tidings and
the worthy fame of the high feats accomplished by the first pilgrim crusaders,
and of the great succour and help that Our Lord had often brought them,
both during the conquest of Antioch and that of the Holy City of Jerusalem
and other places. That is why the holy crusade began again, with yet
more splendour, that crusade that we could and should call the second,
for although there was neither emperor nor king, there were to be found there
nonetheless a number of noble and excellent princes."

(FOL. 106VB)

In the lower register on this page, Jean Colombe depicts a ship in the port of Jaffa. This is undoubtedly the ship of the count of Blois and the duke of Burgundy, which was unable to set sail through lack of wind. At this time, the Turks had assembled a huge army and invaded King Baldwin's lands near Ramleh, inflicting a heavy defeat on the Christians. It is to this defeat that Colombe alludes in his depiction of a battle, in which corpses lie piled up on the ground, which is soaked with blood. The Saracen army appears immense in comparison to the more modest numbers of the opposing Christian troops. In the background, huge, towering rocks convey the impression of an inhospitable and mountainous countryside.

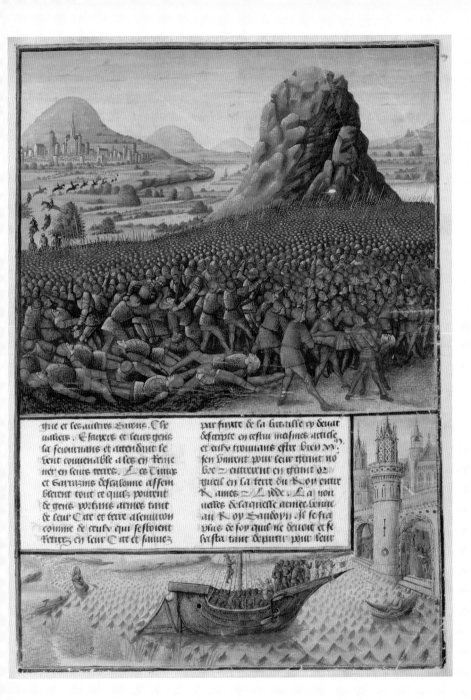

thie et les aultres faiens. Che
ualiers. Escuyers et leurs gens
fa feiourname et attendant se
vont comuenable a ses en retou
ner en leurs terres. Les Turcs
et Sarrazins descaloume assem
blerent tout ce quils peurent
de gens prestement armez tant
de leur Cite et terre alentour
comme de ceulx qui festoient
retirez en leur Cite et sauuez

par fuite de la bataille cy deuat
descripte en cestui maismes article.
et eulx trouuans estre bien xv.
sens huirent pour seur trant no
bre ⁊ entrerent en prant or
gueil en sa terre du Roy entre
Tames ⁊ Lydde ⁊ La non
uelle desaquelle armee venue
au Roy Saudoyn. Il se fia
plus de soy quil ne deuoit et se
hasta tant departir pour seur

concluded, the king had his army go forth both by land and by sea, and he besieged and took the stronghold of Arsuf,[173] during which assault a number of Christians were killed. And then he took by assault the city of Caesarea in Palestine, which was before called the Tower of Straton, but Herod the Ancient had caused it to be rebuilt in greater and richer fashion and had called it Caesarea in honour of Caesar Augustus.[174]

In that city, after an immense massacre of Turks and Saracens, they found, amongst other rich things, a container of green glass, wondrous clear and of most splendid beauty. The Genoese took this against a very great sum of money that they had received as part of their booty from the city, and they carried it away to their own town, believing it to be an emerald, and placed it in their principal church, and it is there that they placed the ashes on the first day of Lent. And then it was, for the first time since they had conquered the Holy City, that the crusaders began to become rich and laden with possessions. Their honour and wealth grew yet greater but a few days later, for the caliph of Egypt sent one of his constables with ten thousand men on horseback and twenty thousand men on foot, thinking to destroy all the Christians in Syria: but that which befell him was, indeed, different.

The king, after he had devoutly prayed to Our Lord, thereupon felt completely assured of victory, although he had with him, between Ramleh and Lydda, where the battle was fought, no more than two hundred and forty men on horseback and nine hundred on foot, and from these he formed six bodies of battle troops. He went towards the enemy, ordering that the True Cross be borne on high by a holy abbot, and he vanquished them utterly, though in the beginning one party of the enemy overcame the first body of the king's troops and carried away in all haste the arms of the Christians who had just been killed to the city of Jaffa. And there they demanded that the citizens, who followed our faith, should surrender the city to them, affirming that the king was dead and the Christians beaten, which the people of Jaffa, in spite of their grief, would not do, but sent this news most speedily and with all haste to Tancred, beseeching him to come to the aid of the Holy Land, for else it would be lost. But when the morning was come, the king removed the spoils from his enemies, of whom there remained five thousand lifeless on the battle-field, and he moved away towards Jaffa and conquered most easily the rest of the Egyptians, for they believed that these were their companions who had conquered the Christians. After he had gone into the city, when he knew that they had called upon Tancred, he sent news to him, thanking him for his goodwill and for his earnest desire to bring help to his kingdom and the people of Our Lord. And for this reason, Tancred, who was already far advanced, praised Our Lord and returned to Antioch.

King Baldwin, too, returned to Jerusalem, but he remained there scarce any time, for he was warned that the count of Poitiers, duke Stephen of Blois and Chartres, Geoffrey, count of Vendôme, Hugh of Lesimare, brother to the count of Toulouse, and the other barons who had journeyed with them and who had departed from Antioch to come to Jerusalem, were greatly delayed on the road because of most dangerous passages. So fearing the enemies of our faith should prevent them from crossing over the river Jihan, he went forward to surround the strong crossing over the river, which was not easy to do, for before he arrived there, he had to pass close to four great fortified cities, well garrisoned with Saracens and Turks: the first city was called Acre, the second Tyre, the third Sidon and the fourth Beirut. And when the king had reached the crossing, the princes and barons who had stopped there came to meet him, most joyful because the way was open to them and also that the king had come out to meet them and was ready to conduct them to Jerusalem himself. They gave him heartfelt thanks for his great courtesy, and he welcomed them willingly and with great joy; and then they all went on together into the Holy City, where they celebrated the feast of Easter, which was approaching.

When they had remained there for some time and had visited the Holy Places, they asked their leave of the king and set sail to return to their own lands. But their voyages were not the same, for the ship of the count of Poitiers returned straightway to Aquitaine and Poitou, while that wherein were the count of Blois and the duke of Burgundy was pushed back by a storm into the port of Jaffa, and they had perforce to wait there until there came a favourable wind to help them out of port. And while Count Stephen of Blois, Duke Stephen of Burgundy and the other barons, knights, squires and their men remained there waiting for a favourable wind to carry them back to their own lands, the Turks and Saracens of Ascalon gathered together all those they could of men bearing arms, both from their own city and from the lands round about, and also from those who had retreated into their city and had taken refuge there during the battle that has already been described in this same account. Being at least fifteen thousand, they came most recklessly into the king's lands, between Ramleh and Lydda.

When the news of this army came to King Baldwin, his confidence in himself was too great and he made such haste to confront them that he did not send for men from his other cities. And what was worse, he would not wait for those princes and barons who were with him. But the two great princes of Blois and Burgundy and their men, who had no horses, would not suffer him to ride out thus alone, as much for the honour of the royal dignity as for love of Our Lord, for whom he was putting himself in great danger. So they sent for horses to borrow and hire, according to their means. And

they departed as qhickly as possible after the king, although they were not fast enough to prevent the Turks and Saracens from observing full well that they were coming on in disorder and were not keeping the same battle order as hitherto, at which the enemy were yet more overweening than before. And the king himself, when he had come near Ramleh[175] and had seen the great number of his enemies, knew that he had put himself into extreme danger, and yet he did not wish to turn back, both because he was most close to them and also lest he encourage them in a desire to attack him, which might offend in his death.

To be brief, when the wisest Turks understood the disarray of our men, they rushed upon them headlong, and our men, seeing that they would die if Our Lord and the force of arms did not safeguard them, defended themselves full long with the utmost strength and boldness, and threw themselves so valiantly on their enemies that they slew a very great number of them, and the others were so dumbstruck that they were ready to take flight. But when they had well observed the small number of our men, they began to gather together again and to urge each other on, and then they hurled themselves after our men with such headlong speed that they conquered them and put them to flight, after Count Stephen of Chartres and of Blois had been slain there in most honourable fashion. For he suffered martyrdom of his own free will, to fulfil the holy faith and thus to wipe out, obliterate and suppress all the shame and reproaches that people might have heaped on him, and on his men likewise, because he had departed so shamefully from the siege of Antioch. And I believe that it was in this fashion that Our Lord God Jesus Christ wished to thank him most highly, to repay him for the great service and expenses that he had made on the two passages, and there were many who also rejoiced greatly thereat, for love of him.

Duke Stephen of Burgundy was likewise killed there, and they mourned him greatly, for he was a valiant and wise prince, and a number of others also departed this life there. The king and those who could escape by flight retreated to Ramleh, thinking to save themselves there, and it was here that the king received the temporal ransom for his generosity towards the wife of the great lord of Araby that I have already told in this account. For her husband, who was one of the mightiest Saracens in the whole army, came to Ramleh at about the midnight hour, when the king was wakeful in his bed, pondering how he might protect himself and his men, seeing that they were encircled by their enemies in a place that he knew to be so weak that they could not defend it. Speaking in a low voice to those who were guarding the city walls, he caused them to go to the king to tell him that he wished to say something to him secretly, and

the king, who was not asleep, had him brought before him. The king understood that he wished to save him through generosity, in acknowledgement of the good deed that he had done for his wife when she was about to be brought to bed, and that there was no other way whereby he might escape thence; and believing that all the others would be lost if he was dead or taken prisoner, he entrusted himself to him. And the Saracen prince conducted him with two of his men into a safe place, and then he turned back with his companions and they took by assault that city of Ramleh and slew there the greater part of the Christians whom they found therein, and led away the others, and the women and children likewise, in chains into their prisons.[176]

It was a most terrible injury that the Christian people suffered there, for never before had there been made in a single day so great a massacre of Christian gentlemen in the kingdom of Syria. And the power of the Christians was thereby sorely weakened in that land, so that those who knew the state of the country well were the most dumbstruck. And if Our Lord God Jesus Christ, through his generosity, had not made known his council amongst them, they would all have left the country, for the population of our people was but small in number, and the pilgrims who came from beyond seas could not pass through easily as far as Jerusalem, for all the cities on the coast belonged to the Turks, except for Jaffa and Caesarea.[177] And when they could reach those cities, as soon as they had made their pilgrimage and visited the Holy Places, they returned straightway to their own countries, for they knew the weakness of our men there and feared they would be surprised and destroyed with them.

And besides, King Baldwin was greatly surprised: after he had hidden all night amidst the mountains, in the morning, having with him but two companions, he passed along the most secluded roads that he could find (and yet they often passed most dangerously close to their enemies), and so they came to the castle of Arsuf, where the king was most joyfully welcomed by his men, and there he ate and drank that he might take strength. For he had hungered and thirsted so greatly that he had well-nigh fainted and had perforce to rest upon his way.

Now it happened (and well it was for him) that the Saracens of Araby had come in force to pass before Arsuf, on the day that he arrived, and had but just departed when he came in. And if he had arrived but a short time earlier, he could not have escaped without dying or being taken captive. But there followed thereafter great good fortune in the Holy Land, for but a short time afterwards he went by sea to Jaffa, and when he was ready to go thence to Jerusalem and had ordered all his men who had been in the mountains to come to him, Hugh of Saint-Omer conquered and drove off a great

EGYPTIAN FLEET BEING DRIVEN INTO A CRUSADER PORT
BY A STORM (1105). THIRD BATTLE OF RAMLEH (1105)

"But they were caught by a storm and many were drowned,
while twenty-five of their ships sought refuge in Christian ports."

(FOL. 112VA)

At the third battle of Ramleh, on 27 August 1105, Baldwin succeeded in decisively defeating the united Muslim troops, who had again mounted an offensive with superior numbers. In the lower register of the page, Jean Colombe conveys the extent of the defeat over the Egyptians by the piles of dead and wounded that litter the ground after the battle. In the upper miniature, the Egyptian fleet can be seen after having been damaged by a storm: some of the ships are sinking, others have run aground and the three in the foreground have found refuge in a Christian port, where their enemies are boarding them. On the left of the picture can be seen the town of Tyre, with the pink façades of the houses at the edge of the water.

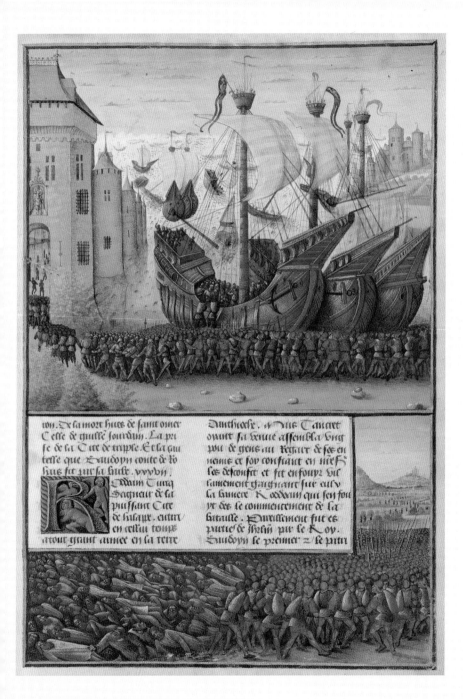

ion. De la mort hues de saint omer
C elle de quille sourdun. La pri
se de la Cite de triple. Et la gau
telle que Baudoyn conte de To
hus sut sur sa suite. xxxbij.

R oddant Turq
Seigneur de la
puissant Cite
de hilaux. entin
en cestui temps
atout grant armee en sa terre

Duithreest. Duc Tancret
ouant sa venue assembla hng
but de gens au regard de see en
nemie et soy confiant en nieff
les desounsit et fit enfouyr hil
sanement gaignant sur eulp
la Sainece Roddaut qui sen fou
yt det le commencement de sa
bataille. Duritstement fut ce
purte de Jtyslu pur le Roy.
Baudoyn se premier z se putri

355

number of his enemies, who thought to come to take him by assault in Jaffa. And thus, he returned to his country, in joy and peace for seven months.

At that time there came also to Edessa, to be with Baldwin of Le Bourg, one of his cousins called Joscelin of Courtenay, which was his native town, near Sens. And Baldwin gave him an estate and men, and he bore himself thereafter so well that he was numbered amongst the most valiant princes of the day, and became, in the end, count of Edessa. But a short time thereafter, the good patriarch Daimbert had also to flee Jerusalem, for the archdeacon Arnulf, through malice, had put him in the king's bad graces, and he went away to Bohemond, who, after he had been four years in prison, succeeded in having a ransom put upon himself and was given authority to seek it. He came to Antioch, which he found, together with all the lordship, well safeguarded and increased in size by his nephew Tancred, who surrendered the city to him and placed it in his hands without any dispute.

These two, Baldwin of Le Bourg and Joscelin of Courtenay, with Daimbert, the patriarch of Jerusalem, Bernard, the patriarch of Antioch, Benedict, the archbishop of Edessa, and their men, determined to gather together in a certain place and to besiege the mighty city of Harran, near Edessa,[178] which some men say is the city whence Abraham left for the Promised Land, at the command of Our Lord. And they did, indeed, besiege it. The citizens, forced by famine, wished to surrender one evening, but were delayed in doing so until the morning by reason of a dispute that arose between Baldwin and Bohemond, to determine to which of them the city should belong and whose banner should be placed on the main tower. But after this neither one nor the other had it, for there came a great number of Turks during the night, who, notwithstanding that they had thought merely to revictual the city, drove our men off, who took flight at the very beginning of the battle, giving no thought to the tents or the armour. The Turks, therefore, lay down their bows and, drawing their swords, they pursued our men whom they saw fleeing without striking a single blow. And after they had slain a great number of them, they kept a number of them alive, amongst others Baldwin of Le Bourg and Joscelin, and they led them away to prison, far off in pagan lands, where they remained as prisoners for five years, although they were in the end set free, leaving hostages. And these hostages killed the men who were guarding them and returned safe and sound to their two lords, who thereafter made war against each other, and most particularly Joscelin made war on Tancred, because he refused at first to give the land and the city of Edessa to Baldwin; nevertheless he did surrender them to him, without condition.

But to take up once more my tale of Bohemond, Tancred and the two patriarchs, they escaped thence by secret ways and so they reached Edessa, whither came also the archbishop but a few days thereafter and was welcomed most joyfully; because he had been captured during the battle and given to a renegade Christian to guard, this man let him go, secretly, for he had seen that he was a simple man and had an honest face. And Bohemond, knowing that Baldwin of Le Bourg and Joscelin had been taken captive, spoke to the people of Edessa and, at his demand, they kept Tancred as their commandant until such time as Baldwin should be freed, through Our Lord, and Tancred gave his word that he would surrender all the lordship to him with no dispute. This defeat did most grave harm to the Christians of Outremer, for one cannot find in any authorised history that there was ever before, across all the lands of the Orient, so dangerous a battle to the Latins, so great a slaughter of valiant men, nor a defeat that was so shameful to the Christians. Because of this great loss, and because of the debt with which Bohemond was laden, he entrusted his principality shortly thereafter to his nephew Tancred to safeguard, and taking with him the patriarch Daimbert, he crossed the sea as far as Apulia and thence he made his way to France, where King Philip I gave him Constance, his daughter born in wedlock, to wife. And he gave him another daughter, called Cecilia (whom he had had with the countess of Anjou, in despite of the interdiction of the Holy Church, his true wedded wife being still alive), that she might be the wife of Tancred, as in truth, she was thereafter. And so Bohemond returned from France with a company of many men and rich presents, but he died shortly thereafter in Apulia even as he was making ready his army to return to Antioch, leaving a son whom he had had with Constance, the daughter of King Philip. And because he was but one year old at the time when his father died, Tancred continued to govern his principality, and he married Cecilia, the natural daughter of King Philip I, who also died in that same year as Bohemond.[179]

But a short while before, in the year 1105, on the last day of February, there departed this life the most valiant, wise and powerful count of Toulouse, the good Raymond of blessed memory, who had caused to be built from nothing the strong Castle Pilgrim, and who had accomplished high feats of arms and noble conquests during the holy crusade: I believe that his soul dwells in Paradise. The passing of this noble prince did great harm to the Christians in the Holy Land, for he had harried the Saracens and weakened them grievously, and was still, on the day of his death, laying siege to the mighty city of Tripoli. His nephew, whose name was William-Jordan, kept up the siege after him and governed his land for a long while, too, until the coming of his own son and lawful heir.

Chapter XXXVII.
How a further army sent by the caliph of Egypt was almost entirely destroyed, by arms but also by a storm. Of the building of the mighty castle of Toron. Of the death of Hugh of Saint-Omer, and of that of William-Jordan. Of the taking of the city of Tripoli, and of the trick played by Baldwin, count of Edessa, with his beard.

At this point, a Turk named Ridwan,[180] lord of the powerful city of Aleppo, entered the territory of Antioch with a great army. But Tancred, learning of his coming, assembled a company very small compared to that of his enemies and, trusting in the Lord, routed them and put them to shameful flight, capturing the standard of Ridwan, who fled no sooner had battle commenced.[181] And likewise in the region of Jerusalem, a land army of fifteen thousand Turks and pagans was routed by Baldwin I and the patriarch of Jerusalem, who bore the True Cross into battle.[182] This army had been sent from Egypt into Syria by the caliph, whose generals had convinced him that he should be ashamed to allow Syria to remain so long in the power of a handful of half-famished Christians. He gained little by the advice, for our men, no more than five hundred horsemen and two thousand on foot, killed four thousand Egyptians, carried off the wealth and spoils of the army and pursued the survivors. Amongst the prisoners was a magistrate from Acre, for whom the king subsequently received twenty thousand bezants in ransom. The other Egyptians and Turks, who had come to the port of Jaffa with a great fleet, were so frightened by the news of this defeat that they fled in great haste over the sea to Tyre. Even there they did not feel safe and, therefore, again took to the seas, hoping to return to Egypt. But they were caught by a storm and many were drowned, while twenty-five of their ships sought refuge in Christian ports. Over two thousand of them were made prisoners and many more died.

Moreover, the valiant knight Hugh of Saint-Omer rebuilt the stronghold at Toron and from there he and others after him wrought havoc on the enemies of the holy faith, though he himself, not long after he had finished the work, was slain by an arrow in combat with the Turks. His men, though fewer than four thousand, nevertheless carried the day. At this point there appeared the comet, two suns and many other signs, whereupon the Turks, Saracens and other pagans of the regions neighbouring the

county of Edessa, gathering their forces in the knowledge that Baldwin and Joscelin were still prisoners, invaded their lands with a great army. Tancred, who was guardian of these territories, understood that he could not by himself ensure the safety of Antioch and Edessa, more especially given the great size of the Turkish army and, therefore, sent messengers to King Baldwin in Jerusalem to come to his assistance as soon as ever he might. This the king very willingly did with a handsome army.

But when the enemy saw the armies of Tancred and Baldwin on the field, they did not dare to put themselves in battle order but took care to postpone the confrontation, knowing that neither the king nor Tancred could long maintain their armies in the field and that each would have to return to their own territory, at which point they would be able to devastate the territory of Edessa without opposition. But the king and Tancred saw through their ruses and placed around the city of Edessa and the other positions that they wished to defend everything necessary for their protection before setting out for their own territories. They came to the Euphrates, where they found few boats and were, therefore, long in crossing the river. During this delay, while the nobles had already crossed and there remained only the poor, the Turks, who had followed them at a distance, seeing that all the mighty were on the far bank, charged down on the poor and weak who remained and killed or captured almost all of them under the very eyes of Tancred, who was stricken with grief at the sight. But there was nothing that he could do, for there was no fording the Euphrates. In this situation each returned to his own territories, though Tancred found no peace there, for at this point Baldwin of Edessa and Joscelin were released, as we have already described, and for a short while he refused to restore their territory to them. Therefore, Joscelin, who had not forgotten this misdeed, assembled all the Christians that he could and, seeing that he was still not strong enough to assail Tancred, obtained the alliance of a number of Turks, both by his petitions and by offering them money, and made an armed incursion into the territory of Antioch. Tancred came out to meet them and set his army in battle order. At the outset, he had the worst of it and lost at least five hundred men, with the result that he and the others, enraged, gave up their battle against the Christians and directing all their strength and energy against the Turks, flung themselves on them, killing so great a number that Joscelin and his Christians fled and Tancred was left master of the field.[183]

At last, however, a number of good and wise men on either side intervened, with the result that they made their peace and pardoned their mutual wrongs. Now Bertrand, son and heir of Count Raymond, arrived in Syria, and there found his cousin, William-Jordan, who was besieging Tripoli.[184] A violent quarrel arose between them, for Bertrand

demanded of William-Jordan the territories that he inherited through his father's death, while William-Jordan replied that he had endured four years of uninterrupted toil in the siege of Tripoli and, therefore, wished to be master of it. Nevertheless, an agreement was reached between them.[185] But it was of short duration, for a quarrel having arisen between the gentlemen of the retinue of the two lords, therefore William-Jordan, a master of reconciliation, ran to the men to appease them, and in so doing was struck in the side by an arrow and fell dead on the spot. It was never known for certain whether Bertrand had ordered this; there were those who said that he had. William-Jordan's death meant that the territory fell to Bertrand in its entirety.

Seventy well-armed Genoese galleries were besieging Tripoli, captained by two Genoese named Ansairy and Hugh Embriaco. Seeing that the siege was unprofitable, they asked the advice of Bertrand of Toulouse and concluded that they should go by sea and the count by land to lay siege to Jebeil. This city was formerly called "Eve" because Eveus, the son of Canaan, son of Ham, son of Noah, founded it. It forms part of the province of Phoenicia, which is under the authority of the archbishop of Tyre. And in the third Book of Kings, it is called "Eve". It was the people of Jebeil who provided the wood and stone to build the Temple of Our Lord. When this city was thus besieged, the inhabitants were so terrified that they surrendered to the two Genoese captains on condition that they might leave safe and sound, with their belongings. And Hugh Embriaco was long master of Jebeil thereafter, having paid a sum of money to Genoa.

After the capture of Jebeil the fleet returned to Tripoli, to which King Baldwin had now come. And shortly afterwards, the inhabitants of the city surrendered[186] and Count Bertrand was made count of Tripoli after he had sworn homage to the king of Jerusalem, as his successors would be bound to do to all the kings reigning thereafter in Jerusalem. While the situation around Jerusalem thus continued to improve, Baldwin of Le Bourg was accomplishing prodigious victories around his county of Edessa.[187] But, aware that he could not pay his horsemen and other men-at-arms, he contrived to have one of them ask him to respect the promise he had made to him and his companions before a great Armenian lord called Gabriel, whose daughter he had married. And since Count Baldwin pretended to ask for more time, the Armenian asked what the knight was demanding with such bitterness. The knight replied that Baldwin had promised to let his beard be cut off if he did not pay them their wages before the end of the day and that, since he had not paid them, they wanted their forfeit, that is, his beard. Gabriel, when he heard this request, clapped his hands together in distress and was so angry that he collapsed backwards and could not immediately collect his wits sufficiently to speak. This was

because Orientals, and particularly Greeks and Armenians, consider the beard the seat of their honour. However, when he was again capable of speech and had heard from the count's own mouth that the promise had, indeed, been made, Gabriel crossed himself several times in succession and, reproaching him strongly for having made such a promise, enquired about the sum. The knight having told him that it was thirty thousand michelots (a sort of gold coin then current),[188] Gabriel paid it on condition that Baldwin would promise never again to stake his beard for anything at all. Thus, Baldwin of Le Bourg hoodwinked the father of his wife in the year 1110.[189] That year, King Baldwin made Bethlehem into an archiepiscopal seat, it having hitherto been only a priory. And the following year, 1111, he besieged the city of Beirut for two months, finally taking it by storm and killing a great number of Turks and Saracens, though those who asked for their lives were saved from death by order of the king, who took pity on them.

Chapter XXXVIII.
Of the expedition undertaken by the brother of the king of Norway, whose reign lies beyond England. How King Baldwin was almost murdered by his chamberlain, whom he trusted above any other man. The capture of Sidon. Of the many attacks by the Persians. The death of Tancred. The defeat of King Baldwin and how he married the countess of Sicily even though his own wife was still alive. How he abandoned her. His conquests and his death.

The news of the great conquests achieved overseas by the Christian crusaders spreading through the world, the brother of the king of Norway became a crusader along with many barons and other men from this kingdom, and, having come via England, they arrived with a handsome fleet in the port of Acre and went from there to Jerusalem, where the king came out to meet them, received them with honours and bestowed rich and handsome gifts on them. Then, asking them if they were not perhaps willing to help him to conquer a city – for he knew that they wanted nothing more – he gathered a fine army and went to besiege by land and sea the city of Sidon, which in ancient times was called Sidon and is still so called in Latin.[190]

During this siege, when the citizens saw that they could not resist, they succeeded in bribing with a large sum one of the chamberlains of the king, called Baldwin in honour of his master, to kill the king that he so loved. The chamberlain was a Saracen knight and had deceitfully and cunningly requested baptism. The king had, therefore,

had him baptised and loved him a great deal and trusted him more than any other man. And indeed, the chamberlain would have accomplished his evil plan had not Our Lord inspired certain Christians who were tributaries in this city to denounce his treachery by letter and send the letter to the army. When the letter was discovered and the traitor had freely confessed his crime, he was hung before the city by order of the wise men, under the eyes of the citizens who, seeing themselves thus accused, asked the king to let the nobles leave safe and sound with their wives and children under his protection and leave the labourers on the land on condition a reasonable sum of tribute money was paid. The king agreed to this and they surrendered the city to him in the year 1111.

That year also saw the death of Gibelin, the patriarch of Jerusalem. In his place they appointed Arnulf,[191] the very wicked archdeacon of whom we have already spoken, who formed part of the retinue of the duke of Normandy. Amongst the many evil actions committed by Arnulf while he was patriarch, one was that, having bestowed his niece in marriage on the greatest lord of the kingdom, Eustace Garnier, the lord of Sidon and Caesarea, he gave him the church's finest property, Jericho, which was worth at least five thousand bezants in rent.

A tribe of Turks living in Persia at this stage made a sortie, in their temerity believing that they would crush Christianity and the Christians around Antioch and then those of Jerusalem. They despised the news circulating at the time of Christian victories, for they thought that they would have greater success than the Persians to whom they had previously paid tribute and who now no longer dared oppose them. While on their way to Antioch, they besieged the stronghold of Turbessel,[192] which belonged to Tancred and held out against their very large army for a whole month. All their cunning was insufficient to persuade Tancred to leave the shelter of another castle of his till the king and the count of Tripoli, whom he had summoned, arrived in the area, precisely at the castle of Rugia, where he awaited them. Then, when our men came forward against them in battle order, the Turks were not so brave as to await them, but returned to their country while our men pursued them till they had left our territory, whereupon the Christian leaders returned each to their own lands. And now, from Lattakieh to Ascalon, which is the furthermost in the kingdom of Jerusalem, there was no city that was Christian except only Tyre. Therefore, the king went there and besieged it by land and sea and had built and raised a number of machines for attacking the walls. But the inhabitants of Tyre built others to set against them and defended themselves so well that the king, realising that he could not gain the city, lifted the siege, which had already

lasted too long and cost large sums of money, and returned to Acre. And the other princes and barons withdrew to their own lands.

It was in this same year of 1112 that the very noble and valiant prince Tancred was stricken with a very serious illness. Feeling his end approach, he called to him Roger,[193] the son of his cousin Richard, and made him the guardian of Antioch, on condition that he would immediately and without dispute cede it to the young Bohemond when the latter arrived. Having said this, he also summoned his wife, the natural daughter of Philip I, and advised her, when he was dead, to marry a young prince raised in his court called Pons,[194] son of Count Bertrand of Tripoli. And when he had told them both that he thought this marriage reasonable and that they, no less than the kingdom, would prove the beneficiaries, begging them to agree to it, he forthwith gave up the ghost. His body was buried amidst universal lamentation and tears, under the porch of the church of Saint Peter at Antioch. After his death, Bertrand, count of Tripoli, also breathed his last and Pons, his son and heir, married the countess of Sicily.

The following year, that is, 1113, a powerful Turk named Mawdud[195] sallied forth from Persia with an army greater in number than any yet seen then and advanced further than any Turkish army had yet done, for he crossed the land known as Lower Syria and, leaving the city of Damascus on his left, continued on beyond mount Lebanon till, passing Tiberias, he encamped his army near the bridge over the Jordan. Therefore, King Baldwin I, learning of his approach, assumed that he must, indeed, have a large army to have come to beard him so close to home. He, therefore, sent urgent messages to prince Roger of Antioch and Count Roger of Tripoli,[196] asking them to come to his aid. But he did not await their arrival, leading the army that he had gathered towards his enemies and encamping near them. The Turks, seeing him so close with so few men compared to their own host, thought they might quickly and easily inveigle him into a trap. To this end, they sent two thousand of their horsemen ahead of the main body of their army. One thousand five hundred of these prepared an ambush while the remaining five hundred came and galloped wildly to and fro in disorder before the army of the king. Baldwin, though he knew the ways of war better than any other man alive, was yet taken in and armed his men and had them ride down on these outliers. Simulating fear, they retreated little by little and succeeded in drawing the king into the ambush prepared by their companions.

The king and his men, therefore, found themselves encircled between the cavalry and the main body of the Turkish army, while the outliers, having pretended to take flight, now returned and charged our men. And so the cruel battle began – it might

FUNERAL OF BALDWIN I. COUNCIL OF CHRISTIANS FOR
THE ELECTION OF THE NEW KING

*"He ate some of the fish and had no sooner risen from the table
than he found himself gravely ill. Moreover, an old wound was now
attacked by gangrene [...]. He was so ill that he had to be carried
in a litter and never saw Jerusalem again."*

(FOL. 118A)

Baldwin I died very suddenly in 1118. His death aroused great emotion, and the funeral of this second Frankish king of Jerusalem is depicted by Jean Colombe as a memorable and solemn event. The funeral procession, accompanied by the patriarch Arnulf of Jerusalem, prelates and clerics as well as the barons, wends its way towards the church of the Holy Sepulchre, while a crowd gathers to pay its last respects. The king's body is displayed on a litter before the procession enters the church. the artist displays the exquisite talent of a goldsmith in his portrayal of statues of saints in niches within the porches, and of vivid pink and green columns crowned with capitals. In the lower picture, the barons and representatives of the Church are holding a council to choose Baldwin I's successor. Joscelin of Courtenay, standing before all those present, is proposing that Baldwin of Le Bourg, cousin of Godfrey of Bouillon, should be elected king of Jerusalem.

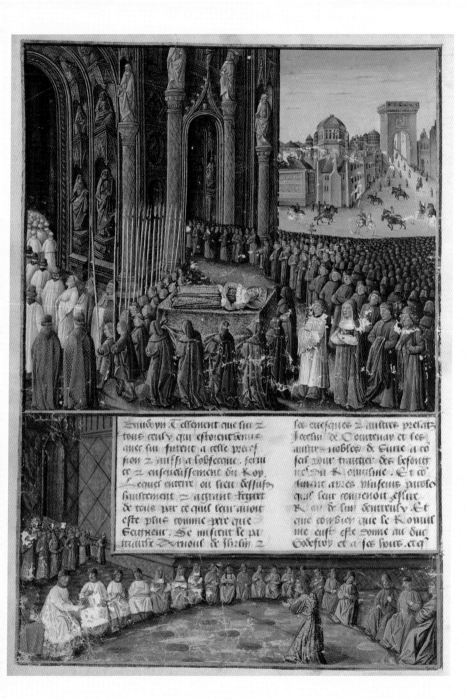

Baudoyn d effencut que lui z
tous ceulx qui eftorent venu
auec lui furent a cefte pzocef
fion z auffi a lobfecque. feirt
ce z enfeuelissement du Roy.
Lequel enterre ou lieu deffus
huistement z agrant regart
de tous par ce quil leur auoit
efte plus comme pere que
Seigneur. Se mifent le par
tienlx D niout de ifzlm z

fes euefques z aultres prelaz
feclm de Courtenay et fes
aultres nobles de Surie a cõ
fel pour traitter des befoing
nes du Roiaulme. Et cõ
duant apzes pluseurs paroles
que leur conuenoit eflire
Roy de lui fentruly. Et
que conduiv que le Roiaul
me euft efte donne au duc
Godefroy et a fes fout. et q'

better be described as a massacre for our men, who were so few compared to the Turks, performed prodigies and killed many Turks. But they were forced to flee by the great multitude of their enemies. Indeed, it was only thanks to their horses that King Baldwin – who had taken up his own banner the better to rally his men – the patriarch Arnulf and other barons escaped and many Christians thus died of the king's impatience, Baldwin having been unwilling to wait for Roger of Antioch and the count of Tripoli, who were due to arrive the following day or, at worst, three days later. It was, therefore, Baldwin who bore the burden and dishonour of this defeat before the prince and the count and the other knights.[197]

After the defeat, the king had those of his army whom he could save withdraw into the mountains, whence he constantly harassed the enemy. The latter, who remained in the plain, understood that they could do little against him, because of the nature of the terrain and, therefore, spread out through the region, wreaking havoc wherever they found unfortified places. In this they were led by Turkish peasants who had been allowed to live on in their villages on payment of tribute, and who now left their houses and did greater destruction than even the Turkish soldiers. Moreover, the Saracens made a sortie from the city of Ascalon when they heard of this defeat and did vast damage, as indeed they did whenever they saw the opportunity, on this occasion pushing as far as the Holy City and burning the undefended houses that lay outside its walls.

But Mawdud, the leader of the Turkish army there, realised that the king's army was growing quickly because the pilgrims who crossed the sea, apprised of the king's situation on their arrival, immediately hastened to join him. Mawdud, therefore, feared that Baldwin would in due course come against him with substantial forces and so led his army back to Damascus. And having gone inside the city, he was treacherously knifed to death within the walls. Though no one knew who the murderers were, rumour had it that the orders had come from Toghtekin, king of Damascus, or at least that he had consented to the murder, because he was very much afraid that the wise and powerful Mawdud would usurp his kingdom.

Another comfort to Baldwin was this: on the recommendation of certain advisers, he had asked for the hand of Adelaide, countess of Sicily, a very rich woman who had been the wife of Roger Borsa, the brother of Robert Guiscard, and was the mother of Roger (later king of Sicily). She arrived shortly afterwards[198] and he married her, promising that, if she had a child by him, that child would inherit the kingship of Jerusalem and that, if they died without any direct heir, Roger, her son, would inherit the throne. The great wealth that she possessed proved very useful to the king of Jerusalem, but

the Christians paid dearly for these benefits, for long afterwards the king fell ill and, during his sickness, promised on the advice of the wise to take back his first wife (who was from Edessa and the daughter of an Armenian) if he recovered his health. However, when he made this second marriage – it were better to say abusive marriage – he had had his first wife relegated to a convent, where she made free with her body. Nevertheless, when the king recovered his health, he took her back and explained the situation to the countess of Sicily. Thereupon, she returned to Sicily and her son Roger, having been deceived and all her wealth having been stolen from her. Roger took his revenge thereafter, causing great harm to the kingdom of Jerusalem and to the pilgrims who passed through his domains in order to bring aid to Jerusalem.

Shortly after the arrival of the countess, Baldwin of Edessa was told that his cousin Joscelin would offer to pay him to leave the county of Edessa and return to France. Baldwin was so enraged by this that he secretly sent for Joscelin and, having reproached him for his ingratitude – for he had granted him land and wealth – imprisoned him till he had restored all that Baldwin had given him and then let him depart ill provided for in either money or retinue. Joscelin, therefore, went to the king of Jerusalem and, having recounted the outrage he had suffered at his cousin's hand, asked to return to France. But King Baldwin knew that Joscelin was of good counsel and a very valiant warrior; having a use for such men, he comforted him greatly and gave him the county of Tiberias with the promise of wealth to follow, and thus kept him with him in Jerusalem.

Not long after, Bursuq,[199] a most powerful Turk, raised a great army to come to Antioch. The prince of Antioch, having received warning of this, asked for the help of the kings of Jerusalem and Damascus, to whom he was allied. They immediately came to his aid with such numbers that Bursuq, not daring to await their onslaught, pretended to return to his own country. Therefore, the others set off again towards their own lands, while the inhabitants of Ascalon twice made a sortie to besiege and attack the city of Jaffa, where many of them were killed, and so they returned in shame to their own city. Now Bursuq had, indeed, made a semblance of returning whence he had come, but when he knew for certain through his spies that Baldwin I had returned to Jerusalem and that the count of Tripoli was again in his county, thinking that they could not again be quickly brought together, he turned about and came with his army to attack the territory of Antioch, burning and pillaging villages, razing towns and fortresses, killing people and doing great execution. Therefore, prince Roger hastily sent for Baldwin, count of Edessa, and having, thanks to him, gathered an army in Antioch, he quickly came out of the city in good order. While he was setting out his lines and awaiting the count of Edessa, he

sent out his spies and one of these returned to tell him where Bursuq was. Overjoyed, as were all his men, he led them towards the army of Bursuq, who, when he learned of the arrival of the prince and the count, set out his troops in battle order, but sought to absent himself from the battle, for, fearing the valour of the Christians, after marshalling his troops, he took his brother and four of his greatest friends, and withdrew to a mountain from which he could see the event of the battle. This was very prejudicial to his cause, for, having at first thought that their great number would enable them to resist the valour of the Christians, his troops took flight, abandoning their tents, riches and pavilions, and a great number of them were killed on the spot or in the pursuit that followed the battle. Bursuq, his brother and their friends were so terrified that they only stopped running when they had reached a safe place far from this defeat, in which more than four thousand Turks were killed and innumerable Christians whom they had made prisoner rescued. When the booty had been equitably shared out between the count and prince on the battlefield, the prince returned to Antioch, where he was received in triumph.

Now, Baldwin, seeing that the city of Jerusalem had so few inhabitants that there were not enough citizens to man the towers and walls, and having heard it said that there were, in Araby, beyond the Jordan, many Christians who lived in slavery under the Turks and other Saracens, sent for them secretly, promising them franchises that, when they came to him in Jerusalem with their wives and children, he respected entirely, indeed, he bestowed on them great properties without any obligation. In short, he granted such advantages to them and to all those who gave up their lands and countries to come and live in Jerusalem, that the Holy City was again, within a short space of time, very well peopled. And he willed and decreed that Jerusalem should be a chartered city and that all the lands that he had conquered and would conquer in that region should be placed under its domain and lordship. He further ordered, after mature deliberation by his council, and confirmation of its decision by the Pope, that all the cities, castles, lands and towns that he and his men conquered would come under the patriarch of Jerusalem and the Pope then published a papal bull to this effect. But Bernard, the patriarch of Antioch, complained of this and declared that he was wronged and that in this way the churches that should obey him were removed from his authority. The Pope then sent him a letter in which he declared that his intention was not to alter the suzerainty previously held by the churches when the entire land was Christian.

Shortly afterwards, the king was struck down with an illness and because of it took back his first wife. The countess Adelaide was forced to return to her own lands, as we have already said. On recovering his health, the king went on the attack in Egypt,

wishing to avenge the great harm that the Egyptians had done in the Holy Land. He took and plundered the city of Farama, which lies at the mouth of the Nile, close to the sea. But he did not long enjoy this victory, for, having left the city to study its fine situation and having set men to fish in the Nile, he ate some of the fish and had no sooner risen from the table than he found himself gravely ill. Moreover, an old wound was now attacked by gangrene and his condition was so serious that he prepared his baggage in order to return to Syria in all haste. He was so ill that he had to be carried in a litter and never saw Jerusalem again, dying in a desert city called al-Arish.[200] His men carried the dead king on his litter into the city of Jerusalem with every sign of grief and pain. They arrived there on Palm Sunday and Baldwin's body was, therefore, carried to the procession then forming in the vale of Jehoshaphat. He was given a royal grave in the church of the Holy Sepulchre, under Calvary, in the place called Golgotha, near his brother, King Godfrey, in the eighteenth year of his reign and in the year 1118.

Chapter XXXIX.
How Baldwin of Le Bourg was elected king of Jerusalem, the second of this name, and Joscelin appointed count of Edessa. Of the great Egyptian army that departed without offering battle. The beginnings of the Order of the Templars. How Ilghazi, prince of the Turcomans, defeated and killed in combat the prince of Antioch, and how King Baldwin II defeated Ilghazi. Of the many misfortunes that followed this event, and of the capture of Baldwin II.

While King Baldwin I was making the voyage in the course of which he fell ill and died, Baldwin of Le Bourg, count of Edessa, decided to go and visit the Holy Places and his cousin, King Baldwin. He was already a great distance from his lands and from the county of Edessa when he was informed of the death of the king and, deeply saddened, thought long and hard before deciding whether he should continue his journey or turn back. Finally, he decided to continue on his pilgrimage and hastened so that he arrived by one of the gates of Jerusalem on Palm Sunday during the aforementioned procession. At the very same moment, the men bearing the body of Baldwin I were entering by another, with the result that he and those who had accompanied him joined the procession and attended the funeral ceremony, the religious service and the burial of the king.

When the burial of Baldwin I had taken place as aforementioned, with great pomp and ceremony and to the great regret of one and all – for he had been more like a father to them than an overlord – the patriarch of Jerusalem, Arnulf, the bishops and other prelates, Joscelin of Courtenay and the other nobles of Syria met in counsel to discuss the affairs of the realm and quickly decided that they should choose a king from amongst their own number. And though the kingdom had been bestowed on Godfrey and his heirs and they were obliged to send for Eustace, count of Boulogne, as certain barons had secretly already done, it was yet necessary to choose a king from amongst themselves, by reason of the great peril that the kingdom would face if it remained without a king during the time required for Eustace to be summoned and to reach Jerusalem. For this reason, when many had given their opinions on this subject, Joscelin of Courtenay, who knew that the patriarch Arnulf would do what he desired, stood up to say, amongst other things and with many fine discourses, that the lineage of Godfrey should continue to reign over the kingdom, and that he wished to elect and crown Baldwin of Le Bourg, count of Edessa, whom he knew to be closely related to Godfrey. He, moreover, explained that they should not think that he advised them to elect Baldwin out of affection, given the very rough justice that he had received from him, as everyone present knew; rather he advised it from his very heart and soul, because he knew Baldwin to be valiant, wise, rich and a great conqueror, so that the throne should certainly fall to him, for he would govern and guard the kingdom marvellously well.

The words and opinion of Count Joscelin having been seconded by the patriarch Arnulf, Baldwin of Le Bourg, count of Edessa, was unanimously elected king of Jerusalem, and the patriarch Arnulf crowned and anointed him in the church of the Holy Sepulchre, on the following Easter Day, before the people as a whole who hailed him "Long live King Baldwin II!" Though the opinion of the patriarch and Joscelin had not perhaps been pure and truthful in relation to Our Lord during this election,[201] he nevertheless disposed matters favourably, for King Baldwin II governed very well and greatly extended the borders of the kingdom. The better to govern and in order to remove any impediment to his government, he summoned his cousin Joscelin of Courtenay to his side, and, having said that he knew him for a wise, valiant and excellent governor, bestowed on him the county of Edessa, for him and his heirs in perpetuity, in the hope that he would safeguard it better than anyone. And he invested him as count of Edessa by the gift of the standard and Joscelin then did homage to him.

A few days later, Joscelin left for the county of Edessa with the authorisation of the king and with the special command that he should send him his wife, the queen, his

daughters and the rest of his men, which Joscelin did. Thus, Baldwin of Le Bourg, the eldest son of the count of Rethel, was made king of Jerusalem, the second of this name, and began to reign in the year of Our Lord 1118, on the second day of the month of April.

While Gelasius II was Pope, Bernard, the first Latin patriarch of Antioch, and Arnulf, the fourth Latin patriarch of Jerusalem, the emperor Alexius died – that great enemy of the Latins, who had so often caused them untold harm by his treachery.[202] His son, named John, succeeded to the imperial throne. He was better intentioned towards the Latins than his father, but wrongly launched attacks against our men over the question of the eastern lands, as we shall see in what follows. During this year and in the beginning of the reign of Baldwin II, the caliph of Egypt gathered a vast army on both land and sea and sent it towards Syria, thinking easily to destroy the kingdom of Jerusalem. But King Baldwin was warned of this, and knowing, too, that Toghtekin, king of Damascus, had joined his army with that of the Egyptians, sent for the knights of Antioch and the count of Tripoli. On their arrival, he established himself on the battlefield before the Egyptians and the two armies remained for many days thus confronted, near a place named Ashdod, while the Egyptians did not dare to attack the Christians because they had many times heard it said that none were so valiant in battle as the French; and our men were afraid to attack the Egyptians because of their great number, so that, in due course, the prince of the Egyptian army decided, following the advice of his barons and knights, that it would be better to return safe and sound the way that he had come than to risk his army in a battle in which victory was uncertain, which he did. Therefore, the king gave leave to the count of Tripoli and the knights of Antioch to depart and returned with his army and men into the city of Jerusalem. There, shortly afterwards, died the patriarch Arnulf, in whose place was elected a very great man named Gormond, a native of Picquigny, whose prayers and petitions to Our Lord were full of happy consequences for the kingdom of Syria.

Now there began in Jerusalem the Order of the Templars, which subsequently distinguished itself by its nobility, power and wealth amongst all the other orders. Those who instituted and began it were two knights, named Hugh of Payens (near Troyes, in Champagne) and Geoffrey of Saint-Omer. These men, having first by their exhortations formed a group of seven other comrades who followed their will and opinions, chose to give up worldly pomp and to live chastely, following a monastic rule, undertaking simply to go to the ports of Syria to meet the pilgrims coming to the Holy Sepulchre and to conduct them to Jerusalem and escort them back again, for they had seen that those men coming without escort were often ambushed, killed or robbed by the Sara-

cens and other Turks inhabiting both these regions and others more distant, who came by night and in secret to raid the pilgrim routes. And this was the principal foundation of their concern, and their body was soon instituted and confirmed as an order of clerics and canons regular by Pope Honorius and the patriarch of Jerusalem, who decreed that there should be in this order two kinds of cleric, the knights and the sergeants, and that they would wear a white tunic and a great cross of red cloth on their robes and cloaks. And Saint Bernard, the abbot of Clairvaux, by order of the Pope, drew up their rule and their way of life. These clerics and their order were called "of the Temple" because, to begin with, they lived in houses near the Temple in Jerusalem.[203]

And though the patriarch was the origin of their foundation and made rich donations to the order from his own wealth and from the rents of his church, many of which he granted to them, certain of the members of the order later managed to obtain exemption from his suzerainty for the following reason: Ilghazi, a powerful prince of the Turcomans,[204] who did not then live in towns, cities or castles but in pavilions or tents,[205] and Toghketin, the king of Damascus, made an alliance against our men and further allied themselves with another powerful pagan prince called Dubais,[206] who was from Araby. And they entered the territory of Antioch with a very great army. Therefore, prince Roger, who had married the daughter of King Baldwin II, humbly sent to him to ask him that he come to his aid. And he did the same to Joscelin, count of Edessa, and to the count of Tripoli.

Nevertheless, without waiting for them, even though they were hastening towards him, he disposed on the battlefield all those men that he had been able to gather together. Worse still, certain knights of his army, thinking to save their own land on which the pagan army was encamped, approached him, advising that he should lead his men towards the enemy. And he came so close that the Turks and Turcomans, discovering the weakness of the prince's army, feigned flight in order to draw him with disordered ranks into a place that was advantageous to him, before the great forces coming to his aid could reach him. And this, indeed, they did. They left the place where they had been encamped and went by night to establish themselves near a castle called Athareb. And the prince, who sent his spies after them secretly to discover whether they intended to besiege the place and whether they wished to fight or to leave the area, was warned that they had constituted three battalions of twenty thousand mounted men and they were even now coming at the trot to do battle with him.

He who was so strong and valiant mounted his horse at this news, and, riding the length of the lines of his men, whom he had already set out, exhorted his men to give

THE SECOND OF THIS NAME.

a good account of themselves. And when battle was joined, their conduct was, indeed, impeccable. They were valiantly led by two knights, Geoffrey the Monk and Guy Fremault, who headed the first two battalions. But when Robert of Saint-Loup, who was leading the third division, sought to join the other two, a great company of Turks fell on him and those whom he was leading were so frightened that they shamefully took to their heels in the middle of the fourth battalion of our men, disorganising them completely. Moreover, though the battle was still in the balance at that point, the Christians were soon put to flight by a great whirling wind from the north, which blew the dust up into their eyes, so that they could barely see each other. They left prince Roger of Antioch dead on the field, though he had done great and doughty deeds of arms, and many more remained there with him. So of the entire army of the prince, which had numbered seven hundred horsemen and three thousand foot soldiers, not to mention the merchants, of those who had taken part in the battle there remained at the end of the day only two men to bring the news of these deaths.

Some said that the fault was prince Roger's, for it was well known that Tancred, before his death, had given him the city of Antioch in guardianship so that he could render it to the young Bohemond without dispute as soon as the latter had reached the necessary age, and that Roger was unwilling to do so, even though he had, on the day of his death, confessed in tears to Peter, bishop of Pamiers, and had promised to mend his ways and give up all his sins if Our Lord allowed him to live on.

The defeat did not prevent Baldwin II and the count of Tripoli, who were already on the march, from hastening through all the difficult passes on the way between Jerusalem and Antioch, where they were joyfully received by all the citizens and nobles of this territory, for they had given themselves up for lost if no help should come. And the danger was, indeed, great, for despite their arrival, prince Ilghazi continued to storm the castles of this region.

Therefore, when the king and the count had spent a short time in Antioch and learned the great harm that Ilghazi was causing, since he was riding unrestrained over all their lands, they sallied out of Antioch with their men and came to find the Turks near the castle of Athareb; moving in the direction of Rugia, they passed Hap and established themselves on a eminence called Dams. Ilghazi attempted to surprise them there when he found out about their presence from his spies, for he ordered all his men to form up in good order by night to attack the Christians at first light and thus conquer them without difficulty because they would find them all asleep. But Our Lord disposed otherwise, for the king took great pains that no one in his army should sleep that night

but, on the contrary, that everyone adjust their harness and armour in order to be ready to receive the enemy valiantly. And Bernard, archbishop of Caesarea,[207] the bearer of the True Cross who accompanied the king to this point, preached a very noble sermon to the people, warning them in gentle terms to be diligent in avenging the people and the lands of Our Lord. During this time, the king organised nine battalions composed of seven hundred horsemen and of the other men that were with them and marched them forth in orderly fashion from their accommodation, sending to the vanguard the three battalions that were to make the first attack.

The count of Tripoli was on the right with his men and the barons of Antioch on horseback on the left. The foot soldiers were placed in the centre and the king brought up the rear, with four battalions. While our men advanced in this formation, a great quantity of Turks poured out of Tabor and came towards our men, making a wild noise and shouting with all their might. Placing their hope in the holy faith and the True Cross, our men performed prodigies of arms in this encounter, though the Turks concentrated their efforts against the foot soldiers, many of whom were killed, to the great sadness of the king. Seeing their fate, he was willing to wait no longer, but assembled the rest of our men and, asking them with great sweetness to come to the aid of their comrades, he was the first to fling himself into the thick of the fray, where he performed innumerable feats of arms. Following his example, his men, too, threw themselves with such vigour at the Turks that those of our men who had first entered battle and were now tired and broken gained renewed strength and courage, so the Turks could no longer bear the celebrated valour of the Christians, but fled in shame without thought for their wealth or tents – which our men then carried off and pillaged unopposed – leaving four thousand dead on the field and many more wounded and captured. As to the Christians, they lost seven hundred foot soldiers and one hundred horsemen in that battle.

This victory was won by King Baldwin II in the second year of his reign, on the eve of the feast of the Assumption of Our Lady in the year 1119.[208] The king thereupon sent the True Cross back to Jerusalem with a great host led by the archbishop of Caesarea; there it was received by a handsome procession in great joy on the day of the Holy Cross. After this defeat and after the various conquests made by Baldwin II, at a time when Toghtekin, king of Damascus, had left Syria after having entered it with a very great army, it came about that the very powerful Turk Balak surprised Joscelin, count of Edessa, and Waleran, his cousin,[209] when they were walking in their lands unaware of his presence and took them as prisoners to a stronghold of his beyond the Euphrates, called Kharpurt. Shortly afterwards, he led King Baldwin to the same place,

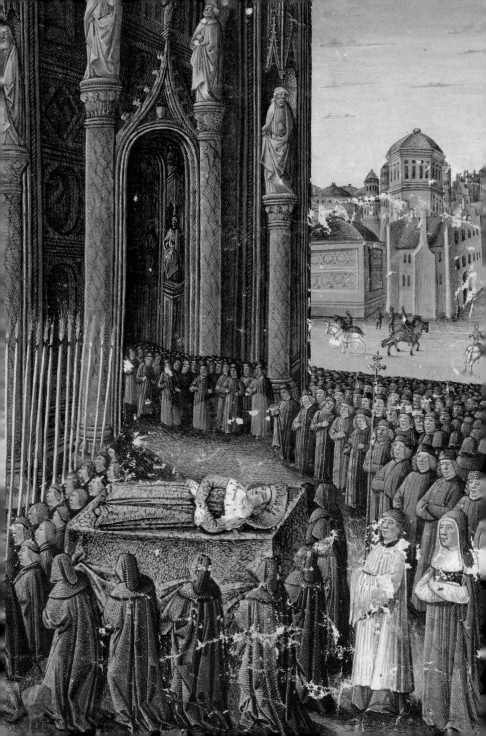

having made him, too, a prisoner.[210] Balak had captured him when he was riding by night, alone, with only his domestic servants, and was visiting the count of Edessa, Baldwin having come in great haste to Antioch and then to Edessa to appoint good governors there, as soon as he heard of Joscelin's capture.

Balak spied on him day and night and was, therefore, able to mount a surprise attack on him during the night, finding all Baldwin's men asleep on their horses; terrified by the noise made by Balak and his men, they took flight as best they might, while Balak seized hold of the reins of the king's horses without even knowing whom he had captured. But once they knew that it was the king, he set off in great haste with his men and took him as quickly as possible to the castle of Kharpurt. Shortly afterwards, the castle was captured by a surprise attack mounted by fifty Armenians of the county of Edessa. For love of their lord, Joscelin, the Armenians formed several groups, some dressed as monks and others as merchants; saying that they wished to complain of the thefts of which they said that they had been the victims, they drew their knives when they were taken within the castle and killed the guards and so many other Turks that they made themselves masters of the place, delivering the king and the two other lords.

Joscelin and his two companions immediately left the castle to seek help, knowing that they would have to endure a siege by the local men once it was known that the castle had been taken. And this, indeed, occurred, for Balak, who had dreamed that night that Joscelin was seizing him and tearing out his eyes with his bare hands, the following morning sent knights to the castle to have Joscelin beheaded, and thus learned that the castle was taken. He, therefore, assembled a huge host and had Kharpurt besieged on all sides, while giving the king the chance to leave with his men, offering a safe conduct to Edessa if he would surrender the place without battle. This the king refused, trusting in the strength of the castle and the help of Joscelin. But the decision recoiled on him, for Balak mined a part of the castle that was built on rock no harder than chalk. One of the towers fell and another part having collapsed, the king was afraid that the whole building might collapse. Therefore, he willingly surrendered to Balak,[211] who said that the king and his nephews and Waleran would not be put to death. Nevertheless, he had them fettered and, shortly afterwards, inflicted a lingering death on the Armenians who had taken the castle.

Joscelin, meanwhile, almost died of hunger and illness, and would not have escaped had he not taken with him two casks of wine. Using these[212] and with the help of his two companions, he succeeded in crossing the great river Euphrates even though he

could not swim, and arrived half dead at Turbessel, which was held by our men. He was then taken to Antioch, where there was much lamentation at the capture of Baldwin. Joscelin went to the help of the king with a great army, leading it almost to the walls of Kharpurt. But, knowing how Balak had retaken it, he sent a part of his company back to their lands while he and his men plundered and despoiled the land around the city of Aleppo and elsewhere.

While Joscelin was in enemy territory, news of the king's capture reached Egypt. The caliph was delighted, believing that he could now easily recapture the kingdom of Jerusalem. To this end he dispatched two great armies, one by land and one by sea. One of these armies, having laid siege to Jaffa by sea, was forced to retreat onto the high seas until it had found out what course would be followed by the land army. The patriarch of Jerusalem, carrying the True Cross, and a great baron named Eustace Garnier, constable of the kingdom, to whom the patriarch and the other prelates and barons had entrusted the safety of the kingdom, with the other barons, went out to meet them. It was for fear of this army that the Egyptians had lifted the siege of Jaffa. They found the enemy at a place called Ibelin.

The Egyptians were terrified by the great temerity of our men, since, the armed and unarmed taken together, they amounted to no more than seven thousand, whereas the Egyptians were more than sixteen thousand, not counting the army at sea. When the battle was started by our men, who as always had the True Cross carried before their banners, the Egyptians were quickly defeated and put to flight so shamefully that not one of them so much as turned his horse's head back. There were seven thousand dead and so many prisoners that very few of their army escaped. Not long after this victory,[213] Eustace Garnier died. In his place, a very wise and valiant baron named William of Bures was made constable and governor of the kingdom.[214]

Chapter XL.

How the Venetians dispatched a great army, which defeated the caliph of Egypt's fleet. Of the city of Tyre and its siege. Of the various assaults and sallies that took place during the siege, and of Joscelin, who killed Balak. The surrender of Tyre and the liberation of King Baldwin. The marriage of the young Bohemond II, his courage and his death.

News of the capture of the king of Jerusalem, having circulated in various lands, finally came to the ears of Venice, whereupon the Venetians mustered a fleet of four large galleons with forty well-armed galleys and twenty-eight vessels of the kind they call *chas*, one of which was chosen as the flagship of the doge.[215] Having come to Cyprus and heard that the Egyptian fleet was still at sea off Jaffa, he refused to allow any of his men to set foot on land, but made all speed with his fleet to catch the Egyptians near that city. In fact, he did not set off for Jaffa, but steered directly to Ascalon, having been alerted by a merchant ship that the Egyptian fleet had withdrawn to that port, terrified by the defeat inflicted on their land army. When the doge was sure that Ascalon was close, he brought his fleet to a halt and ordered his men to remain at their stations all through the night and be ready to give battle at first light. This they did and at dawn the Egyptians, terrified though they were at finding themselves thus surprised by the Venetians, prepared to defend themselves as best they might. But the Venetian doge, initiating hostilities, steered directly for the galley that he thought must hold the captain of the Egyptians and sank it outright. And his companions did the same with almost the entire enemy fleet and killed so many Egyptians that the coast was, so they said, reddened with blood over more than ten miles. Unable to endure this massacre, the Egyptians took flight, abandoning one of their galleons, four galleys and four *chas*, all of them promptly captured by our men. And they pursued the Egyptians as far as Egypt, pressing them so close that they captured another five of their galleys laden with great riches near the city of al-Arish, which lies on the desert coast.

After this great victory, the Venetians returned with their plunder to the port of Jaffa. There the patriarch, William of Bures, constable of Jerusalem, and a great and noble cleric named Pagan, chancellor of Syria, along with certain other prelates were dispatched to request that the doge help them wrest some further city from the hands

of the Turks or Saracens. The doge, who wished to visit the Holy Places, appointed a fitting commander for his men and set off for Jerusalem. God knows he was received there with great manifestations of joy thanks to the renown of his recent victory.

Having visited the Holy Places, he declared that he did, indeed, wish to conquer a city. But it seemed that a dispute would arise and halt this enterprise. For the men of Jerusalem, Ramleh, Nablus and the neighbouring lands tried to show that Ascalon should, for various reasons, be besieged: the city was closer and weaker and for this reason would cost less money and effort to take. But the men of Acre, Nazareth, Tiberias, Sidon, Beirut and the other coastal cities said that it was more urgent to besiege the city of Tyre, a noble and well-defended city: the expense and effort were necessary because the Turks might yet, thanks to the power of the city of Tyre, reconquer all that they had lost in this region. Finally, they took two sheets of parchment and on one wrote "Tyre", on the other "Ascalon"; then, placing them on an altar, they called a simple and innocent child, who knew nothing of their decision that they would besiege the city whose name was on the sheet that the child chose. The child chose the sheet on which was written "Tyre", and they, therefore, agreed to lay siege to that city. The king and the Venetians had first come to an agreement, whereby in all the cities held by the king, along with all those that he would hereafter add to his domain and all those that he held in fiefdom, the Venetians would be granted an entire street and a church, a bath-house and a bakery made over to them as their property, free of all charges, held, in short, as the king held his own property. Second, in Jerusalem they would receive for their property an income equal to that of the king himself. Third, in Acre they should, if they wished, have in their street a bakery, a mill, a bathhouse, scales, weights and *minas* to measure grain, and pots to measure wine, oil and honey. And all who wished to cook, bathe, measure or mill there might do so as freely as if these things belonged to the king himself. The fourth was that, if the city of Tyre was taken, they would grant to the doge and the people of Venice the right to take for ever and in perpetuity from the funds of Tyre three hundred Saracen bezants on the feast day of Saint Peter and Saint Paul. Fifth, if a Venetian should bring a case against another Venetian, the proceedings and verdict would be subject to the laws of Venice and be decided in Venice, whereas, if a conflict arose between a Venetian and men of other lands, the trial would be determined by the king. Sixth, if both Tyre and Ascalon were taken, the Venetians would be granted a third share of each. Many other conditions and pacts were also concluded on this occasion, and the prelates and barons of Syria promised that, should the king be freed from his captivity, they would make him swear to abide by them.

This promise once made, the Venetians left and went to besiege by sea the well-fortified and noble city of Tyre. It is a city of great, noble and ancient origins, for it was founded by Tiras, son of Japheth, son of Noah, and on that account called Tir. This was the native city of Agenor, who had two sons and a daughter: his eldest son, called Cadmus, founded the great Greek city of Thebes and invented the Greek alphabet; his younger son was named Phoenix and was lord of Phoenicia, which bears his name; his daughter was called Europa and it is in her honour that the third part of the world is so named. From Tyre or thereabouts came King Hiram, who contributed such great gifts to build the Temple in Jerusalem, in the times of David and Solomon. Ulpian, who made many laws, was also a native of this city, and in Tyre the great doctor Origen was buried. And though this noble, rich and powerful city of Tyre is almost entirely surrounded by water, like an island, there is nevertheless before one of its gates a very large and beautiful plain of ploughland so fertile that, though not so large as those of other cities, it gives a higher yield than that of much greater acreage. To the south, the land remains arable for four or five miles, as far as the pass of Scandelion. And on the other side, to the north, where the road runs to Sidon, it extends over some two or three miles. Amongst a number of springs that rise there, giving excellent water in great quantity, is the noble spring that King Solomon calls "a fountain of gardens, a well of living waters". This is enclosed within a tall, ornate tower, from which issue the conduits that water the gardens, in which there grow fine trees that bear delicious fruits of all kinds. Amongst other plants, sugar cane grows there.

I shall not describe the various sorties made by the men of Tyre and the kinds of great machines with which the Christians battered and demolished the walls and houses of the city in a number of places. All this would be too long in the telling. Therefore, I pass rapidly over them. During this siege the men of Ascalon came and made raids into Syria, in the knowledge that the king and the flower of Syrian nobility were encamped beneath the walls of Tyre. But the men of Jerusalem defended themselves with great valour and killed forty-two of the enemy during their retreat through the passes, capturing seventeen horses. Now many of the inhabitants of Tyre were wounded and all were exhausted; provisions were lacking, while the audacity they perceived in our soldiers all but drained them of hope. Therefore, they secretly – amidst tears and lamentation – sent letters and messengers to the caliph of Egypt and to Toghtekin, king of Damascus, asking them to come to their aid, for without aid they considered themselves lost. A third-share of the city belonged to Toghtekin by agreement with the caliph, who retained only two-thirds so that Toghtekin, who was near neighbour to Tyre, would be the more

anxious to come to the city's aid. Toghtekin, therefore, gathered a very large army, which he encamped four miles from Tyre. And it was also said that the fleet of Egypt, comprising a multitude of ships, was on its way.

Therefore, our men, having taken counsel on this subject, sent the doge of Venice with most of his men to combat the Egyptians out at sea, while the count of Tripoli and William of Bures, the constable of Syria, went to meet the king of Damascus, with all the members of the army, foot soldiers and knights alike, and the men who had come with the count. And they ordered the barons, knights and other men of Syria, who remained with a section of the Venetians, to guard the army and particularly the wooden castles, so that they were not set alight and could hurl their siege machinery against the walls. This was accomplished most wisely, and they attacked the city so incessantly while their comrades were absent that it seemed the whole army yet lay at the foot of the walls. When the king of Damascus knew for certain that the count of Tripoli and the Christians were advancing on him, he did not dare await them, for he still feared the valour of the Christians, but withdrew his army to within Damascene territory. So the count of Tripoli and William of Bures led their own army back to the camp. The doge of Venice did the same, having received news of the flight of the king of Damascus; he had discovered that the Egyptians had not approached Tyre, for he went as far as Scandelion, a castle six miles from Tyre, which the great king Alexander had once had built, when he had besieged the city of Tyre, and had so named it.

Their only help was thus lost to the men of Tyre and they were close to despair. So young men from the city made a sally, to encourage their compatriots, secretly issuing forth and setting fire to one of the catapults that was doing particular damage. Attempting to do the same with another, they were captured and the fire was extinguished, for a young master-carpenter climbed onto the burning machine and threw over it a great quantity of water brought by the army. Nor did he descend till the fire was out, though he was the mark of innumerable arrows and crossbow-bolts fired from the city. And that he was not injured in any way but came down safe and sound was considered a miracle by all our men. They now hanged the Turks who had set the fire before the city, whose citizens felt great fear at this sight. Nevertheless, they continued to defend themselves as best they might.

When Balak, who was holding King Baldwin captive, found out that the Christian armies were besieging Tyre, he gathered a large army and entered the land of his neighbours near Edessa, capturing a stronghold and beheading its Turkish lord. Joscelin, having learned this, mustered a small army and went off to attack Balak, who had

set siege to another castle; there Joscelin defeated him quickly and set off in pursuit of him. While Balak was in flight, Joscelin cut off his head, not knowing that it was Balak.[216] Overjoyed when he found out, he sent Balak's head to Antioch and thence to the siege of Tyre. The count of Tripoli, now the senior prince at the siege, had conducted himself with great courage; so delighted was he by this present that, in honour of the good news and of Joscelin, count of Edessa, he knighted in the most honorific manner the man who had brought the news and head. And he and the other Christians attacked with ever greater persistence the city of Tyre. At last the inhabitants began to perceive that they could no longer defend themselves and were talking amongst themselves of surrender. But at this juncture, the king of Damascus again came to help the city with a great army and established a camp four leagues from Tyre, on the banks of the river where he had encamped on the previous occasion. Our men prepared for battle. But Toghtekin was still unwilling to risk a battle and, attempting to help those within Tyre by his dissimulation, began negotiations with the patriarch, the doge, the count of Tripoli, the constable and the other barons, with the result that peace was agreed between them and it was decided that the city would surrender and that all who were in it and wished to leave might take with them their wives and children and their chattels. And they would be given safe conduct to a place of safety. If any wished to remain under Christian rule, they would be able to keep all their land and property on payment of a reasonable tribute.

It seemed as though a conflict might break out between the rich and poor amongst the besieging forces, but peace was made and our men entered the noble and strong-walled city of Tyre on the last day of June in the year 1124.[217] Within the walls, our men found only five hogsheads of wheat (as it is measured in that region), which was barely enough for a single day. In this was manifest the courage of the defenders of Tyre and the great valour of our own men, who had persevered unswervingly in their enterprise. Shortly afterwards, in this same year, King Baldwin II asked to be ransomed and this was agreed because Balak was dead. Thus, he left his prison, where he had remained seventeen months, and was delivered on promising to pay one hundred thousand michelots and leaving a hostage as his guarantor. He went to Antioch, where he mustered his men of war and immediately went to besiege Aleppo. But there came so great a number of Turks to oppose him that he lifted the siege before their arrival and returned to Antioch and thence to Jerusalem, where he was received with great joy.

When il-Bursuqi discovered that the king was in Jerusalem, he summoned Toghtekin, king of Damascus, to his aid and entered the territory of Antioch, where, by numerous

and continued assaults, he took the castle of Kafartab and immediately attempted to storm Zerdana castle,[218] having been warned that Baldwin had been summoned and was coming to the aid of the people of Antioch. Unable to take it by storm, he persisted in his siege. This was the juncture at which King Baldwin arrived, having with him the count of Tripoli and Joscelin, count of Edessa, along with some six hundred horsemen and two thousand foot soldiers. They attacked il-Bursuqi and defeated him in battle with no greater loss to themselves than eighty-four men, though the enemy army comprised at least fifteen thousand horsemen, two thousand of whom were left dead on the field and many others made captive. The barons gave them all up to King Baldwin, with a large share of the booty, which was of inestimable wealth. Then he paid his own ransom and secured the return of his daughter, who had remained a hostage for five months in his stead.

The following year, 1128,[219] the king assembled a host of warriors and invaded the land of Damascus.[220] King Toghtekin was very angry and came to meet them with an army much greater in number than ours, which nevertheless routed and put it to flight after a great massacre of the Turks; having pillaged their tents and taken their wealth, they returned rich and satisfied to Jerusalem, arriving unscathed, and indeed, on their route back captured two towers many miles apart. In the first, ninety-six Turks had taken refuge and in the second twenty, all of whom they put to the sword.

It was very shortly after this that the young Bohemond, son of Bohemond I, prince of Antioch and dame Constance, daughter to Philip I, came to the principality, which was promptly handed over to him by King Baldwin.[221] The latter had come only recently to the region, for the barons had sent for him, asking for his help against the army of il-Bursuqi. But when il-Bursuqi heard of Baldwin's coming, he abandoned the siege of Athareb castle and withdrew to his own lands, where his own men cut him down. After many fine speeches and exhortations, King Baldwin gave his second daughter, named Alice, in marriage to the young prince Bohemond, who shortly afterwards entered into conflict with Joscelin; Joscelin called on the Turks for help, though a peace agreement was quickly reached. Now there came to Syria and then Jerusalem Fulk, count of Anjou, whom King Baldwin had summoned from France; he bestowed his elder daughter, Melisende, on him, and with her the assurance that Fulk would be king after Baldwin's own death.[222] Fulk accepted.

Now it came about that Ridwan, the Turkish lord of Aleppo, gathered a great army and invaded the territory of Antioch. The young prince Bohemond marched against him with all the men that he could muster. But he wished to pass through Cilicia, hav-

"Coming across a hare that his hounds had raised, he [King Fulk] attempted to kill it with a lance, but could not because the hare leapt and ran off. The king spurred his horse, which, alas, put its head between its legs and threw off the king; worse, the horse was thrown over his head, so that the pommel of the saddle opened up his head and the king died of this blow three days later."

(FOL. 134A)

In his pictures, Jean Colombe emphasises the high points of the history of the kingdom of Jerusalem. In the principal illumination, he has chosen to depict the coronation of Fulk V of Anjou and his wife Melisende, daughter of Baldwin II, which took place in 1136. The new king kneels while William, patriarch of Jerusalem, places the crown on his head; his wife kneels behind him in prayer. As usual, the artist pays great attention to the depiction of the interior of the church where the ceremony is taking place, stressing the height of the nave, the decoration of the pillars and the size and prominence of the statues. In the lower register, Colombe depicts a scene in which crusaders and Turks stand facing each other, ready to attack: on the left, the foot soldiers of the crusader army are drawing their bows, while on the right, Muslim horsemen with drummers advance in the van, while armed archers stand ready to repel the enemy.

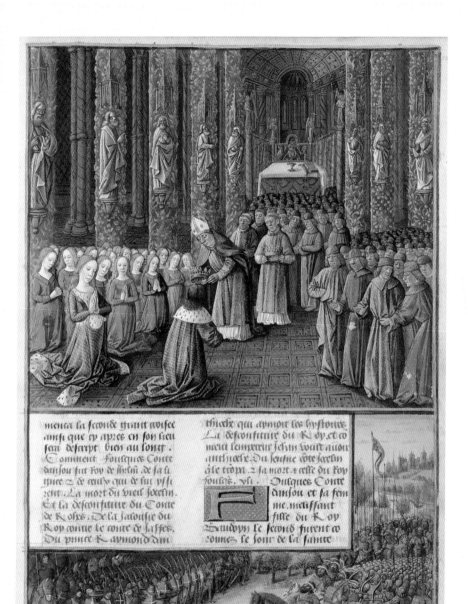

mença la seconde trait avisée
ainsi que cy après en son lieu
sera descript biens au long.
Comment Foulques Conte
danjou fut Roy de Jhrlm de sa li
gnie & de ceulx qui de lui yssi
rent. La mort du vieil Joscelin.
Et la desconfiture du Conte
de Rohes. De la jalousie du
Roy contre le conte de Jaffes.
Du prince Raymond dan

thioche qui aymoit les hystoires.
La desconfiture du Roy, et co
ment lemperur Jehan voult allier
anthioche. Du jeune conte Joscelin
& le trespas & sa mort & celle du Roy
foulques. vli.
F Oulques Conte
danjou et sa fem
me melissant
fille du Roy
Baudoyn le second furent co
ronnez le jour de la sainte

387

ing something to do in that land and believing himself safe so far from his enemies. However, they were marching secretly at his heels and made a sudden attack on him while he and his men were resting unconcerned in a place called the Meadow of Straw. The Turks routed them all and put them to flight, with the exception of the young prince Bohemond, who performed prodigies of arms in defending his standard with a few companions who remained at his side. But he and all of them were killed where they stood.[223]

When the men of Antioch announced Bohemond's death to the king, he left Jerusalem to go to the aid of Antioch. There he discovered that his daughter was seeking to place in a convent the little girl she had borne to the young Bohemond and that she was sending jewels and a messenger to a powerful Turk called Zengi[224] to persuade him to guarantee her right to Antioch against one and all. King Baldwin with great sagacity found a solution to this state of affairs with the help of the barons of the land, who secretly brought the king's son-in-law, Fulk, count of Anjou, to Antioch. Some days later, he placed trustworthy guardians in the city and the other places belonging to the principality, with the exception of a few small castles that could do no harm; these he gave to his daughter as dower, so that her status should be maintained. But he made the barons of Antioch swear an oath that, if he should die before Bohemond's little daughter was of a marriageable age, they would guard the city against one and all and would obey her as their own true lady.

This done, he returned to the city of Jerusalem, where he was stricken on his arrival with a malady so grave that he understood that he must pay the great human forfeit. Therefore, he had himself carried to the residence of the patriarch, because it stands by the Sepulchre of Our Lord, and there made confession, receiving Our Lord Jesus Christ and the Holy Extreme Unction before the barons whom he had summoned, and, casting off the trappings of kingship and kingdom, he handed them to his son-in-law and his daughter, blessing them. Then he had himself dressed in the habit of the order of canons regular of the Holy Sepulchre, wishing, he said, to die thus attired and so follow Our Lord Jesus Christ, who sought always to be poor in this world.

Thus, he died, in the year of grace of Our Lord 1136, on the twentieth day of August, in the eighth year of his reign.[225] Despite the religious habit that he had endued, his body was very nobly buried in royal garb, under the mount of Calvary in the place called Golgotha. And let the reader be aware that the chronicler of Soissons has continued with the events of the First Great Crusade up till the death of Baldwin II as if it were a single story because Baldwin was one of the main princes and one of the first

who undertook this great crusade, and it was he who survived longest in the Holy Land. But he does not intend to proceed in so circumstantial a manner as he has done so far with the deeds of the kings of Jerusalem who followed in succession between the death of Baldwin II and the time of King Baldwin III, when the Second Great Crusade began, as will be described in detail in its proper place below.

Chapter XLI.
How Fulk, count of Anjou, became king of Jerusalem. Of his lineage and those who descended from him. The death of the old Joscelin and the defeat of the count of Edessa. Of the king's jealousy of the count of Jaffa. Of prince Raymond of Antioch, who loved stories. The defeat of the king and how the emperor John sought to lay hands on Antioch. Of the young count Joscelin, who tricked John. And of the deaths of Joscelin, and King Fulk.

Fulk, count of Anjou, and his wife, Melisende, daughter of King Baldwin II, were crowned on the day of the Holy Cross in September by William, patriarch of Jerusalem, in the year 1136. King Fulk was the son of the old Fulk, formerly count of Angers, who was married to Bertrada, sister to Amaury of Montfort, with whom he had two sons and a daughter. King Fulk was one of these sons and Geoffrey Martel the other. The daughter was called Ermengarde and was married to William of Poitiers, who abandoned her in defiance of the prescriptions of the Holy Church. The count of Brittany then married her and had a son named Conan, who in due course became Count of Brittany and was known as Conan the Fat. When Bertrada had borne these three children to Fulk the Elder, she left her husband and became the mistress of King Philip I of France, who dismissed his own wife and took Bertrada as his lover, with the result that the Pope excommunicated him long after the event. With Philip, she had three children, Fleury, Philip and Cecilia. The last-named became the wife of Tancred, as we have said, and after his death, was married to Raymond, count of Tripoli.[226]

King Fulk had two sons and two daughters with his wife, the daughter of the count of Le Mans. The eldest was named Geoffrey and was made count of Anjou in succession to his father, taking for wife the empress Matilda, daughter of Henry I of England and former wife to the emperor Henry of Germany. Geoffrey had three children with Matilda, the eldest of whom, Henry,[227] was subsequently king of England, duke of

Normandy and count of Anjou, Touraine and Maine by full right of property, a right that the English seek to maintain. But for a number of reasons I believe that he usurped this duchy against all justice and that this is no less true of the duchy of Aquitaine and the county of Poitou, which he usurped in similar fashion because of Eleanor, his wife, the daughter of the count of Poitiers and duke of Aquitaine, William, who died during the pilgrimage to Santiago. Eleanor had formerly been the wife of Louis the Younger,[228] as we will see below at greater length. For even if the kings of France have made a pretence of allowing daughters to succeed to duchies and counties given to the royal children or others out of a sense of obligation or family loyalty and in order to find a means of peacefully retaining the rest of the kingdom, this is not something that they could in fact do and it cannot and should not prevent King Louis now reigning – nor his heirs – from reclaiming them and restoring them to the Crown, however long it was since they were thus inherited by a woman, and doing so now or at whenever it should suit them, and none of those who currently hold or rather lay usurping claim to them can have any grounds for complaint. The second son of this Count Geoffrey was called Geoffrey Plantagenet[229] and the third William Longsword.

The second son of Fulk the Younger, king of Jerusalem, was called Elias and his first daughter Sybilla; she married Thierry, count of Flanders, and bore him Philip of Flanders, who performed such great feats of arms in Outremer, where he died. When Philip II Augustus of France came to the Holy Land, the second daughter of King Fulk, Alice, was married to the only son of King Henry I of England, William Adelin, who died in a storm at sea. Whereupon she swore that she would remain chaste and took the veil at the abbey of Fontrevault, near Poitiers, where she died a nun.

Enough has been said to make clear the genealogy of King Fulk. At the time of his coronation, the old count of Edessa, Joscelin, was very ill. Nevertheless, because his son Joscelin the Younger dared not march against the sultan of Konya, who had entered Edessan territory and was besieging one of its castles, he gathered his army and, carried in a litter, led his men into combat with the sultan, who, learning of his coming and terrified in previous encounters by his valour, dared not await Joscelin but lifted the siege and scurried back into his own territory. When this news was brought to him, Joscelin the elder was so happy that, with the last of his courage, he forced himself upright in his bed, and humbly thanked Our Lord for the grace that He had vouchsafed him by thus driving his enemies to flight while he himself was already half dead. And so his glorious soul left his body. His son, the younger Joscelin, was his heir; by his wife Beatrice, he had a son, Joscelin III, and two daughters. One of these, Agnes, was later

the wife of King Amalric I of Jerusalem; their son, Baldwin VI, was king of Jerusalem.[230] Moreover, the dowager princess of Antioch, Alice, aided by Pons, the count of Tripoli, attempted to obtain the reins of the principality, at which King Fulk, whose assistance was requested by certain of the Antiochene barons, came with his army and, when the count of Tripoli attempted to prevent his passage, defeated him in battle.

Having won this victory, the king pardoned all the sins of the count some days afterwards at the request of certain barons and handed back all the prisoners that he had taken. He, moreover, stayed on in Antioch till he had set the affairs of the principality in good order, when he returned to Jerusalem, having won the praise and affection of one and all. But he returned shortly afterwards at the summons of the barons of Antioch to rout a great Turkish army, three thousand of whom were left dead on the field and a great many made prisoner by the king.

Shortly thereafter, Raymond, younger brother of William of Poitiers, was called to Outremer and received in marriage Constance, the daughter of the young Bohemond, along with the principality of Antioch. Armed conflicts often arose, such as disputes between prelates and other forms of discord. Some did not attain to their station by the proper means and others behaved very badly during their pilgrimages. But I give them short shrift because the intention of my lord and master, monsignor Louis de Laval, lord of Châtillon and Gaël, aforecited, has been and is that I should succinctly recount the battles that occurred during these expeditions.

King Fulk was, moreover, extremely jealous of the queen and Count Hugh of Jaffa,[231] even though Hugh was Melisende's cousin; matters came to such a head that Hugh had to be exiled for a while. Waiting to cross the Mediterranean, he was playing backgammon in a furrier's shop one day when attacked and wounded in several parts of his body by a Breton knight. The knight was taken prisoner by officers of the law on the orders of the king – who understood that the people were muttering against him and saying that he had instigated the attack – condemned to be amputated of his limbs while still alive and his head cut off at the last. The knight maintained that he had acted of his own volition, hoping that the king would be grateful since he detested Hugh. Thus, he died, his head struck off, having first exonerated the king – who was much praised for his wisdom in bringing the truth so clearly to light.

While the king thus ensured that justice prevailed in Jerusalem, prince Raymond was governing the principality of Antioch.[232] It has been written of him that he was the strongest and most valiant prince ever to walk this earth; that he greatly loved to serve Our Lord and very much liked to attend mass. He often had books of history read to

him, listening to them with much pleasure; and he greatly honoured and loved historians, though he was himself unable to read – God forgive his sins and those of all his rank! Roger, count and later king of Sicily, knowing that the barons of Antioch had sent for this Raymond to be their prince, carefully watched the crossings, hoping to capture Raymond, for he claimed that the principality was his by right, he and the young Bohemond, on the latter's departure from Sicily, having promised each other that the surviving party should come into possession of the territories of both, since they were the sons of two brothers. Raymond, however, having been warned of this, so often changed his costumes and disguises (garbed now as a merchant, now in other forms) that he reached Antioch safe and sound.

More or less at this time, the constable of Damascus defeated and killed in set battle Pons, the count of Tripoli. And with him were lost almost all the barons and rich citizens of Tripoli. Pons had a young son named Raymond, who, secretly mustering those of his compatriots still capable of bearing arms, made a sudden attack on mount Lebanon, seizing several traitors who had been accomplices in the death of his father and putting them to death in various ways. Also at this time, the emperor John of Constantinople gathered an army immense in size and wealth, and, having crossed the strait of Saint George, captured all the cities as far as Antioch, which he besieged and invested with his great army. During this siege, Zengi of Aleppo also invaded the county of Tripoli with a great army of Turks and besieged a stronghold. For this reason, King Fulk, who had left Jerusalem with an army in order to aid Tripoli, when he received the prince's messengers, decided to go to his assistance, but first to deliver Tripoli. And he was, whether by folly or treachery, led through rugged, narrow passes in which soldiers could not easily defend themselves.

Zengi was informed of this and, therefore, lifted his siege and led his men to Fulk, routing our men without difficulty because they could not come to one another's aid in the narrow defile. Thus, they lost – in addition to all those who died or were taken prisoner – all their armour, wealth and provisions, which the Turks carried off. With them was the count of Tripoli, whom they had also captured. The king and several great barons accompanying him were forced to retreat to the castle of Montferrand, where there was almost no food left. For this reason, they hastily sought help from Jerusalem, Edessa and Antioch, whose prince, though his city was besieged, gave his city to the care of Our Lord, and, taking with him as great a number of knights and others as he might – there was no shortage, for they all offered to take part in the expedition, so seriously did they take the matter – left by the most direct route for Tripoli.

The patriarch of Jerusalem, William, also mustered as many men as possible and left in the same direction, bearing in his hands the True Cross. And while all were gathering forces in this way, the constable of Damascus suddenly invaded the territory of Syria, where he took the city of Nablus without difficulty, killing all the inhabitants who could not flee, whether man, woman or child, for they had not expected any such raids and the city was not enclosed by walls nor equipped to endure a siege.

During this time, Zengi, persisting with his siege and making continuous assaults on the castle – such that our men, who were almost starving to death, were for the most part badly wounded or half dead – learned that the count of Edessa, prince Raymond, and the patriarch were soon to arrive in force. He, therefore, proposed that if the king would surrender the castle devoid of its inhabitants, he would allow him to leave with all his men and belongings, making no other conditions, and would restore to him the count of Tripoli and the other prisoners that he had taken. This the king and his men accepted and so the matter was settled, though they well knew that help was close, since this very cruel Turk made them such an offer. And it was true that help was at hand. But they were driven to accept owing to the great suffering endured and the hardships of starvation and sleeplessness. As to Zengi, he kept his promise to them, handing over the count of Tripoli and the other prisoners, with whom the king left the castle.[233] And then, as the king was returning, he encountered the three armies, which he thanked with all his heart for their good intentions.

When he had taken his leave of each of the princes, they led their men back to their own territories. Raymond, in particular, immediately returned to Antioch. After his arrival, he paid homage to the emperor in his imperial tent, and became his vassal for the principality of Antioch, swearing upon the Holy Relics that, whenever he wished, he would let the emperor enter the city and fortress of Antioch as and when he wished, and also that, if the emperor could conquer Aleppo and Shaizar, Hama and Homs, he would give them to the prince and the prince would then make over Antioch to the emperor as his own property. The emperor having promised to return the following summer with a much greater army, his standard was raised over the principal tower of the fortress to show that he was lord of the city, which caused extreme joy amongst the Greeks. And the emperor then led his great army back to Constantinople, promising to return when the winter was over with an ever more numerous army. This he did.

No sooner had he arrived than he laid siege to the fortified city of Shaizar,[234] which lies beyond the city of Antioch. The prince of Antioch and the count of Edessa came

to meet him with a great army but, despite the emperor's petitions and remonstrations, they refused to do other than play backgammon and chess and eat and drink, and would not do as he did. The emperor often sent to fetch them from their pavilions in order to make them join in the assault or at least approach the enemy. He himself remained in the front line, wearing a habergeon and iron helmet, watching and encouraging the attackers and handsomely rewarding the valiant and the bold. Finally, realising that the prince and count were making no effort to help him lead the army and that his men were not able to take the city by storm, the emperor accepted a great sum of money from Machedole, the Armenian lord of the castle (who feared that the Greeks might suddenly burst through the castle's defences). Then, despising the two young princes, who laughed at those who returned from the attack bearing a wound, he lifted the siege and returned to Antioch.[235] There he had so large a contingent of his men enter that they were the stronger in the city. He then summoned the prince before him and demanded that he cede to him the city and fortress of Antioch, according to his promise. He added that he would soon be in a position to keep his own promises, explaining that there was no city in the region so well placed for him and his men to take as their base nor from which he could do so much harm to the enemies of the faith.

Now it happened that Raymond of Antioch and several of his barons were present at this scene and so astonished by the emperor's demand that they were speechless, knowing that he was the stronger within the city. Moroever, the emperor's decision to restore to the Greeks – who were so deficient in strength and courage alike that they could hardly have held out against an army of women – the most excellent city of Antioch, one that had cost so much French and Latin blood, bewildered them.[236] Therefore, the young Joscelin, count of Edessa, with remarkable resource, spoke in the name of the prince. He cunningly replied: "Sire, we are certain that the promise that you have given and the proposal that you have made – showing your willingness to expose to the enemies of the faith your men, your wealth and your excellent self for the sake of the people of Our Lord – are God-given. He alone can have implanted such goodness in your heart. But you are asking for unheard-of things, and the people of this land are prompt to take fright when change is imposed. And, in all truth, what you request is not within the prince's authority, but, as you know better than I can say, must be decided also by the barons of the land, who are not here present. Therefore, you must, if you please, accord a delay, specifying the term to the prince, so that he can assemble them in council and the people, too. If that is done, they will easily be per-

suaded to consent to your decision, but if it is done suddenly, I am afraid that some harm or undesirable consequence may ensue."

Having heard this reply, the emperor granted a day's let to the prince, hoping that the thing could be done in that space of time. And during this time, moreover, he was retained within the palace and guarded by the emperor's men as if he were a prisoner, even though they let the count of Edessa depart. Carrying the news of the peace proposed by the Greeks, the count immediately went to his Antioch residence, and no sooner arrived there, secretly sent his men out into the streets of the city, declaring to the people that emperor and Greeks wished to lay hands on the city of Antioch and there establish a garrison by force; that the prince and all the barons must, therefore, leave; and without immediate remedy, the emperor would lay hold of the city forthwith. These words spread through the city and immediately there arose throughout Antioch an immense tumult, a riot attended by prodigious cries.

When the count saw that the people were greatly moved, he hastened out on his horse and, galloping as best he might through the streets, he came as though pursued to the very feet of the emperor, there throwing himself down as if in a faint, like a man hunted by foes intent on slaughtering him. The emperor was completely astounded and indeed, his guards were extremely angry that he should approach the emperor thus, telling the count so in no uncertain terms. But the count appeased them cunningly, crying mercy and claiming that it was from fear of death that he had thus intruded so roughly. When the emperor questioned him to find out what was the matter, the count pretended that he could hardly speak for fear. And nevertheless, with every show of terror, he at last announced: "Sire, I had only just left you and betaken myself to my house, where I had hoped to rest, when the people of this city, the great and the small, all armed alike, came rioting before my abode, shouting aloud and saying 'Where is the traitor, the murderer, the evil prince who sold this city for the promise of great wealth? We shall tear everything apart, and first and foremost the count of Edessa who advised him! We shall kill him if we find him!' And they then began to batter down the doors of my house to kill me, though I, by the grace of God, mounted my horse and left in all haste by a concealed gate, coming unscathed to you with the utmost speed through numerous perils, for it was a terrible thing to hear the cries that they made when they saw me and sought to lay hold of me."

When the emperor heard this news, he and his men were greatly affeared and, in all haste, had the gates of the palace closed. And in truth, their fear was not unreasonable, for the people of the city were running through the streets and their conduct was

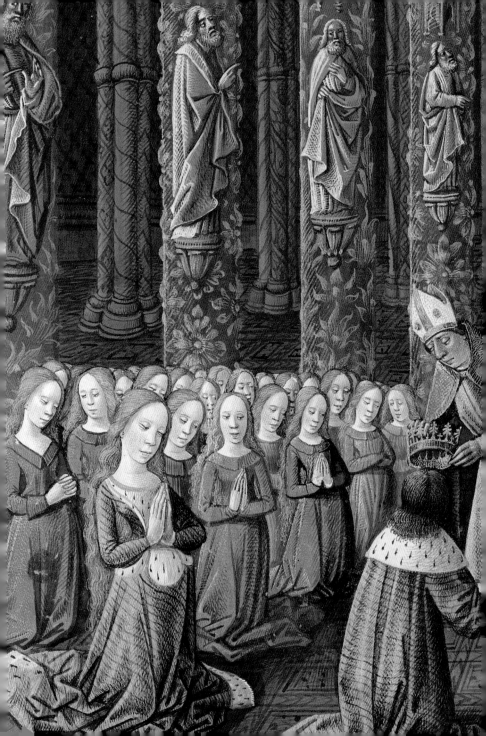

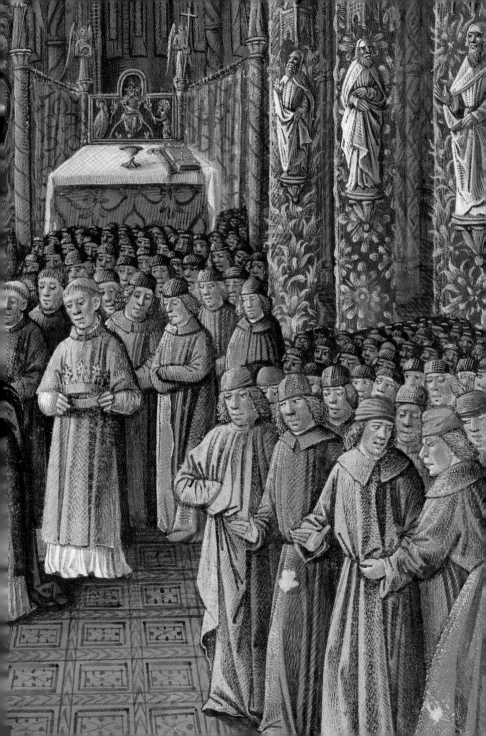

horrible to behold and their shouting terrible to hear: the Greeks had come to take their property, they cried, and wished to lead them into slavery. Each man did what he could to worsen the situation. When they found the emperor's men in the city, they threw them down from their horses and dragged them in the dirt, and those who sought revenge cut them in pieces and showed no pity. The emperor, seeing his knights and squires return having been thus basely treated, feared the worse, and summoning the prince and the count of Edessa with the other barons of his country, he spoke these mollifying words: "I asked you for something that I thought would be profitable for you and for your land. But, since I understand that it does not suit your people and that they might, therefore, commit some great folly, I, as emperor, hereby state and affirm that I renounce this plan and that I have changed my mind. I now wish you to possess the entire city of Antioch and its fortress as you have always done.[237] And it is quite sufficient for me to maintain my empire alongside yours as my predecessors have done. Go hence into the streets and appease the representatives of the people. Tell them that, if they are suspicious of my stay in the city, I shall leave in the morning without inflicting harm or humiliation and return peacefully to my own country."

The prince and count went to pacify the people by strongly praising the emperor and claiming that they wished to obey him in all matters. And the following day, the emperor left the city with his son, his other barons and his own men, taking care to dissimulate his true feelings. However, he established his men close to the city with the intention of besieging Antioch and taking his revenge: the wisest of the inhabitants felt sure that he had not forgotten the offence he had suffered and, therefore, they sent to him in all haste ambassadors from amongst those in the city who were wise and clever speakers and these ambassadors offered him both the city and the people, arguing, amongst other things, that the good should not be punished because of the offences of the wicked. Thus, they appeased him with sweet and humble words and he promised to return to aid the Christians of Syria, Cilicia and Armenia with a very large army. And this, indeed, he did.

During this time, a number of great events took place in the Holy Land. Thierry, count of Flanders, having married the king's sister (as we have seen),[238] came with a great number of knights and men and remained there for a long time. And Robert the Burgundian, native of Poitou and master of the Temple, and Bertrand Vacher, governor of the kingdom, conquered a Turkish army whose raids were doing great harm. But while our men were dispersed in pursuit of the Turks to regain their booty, the Turks rallied near Hebron and killed a great many of our men, such that the Turks gained

both the victory and the plunder. At this point, Zengi also sought to conquer the kingdom of Damascus. Whereupon the constable of Damascus requested an alliance with King Fulk, promising him money if the latter would come to his assistance. Moreover, if Zengi was defeated, the constable promised that Fulk would be able to recapture the city of Banyas, which had been lost to the Christians. Fulk, having taken counsel, went to the aid of Damascus, and Zengi retreated from this kingdom to his own territory in fear of the king.[239] Fulk then besieged and took Banyas, thanks to a ruse known to the constable, who kept his promises.

Shortly thereafter, the emperor John left Constantinople with great treasures and an army more numerous again than the last. He came to Edessa, where the count, of whom he had requested hostages by messenger, sent him one of his daughters. Then, setting off to Antioch, he demanded that the prince, too, send him hostages in accordance with the latter's promises. But when the prince of Antioch asked his barons, they were not willing to hand over the city to the Greeks, for they had a very low opinion of the Greek's military capacity and informed the emperor that the prince could not grant what he had promised without their permission. The emperor was furious at this and, thinking to take his revenge, he began his campaign at the advent of spring. At the same time, he informed King Fulk that he would very much like to make a pilgrimage to Jerusalem and that he would help him to conquer whatever cities he should choose. King Fulk replied that, if he were willing to come with just five thousand knights, the Syrian territory could supply them, but not more than this. When he heard this, the emperor, who was accustomed to cover the entire territory in which he was campaigning, changed his mind. He remained near the city of Tarsus, awaiting the end of the winter.

One day, while out hunting, he attempted to strike a great boar with a Turkish bow, but drew the cord out so far that the barb of the arrow, which had been dipped in poison, as was the habit with the hunters of this region, slightly wounded the emperor's hand. He, therefore, returned to his tents, calling upon his surgeons and doctors, who could find no cure. They told him that there was no other remedy than to cut off the arm before the other parts of the body became infected, for it was horribly swollen. But the emperor, who was a man of great courage, replied that he could already feel the strength of the poison in his bowels and that he would never let his hand be cut off in order that he should be cured, for it would be terribly shaming for the empire of Constantinople to be ruled by a one-handed man. That said, he understood that his death was imminent, and summoned his barons and sons to his side, where he instructed

them in many things, amongst them that his elder son Isaac, who was in Constantinople, should have been emperor after him by right of nature; nevertheless, Manuel, the youngest son, who was amongst those brought to his bedside, seemed the aptest to govern the empire, and he, therefore, advised them to make him emperor, for they could not safely return without a leader. Respecting his will and advice, they finally chose Manuel as emperor while his father yet lived – to the great happiness of John (though some who would have preferred Isaac). And thus, near the city of Anazarbus, the greatest city of Cilicia Secunda, died the very noble and valiant emperor John of Constantinople in the year 1137, in the month of April of the twenty-seventh year of his reign.[240]

King Fulk, the patriarch and the other barons of Syria at this period built two strongholds near Ascalon, which allowed them to keep a close eye on the Turks who had retreated within the walls of that city. But a grave misfortune occurred shortly afterwards. King Fulk was staying in the city of Acre. The queen had gone out hunting in the vicinity and he wished to follow suit. Coming across a hare that his hounds had raised, he attempted to kill it with a lance, but could not because the hare leapt and ran off. The king spurred his horse, which, alas, put its head between its legs and threw off the king; worse, the horse was thrown over his head, so that the pommel of the saddle opened up his head and the king died of this blow three days later, to the great grief and desolation of the entire kingdom.[241] His body was buried with every honour beneath mount Calvary, with the other kings.

Chapter XLII.
How Baldwin III was made king of Jerusalem. How Zengi captured by force the city of Edessa. Of the great Turkish lord who wished to bestow his city on the king and of his wife, who prevented him. Of the difficulties faced by the king and his men. Of the unknown knight. Of the reconquest of Edessa and its subsequent loss.

King Fulk of Jerusalem left two sons. The elder, named Baldwin III, was crowned king by the patriarch in the presence of the barons on the Christmas Day after the death of his father, but was only nine years old. The younger, named Amalric, was only seven and was first called "count of Jaffa", though he, too, in due course was crowned

king of Jerusalem. And that same year, between the death of King Fulk and the coronation of King Baldwin III, Zengi, who was the emir of Mosul, formerly called Niniveh and the greatest city of Assyria, invested the noble city of Edessa[242] at a time when Joscelin, the count of Edessa, had long been absent from it, having retired to the castle of Turbessel, on the river Euphrates, and left the city under the guardianship of Armenian and Chaldean merchants, who knew nothing of war. There was no one else to whom he could entrust it, the few warriors remaining to him having all left, since they were never paid. And even amongst the small number of merchants remaining in Edessa, there were only evil men, for the good men had left because of the delay in paying their wages. And, if the truth be known, their wages were sometimes a year late. And Joscelin, unwilling to hear their plaints or those of his subjects in the hinterland of the city, who had to endure constant raids and complained of it, had moved away from Edessa, living amidst his pleasures and leaving the good city of Edessa without either guardians or defenders.

Zengi had, in the course of his attacks, noticed this. He knew that prince Raymond of Antioch and Count Joscelin of Edessa, who had long detested each other in secret, were now open enemies, each delighting in any harm inflicted on the other. He knew, too, that Joscelin had appealed to and begged Queen Melisende of Jerusalem (who was still governing the kingdom) to send a substantial army and that the prince of Antioch was coming, too, with a handsome army to raise the siege. He made haste to mine the walls and construct siege-machines. The citizens knew nothing of military matters and were afraid to defend themselves. So the city was taken by storm and almost all the citizens cruelly killed before the relieving forces could reach them. Thus, the Turks captured the city of Edessa,[243] which had been converted by the preaching of the apostles. Abgar was formerly king of this city; he sent a letter to Our Lord Jesus Christ while he was preaching in Jerusalem and Our Lord sent a reply.

It happened, too, then that the king of Damascus, and more particularly its regent, Unur, also called Mu'in-ad-Din, who has been much spoken of, conceived a great hatred of the Turkish prince Altuntash, lord of the city of Bosra, formerly called Bostra, which was the greatest in all Araby. Altuntash possessed a stronghold named Salkhad. And their hatred attained such a degree that Unur besieged the city of Bosra. For this reason, Altuntash, a rich and powerful Turk, came to Jerusalem with a handsome retinue, offering to place his territories in the hands of the king if he would come to his aid. On the advice of his mother and barons, King Baldwin accepted and undertook to defend Altuntash, gathering an army that he raised and led out of Jerusalem as quickly as possible.

But, before he could go very far, Unur sent messengers and clearly showed that Baldwin was wrong to invade the territory of the king of Damascus, of whom he was a friend and an ally, and to support against him one of his own subjects who had quite wrongly attempted to escape his suzerainty. He, moreover, offered to pay all Baldwin's expenses if he agreed to return home, and sent him a number of messengers, one after another, not only in the hope of making him turn back, but also in order to make use of the delay thus obtained to muster men-at-arms, which he summoned from all around, not only through their duties as vassals but by payment. And, if the truth be told, whatever his intentions were, Unur offered the king many gifts and showed himself full of goodwill and love towards the other Christians. Bernard Vacher, a very wise and valiant knight, who had previously been close to this Unur, advised the king to accept Unur's demands. But the people and others were furious with him and accused him of having been secretly bribed. But it was not long before they understood that he was a wise and good knight, for they entered a great plain, where they found a Turkish army of such numbers that they thought that this entire land had never before borne so large a number of warriors. And those who had advised the king not to turn back would gladly have repented of their advice and they advised him to encamp in this plain.

The following day, they again set out, but they were followed constantly on either flank, and at times were preceded by the Turks, who fired innumerable arrows. And the good Christians, who were dying of thirst and could find no water except in wells that stank because of the great quantity of locusts carried into them by the wind, nevertheless took care of one another and never diverged from their road in the various regions through which they passed despite the innumerable Turks from whom they endured the most prodigious attacks. At last they saw in the distance the city that was promised to them, which was a consolation to them because they thought that they would enter it the following day. But during the night there came a messenger from the city, who, having been conducted before the king, told him in the presence of the barons and, indeed, of Altuntash that the latter's wife had surrendered the city to the Turks and that they had already taken possession of the walls and towers and had thrown down from them those who were guarding them. At this information, the fear and dismay of our men was considerable and certain of the barons advised that they should set the king on their finest steed and that he should attempt to escape with the Holy Cross, since the remainder were as good as lost. But the king refused, and young as he was, said: "I shall not do this, and would never wish to escape when the good and true men that I have led here go to their deaths."

And so, full of admiration for the king, they began to organise the return journey, during which they endured numerous ordeals; amongst others, the Turks set fire to the dried grass and shrubs, so that the wind would bring the smoke into the faces of our men. And so it passed and they were all but suffocated. But our men, who understood that human strength was lacking, appealed humbly to Our Lord, and begged the archbishop Robert of Nazareth, who bore the True Cross before them, to pray to Our Lord to release them from this peril, for they had no hope of other assistance. Therefore, the archbishop, seeing that they were all black as charcoal-burners because of the flames and the very noisome smoke, dismounted from his horse, and humbly kneeling on the ground, full of tears, he begged Our Lord to take pity on his people, who, in order to glorify His Holy Faith, had suffered and was suffering such great and multiple dangers.

And when his prayer was ended, he stood up and raised the Holy Cross against the flames and smoke, and Our Lord then showed a very evident miracle, for the wind immediately turned and suddenly sent the flames and smoke into the faces of the Turks and Saracens who had set the fire, so that they were forced to scatter here and there through the fields. Seeing this, our men began to weep for very joy and rendered humble thanks to Our Lord. From this moment on, the sight of the miracle gave them new strength in their bodies and new belief in their hearts to endure further pains in the service of Our Lord. By contrast, the Turks and infidels were dumbfounded and mortified and knew not what they should do in the face of the very evident miracle that they had seen Our Lord accomplish. Numbers of them, indeed, declared that, in truth, there was no other religion than the Christian one, for Our Lord Jesus Christ always performed what the Christians asked of Him at just the right moment.

Shortly afterwards, Unur made an offer to the king through one of his messengers: for the sake of their past alliance, he would prepare for the king and his men a great quantity of provisions in a broad plain situated beyond the pass called the Vault of ar-Rahub. Though the army had great need of these provisions, on the advice of the barons the king refused them, for they told him that one should always beware of the services and kindnesses offered by one's enemies and also that Unur perhaps wished to inveigle them, under pretext of kindness, into perilous valleys from which they might not easily escape. And the barons ordered that, by the king's will, the army would continue on its return journey, but by another route that was not so perilous, even though none of them knew the way. Our Lord, who had already come to their assistance, remedied this lack, for a knight wearing a hauberk whose sleeves did not come down to his elbows and bearing a red banner, mounted on a great white horse, appeared so suddenly that no one

in the army then or later knew where he had come from. He engaged to lead the army and placed himself alone at its head; and he led them well and safely, always showing them fine, cool, caves, of which they had great need. And he made them always encamp in excellent places, well suited to this use and to people such as themselves.

He led them so well that they arrived on the third day at the city of Gadara, where they were out of danger. The knight then departed as suddenly as he had come, for they never could find him in the entire army, nor discover what had become of him, just as they did not know whence he had come and who he was, nor where he spent the night, for he was not seen from the time the army encamped in the evening till the morning came and he again put himself at the army's head. Undoubtedly (as I myself believe), it was Saint George, the good knight who has so often brought succour by evident miracles to those who serve with a true heart and most particularly to the Christians fighting for the Holy Land. And when the Saracens saw that our troops were approaching this city, they strove to break up their formation by showering them with arrows and attacking. But they did not succeed and, therefore, could no longer hope to do them harm. So they took leave of one another and returned to their own lands. And the king and his army arrived that same day at Tiberias, whence they returned to Jerusalem, where they and the Holy Cross were received with great joy. The wise men who had taken part in this campaign said that never before had the army of the Holy Land marched amidst such perils without suffering defeat.[244]

Shortly afterwards, Altuntash, the Turk who had led the king to his city in order to surrender it, was deceived. For, secure as he was in the territory of the king, he went to meet Unur, who had conveyed to him that it would be good for him to be at peace with the king of Damascus. But he was no sooner arrived at Damascus than Unur had him treacherously captured, blinded and thrown into prison to the former's shame and dishonour. A further painful event occurred during the same period, which resulted from the recent death of Zengi, that terrible enemy of Christianity. In order to take possession of his territory, Nur ed-Din, his son, went with a great army to Mosul, since certain people sought to contest his right to the city. He had to fight a number of battles in that region.

Now the good citizens of Edessa (there were still a great number whom the Saracens had allowed to continue residing in the city on payment of tribute after they had captured Edessa because there were insufficient Muslims to populate it), when they saw that there was no Turkish army in the vicinity but only a few men garrisoning the gates and towers, decided to restore Joscelin to his power in the city and summoned him. They

welcomed him and took him and all the men that he had brought with him within the walls.[245] But they had brought no siege-machines and could not, at Edessa, find the wood needed to construct such machines and attack the fortifications and towers, for these were well garrisoned with Turks, who had artillery and abundant provisions. Therefore, Joscelin sent messengers to Christians near and far saying that he had recovered the city of Edessa and asking them please to help him for the sake of Our Lord. And in fact, many armies were raised in many different countries, which all set off to Edessa to assist the prince. But they were not quick enough: Nur ed-Din, when he heard that the city had been lost, abandoned all his other wars and hastened to lay siege to Edessa, which he suddenly did some days later, with innumerable infidels whom he mustered in a number of lands by gifts, promises and petitions. The young Count Joscelin saw that he was besieged in a city where provisions were lacking and his men were of the view that it was better to make a sally and fight the Turks, force a passage through them and thus save themselves, revenging their own death by massacring a great number of their adversaries, than to die of starvation within the walls or again, if the Turks of the gates and towers were to let in the besieging army, be murdered in horrible fashion if they were caught scattered throughout the city. So he had the gates on one side of the city opened and he and his men threw themselves on their enemies outside the walls.

But when the Turks of the towers and keeps of the city saw that the Christian army sought to leave the city and the citizens were following in their footsteps, preferring death to the prospect of remaining at the mercy of their enemies, the former came down from their positions and ran after them with a great number of those from outside the walls who had been brought into the city by the Turkish guards. Thus began a terrible battle, for the Turks on the outside, hearing the noise, came out from their tents and forced our men back into the city. They were, therefore, squeezed, as it were, between two mill wheels, that is, the Turks from the inside and those from the outside, and a horrible massacre ensued. Women, old men and children were almost all stifled and killed in the press. The count of Edessa, however, mustered his army of knights and, despite all that the Turks could do, escaped out of the gates and left with his men in the direction of the Euphrates. But there was no lack of skirmishing for them throughout their journey, which was of fourteen miles, for Nur ed-Din, who knew that the count was amongst those in the army, always placed in the vanguard his most valiant and enthusiastic knights so that they would attack him. Our men fought their way through by dint of sword and lance-stroke. Here was killed a very valiant knight of great nobility called Baldwin of Marash, who had conducted himself with the greatest

"Opening wide the treasury of the Church, he [Pope Eugene III]
vouchsafed complete forgiveness and remission of penance for their sins
to each and every one of those who, thanks to the holy preaching, and
that they might come to the aid of the Holy Land, would take the Holy Cross
as a sign of their support and would take part in this crusade."

(FOL. 137VB–138B)

Here Jean Colombe depicts in symbolic fashion the beginning of the Second Crusade. In 1144, the Saracens regained the county of Edessa, which had been held by the crusaders since the First Crusade. This event threatened the kingdom of Jerusalem and more generally the interests of the Franks in the Holy Land. The West reacted swiftly and, on 1 December 1145, Pope Eugene III called for a new crusade. Since the enthusiasm of earlier times was slow to manifest itself, the Pope appointed Abbot Bernard of Clairvaux, a charismatic speaker with great authority, to preach the crusade and announced that an assembly would be held at Vézelay in Burgundy.

Such multitudes gathered on hearing that Bernard was going to preach that he was obliged to address them in a valley outside the town: he is portrayed in the left foreground, wearing the habit of a Cistercian monk. The French king, Louis VII, seen here in full regalia, is the first to take the vow to set off for the Holy Land and to receive the cross from the bishop of Vézelay: behind him, a throng of nobles prepares to follow his example. In the lower register, the king is depicted setting off on crusade. His royal rank is indicated by his horse's resplendent blue caparison dotted with *fleurs-de-lis*, while he himself wears equally splendid garments.

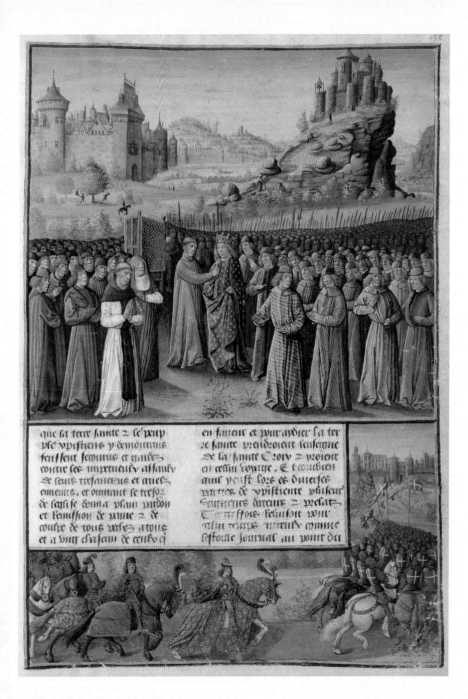

que la terre sainte z le puy
ple xpistiens y demourans
feussent secourus et gardes
contre les mescreaux assaulx
de leurs tresanciens z anci
ennemis. et ouurant le tresor
de leglise donna plain pardon
et remission de paine z de
coulpe de tous leurs attons
et a uint chascun de ceulx q

en faueur et pour aidier la ter
re sainte prendroient leusaigne
de la sainte Croix z yroient
en cellui voyaige. Et combien
que peust lors ce diuerses
partues de xpistiente plusieur
seigneurs ducons z prelats
Coutesfois feusoit pour
cellui temps retraire comme
lestoire iournal au point du

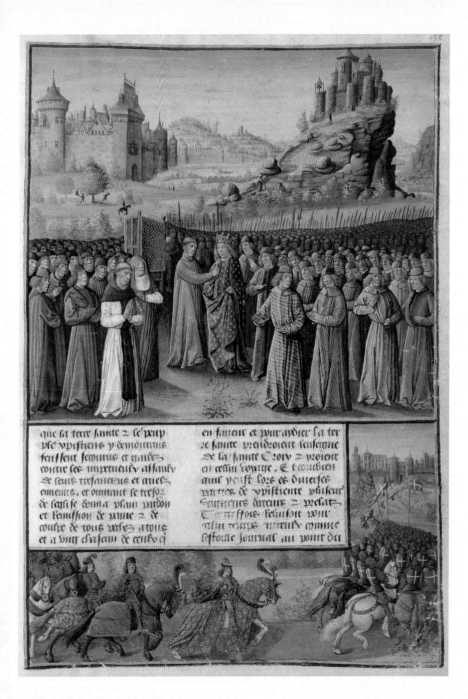

407

bravery, as were numerous others besides. Count Joscelin, finding his forces inferior in number, fled on horseback and, crossing the Euphrates, took refuge in the city of Samosata. His other knights and anyone else still able to flee went wherever they could find refuge.

And so the city of Edessa was recaptured from the Christians by the Turks and Saracens, who, therefore, held uncontested sway there, whereas the Christian people had till then always been masters and lords of that city, from the preaching of the apostles to shortly before it was recaptured through the negligence of the young Count Joscelin.

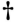

Chapter XLIII.
The Third Great[246] Crusade, which was led by Conrad, emperor of Germany, and Louis the Younger, king of France. How the crusade was preached at the behest of the Pope and undertaken by the princes, and how they left their lands and took up arms at Constantinople.

Now when Eugene III,[247] who was at the time Pope under that name, was told[248] of the lamentable loss of Edessa and of the great conquests made by the Turks and Saracens against the Christians of Outremer and elsewhere, he sent a number of prelates who were mighty clerics to preach the crusade against the infidels. And he issued as well papal bulls wherein were most desirable privileges and, through the mouths of his own legates, both demanded and commanded all the princes and people of Christendom, and most particularly those of Italy, France, Germany, Spain and England, that they should of their goodness, without tarrying, undertake and make ready a new crusade, that the Holy Land and the Christian people who dwelt there should be succoured and protected against the brutal attacks of their longstanding and cruel enemies. Opening wide the treasury of the Church, he vouchsafed complete forgiveness and remission of penance for their sins to each and every one of those who, thanks to the holy preaching, and that they might come to the aid of the Holy Land, would take the Holy Cross as a sign of their support and would take part in this crusade.

Although there were then in the divers countries of Christendom a number of mighty doctors and prelates, there shone amongst them at that time, like the Morning Star amongst all other stars, the most illustrious abbot of Clairvaux, monsignor Saint

Bernard. And this prelate, although he was already deeply wearied through abstinence, nightwatches and fasts, began, in the year 1145, to preach this holy crusade and to move the hearts of the princes, barons and peoples of the kingdom of France. Amongst the noble words that he pronounced to exhort them, he asserted that, in exchange for two most great privileges, no good Christian, save that he had a most worthy excuse, could refuse to take part in the crusade and to undertake this Holy Journey. The first privilege was that they would most surely acquire honour and worldly glory beyond that which attached to any other deed if they fought to defend the patrimony of Jesus Christ, and the other was that, in so doing, they would also acquire heavenly glory. Indeed, without one single exception, all those who met their death by making this journey, as well as those who lived to accomplish it, would go in perfect glory to Heaven and would suffer none of the torments of hell or purgatory, provided that they kept themselves in a state of grace, as it behoves each good Christian so to do. And because the good and holy abbot was frail and most weary, he sent also certain of his venerable monks into Germany, Lorraine and other countries, and in each of these lands, this holy preaching was welcomed whole-heartedly.[249] And, that this undertaking should achieve the greatest possible success, the king commanded and made ready a gathering of all the prelates and barons of France in the town of Vézelay.

At that time, the most noble and valiant King Louis the Younger was reigning over France. He was thus called because King Louis the Fat, who had died but a short time before, had had two sons. The elder, named Philip, had, while his father yet lived and by his father's wish, been anointed and consecrated king at Rheims. But in that same year of his coronation, when he had gone out to disport himself in the lanes outside Paris, a boar chanced to hurl itself between the hooves of his horse and caused it to fall, and the young King Philip, who was beneath his mount, was so grievously wounded that he died but a few days later. That he might be distinguished from his brother, who had been the oldest son of the king, the young Louis who was king thereafter had heretofore been called in Latin "Junior" and in French "the Younger". And so this surname is always given to him by most historians, both as a reminder of his first title and also to identify him more clearly amongst all those French kings who were called Louis.

When the moment of the gathering had come[250] and the greater part of the prelates and barons of France were assembled at Vézelay, monsignor Saint Bernard preached a most remarkable sermon, that he might move the hearts of those who were present and exhort them to take the Holy Cross. This most valiant King Louis begged to be the first to take the cross, and in the presence of monsignor Saint Bernard and all the other prel-

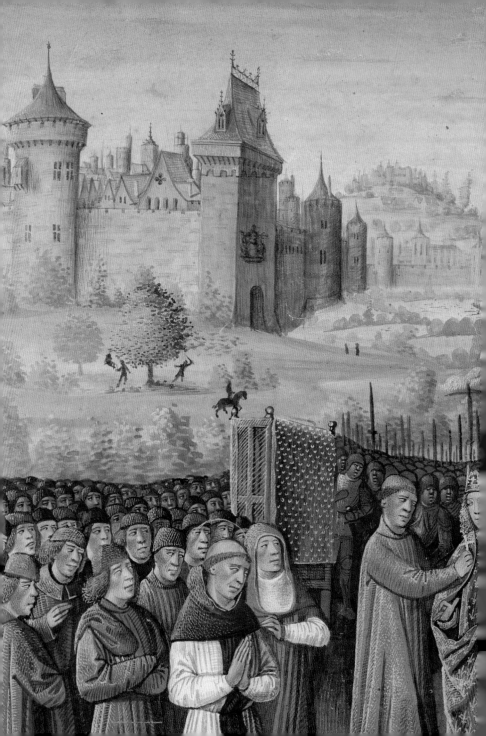

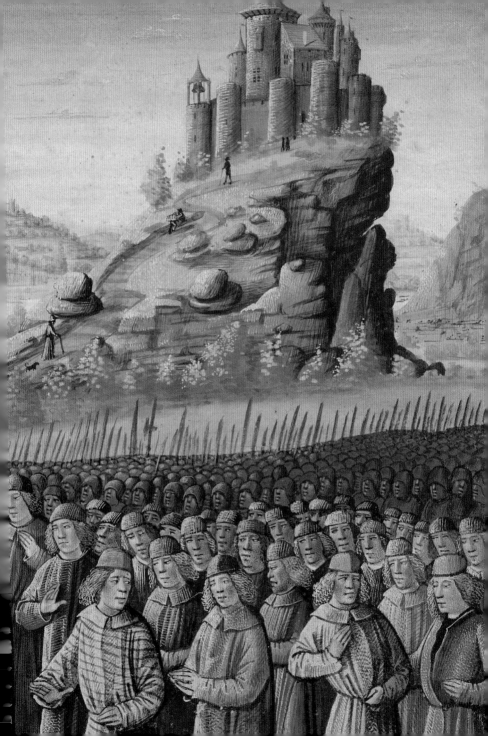

ates, princes and barons, he made his vow to undertake the Holy Journey and he took the cross, which the bishop of Vézelay, the papal legate, placed upon his shoulder. And following his example, there then made the vow to undertake this Holy Journey the most noble and illustrious prince Henry I, count of Champagne, he who founded the collegiate church of Saint Stephen in Troyes along with twelve other churches and thirteen hospitals. This Count Henry, according to the Chronicle of France, was a man of courage and great heart; he was son to the good count Tibald the Elder, who was at that time still living and who was buried at Lagny, where his body remains to this day. There then took the cross also Alfonso-Jordan, count of Toulouse and Saint-Gilles; Thierry, count of Flanders; Guy, count of Nevers; Renaut, his brother, the count of Tonnerre; Count Robert of Le Perche, brother to King Henry of England; Yves, count of Soissons; William, count of Ponthieu; and William, count of Garence; Archimbald of Bourbon; Hugh of Lusignan; Enguerrand of Coucy; Geoffrey of Manton; William of Courtney; Renaut of Montargis; Ytier of Coucy; Gauché of Mautray; Evrard of Breteuil; Drago of Moncy; Mennecier of Bugliers; Anselm of Tens; Garin, his brother, William le Bouteillier; William Aguillon of Trie; and a number of other knights, not counting the men of the common people. And a most great number of prelates also took the cross; there took the cross also Simon, bishop of Noyon; Godfrey, bishop of Langres; Arnulf, bishop of Lisieux; Hubert, bishop of Saint-Pol; and a number of other prelates. In honour of this holy crusade and in memory of this holy gathering, the bishop of Vézelay founded, on the place where the sermon had been preached, a church of the Holy Cross, on the slope of the hill situated close to Vézelay, in the meadows where the Holy Crosses had been given and accepted during that gathering, and in this church of the Holy Cross Our Lord thereafter accomplished many great miracles.

And at the same time there took the cross besides, in Germany, the emperor Conrad[251]; Otto, his brother, bishop of Freisingen; and Frederick, their nephew, duke of Swabia, who was emperor thereafter; Stephen, bishop of Metz; Henry, bishop of Toul, brother, of Thierry, count of Flanders; Theodwin, German by birth, bishop of Porto and papal legate within the army of the emperor; Duke Welf; the marquis of Verona; the duke of Bavaria, that is to say Berton of Les Andes, who was thereafter duke; William, marquis of Montferrat, brother-in-law to the emperor; Count Blandin, who married the sister of this Marquis William; and with them a most great number of other princes, barons, knights and men of divers social rank.

These two great princes and their prelates and barons, when they had determined to make this journey, made known their decision to each other and made alliance,

promising to show sincere and brotherly love to each other. And yet they did not set out in that same year, for King Louis took the cross at Easter of the year 1145,[252] but he did notdepart before the feast of Pentecost in the year 1146.[253] And at about the same time, there took the road also the emperor Conrad,[254] but they did not travel at the same time lest they should not be able to find enough food for the great numbers of pilgrim crusaders whom they were taking with them; they also feared lest disputes should arise amongst their men, who did not speak the same language. Nevertheless, they decided that the two armies should follow each other and would take the same road and that they would meet at Constantinople. And this they did.

They set out across Bavaria and crossed the great river Danube and, when they had left it on their left, went down to Austria and thence moved into Hungary, where the king[255] welcomed them with great honour and sent them fine presents. Thence they passed through Pannonia, where was born Saint Martin, and went on to Bulgaria and, leaving the Rodopi mountains on their left, crossed over the two regions of Thrace. They then passed through the rich towns of Sinope and Adrianople and so continued their journey, enduring many harsh ordeals, until they came to the most rich and mighty city of Constantinople. There they were received with great magnificence and celebrations by the emperor Manuel and they rested there for a number of days because they were most weary. And during this time, these three great princes spoke at length and secretly together of what they might do for this crusade.

✝

Chapter XLIV.
How Emperor Conrad and King Louis the Younger parted company after crossing the strait of Saint George. Of the perfidy of the Greeks, who betrayed the emperor Conrad, and of his rout. Of the help that King Louis provided him and how, in spite of everything, he returned to Constantinople.

Emperor Conrad and King Louis, wishing to fulfil their vow, took their leave of the emperor and, passing over the strait of Saint George at Constantinople, came to the land of Bithynia, where they parted company, for the emperor Conrad wished to lead his army separately, which he did. Leaving the lands of Galacia and Paphlagonia to his left and to his right Lydia and Asia Minor, he led his men close by the city of Nicomedia,[256] passing through the mighty city of Nicaea. Thence they came to the land

ARRIVAL OF CONRAD III AND HIS TROOPS AT CONSTANTINOPLE.
SKIRMISHES BETWEEN THE GERMANS AND THE TURKS

"Indeed, without one single exception, all those who met their death
by making this journey, as well as those who lived to accomplish it, would go
in perfect glory to Heaven and would suffer none of the torments
of hell or purgatory, provided that they kept themselves in a state of grace,
as it behoves each good Christian so to do."

(FOL. 138VA)

Conrad III, the king of Germany, was also unable to resist the appeal of Bernard of Clairvaux and the Pope and, at Christmas 1146, he joined the crusade, together with many members of the German nobility. In May 1147, Conrad set off with his troops from Regensburg for Constantinople. In the lower register of this page, Colombe depicts troops that have just crossed over a stretch of water, no doubt the Bosphorus near Constantinople. The principal picture shows how the crusaders allowed themselves to be guided by the Greeks, who intended to lead them astray in difficult and dangerous paths, illustrated here by a rugged, rocky landscape. On the tent in the foreground, the emblem of the king can be seen, and an inscription that reads "O mater dei memento mei" – "O Mother of God, remember me".

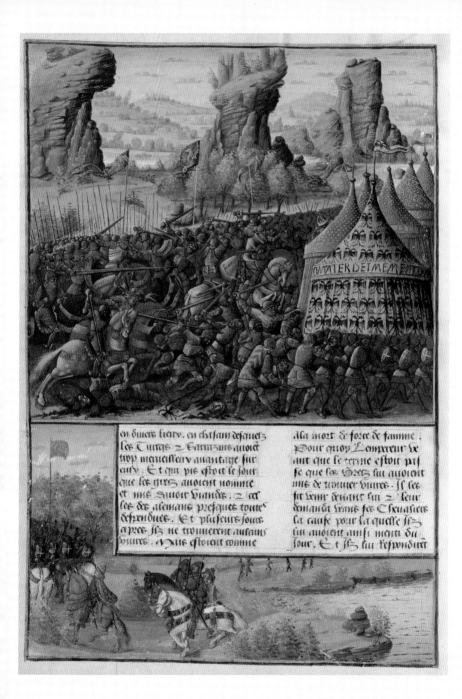

en diuers lieux. en chaſant deſiouez
les Turqs ⁊ Sarazins auoiẽt
trop merueilleuſe auantaige ſur
eulx. Et qui pis eſtoit ſe ſout
que les griex auoient nommé
et mis ſauoir viandes. ⁊ cel
les des alemans preſques toutes
deſpendues. Et pluſeurs ſouẽ
apres ſis ne trouuerent autant
viures. Nuis eſtoient comme

a ſa mort de force de famine.
Pour quoy L'empereur ſe
aut que ſe terme eſtoit priſ
ſe que les Griex ſui auoient
mis de trouuer viures. Il les
ſit venir deuant ſui ⁊ ſeur
demanda frans ſes Croiſiers
la cauſe pour la quelle ſis
ſui auoient ainſi menti du
jour. Et ⁊ ſis ſui reſpondirẽt

of Licaonia, where they turned off the great high road and followed those roads that the Greeks,[257] who had been sent by the emperor Manuel to the emperor Conrad to guide them by the best way, told them were the best. But they were lying, as it became clear thereafter, and betrayed the Christians. Indeed, they multiplied their perfidy, for they led our men through narrow and perilous passes, and no sooner had they brought them into the lands of the Turks and other Saracens than they came to find the captains and chiefs of the Christians in the army, saying to them that they need take and carry with them only food enough to last to a date that they told them, pretending falsely that on that day they would find food in great abundance for both the men and the beasts.

And none knew if they acted thus on the orders of their emperor Manuel or to obtain money from the infidels. However this may be, they led the army of Christians through narrow and difficult ways and lured them into divers places where the Turks and Saracens could take full advantage of them. Soon, there came the day when the Greeks had said and promised that there would be supplies of food, when the food of the Germans was almost completely exhausted, but yet a number of days thereafter they had still found no fresh supplies and were on the point of dying of famine. The emperor, seeing that the date on which the Greeks had told them they should find food had passed, called them before him and demanded of them why they had thus lied to him about this date. And they replied to him, hypocritically, that they had thought that the army would have gone forward with greater speed and made longer stages, and they swore to him that three days thereafter they would reach without fail the city of Konya, which was so rich that they would lack nothing. The emperor, who was a credulous prince, believed what they said and told them that he would wait three days more, that he might see if they told the truth. But when night fell and the men of his army slumbered, the perfidious Greeks fled secretly, profiting from the first deep sleep of the Christians, and on the following morning, when those who were to lead the army wished the troops to move forward, they could not find the Greeks who had heretofore guided them.

The emperor Conrad was dumbstruck and called his barons to council. One part of them thought that, since they could find none to tell them where they were nor in which direction they should go, they should turn back on their tracks until such time as they found food, for they now had none left whatsoever; but the others recommended that they should go forward, with greater hope of finding food ahead than if they went back the way they had come. These two opinions were hotly debated and the emperor

knew not which solution to choose, and they remained, therefore, a long while without taking any decision. And during this time, some men from the army, who had gone out to see if they could find food in the land round about, returned and told them that there were gathered together nearby a great number of Turks, all armed.

This was indeed so. In truth, the perfidious Greeks who had guided them had led them away from Konya and had caused them to go into the vast desert of Cappadocia, where there was neither hedge, nor bush, nor track: whereas, if they had taken them through Licaonia, rather than leaving it on their right, they would have found a speedier road with cultivated lands and food of all kinds in abundance. It was the emperor Manuel, or so they said at the time, who had ordered this betrayal, for neither he nor the other Greeks had any love for the Germans, for the emperor Conrad had caused himself to be proclaimed emperor of the Romans in like manner as had the emperor Manuel. And as for the Greeks, they maintained that the emperor of Constantinople should be the lord of the whole world.

However this may be, this secret hatred did no service to the Christians, for the sultan of Konya had the greatest army that the Germans had encountered, which he had gathered together in case the moment or the circumstances might come about when he could do harm to the great armies of Christians who were crossing his lands. In truth, well-nigh all the kings and great lords of the pagans, Turks and Saracens were overwhelmed and terrified by these hordes who were arriving in their lands, for they had been told with certainty, from divers sources, that if the Christians passed through their lands in safety and without hindrance, they would have the means to annihilate and to conquer all the princes and barons whom they met, and would thus, in a short while, possess the whole land of the Orient.

So great was the renown of these armies amongst the pagans that it was said that there were such numbers of men and horses that, when they were encamped along the banks of a mighty, flowing river, it would quickly run dry, for the quantity of water of which they had need was so great that it would not suffice to satisfy the need for water of both men and horses. And it was also said that even a most great kingdom could feed them only with difficulty for a very few days. Although this was none of it true, nevertheless, within these two armies were surpassing great numbers of men and horses. In the army of the emperor Conrad, there were a good seventy thousand men on horseback clad in coats of mail, and there were the foot soldiers as well, and the rest of the knights who were more lightly armed. As for the army of King Louis the Younger, this was as great in numbers and consisted of most valorous men, not counting the foot

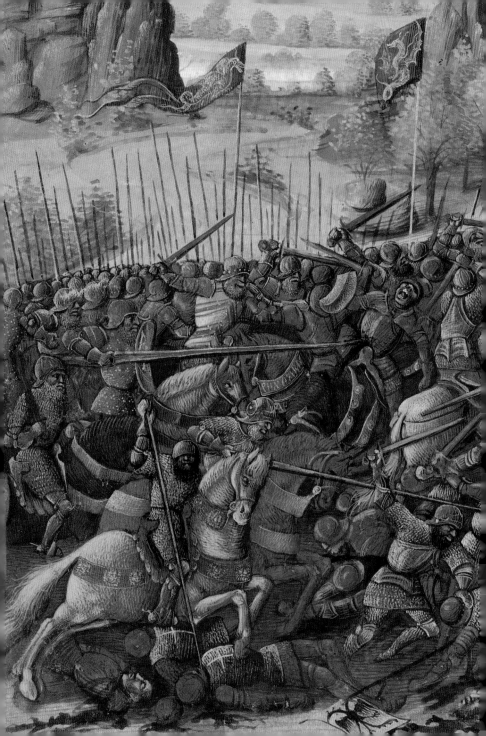

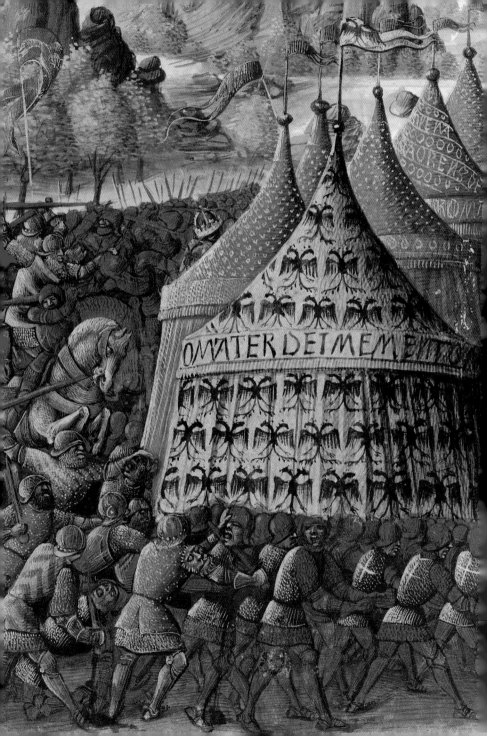

soldiers, who were without number. Wherever they passed the land was covered with men and it truly appeared that they could conquer all the lands of the infidel.

And this is why, as it has already been told, the emperor Conrad and his men, when they found themselves in the deserts of Cappadocia, were so stunned and lost that they knew not which path to take, or whether they should go forward or retrace their steps. And besides they were so weary and worn out by reason of the terrible paths, both rough and steep, which they had been obliged to follow, and so weakened through famine and thirst that there was scarce a man or horse that could go any further. The Turks, who were forewarned of this situation, came up and fell upon them suddenly with large bodies of troops; the Christians were in their tents and unsuspecting of any such attack, and in a short time the Turks had done them most great harm. In truth, the sultan's men, who had received help from the Turks and from the other pagans and Saracens from the two Armenias and from Cappadocia, Isauria, Cilicia and Medea, were not tired and their horses were well rested, for they had been well fed and had received every care of which they had need. Nevertheless, the Germans withstood their divers assaults, defending themselves to the utmost of their power, but they could not succeed in harming the enemy. When they tried to push them back thanks to the skill of our men's flights of arrows, let loose as if against hunted animals, the Turks, although repulsed, fled to protected places far from the Germans who, by reason of the weakness of their horses, could not pursue them at length and harm them. The sultan of Konya was not in this army because there was in his place as chief one of his barons, most mighty and powerful, called Mas'ud. To be brief, on that day the emperor lost so many men that, of the great multitude of princes, great barons, knights and other people whom he had led there, there escaped not the tenth part, for all the others died of hunger or were killed or taken prisoner and led away by the Turks at will.

Nevertheless, the emperor and certain of his princes and barons made their escape and returned to Nicaea as best they could, leaving their tents and accoutrements to the Turks, who pillaged them at will. They sent their spies after the Christians so that they might learn the state of the army of King Louis the Younger, in the hope that they would vanquish him since they had vanquished the emperor of Germany, who had, so they said, a more powerful army. Meanwhile, the Greeks, who had betrayed the emperor Conrad, afforded them great aid, for thinking to betray King Louis the Younger, they came to find him and told him that they had led the emperor and his men so that he had taken and pillaged by force the most rich city of Konya and had vanquished all the Turks who had wished to come out against them.

They invented this lie for they feared lest the king, if he had known of the great danger that the emperor Conrad ran, would have sought to avenge himself against them and would have gone to the aid of the emperor Conrad. The latter, hearing men say that the army of King Louis was very close, sent to him his nephew Frederick, the duke of Swabia, who was emperor thereafter, and had him tell of his misfortune to the king, that they might discuss together what they should do. Yet even before the coming of the duke, these tidings were already spreading amongst the king's army while they were in Bithynia, and yet they placed no great faith in the news since they did not know who was spreading it.

But when the king and the barons of France knew the truth, they bewailed themselves and showed their grief; and to give heart to the emperor, King Louis straightway took with him certain of his most powerful princes together with other barons and men of war and went as swiftly as possible to him with the duke of Swabia, for the distance was not great. And after they had embraced and greeted each other most fondly, the king comforted him and proposed that he should give him as much money and as many men as he desired, promising to serve him and to bear him company most loyally. This having been done, they summoned their princes and barons and determined that they would set off together to accomplish the service of Our Lord and to fulfil their vows. And yet there were many of the emperor's subjects who said that they had lost that money that they had contributed for their expenses, and for this reason, they could go no further, and they did, indeed, return thence to Constantinople, giving no consideration to their vows nor to the fact that they were abandoning their lord the emperor. And to tell the truth, they were terrified by the dangers of the war in which they had taken part and the long sufferings that were yet to come.

Nevertheless, these two princes took the road again to accomplish their pilgrimage, but they did not follow the road that the emperor had taken; leaving it to their left, they bent their steps towards Suse la Mineure and, keeping to the coast, they arrived to the left of the land of Philadelphia. Thence they departed towards the city of Smyrna and went to Ephesus, the city where was buried monsignor Saint John the Evangelist. And when they found themselves in this city, the emperor Conrad pondered: he was deemed the greatest prince in the world amongst the laity, but considering that he had with him no army worthy of his great renown and that he was, as well, under the authority of the king of France and the French and could do nothing without them, he concluded that it was shameful to continue thus and would, therefore, go back. There were other reasons that drove him to this conclusion, but in truth, no one knew

BATTLE BETWEEN THE ARMY OF LOUIS VII AND THE TURKS.
THE VANGUARD COMMANDED BY GEOFFREY OF RANÇON
SEEKING A PLACE TO CAMP

*"It is written in certain chronicles that the king remained quite alone
all night on the hill and that his enemies fought against him for a long while
not knowing who he was, and that he defended himself with great courage,
even though he was no longer on horseback. It is also said that when
it was well-nigh complete black night, he climbed up on the hill, defending
himself bravely with his sword."*

(FOL. 144VB)

On this page, Jean Colombe once again paints a mountainous landscape with rugged rocks in order to give an impression of the difficulty of the crusaders' journey across Turkey. The troops have reached the valley of the Lykos and decide to make camp at the top of a mountain. Geoffrey of Rançon, commanding the vanguard, was supposed to await the rest of the army there, but he decided instead to lead his men further on and seek a different place to camp. It is this episode that the artist depicts in the lower register of the page. The principal picture shows how the Turks, taking advantage of the fact that the Christian army has split up, have taken the mountain and are attacking the rearguard, who do not find the hoped-for reinforcements when they arrive. Two standards are flying in the wind – that of the king of France and that of King Conrad. The Christian armies subsequently suffer a heavy defeat. As usual, Colombe chooses to illustrate the most dramatic moments of the crusade and to follow Sébastien Mamerot's text faithfully.

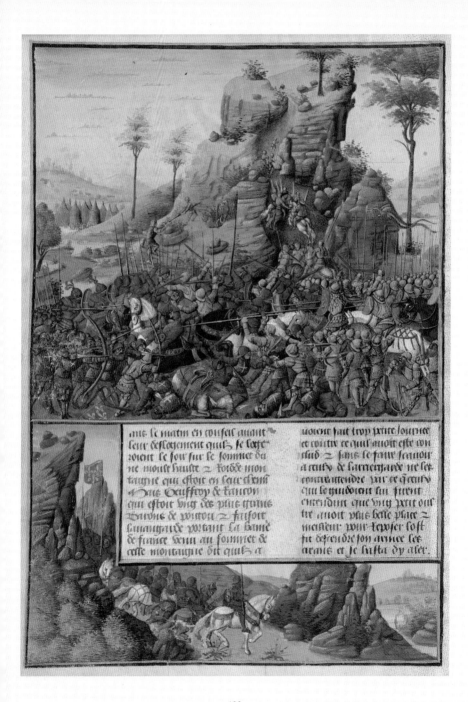

mes le matin en conseil auant
leur deslogement quilz se loge-
roient le soir sur le sommet du
ne monst haulte z forte mon-
taigne qui estoit en leur chemin
z Duc Geoffroy de Laucon
qui estoit vng des plus grans
barons de poitou z faisoit
lauantgarde portant la baniere
de france venu au sommet de
ceste montaigne dit quilz a-

uoient fait trop petite iournee
et coutiz ce quil auoit este con-
clud z sans le faire scauoir
a ceulx de larrieregarde ne les
commandantendre sur ce quentz
qui se tiendroient sur furent
entresdit que vng petit ouI-
tre auoit plus belle place z
meilleur pour reposer sost
fit descendre son armee les
arans et se hasta dy aler.

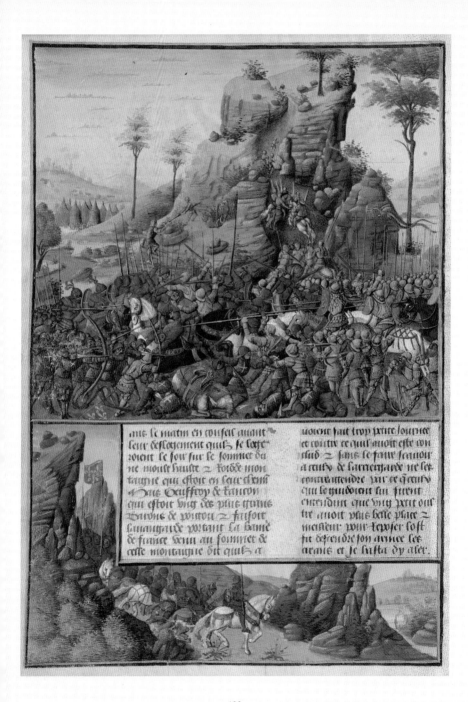

what they were. However this may be, he gave the command that his men should return overland to Constantinople while he would return by sea with a very small troop. He came back to the emperor Manuel, who welcomed him and feasted him most splendidly throughout his stay, until the next season. There was a great affinity between these two, because they had married two sisters, daughters of the old Beranger, count of Luxemburg,[258] one of the greatest princes of Germany.

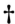

Chapter XLV.

How the French overcame an army of Turks, but were vanquished by another troop because he who directed the vanguard did not abide by the decision taken in council. How King Louis, escaping from the defeat, succeeded in gathering his army together again and in leading it to safety after he had endured great losses.

King Louis the Younger, seeing that the emperor had thus parted company from him, continued to lead his army onwards. And when, after a number of days, he arrived with his men at the fords of the river Meander, in that place where swans are found in great number, they made camp there in a beautiful meadow, and on the other side of the ford the French found that which they had long sought. Indeed, great numbers of Saracens, Turks and pagans were gathered together close by, furnished with all kinds of arrows, which enabled them to wound many of our men and their horses, whom they prevented from going to be watered. Nevertheless, the Christians searched and questioned until the inhabitants of the region showed them a ford, through which they straightway passed in great numbers, and they threw themselves with such ardour on their enemies that they killed and took prisoner a most great number of them. The others took flight, abandoning their tents and pavilions that were furnished with most rich things, which our men took as booty. They turned back, well contented, and went back through the ford to return to their own tents, praising God and thanking him for having given them this first victory. And on the next day, when it was light, they left the meadowland and came to the town of Lice and there they seized all the food of which they had need, for they were accustomed to act in this way.

Then they took the road again, determining in council on the morning before their departure that they would camp that evening on the top of a very high and steep

mountain that was on their road. But when Geoffrey of Rançon, one of the greatest barons of Poitou, who was in the vanguard bearing the banner of France, reached the summit of this mountain, he said that they had made too short a stage. And he went against what had been decided, and neither warning those in the rearguard nor waiting for them, he trusted those who were guiding him when they explained that but a short way further on was a beautiful place that was more suitable for allowing the army to rest, and he led his army swiftly down to this place.

Those in the rearguard, on the other hand, thinking that the whole army would make camp as had been decided, were coming on without haste, and thus in a very short time they left a great distance between them.

When they saw this, the Turks and other Saracens, who were still following them in great numbers in case they could take them by surprise when they were in disorder, spurred on their horses and sallied swiftly forth to take the summit of this mountain, closing off the paths and passages by which our men could have joined up with each other again. Having done this, they began to attack the French and to rain down on them flights of arrows shot from their bows, and then they came to attack them in force in the midst of their ranks, armed with great hammers and swords, and they caused them great injury, because their army was separated and divided. So many were the beasts of burden and obstacles obstructing the narrow ways that the knights and other Frenchmen who courageously wished to defend themselves and to attack the Turks could neither get through easily nor rejoin them, so that during this attack many of our men were killed.

But in the end, the most courageous and bold began in their turn to kill the Turks and, exhorting each other to fight bravely, gave heart to their companions by saying that the Turks were poor and cowardly soldiers: of this they had had proof but a short time before when they had beaten them at the fords of the Meander, defending themselves with such strength and courage that they had rallied around them a good number of soldiers and had thus been able to cut their way through the ranks of their enemies. The Turks, in like manner, were exhorting each other in their own language, recalling how they had but a short time before vanquished the emperor of Germany, who was more powerful than the king of France. And so it was that this hard and bitter battle lasted for a long time, and many of our men were killed and many of the enemy were wounded. But the Turks were in such numbers that when their wounded and those who were exhausted withdrew to the rear, fresh soldiers straightway filled their places, whereas our men could not change their troops in this way. This is why they were finally conquered, and there were many dead and yet more led away captive

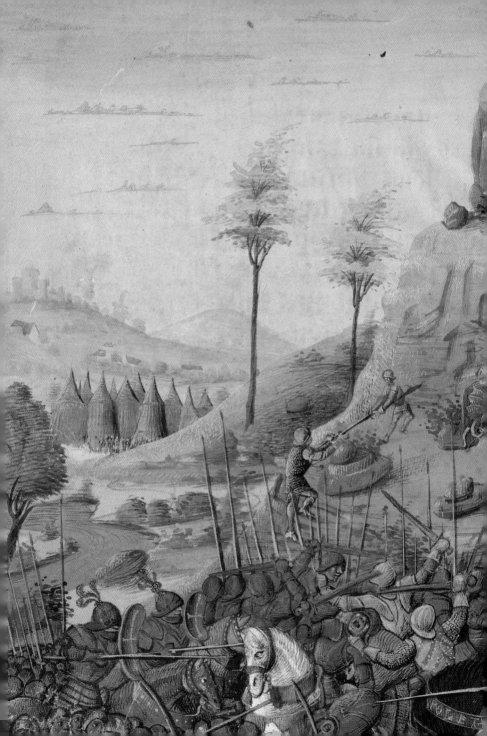

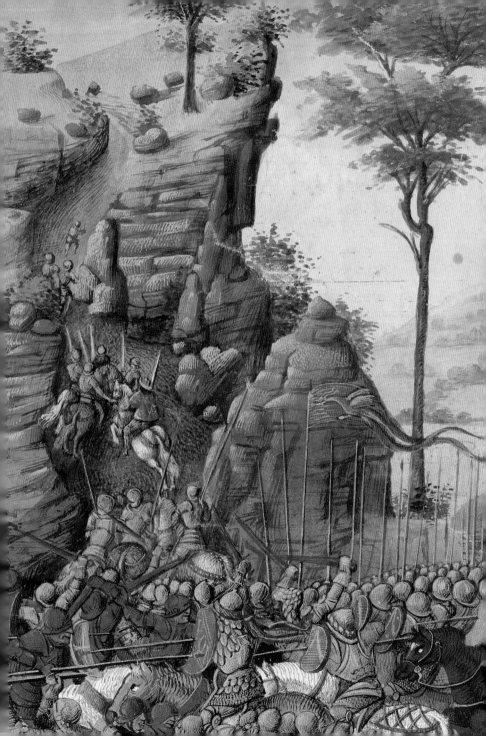

to sundry places by the Turks. And amongst the dead and those whose fate was unknown there were four great and powerful princes: the count of Garence, Gauché of Montray, Evrard of Breteuil and Ytier of Maignac.

In the meantime, the vanguard, not knowing of this rout, had set up their pavilions and the men were taking their rest. But, when they saw that the rearguard took so long to rejoin them, they were seized with suspicion and feared lest their companions had encountered some difficulty. King Louis himself had taken part in this battle, but certain knights of France, when they foresaw the terrible defeat that awaited them, caught hold of his horse by the bridle and, drawing him away from the mêlée, succeeded in leading him up to the top of a high hill that rose behind them, and there they remained until nightfall. When it was deepest night, they said to each other that they should not remain there until day came and so they went away, following a path at random.

But indeed, the king was still in great danger, for he was surrounded on all sides by his enemies and had lost the greater part of his rearguard; besides, not one of his companions knew which way to go. When Our Lord, in whom the king placed great hope, saw this, he guided their steps so well that they had scarce come down from the hill when they saw the commanders' staffs planted in the place where the vanguard was, and when they recognised them, they went in that direction. It is written in certain chronicles that the king remained quite alone all night on the hill and that his enemies fought against him for a long while not knowing who he was, and that he defended himself with great courage, even though he was no longer on horseback. It is also said that when it was well-nigh complete black night, he climbed up on the hill, defending himself bravely with his sword, and then reached the tents and pavilions of his vanguard. His men, when they saw their lord coming thus and learned of the cruel defeat that had befallen them, began to bewail themselves, for there was not one who had not lost one of his friends, and in these circumstances, it was most likely that they too would go to their death.

Indeed, if the Turks had known of the state and of the extreme despondency of the Christians, they could most easily have taken them, and made them prisoners or led them to defeat. They could not prevent themselves from crying out, this one for his father, that one for his brother, cousin or uncle, each one seeking the kinsman whom he had lost. They found some of them who had been able to escape by hiding in the caves or the bushes, but few returned alive compared to the numbers of those who were dead or captive. This grievous misadventure befell the French in the month of January of the year 1146[259] and from that time onwards, the state of the valorous French

ceased not to worsen. Indeed, from that very day onwards, there began to be a cruel shortage of food, for no victuals might reach the army. Besides, there were none amongst them who had already been in that region and could know the roads and places by which to go, which increased their despair and caused them to run great risks, as they went now to the left, now to the right, like people who were lost. In the end, Our Lord came to their aid, for after they had crossed over high mountains and deep valleys, they came without hindrance to the town of Attalia.[260] Never, since that great defeat, did this town know such an incredible attack or such destruction caused by the Turks. But I believe that Our Lord, by his extraordinary grace, brought this support to the Christians.

This town of Attilia, situated on the coast, belonged to the Greeks and was governed by the emperor of Constantinople. And despite being surrounded by fields that were most excellent for cultivation, these lands availed the inhabitants nothing, for the town was encircled by the Turks and was so close to them that they could not cultivate them. Nevertheless, one finds there all that is needful: beautiful springs, fine gardens and trees laden with all kinds of fruit. It was a marvellous place, where it was most agreeable to dwell. As for wheat and wines, merchants brought them in by sea in sufficient quantity, so that there was not the slightest scarcity. But despite this abundance of food, the town could not resist the Turks and would be destroyed if it did not pay them each year a most large tribute. The Greeks called this town Attalia and the neighbouring mountain stretches as far as the island of Cyprus. The French gave to the sea on which it stands the name of the gulf of Attalia and the town retains that name to this day.

When King Louis the Younger came there with those men who still remained to him, he found little food for so many people, but despite everything, he stayed there for some while, and many men died in his army then. After he had lingered a while in that town, he left the foot soldiers there, that they might rest longer and, with the princes, barons, knights and nobles of his army, he set sail. Leaving on his left the regions of Isauria and on his right Cyprus, he directed his ships towards Antioch. The favourable wind caused him to arrive in a few days at the port of Saint Symeon, where the river Orontes, which flows by Antioch, runs into the sea, close to an ancient town that is called Seleucia, which was founded by one of the princes of Alexander the Great called Seleucus and which is ten miles from Antioch.

LOUIS VII AND RAYMOND OF POITIERS.
ARRIVAL OF LOUIS VII AT ANTIOCH

"Accompanied by the greatest princes of his principality and by a fine retinue, he [Raymond, prince of Antioch] went before the king and welcomed him, and all the other princes, barons and French nobles in like manner, showing clearly his most great joy amidst a great number of celebrations, and then he had them make their entry into Antioch."

(FOL. 145VB–146A)

On 19 March 1148, Louis VII arrived at Antioch with the crusader army, where they were received by a procession of clerics and citizens before the city gates, as is shown in the lower register of this illumination. In the upper register, Jean Colombe depicts the French king being welcomed deferentially by his uncle, Raymond of Poitiers, prince of Antioch from 1136 to 1149. The latter prostrates himself before the king, who can be identified by his robes decorated with *fleurs-de-lis* and his crown. The scene takes place before one of the city gates. The relationship between the king and Raymond of Antioch subsequently deteriorated because the king refused to help Raymond in his plans for territorial conquest.

tenut fore z festoyement et
auffi tous les autres princes
barons et nobles francois. et
les emmena dedens Antioche
la ou le Roy fut tenu par
le clergie et noblesse et solen
nelle possession z auffi par
tout le peuple. Et dieu scet
comment il festoyoit le Roy
par autant souue z lui fist
de riches et beaux presens

et a cheteau des princes barons
et cheualiers. En France mef
mes auoit il enuoye de Robe
presence au Roy si tost quil
sceut quil sestoit auise. z vue
celle feste tourna tost a grief
ue doleur. Car le prince fit
remonstrer au Roy son par
auteme sez princez. et apres
par soy mesmes demonstra
que sil lui plaisoit aydier et

431

Chapter XLVI.

How King Louis the Younger was received in triumph at Antioch. Of the munificence of prince Raymond and of the profound hatred that he conceived for the king, who refused his request. How the emperor Conrad entered Jerusalem, followed by King Louis the Younger. Of the great assembly that took place in Acre and how our men led their armies to the city of Damascus.

Raymond, prince of Antioch, was most happy when he knew that King Louis had arrived in his lands, for he had ardently longed for his coming. He hoped (and, indeed, he was sure that this would come about) that, thanks to his help and that of his men, he would be able to conquer the cities of Aleppo and Shaizar and the other fortresses that the Turks[261] held on his lands and in the neighbourhood of Antioch. And indeed, Queen Eleanor, wife of King Louis and who was with the army, was his niece, daughter to his older brother William, count of Poitiers, as has already been shown above in those passages where it was told how this prince came for the first time to Antioch.

Accompanied by the greatest princes of his principality and by a fine retinue, he went before the king and welcomed him, and all the other princes, barons and French nobles in like manner, showing clearly his most great joy amidst a great number of celebrations, and then he had them make their entry into Antioch. There the king was received by a most fine and solemn procession composed of the members of the clergy and all the people. God knows how he feasted the king throughout a number of days and gave rich and magnificent presents to him and to each of the princes, barons and knights as well! He had besides sent splendid gifts to the king in France as soon as he had heard that he had taken the cross. But this feasting was swiftly transformed into deep grief.

In truth, the prince of Antioch had caused certain of his princes to declare to King Louis, and he then himself declared likewise, that if he agreed to help him and to lead his army before the cities of Aleppo and Shaizar and also before certain fortresses in the neighbourhood of Antioch, he had no doubt but that they would seize them in a short time, and this would be a great source of profit for all the land of Syria and for all the Christians, and a great honour for the king and for the French. And, in truth, the Turks who held these towns and strongholds were so terrified by the coming and

the renown of the French that they would not have awaited help, but would have surrendered without a true fight.

However, they could not persuade the king to agree, and he replied to the prince, saying, amongst other reasons, that he had left France because he had taken a vow to go on pilgrimage to Jerusalem, and that hitherto he had perforce endured so many dangers that he would undertake no other thing before he had fulfilled his vow. Once he had fulfilled this vow, then he would willingly listen to the proposals of the prince and barons of the land of Syria and, in accordance with their opinion, he would then act in the best way possible for the good and for the service of Our Lord Jesus Christ. And when prince Raymond understood that he would obtain none of those things that he had asked of the king, his heart was filled with such rage and hatred that he did his utmost thenceforward to do the king all the harm that he could to anger him. And he influenced most particularly the queen, his niece, so that she desired to leave the king and to separate from him. She did not behave with propriety and her conduct earned her harsh censure in that land, for, as people said, she did not respect her marriage vow of fidelity.[262] Besides, it was reported to the king that the prince hated him and wished him no good, and for that reason, after he had consulted his noble councillors and with their agreement, he took leave of Antioch secretly during the night. And as all the people were not told of this, he was not escorted on his departure as he had been on his arrival and there were those who said that it was not honourable for the king to depart in such a manner. However, whatever one may say, he withdrew his troops from Antioch thereafter and led them towards Tripoli so that he could go to Jerusalem.

The emperor Conrad, after he had remained for the whole winter in Constantinople, departed from the city with great honours, and with the help of the emperor Manuel set sail for Acre, and thence he went overland to Jerusalem, where he arrived before King Louis. God knows what honour and what joy were shown to him by the king,[263] the patriarch and the other princes, barons, prelates and noble lords of Jerusalem! They came to meet him in a solemn procession. But it would take too long to tell of the rejoicing and the triumphs that took place then, and I will not attempt to do so.

And at that same time, Count Alfonso-Jordan of Toulouse,[264] son of the most illustrious and valiant prince, the excellent Count Raymond of Toulouse, crossed the sea and arrived in the port of Acre. His father was of the highest renown, for he had accomplished many extraordinary and glorious deeds and had made many conquests during that First Great Crusade, when the French seized Antioch and Jerusalem and made Godfrey of Bouillon its king, as I have already briefly told.

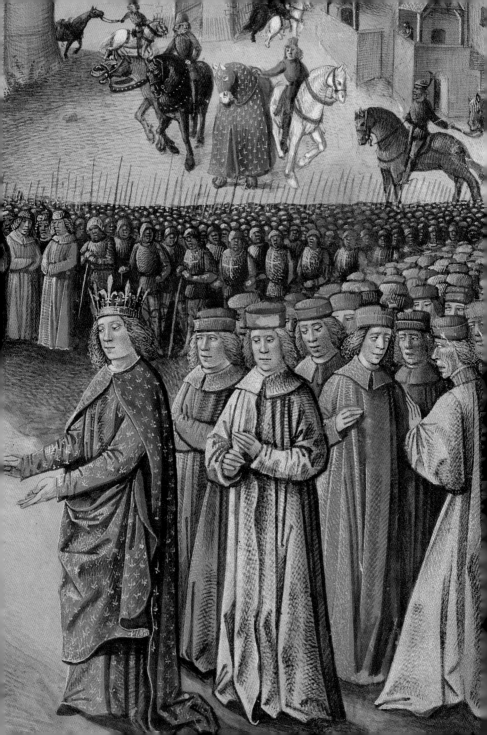

Alas! In the land of Syria, men had awaited and desired for so long this dearly beloved Count Alfonso-Jordan! All their hopes were placed in his noble valour and in the glorious feats of his father, in the belief that he would help, support and succour the Syrians. But when he was on the road to go from Acre to Jerusalem and came to Caesarea, which was situated on the coast, some devilish person poisoned his food, so that he straightway died, and none could ever know who poisoned him.[265] As for the grief that his death caused in Syria, I must forbear to speak of it, for it would take too long to tell.

The king of Jerusalem, when he heard it said that King Louis had left Antioch and was approaching Tripoli, took counsel of his barons and sent Fulcher, patriarch of Jerusalem, to meet him, that the king might desire to come as directly and as swiftly as possible to the Holy City, where the emperor of Germany and King Baldwin III were awaiting him. To speak the truth, King Baldwin and his barons feared lest the prince of Antioch should find means to be reconciled with the king and to cause him to turn back to his principality, or lest the count of Tripoli, who was his cousin, might prevail on him to stay with him and help him to capture from his enemies some city, town or fortress.

In fact, the land that the Latin Christians possessed at that time in Syria and in the surrounding areas was divided into four great lordships. The first was the kingdom of Jerusalem, which, turning towards the south, began at the river that flows between the cities of Jebeil and Beirut, situated in Phoenicia, on the coast, and extended as far as the deserts that lie the other side of Daron towards Egypt. The second great lordship, turning towards the north, was the county of Tripoli, which began at that river that I have already named and stretched towards the east as far as another river that flows between the two towns of Maraclea[266] and Banyas, which are situated on the coast likewise. The third great lordship was the principality of Antioch and this began at that river and extended towards the east as far as the city of Tarsus in Cilicia. The fourth great lordship was the county of Edessa, which began hard by a forest called Marris and stretched towards the east, beyond the great river Euphrates as far as the territories of the pagans, Turks and Saracens. And in truth, the king and the three other princes of these great lordships had each, for a long time since, been sending letters and all manner of gifts to these two great princes and explaining what was in their mind so that, with their help, they could capture certain lands, cities, towns and castles from the enemies of the Christian faith, who were their close neighbours.

But King Baldwin obtained that which he desired. Indeed, King Louis, in the presence of the patriarch who had addressed this request to him, made the greatest possible haste to arrive in Jerusalem, where he was welcomed in most great triumph, as

the emperor had been likewise. King Baldwin and the other princes and barons, after they had taken him to visit the Holy Places all around, held a number of gatherings with King Louis, and there it was determined that the princes and prelates who were in the Holy Land would come together for a general assembly in the town of Acre to determine in which direction they should lead their armies. They chose a date[267] on which they would meet in Acre, and all those whose names mentioned below took part in this great assembly. First of all there were the Germans and the Italians: Conrad, emperor of Germany; Otto, his brother, bishop of Freisingen; Theodwin, bishop of Porto and papal legate in the army of the emperor; Stephen, bishop of Metz; Henry, bishop of Toul; Henry, duke of Austria; brother to the emperor; Duke Welf; and Frederick, duke of Swabia, nephew to the emperor; the marquis of Verona; Berton of Les Andes, who was duke of Bavaria thereafter; William of Montferrat; and Count Blandin.

And from France there was King Louis the Younger; Guido of Florence, cardinal of the order of Saint Grisogoine, papal legate in the army of France; and that most illustrious prince who has already and most rightly been named a number of times, Henry I, who bore the name and the arms of the county of Champagne, only son to the old Count Tibald of Chartres and Blois, and with him his wife, lady Mary, daughter of King Louis and of Queen Eleanor, who married the king of England thereafter. With them, there was also Count Thierry of Flanders, who had married the sister of King Baldwin of Jerusalem; and Yves of Nesle, of the bishopric of Noyon, that wise and loyal knight.

From Outremer there were King Baldwin III and Queen Melisende, his mother; Fulcher patriarch of Jerusalem; Baldwin, archbishop of Caesarea; Robert, archbishop of Nazareth; René, bishop of Acre; the master of the Temple; the master of the Hospital of Saint John of Jerusalem; and a number of other bishops, prelates, counts, barons, knights, squires and men of divers estates who came from the lands and lordships belonging to those princes already named.

And they all spoke and discussed together and determined that they should go with their armies to lay siege to the rich city of Damascus and that they should meet again in readiness for this venture at Tabaria, the town that the Evangelist calls Caesarea Philippi,[268] on the twenty-fifth of May of the year 1147.[269] And on the morrow of that day, they carried the True Cross, placing it at their head as was the custom when the king and the people of Jerusalem went out to war. They came and encamped their armies, which were immense, before a town called Daire, situated between mount Lebanon and the city of Damascus on the side where the gardens lay. They decided in the first place to take these gardens by force, and indeed, the wise men of Jerusalem believed that once

"Damascus is the greatest city in the land of Syria Minor;
another name for it is the Phoenicia of Lebanon and the prophet speaks of this city
as the capital of Syria. It was one of the servants of Abraham, called Damas,
who founded this city and that is why it was given this name."

(FOL. 148VB–149A)

The decision to lead an assault against Damascus was taken during a council meeting held at Acre on 24 June 1148. The crusader army is seen approaching the city. Jean Colombe shows troops of foot soldiers and then of horsemen as they cross a bridge leading to the outlying areas. The standards bearing the colours of the kingdom of Jerusalem and Germany indicate that these are the armies of King Baldwin and King Conrad. Sébastien Mamerot describes at length how the river that descends from the mountains waters the lands bordering it and makes it possible for orchards to flourish; a little further on, he also writes about the imposing fortifications protecting the city. The picture in the lower register shows how a group of crusaders who have left the camp some distance behind and have come to get water from the river are attacked in strength by the Saracen archers and soldiers hurling javelins. The Christians counter-attack but suffer some losses, represented by the dead bodies stretched out on the riverbank.

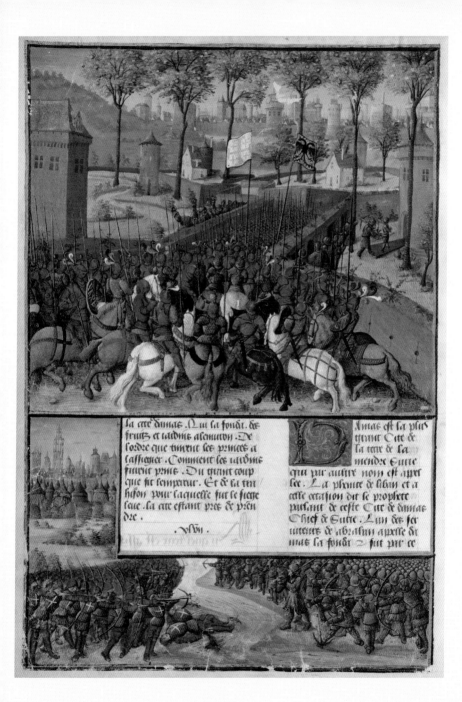

la cité dunias . Qui la foundi . de
fruitz et iardins alenuiron . De
lordre que turent les princes a
lassieger . Comment les iardins
furent prins . Du grant coup
que fut lempereur . Et de la rut
hison pour laquelle fut le siege
leue . la cite estant pres de pren
dre .

 Vsbn .

Dmas est la plus
grant Cite de
la tere de la
mendre Surie
qui par austre nom est appel
lee . La phenue de liban et a
ceste occasion dit se prophete
parlant de ceste Cite de dunias
Chief de Surie . Lun des ser
uiteurs de abraham apesse de
mas la foundi z fut par ce

these gardens had been captured, the city of Damascus could no longer offer any resistance. God knows what a fine spectacle this army presented, with the tents and pavilions of the Christians in such great numbers that no man could count them! That they might gaze upon them, the inhabitants of Damascus went up onto their ramparts and the high towers of the city, and when they saw the Christians, they were filled with an extraordinary terror, which was all the greater seeing that the Christians were still around the town of Daire, which is four or five miles distant from Damascus.

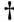

Chapter XLVII.

Of the land in which Damascus lies and of he who founded it, and of the fruit trees and gardens that surround it. Of the order given by the princes to besiege the city, and how the gardens were taken. Of the massive blow struck by the emperor. Of the treachery that caused the siege to be raised when the city was on the point of being captured.

Damascus is the greatest city in the land of Syria Minor; another name for it is the Phoenicia of Lebanon and the prophet speaks of this city as the capital of Syria. It was one of the servants of Abraham, called Damas, who founded this city and that is why it was given this name. It lies in plains where the land is so dry that it can be ploughed only if the farmers render it fertile and productive by means of the waters of a river that flows down from the mountain, which are led through streams and channels to those places where they are needful. In the part to the east of the city, there grow in great abundance on the two banks of the river trees bearing fruits of all kinds, which come right up to the city walls. Our men came before this city on the morrow, all drawn up in order of battle, with all their forces split into three armies. The first was led by King Baldwin III, for his men knew the country better than the pilgrims who had come from lands afar. King Louis the Younger led the second army, that he might come to the aid of those in the vanguard if it was deemed necessary, and the third army was led by the emperor and the men who had come from his lands.

Towards the west, on that side whence came our men, were found the gardens that stretched over four or five miles, all planted with trees so tall and so thick that they appeared like a great forest. And as well, the city was likewise protected by greater fortifications, for each inhabitant had enclosed the garden that he owned with earthen

walls, for there are but few stones in that land. And the paths joining each garden to the other are most narrow, although there is a common road by which men go up to the city, and yet a man leading a single horse laden with fruit can scarce pass along it. And thanks to these kinds of walls and to the channels that flow through the gardens, and likewise to the narrow ways that are stopped up here and there, the city is better protected on this side than on the other. Nevertheless, it was determined that the army would go through that way to enter the city, and this was for two reasons: the first was that if the gardens were taken, then the city would be, as it were, open and already half captured, while the other reason was that there was already on the trees a great quantity of well-ripened fruit that would be of great benefit to the army. And likewise the fresh water that flowed on that side would be most needful to all the armies.

King Baldwin ordered his men to go into the gardens, but they encountered strong resistance, for indeed, on the other side of the earthen walls there were in divers places a great number of Turks and other pagans who ceaselessly let loose, through narrow arrow-slits well spaced out, flights of arrows through which our men could not advance. And other Turks, equal to them in number, attacked them in the paths and defended these passages most valiantly, for all who dwelt in the city and knew how to bear arms had come out and were gone into the gardens to safeguard them and defend them to the utmost, that our men might not seize them. There were also in the gardens, placed here and there, beautiful tunnels, quite high, which the rich people in Damascus had had built, that they might rest there in the shade at those times when their people were picking the fruit. And here had been placed large Turkish reinforcements, who with quantities of arrows and stones caused great injury to our men, who were ceaselessly hit by arrows and stones shot through the arrow-slits in the walls. To be brief, by reason of the attacks with arrows and stones, they found themselves in a most perilous position; there were such numbers of dead that the princes and barons regretted most often that they had engaged in a siege of the city from this side.

King Baldwin, though he was yet young, showed that he would be of great military renown, for he assembled his barons and knights and other men-at-arms and placed them with skill by the path that ran alongside the earthen walls. And he caused these walls to be battered down and demolished so suddenly that the greater part of the Turks within them were taken prisoner or slain before they could flee and take refuge behind other walls, and our men acted in like manner in a number of other places. The Turks and the pagans who were in the other gardens and heard men saying that our men were battering down the walls and killing all those whom they found in the gardens were so

deeply terrified that they fled in a mass towards the city and abandoned the gardens, which were then left in the hands of our men: these latter might then walk through the paths and the lanes at will, finding none to prevent them from doing so.

Meanwhile, the Turks, when they knew that the city would be besieged from that side and knowing that the Christians would need to go to the river to get water for themselves and to water their horses, positioned knights, archers and other men-at-arms in the paths, that they might prevent our men from approaching the water. And so it was that, when the army of King Baldwin had all but passed through the gardens and his men wished to get water, the Turks who had been placed there to guard the river attacked them in force with flights of arrows, spears and volleys of stones, so that they pushed them back. Yet they fell back but a little, for they straightway formed up again and strove to get to the river by force, as they fought against the Turks: they threw themselves most violently amongst them and there took place a hard-fought skirmish, but in the end, our men were yet again pushed back.

King Louis the Younger had not yet entered the fray, for he intended to await the moment when help would be needed and when the soldiers of the vanguard were exhausted, as it had been determined. But when the emperor Conrad, who was bringing up the rear with his army, asked what was the noise he could hear, they then told him that the vanguard was engaging the Turks. The Germans, who are not knowledgeable in arms and who are but little able to hold back and wait in patience, threw themselves forward, all in disarray, as did the emperor himself, and they pushed through the troops of King Louis and the French, nor did they stop until they came to the place where the skirmish was, hard by the river. There they all dismounted and, covering themselves with their shields and drawing their long swords, they hurled themselves so ardently amongst the Turks that the latter could not withstand their assault and, without waiting, they straightway left the river and retreated into their city, and the river was thus abandoned to our men.

During this skirmish, the emperor Conrad struck a most extraordinary blow with his sword: a Turk, clad in a coat of mail, was pressing him hard and close when the emperor, who was then on foot and had in his hand a most excellent sword, raised it high and delivered the Turk a most violent blow. He struck him with such force between the neck and the left shoulder that the sword sliced through the whole shoulder and breast and, cutting through to the right side, caused the head to fall to the ground and likewise the shoulder and the Turk's right arm. When his companions saw this sword stroke, each and every one ran away and ceased not until they had all retreated, in the utmost terror,

into their city, and there they filled with fear those who dwelt in Damascus as they told them of the great blow struck by the emperor. And they began to feel such great fear that they lost all hope that they could withstand enemies who were so strong and mighty.

And in truth, not hiding their despair, they went up onto their walls and saw our men who were setting up their rich tents and their pavilions around the city and most particularly in the gardens and along the riverbanks, and then they feared lest so great a host of people who were such valiant soldiers should attack them suddenly, take the city and kill them. So they talked of this together and with one accord determined to set up sturdy barriers in all the paths on that side of the city where the siege was: this they did so that, if it should be that the city was taken by assault, they might have the time and the chance to get out through the other gates, taking their women and children. This was of a surety proof that they were not set upon defending themselves and that they could have been taken prisoner in but a short time. Iindeed, certain Saracens had already packed and tied up some part of their valuable goods, that they could take them and carry them away in all haste if perchance they were forced to flee.

But it did not come to pass in this fashion for Our Lord, either by reason of the sins of the Christians or through his divine will, decreed otherwise. Certain of the most spirited and knowledgeable of the Turks of Damascus knew that the leaders of so great and valiant a Christian army, drawn from so many divers and distant countries from the West, would neither be easy to conquer nor turn aside from that purpose for which they had left their lands and already endured misfortunes without number. And besides, knowing that, amongst these brave foreigners, certain of the barons of Christian Syria were consumed with great covetousness, they strove by means of promises and pledges to turn them and cause them to betray the noble French and Germans, notwithstanding the fact, which they knew full well, that they had come to bring them help. And by means of secret messages, they made so many promises to them that a great number of the treacherous Syrian barons and knights, though not all, undertook to raise the siege.

They came to find Emperor Conrad, King Louis and King Baldwin, who had great confidence in them, and gave them to understand, as if their intentions were of the best and they wished to hasten the capture of Damascus, that they had not been well counselled to lay siege to this city from the side of the gardens, since it would, indeed, be more difficult to take Damascus from that side than from any other. They asked them and counselled them, lest they should lose yet more time and endure yet more suffering and yet more expense, that they should move their army and lay siege to the city from the opposite side.

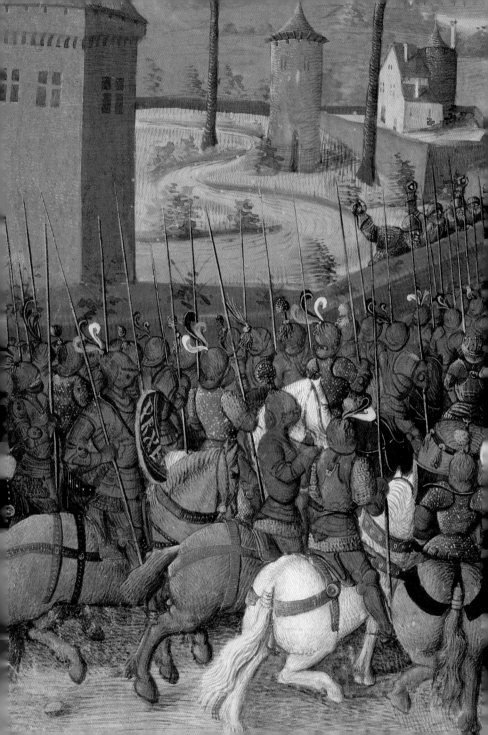

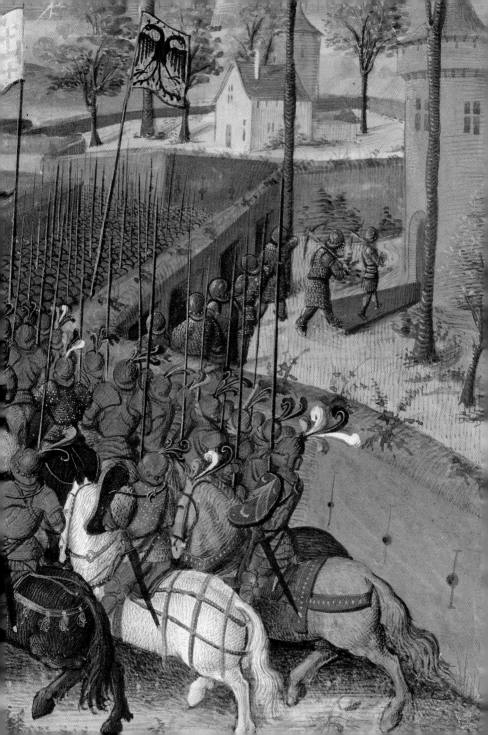

And, to multiply their treachery, they maintained that in those parts of the city situated to the east and south, there were neither gardens nor trees that might prevent their passage, and that the river, which would be difficult to secure, did not flow there, while the walls were so low and so weak that they would need no machines of war to batter them down since they could be taken straightway.

Convinced by these words and by other lies, the princes placed their confidence in the advice of these Syrian traitors, whose names none were prepared to record or to indite in the chronicles. So they then had the order sounded to change camp and to follow the traitors, who went on ahead of them as if they were true guides and led them into that part of the city where they knew they need have no fear of assault. Furthermore, in that place the army would have such great need of so many things that they would not be able to remain there. So they planted the banners of the princes in that place and had the tents set up all around. But our men had scarce come there than they perceived that they had been deceived and that it had been a great betrayal to have them go there, for in truth, they had been led away both from the river, which so great an army could not dispense with, and from the fruits in the gardens that had procured them such well-being and pleasure. And besides, the army began most cruelly to lack food, and in particular those pilgrims from foreign lands, for they could get nothing brought in from Syria. They had few provisions, for they had been told that they would take the city as soon as they arrived, and to prevent them from furnishing themselves with victuals, they had been told that they would find food enough in the city, which would certainly be unable to hold out for longer than three days.

When all the noble pilgrims found themselves in a position where they lacked everything, they became so enraged and so dumbstruck that they abandoned the attack on the city, knowing that, by reason of the strength of the ramparts, they would be wasting their effort. They could not return to the gardens whence they had departed through treachery, for no sooner had they left them than the Turks had straightway gone in without tarrying, in such great numbers that within but a short time they had dug trenches and set up sturdy barriers, fortified the passages and even piled up chopped-down trees. And they garrisoned these places with great numbers of crossbowmen and archers, so that the Christians could more easily have taken a strong city than have returned thither by force. And for another thing, it was not possible that they remain there and continue their siege at length, for they saw most clearly that they could no longer find anything to eat or drink.

Emperor Conrad and King Louis conferred together and recognised that the men of that land, those whom they had come to aid and for whom they had suffered and spent so much, those very men in whose good faith and conduct they had trusted, had betrayed them by leading them to a place that could profit them nothing. They determined, therefore, together with their princes and barons, that they would turn back and thenceforth be more suspicious of any treachery, so they raised the siege and made ready to return with their men to Jerusalem.

And thus it was that they abandoned the siege of Damascus and that the two greatest princes of Christendom left again having gained nothing at all, either for themselves or for the other Christians. And they, and the other great lords likewise, began to weary of the fate of the Holy Land and they no longer wished to do anything to bring succour to it. And even the common people who had come from France said openly to the Syrians that it would do no good to capture towns for them, for the Turks were more worthy than they were. And to tell the truth, the men of France had until that time remained most willingly in the kingdom of Jerusalem and had accomplished fine deeds there, but after this betrayal, they could no longer agree with the Syrians as they had done hitherto, and when they came on pilgrimage, they left as soon as they could after they had visited the Holy Places.

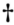

Chapter XLVIII.
Of the various reasons that caused the betrayal before Damascus. Of the return of the emperor and King Louis the Younger to their own countries. Of the separation and divorce of King Louis and Queen Eleanor, and how Henry, count of Anjou, who was king of England thereafter, married her.

That it might be known by whom and for what reason so great a betrayal was made, a number of people, of different origins, sought to enquire into the matter, and they asked as many questions as they might of a number of wise men who had been in that army. And most particularly William, archbishop of Tyre, a most noteworthy cleric and historian, enquired discreetly in divers places of a number of lords and other men, and they were of different minds. For some said that Count Thierry of Flanders bore greater responsibility in this matter than any other man, though he had not been told about it. For, as soon as he knew that the gardens of Damascus had been taken

and that control of the river had been gained by force, he believed that the city could not long resist, and so he went to find Emperor Conrad, King Louis and King Baldwin and besought them to give him this city of Damascus once they had taken it. And he addressed the same demand to all the barons of France and Germany, and they all agreed without demur, for he promised them that he would protect it well and would drive the Saracens out of it by force of arms.

When the barons of Syria were told of this, they became enraged and they felt great contempt for so mighty a prince who, though he possessed so many lands in his own country and was come thither as a pilgrim, was still desirous of availing himself of one of the most noble and wealthy parts of the kingdom of Syria. They were of the mind that this land, if King Baldwin had no desire to add it to his own realm, ought rather to come to one of their own number, since they were constantly at war against the Turks and the Saracens, having no other means elsewhere by which to live. And this was unlike the pilgrims who, when they had accomplished their vows, returned to the other side of the sea to their own lands, which were rich and fertile. This is why, because Count Thierry was to have this city that should have come to them if it was captured, the barons of Syria preferred that it should be the Turks and the Saracens who continued to hold it rather than him, and why, that they might prevent him from having it, they agreed amongst themselves on this betrayal.

There were others who said that prince Raymond of Antioch, who was of most evil intent and quick-tempered, had never ceased, driven by his rage and from the moment that King Louis had left him, to seek the means to do him harm and injure his honour. This is why he had demanded most forcefully of the barons of Syria, who were his companions and his allies, that they should do all that they could to destroy the reputation and honour of King Louis, and to act in such a way that not one of his deeds might allow him to cover himself with glory. And that they might respond to the pleas of Raymond of Antioch, they had conceived and woven this scheme of betrayal.

And thirdly, there were those who said that men had sought to betray the French through pure covetousness, that they might grasp great sums of money given by the people of Damascus to certain of the barons of Syria, as has been told heretofore.

Now when these three great princes were back in Jerusalem, they chose a day on which they swiftly gathered together their barons, knights and other men, and it was decided then that they should accomplish some great feat that should be of use in the service of Our Lord and that would shed honour on them for evermore. And amongst

other things, it was also determined that both their honour and the good of the Holy Land would be assured in fine fashion if they laid siege to the city of Ascalon, a thing that could be most easily done, for the city lay, as it were, in the centre of the kingdom of Jerusalem, which would allow food to be brought in from all sides in perfect safety, and also because it could not long withstand so great an army. Though there was much talk of this plan, they came to no decision, for there were some who stirred up trouble and wished rather to return to their own lands than to lay siege to towns in Syria, despite the great treachery conceived by the Syrians before Damascus against them and God. And so the gathering broke up and nothing was undertaken.

The emperor Conrad, when he saw that matters were going so badly and that the barons could not come to any agreement amongst themselves to undertake any conquest that would be worthy of the effort, said that he had enough to do to govern his own lands and, giving orders to make ready his ships, he took his leave of those who remained there and returned safely to his own country.[270] But he lived there no longer than two or three years more, when he fell ill and died of his illness in the city of Bamberg, and there he was buried in the cathedral church with the highest honours, deeply mourned as a most worthy emperor.

After his death, his nephew Frederick, duke of Swabia,[271] of whom I have often spoken before, was made emperor and governed the empire most royally. And as for King Louis the Younger, after he had remained for a whole year in Syria, when the time for the March sea passage came, he celebrated the Easter feast in Jerusalem in company with his wife and barons. Then he took his leave of King Baldwin, and of the patriarchs, barons and other prelates likewise, and went back in perfect safety by sea to his kingdom of France. There, but a short time after his return, he assembled his prelates and barons, where it was proved that Queen Eleanor had ties of most close kinship with him, which allowed the prelates to set aside their marriage. But Eleanor returned to her country of Aquitaine and Henry, count of Anjou and duke of Normandy, who was king of England thereafter, married her. And by reason of the lands owned by this lady Eleanor and of his own lands likewise, from that time onwards Henry had to wage a long and bitter war against King Stephen[272] of England, who usurped it of him.

Thus finishes the fourth of the expeditions made by the French, which is called by the chronicler of Soissons the Second[273] Great Crusade.

BATTLE OF FONTS MARETS (1149).
RAYMOND OF ANTIOCH IS FOUND DEAD

"And so it was that died the most valiant Raymond, prince of Antioch, who was of high courage and a mighty, fearless and bold knight. Neither lions nor leopards were so greatly feared by his foes as was this prince, and though he had known defeats in his combats, one could write a book upon his acts of bravery, prowess and fine and mighty feats on the battlefield!"

(FOL. 154VA)

Shortly after the departure of the last European crusaders, in particular King Conrad and King Louis, Nur ed-Din invaded Antioch. The first thing he did was to besiege the castle of Nepe and it was at this moment that the prince of Antioch, headstrong and obstinate, attacked him with a mere handful of men, who were massacred near a place known as Fonts Marets. In the principal picture, Jean Colombe conveys the violence of the fighting by painting dead bodies strewn across the ground and terrified horses rearing up. The Saracen standard flying at the centre of the battle scene shows that the advantage lies with the enemies of the Christians. The stronghold, a vast structure high on a steep hillside, is shown in the background. In the picture in the lower register, the dead bodies have been gathered for identification: this is how, according to Sébastien Mamerot's description, the mutilated body of Raymond, prince of Antioch, was discovered.

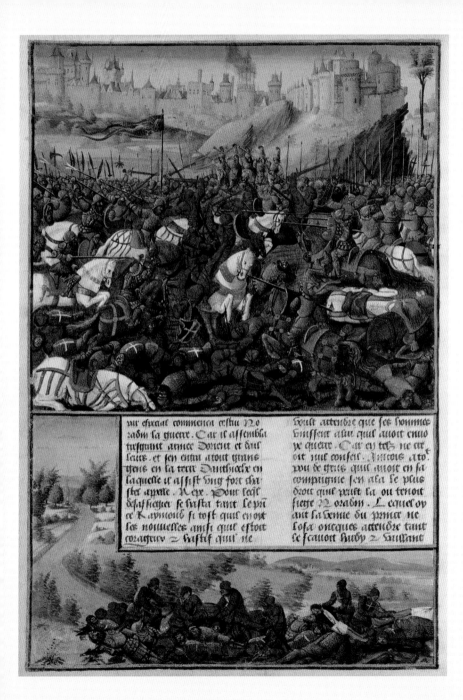

vir eschaal commença cestui No
radin sa guerre. Car il assembla
tresgrant armee dorient et dail
leurs. et sen vint atout grans
gens en la terre dantiuoche en
laquelle il assist vng fort chas
tel appelle Rege. Pour lequel
desassieger se hasta tant le prin
ce Raymond si tost quil eust
les nouuelles ainsi quil estoit
couragieux z hastif quil ne

hoult attendre que ses hommes
fuissent a luy quil auoit enuo
ye querre. Car en tels ne fei
oit nul conseil. Aincois atot
vn de troys quil auoit en sa
compaignie sen ala le plus
droit quil peult la ou tenoit
siege Noradin. Lequel oy
ant la venue du prince ne
losa oncques attendre tant
se scauoit subty z buissant

Chapter XLIX.
Of other feats in Outremer. How Nur ed-Din conquered and slew the most valiant prince Raymond. Of the capture and death of the young Count Joscelin. Of the quarrel that set King Baldwin against his mother and of the loss of the land of Edessa.

Nur ed-Din, son of Zengi, lord of Aleppo, showed great arrogance, as did all the lords of the Orient likewise, when he learned of the return of the emperor and King Louis. For they thought that they need wait no longer to exterminate those few Christians who had remained in the lands of Syria, Antioch and Edessa, and they did great harm to them. The intent of the chronicler of Soissons is, with the help of God, to tell quickly of the most important of these feats, and then to return to the stories of King Guy and King John of Jerusalem, in whose reigns the Third Great Crusade was undertaken by those most glorious kings Philip II Augustus,[274] king of France, and Richard, king of England.[275]

Before all else, this Nur ed-Din made ready for war, and he assembled a most great army, drawn both from the Orient and elsewhere, and he entered with a great force into the land of Antioch, where he laid siege to a stronghold called Nepe. When he was told of this, the prince of Antioch made haste straightway to put an end to this siege, but being high-hearted and quick to act, he would not wait until those men whom he had sent for came to join him. Indeed, in such situations, he would put no trust in the counsel of any other person, so with the small number of men who were with him, he went by the most rapid way he could to the place that Nur ed-Din was besieging. But the latter, when he was told of the coming of the prince, dared not await him, for he knew of his boldness and valour, and besides, he could never have believed that the prince would approach him in so foolhardy a manner and with so few soldiers. Nevertheless, Nur ed-Din did not go far away, for as soon as he had positioned his force in a safe place nearby, he sent out certain of his spies, that he might know how many men prince Raymond had with him. These told him that he had scarce a thousand men with him and that he was exceedingly proud that he had caused the siege to be raised; and besides, he was sleeping that very night with not the slightest misgivings on the same field that they had abandoned through fear of him.

Alas! This good and valiant prince, if he had wished it, could have retreated quietly into a safe and sheltered place to await his reinforcements and to assemble his whole force against his foes. But he could not follow this course, for his confidence in himself had been too great, and during the night he found himself surrounded by the men of Nur ed-Din, who had ordered them to fall back into this place when he knew of the small number of the prince's men. When the day came, at first dawn, the prince said that he had made a bad decision and that he was surrounded by his foes, who outnumbered his own men. Nevertheless, when he saw that he could not save himself unless he fought, he drew up those few men he had in battle order, and exhorting them to risk their lives and explaining to them that they had no other means of saving themselves, he hurled himself into the midst of the Saracens and there made a great massacre. But in the end, since they could not fight against such great numbers nor withstand them, his men fled, leaving the prince together with some few knights who would not abandon him. They performed great feats as long as they could withstand, and the prince, most particularly, slaughtered and killed all those around him who were within his reach, but in the end, he was exhausted and none came to his aid. His enemies rushed upon him all together, and he was killed by lance thrusts and sword strokes, as all those who could get to him rained blows upon him.

The cruel Nur ed-Din ordered that his head and his right arm be cut off and he bore them away that he might prove that he had conquered and slain the finest of Christian knights, for I do, indeed, believe that, of his age, this prince was the best of knights! May Our Lord pardon his sins! All those who had remained with him were likewise slain and there died amongst others a most valiant man, wise, loyal and a good knight, whose name was Reynald of Marash and who had married the daughter of the count of Edessa, and they made most great mourning for his death.

And so it was that died the most valiant Raymond, prince of Antioch, who was of high courage and a mighty, fearless and bold knight. Neither lions nor leopards were so greatly feared by his foes as was this prince, and though he had known defeats in his combats, one could write a book upon his acts of bravery, prowess and fine and mighty feats on the battlefield!

This defeat, which took place between the city of Paumiers and the castle of Rugia, in a place called the Fonds Maret, befell in the year of grace of Our Lord 1148, on the day of the feast of Saint Peter and Saint Paul, in June, in the fourteenth year of the principality of Antioch.[276] The mutilated body of the prince was found amidst the other corpses by the chamberlains, who knew it by reason of the position of the wounds that he had received and that had long since healed. When the Saracens had departed, his

body was borne away to Antioch and there he was buried with great honours in one aisle of the cathedral church that was dedicated to Saint Peter, alongside the other princes who had gone before him.

The princess Constance, his wife, who had had of him two sons and two daughters, undertook to govern the principality to the best of her power, and to withstand Nur ed-Din, who, knowing that he had vanquished and slain prince Raymond, came into his lands with arrogance and caused great damage there. And this is why the patriarch Aimery, who passed nevertheless for a most miserly man, conducted himself most wisely on this occasion, for he opened his treasury and sent far and wide to seek for knights and soldiers, and gave them such great sums that they came in great numbers and the strongholds were well guarded. Moreover, King Baldwin III, as soon as he knew of this great misfortune, assembled straightway all the men that he could and came as fast as he might, and at that same moment there suddenly appeared likewise the sultan of Konya, for he perceived that he might do great harm, and he went to lay siege to Joscelin and his wife and children in the castle of Turbessel. And Count Joscelin, that he might cause him to raise the siege, surrendered to him those prisoners who came from his own country and gave him twelve suits of knightly armour, so the sultan departed and Joscelin came to Antioch before the king to give thanks to him for the succour that he had brought to his ravaged land. Now Joscelin took his leave of the king and returned to his own lands and, some days thereafter, when the king had well provided for the protection of the strongholds of Antioch and had returned thence to his own kingdom, this Count Joscelin, who was not like his father, and who rejoiced at the death of prince Raymond whom he hated, acted like a fool, for he left his lands to go up to Antioch to the patriarch who had, so it was said, summoned him thither.

One night when he, together with one of his squires, had left his men and had got off his horse to pass water, he was taken captive by Turkish highwaymen and led away to prison in Aleppo, and there he died but a short while after in the most vile conditions, despised and most wretched. At daybreak his men, who thought that he was still with them, wondered greatly what had befallen him, but they learned shortly afterwards that he had been taken as prisoner to Aleppo, so they went to find his wife,[277] who was a woman of excellent sense and who had of her husband a son and four daughters. And so it was that those two great lands of Antioch and Edessa remained ravaged throughout one whole season.

It was at that time that the king and the patriarch of Jerusalem caused a stronghold to be built in the place where once had stood one of the five cities of the Philistines,

called Gaza, on a hill that was quite high. There were still to be found there great city walls, ruined churches and cisterns that had fallen in and wells where once was fresh running water, but the ramparts of old had been most strong and they could see that, to build them again as once they had been, much time and money would be needed. They, therefore, took but one single part of this hill and there they built thick, high walls, broad, solid towers and wide, deep ditches, and with the accord of all the barons, they gave this place to the Templars, for indeed, there were then at the heart of this order a number of brothers who were good and valiant knights, who from that time onwards caused great harm to the Turks. As for the people of Ascalon who had hitherto been wont to make great incursions and to pillage across all of Syria, they would have been but too happy to be left quietly in their city.

This stronghold thus fortified was, as it were, the frontier that separated them from the Egyptians to the south of the kingdom and this suited well the Christians of Syria, for the Egyptians were accustomed to send a strong force three or four times a year to the men of Ascalon to renew the defence of the city. Now at that time, they sent reinforcements in even greater numbers than was their wont and came straight on to lay siege to this new castle and to attack it. But the Templars defended it so well that, some days thereafter, the captains of the Egyptians saw that they were losing more than they were gaining and so they raised the siege and went back to Ascalon. So discomfited were they that they nevermore attempted that castle and also, since those in the castle kept such close watch over Ascalon, when the Egyptians were desirous of sending aid and provisions to the city, they dared no more do so overland but had perforce to send these things by sea, for fear of the Templars.

Some days thereafter, there arose a great quarrel in Syria. The queen, that is to say the mother to King Baldwin III, from the time when she had undertaken to govern the kingdom, had straightway named as constable of Jerusalem one of her cousins, called Manasses of Hierges. Now this man had the queen's full confidence and so he bore himself with such arrogance that he aroused the hatred of the barons and the wrath of the king, so that the latter would not wear his crown on Easter Day and on the day following the barons had begged him to agree that his mother should likewise go crowned with him. But on the third day, when his mother was not in the church, he went there wearing his crown, in the presence of a number of the barons,[278] amongst whom was to be found the most valiant Yves of Nesle, count of Soissons, who had not wished to leave the Holy Land as swiftly as Emperor Conrad and King Louis the Younger and the other barons of the army. On that day King Baldwin caused a great feast to be celebrated and

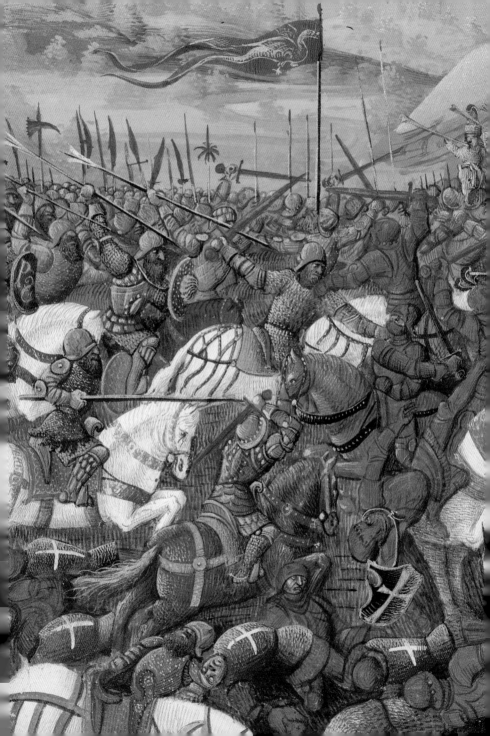

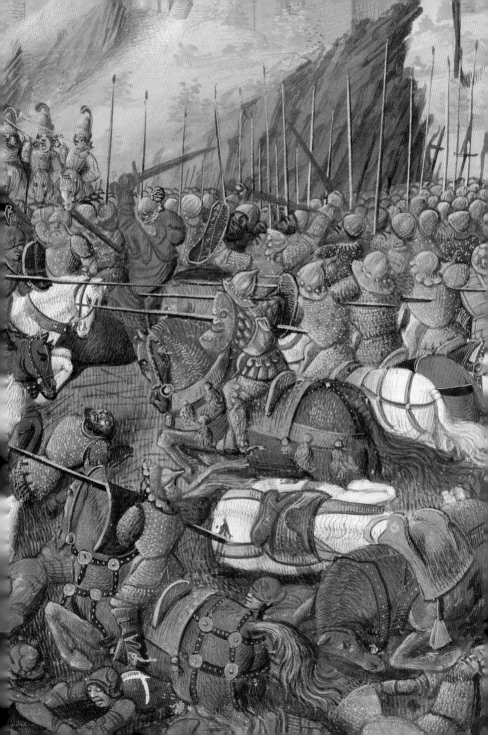

he said to his mother before all the barons that there was no reason that the kingdom should henceforth be ruled in this manner and that he would have his own land. And when all remonstrated with her, this excellent lady agreed and, despite the fact that the kingdom was hers through inheritance, accepted that it be divided into two halves, of which the one should come to her and the other should be for her son, which was done.

But because the queen had to her part the city of Jerusalem, King Baldwin her son, having made Humphrey of Toron his constable, took it from her but a few days later. He entered with a great army into Jerusalem, for the terrified inhabitants opened the gates to him, and he gave orders to besiege and attack most violently the Tower of Sion, where his mother was, but the tower was defended so strongly that he could not seize it. And in the end, they made peace, for the city of Jerusalem, which was the capital of the kingdom, remained in the hands of the king while the queen betook herself to the town of Nablus, of which she had possession together with those lands that were its dependencies. After this peace, the king led his army to Antioch and into the land of Edessa, for he knew of a surety that the sultan of Konya had invaded this land with all his army and had already seized well-nigh all the strongholds on the frontier of his lands; but the king could not tarry there, for there came other tidings that compelled him to lead his troops back into his own lands.

In any case, the land of Edessa did not remain at peace, for Nur ed-Din, that most bitter enemy to the Christians, sent thither so many lightly armed troops that, save by running great risks, its people dared not leave their strongholds. Moreover, the emperor Manuel heard tell of the dreadful state of the land of Edessa and he sent to the countess one of his barons, together with a number of knights, who on his behalf offered to this lady a most great sum of money that should be paid to her each year, which would allow her to live with her children with dignity and in great state, provided that she agreed to give him those lands and strongholds that were still in her governance. Now this offer divided the opinions of the barons and knights of Edessa, for some counselled that she accept the offer of the emperor while others contradicted them, alleging that it would be sheer madness to give such strongholds to the Greeks, who were such feeble soldiers that they would lose them in but a short while. Nevertheless, notwithstanding that he believed the latter counsel, the king accepted the offer of the emperor, for indeed, he would rather the strongholds be lost through the fault of the emperor than through his own, for he knew full well that he could no longer succour or defend the lands of Edessa, which lay at least fifteen days' march from his kingdom. And so these strongholds were given to the Greeks and the king caused all those inhabitants

who wished to do so to gather up their possessions and leave, that they might be conducted to a safe place.

When Nur ed-Din was told of what had happened, he hoped to gain rich booty and followed the king in all haste and caught up with him when he had gone no further than the city of Tulube, which lay six miles from Turbessel. But the king had placed his chariot at the head of his men and, after he had crossed through a most difficult pass, took refuge in the castle of Aintab, and Nur ed-Din could not reach him before he had passed this perilous place. And the king and his men, after they had rested at Aintab,[279] departed again, surrendering the place to the Greeks, but taking with them all those who dwelt in that country. It was pitiful to see them and to hear the weeping, lamentations and grief of the lords of that land, who took with them their wives, their daughters not yet wed and their little children, abandoning their lands and houses where they had been born as they left their country behind for ever, not knowing where they might dwell.

Nur ed-Din pursued our men, raining down arrows upon them and making divers attacks, yet despite these assaults and the burning sun and the rough and dangerous road, the Christians bore themselves most bravely. And when night fell, Nur ed-Din, who knew their valour and who had no food remaining, led his men back to his lands, and the king led his men back to Antioch. He wished to offer a most valiant and noble lord as husband to the princess of Antioch, but she would not accept him, for she both dearly wished to govern for herself and also meant to do as she wished.

The king returned to his kingdom and gathered together in assembly at Tripoli all his prelates and barons. There, together with the count of Tripoli, he tried to change the mind of the princess of Antioch, who was their cousin, but she refused and the gathering ended having decided nothing. Some days thereafter, the count of Tripoli was killed by certain assassins at the gate of his city, together with Ralph of Merle, a most excellent knight, who wished to defend him. Scarce one year had passed after the Greeks had taken responsibility for the lands of the county of Edessa when Nur ed-Din seized all the strongholds, one after the other, and drove out thence all the emperor's men.

However, in that time, certain Saracen emirs who were brothers and whose forebears had once been lords of Jerusalem, seeking to recapture the city, raised a wondrous great army and came as far as the mountain on which stands the city of Jerusalem. Certain brave Christians went out of the city and made their way to Nablus, where the great barons and knights of the realm were gathered together. And, to be brief, the Saracens were taken by surprise and slain in narrow ways or vanquished in divers places, so that they took flight to go back across the river Jordan, where a number were drowned.

For some amongst them, as they reached the fords that they had passed through as they came, found Christians from Nablus in Syria who had been placed there to guard the crossings and who slew them in great numbers, whilst others, caring only to get across, flung themselves straightway into the water at the first place on the banks that they reached. And thus was annihilated well-nigh all of that great army, and the Saracen brothers, the emirs, returned to their own country in shame. It was their mother who had urged them to set off in such vainglory and the Christians of Syria took from them riches without number, which afterwards gave them the courage to undertake most great and fine conquests.

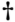

Chapter L.
Of the siege of Ascalon. The stratagems used and the assaults and sorties made. How Nur ed-Din captured Damascus and Ascalon surrendered. Of the cruelty of Reynald, prince of Antioch. Of the origins of the Commanders of Rhodes, known as the Hospitallers of Saint John of Jerusalem. How the caliph of Egypt was killed and of the cruelty of the Templars.

Ascalon is one of the five cities founded by the Philistines. It lies on the sea and is semicircular in shape, as if in a hollow sloping downward to the shore. The ramparts that encircle it were made of earth transported to the site and are as solid as if constructed in lime or sand. On these, the walls and towers are built; the walls are very thick and high, the moats deep and the defences before the four gates excellent. The entire city and its neighbourhood boast but a single spring, though there are many wells with water suitable for drinking and cooking. There are also numerous troughs at which horses can drink. Ascalon lacks a port in which ships can take refuge from storms or pirates; there is only an open beach, unprotected from the fierce winds that beat the shore. There anchor-cables would inevitably give way and the ships break up on the shore. Around the city, there is no arable land other than a few little north-facing valleys. However the sandy soil in the city and around it suits the cultivation of vines and gardens and there were many such vineyards and gardens at the time of Baldwin's rout of the Turkish and Saracen emirs, as we have said in the previous chapter. That was so profitable a victory in terms of booty that it inspired in the king and his barons the desire to take further action against their enemies. Remembering the great harm that they had suffered through

the people of Ascalon, they decided to make a sudden expedition to tear up the vines and trees outside the city walls. Thus, they left Jerusalem with a very small army to execute their plan and arrived before the city of Ascalon. When the inhabitants saw them, they were so terrified that none dared set foot beyond the city walls. Seeing the cowardice of the inhabitants, the king and the other Christians in the army swore that they would besiege the city. While they lay encamped around the walls, the king sent to Jerusalem for the True Cross and to notify the other barons and prelates of his intention.

Barons and men came in such large numbers that, by the feast of the Conversion of Saint Paul,[280] the siege could be laid. Amongst those present were Baldwin III and Fulcher, patriarch of Jerusalem; three archbishops: Peter of Tyre, Baldwin of Caesarea and Robert of Nazareth; two bishops: Ferry of Acre and Gerard of Bethlehem; and certain of their abbots, such as Bernard of Trémelay, master of the Temple, and Raymond, master of the Hospitallers. Amongst the barons were Hugh of Ibelin, Philip of Nablus in Syria, Humphrey of Toron, Simon of Tiberias, Gerard of Sidon, Guy of Baruch, Maurice of Montreal and two great lords of France who had entered the service of the king, Reynald of Châtillon and Walter of Saint-Omer. On their advice, many siege-machines were built and used to assail the city. The assaults were violent and the city defended itself vigorously. As often in war, when one side won a battle, they lost the next. There were so many within the walls in the service of the caliph of Egypt that it was said that every child born in this place was in the caliph's pay from birth. The Egyptians strove above all other things to aid the city and went to great expense to do so; they revictualled the city and brought in fresh men and provisions by land and sea four times a year. And true it is that, from the very first day of the siege till the city was taken, there was a great quantity of provisions and arms within the city and half as many troops again as in the besieging army. The caliph and his council knew that this city was effectively the bulwark of the Egyptian kingdom; if the Christians took it, they could invade at will. It was nevertheless useful to the caliph because it marked the frontier with Syria.

From the very start, our men had ships on the sea and placed Gerard of Sidon in command of them so that no reinforcements could enter the harbour. Then they sent their spies to Gaza and its vicinity so they would be warned if an army was advancing from Egypt and could not, therefore, be surprised from that quarter. They had also installed great defensive works opposite the gates of the city so that the Ascalonites could not make sudden sorties, for they had till then sallied out whenever they pleased. The siege had lasted two months when several ships came to land bearing pilgrims as was the custom at Easter. The king sent for these ships and had them brought before

SIEGE OF ASCALON (1153). BALDWIN III AND THE KNIGHTS
HOLDING COUNCIL BEFORE THE TRUE CROSS

*"Ascalon is one of the five cities founded by the Philistines. It lies
on the sea and is semicircular in shape, as if in a hollow sloping downward
to the shore. The ramparts that encircle it were made of earth
transported to the site and are as solid as if constructed in lime or sand.
On these, the walls and towers are built."*

(FOL. 157A–157B)

In Chapter L, Sébastien Mamerot recalls the siege of Ascalon, which took place in 1153. He gives a lengthy description of the fortified city by the sea. In the upper part of the picture, Jean Colombe depicts the formidable fortress surrounded by thick, high walls, raised up on earth embankments, with massive gates and towers, which protected the houses and churches, whose roofs can be seen. In the foreground, in open country, the red, blue and gold tents of the crusaders are pitched. The army is assembled in front of the camp. On the right of the picture is a soldier armed with a cross-bow; cannons (with which Colombe, a man of the fifteenth century, was familiar but which did not exist at the end of the twelfth century) are drawn up in combat position behind wooden defences. In the background, the ships of the Egyptian fleet that brought supplies to the besieged city by sea can be seen. In July, after a failed attempt to storm the fortress, a council was held in the king's tent in the presence of the relic of the True Cross, a scene depicted by Colombe in the lower register; at this council, the knights resolved to continue the siege. The fortress of Ascalon fell on 19 August 1153, after a siege lasting seven months. Godfrey of Bouillon had already laid siege to this well-nigh impregnable fortress without success; an Egyptian outpost on Palestinian soil, close to the border, it was of great strategic importance, and its capture was one of the few real victories of the crusader states during this period.

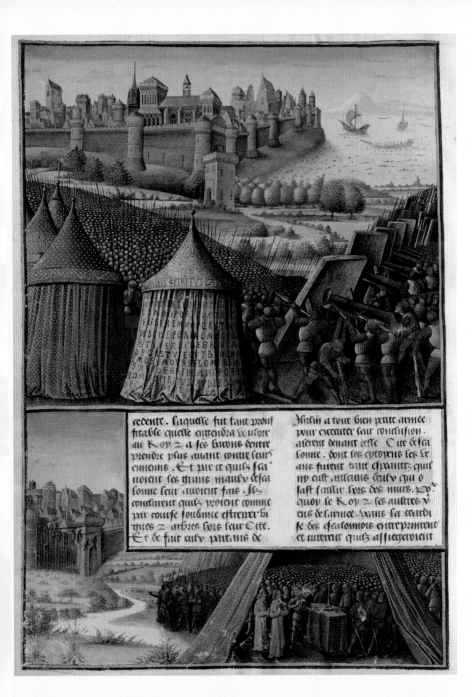

cedente. Laquelle fut tant prouf
fitable quelle entendra consoir
au Roy z a ses sinous dentre
prendre plus auant contre seurs
enemins .Et pur ce quils sça
noient ses mauly mauly desar
somme seur auoient fait . Ils
consiurent quils voient comme
pur course soudaine estrener bi
gnes z arbres hors seur Cite.
Et de fait culv pru ans de

Hirlin a tour bien petite armee
pour executer seur conclusion.
aserent denant este Cite desca
somme. dont ses cytoyens ses sr
ans surent tant espoantez quil
ny eust aulcuns dculy qui o
sast saillir sore des murs. Po
cuoy se Roy z ses auistres v
ens de sarmee .hains sa condi
se des escalonnes enterpuneut
et aueient quils assiegerient

Ascalon. Moreover, the host of the besiegers was strengthened with every new day by the influx of knights and other fighting men and provisions of all sorts, so that the Christians were in ever greater heart and the Turks correspondingly disheartened. Seeing the number of their men daily diminish as they were killed while the Christian army waxed ever greater and more confident, they were terrified and at their wits' end when, after five months of siege, the Egyptian fleet appeared. Gerard of Sidon and his ships and galleys were helpless and forced to retreat. The fleet then ceremoniously entered the port of Ascalon, reprovisioned the city and brought abundant fresh men and victuals. This allowed them to make a few sallies. But our men killed so many of these recent arrivals – who were incompetent soldiers and had no experience of the Franks – that the enemy made no further sorties.

During this siege, the princess of Antioch herself took the decision – King Baldwin having first given his consent – to marry Reynald of Châtillon,[281] though she had refused a number of nobler suitors who would have better served her and the principality. Now Nur ed-Din knew that King Baldwin and the princes of Jerusalem were so absorbed by the siege of Ascalon that they would not abandon it to go to the aid of others and, therefore, assembled a great army and encamped before Damascus. The men of the city came to meet him and surrendered the town without combat. Nur ed-Din expelled the king on the grounds that he was mad and much given to vices, forcing him to flee to the Orient without land or money. And, proclaiming the importance of the loss of Damascus to the Christians, he quickly assembled a huge army and came in all haste to besiege the city of Banyas in the hope that he could thus raise the siege of Ascalon. But by the grace of God, his efforts came to nought, for the city was so well defended that he raised his siege and returned home with no more ado. Our men did not on this account give up their siege, continuing their assaults and working their siege-machines hard. One of these causing the city great damage, some elite Turkish troops made a sortie with combustibles and set fire to it. But Our Lord turned the force of the flames against the ramparts and the city walls, which burned all night, so that in the morning, between two towers, a great stretch of wall from which a number of Turks were keeping watch collapsed, throwing them to the ground. Hearing the noise of the falling masonry, the whole army took up their arms to enter the city by force.

However, the master of the Temple gave the Templars precedence, one section of them entering the city and another remaining outside to prevent any other combatants entering so that the plunder would be theirs. And this was the custom in Outremer, to encourage the soldiers to accomplish audacious actions and to motivate them

by covetousness and the thirst for glory. When a fortress was taken, any man penetrating the walls gathered for himself and his heirs whatever he could take. But the Turks of the city, fleeing in fear of capture, now realised that there were only forty Templars in the city with no other Christians at their heels, and so turned on them with great troops of men and killed every one. Thus, confidence replaced their fear and while some boldly defended the breach, others sought great beams and planks, blocking the holes and breach so solidly that not a single Christian could enter. Moreover, those guarding the nearest towers had fled because of the fierce fire, but now the towers were again filled with archers and defenders. Thus, the assault ended. And the Turks hung the bodies of the Templars from the outside of the walls, which caused great anger amongst our men, but dampened their ardour.

The king then summoned the barons, knights and wise men before the True Cross, which was kept in his tent, and asked them what should be done given the state of the siege. Some, men and barons alike, argued that the siege should be raised on account of the death of many of their comrades and the great strength and defences of the city. But the others argued the contrary, pointing to the great shame and harm that it would bring to the Christians if they abandoned their goal and thus encouraged their enemies. And so it was decided that the siege be continued and that they should pray to Our Lord, which they did. After these prayers and orisons, they all set off under arms towards the moats, where they expected to find their enemies and, getting within them, set about the enemy with such boldness and vigour that, after a long battle, the Turks and Saracens were so oppressed that they were forced to flee into the city, leaving all their captains in the field and so many compatriots killed that there was no great household within the city that did not that day mourn its dead. And indeed, from the first day of the siege till that moment, they had never suffered such losses and harm, so that the death of the Templars was well and truly avenged. Moreover, when the Turks assembled and heard of the death of their leaders and the rich and powerful burghers of the city, they were in despair and sent a herald to ask the Christians to grant them a truce and hand over the bodies of the soldiers who had been killed during this sally so that they might bury them, offering in exchange to restore the bodies of our dead. This the king granted.

Hard on the heels of this catastrophe came another that afflicted the people of Ascalon, bringing the sufferings of the besieged to a head. While forty of their strongest and most valiant were carrying a ship's mast, a stone from one of our machines fell on it, smashing it to the ground and crushing all the men beneath it: not one sur-

vived. Terrified, they believed that Our Lord had done this deed – as do I: thus He sought to exalt the holy Christian faith. Therefore, they met in council and, sending a message to the king and barons, surrendered the city, making only the condition that the king on his entry into the city, having taken hostages from amongst them, should then give them safe conduct with all their goods so that they could reach the city of al-Arish in the desert. However, just when they thought themselves safe, they were betrayed by a Turkish lord who had served with them as a mercenary. Knowing of the great treasure they had, he joined them and declared that he would lead them into Egypt. But once they were well out into the desert, he had his soldiers attack them, stole what he chose of their belongings and made off, leaving them lost and distraught.

So Ascalon was taken in the tenth year of Baldwin's reign on the twelfth of August of the year 1153.[282] Baldwin thus became count of Ascalon, a title he passed to his brother Amalric, count of Jaffa. However, he first ordered that the most beautiful Turkish oratory in the city should be rebuilt as a cathedral in honour of the apostle Saint Paul.[283] Shortly thereafter, there came great shame to Antioch. Reynald of Châtillon knew that his promotion had displeased the patriarch Aimery[284]. Now in receipt of a false report that the latter disliked and had undermined him in every possible way when his marriage was being criticised and that Aimery spoke against Reynald because he was powerful and did not fear the patriarch, he had Aimery taken captive and thrown ignominiously into the dungeons of Antioch, notwithstanding the fact that he was Reynald's prelate and that Aimery held the see of Antioch that Saint Peter himself had first held and where the latter had first worn the pontifical robe. Aimery was, moreover, old and ailing. Then Reynald brought him bound to the top of a tower, covered his head in honey and left him a prey to the flies on a very hot summer's day. When news of this reached Baldwin III, he was profoundly displeased and conveyed to the prince that he had acted very wrongly and he should fear the king's anger if he did not restore all of Aimery's possessions. The prince, fearing the king, complied, and the patriarch on his release left for Jerusalem, where he was received with honour by the king, the queen, his mother,[285] the patriarch of Jerusalem and all the nobles, clerics and people. There he remained for a number of years.

Now there arose a great disagreement between the patriarch and the other prelates of the kingdom of Jerusalem and the Hospitallers. For when certain of the prelates' spiritual vassals were excommunicated by one of the prelates, the Hospitallers received them in their churches and allowed them to attend services and receive the sacraments. And when they were ill, they bestowed on them the sacred body of Our Lord and gave

them the Last Rites and after their death buried them in their churches and graveyards. Therefore, the prelates, in their outrage, criticised and rebuked the Hospitallers. But in their frustration, they did worse: they fired several arrows into the Church of the Holy Sepulchre in order to wound or kill the ministers of God and attempted to enter by force without respect for so holy a place. And this quarrel was of long duration. For the sake of brevity, I say no more about it.

The Hospitallers were founded by merchants who had come from an Italian town called Amalfi[286] in Apulia, which lies seven leagues from Salerno. These merchants first brought to the land of Syria Italian goods such as the Saracens had never before seen. And they were so assiduous that the caliph of Egypt, who then held sway over all Syria, was very glad of them. Since they were good and devout Christians, they often went to Jerusalem where they visited the Holy Places and made great gifts. They, therefore, felt the need for a house in Jerusalem where they could stay. For this purpose, the caliph of Egypt granted them – in the only quarter of the city open to Christians – a considerable piece of land; it stood opposite the Church of the Holy Sepulchre and a mere stone's throw away from it. There they could build their house. And the merchants, collecting money between them, commissioned a church dedicated to Our Lady and a house where monks could live and, beside it, a hostelry where foreign visitors could lodge. When these were complete, they brought from their own country an abbot and monks and established them in this abbey, where they served God according to the Latin rite.

For at that time, in all Jerusalem, the only Christians were Greek or Armenian. This church was, therefore, known as the monastery of Latinity. Then the same merchants built a little church dedicated to Saint Mary Magdalene and a comfortable house to receive pilgrims and also to preserve from reproach certain widows, women of means who came to them for accommodation. And in this house they established nuns to welcome and serve these pilgrim widows. Then, aware of the great need felt by many pilgrims in Jerusalem, noble or common, who came from many different countries and were some of them robbed and others gravely ill and with nowhere to lay their heads, the same merchants had built in their precinct a hospice to accommodate poor pilgrims, in sound or ill health, thanks to the money remaining unused from the two abbeys that had already been built by them. And they built there also a church in honour of Saint John the Almsgiver, patriarch of Alexandria. And in truth, these three churches had no income or rents nor any possession other than their precinct. But the merchants and the citizens who stayed at home each year collected a tithe and so amassed so much money that, through the abbot, who received all this money from them, the brothers and sisters of these abbeys in Jeru-

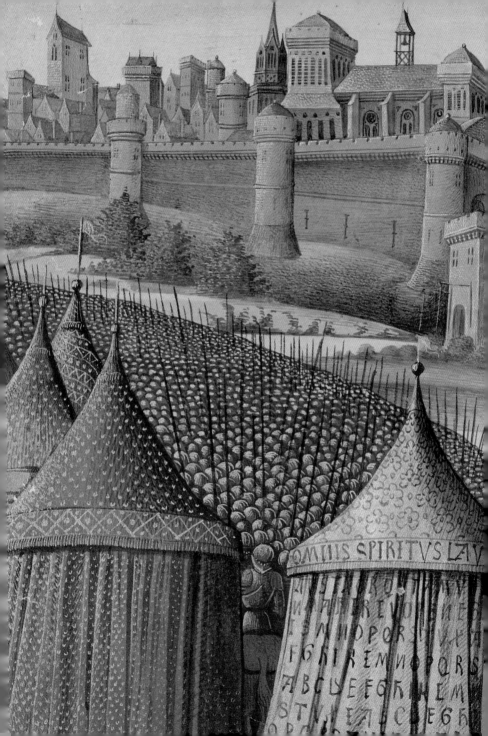

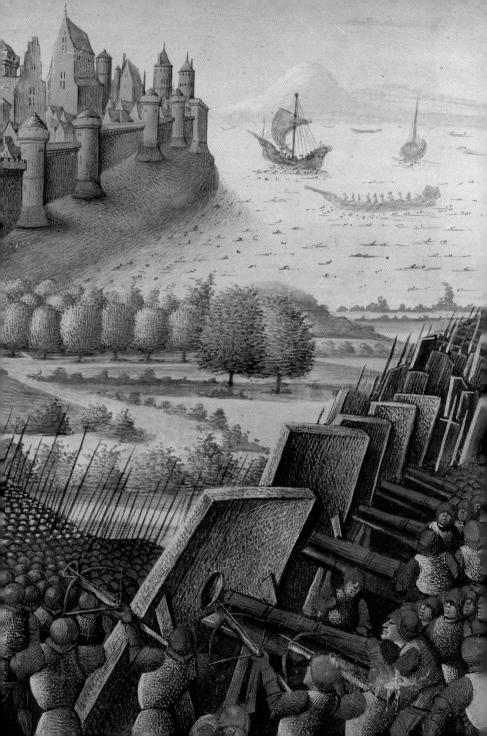

salem were supported and with the rest they did whatever good they might amongst the poor of these houses of God.

They continued to receive this aid till the city of Jerusalem was reconquered and Godfrey of Bouillon was made king. Thereafter he and the other noble princes, prelates, barons, knights and other Christians began to endow them with rents, possessions and other forms of wealth so that they became very rich. And there was in the abbey of the nuns an abbess, a holy woman of noble lineage, and in the abbey of the men a monk of holy life who, by order of the abbot and the monks, had long served the poor in this house of God while the Saracens still held sway over the Holy City and had shown them great manifestations of charity such as their poverty behoved. So they made him the first abbot of the hospice, there having been no other before him. After his death, the master of the Hospitallers was the Raymond of whom I spoke during the siege of Ascalon and under whom began the quarrel with the clergy of Jerusalem. And thereafter they gained still more possessions, such as Rhodes and five islands situated in its vicinity, which they seized in the year 1310 after a three-year war, ever since which they have maintained control of these islands. Their name was given to this hospital and they are called masters, commanders and monks of the order of Saint John of the Hospital of Jerusalem, though now they are commonly called Commanders of Rhodes.

Also during the reign of Baldwin III, the sultan of Egypt, whose name was Abbas – the greatest lord of Egypt after the caliph – came before the caliph and pretended humbly to adore him as if he were a god, such being the custom of that country. Then, claiming that he wished to speak with him about the affairs of the land, he took him aside to a secret part of the palace, and there killed him by treachery in the hope that his son Nasr, a wise and valiant warrior, might become caliph and he himself master of the country. He expected to hide this crime until the relatives and friends that he had secretly summoned to the palace had arrived, so that he could, with their assistance, defend himself against the inhabitants of the city and gain time to seize the treasure. But things did not turn out as he had planned: the crime was discovered sooner than he intended, so that the common people in their dismay came to attack the palace, crying "Where is the murderer who has killed our lord?" Fearing that they might break down the gates and kill him before his allies and friends arrived, he had the treasury opened and gold cups, hanaps, containers and jewels set in gold, along with pieces of silk, were thrown out the windows. So the people stopped their attack to seize these valuable objects, during which time the sons, nephews and friends of Abbas arrived

and he had what remained of the treasure packed up and carried away, sallying out with so great a company that he was able to depart in safety, despite the hostility of the people, and set out for Damascus. But the common people nevertheless followed them, shouting and seeking to kill them if they could. His eldest son and some members of his family, who were valiant knights, remained behind and held up those who were in pursuit so that the convoy might make its escape. Often they had to throw out rich items of the treasure when their assailants were too close on their heels and they also killed many of the people so that the latter abandoned their pursuit and returned to their homes.

The vizier and his family, thinking themselves safe at last, now fell into still greater peril. For the Christians had heard it rumoured that Abbas and his men were setting out in this way and so mustered a force and prepared an ambush on the road down which they must go and fell on them when they passed unsuspecting. Abbas was killed in this ambush and almost all the others were either killed or made prisoner. Thus, the great riches of Egypt that they were carrying fell into the possession of our men, which made them all rich. The nobles shared out this wealth and gave a sum of money to the common people, then shared out the chattels and prisoners according to the number of knights. The Templars, who were the most numerous of the party, had the greatest share. Amongst others, they captured Nasr, the son of the vizier, who was much feared throughout the land of Egypt: he was so proud and fierce that they hardly dared look him in the eye. When imprisoned by the Templars, this man often heard speak of our religion; attracted by the principles of Christianity, he quickly acquired our alphabet and language, learning to read them well, and finally asked in all sincerity that he might be baptised. But the Templars, paying no heed to this request, committed an act of great cruelty. For sixty thousand bezants, they sold him and handed him over to the Egyptians, who could not rest while they knew that he still lived. They carried him off, hands and feet tied, and placing him in a cage, they took him on horseback to their country, where they subjected him to great tortures before cutting him up into little bits.

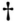

Chapter LI.
How the emperor Manuel broke the promises that he had made to the prince of Antioch. The revenge that he took and the defeat of King Baldwin. A quarrel that arose with the count of Flanders. How the emperor gave the hand of his niece to King Baldwin and came to Antioch. And the death of King Baldwin.

In the land of Cilicia, near the city of Tarsus, there was a great Armenian lord named Thoros,[287] a very powerful and valiant man, overlord of many castles, who did great harm to the subjects of the emperor of Constantinople. So the emperor sent a missive to prince Reynald of Antioch, asking him to muster an army sufficient to chase this Armenian out of his lands, promising to open his treasury to reward him. Therefore, Reynald expelled the Armenian from the imperial territory, but the emperor refused to give him a single denier for his services and Reynald was furious. Following mischievous advice, he took his army overseas to Cyprus,[288] a land then under the sway of the emperor Manuel, and there committed many acts of cruelty and pillage, returning thence to Antioch much enriched by his plunder.

At this period, King Baldwin III, badly advised, also did something dishonest,[289] taking his army to pillage and steal cattle and goods belonging to certain Turcomans from Araby. These men lived in tents and pavilions and had paid tribute money to enter his kingdom in search of pasture under safe conduct. The Hospitallers had a share in the booty and wished to place it in the city of Banyas, of which Humphrey of Toron had given them a half-share. But Turks who lived close to Banyas captured the booty and killed and captured many of the Hospitallers. And the master and the other Hospitallers, noting their losses and seeing that Banyas required a great garrison if it was to be defended, returned their share to Humphrey.

Nur ed-Din, believing that Humphrey was incapable of defending the city, besieged it with a great army.[290] Humphrey, his sons and his knights having made a reckless sally against the Turks, were forced back within the city walls and sought refuge in the keep. The king learned what had happened and sent his troops to recapture the city and defend it. Familiar with the valour of the king, Nur ed-Din did not dare await his arrival but, setting fire to the city and demolishing its walls and towers, raised his siege and took his men into the great forest that grew nearby, not letting them depart, but send-

ing for more troops. And there he remained to spy out the king's activities. The king arrived at Banyas and summoned masons and carpenters, and the burghers and the sergeants of the Temple rebuilt the city and the houses so that everything was more solid than ever.

The king remained a while and equipped the castle and city with provisions and arms. He left his foot soldiers there so that they could take part in the reconstruction and, with his mounted men, went to Tiberias. The following day, he set off again, towards the south to a lake named Melka. Thinking that Nur ed-Din had fled before him and dispersed his army because he dared not remain in the king's vicinity, Baldwin made camp there in reckless fashion, leaving the army without guards. This was a mistake. For the next day, after the king, setting out, had bid farewell to Philip of Nablus and some other barons, Nur ed-Din, knowing that the force was thus weakened, led his own troops so swiftly that they prepared an ambush that same evening in a place called Jacob's Ford, by which the king must pass the following day. In short, the following morning, while our men were crossing the ford talking of this and that, they were suddenly attacked by Nur ed-Din and easily routed. Many were killed and others captured; the king took flight, galloping up to the mountain castle of Safed.[291] As soon as the Turks had left the area, he took a small company of men with him and left Safed for Acre. This defeat occurred on the feast of Saint Gervase and Saint Protase.

Nur ed-Din then returned to besiege the city of Banyas, which the citizens immediately abandoned to seek refuge in the keep. He, therefore, resumed his siege of the keep, against which he launched many attacks and attempted various assaults. However, just when the siege had become so intense that the defenders must necessarily surrender, he raised it. For he had found out that King Baldwin, the prince of Antioch, the count of Tripoli and others of whose courage he was well apprised were approaching Banyas and ready to do battle, so he returned to his own lands, feeling that his victory had given him the upper hand, but unwilling to expose his men to battle, since he knew them to be less valiant than the Christians.

Shortly after this, Thierry, count of Flanders, arrived in Syria[292] with his wife, who was sister to Queen Melisende.[293] On their arrival, there was great joy in the kingdom, which had till then been sunk in depression because of the great number of barons and noble lords who had been made captive during the rout of Baldwin. At Thierry's coming, the king and all others, with the aid of God, gathered new courage and found new strength. On the advice of his men, the king asked Manuel to give him one of his relatives in marriage.[294] Then he readied his army and set forth to besiege the castle of Rugia. During the

siege, he learned that Nur ed-Din was ill or perhaps already dead, for his doctors were convinced that he could not recover. So he raised that siege and went to besiege Shaizar,[295] near Antioch. With Thoros, the great lord aforementioned, and the men of Antioch, he attacked the city with such vigour that it was stormed and pillaged. But though he would then have liked to take the keep by siege – something they would easily have achieved because the defenders were running out of food – everything was abandoned and the city destroyed because Count Thierry had asked the king and barons to grant him the city and castle and had promised to defend them well; all agreed except prince Reynald of Antioch, who wanted Thierry to pay homage to him because the town formed part of his principality. The count refused, saying that he would never hold land in vassalage to anyone less than the king. So, sharing out their plunder, they gave up this city and castle, which might otherwise have proved invaluable to the Christians of Outremer.

The army left Shaizar and laid siege to a solidly fortified castle with many great outbuildings twelve miles from Antioch, which they so bombarded and undermined that the defenders, making certain conditions, surrendered it. But now Nur ed-Din was cured and, as soon as he could ride, he led his men to besiege a castle of ours in the territory of Sidon and did such destruction with siege-machines that the defenders promised to surrender the place if no help arrived within ten days. The king was informed of this and he and the count of Flanders led their army to rescue the castle. Nur ed-Din raised his siege and, coming to meet them, gave battle, by the end of which Nur ed-Din and his men and his general Shirkuh were defeated. This occurred on the eighth of July in the fifteenth year of the reign of King Baldwin III. After his victory, the king went to the castle and rebuilt its defences, then returned to his kingdom. Shortly afterwards, Theodora, daughter of his elder brother Isaac, was most ceremoniously sent by Emperor Manuel to King Baldwin, who married her with great pomp and solemnity.[296]

The emperor himself followed soon after with a great army to revenge himself upon Thoros the Armenian and prince Reynald. Thoros dared not abide his coming, but fled to the high mountains[297] when he learned that Manuel was approaching Tarsus in Cilicia. When Reynald heard this, he sent the archbishop of Lattakieh,[298] Gerard, to find some way of reconciling him with Manuel. This he did, promising to the emperor that Reynald would appear before him wearing a woollen tunic[299] whose sleeves did not come down to his elbows, barefoot and with his sword-belt around his neck and holding by the point a sword bare of its scabbard. He held out the handle to the emperor and demanded pity on his knees. The emperor was a very vain man, as Greeks generally are, and allowed him to remain so long before him in that position[300] that a number of

Frenchmen afterwards criticised the prince for not rising earlier, but he replied that he was unwilling to waste all that he had done before for a mere matter of minutes. Finally, the emperor raised him up, taking him by the hand and kissing him on the mouth, and pardoned all his misdemeanours and accepted him entirely into his good graces.

King Baldwin, when he knew that the emperor was in Antiochene territory, left the count of Flanders in Jerusalem and set forward to Antioch, and thence sent messages ahead of him. He then appeared before the emperor, who welcomed him with great pomp and rich gifts. In the ten days that he spent with him, he contrived to appease Thoros, who did homage to the emperor. The latter, in turn, restored Thoros's lordship over certain places that he desired. All this having been done, Baldwin went back to Jerusalem, returning after Easter to Antioch, where the emperor resided in great triumph. However, the latter returned to his own land without waging war on the infidels, whereupon Nur ed-Din in his joy at this attacked the sultan of Konya and captured the city of Marès and two strongholds and did him much other harm over the course of his raid – during which time King Baldwin, apprised of Nur ed-Din's absence, had the notion of raiding the land of Damascus and this, indeed, he did. But Majd ed-Din, whom Nur ed-Din had left as his lieutenant in Damascus, seeing that he could not resist the king's attack, gave him four thousand bezants and released six poor captive knights. Accepting this ransom, the king returned to Jerusalem.

In this season, prince Reynald of Antioch raided a land inhabited by Armenian Christians who were subject to the Turks and lived by working the land. But on his return thence, bearing quantities of plunder, he was pursued by Majd ed-Din, whom Nur ed-Din had left in Damascus. And though the prince could have returned safe and sound to Antioch, he believed the advice of some of his men and gave battle. His army was defeated, he was captured and taken away because not all his men stood and defended themselves as he did. Baldwin no sooner heard of his capture[301] through the Antiochene barons than he went to ensure that Reynald's territory was safeguarded.

Also at that time, Manuel[302] told Baldwin that, out of affection for the king, he would like to have a woman of Baldwin's line as wife and that he should inform Manuel which of two women he wanted him to marry: the daughter of the count of Tripoli[303] or the daughter of the young prince of Antioch.[304] And the king chose the daughter of the count of Tripoli. The latter was so delighted that he went to great expense on her clothing, indeed, as great as can be. But at last, though the matter had been agreed, the emperor Manuel abandoned the sister of the count of Tripoli and by message summoned to his court the daughter of the young prince of Antioch. The count was furious

"Amalric liked to attend mass and services and loved, honoured
and esteemed the clergy and often had them debate before him concerning
the Holy Scripture and put great questions to them in order to be better informed
about the faith and the commandments of our Holy Mother Church. [...]
when the fever had abated he summoned to the castle the very famous and wise
and notable cleric, William, later archbishop of Tyre, who wrote in Latin
A History of Deeds Done beyond the Sea up to the period of his own lifetime."

(ғᴏʟ. 166ᴀ–166ʙ)

Amalric, count of Jaffa, was crowned king after the death of Baldwin III. He took pleasure in assembling clerics and doctors who would discuss theological matters with him. It is clear that the principal scene represents one such gathering, which took place at Tyre and to which he summoned Archbishop William of Tyre; according to Sébastien Mamerot, Amalric wished to discuss with the archbishop the punishments or the eternal glory that are to be man's lot after death. Although the picture is certainly intended to emphasise the interest the king took in such questions, it may also be seen as a homage paid to William of Tyre, to whom Mamerot refers with admiration on a number of occasions. The archbishop's *Chronique d'Outremer* was one of the sources for *Les Passages d'Outremer*. The clerics, gathered around the king seated on his throne, take part in the discussion, conveying by hand gestures their interest in the debate. The palace courtyard is sumptuous and is surrounded by long walls pierced with a regular line of niches containing white statues: these stand out against the multi-coloured background and are surmounted with monochrome medallions decorated with friezes. In the lower register, Jean Colombe alludes once again to the fighting, in a picture of the Christian cavalry putting a Saracen army to flight.

A 　lmaulry conte de
Jaffes estoit de
moult seul sir
ge du Roy
Baudoyn le tiers
qui sestoit tresphisse sans loir
de son corps. Mais ce non
obstant sourdit grant discort
entre les Barons de surie por
couronner roy. Car les aul
cuns disoient que cestui al

maulry ne se deuoit estre. Et
ses aultres se vouloient mal
que tous ses contredisans. et
la plusprut des Barons se
voulans et consentans cou
ronuer. Combien quen la
fin nostresieuneur aydant
fut cestui Almaulry auint
vrbu. aus par lacord des
patriarsse. arreuesques. e
uesques et tout le clergie

477

and in his ill will towards the emperor he did great harm and damage to the imperial territory.

Shortly afterwards, King Baldwin III died. When in Antioch he had taken pills to purge himself, with no other medical advice than that of his wife, the princes of Outremer being at this time guided by the advice of their wives and paying no heed to doctors since there were at the time Jewish, Saracen, Samaritan and Syrian physicians who knew nothing of medicine and who gave potions and pills to all the great lords. Thus, King Baldwin took medicine from the hand of one Barac,[305] doctor to the count of Tripoli. But when he reached Tripoli, he was gravely ill and at this some of his men gave a dog the remainder of the medicine given to the king and the dog never ate again, but died on the third day, for which reason some said that the king had been poisoned. Whatever the cause, the king suffered from the flux and wasted away. Having been ill for two months, he had himself carried from Tripoli to Beirut, whence he sent to all the prelates and barons of his kingdom, asking their pardon for any wrong he had ever done them and, stating loud and clear that he was dying in the faith of Jesus Christ, he declared the articles of the faith one after another, whereupon his glorious soul returned to Our Lord in the year of the Incarnation 1162, in the twenty-fourth year of his reign and the thirty-third year of his life, on the day following the feast of Saint Agatha, on the sixth day of the month of February.[306] The prelates and barons solemnly carried his body to Jerusalem[307] for burial. And never was any prince on earth so deeply mourned. For it took them eight days to go from Beirut to Jerusalem, and every day the land was covered with people who cried out wondrously as the body passed. And from the mountains themselves came great crowds of Turks and Saracens who joined the crowds by the road and in all sincerity grieved like the Christians.

Now that the land of Syria was in such distress, Turks and Saracens came to Nur ed-Din and advised him that, since he was nearby, he should invade the kingdom of Jerusalem and that he might make great gains because the kingdom had no chiefs and the barons thought of nothing but their grief so that there would be none to oppose him. But Nur ed-Din replied that he would by no means do so and that all peoples should have great compassion for the Christians who were grieving for the lord that they had lost – as well they might, for there had never been a better prince on earth.

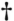

Chapter LII.
Of King Amalric. Of the question that he posed concerning eternal punishment and glory. Of his expedition into Egypt. The defeat of our men by Nur ed-Din. Of the two castles that the Saracens captured from us. How the captain was punished and the Templars were hanged.

Amalric, count of Jaffa, was the only brother of King Baldwin III, who had died without direct heir. But a great debate arose amongst the barons of Syria concerning the coronation of the king, for some said that Amalric should not be king, while others desired his coronation. Despite all opposition, most barons wanted him crowned. But at last, with the aid of Our Lord, Amalric, who was then twenty-seven, by agreement with the patriarchs, archbishops, bishops and all the clergy, was anointed and crowned king by the patriarch Amalric of Jerusalem on the fourth day of February in the year 1162,[308] in the twelfth year since the city had been reconquered by our men, while Alexander[309] was Pope, Amalric, patriarch of Jerusalem, Aimery, patriarch of Antioch, and Peter, archbishop of Tyre. The said King Amalric began his reign in high prosperity for the great justice that he rendered and enforced for his subjects. Though not impeccable in his personal habits, he won the favour of those around him, for he was generous and brave and spent great sums when the occasion required and frequently exposed his own body to peril both to expand his kingdom and to defend and maintain it. He liked to attend mass and services and loved, honoured and esteemed the clergy and often had them debate before him concerning the Holy Scripture and put great questions to them in order to be better informed about the faith and the commandments of our Holy Mother Church.

Amongst many such occasions, at a time long after his coronation, when he was staying in the city of Tyre because he was suffering from a fierce fever, when the fever had abated he summoned to the castle the very famous and wise and notable cleric, William, later archbishop of Tyre, who wrote in Latin *A History of Deeds Done beyond the Sea*[310] up to the period of his own lifetime. And after putting to him a number of questions concerning the divinity, he asked: "I believe all the articles of our faith as they are set down in the Creed, and that after this life, which lasts only in this world, there will be another that lasts for ever, as our faith declares. But I should nevertheless like to know how this can be proved." And William of Tyre, a most excellent cleric,

replied: "Our Lord says in the Gospels that he will come to judge the living and the dead. And he will say to the good: 'Come, take the kingdom of Paradise prepared for you when this world was first made'. And he will say to the sinners: 'Go into that everlasting fire that was prepared for the Devil and his companions'. And our lord Saint Peter says in his second epistle that God has prepared torment for the evil on the Day of Judgement." And the king, having heard the archdeacon, said: "I know very clearly that the Gospels speak of this in many places and that the holy men who have been of our faith say clearly that the good will have lasting joy after this life and that the evil will be in pain and torment for ever. But when speaking to infidels who do not accept or believe the Holy Scriptures, I should like very much to know how I can show them without the witness of Scripture that the other life will come and that there will be another world after this one." Then the archdeacon told him: "Sire, I can easily prove this to you if you are willing to reply correctly. Put yourself in the place of the infidel and reply as he would do: 'You know that God exists'." The king replied: "It is so". The archdeacon next said: "He has all goodness in Him; He would not be God if there were good things lacking in Him, for from Him all good things flow. And He is, therefore, just. And so He renders good for good and evil for evil, nor would He be God if He did otherwise." The king said: "I doubt it not." The archdeacon went on: "You see that He does not do this everywhere in this world. For in this life, good men endure the poverty and injustice and suffering inflicted on them. And the evil are rich and powerful and have abundant pleasure of all kinds. Many like to do evil and gain by evil deeds. And you see by this that Our Lord does not execute his judgement in this world. Know, therefore, that he will do so in the next, for otherwise the evil would retain their wealth and the good would continue to suffer. And for this reason, there will be another world, in which those who have done good will receive their reward and the others will pay in the new life for the evil deeds that they have performed in this world." And when the king had heard these reasons, he was overjoyed and said that none could deny that there was no other world after this life, but that it was as the Scriptures declared.

Having cleared up this question, I return to my task and recount the deeds of King Amalric. The prelates and barons had long heard it said that Agnes,[311] the daughter of the young Count Joscelin, whom Amalric had married before he was king, was related to him in the fourth degree. They made him swear that the marriage would be annulled and so it was done. For lady Stephanie, daughter of Joscelin the Elder and the sister of Roger, prince of Antioch, gave the following testimony. Stephanie was the abbess

of Our Lady the Major, which stands before the church of the Sepulchre, and though she was of a great age, she set out their genealogy thus: "Baldwin of Le Bourg, who was king of Jerusalem, and Joscelin the Elder were the sons of two sisters. From Baldwin was born Queen Melisende, who gave birth to King Amalric, and from Joscelin the Elder was born the young Joscelin, who was the father of this lady Agnes. Monseigneur John, cardinal of the order of Saint John and Saint Paul and legate of Pope Anicille[312] was present at this marriage." They, therefore, granted to Agnes the right to marry again, which she twice did during the lifetime of Amalric. Judgement was given that the children she had borne to Amalric when he was still only count of Jaffa and Ascalon should remain the king's legitimate heirs when it came to his succession.

These decisions once taken, before the end of his first year as king, Amalric mustered a great army and invaded Egypt because the Egyptians were refusing to pay him the tribute that they had promised to Baldwin III, his brother. And there he defeated in battle Dhirgham, the sultan of Egypt, who had come to meet him with a large army. The Egyptians were so frightened by this defeat that they opened the dykes and levees bordering the Nile. Seeing that he could go no further, Amalric returned to his kingdom richly laden with plunder from his enemies. However, a short while later, Dhirgham hastily sent messengers to Jerusalem to hand over the tribute that his brother Baldwin customarily received from Egypt. Indeed, he gave him a greater sum in order that the king should come to his aid and take arms against Nur ed-Din in Egypt. For the latter, at the request and petition of Shawar, the former sultan of Egypt, who had been ejected by the guile and power of Dhirgham, wished to obtain the sultanship for himself. Dhirgham feared that it would not be easy to throw the king's army out of Egypt once it had entered. The king, having heard the prayers and promises of Dhirgham, was also aware that the state of the Holy Land might be threatened if Nur ed-Din conquered the rich kingdom of Egypt, and would quickly have granted his request. But while they were discussing this matter, Dhirgham learned that Shawar and his forces had invaded Egypt and spread through the country, committing excesses while awaiting Shirkuh, captain of the troops that Nur ed-Din was sending from Damascus. Therefore, Dhirgham attacked them and caused them great losses. However, they reassembled their forces after he had retired. Now when the two armies were on the point of engaging, Dhirgham was wounded by an arrow and killed amidst his men. Who fired the arrow, no one knew.

Thanks to these circumstances, Shawar was again master of Egypt and resumed his sultanate. He went to Cairo, where he met with no resistance and had killed all who

belonged to the line of Dhirgham or his friends. As to Shirkuh, the brother of Najm ed-Din, father of Saladin, he was a most skilled soldier despite his servile origins. For indeed, the father of these two brothers was the serf of another Saracen. With the help of Nur ed-Din's troops, Shirkuh attempted to reconquer the kingdom of Egypt and went to besiege and assail by continuous assaults the very rich city of Bilbeis, claiming that he would capture it despite anything that Shawar could do. On learning this, and seeing the great honesty and courtesy of the Christians, and of the Franks in particular, Shawar immediately sent messengers to King Amalric in Syria. They offered to pay what Dhirgham had promised and more again if he agreed to help Shawar. The king, having received pledges concerning Shawar's offer, gathered his army again with the agreement of his barons and, in the second year of his reign, he again left for Egypt. Shawar came to meet him with his army and, having united their forces, they moved directly onto the city of Bilbeis, which Shirkuh had taken and now considered his own. They besieged it for so long that Shirkuh eventually surrendered the city on condition that he could leave in safety with his men, marching through the desert and returning to Damascus as they had come. While King Amalric was still in Egypt, there came in pilgrimage to Jerusalem two great lords of France, Geoffrey Martel, the brother of the count of Angoulême, and Hugh of Lusignan. These two lords, returning to Antioch, heard that Nur ed-Din was behaving in arrogant fashion towards the territory of Tripoli because of the handsome victories that he had won. Fearless, they took with them the master of the Temple, who was close to Antioch, Robert Martel, and other captains and all the soldiers they could find and secretly left to attack the army of Nur ed-Din. They won their battle and earned themselves very rich booty. The rout was so serious that Nur ed-Din himself escaped only through multiple dangers, for he had one foot shod and the other bare, and, riding on a mule, he fled ignominiously and was in grave danger of dying there.

However, to avenge this shameful defeat, he assembled a great army and came to besiege the castle of Harenc in the territory of Antioch. Therefore, the prince and the count of Tripoli, Thoros, the powerful Armenian, and several other lords also mustered a great army and set out to raise the siege. But Nur ed-Din dared not await their arrival and withdrew. The pride of our men was so swollen that they set out in pursuit of them without even placing themselves in battle order. When Nur ed-Din and his captains saw this, they turned about and placed their own men in battle order and attacked our men with such vigour and fire that they were stupefied and aghast; barely one of them drew his sword in self-defence, but all cried pity and surrendered. So our

men were conquered, and all were killed or taken as prisoners to Aleppo and humiliated, with the exception of Thoros, who had opposed the pursuit of the enemy beyond Harenc, and, when he saw the rout, he fled, looking to save himself.

This battle took place on the feast of Saint Lawrence in 1165.[313] Amongst those made captive were Bohemond, the young prince of Antioch; Raymond, count of Tripoli; Constantine Coloman, the magistrate of Cilicia who represented the emperor of Constantinople; Hugh of Lusignan; Joscelin III (son of Joscelin II, former count of Edessa) and several other lords who surrendered to their enemies with clasped hands. The Turks then took advantage of this misfortune to wreak great damage in this area. As to Nur ed-Din, he returned, hope renewed, to Harenc, whose populace, terrified and distressed, immediately surrendered to him. Yet help was coming, for Thierry, count of Flanders, and his wife (who was the sister of King Amalric), arrived shortly afterwards in Cilicia with many valiant soldiers, who for a while restored the courage of the Christians of this region. Despite this, Nur ed-Din went to besiege the city of Banyas and forced its surrender, which was made on condition that the inhabitants could leave in safety with their chattels.

Banyas lies at the foot of mount Lebanon and was called Dan by the children of Israel living there, in honour of one of the twelve sons of Jacob, who inherited this neighbourhood. And this city was the jewel of their inheritance to the north and Beersheba the best in the south. Thus, the Scriptures, measuring the Promised Land, state that it extended from Dan to Bethsheba. This city was subsequently enlarged and developed by Philip, the elder son of Herod, who named it Caesarea Philippi in honour of Tiberius, who was then Roman emperor, though its true name was Paneas. But the French call this city Banyas. Nearby there are two springs, one named Jor and the other Dan. These two names put together make up the name Jordan. When King Amalric had thus chased Shirkuh out of Egypt and learned of the damage caused to the Christians by Nur ed-Din, he returned to his kingdom as quickly as he could. He met up with the count of Flanders and led him with all the troops that he could muster into the land of Antioch to bring aid to the region. Then he went back after the young prince Bohemond had joined him, he whose sister had been married to the emperor of Constantinople. Some said that Nur ed-Din had freed Bohemond[314] because he feared the emperor and was anxious that the emperor might demand the release of Bohemond as a gift, something that Nur ed-Din would not have dared refuse. Others claimed that Nur ed-Din, who was a cunning man, had freed him and restored him to his country because he was young and could not do him such harm as King Amal-

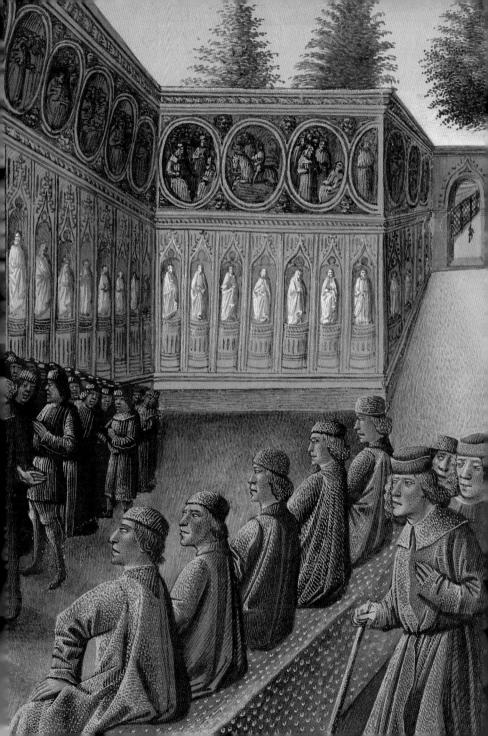

ric, governing his lands on his behalf, might do if Nur ed-Din had kept Bohemond in prison.

At the same time, Shirkuh attacked and took by treason a Syrian stronghold called the cave of Tyron, whose inhabitants left with the Turks for fear that they would be punished. But the captain of the castle was found shortly afterwards in that region and taken to Sidon and hanged. By a similar piece of treachery, Shirkuh recovered another castle that was reputed impregnable, on the far bank of the Jordan on the border of Araby. The king brought his army back to this castle to relieve it, but before he could reach it was informed that the Templars defending it had surrendered it without so much as asking for his assistance. The king was so angered by this that he sent for and forthwith hanged the twelve Templars responsible for this betrayal.

Chapter LIII.
How King Amalric went to the aid of Egypt for a second time, and of the trouble he and his men had in crossing over the Nile and in crossing back, that they might fight against Shirkuh. And of the agreement made between those two, so that no grievous battle was fought.

Shirkuh,[315] seeing that King Amalric pursued him hotly, knew that he could no longer gain anything in Syria, and so he thought rather to seize the kingdom of Egypt and went, therefore, before the caliph of Baghdad, who was at that time the most mighty prince of all the Saracens, and he honoured him like a god. And Shirkuh showed him how Egypt, which was the finest and the most delightful country in the world, was in the hands of Egyptians who knew nothing of the skills of warfare. And furthermore, they had a prince and a lord so puffed up with presumption that he caused himself to be addressed as caliph, in like manner to himself, and held himself to be the most great and true prince of the faith of Mohammed and maintained that all those of that faith should obey him. And then he said, too, that it was most shameful to him that he should be thus debased by so wicked a people and that, if he would but give him the order, the time was then ripe to avenge himself on this prince of Egypt and his people. Through such words and other like proposals, the caliph of Baghdad was so moved that he consented to do what Shirkuh asked, and he, therefore, sent letters to all the barons who were at his command and ordered that they should come in all haste with great

force of arms and should follow Shirkuh whithersoever he would lead them. One need not ask how great was the army that he gathered together from divers parts of the Orient and that he led towards Egypt!

When King Amalric was warned of this, deeming that such a neighbour would be most troublesome to him, he took with him all those knights and other men whom he could gather together most speedily and moved out to deny Shirkuh the passage through the deserts, and they galloped so swiftly that they came to Kadesh Barnea, but they did not find him. So he left that place as soon as he might, because it was not wise to linger there. And he issued a great summons, proclaiming throughout all the land that all should assemble, both on foot and on horseback, in the city of Ascalon, and thus it was done, so that he departed thence on the third day before the feast of the Candle with all his army, taking with him as many men and as much food as seemed fitting to him. And going by the way that went through Gaza, the last city in the kingdom of Jerusalem, he came into Egypt, to an ancient desert city called al-Arish, and thence went on and came to Bilbeis – which was once called Pelusium. Shawar, hearing of the sudden arrival of King Amalric, was seized with terror, for he could not have believed that he would come to his aid.

Nevertheless, when the latter sent him messengers and he learned through them of the king's great good will towards him, he rejoiced greatly and praised the boldness and great goodness of the king and the Christians, and thenceforward acceded to all that they requested, both of himself and of the riches of Egypt; and he gave to them a very great part of the treasures of the caliph, so that each one of them rejoiced thereat. And thenceforward, their two armies joined together, they took the road until they made camp on the banks of the river Nile near the city of Babylon in Egypt, which, according to some, was in olden times called Memphis, but some say this was not so. For at about ten miles distant from this place on the Nile, there can be seen to this day the ruins of a most great city, which those who dwell in this country declare was Memphis,[316] saying that the inhabitants left it of their own free will and went with all their possessions to dwell in the new Babylon, for it was closer to the Nile. And one can find, in a book made concerning the princes of the Orient, that this city of Babylon and that of Cairo likewise were founded in the year 361 after Mohammed by Gawhar Al-Siqilli, constable of a mighty king of Africa called Al-Muizz Lideenillah, who conquered all of Egypt for his master and made Cairo the chief city of the whole kingdom. Here, the king came to dwell, leaving his city of Kairouan and all the other towns of Africa because of the delights that he found in this city of Cairo.

Now when our men and the Egyptians likewise were encamped at about a half-league from Babylon, they determined that it would better avail them to cross over the river Nile and to go ahead of Shirkuh to do battle with him at the entry to their own land. For if they waited until he had crossed over the river, they would find him and his men more bold and difficult to defeat, for they would have nowhere to flee to because it would be too grievous a matter for them to go back across the Nile.

But they could not go fast enough, for when they had crossed over the river and come to that place where Shirkuh had been before, he had, indeed, already crossed onto the other bank and they found there but a handful of Turks of his men, who had not yet been able to cross over. From these, after they had taken and bound them, they learned of the condition of Shirkuh, and of the number of his men and of what he meant to do. Thus they learned that, after he had passed through southern Syria and went into the desert, he lost a great number of his men because of a most great tempest that arose in the desert at the very moment when they were passing through. For the wind swept through so violently that his men were forced to get down off their horses and to lie down on the ground, otherwise they would have been carried away. Moreover, at the same time, there was heaped upon them so great an abundance of sand that they lay beneath it all covered up as if buried and they knew not what to do. And indeed, in these deserts there often arise such tempests, as dangerous as those upon the sea, and the heaps of sand move in waves like the flow of the sea.

When our men had heard these tidings and knew that Shirkuh had already crossed over, they crossed the Nile and went to make camp near Babylon, in that place where they had been before. And since matters fared thus in Egypt, Shawar knew that the war would not soon be over and that he had a mighty enemy to deal with, and, therefore, he sought a fitting way to remedy this. And fearing lest the king and his barons and their men should return to Syria, for they had not enough money to pay the troops and to maintain their army, he came to the king and his council and said to them that it would be wise to renew the covenants that were between them and the caliph. For against those services that the king rendered him, the sums to be paid in tribute ought most certainly to be greater than they had been hitherto, and they should speak of this matter, for it was plain to see that the war could not come to a speedy end. The king and his barons, when they had heard Shawar the sultan, spoke at length of these matters until they had agreed on certain sums of money and covenants, to which the caliph should give his word and which he should promise to keep. And the king, for his part, should give his word and should promise that he would not depart from Egypt until

Shirkuh and all his army had been driven out, or had been routed so that they could do no more harm to any part of the kingdom.

They sent to the caliph to receive his oath for these covenants a young knight called Hugh of Caesarea[317] and certain companions: and these, when they had come to Cairo, saw there the houses, palaces, sumptuous things and other delightful places so extraordinary that, if you had heard tell of them, you would not believe it. Now the caliph wished to swear his oath with a glove on his hand, but it was determined that he should swear the oath bare-handed,[318] which he did, lest he displease Hugh of Caesarea, who would accept no other fashion. A number of great Egyptian lords who were present were greatly angered by this, for they guarded the caliph in his kingdom and honoured him like a god. And the men of Baghdad of whom I have spoken before in this chapter do likewise with their caliph, and each caliph maintains that he is the true successor of Mohammed.

As for Hugh of Caesarea and his companions, they swiftly returned to the army and told of the surety the caliph had given them that he would keep the covenants. And for this reason, they took up their task with greater courage and, when they had raised camp, they galloped against Shirkuh that they might drive him out of the land. When they were near the river, they made camp for the night, but on the morrow in the morning they saw that Shirkuh and all his men were come up opposite them on the bank of the river, and were positioned there to prevent them from crossing. The king, when he saw this, sent for ships and caused a bridge to be made that they might pass to the other side, but when the bridge had been made as far as the middle of the river, Shirkuh's men loosed such numbers of arrows and hurled such numbers of stones at them with slings that the task was abandoned. And so the two armies remained a good month, whilst our men could not cross over and Shirkuh's men dared not abandon the bank lest our men should cross over and confront them.

Nevertheless, in the end, Shirkuh sent out a party of his people who seized an island nearby, but the king sent against them Miles of Plancy and Kamil, son of Shawar, with a great band of Christian and Egyptian knights, by whom the Turks were put to flight in a pitched skirmish and battle: some were killed in battle while others were drowned as they sought to go back across the river, and so it was that Shirkuh lost a good five hundred knights and, for this reason, he began most deeply to regret this action. Shortly thereafter, there returned to the aid of the Christians Humphrey of Toron, constable of Jerusalem, and Philip of Nablus, who had remained in the Holy Land for some other reason, accompanied by a great army, at which the army of the king was much com-

forted and rejoiced greatly. And after their coming, the king left Hugh of Ibelin with a party of his men to guard the bridge that he had begun and, on the counsel of his barons, led his great army so that it might cross the Nile by an island that lay twenty miles thence, for all were of the opinion that they might thus surprise Shirkuh, who feared nothing from that side. But after the king and his army had crossed onto the island and sought to cross the other arm of the Nile to move against Shirkuh, there arose so great a wind that they could not go over, and were forced to retreat from that island. Nevertheless, in the end, they crossed over six arms of the Nile, but when they came, in the night, to the last arm that they meant to cross over, on the morrow Shirkuh went back on the road by which he had come. This they saw as soon as it was light, for he was no longer in that place where he and his army had camped, on the bank before them, and then the king's troops knew that they had, in truth, gone away.

The king, therefore, sent a party of his men to garrison the city of Cairo, fearing lest Shirkuh should go there rapidly, and he and the rest of his army caused Gerard of Pougi and Maadain, one of the sons of the sultan, to cross to the other side of the Nile, and furnished them with men enough to follow Shirkuh rapidly, that they might confront him if by chance he thought to come back across the river. The king and Shawar pursued Shirkuh thus for three days and on the fourth they knew that he was nearby, and thereupon battle was joined, although their forces were not equal in numbers of men. For Shirkuh had nine thousand Turks, well armed, and three thousand archers together with ten thousand Arabians, but as for the king, he had then no more than three hundred and seventy-four knights and horsemen, together with Shawar and his Egyptians, whose skill in arms was so poor that they were an encumbrance rather than an aid.

Now Shirkuh, most subtle in warfare, had ordered his men to go up onto a most steep and sandy mountain. And yet, notwithstanding all these things, with the help of Our Lord, he was beaten, and they fled, he and his men, as quickly as they could, save for his nephew Saladin and with him a party of Turks, whom Hugh of Caesarea attacked. But he was taken prisoner by Saladin and led away, after a number of Christians of his company had been killed and taken and others driven away, without the men in the great army of King Amalric knowing anything about it. And in this defeat, Shirkuh lost one thousand five hundred knights and the king lost but a hundred. When night fell, Shirkuh rallied his men and moved off towards the city of Alexandria, whose citizens opened the gates to him, believing him to be victorious. For this reason, the king and the sultan, when they heard this news, went straightway to besiege the city and encir-

cled it so tightly that those who dwelt there began to suffer famine. Shirkuh, therefore, who knew that he and his men might court disaster for want of food if they remained longer in that city, gave to his nephew Saladin one thousand knights and horsemen and entrusted to him the guarding of the city. And when he had done and ordered this, he sallied forth into the fields by night and passed close by the army of the king so secretly that the latter knew nothing of it until morning, when he sent his men after him as swiftly as he could.

But when he was in Babylon, there came to him a great lord of Egypt called Benercarselle, who said to him that he had cousins in the city of Alexandria who had assured him that, if the king would go back there, the people would surrender the city to him by reason of the great famine that was there. And so the king took counsel and then returned before Alexandria: when Shirkuh heard of this, he went before the city of Chus, thinking to take it by force, but he could not do this, despite all his money, and so he moved on before Babylon, where he found Hugh of Ibelin, who defended it strongly.

And then, knowing the difficulties suffered by Saladin, his nephew, he spoke to Hugh of Caesarea, who was his prisoner. And amongst other things, after he had both greatly praised and bitterly blamed the Egyptians, he set before him how they were so cowardly he could have taken from them their kingdom, which they were not worthy to hold, had the king not acted unwisely in succouring so wicked a people. And he besought him to go and treat with Amalric, that peace might be made between the king and himself, and he would surrender Alexandria. Hugh of Caesarea, by way of excuse, said that he would not readily be believed, for it would be thought that he asked this thing but for his own deliverance, but counselled him to send first another well-known knight to the king to treat with him, and then he could go thereafter. Thus it was done, on condition that those prisoners whom Shirkuh held should be surrendered, and when the city had been given up, Shirkuh and Saladin and all their men came forth freely from the city and the surrounding country under the safeguard of the king, as it had been agreed.

The king, but a few days thereafter, hearing that his kingdom was sore oppressed by certain Turkish enemies who knew that he was not there, called Shawar, at whose request he had treated with Shirkuh, and ordered him to come to Alexandria. And there, after he had punished certain of the citizens by death and others by exacting money, he appointed officials as he saw fit. Then they moved off again with their armies and returned to the city of Babylon, which was most freely given up to them by Hugh of Ibelin, as he had promised. And when King Amalric had confirmed the sultan Shawar

in its lordship and, with this city, the lordship of all of Egypt likewise, he returned to his kingdom and came to the city of Ascalon on the eve of the feast of Our Lady, in the middle of the month of August[319] in the year of grace of Our Lord 1167, or the fourth year of his reign.

<div align="center">✝</div>

Chapter LIV.
How King Amalric returned to Egypt. Of the cursed navy, which was the reason why the kingdom of Egypt did not fall into the hands of the Christians. Of the treachery of Shirkuh and how he became lord of Egypt. Of the army that the king led before Damietta, of the other armies of Saladin and how King Amalric went to Constantinople and to his death.

Some days thereafter Manuel, the emperor of Constantinople, sent two of his princes before King Amalric, whom they found in the city of Tyre; and they declared to him that the emperor had heard that the kingdom of Egypt, which was once so rich, had fallen into the hands of wicked and cowardly people, and, therefore, he wished to seize it from these heathens if the king was ready to help him. The king assembled his council and gave his accord and swore, in all things concerning this matter, all that the emperor asked of him. And for this reason, shortly afterwards, he had the rumour spread secretly throughout Jerusalem that Shawar would no longer keep the conventions, as he had promised him, and that he was seeking by all the means he might to make an alliance with Nur ed-Din, king of Damascus. And on this pretext, before he had received a reply to certain messages that he had sent to the emperor Manuel, he assembled his army and took the road to conquer Egypt. And although the sultan Shawar was keeping and meant to keep those promises he had made to him, he crossed the desert in ten days, encamped his army before the city of Bilbeis in Egypt and, taking it by surprise, attacked it so continuously and with such force that he took it by assault and pillaged it, after he had made a great massacre of the Egyptians and taken a number of prisoners from whom he and his men thought to extract money.

King Amalric, having thus had his way at Bilbeis, led his army before Cairo, but he went in an ill-ordered fashion and too slowly, for, as a number of those who know of the matter have said since, if he had gone there in one day or but a little more, as he could well have done, he would have found the city so lacking in food and defenders

that it would most easily have been surrendered to him. And if he had taken the city, he would then have found none in Egypt who could have withstood him, and thus he would have had his entire will of the kingdom. But he took ten days to do what he should have done in one because, as it was said afterwards, he had hoped to entice Shawar to give him a great quantity of deniers, for he believed that if he went to pillage the towns and cities as he had done at Bilbeis, then those in his army would take so great a part of the spoils that scarce any would be left to him.

Moreover, Shawar, who knew well the king and a number of his intimates likewise, declared most humbly to him by his messengers that he would give him a certain sum of money, if in return he would be ready to go back to his kingdom of Jerusalem. When the messengers came before the king, they promised him on behalf of Shawar that he would give him twenty times a hundred thousand bezants, so the king promised that, in this case, he would depart again and return to him his son, whom he was holding prisoner. When these conventions had been agreed, the messengers of the sultan said that the money was not all in one place and they gave him one hundred thousand bezants and two hundred noble children as hostages. So the king, raising his siege, led his army to an island six miles distant from Cairo, and then he gave back one of the sons and the nephew of the sultan, and awaited on the island the payment of the whole sum. Yet he had but just arrived there when he learned most certainly that Shirkuh, because the sultan had besought him and made him secret promises, had already left Damascus with a most great army and was preparing to come into Egypt. So the king, thinking to forestall him and with all the haste he could, led his army into the desert to fight him before he could join up with the men of Egypt, but he could not, however, go fast enough to prevent Shirkuh from coming into the country by another way that crossed the desert.

When the king heard this and knew that Shawar had deceived him, he determined that, since the forces of the Egyptians were now doubled, he would return to his own kingdom, which he did. Then Shirkuh, feasted most splendidly by Shawar, drew up his army near Cairo, keeping close to his heart his evil intent and thinking that the time was come when he might conquer Egypt, and he made great show of affection for Shawar. The latter trusted him and went often to his tents to see him, and made him great gifts and returned then to Cairo. But when Shirkuh saw that Shawar distrusted him no more, he ordered his secret intent to be carried out, so that when one day Shawar came before Shirkuh as was his wont with a number of emirs and their sons, certain Turks, taking hold of his horse by the bridle, slew Shawar and cut off his head, and the

emirs, and their sons likewise, took flight and returned most terrified to the city of Cairo, where they told the caliph of the treachery of Shirkuh. Now the latter promised to the two sons of Shawar that he would protect them from all harm and from the forces of Shirkuh, provided they stayed constant and loyal to him and neither went nor sent messages to Shirkuh, but they did none of these things. A few days later, they sent messages to Shirkuh and besought him to make peace with them and give them sureties, and when the caliph heard of this, he had their heads cut off. And as soon as Shirkuh knew this, he straightway ranged throughout the land and took and garrisoned all the cities, encountering no resistance, and then he came to Cairo. There he abased himself before the caliph and honoured him like a god, as was their custom, and was received with great state, so that he was made sultan of Egypt and entered into possession thereof by the gift of a sword. And thus through covetousness was the kingdom of Egypt lost to the Christians and won by their enemies, which brought great increase in might to the latter. But thenceforward the might of the kingdom of Jerusalem and all the Holy Land waned and never ceased to decline, as will be seen hereafter.

For Shirkuh died shortly thereafter,[320] and so there came into the lordship that most great enemy of the people, the heathen Saladin, his nephew, who at the outset exercised his office in most savage fashion. For even as he came before the caliph feigning to bow before him that he might receive the state and charge of sultan, he took a great hammer and struck him so great a blow on the forehead that he felled him dead to the ground, and certain of his men, who were forewarned of what was afoot, killed all the children of the caliph. Thus it was that Saladin remained the sole king and master of Egypt and did away with the office of caliph and sultan. And though he entered into his new estate in most tyrannical fashion, nevertheless, there were those who said thereafter that the caliph and the Egyptians, who already hated the lordship of the Turks, had undertaken to kill Saladin if he thought to hold the honourable office of sultan, but that he was warned of it and so forestalled his enemies. The caliph and his children being thus slain, Saladin seized their treasures and shared it amongst his knights. And there are also those who tell that the Egyptians hid certain of the children of the caliph so that, if the land were ever in a better state, they would have some who were of that lineage.

Moreover, in the year 1169, the emperor Manuel sent a fleet of ships in which were one hundred and fifty galleys and divers other vessels, which came at the end of September into Tyre and then into Acre, so that, when the king had joined his army with that of the Greeks at the port of Ascalon, they set sail and came before Damietta and laid siege to it. And in truth, if they had attacked it as soon as they arrived, they

would have taken it most easily because it was as if empty of defenders, but they spent three days searching the gardens and they lost time through the disloyalty of certain people.

And during this time, there came to succour those in the city, from Babylon and Cairo, great numbers of men and other armaments that went into Damietta, and they defended it strongly against the assaults and machines of our men, and thus, being there in such great numbers, they could also have held the countryside around. In the end, certain of the Greeks at first, and then the king, princes and barons, saw that the men of the emperor Manuel, who had in the beginning promised to send limitless treasures for the pay and expenses of all the army, went about from day to day lamenting that they were forced to borrow. The rain also continued so heavy that the tents and pavilions rotted right away and the people in the city, too, defended themselves with great strength and showed no desire whatsoever to surrender. So they made terms and conventions with the most mighty emir in the city, who was called Genelin, and when the matter was concluded, for a period of three days the Christians passed freely into the city and the Turks and Egyptians rejoined their armies. When the three days were over, the king returned to his kingdom, so that he came into Acre on Christmas Eve. But the Greeks suffered so great a tempest that they lost almost all their great ships and the small ones, too. To be brief, of all that navy there remained but little that was sea-worthy, and thus it was that so noble and excellent an army vanished in so short a time.

In the summer that followed,[321] the earth shook so mightily that part of the city of Antioch was destroyed, and a number of other towns and castles of Syria likewise. The cities of Jebail and Lattakieh, which lie on the coast, collapsed also and likewise the cities of Aleppo, Shaizar and Hama, which are inland, together with so many castles, that it seemed beyond belief.

And as well as all these dreadful happenings, in the following year, Saladin raised a great army from Egypt and Damascus and came to lay siege to the stronghold of Daron, and King Amalric, that he might go to their aid, assembled his army, in which there were but two hundred knights on horseback and around two thousand on foot, and set off for Daron. Certain knights of Saladin made a number of sallies and rapid attacks against the Christians, but in the end, the Turks, after they had taken by force the lower town of Gaza and slain and taken prisoner certain of the Christians, both amongst those who were defending the city and likewise fifty others who had foolishly strayed from the king's army, went back into Egypt and did no more.

In the year 1170, Henry, king of England, husband to Queen Eleanor, had martyred in England Saint Thomas of Canterbury, for love of whom Our Lord performed thereafter and performs to this day miracles without number. And in the following year, 1171, King Amalric had assembled the three estates of the kingdom of Jerusalem, and there it was concluded that, to bring succour to the Holy Land and to the other lands of Outremer, they must send to the emperor Manuel. And when the king knew that there were none who dared to undertake this journey, he said that he would go himself, and so it was done, which greatly delighted the emperor Manuel, who welcomed him and feasted him with great state and most amicably. And then he gave him most splendid and rich gifts, and the Protosebastus John Comnenus behaved in like manner. Now the king had married his daughter, who bore him a daughter whom he wished, after he had returned to Syria, to give in marriage to Count Stephen of Champagne, who was the son of the old count Tibald of Blois and Chartres. But when the latter arrived in Jerusalem, he was too particular and would not marry the young maiden, and he returned to France in a most wretched state, for he had been robbed in Cilicia by the brother of Thoros,[322] the rich Armenian, who set spies to watch him. And these left him nothing but a poor nag on which he made his way to Constantinople, where he found money enough, for men knew well that he was a great and rich prince.

In the year that came after,[323] Saladin gathered together a great army of men of Egypt and other Turks that he might go into Syria. And King Amalric for his part assembled his own army likewise, wherein was the patriarch bearing the True Cross, and he went towards Saladin, but in such a way that neither army could find the other and so they each returned and did no more. And in the following year, which was the tenth year of the reign of King Amalric, Saladin once more raised a great army and came into southern Syria and the king led his army against him. But because he feared, if he went to one end of his kingdom, lest Saladin should attack the other end, he remained by mount Carmel and did not go forth to attack. And when Saladin knew this, he ranged throughout the land, tearing out the vines and trees, and burning and laying waste a number of villages that were not walled, and then he returned to Egypt as he had already done before.

In that year, the Templars committed a most cruel deed, for in the archiepiscopal see of Tyre in the land of Phoenicia, beyond the bishopric of Tortosa, there dwelt a race and men who were called the Assassins. They had around ten castles and certain villages between them and they had followed the laws of Mohammed most faithfully for a good four hundred years, so that all the other Saracens called them the true dis-

ciples of Mohammed. And this continued until that time when, in accordance with
their custom, they elected one of their number to be their lord, for none could succeed
in any other fashion to their principality. Now this new lord, who was most noble and
of high ability, had seen that in the Koran and the book of the law of Mohammed there
were a number of things that were dishonourable and that men could neither do nor
believe in accordance with strict justice and upright usage.

So he obtained the Gospels of Our Lord and the epistles of Saint Paul likewise,
and as he read them and read them again, he understood by the grace of God that the
Christian faith was the only true path to Heaven. For this reason, he first set forth in
secret to the wisest men of his land how this was so and converted them to the
Catholic faith, and thereafter he himself preached publicly the advent of Our Lord Jesus
Christ and his faith to the rest of his people. And in the end, he converted them all and,
forbidding them to follow the false teachings of Mohammed, he caused them to drink
wine and to eat the flesh of the pig and of other beasts, which Mohammed forbids them
to drink or eat. And when he saw that all his people were ready to receive baptism, he
sent one of his wisest men to declare to King Amalric what he had done,[324] and to say
that he and his people were ready to receive baptism and to keep henceforth and for
ever to the Catholic faith, if the king would be pleased to grant them certain small and
most reasonable requests. And so they asked that the Templars should release them
from some two thousand bezants of rents or other revenue that they raised from them
each year on their ten castles and their other villages.

At this, the king rejoiced exceedingly and granted most willingly the requests that
they had made. And regarding the Templars, he spoke to the master and other broth-
ers of the order and asked that they agree to release them from their rents, that Our
Lord might thus have at his service so mighty and so rich a people who had a good
sixty thousand men bearing arms, and that the Holy Land should have their help and
succour. And against these rents, he offered the Templars comparable lands in his own
kingdom, and these lands they might choose in whatsoever part of the country seemed
pleasing to them. And once this was done, he agreed to that which the messenger of
the Assassins had requested and gave him rich gifts and bade him take his leave and
return to his lord, who was called the Old Man of the Mountains, and he gave him safe
conduct for a great distance.

But the harshness and pride of the Templars, and likewise their insatiable avarice,
moved them to commit a most cruel deed, for when this wise man, who already con-
ducted himself like a Christian and mistrusted nothing, seeing that he had the king's

ANOINTING AND CROWNING OF BALDWIN IV.
DEFEAT OF THE SARACENS (1177)

"Now it befell, while the army was in that place, that King Baldwin IV,
being at Nazareth, was taken with a most high fever and suffered greatly. [...]
the leprosy that he had before he was crowned had attacked him so grievously that he
had lost his sight and could do nothing for himself, either with his feet or hands."

(FOL. 187VB)

Amalric's son, Baldwin IV (the Leper), came to the throne in July 1174, at the age of thirteen. This chapter begins with the depiction of the ceremony at which the youth is anointed with the Holy Oils and then crowned by Amalric, patriarch of Jerusalem, in the presence of a throng of prelates and barons. The young king is naked to receive the unction, while a cleric holds a book of holy writings. Jean Colombe provides an imposing setting for this ceremony, which was so important for the kingdom of Jerusalem: it takes place in a vast and magnificently decorated church, whose choir and nave are lighted by glass windows and adorned with great, multi-coloured statues of saints and apostles standing on high columns. A *pietà* can be seen at the entrance to the choir, evidence of the artist's taste for all things connected with sculpture and architectural decoration. Depicted in the lower register is a violent clash between two armies, in which the Christians are pursuing the Saracens. This should perhaps be seen as a reference to one of the important battles fought by King Baldwin soon after his coronation, with Sébastien Mamerot alluding at this point in the story to the manner in which Baldwin succeeded in putting to flight one of Saladin's brothers, Shams ad-Dawla, in the territory of Ituraea.

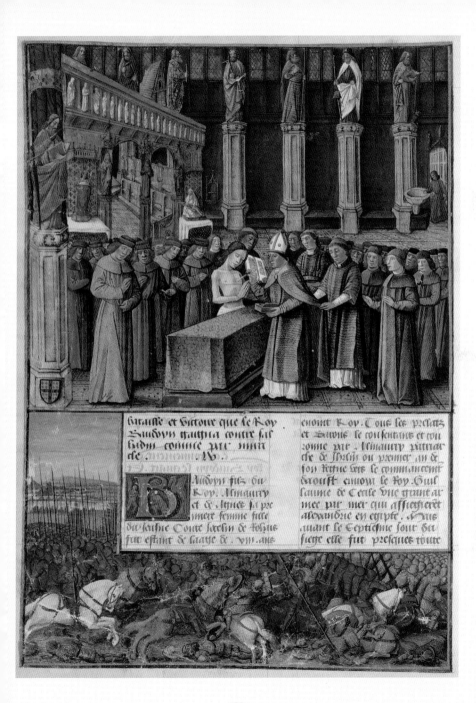

biraille et histoire que le Roy
Bauduyn traictra contre sar-
bidin comme par cuurt
ce... IX.

Bauduyn filz du
Roy Almaury
et de Agnes sa pre-
mier femme fille
du saisme Conte Ioselin de Iohins
fut estant de l'aage de .xiii. ans

enoint Roy. Tous les prelats
et barons se consentans et cou-
ronne par Almaury patriar-
che de Iherlm ou premier an de
son regne firs se commencerent
desrousf enuois le Roy Guil-
laume de Cecile vne grant ar-
mee par mer qui assiegerent
alexandrie en egipte. Ar vne
auant le septiesme jour du
siege elle fut presques toute

safe conduct, was hard by his own country, certain Templars, inspired by the Devil, sprang forth from ambush[325] and slew him and cut him into pieces. When this murder came to the knowledge of King Amalric, he lamented it most grievously, both for the great loss to Our Lord of so many souls and to the Holy Land likewise of such strong reinforcement, but also because he feared lest this Old Man of the Mountains might have him killed, believing that he had been party to this vile act. For when this old lord of the Assassins hated any prince and commanded certain of his people to kill him, they knew no rest until the moment when they had accomplished his command, for they believed that nothing was more worthy than to obey him and that the death suffered in such a cause was the most glorious of all. And for this reason, the king called together the three estates of his kingdom and sent before the master of the Temple that he should deliver the murderer. And in the end, the king himself went in person, and caused a number of Templars to be taken by force and, in particular, the murderers, and he sent them to Acre, where they were imprisoned so that he might make plain to all of Christendom the great outrage that the Templars had done. But shortly thereafter, he departed this life.

Now because Nur ed-Din, king of Damascus, had died but a short while before,[326] King Amalric had gone to besiege the queen, the wife of Nur ed-Din, in the city of Banyas.[327] This lady sought help from Damascus and from all her allies. But because she gave the king great sums of money, he raised the siege, which he had held for fifteen days and returned, already ill from the flux, to Jerusalem. And after he had come there, his illness grew so much worse that he died of it in the year of grace of Our Lord 1173 in the month of July, on the eighth day after the holy day of Saint Martin in the summer, having reigned for twelve years and five months.[328] He was a great lawgiver and a good and wise king and thus he was deeply mourned by all his subjects and a number of others likewise. His body was buried with great state and with most great lamentations on the mount of Calvary, where were buried likewise the other Christian kings of Jerusalem, his successors. May Our Lord God pardon him his sins!

Chapter LV.
The crowning of King Baldwin IV. How Saladin became king of Damascus and wished to seize Aleppo, and of the coming of Count Philip of Flanders. Of the messengers from the emperor Manuel and of the great battle and victory that King Baldwin won against Saladin as if by a miracle.

Baldwin, son to King Amalric and his first wife, Agnes, who was daughter to Count Joscelin II of Edessa, was at the age of thirteen years anointed with the holy oils and proclaimed king, with the consent of all the prelates and barons, and he was crowned[329] by Amalric, patriarch of Jerusalem. In the first year of his reign, towards the beginning of August,[330] there was sent by King William of Sicily a great sea-borne army that laid siege to Alexandria in Egypt. But before the seventh day of the siege, this army was well-nigh utterly destroyed by the Turks, who came to succour the besieged. And they perceived that the chief of the Sicilians did not know how to conduct this kind of warfare, for few of his men escaped thence, and then only by fleeing in all haste.

The count of Tripoli came straightway to the court of the king of Jerusalem and set forth a number of reasons why he should have the government of the king and the kingdom.[331] But the king made answer, in accordance with the counsel of his barons, that not all the prelates and princes and barons were gathered there and that, without them, neither could there nor would there be made so great a decision. But he would have them convene at another time and whatever he then did, the count should content himself therewith. And but a short time afterwards, because of this matter of the government, there was slain and murdered the king's seneschal,[332] called Miles of Plancy in Champagne, by certain men whose names were not known. Nevertheless, it was said that a number of the barons had caused him to be killed, because, after the death of King Amalric, he had governed the king and the kingdom at his pleasure, with no respect for right or justice, and not deigning to call any of them to give counsel nor to order the affairs of the kingdom. And it was said that he had been thus raised to this office because he was cousin to Count Henry of Champagne and had directed King Amalric and would continue to do as he pleased with the young king, his son.

A few days later, the king called together his three estates and, at the end of their deliberations, he entrusted and committed to the count of Tripoli the guard and govern-

ment of his own person and his kingdom. And in that very same year, the Saracens of Damascus sent secretly to Saladin and besought him to come to them straightway, and they would give him their city and all its lands so that he might oppose their lord and king who was called Malik as-Salih Ismail, son to King Nur ed-Din, who was still a child and who was at Aleppo. And so Saladin, forgetting that it was Nur ed-Din who had raised him up and ungrateful for the possessions he had received at his hands, undertook to disinherit his son and, assembling his army, he entered the kingdom and there, but a few days later, received the city of Damascus from the hands of its citizens. This having been done, he conquered the whole kingdom but a short time thereafter. To resist him, Qutb ed-Din, lord of the great city of Mosul, once called Nineveh[333] but rebuilt in smaller form and called Mosul, came with a great army. He was brother to Nur ed-Din and wished to come to the aid of his nephew, for he felt bitter resentment when he saw that Saladin, who had been the vassal and servant of his nephew, desired thus to disinherit him.

Moreover, the council of King Baldwin raised a very great army, and this was entrusted to the count of Tripoli to lead, that he might go to the aid of Qutb ed-Din and his nephew. And he was to do all manner of harm that he might to Saladin, to prevent so many great lands and kingdoms that were neighbours and lay close to Jerusalem and Syria from passing into the lordship of one sole man, and that man so ardent and so mighty an enemy and adversary of the Christians as was Saladin. And although the count of Tripoli had a very fine and powerful army and pressed forward towards Aleppo to offer aid to the son of Nur ed-Din, nevertheless certain Turks of the party of the barons, who were besieged by Saladin in the keep and castle of the city of Homs,[334] which had already been captured, held in this same castle hostages that had been given by the count of Tripoli as surety for his ransom. Thinking to pay him in words alone and feigning, the more to deceive him, that they would do all that he wished, they offered to surrender his hostages to him in the hope that he would come to their aid and that, through fear of him, Saladin would raise the siege. But then they did not mean to surrender what they had promised, as appeared most clearly thereafter. For when the count with all his army had come up hard by the castle,[335] there came often to him a number of messengers, always demanding more time and delays, none of which bore any result. And when he realised this, he returned to the place whence he had come, far from the siege.

And for this reason, Saladin, when he heard of this, deemed those who remained of little importance and, raising the siege, went as swiftly as he might towards Aleppo to confront the army of Qutb ed-Din, so that the two armies met in battle. At the end of the battle and after a great slaughter, Qutb ed-Din was defeated and driven off by

Saladin who, after this victory, returned before the castle, which, together with all those inside, was surrendered to him to do as he would. And all these people, and the hostages of the count likewise, he sent straightway to the count, begging him not to prevent him from making war on the son of Nur ed-Din, but that in all other things he would do all that he might to please him. This the count granted him, for Humphrey the constable was of the same opinion as he was, and in such fashion the great army of Jerusalem returned, having profited nothing and grateful to Saladin, notwithstanding that it was to do harm to him that the army had been entrusted to the count of Tripoli. For this, he was thereafter greatly blamed and criticised and covered with shame, together with all the Christians of the Holy Land.

Nevertheless, after the count had thus returned, in that very same year King Baldwin, in accordance with the counsel of his barons, raised another great army and rode out to range across the kingdom of Damascus, for he had been informed that Saladin was positioned around Aleppo. On that journey our men came as far as the town of Daron, which is four miles distant from Damascus, and thence they approached Damascus and took by force the castle of Bedegene, where the fine springs of Damascus gush forth, which are of great renown. And returning thence, they burned and pillaged all the flat lands through which they passed and, finding none to oppose them, reached Jerusalem laden with rich things.

In that year, too, the most excellent cleric, William, he who set down in Latin the history of Outremer, was made archbishop of Tyre[336] by election of the clergy and on the entreaty of the king. And in the second year of the reign of King Baldwin IV, he returned again to the kingdom of Damascus, into a country called Ituraea, and captured a great quantity of booty. For besides pillaging the flat lands, he defeated in battle there and drove away Shams ad-Dawla, one of the brothers of Saladin, who held this land for himself and who, thinking to defend it, came to give battle to Baldwin believing that he should take him by surprise, for the Christians, that they might gain yet more booty, were widely scattered.

In the fourth year of the reign of King Baldwin IV, that is to say in the year 1177,[337] at the beginning of the month of August, there arrived in Syria[338] Philip, count of Flanders, and he came up to Jerusalem, where he was received with most exceeding joy and in great state by King Baldwin. A few days later, after he had called together his council, the king entreated him and offered to entrust to his guard and defence the kingdom of Jerusalem, saying that all would obey him, so that he might do as he would with the subjects, rents and treasures of the kingdom. But this the count of Flanders refused, and

made a show of excusing himself by saying that he was come to the Holy Land as a simple pilgrim and, for that reason, did not wish to assume a charge that he could not relinquish whensoever it should please him, that he might return into his own country. But he said that if it pleased the king to elect and institute any one of the other barons, then he would obey him, as long as he was in that kingdom, just as he would obey the king of France, whose liegeman he was, if King Louis were there in person. And then the king entreated him that he might see fit to be the chief of his army, which he wished to send to Egypt together with the army of the emperor of Constantinople, that he might fulfil the promises and covenants made with regard to this undertaking by King Amalric, his father, and by himself likewise to the emperor Manuel, but nor did the count of Flanders wish to do this. And this is why, in accordance with his council, King Baldwin IV made chief of his army and governor of his whole kingdom Reynald of Châtillon, who had been prince of Antioch in right of his wife.

This lord had then but scarce returned from prison in Aleppo, where he had been for a long time with Joscelin III of Edessa, who had likewise been released thence with him. And the king commanded him that he should undertake and order all matters according to the counsel of the count of Flanders. But then, when the count of Flanders knew of the charge and the honour that the king had entrusted to Reynald of Châtillon, he said to the barons of the king that it did not seem to him that this Reynald would be a good captain, but rather that the king should make chief amongst his subjects, upon whom would depend the loss or the gain of any undertaking, a man who would make a good king of the land of Egypt if the Lord should put it within their hands. But the barons answered him that the king could not do such a thing, save if he were ready to renounce the crown, which he had no desire whatsoever to do.

And thereafter, the ends that the count of Flanders had in mind were well enough known, for he had with him a great lord of his country, the advocate of Bethune, who held a number of great estates in Flanders,[339] all of which the count would have if he could so order matters that the two sons of the advocate might have in marriage the two sisters of the king, the daughters to King Amalric.[340] Now when the count broached this matter, they told him that the custom of Syria was that widows should not marry again until the first year of their widowhood was accomplished, and it was but three months since the marquis of Montferrat, the husband of the older, had departed this life. And when they thus answered the count of Flanders, he was by no means content, for he could not succeed in his undertaking.

Shortly thereafter, there came also before the king the ambassadors of the emperor Manuel, requesting the undertaking of the campaign into Egypt, and so the king spoke of this a number of times to the count of Flanders, but could receive from him no firm answer. Now the count delayed so long that it was almost past the season to set sail, which had become well-nigh impossible, when, having visited the Holy Places and placed the pilgrim's scarf around his neck, he took the road to return. But when he had come into the city of Nablus in Syria, he sent back the advocate of Bethune and others of his people to Jerusalem before the king, and ordered them to say to him that he had taken counsel and was now ready to go into Egypt if he wished, or whithersoever else either he or his captains desired him to go. The barons of Syria could well perceive that the blame that should be his he sought to cast on them, by noising it abroad, in France and elsewhere, that it was not through his doing but through that of the men of their land that the undertaking of the emperor Manuel had not been accomplished, and it seemed most clear to them that what he offered was nothing but a mockery. However, albeit with great doubt and shame, they told the ambassadors of the emperor of the wish of the count of Flanders, and asked them if they still were prepared to go into Egypt if the count went with them.

To this they made answer that the season to set out was now passed. Nevertheless, if the count was prepared to swear on oath that he would go and that, if he should fall ill when he was with the army, he would still remain with them as long as the other barons were there, and also that he should not, by going to the aid of others, fail to keep these covenants, then they would disregard the misfortune of the lateness of the season to the undertaking, and on these conditions they would set out on the journey. And the advocate agreed to all the Greeks asked, but he could only promise that the count would not swear to any condition that he would not accept, and this being so, the undertaking was then abandoned by the Greeks, who returned before the emperor. There are those who say that the prince of Antioch and the count of Tripoli secretly turned the count of Flanders against going into Egypt, that he might instead help them to reconquer their lands that were under Saracen rule.

In fact, after the Greeks had departed, the count of Flanders offered so ardently to help the Holy Land that the king gave him one hundred knights and two thousand men on foot with whom, together with his own men, he went towards Tripoli and Antioch, that he might aid the lords of these two lands, who were likewise with him, and they went to lay siege to the castle of Harenc. Now when Saladin, who was in Egypt, knew of this, he knew also that, since the count of Flanders, the prince of Antioch and the

count of Tripoli, with their whole army and part of the army of Jerusalem, too, were in the land of Antioch, then the kingdom of Jerusalem was as if without defenders, and so he believed that he could most easily have his will there, or at the very least do it such great harm that, in the end, he would destroy it. And thereupon, he crossed the desert with his army as rapidly as he might and came into Syria, sending his advance party before the city of Ascalon, wherein, but a few days before and so that he might counter Saladin's movements, King Baldwin had taken up his position with all the armed men he had been able to gather together. Some of these the king sent out to attack Saladin's advance party, but in a very short time there arrived the whole army of Saladin, which was without number, and when our men saw their great multitude and knew that it would be too dangerous to leave the safety of their own ramparts, they retreated within the city. And Saladin came up in great arrogance and sent his men to pillage and strip bare the whole countryside, both near and far, in divers great bands and in disorder, for he believed that they would encounter no resistance save in the cities and castles.

And in truth, the people of the Holy Land were so harmed and so disheartened by them that those in Jerusalem determined that, if they should come towards them, then they would abandon the city and take refuge inside the place and the keep that is called the Tower of David. For this reason, when King Baldwin heard the news I have recounted, he concluded in his council that it would be better for him to venture out to do combat with his enemy than that they should lay waste his kingdom and destroy his people. And therefore, he sallied forth from Ascalon and led his army as secretly as he might by the coast road, for that way was less open, and he wished to show himself suddenly in the plains where Saladin was. And when he came into a wide open space, he drew up all his men in order, both on foot and on horseback, and they all streamed forth in fine battle array, inspired above all with the greatest ardour and courage to avenge the outrage that the Turks had done and were still doing to them, for they could see on all sides the flames from their burning villages, which increased in each one of them their strength, boldness and longing to take revenge.

Being of this mind, they approached the Turks so closely that they could see them camped in their army hard by, and it was about the hour of nones.[341] And when Saladin saw our men and knew for certain from his spies that they were coming to give battle, he began to fear their coming more than he had done hitherto. For this reason, he called back his advance parties in all haste, sounded the trumpets and drums and drew up his battalions and galloped the length of his army, instructing his captains after the manner of a man who was well versed in such matters.

At his side, King Baldwin IV had prince Reynald of Châtillon; Odo of Saint-Amant, the master of the Temple, together with four hundred Templars, all armed; Baldwin of Ramleh; Balian, his brother; Reynald of Sidon; Count Joscelin, uncle to the king and seneschal of the kingdom, together with their men, who were no more all told than three thousand and seventy-six. And he caused the True Cross to be borne before them and he entreated Our Lord, most devoutly and weeping great tears, that in this their time of need He might send them aid and succour to defend the holy faith, for it was his deep desire to live and die defending and maintaining the same.

It happened that, as they approached the army of their enemies, they saw those who had just now been setting fire to the countryside returning in a great horde into the midst of the other Turks, which greatly increased the strength of Saladin. It is, therefore, no wonder that they were fearful of going into battle against so great a number of men who were seasoned soldiers and desired ardently to make war. To be short, the battalions approached each other so closely that they joined battle, but they were not equal, for the Turks were so great in number that they enclosed our men in their midst. But Our Lord through his grace sent to them suddenly such strength and boldness, both of body and spirit, that they were not one whit frightened when they were thus encircled as if lost in the midst of their enemies. And so they began to spur their horses on to bear down upon the enemy battalions, for each man of them felt most sure in his heart that Our Lord would send them his grace, and this brought such great comfort to them that they feared nothing, but made so great a slaughter of their enemies that their blood ran in streams through the field. At first the Turks marvelled greatly that our men could even think of escaping them, but when they saw their bearing and boldness, they were so terrified that each one of them drew back and made way for them. And the battle lasted for a great while, so that, in the end, the Turks could no longer withstand our men and thus took flight to save their lives.

And this was one of the greatest and most clear miracles that Our Lord had vouchsafed for a long time since in the battles of Outremer. For it is perfectly true that the Turks who were on horseback and well armed for combat numbered twenty-six thousand, not counting those who were on pack horses and mules, of which there was an exceeding great number, and of these twenty-six thousand there were a full eight thousand who were most valiant and bold, and were called "watchdogs".[342] And these eight thousand were all on horseback and bore arms, and there were amongst them a good thousand who bore the colours of Saladin and kept always about their lord to be his bodyguard. For in the land of the pagans, both Turk and Saracen, it was their cus-

tom and still is for the great princes to nurture most carefully certain children whom they buy, and others also whom they win in battle, and even certain of those born of their own women, and they cause them to be instructed in the use of arms in divers ways as they grow and become stronger, and then they pay them according to what they are worth. These kinds of men, thus nurtured, stay constantly around the body of their lord in battle and never leave him, for fear of death, and Saladin had a thousand such men around him who would never be ready to leave the battlefield until they saw him flee, and for this reason, they were almost all slain, even though they fought so doughtily around him. On that day our men pursued the Turks, killing and cutting them into pieces, from that place where the battlefield was, called Montgisard,[343] as far as the marsh called Licanons, which is twelve miles distant. And there black night overtook them and so they left off pursuing and slaughtering, and for a surety not one Turk would have remained alive or escaped being taken captive if night had not fallen so quickly. A great number of Turks were thus taken captive while others perished, whereas, when our men assembled again, only around five hundred of those on horseback had been killed and a certain number of those on foot.

On the Turkish side, there were so many killed that Saladin, who escaped on his powerful warhorse, could not gather together again so many as a hundred knights of all that great multitude that he had led, and he lost as well his harness and his baggage that he had left behind him as he came, so that he might go more swiftly to the city of al-Arish in the desert. And the Bedouins of Araby, seeing that he had been vanquished, went straightway in that direction and, proclaiming the defeat to those who had remained there, they pillaged them and bore away all their possessions, for this is the custom of the Bedouins, who gather together at the last possible moment, awaiting the end, when they can pillage the vanquished. And it was most plain to see that it was through a miracle that Our Lord had given this victory gained by King Baldwin, on Saint Catharine's day in November of the year 1177, for from that day onwards it rained most heavily for ten days continuously, a thing that had never before been seen in the whole land, while hitherto the weather had been wondrous fine.

On the fourth day those who had been pursuing returned all laden with rich booty to Ascalon, where the king had gone to await them and, giving humble thanks to Our Lord, he shared out amongst them all their great gains according to what each man deserved, so that all those who had hitherto been almost destitute and in great poverty were rich and laden with good things. And whereas the king had gained great honour and profit without the aid of the count of Flanders, the prince of Antioch and the count

of Tripoli, they on the contrary acquitted themselves most wretchedly at the siege of Harenc, and their men with them. For they did nothing but sit in their tents and pavilions playing at cards and dice, and the greater number of them went often to the bathhouses and taverns of Antioch and behaved so immorally that those in the castle felt scarce any fear of them, and, in the end, the prince of Antioch even found a way to exact a great sum of money from the citizens to raise the siege, which he did. And so they returned, each one to his own land, and most particularly Count Philip of Flanders had gained scarce any honour and no profit from his time in the Holy Land.

Chapter LVI.
How King Baldwin IV was defeated and many of his men were killed because they foolishly went out to pillage. Of the return of Saladin and how, through the arrogance of the master of the Temple, he defeated the king. Of Guy of Lusignan, who became king thereafter. How Saladin went away, and of the great quarrels and hatred that sprang up amongst the Christians of Outremer, provoking great confusion.

A general council having been convened in Rome in the year 1178, King Baldwin IV built and fortified a new castle on the other side of the river Jordan,[344] in the place that was called Jacob's Ford, so named because Jacob[345] had crossed the river there when he returned from Mesopotamia together with his two wives and their families and great riches. When the castle was finished, and after he and his men had taken alive nine robbers and killed seventy who were stealing on the roads round about, he went with his whole army, thinking to capture by surprise certain beasts that were grazing in the pastures around the city of Banyas.[346] But his men went off hither and thither to capture the beasts, and the company that was with the king was most unwisely surprised in a narrow defile[347] and was defeated by a number of those who dwelt thereabouts who had hidden themselves there for fear of him. But when these men saw that they would die or be taken captive if they did not defend themselves, they put up so strong a fight and attacked the king so hard that they defeated him and put his men to flight, and it was but with great difficulty that the king himself was saved and removed from the press, leaving behind many a valiant baron, knight or foot soldier dead or captive.

After this defeat had occurred, Saladin returned in all haste with his whole great army and laid siege to Jacob's Ford, but while he launched divers and continual assaults against them, Rainier of Maron, a knight who was there in the garrison, killed with one shot from his crossbow one of the richest emirs at the siege, striking him right in the heart, whereupon all the other Turks were so disheartened and grief-stricken that they raised the siege and returned to those places whence they had come. Nevertheless, in the following month Saladin returned to the area between Banyas and the river Jordan and sent out thence his advance parties to strip, pillage and lay waste all the land, as he had already done a number of times without encountering any to oppose him, which but increased his boldness to afflict our men yet more.

For this reason, the king, when he heard of the havoc wreaked by the advance parties, gathered together his army, which he led up onto a high mountain, whence he could see afar the tents of Saladin, but in the valley hard by he and his men saw the advance parties who were burning and laying waste the whole land, and at this they were so incensed that they could no longer suffer this havoc. And so those on horseback began to descend so rapidly that those on foot could not follow them, although certain of the strongest and most agile made such haste that they came soon after, and when they had come down to the plains into a place that men called Marj Ayun,[348] they stopped a while to take counsel as to what they should do.

For his part, Saladin was amazed and astounded when he knew of this most sudden coming of the king, and he feared greatly lest the latter should take his advance parties by surprise. And because he feared also lest the king should capture his tents and pavilions and all that was in them, he had all his own harness and armour and the harness of the packhorses of the army taken inside the walls and the outer defences of the city of Banyas hard by, wishing to be defended and yet unhampered no matter in which direction our men turned. And so the advance parties, observing the army of the king, were afraid and crossed the river that divides the mountains from the plains, for their only hope was that they might withdraw into the midst of their other comrades-in-arms. But this they could not do, for once they had crossed the river, our men came up before them and easily put them to flight: some were slain and others taken captive, and those who were left who could escape fled to the army of Saladin.

While matters went thus, and our men were pursuing the advance parties to amass booty in divers places, Odo, master of the Temple, together with the count of Tripoli and their men retreated to a mound that was before them, leaving the river on their left. And in the plains before them to their right were the tents and shelters of the Turks,

whence came forth Saladin, deeply angered, because his advance parties, which he saw coming towards him, had all been routed. And he went forth against our men as quickly as he might, asking and demanding of his people that they should show themselves valiant in avenging the death of their companions, and gathering to him those who were fleeing, whom he ordered to return with him, one by one, as he found them. And in this state, when his battalions were drawn up and in order, he came and struck suddenly amidst our men, whom he found scattered here and there for they believed they had already won outright.

Now the men on foot had already made camp on the bank of the river, while those on horseback, returning thus most joyfully from the pursuit, found their joy was short-lived. Though there was no room for them to join up with those on foot nor to draw up their battalions in order, nevertheless, they defended themselves long and most excellently. But in the end, they were defeated by reason of the great multitude of the Turks and they took flight towards the rocks and the narrow defiles, and there a number of them were taken and slain, which would not have happened if they had stationed themselves in the plain, where those who were the best mounted could have won the day.

The king escaped from this defeat through the efforts of his own men, and the count of Tripoli likewise, who fled with a small company, but a great number of our men were killed there and a number taken prisoner who were of the highest nobility. Amongst others, there was taken Odo,[349] master of the Temple, who was renowned for his great pride and who died in prison within the year, little regretted, for men said that it was he who was the cause of this foolish undertaking.

And in that same season there came once more the good Count Henry of Champagne, founder of the collegiate church of monsignor Saint Stephen in Troyes, my patron, who had already been in the Holy Land long before with King Louis the Younger of France, as I have already told. And thither he returned in that year, bringing with him a fine and great company of rich and noble princes, barons and knights, and amongst others there came with him Peter of Courtenay, brother to King Louis of France, and Philip, his nephew, son to Count Robert.[350] Notwithstanding the arrival of this company, Saladin did not abandon his intent to lead his army into the kingdom and went once more to lay siege to the castle of Jacob's Ford. That he might bring aid, King Baldwin gathered together the army of the Holy Land with that of Count Henry of Champagne and others but newly come from France. But before they could make ready their army, even though they acted with the greatest speed, Saladin, knowing that our men were coming, battered the castle so heavily with machines and assaulted

it so continuously that he took it by force.[351] And he killed or took prisoner the Templars who were therein and to whom the king had entrusted it for safeguarding, and so the king did not move.

Then also were renewed those promises that had been agreed, whereby the duke of Burgundy[352] should come to the Holy Land and take in marriage, as he had promised and sworn, the eldest sister of the king, but he did not keep his word. And that is why, some months later, the king, seeing that he had deceived him and hearing that the young prince Bohemond, prince of Antioch,[353] together with the count of Tripoli, were come into his kingdom with a great company of knights, and fearing lest they wished to depose him, for it was plain to see that he was a leper, wished to marry his eldest sister to some lord who could prevent this. And he acted in such haste that, without taking counsel, he gave her in marriage to Guy of Lusignan, son of Hugh of Lusignan, who was amongst the greatest nobles of Poitou,[354] but yet had not enough means to defend the kingdom, since he was neither as rich nor as powerful as was needful. And yet the king might well have found such a man, for indeed, he had already refused a number of those who would have undertaken this charge most willingly in the hope of succeeding to the Crown.

Moreover, the prince and the count, when they came to Jerusalem and understood that the king was mistrustful of them, prayed before the Holy Places and then departed again. On the return road, it happened that, as they came one night into Tiberias, on the morrow Saladin arrived before the town thinking to lay siege to it and take it by surprise, and the prince and the count rode out with their men to give combat to Saladin. Saladin, when he saw this, broke camp and retreated far off into other lands, and the two lords went back into their city. And then the king sent requesting a truce[355] of Saladin, who granted this willingly, although he was the stronger and had the upper hand. But because there had been a great drought in the land of Damascus and there had been no rain whatsoever throughout that season, Saladin lacked all manner of food, both for man and beast.

Since the arrival in the Holy Land of the first pilgrims to take the cross in the time of King Godfrey, never had a truce been agreed between them and the Turks without our men thereby gaining some advantage and profit to themselves, save for this one occasion when they gained nothing. And when summer came, Saladin laid waste and burned a great part of the land of the count of Tripoli, saying that this land was not included in the truce, but nevertheless, in the end, he did grant the truce to the count likewise, and recalled his galleys that already stood off before the city of Tortosa, the

same that in olden times was called Antaradus, from the name of Aradin, son of Canaan, son of Ham, son of Noah,[356] for it was there that he dwelt first of all. But a short time afterwards Amalric, patriarch of Jerusalem, died and within ten days there was made patriarch in his place Heraclius, archbishop of Caesarea.[357] Touching this patriarch, and before he was elected, William archbishop of Tyre, a most remarkable cleric, had written to the canons of the Holy Sepulchre concerning that which he had found in certain most well-authorised scriptures, to wit that, just as the emperor Heraclius[358] had taken back to Jerusalem the True Cross of Our Lord, so it would be removed and lost by another Heraclius, who would be patriarch.[359] And for this reason, he warned them and begged them to consider carefully him whom they would elect. But nevertheless, since the custom at that time was that they might elect and present two names and the king would choose from them which one he wanted, so they named to the king this Heraclius and also William of Tyre. And the king, at the entreaty of his mother, who was very fond of Heraclius, chose him, so that he was elected and consecrated patriarch.

In the year 1181[360] there departed this life the emperor Manuel, in whose place was made emperor of Constantinople his only son, who was called Alexius, who carried out a most dreadful punishment against certain princes and barons of his empire who had conspired against him because he was so young,[361] although he was ripe in good sense. Moreover, in that same year Bohemond, prince of Antioch, set aside his true wife and married another. And because the patriarch of Antioch and other men of the church made plain to him that he had done wrong, he behaved most tyrannically towards the clergy of his land for a very long time. At that season the count of Tripoli thought to visit King Baldwin at Jerusalem, but the king, who was misled and misinformed both by flatterers and also by his own mother, who was of little judgement, commanded him that he should take care not to enter his kingdom. Nevertheless, the barons, knowing that the count was very wise and that they had need of him because the king's whole body was already rotten with leprosy, spoke to the king so that he consented that the count should come before him and they made peace.

As matters went thus in the Holy Land, there was great trouble in Constantinople in the month of April in the year 1182. For the Protosebastus Alexius Comnenus,[362] who was governor to the young emperor Alexius, the son of Manuel, was so tenacious of the treasures of the empire that, on a certain occasion, he had not shared them, and for that reason he incurred the indignation of the barons. Now these matters came to the knowledge of a disloyal Greek called Andronicus,[363] who for his treachery had been driven

GUY OF LUSIGNAN RECEIVING THE REGENCY.
CAMP OF THE FRANKS AT THE SPRINGS OF TIBERIAS

"King Baldwin IV had perforce to appoint a governor in his place
of the kingdom. Yet he did this with a heavy heart, for though he was feeble
in body, he was great in heart and spirit [...]. However, as he believed
then that he would certainly die, he called upon Guy of Lusignan, count of Jaffa,
who had married his eldest sister, and retaining for the upkeep of his own state
ten thousand bezants of rent and the city of Jerusalem, he entrusted the count with
the government of all the rest of the kingdom. And he had him swear on oath
and promise that he would not have himself crowned king until after his death."

(FOL. 187VB–188VA)

In this miniature, Jean Colombe shows King Baldwin IV sitting on his throne in his bedchamber. The scene takes place in February 1183 in Nazareth. The king is ill and, believing that he is about to die, he entrusts the government of the kingdom to his brother-in-law, Guy of Lusignan, count of Jaffa. The latter, kneeling before the king, makes a gesture with his right hand and appears to promise that he will respect the Baldwin's wishes. The view of the room is centred on a vast bed covered and curtained with draperies. The white pillow placed in the centre forms a luminous contrast to the red and gold cloth. Pages are engaged in smoothing the covers. The scene is thus both solemn and moving, subtlety suggesting the king's sufferings. Beyond the room lies the antechamber decorated with frescoes, which in its turn leads to a corridor adorned with statues, the whole conveying the effect of perspective in masterly fashion. Two people sit chatting on the sill of a high window; in the distance is a glimpse of a countryside composed of meadows and hills. At the bottom of the page, the artist has chosen to illustrate an incident that took place at the springs of Tiberias. This is depicted, anachronistically, as an ornamental fountain with sculptures in the style of the fifteenth century, decorated with lions' heads, from whose mouths water flows by means of an ingenious hydraulic system. Saladin has allowed the Christians access to the springs and the Christians have set up their camp around them.

tout il de son coraige et vigou
reux. et nauoit onques lou
sir oyr ses plus saiges qui lui
conseilloient quil print par
tie des rentes et se retraist
en quelque lieu ou eust bon
air. Et luifaist se gouuer
nement de son royaulme
a quelque saige prince. Et
toutesfois par ce quil luy

doit fors bien mort il ap
pella Guy de lezignen
Conte de Jaffre qui auoit
espousee sa seur ainsnee.
Et retenant .v. sris.
besans de rente et la cite
de Jherlm pour sentretenement
de son estat. il lui baila le
gouuernement de tout le
demourant du royaulme

away from Constantinople, but had nevertheless been allowed by the emperor Manuel to dwell on an island far off, because he was his kinsman. He gathered together as many armed men as he could and came before Constantinople,[364] pretending that he wished only to govern the empire because the emperor was still young and Alexius Comnenus was wasting everything. When he came before the city, there came forth a number of Greek princes and barons as if they wished to do combat with him, but while feigning to love Alexius, they surrendered to Andronicus who but a few days later entered the city and seized the Protosebastus Alexius Comnenus and put out his eyes and cut off his genitals.[365]

The city was in uproar and Andronicus, knowing that as long as the Latins who dwelt there remained he could not have his cruel will of either the emperor or the empire, conspired to massacre them all. Some part of them, and those the most wise, were forewarned of this and, carrying their possessions, they went on board twenty-four galleys and took flight. But a great number of other Latins who remained either through illness, idleness or poverty were almost all most shamefully slain by the Greeks, notwithstanding that they defended their streets and houses and took great toll of the Greeks. During this tumult the Greeks massacred and put to death in most shameful fashion the priests and Latin clerics, and in particular they subjected a papal legate to most shameful and infamous treatment. For they cut off his head and, to spite the Church of Rome, tied it to the tail of a hound bitch that they chased thus through all those parts of the city that were of bad repute. And besides, they dug up the corpses of the Christian faithful and bore them out of the cemeteries, having treated them most shamefully. And even within Saint John's hospital, they slew all the Latin sick. And to be brief, both in the churches and in their homes, they put them all to death, save about four thousand, both men and women, who had hitherto been well known to certain amongst them, and them they saved from the slaughter and hid, yet nevertheless they sold them thereafter into slavery.

These cruel deeds that had thus been committed against the Latins of Constantinople became known and cost the other Greeks dearly. For those Latins who had escaped in the twenty-four galleys, together with others who had also been able to escape by boat, when they were told of the execrable deeds committed by the Greeks of Rome, headed out to sea through the strait of Saint George. And when they were two hundred miles from Constantinople, they slew all the Greeks, priests, clerics, men, women and children that they could find on the islands around, and then they burned and laid waste towns, villages and castles without number. Alas! By such deeds waned

and dwindled on all sides the might and authority of the Christians of Outremer. And before that same year was out, matters became worse yet, for a ship, in which were one thousand five hundred pilgrims coming to the aid of the Holy Land, broke up off Damietta, and those on board who escaped and were saved from the tempest were captured and taken prisoner by Saladin, despite the truces he had agreed upon with the king of Jerusalem, which included as well all pilgrims.

And lest the king require of him that he set them free, he made known to him in haste that he wished the king to observe certain conditions that were never requested or agreed at that time when the truces were made, and on these grounds, he kept the pilgrims as his prisoners. But shortly thereafter, the truces ended and so Saladin gathered together a great army to come to Syria. And the king with all his army thought to go out against him, but Saladin was distant some thirty-six miles from the king and sent out advance parties to pillage and lay waste his lands. Moreover, he sent out a great part of his main army, so that they took two strongholds hard by Tiberias, and one of these, which was called La Caire, was surrendered to them by certain Syrians who abjured their faith.

When the king heard this news, he knew then but too well that those who had led him and taken him far away from Saladin had deceived him, and in truth, if he had gone straightway against him, he could have vanquished him most easily, for not only had Saladin lost a part of his men in the desert, but the others, too, were well-nigh dead of thirst. So he passed freely through our lands and led his army into his kingdom of Damascus. And for this reason, the king took counsel and, that Saladin might not enter into Syria as he pleased if he returned suddenly from Damascus, he gathered together the whole armed power of the men of his kingdom at the springs of Sephoria[366] and there, bearing with them the True Cross, they awaited the coming of Saladin, that he might measure his strength against them.

Chapter LVII.
How King Baldwin IV once defeated Saladin. Of his return and of the siege of Beirut. How he took the field against the heirs of Nur ed-Din and of the conquests that he made then. And how Saladin seized Aleppo.

Saladin, when he had reinforced his army with fresh men on foot and on horseback both from Egypt and other places, returned suddenly to the kingdom of Jerusalem and took up his position between two rivers, four miles distant from Tiberias, and when King Baldwin knew this, he led his army in that direction. For this reason, Saladin, when he was forewarned of his coming, crossed back over the river Jordan and, going towards Bethlehem in the bishopric of Galilee between mount Gilboa and mount Jordan, went to attack a small castle that lay in the marshes. But since he could not take it, he went away to another castle called Belvoir, which lies between the city of Tiberias and Bethlehem, and there he began to make ready his men to give combat to our men, who had great difficulty in coming there, by reason both of the mountains and the heat. And when the morning was come and they came down from the mountains and beheld the great multitude of their enemies, they marvelled greatly, for they were not accustomed to see so great a number together. And in truth, they were a good twenty thousand and our men were no more than five hundred on horseback, whom Saladin and his emirs thought to surround exactly as they pleased, and to capture or to kill them all. But it fell out quite differently, with the help of Our Lord, for our men placed their trust and their confidence in Him and routed the Turks and slew a most great number. But how many was never known, for when certain of them were wounded or killed, the others took them and bore them away, and then they buried them by night amidst their tents and pavilions lest those who remained should be terrified, and lest our men might know how great was the slaughter they had made and thereby fail to increase in strength and courage.

The battle was long, and at three different times there were killed certain rich emirs for whom the others mourned deeply and were sorely grieved, and were, indeed, so troubled and discomfited that they fled in great affliction from the battlefield. Moreover, by reason of the heat of that day and of the days before, a number of men in their army died and in ours, too. And once the enemies were thus defeated, our men went back

to the springs of Sephoria while Saladin, deeply angered by the great harm that had been done to him, took counsel and sent accordingly to al-Adil Saif ed-Din, his brother, whom he had left to guard the kingdom of Egypt. And he ordered him most strictly that he should straightway gather together the whole navy of the kingdom and send it to him, well supplied with men, as soon as he might, for he wished to attack the Holy Land on divers sides and he meant most particularly to lay siege to Beirut. And this navy sent by his brother should assemble all the armed might of the kingdom. These forces should then go overland from the south coast, around the cities of Gadara and Ascalon and Daron, which were the last fortresses that the king had towards Egypt, and should do their utmost to lay waste all that they could find unguarded in the fields. But besides this, it was Saladin's intention to use the sallies of his brother al-Adil Saif ed-Din and this burning of the land to draw the king in that direction, and thus he himself would have the opportunity to fall upon Beirut, which he wished to besiege.

His brother obeyed his command, for he sent him thirty galleys and, moreover, he came himself with a great army from Egypt and surrounded Daron. Now when the fame of these new armies was known to the king, there were divers opinions in his council, for some wanted him to go out against Saladin, who was laying waste the flat lands, or to send out instead a part of his forces. But in the end, when others said that he had not men enough to split into two forces, he led his whole force towards Beirut, which was already under siege. For this reason, Saladin, when he was told of this, attacked the city hard and relentlessly by changing and renewing his men so that he might seize the city before the king could come to its aid, while those inside defended themselves likewise with all their might, sure in the belief that they would be saved. While Beirut was thus hard pressed by a tight siege and repeated attacks, there came one day to Saladin one of his greatest emirs, who said to him that they should attack the city and that he would surrender it to him as soon as he had taken it, thanks to those actions they had already taken. And with the consent of Saladin, he led out his attackers and observed the situation and commanded how the assault should be made. But even as he gave commands to his men, an arrow shot from the city hit him in the face next to the eye and killed him there and then. His death drained all courage from the others, so that they abandoned the assault.

And three days later, Saladin raised the siege, for he saw that it would profit him nothing, and he caused his galleys to return to Egypt, but because it was still his intention to lay siege at another time to the city of Beirut, he laid waste all the vineyards and orchards. And he caused the narrow roads to be blocked up with stones with no

mortar, for he believed that our men might come that way to bring succour to Beirut, and he set guards on all the roads down to the coast. In spite of this, at the last minute he changed his mind, for he learned, through a messenger whom he captured bearing letters to Beirut, that the king demanded that he raise the siege within three days and so he led his army elsewhere. For he made a great proclamation throughout those lands who owed allegiance to him and, that he might increase his lordship, he crossed over the river Euphrates and entered the land of Mesopotamia. There he imposed his will almost as he pleased, even against those who were of his faith, so that in but a short time, both by force and by dint of gifts, he had seized Edessa, Harran[367] and many other castles and almost all the land held by the lord of Mosul. For he sent so many great and rich gifts to the barons and great lords of this land that he turned the allegiance of well-nigh all of them against their own true lord, who for this reason, dared not confront Saladin; and what was worse, he was so gravely sick that he thought he would die, and rumour had it that it was Saladin who had caused him to be poisoned.[368] Well-nigh all the land of Mesopotamia having thus been conquered by Saladin, divers reports of him were noised abroad in Jerusalem, for there were some who said that he did as he pleased, while others said that his emirs who dwelt in that land, not wishing to be subject to one sole lord, had gathered together and routed him completely in battle.

Moreover, the king led his army into those lands around his kingdom who owed allegiance to Saladin while the latter was in Mesopotamia and stripped the land of all that grew there through burning and pillaging. And amongst other things, he regained the stronghold of La Cave, which was surrendered to him by means of a siege in the year 1182 in the month of October. Thereafter, because he feared lest Saladin might return, a great tax was levied on the common people, and the money from this should be collected by three or four wise men in each town or city, and this money should be placed under guard in divers places in the kingdom in a coffer or a treasure chest. And each of these should have at least three keys, and each one of the three wise men of divers estates from each town or land should hold one.

And truly they had great need of this money, for after Saladin had had his will in Mesopotamia, he returned thence across the land of Aleppo, and the lord of this city, who knew that his brother Qutb ed-Din, lord of Mosul, had not been able to withstand him, sent messengers to him and offered to surrender to him and put into his hands the rich and powerful city of Aleppo, if it would please him to leave Saiar and other castles in that part in peace. Now Saladin had from the very beginning desired above all things to have this city of Aleppo, and he agreed to this most joyfully and moved

on. And the lord opened the gates of the city to him[369] and gave him the keys without the knowledge of the citizens, and Saladin for his part did as he had promised. Nevertheless, after he had stocked the city well with victuals and with men, he withdrew his men as quickly as he could, that he might come to Damascus and into Syria. The prince of Antioch, who knew of this exploit of Saladin's and that he now had him as neighbour, was most afraid, and not without reason. And so he came with a small company before the king and barons, begging most humbly and tearfully for their aid and succour, and all took pity on him and gave him three hundred knights and other men on horseback, and these he took with him and went back into his principality as swiftly as he might. But when he had returned to his own land, he bethought himself that it would be better that he should try to protect himself without making war and so, to test the resolve of Saladin, he sent to him requesting truces, which the latter accorded most readily, for he had no desire to remain any longer in that land. Therefore, once the truces were confirmed, Saladin went back to Damascus and the prince sent back the three hundred soldiers.

Chapter LVIII.

How Guy of Lusignan, count of Jaffa, was made governor of the kingdom of Jerusalem, and how his army acquitted itself badly against Saladin and he was ousted from the office of governor. Of the great hatred that King Baldwin bore him. Of the coronation of the young King Baldwin V and how the kingdom was entrusted to the count of Tripoli to safeguard it.

While the people of Our Lord thus knew a time of repose in the Holy Land, Saladin was gathering together an even greater number of the men of Egypt than hitherto. For that reason, the army from Jerusalem, Tripoli and Antioch was assembled at the springs of Sephoria, as was the custom then, that they might be more ready to turn to that side where it was clear that the enemies of the faith would enter. Now it befell, while the army was in that place, that King Baldwin IV, being at Nazareth, was taken with a most high fever and suffered greatly. Besides that, because the leprosy that he had before he was crowned had attacked him so grievously that he had lost his sight and could do nothing for himself, either with his feet or hands, he had perforce to appoint a governor in his place of the kingdom. Yet he did this with a heavy heart, for

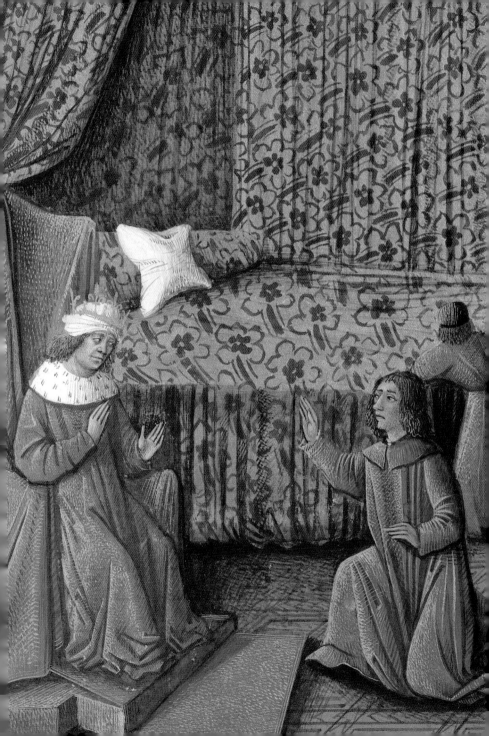

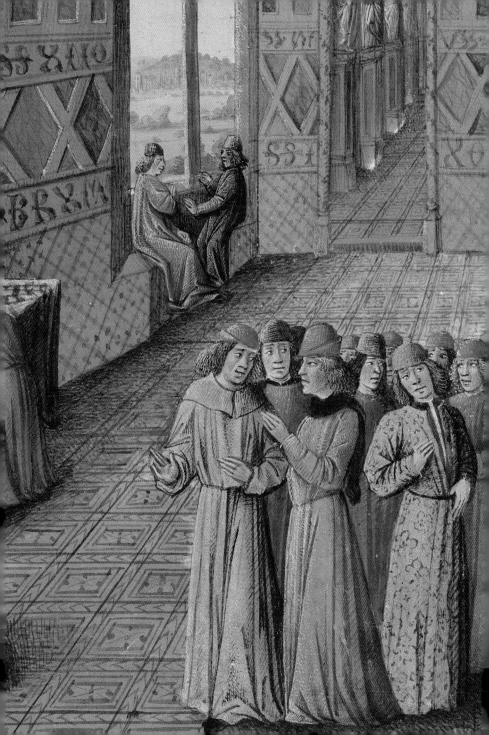

though he was feeble in body, he was great in heart and spirit, and never once had he wished to listen to the wisest amongst them, who counselled him that he should take some part of his rents and withdraw into some place where the air was good, entrusting the government of his kingdom to some wise prince.

However, as he believed then that he would certainly die, he called upon Guy of Lusignan, count of Jaffa, who had married his eldest sister, and retaining for the upkeep of his own state ten thousand bezants of rent and the city of Jerusalem, he entrusted the count with the government of all the rest of the kingdom. And he had him swear on oath and promise that he would not have himself crowned king until after his death, nor would he give into any other hands any of the cities and castles. He made him promise this, for it was said that the count had promised to certain of the barons that he would give them the best parts of the land, that they might help him to become king. When this charge and the government of the kingdom was thus given to Count Guy, a number of the barons and knights were greatly displeased, alleging that he was a man who ought neither to have nor to govern the kingdom, and indeed, he held the office for scarce any time. For Saladin, who had gathered together a great army of men on horseback, came into the kingdom of Jerusalem along the shores of the sea of Galilee,[370] whence he sent out his advance parties throughout Galilee, so that they passed very close to Bethlehem, which was once the main city of Galilee but was at that time in ruins. And there, after destroying a small castle that had been built there but that had been abandoned for fear of them, they separated and divided their army into two parts, and they moved off and camped, that they might be close to water, by the springs of Tiberias, which rise at the foot of mount Gilboa.

And when our men at the springs of Sephoria, who had waited long to see where the advance parties of Saladin would go, learned that they had spread out across the plains of Bethlehem and were laying waste the land, they took up their arms and formed into battle ranks and set off as had been before determined, bearing ever before them the True Cross. And crossing over the mountains amongst which lies the city of Nazareth, they came down into the valley of Esdraelon and thence went towards the city of Licaonia where Saladin was camped with so great a multitude that one could not count them. They thought then that there would surely be a great trial of strength between them before they could get back to the water, but Saladin, when he saw that they were coming, left his camp and departed thence with all his army and left the springs to them, and he had his tents and pavilions set up a mile further down, on the stream that flows from that same springs.

Before this came to pass, two of the advance parties of Saladin had, each of them separately, taken by force two Christian fortresses and had pillaged them, while men from a third party had done great harm to the men of our army, for they harried them so that none dared stray from the main force lest they be killed or taken prisoner.

And some of this third party left the rest and went up to mount Tabor and captured and pillaged by force an abbey of Greeks founded by Saint Helia, which had never before been pillaged. In that same place there was another, greater abbey that they thought to pillage in like fashion, but it was too well defended by ramparts and men so that they could not enter there. There were yet other Saracens who left this third party and went up into the mountains of Nazareth, and the women and common people who were in that city, whose foundations were built into the foot of the mountains, were so terrified that they took flight in so great a disarray that a number of them were killed in the press even as they fled into the church to save themselves, for the greater part of those men who could bear arms had already taken flight to the city of Acre.

As matters fared thus dangerously in the Holy Land, there befell a yet greater misfortune, for the army of the king was in desperate need of food. But Our Lord took pity upon his people, for the barons, when they saw the agonies of hunger that their men suffered, commanded all the cities around them to bring food to them in all haste, and so it was done. And that these provisions might be brought in all safety, they sent out a number of knights and other men, so that they encountered no hindrance save to some of their number who strayed most foolishly from the others.

Thus all those in the army had a great abundance of food; and this was, indeed, one of the greatest armies, provided with the greatest number of noble and valiant Christians, that had been gathered together for one campaign in the Holy Land for a great time past. For there were a good fifteen thousand men on foot and one thousand three hundred knights and others on horseback: amongst them were Raymond, count of Tripoli; Henry, duke of Louvain; Ralph of Mauléon; Reynald of Châtillon, who had been prince of Antioch; Guy of Lusignan, count of Jaffa; Baldwin of Ramleh; Gallien of Nablus, his brother; Reynald of Sidon; Walter of Caesarea; and Joscelin III, seneschal to the king and brother to his mother, son of Joscelin the Younger who was himself son to Joscelin the Elder, count of Edessa. Nonetheless, they acquitted themselves badly, notwithstanding that the greater part of them were practised and well versed in the art of war. For indeed, Saladin and the Turks and other Saracens were so widely and foolishly scattered in divers places that were dangerous for them that our men could most easily have routed them, or at the least could have done them very great

harm. But they did not do this, either through hatred or through resentment that the king had made chief amongst them and governor of the kingdom Count Guy of Jaffa, who was neither wise nor powerful enough to defend and govern it. And what was worse, from the moment he had assumed the governorship, he had already shown overweening pride.

For this reason, they were all the more contemptuous of him and it greatly displeased them that a man whom they considered a foreigner, for he was not born in Syria, should be their lord. And so they let the Turks and Saracens, who were encamped a mile distant from them, lay waste and pillage a full eight days all the flat lands and the weakest strongholds of the kingdom, and the barons would in no way suffer that other men from the army should go out from the main body, to fall upon those whom they observed burning and laying waste their land. And when men made clear to them the great harm suffered by the Holy Land because they would not attack their enemies, they answered saying that Saladin was encamped in a place that was too strong and that gave him too great an advantage, for it was very rocky and he had placed at the forefront of his army a great number of archers who would loose flights of arrows without number on our men if they went to attack them. But they lied and said these things falsely, for they would rather that the Turks should escape and lay waste the land than that Count Guy should have the honour of defeating them. And so the Turks gathered together their advance parties and, without any to oppose them, they burst forth from that place where they had been so perilously encamped and set out on the road and returned to their lands. When the barons saw this, mistrusting that the Turks might not truly have departed, they led the army once again to the springs of Tiberias, and in the stream that flows from them, where never had fish been seen before, they found good, fat fish in such plenty that there was enough for the whole army to eat all the time that they stayed there.

Moreover, Saladin returned but shortly thereafter with yet more men than he had before, and with his army plentifully equipped with machines and food, he led his people on to lay siege to the city called in ancient times the Stone of the Desert, but at that time known as Kerak. And for this reason, Reynald of Châtillon, who was lord there through right of his wife, went there as speedily as he might, and since there was a small town at the foot of the castle, he wished that the citizens should fortify and defend it, but this turned out badly. For while they were doing their utmost to fortify the town, the Turks passed at their ease through the steep mountain passes and ravines, which could most easily have been defended if the order had not been given to fortify and

guard the town, to which end so many men remained there that those who were left outside were too few and could not resist the Turks. One part of those who were defending these passes were killed, and the others fled to take refuge in the castle, but the Turks followed them and pressed them so close that they would have come in pell-mell with them, had it not been for the strength, valour and renowned boldness of a single knight called Ivan.

He took up his stand alone before the gate and, as long as there were still men of ours to come in, he would not leave his post nor go into the castle. And so he laid about him in the midst of this press of Turks who came at him and, striking to right and to left, he slew and felled the enemy on all sides, striking many a fine blow, so that the Turks marvelled at him. On their side, they loosed and hurled from afar all manner of arrows and spears, whilst the bolder amongst them came forward to attack him and delivered blows without number. But in the end, having suffered greatly, he retreated, despite the Turks, inside the castle with the others. Now the citizens who had thus retreated inside the castle had lost their possessions, which were in their houses in the town below, which prince Reynald had caused them to abandon in spite of their own wishes. So terrified were they at the great multitude of Turks that they pulled down the drawbridge into the moat, which was a most foolish action. For there were in that castle, which was but small, a most great number of people for a wedding, which was celebrated on the day before the coming of Saladin between the godson of prince Reynald and the younger sister to the king. There was a great company of jugglers and people from the country who were called Syrians, and none of them could defend themselves and, moreover, they lacked courage, so that when the strong and swift men wished to go to defend the castle, they could not, for the press of these others.

When those in Kerak were thus besieged and oppressed whilst our army remained at the springs of Tiberias having done no harm to the Turks, all the blame was visited upon Count Guy of Jaffa. And for this reason, the king, when he heard the report of the bad government of this same Count Guy, was displeased and repented of having thus made him governor of the kingdom and it was for this that he determined to abase him just as he had before raised him.

However, there were those who alleged that this desire had come to him because, as has already been said, he had retained for himself the city of Jerusalem and a rent of ten thousand bezants each year for the upkeep of his own state as long as he should live, but he afterwards bethought himself that the city of Tyre was more powerful than that of Jerusalem and so he wished to change and to take the one city for the other. And

when Guy of Lusignan, count of Jaffa, to whom he had given all, learned of this, he was so enraged and spoke so wildly that he incurred such great indignation on the part of the king that Baldwin took away from him the whole government of the kingdom, and with it all hope he might have that, through his wife, he might become king without dispute.

For in accordance with the counsel of Bohemond, prince of Antioch; Raymond, count of Tripoli; Reynald, count of Sidon; Baldwin of Ramleh; Gallien, his brother; and of a number of other barons, and with the consent even of the queen, his niece, he commanded and declared that the young Baldwin, who was not yet seven years old, son to his oldest sister and the marquis William of Montferrat, who departed this world, as has already been told, should be king of Jerusalem.[371] And straightway in the presence of Count Guy, second husband to this oldest sister and who could thus not gainsay this thing, he caused him to be anointed with the holy oils and crowned king in the church of the Temple, to the great approval and rejoicing of the clergy and of all the people likewise, and all the barons did him homage straightway, save only the count of Jaffa, and this was not asked of him. And though this coronation was greatly pleasing to all, nevertheless there were many men in the kingdom who said that it would not profit the Holy Land to make so young a child king, for now they had two kings, yet neither of them, one through his sickness and the other through his young age, could govern nor safeguard nor maintain the country. And for this reason, the barons agreed together that one amongst them must be elected as chief and as governor of the land and that there was none more fitting than the count of Tripoli, but King Baldwin IV would not countenance him. And thus was crowned and made king of Jerusalem King Baldwin V, in the month of November in the year of grace of Our Lord Jesus Christ 1183.[372]

But to return to Saladin, he was already hard by the castle of Kerak and was constantly bombarding those inside with his machines, and most particularly with the stone throwers, and he used eight of these machines by night, and six of them by day in the place where the old city had been and the other two where the other city was. Moreover, he caused such an abundance of spears and arrows to be hurled and loosed that those inside dared not go up onto the battlements but looked out, to their great peril, through the arrow-slits and beheld thence, terrified as they were, that which caused them fresh anguish. For they kept in their dry moats a number of beasts that they fed and from amongst which they took as was needful, but the Turks, observing that such was the case, killed the beasts and pulled them one after the other from the moats, while our men looked on but could not prevent them, by reason of the great numbers

of their machines. And so our enemies were furnished with meat while our men were deprived and in the depths of despair. When King Baldwin heard how dire were their straits, he gathered together what army he could and, commanding that the True Cross be borne at its head, entrusted its command to the count of Tripoli, and when Saladin was warned by his spies of the coming of the Christians and that they were led by the count of Tripoli, he raised the siege and went back into his lands. Though the king knew that he had departed, he went himself to the castle and had it well repaired and garrisoned. Then he returned to Jerusalem and there, even as the hatred between himself and Count Guy of Jaffa grew ever deeper, he still thought to find ways of dissolving the marriage between him and his sister.

For this reason, Count Guy, being forewarned of this, went away to Ascalon and besought the lady to follow him, which she did. And the king, when he knew of the departure of Count Guy, demanded of him by means of a number of messengers that he should come to court, but the latter maintained always that he was sick and could not come. And so the king said that he would go to him, and yet when he was at the gates of Ascalon and had knocked three times with his own hand, crying out that they should open to him, none answered him. And so the king made his way back to the city of Jaffa, and the citizens and the clergy came out before him bearing the keys to the city and he left some of his own men there and went away to Acre, and there he called together the three estates of his kingdom. And there came to him there the patriarch of Jerusalem, and with him the master of the Temple and the master of the Hospital, and kneeling before the king, they entreated him most humbly that he would pardon the count of Jaffa his wrongdoing and that he would permit him to come before him. But the king would in no way accede to this, and they felt such contempt that a man so enfeebled by sickness as he was should show himself so vindictive that they departed in anger and spoke no more of the need to send for help from France, though this was, in truth, the reason that parliament had been convened. The patriarch, whose charge this was, seeing that his first and most just request had been refused, did not wish to be the first to speak of this.

Moreover, when the parliament had dispersed, the count of Jaffa heard it said that the king would have no pity on him and that neither for love nor prayer would he make peace with him, and so he went away with a most great company of men-at-arms to the castle of Daron. And there he surprised certain Turks of Araby called Bedouins, who were watching over a great herd of cattle and believed themselves in safety since they had safe conduct of the king. But little this availed them, for the count of Jaffa and his men killed

ISAAC (II ANGELUS) KILLING THE COUNSELLOR OF ANDRONICUS I.
HUMILIATION OF ANDRONICUS

"Andronicus was then committing all kinds of outrages in Constantinople,
having had mutilated and blinded all the relatives of the emperor Manuel on whom
he could lay hands. Moreover, there was not a nun in an abbey nor any daughter
of knight or burgher whom he had not, if he desired her, raped and deflowered."

(FOL. 193B)

Jean Colombe here recalls two bloody episodes that were typical of the struggles that took place in Constantinople at the heart of the Comnenus dynasty. The principal scene is complex and shows how a knight, Isaac, motivated by bitter jealousy of Emperor Andronicus I Comnenus, kills Stephen Hagiochristophorites, one of the ruler's counsellors, in a city street. In the foreground, Stephen lies on the ground, beheaded, while Isaac, brandishing his sword, gallops towards the castle of the Lion's Mouth (Bouche-de-Lion) to seize the imperial treasure. The gate of the castle can be seen on the right. A colourful crowd is looking on, horrified by the murder. In the lower register, Colombe paints a graphic picture of the outrages suffered by Andronicus, whose throne Isaac has usurped. Naked, bound, hooted with derision, forced to ride backwards on a donkey holding on to the animal's tail, he passes through the streets in this humiliating fashion. All these details reproduced in the picture can be found in Sébastien Mamerot's text, together with that of the women who hurl excrement and urine at Andronicus. The artist does not, however, go so far as to depict the next scene described in the text, where these same women throw themselves upon Andronicus and brutally tear him to pieces.

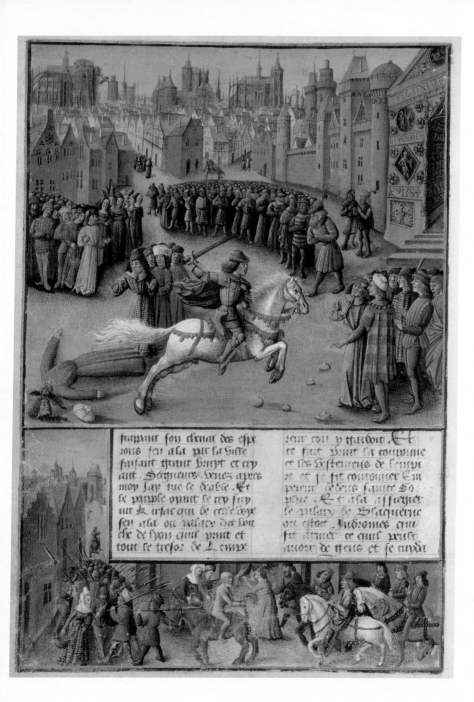

frappant son cheual des espe
rons sen ala par la Halle
faisant grant bruyt et cy
ault. Seigneurs venes apres
moy iay tue le deable. Et
le peuple oyant le cry suy
uit le roy car qui de celle voye
sen ala ou Wilart du son
che de lyon ciuil print et
tout le tresor de Lempe

reur ou y trouoit. Et
ce fut pris sa conuune
et les historiens de lempi
re et se fist couronner Em
preur deuis sainte So
phie. Et ala assieger
le rulan de Blacquerne
ou estoit Indromes qui
fit armer ce quil peust
auoir de gens et se aydi

and took prisoner a great part of the Turks and took away from them to Ascalon a most great and rich booty. For this reason, when King Baldwin heard this news, he was like one out of his mind and called straightway for the count of Tripoli, trusting in his good sense and his upright conduct. And he entrusted to him the guard and the government of the whole kingdom, and at this the barons and the other people were most joyful, for they said there was no other way that matters in the land of Syria might be well ordered. This charge the count assumed, but on condition that he should not have the guard of the nephew of the king, who was but a young child, lest, if he died before he was ten years old, men might say that he had caused his death. And he also wished that the castles and strongholds should be put into the hands of the Templars and the Hospitallers. And besides, the count requested that he should be assigned, in all those places where he had to go, certain expenses that he might maintain and guard the kingdom.

For at that time there were no truces and the kingdom had not sufficient revenues to suffer him to keep an army in the field against the Saracens with no other treasury than that of the king. And it was also agreed, in accordance with his request, that he should have the government of the kingdom for ten full years, but should it befall that the young king died before those years were accomplished, he should not be bound in that case to entrust the government to one of the two sisters of the king until the Pope, the emperor of Germany, the king of France and the king of England should judge to which of the two he should entrust it. For King Amalric had had the older daughter before he was king, by his first wife who had been separated from him when he began his reign, while the younger was daughter to the king and the queen. And so it was that the barons did not wish that the older daughter should be made queen, if the young Baldwin who was yet a child and was nephew to the king should die, until these four men had made their judgement. With regard to the child, he was entrusted to the guard of Count Joscelin, brother to his mother, while Beirut was given to the count of Tripoli as surety against the money that he should spend for the kingdom. When these matters had thus been ordered, the young child, who was but five years of age, was crowned in the year 1183[373] as Baldwin V, and he wore the crown from the Temple, where he had received it, as far as the Sepulchre, for this was the custom as has already been told. And shortly thereafter, there died King Baldwin IV, who was a leper, and the barons buried him with the other kings in the church of the Sepulchre in the year 1184.[374]

In the first year of the reign of this young king there fell no rain on Jerusalem, and the Christians there would have suffered great hardship through lack of water had it not been for the great charity of a rich burgher called Germain who was born in that

city and who had furnished it plentifully with water. For he had found as if by a miracle the well that Jacob had first sunk in olden times, despite the fact that it had long been covered and forgotten, so that men ploughed the land over it. Now when the count of Tripoli saw that, by reason of the drought, famine was beginning to afflict the Christians of the land of Syria, he called together in council the masters of the Temple and of the Hospital, together with the barons, and he showed them how it would be wise, that they might avoid the famine, to demand truces of the Saracens. These he obtained for four years, with the consent of Saladin, and for this he was highly esteemed in the Holy Land because of the great profit and succour that came about through the goods that were brought to them by the Saracens during the years of truce.

There was at that time in Lombardy a great lord called Boniface, marquis of Montferrat, who was grandfather to the young child king Baldwin V and son of William Longsword who had been married to the sister of King Baldwin IV.[375] Now this same marquis, hearing that his nephew[376] was king of Jerusalem, decided to embark on a journey to Outremer. After leaving his lands to his eldest son, he went off to Syria,[377] where he was received most honourably by King Baldwin and the count of Tripoli. And the king gave to him the castle of Saint Helia, the place where, so men say, the saint fasted for forty days, and it lies in the desert, on the other side of the river, hard by the place where Our Lord Jesus Christ fasted likewise for forty days.

Chapter LIX.
Of the malice of Andronicus, emperor of Constantinople. His shameful death and the reign of Isaac Angelus. The death of the boy king Baldwin V. The crowning of Guy of Lusignan and the dissension of the barons of Syria.

Now while Andronicus,[378] having usurped the empire of Constantinople, was on the throne, Conrad,[379] one of the sons of Marquis Boniface of Montferrat, fortuitously came to that city by sea, having followed his father's example, taken the cross and set sail. Andronicus was then committing all kinds of outrages in Constantinople, having had mutilated and blinded all the relatives of the emperor Manuel on whom he could lay hands. Moreover, there was not a nun in an abbey nor any daughter of knight or burgher whom he had not, if he desired her, raped and deflowered. Now at the prompting of one of his copyists, a man named Stephen Hagiochristophorites, who exercised

a powerful influence over him, Andronicus sent for a relative of Manuel, a knight named Isaac.[380] Aware of the cruelty inflicted on Manuel's line by the emperor, Isaac summoned one of his brothers and a number of his friends, on their advice donning armour beneath his clothes, and set off for the court. But before reaching the palace of Blachernae, where the emperor was, he came across Stephen Hagiochristophorites in a narrow street and, drawing his sword, struck off his head. Then, spurring his horse, he galloped through the city crying: "Lords, follow me! I have killed the Devil!"[381] And the people hearing Isaac's cry, followed him as he went from the alleyway to the palace called Hormisdas, which he captured with the whole of the treasure that the emperor kept there. Isaac now took the crown and vestments of the empire and had himself crowned emperor in Haghia Sophia. Then he went to besiege Andronicus at the palace of Blachernae. Andronicus armed all the men that he could muster and attempted a defence, but failed, for his soldiers, perceiving the great multitude of Isaac's followers, surrendered to them. Isaac had Andronicus made captive and brought to the palace of Hormisdas, where, to revenge the young emperor, Andronicus's sovereign lord, whom the latter had ordered to be drowned, he had Andronicus stripped and shaved and, having crowned him as if he were a king, mounted him backwards on a donkey with the tail in his hands as if it were a rein. And in this state he had him led through the streets of Constantinople, where women threw urine and other foul things at him as he passed before the houses. And when he was outside the city, he delivered Andronicus up to them and they threw themselves on him like a starving dog on a carcass and tore him in pieces. They scraped his bones with knifes and ate his flesh so that not a joint or little bone remained. And they said that those who had eaten his flesh were saved because they had in some measure avenged the cruelty that he had done.[382]

These events having taken place and Isaac now peacefully reigning over Constantinople as emperor, he sent to the king of Hungary[383] asking for one of the king's sisters to come to Constantinople, which was done and Isaac took her for wife and by her had a son called John Angelus. However, shortly afterwards, Isaac was surprised in an abbey near the city of Philip of Macedon, the city in which the great king Alexander was born, where he was staying with only a small retinue. He was taken by Alexius,[384] his brother, who had his eyes put out. Alexius then had himself crowned emperor of Constantinople whither he brought Isaac and had him supplied with the bare minimum for life. Therefore, the empress, Isaac's wife, had their son Alexius[385] secretly sent to Hungary for fear that his uncle Alexius have him put to death.

In Greece had remained another great lord and relative of the emperor Manuel,

whose name was Alexius Branas,[386] who, when he saw that Alexius now held the reins of the empire, collected a great host and came before Constantinople seeking to conquer it and gain the empire on the grounds that he was more closely related to Manuel than Alexius. The latter nevertheless attempted to maintain his status, yet dared not sally out of Constantinople because he knew that Branas was a man of noble lineage. For this reason, he asked Marquis Conrad to make a sortie against Branas. The marquis being in armour and well mounted sallied forth from the city. When Branas was pointed out to him, he set his horse to charge with all his might and struck him with such force that he laid him dead upon the ground, returning safe and sound to Constantinople, for Branas's men thought when they saw him coming that he had left the city to surrender to their lord. Seeing their master dead, they raised their siege and departed. And the emperor retained Conrad in his palace with him for fear that Branas's relatives in the city should do him harm. And so Conrad remained in Constantinople as its defender till the time came for him to go across the seas to Syria.

Then a great event occurred that brought change to the kingdom of Jerusalem also. For the young King Baldwin V[387] died of illness while in the guardianship of Count Joscelin, his maternal uncle. With the king thus dead, Count Joscelin treacherously suggested to the count of Tripoli that he go to Tiberias rather than with the king's body to Jerusalem and that none of the barons of the region should go with the king, but that the conveyance of Baldwin's body to the grave should be entrusted to the Templars. Then Joscelin went to seize the city of Acre and thence to Beirut, of which the count of Tripoli held the magistrature, and garrisoned it with his knights and other men. Now he sent to the countess of Jaffa,[388] his niece, telling her to go to Jerusalem with all her knights, and that, when the king, her son, was buried, she should seize the city and garrison it and assume the Crown.

When the count of Tripoli learned of Joscelin's treachery, he sent to all the barons of the land, telling them to join him at Nablus, and all except Joscelin, who was unwilling to leave Acre, joined him there, excepting prince Reynald.[389] But Sibylla, countess of Jaffa, was now in Jerusalem and having buried King Baldwin V, her son, she begged Marquis Boniface, her uncle, and the masters of the Temple and the Hospital, to advise and assist her. The master of the Hospital[390] replied that he could not consent to her coronation and that they must await the other barons and the patriarch. The master of the Temple[391] and prince Reynald replied that they would not wait but would, on the contrary, crown her. The master of the Temple, arguing that they acted against God's will and their promises, refused to join them. But they nevertheless had the gates

of the city closed and guarded so that none could enter or leave, being afraid that the barons who were at Nablus only twelve miles away might enter the city and incite the population to war while they were crowning Sibylla. Then the master of the Temple and prince Reynald took the lady to the Sepulchre to crown her there. On their arrival, the patriarch demanded of the master of the Temple the keys of the treasury[392] where the crowns were kept and the master willingly entrusted him with his. Then they sent to the master of the Hospital, asking that he should bring the other keys in his guardianship. But he replied that he would hand over no keys without the authority of the barons of the land. When they heard this response, the patriarch, the master of the Temple and prince Reynald went to find him; he, however, hid himself so well that they did not find him till the nones.[393] Even then he would not hand over the keys but, holding them in his hands for fear that one of his monks might hand them over, he was so provoked by their continued imprecations that he threw the keys into the square.[394] The three legates then gathered them up and opened the treasury, from which they removed two gold crowns. One of these the patriarch placed on the altar of the Holy Sepulchre and with the other he crowned the countess of Jaffa. Then he said: "Lady, you are a woman. It is fitting that you should have someone who can help you govern your kingdom. You see there a crown. Take it up and bestow it on the man who can best govern the kingdom." And she took the crown and, calling forward her husband Guy of Lusignan, count of Jaffa, she said: "Sir, come forward and receive this crown, for I know not where I might better bestow it." And the count, her husband, knelt as she placed the crown on his head and was thus made king and a great feast was held.

All these things, seen and heard by a friend whom they had sent disguised in a monk's habit, were reported to the barons at Nablus, at which Baldwin of Ramleh,[395] hearing that Guy of Lusignan was king of Jerusalem, said that he would remain so for less than a year and in this he was not mistaken. For he was crowned in mid-September but captured by Saladin with the loss of his kingdom in the very same year, on the feast of Saint Martin of Bouillant, which was the fourth day of the following July.[396] And Baldwin of Ramleh also told the count of Tripoli[397] and the other barons: "My lords, do what best you may, for the land is lost and I shall leave it because I do not wish any blame or reproach to befall me because I was there when it was lost. For the man who is now king I know to be a fool and so senseless that he will do nothing on my advice or yours, but on the contrary follow the counsel of those who know nothing. Therefore, I shall now depart this land." And the count of Tripoli answered him, saying: "Sire

before God, mercy! Have pity on Christendom! Let us take counsel how we may preserve this land. We have here the daughter of King Amalric and her husband Humphrey.[398] We shall crown her and go to Jerusalem and take it by force, for we have the power of the barons and the master of the Hospital. Moreover, I have a truce with the Saracens that will last as long as I wish it to, so we shall suffer no harm from them, rather they will come to our aid should we stand in need thereof." The count having thus spoken, all the barons commended his advice and promised that on the morrow they would crown Humphrey. But when he discovered that they wished to crown him, he bethought himself that he would not be able to endure the burden of governing the kingdom.[399] And so when night fell, he and his knights mounted and travelled all through the night till they reached Jerusalem. And when on the morrow, on the day on which they thought to crown him, they heard that he had fled during the night to King Guy in Jerusalem, they were astounded and the decisions of their council annihilated.

And when Humphrey came before the queen and greeted her, she did not reply because he had been against her and had not been present at her coronation. And he was very ashamed and began to scratch his head like a child and said: "Lady, there is nothing I can do if you do not trust me. For they wished to crown me by force and this is why I have come." Then she said: "Humphrey, in that case you are in the right and since you have done this, I renounce my anger. Now do homage to the king." And this he straightway did.

When the barons at Nablus heard this, they were even more astounded and requested that the count of Tripoli advise them. And the count told them that they should hold to the word that they had given and that he had no other counsel to give them. And they replied: "Sire, since there is a king in Jerusalem, as you know, we cannot go against him without dishonour. We, therefore, beg that you will not take this in bad part. Go to Tiberias and stay there. We shall go to the king to pay our homage and whatever help we can give you without attaint to our honour we shall assiduously do, so that you are paid all the expenses that you have disbursed in defending and safeguarding the kingdom, for which reason King Baldwin entrusted you with the magistrature of Beirut." But Baldwin of Ramleh was reluctant to attend this council. And so when it was clear to the count of Tripoli that all the barons had broken their word to him, he returned to Tiberias[400] and they all went to Jerusalem to pay homage to King Guy, except Baldwin of Ramleh, who was unwilling to go, but sent his own son[401] and asked the barons to beg the king to grant him seisin of his lands and accept his homage, which they did as soon as their own homage had been paid. But the king replied that he would not do

BATTLE AT THE SPRINGS OF CRESSON (1187).
RAYMOND II PAYING HOMAGE TO GUY OF LUSIGNAN

"And because King Guy had insufficient money to pay his men,
the master of the Temple entrusted him with a great treasure that had been placed
in safety with the Templars. For since King Henry of England had had
Saint Thomas Becket martyred, he had for every year that he lived sent
a large sum of money to be deposited with the Templars in Jerusalem in hope
that he might in remission of his sin make an expedition to Outremer."

(FOL. 198A–198B)

Baldwin IV died in 1185 at the age of twenty-four. His nephew Baldwin V was proclaimed his successor, but because he was still a minor, Raymond III of Tripoli was appointed as regent. Raymond immediately negotiated a truce with Saladin. Baldwin V died in 1186, and Guy of Lusignan was anointed king instead of Raymond of Tripoli. Raymond felt he had been passed over and refused to pay homage to the new king. He angrily withdrew to Tiberias and sought an alliance with the Saracens who, led by a son of Saladin, passed through Syria with the permission of the count of Tripoli. The Templars, suspicious that the count had negotiated a truce, attacked the Saracens near the springs of Cresson. The Christians consisted of a handful of horsemen, who found themselves faced with an enemy 40,000 strong. The massacre was frightful. In the centre of the picture, Colombe depicts a fountain, once more based on a fifteenth-century design, as a symbol of the place. The mass of opposing troops fills the space around the fountain. Syrian castles rise up against a landscape in the background whose hazy blue softens the violence of the foreground scene. In the lower register, the artist paints a scene in which, after this battle (1187), the count of Tripoli sets off to find King Guy. The king rides out of Nablus, shown on the right, and goes to meet the count in the open countryside. As soon as he sees him, he dismounts. The count also dismounts and kneels before the king, who raises him up and embraces him. The historiated letter "G" at the outset of this chapter incorporates a portrait of Guy of Lusignan wearing his crown.

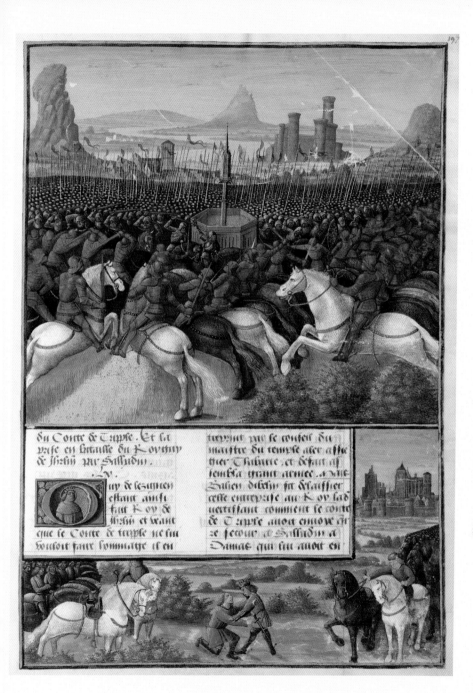

du Conte de Triple. Et la
prise en bataille du Royaume
de Jhrlm par Salladin.

Luy de ce ainsi
estant ainsi
fait Roy de
Jhrlm et voiant
que le Conte de triple ne sou
soiloit faire hommaige il en

treprint par le conseil du
maistre du temple aler asse
ger Thuberie et desault as
sembla grant armee. Mais
Balien debam se effraisser
ceste entreprise au Roy sad
uertissant comment le conte
de Triple avoit enuoye qu
re secour a Salladin a
Damas qui sui auoit en

this nor receive the homage of the son till the father had paid his. If Baldwin paid homage, he would forthwith grant the son seisin of the land, but if Baldwin did not pay homage, he would seize his land. And when Baldwin saw that he would have to pay homage to Guy or lose his land, he came before him without greeting and said "King Guy, I pay homage to you as one who will not owe his lands to you now or ever". This was the homage Baldwin paid to Guy. And King Guy, therefore, did not kiss him but invested the son of Baldwin with his land after he had done him homage.

This being done, Baldwin requested of the king a safe conduct out of his land and the king granted it. And Baldwin having obtained the safe conduct went to his brother, Balian of Ibelin, and entrusted him with his son and the safeguard of his land. Then he took his leave and departed, which was a source of great grief and harm to the land and made the Saracens so joyful that they no longer feared anyone except Balian, his brother, who remained and the very valiant prince Reynald of Châtillon. And though the king had given his assurance to Baldwin of Ramleh, Baldwin mistrusted him and, taking his brother Balian and a number of knights of the land, he travelled by night and day alike till they were out of the king's territory, and, only then taking leave of his brother and the other knights, he went to the prince of Antioch.[402] The latter, hearing that Baldwin was coming to Antioch, rejoiced at the news and, therefore, went before him and received him with great ceremony and gave him three times as much land as he had left behind in the kingdom of Jerusalem.

$$\dagger$$

Chapter LX.
How the king and the count of Tripoli were reconciled. Of the expedition made by Saladin's son in the Holy Land by the consent of the count of Tripoli and the defeat of the masters of the Temple and the Hospital. The bad advice given by the count of Tripoli. And of Saladin's capture of King Guy of Jerusalem in battle.

Guy of Lusignan having thus been made king of Jerusalem, and seeing that the count of Tripoli was unwilling to pay homage to him, attempted on the counsel of the master of the Temple to besiege Tiberias and did, indeed, assemble a great army. But Balian of Ibelin made the king abandon this enterprise by warning him that the count of Tripoli had sent to Damascus to ask Saladin for help and the latter had sent a num-

ber of Saracens and made reply that were Raymond besieged in the morning, he would raise the siege by the evening of the same day.

With this project, therefore, abandoned and the winter having passed, King Guy was aware that Saladin was mustering his army to re-enter Syria and called together his council around Easter and there found that he could do no good without the count of Tripoli. In order to have Raymond at his side, he sent to him the archbishop of Tyre,[403] the masters of the Temple and the Hospital, Balian of Ibelin and Reynald of Sidon.[404] But they did not all go because the count of Tripoli, not daring to refuse a request of the son of Saladin,[405] which he granted in honour of the latter's recent knighthood, agreed that he might openly make an expedition through his land and enter the kingdom of Syria on condition that he did no damage to any town, city, castle or house and should cross the river at daybreak and have crossed back by sunset. And though the count of Tripoli had in good time given warning to the Christians of his territory that they should not stir out of their towns and castles, the master of the Temple nevertheless, having heard that the son of Saladin would be passing through the territory, assembled as many Templars and Hospitallers as he could till they found themselves, he and the master of the Hospital, with ninety knights and a further forty whom they took from the garrison of Nazareth; they managed to encounter the Saracens, who were in number more than four thousand horsemen, at the springs of Cresson, whence they were returning having done no damage to the territory and sought only to recross the river. The Templars nevertheless attacked them and were confounded. For the master of the Hospital had his head cut off while the forty knights of the king's garrison and the knights of the Temple and the Hospital, with the exception of the master of the Temple, who escaped with three knights, were all captured. In respect of armour and equipment, the Saracens gained little or nothing for the principal servants of the Temple and the Hospital, seeing that the knights had charged into the Turks, took flight and saved their own lives and their masters' baggage.

This dreadful defeat took place on a Friday, on the feast of Saint James and Saint Philip, the first of May.[406] And the archbishop of Tyre and Balian, who had taken a different road, came to Tiberias and the count of Tripoli went out to meet them and received them with great ceremony. Finally, after they had strongly reprehended him for allowing Saracens to enter Tiberias, he expelled the latter on their advice and went to King Guy, who, having heard of his coming, came to meet him at Nablus and dismounted as soon as he saw him. And the count, seeing him, also dismounted and came forward on foot till he stood before him, where he kneeled and the king took him

in his arms and, raising him up, kissed him. At this they returned to Nablus, where, following the advice of the count and the other barons, the king concluded that he could no better than assemble his army at the springs of Sephoria and send to the prince of Antioch for help. The council at an end, the king adopted this strategy and assembling his army near the said springs sent to the prince begging for his help. And because King Guy had insufficient money to pay his men, the master of the Temple entrusted him with a great treasure that had been placed in safety with the Templars. For since King Henry of England had had Saint Thomas Becket martyred, he had for every year that he lived sent a large sum of money to be deposited with the Templars in Jerusalem in hope that he might in remission of his sin make an expedition to Outremer, where he wished to find a great sum of money ready on his arrival the better to assist the men of the Holy Land and do battle with the Saracens. And so great was this treasure that King Guy could generously pay his army, which he did, and assembled so many other men-at-arms for hire that he could easily muster an army to give battle against the Saracens. And for the honour of the king of England, whence the money had come, he had great banners bearing the arms of England made and had them borne by the constables and the head of the mercenaries.

Shortly afterwards,[407] Saladin went to besiege Tiberias, where no men-of-arms had stayed but only the countess of Tripoli. King Guy, on receipt of the message from her revealing this and asking for help,[408] assembled his council and first asked what should be done of the count of Tripoli, who replied in everyone's hearing: "I advise that Tiberias be allowed to fall and I shall tell you why. Tiberias is mine and my wife is there, and, therefore, should the city be taken, there will be no loss so great as mine. And I am certain that the Saracens will not attempt to hold the city but will raze it and then return to their own lands without coming here to seek you out in your camp. If they take my wife, my men and my wealth and demolish my city, I shall do what I can to have them back. For I should prefer Tiberias to be taken and razed than that the whole land should be lost. And to make it clear why I speak in these terms, between here and Tiberias there is no water except a little spring called Cresson, which has little enough water. And I know for certain that when you leave this place, the Saracens will retreat before you and will constantly harry you with attacks throughout the day's march between here and Tiberias and the result will be that they will force you to make camp, whether you want to or not, because you will not be able to fight for the heat and because the foot soldiers will have nothing to drink. And if they make you camp, of what use will your men and horses be, given that they will all be half dead of thirst? Undoubtedly the

Saracens will capture you the following day at their leisure, for, having enough to eat and drink, they will all be fresh and all of you will be killed or captured. Therefore, I advise and recommend that you allow Tiberias to be taken rather than that the whole land should be lost."

When the count of Tripoli had thus spoken, the master of the Temple stood up and said out loud that there was treachery afoot.[409] The count heard him well enough, but acting as if he had not, said to the king: "Sire, if you go to Tiberias and it does not fall out entirely as I have predicted, I give you my head to be cut off". The council, therefore, came to an end with the king's promise, made on the advice of the master of the Temple and all the barons, to follow the count's advice. But when it was near to midnight and the king had just taken a late supper, the master of the Temple came to him and said: "Sire, do you place your trust in the traitor who has advised you thus? His goal is to ensure your dishonour while you are yet newly crowned. For there never was a king of this land who in so short a time was master of as many troops as you now have. And it will, indeed, be a great blot on your honour if you allow a city to be destroyed that lies only five miles from your army, when this is the first task that has fallen to you since you were crowned. Know that the Templars would rather throw off their white robes and sell everything they own than fail to revenge the shame that the Saracens have done me. Therefore, now have it cried through the army that everyone should stand to arms and prepare for battle and follow the True Cross."

King Guy did not dare refuse the master of the Temple and had the word given as he recommended, for he loved and feared the master as the man who had made him king and who had handed over to him the treasure of the king of England. But the barons, when they heard the order given, were astounded and wished to know whence came this counsel and went to the king's tent to convince him to change his mind. But he would not be moved. And therefore, they obeyed and went to arm themselves in high dudgeon, knowing that no good could come of it.

And the Saracens did, indeed, do as the count had said they would once the king had left his camp. Then it happened that the foot soldiers of the rearguard moving around the host discovered an old Saracen woman,[410] the slave of a Syrian from Nazareth, mounted on a female ass, who confessed[411] that she had cast spells over the army for two nights and that, if she could have done so for a third, she would have bound the people in the camp so firmly that the Saracens might have captured them at their leisure. For none would have been able to flee the magic circle that she would have

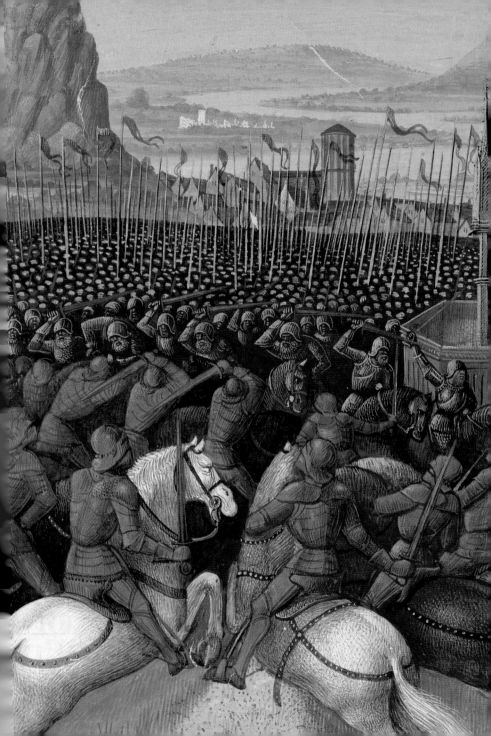

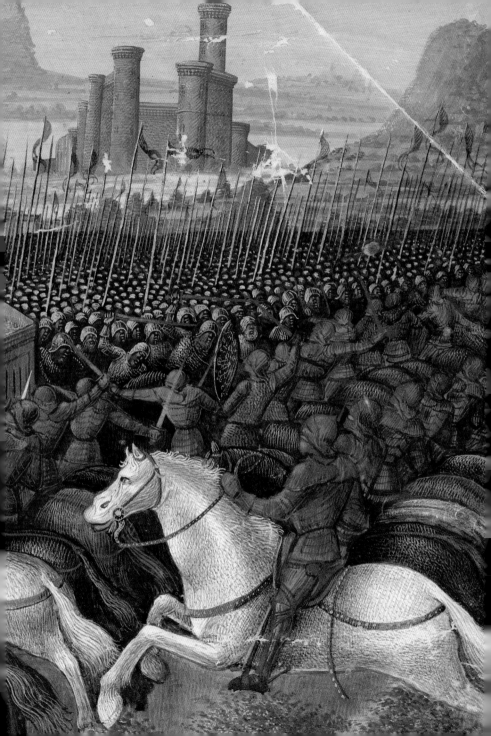

woven around them, for which Saladin had paid a great sum of money. Having forced this confession out of her, our men several times threw her into a great fire from which she each time emerged unscathed, whereupon one of the men finally struck her a blow on the head with an axe and so killed her. Now when King Guy and his men came forth from their camp, they were assailed by a great number of Saracens who harried them as the count of Tripoli had foreseen and did so incessantly. And when it was nones[412] and our men were midway between the springs of Sephoria and Tiberias, the king asked the count what he would do. And he gave bad advice, for he recommended that they make camp,[413] whereas there were some in the army who said that if they had then attacked the Saracens, they would have defeated them. And so the king complied with the bad advice and would not trust the good. When the Saracens saw that the Christians had encamped, they arranged themselves all around them, so close that the two camps were within earshot of each other. And they so completely encircled them that if even a cat had slipped out of the Christian host, it could not have escaped capture by the Saracens. That whole night was a torment for the Christians, for neither man nor beast had a drop to drink throughout it.

The following day was Saturday and the fourth of July, the day of the feast of the bishop Saint Martin, in the summer of 1188.[414] Our men set forth prepared for combat. But the Saracens retreated before them till the heat of the day, for the Christians were moving through tall grass and broom to which the Saracens set fire on all sides and left them so till the terce. At which point certain knights from the squadron of the count of Tripoli left their ranks and went to Saladin to say: "Sire, what are you waiting for? Strike! They can no longer defend themselves!" Whereupon the Saracens came down from the mountains and charged our foot soldiers, who threw down their arms and surrendered, their mouths agape with thirst. And when King Guy saw the distress and the anguish of the host and how his foot soldiers had surrendered, he sent to the count of Tripoli to charge the Saracens, since, the battle being fought on Raymond's territory, the right of first encounter with the enemy fell to him. And the count spurred his horse and his men did likewise and charged the Saracens, who, recognising his banners, opened their ranks[415] and made way before them so that they passed through the middle of the Saracen army and went their various ways. No sooner were they past than Saladin's host closed ranks and charged the king's army, capturing him and all those who were with him except Balian of Ibelin and those of the rearguard, who escaped. The same fate befell the son of the prince of Antioch and his men and the four stepsons of the count of Tripoli. And there was lost the part of the True Cross that Saint Helena,

mother of the holy emperor Constantine, called the Great, had left in Jerusalem and no certain news of it was heard ever again.

Saladin, having thus defeated the Christians, encamped and ordered that all the prisoners should be brought before him, the non-nobles around his tent and the nobles within. Therefore, King Guy was brought and Saladin had him seated in front of him. After him were brought Reynald of Châtillon, lord of Krak, and Humphrey, his stepson, and the master of the Temple, Marquis Boniface[416] of Montferrat, and Count Joscelin, the constable Aimery, brother to the king, and the marshal. When Saladin saw them, he rejoiced heartily, and because he knew that the king was very hot and thirsty, he had him brought a cup of flavoured water to cool him down. The king, having drunk, handed the cup to Reynald who was next to him. At which Saladin, who hated Reynald above any other man, was greatly displeased and told the king that it grieved him that he had given it to Reynald and that Reynald should boldly drink his fill, for this was the last drink that he would ever have, and that nothing would prevent him cutting off Reynald's head with his own hand, for Reynald had never kept faith nor promise in the truces that he had granted. And when the glorious prince Reynald had drunk, Saladin had him brought out of his tent and there with a sword cut off his head and had the body dragged through all the cities and castles of his territory. O glorious triumph of martyrdom there received without trace of fear by that flower of chivalry, Reynald of Châtillon-sur-Marne in the diocese of Soissons, because he had supported, defended and augmented the very holy Catholic faith, on behalf of which he had by worthy valour and force of arms killed innumerable Turks and Saracens and more especially those under Saladin's command.

Saladin, after this dreadful defeat of the Christians and after the inhuman beheading of the highly renowned prince Reynald of Châtillon, had the king and all the other prisoners led to prison in Damascus, while he went on to lay siege to Tiberias, which was surrendered[417] to him, as was Nazareth. And on Wednesday he went to Acre,[418] which was also surrendered to him. Then he went to Tyre, but was reluctant to lay siege to it because the knights who had escaped from the battle were still there. Balian was there and obtained a safe conduct from Saladin to go to Jerusalem and pass a single day there so that he could bring away from it his wife, the queen,[419] and children. But when he arrived there, the patriarch freed him from the promise that he had given and added his prayers to those of the others, arguing that he would be the most dishonourable man in the world if he thus departed abandoning the Holy City in its desolation, wherefore he remained there, having it garrisoned and provisioned as best

he might. For which the patriarch and Balian took the silver with which the monument of the Sepulchre was covered and minted it to pay the knights and other men-of-arms so that they would defend the Holy City.

Chapter LXI.
How Saladin took many cities and castles in Syria and besieged Tyre. And of the aid sent by Our Lord.

Saladin, leaving Tyre in peace, brought his army before Sidon, which is five miles from Tyre, and that city was surrendered to him. Then he entered the territory of Tripoli and took Jebail and the castle of Daron. The lady whom the count of Tripoli would not cede to Gerard of Ridfort[420]– who then in dudgeon entered the Order of the Templars – came from that castle, whence arose the hatred by which the Holy Land was lost. When the false and disloyal traitor, the count of Tripoli, who had falsely betrayed the king and the army and had ridden on in safety to Tyre, learned, while still at Tyre, that Saladin had entered his territory, he and the son of the prince of Antioch took ship with the few knights that they could muster and went to Tripoli. But he was not long there before he died suddenly,[421] some said of grief; but he left a special sign of his treachery, for it appeared that he was circumcised in the manner of Saladin and certain other Saracens. He had left his land[422] to the son of the prince of Antioch, who was thereafter count of Tripoli. And when Reynald of Sidon and the castellan of Tyre saw that all the knights had left and that they had few men and provisions, they sent to Saladin saying that he should return and they would surrender Tyre. Saladin in great joy handed his banner to a knight and sent it to Tyre so that they could fly it over the castle. But the castellan replied that for fear of the inhabitants he would not dare to fly it unless Saladin was present, and so the knight returned. Hearing this reply, Saladin hastened to Tyre, but could make not such speed as to prevent Our Lord bringing help to Tyre before he could reach it.

For Marquis Conrad,[423] who was in Constantinople with the emperor, one day said: "Sire, my knights wish to go to the Sepulchre and I cannot hold them back. But they have promised me that they will return as soon as they have completed their pilgrimage." And he spoke thus intending that neither the emperor nor the citizens of Constantinople should know that he wished to leave, for fear that the relatives of Branas

whom he had killed seek to avenge him. Accepting his request, the emperor had a ship fitted out and loaded with victuals and arms. And when his men were on board, Conrad, who was then in the company of the emperor at Bucoleon, pretended that he had forgotten something that he must communicate to them. Therefore, he took a small boat and put to sea and went on board their ship, had the sails set and by divine grace they had such favourable winds that they arrived in a few short days before Acre, where, thinking to anchor, they were greatly astonished that they heard no bells and that no other vessel came out to meet them. On this account they dared not anchor, but made away from the port. And when the Saracens of Acre saw that they would not anchor, a Saracen knight came out to the ship and, with the marquis forbidding any of his men to speak, they heard from the knight that Acre was now in Saladin's hands and that they might rely on Saladin's word and, if they were merchants, disembark, for the marquis had said that they were carrying merchandise. And when the marquis heard from the Saracen knight that the entire kingdom was lost, with the exception of Jerusalem and Tyre, which were, as he believed, besieged by Saladin, he had his steersmen make for Tyre. And Our Lord in his grace sent him a wind such that, though the Saracens had vessels armed and sent in pursuit, they could not catch him; on the contrary, he reached Tyre very quickly[424] and was there received with great joy and a handsome procession by the men of the church, praising Our Lord that such help had been sent to them and leading Conrad and his men into their city and castle. Now Reynald of Sidon and the castellan, seeing that the burghers of Tyre had surrendered the city and the castle to the marquis, were afraid that they might pay the price for being unable to surrender the city to Saladin. Therefore, one night they took ship and fled to Tripoli.

Marquis Conrad thus became master of Tyre and, searching the castle for men, provisions and arms, came upon the two banners of Saladin and, when he heard why they had been sent, had them thrown into the moat. Surely we must believe that Our Lord sent the marquis to save Tyre! For the day after his arrival, Saladin came to the gates, believing that the city would immediately be surrendered to him. And he found the contrary. Therefore, when he knew the cause and that amongst his captives was the father of Marquis Conrad, he thought that by offering money and Conrad's father he would obtain possession of the city. So he sent to Damascus to have Marquis Boniface[425] brought to him at Tyre, and on his arrival let Marquis Conrad know that if he were willing to surrender Tyre, he would give him a great sum of money and restore his father to him. To which Marquis Conrad replied that he would not give

THE PATRIARCH OF JERUSALEM PREACHING PEACE TO THE INHABITANTS.
SALADIN AND BALIAN II OF IBELIN

*"And it was a great sadness to see the old mothers and young ladies
barefoot and unkempt and the young girls all naked and also the children going
in processions all day long to the Holy Places and submerging themselves
in tuns and buckets of water, screaming and piteously lamenting and calling
upon divine aid. But truly the people of the Holy City were so filled with
pride, gluttony and lust – and many of them more especially with the very
wicked and ignoble and detestable sin against nature."*

(FOL. 203B–203VA)

This picture represents Jerusalem. Saladin has seized all the towns and cities around, but he does not wish to take Jerusalem by force: he lays siege to the city and confines the inhabitants inside. The people are in despair and contemplate escaping and giving combat to Saladin, even if they die in the attempt. The patriarch of Jerusalem preaches a sermon to the inhabitants and exhorts them to abandon the idea of fighting and instead to negotiate an agreement with Saladin by which they will surrender the city. This is the scene shown in the principal picture: the patriarch, standing before the porch of the church, is speaking to a vast crowd, while on the left of the picture processions of young maidens approach, their hands joined in prayer. The architectural decoration of the church porch is most skilfully executed; the columns and *voussoirs* are covered with sculptures. The delicacy and complexity of Gothic art are emphasised here. In the lower register, the knight Balian of Ibelin has been sent by the Christians and is seen in Saladin's tent, on his knees, negotiating conditions for the surrender of the Holy City.

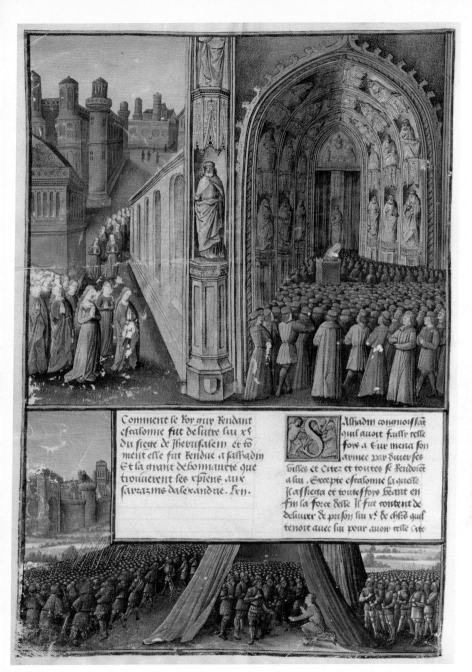

Comment le Roy guy Rendant
escalonne fut delivre Su roy
du siege de Jherusalem et co[m]-
ment elle fut Rendue a saffadin
Et la grant dehonnaurte que
trouuerent ses xpiens aux
sarrazins dalexandrie. Fin.

Alhadin cognoissoit
quil auoit fully ceste
fois a Eur mena son
armee par duerses
billes et Citez et toutes se Rendoict
a lui. Excepte escalonne la quelle
saffieta et toutesfoys Heant en
fin la force delle Il fut content de
deliurer de prison Su roy de chr̃ꝰ quil
tenoit auec lui pour auoir celle Cite

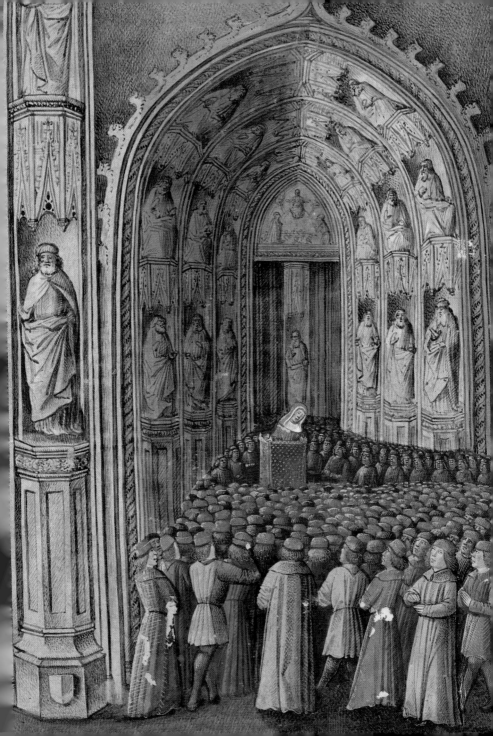

a single stone of Tyre for the liberty of his father; let Saladin bind him to a stake and they would use him as a target because he was too old.[426] And thus was Tyre held and defended against Saladin by Marquis Conrad.

Chapter LXII.
How King Guy surrendered Ascalon and was delivered, he and nine of his knights. The siege of Jerusalem and how the city was surrendered to Saladin. And the great kindness shown to the Christians by the Saracens of Alexandria.

Saladin, realising that he had for now fallen short at Tyre, took his army before many other towns and cities, all of which surrendered, except Ascalon, which he besieged. But finally understanding how strong the city was, he was content to deliver from prison the king and nine of his knights whom he had brought with him in order to gain the city of Ascalon. Nevertheless, when he had gained possession of it, which was in the month of August,[427] he did not deliver King Guy, who was released only in March of the following year. For thus it had been agreed. And certainly Guy was unwilling to counsel the inhabitants through his envoys that they should surrender a stronghold such as Ascalon to Saladin, greatly though he desired to be free. But when the men of Ascalon had taken counsel amongst themselves, considering that no assistance could come to them in time, they granted Saladin's request. He then loyally escorted them and their goods into Christian territory and shortly afterwards, having taken all the towns and cities around Jerusalem, sent to the citizens of the Holy City saying that they should come and parley with him in all safety at Ascalon.

And when they had come, he made them many great offers if they were willing to surrender without battle, and they would not hear of his demands, whereupon he said to them: "I should be most reluctant to do harm to Jerusalem if I could gain possession of it peacefully, for I believe it to be the true house of God. Now, since you are so intent on holding it against me, if you wish, I will give you three thousand bezants to strengthen and reinforce your city and I will allow you land to plough for five miles around the city. Moreover, I shall have brought to you great abundance of provisions such as you could not obtain more cheaply by any other means, on condition that, if no help comes to you by Pentecost in the form of men who can resist my army in the

field, you will surrender the city to me. And I will then ensure safe conduct for you and your goods into Christian territory." But the citizens replied that they would not treat with him, which greatly displeased him; he now swore that he would take the city by force of arms.

Therefore, when the citizens returned to Jerusalem, they were soon afterwards besieged by Saladin, who battered and undermined the walls[128] and so encircled and tightened his grip on the city that they could not go out to the fields far from the city, nor receive any help in the form of provisions. Ask not of the pitiful situation then prevailing in the Holy City! For there were innumerable people there, not only the inhabitants of the city but other Christians who had come seeking refuge[129] from many towns, castles and cities, all of whom had come to Jerusalem. And it was a great sadness to see the old mothers and young ladies barefoot and unkempt and the young girls all naked and also the children going in processions all day long to the Holy Places and submerging themselves in tuns and buckets of water, screaming and piteously lamenting and calling upon divine aid. But truly the people of the Holy City were so filled with pride, gluttony and lust – and many of them more especially with the very wicked and ignoble and detestable sin against nature – that these mortifications did not please Our Lord and He was unwilling to allow that such people, Christians as they were and fully cognizant of his commandments, which they nevertheless abhorred, should any longer sully the very holy house of God. Rather he left them, as it were, abandoned to the temporal punishment of their misdeeds.

At the last, when the inhabitants saw that Saladin had so greatly undermined their walls that more than thirty yards of it had fallen all at once, they were so terrified that they deliberated in council how they might sally forth from the Holy City and fight to the death against the Saracens, electing rather to die in fighting and in defending the city and the place where Our Lord Jesus Christ was willing to suffer the Passion for us than to let themselves be captured within and suffer a cowardly and shameful death. But the patriarch in a long sermon reprehended them and showed them that this way of dying would be neither useful nor honourable. For when it happened that those who could bear arms were all thus exterminated, there would still remain in the city fifty people for every one who could bear arms and they would suffer so greatly from the tyranny of the Saracens that most of them would turn aside into their evil sect. Therefore, the best thing would be to try and obtain the safety of all at once if they might do so by any pact or condition. Then all in one voice approved the counsel of the patriarch, and the worthy knight Balian of Ibelin was sent to Saladin to request

a treaty. And this, thanks to the remonstrations made by Balian, whom he liked, Saladin eventually granted, though he was reluctant to do so because of the oath that he had sworn.

Thus, the Holy City of Jerusalem was surrendered, under these conditions: that every man of over ten years should pay twenty bezants and every woman ten and every child of less than ten years should pay five.[430] And at this price the Christians might take with them all their chattels. And thus, Balian sent the keys of the Holy City of Jerusalem, which Saladin entered on the twelfth day of the month of August in the year 1187.[431] Of the redeemed there were first taken forth one thousand for three thousand bezants that the master of the Hospital took from the treasure of King Henry of England, he who had ordered the martyrdom of Thomas of Canterbury, in repentance of which wrong he sent every year a great treasure to those of the Temple and the Hospital, hoping to go in person to the aid of the Holy Land of Jerusalem. Others were redeemed by the Templars and Hospitallers from their own funds, but not so great a number as they would have done, had they not known Saladin for a noble man, who, they thought, would be willing to bargain. Others again sallied out of the city without paying their ransom but there remained a great number who had not the wherewithal to redeem themselves.

Therefore, al-Adil Saif ed-Din, Saladin's brother, begged Saladin that he would give him some of them, and he gave him a thousand, whom al-Adil Saif ed-Din immediately and generously freed. The patriarch and Balian made the same request and he granted them each five hundred, whom they also immediately freed. At this Saladin said: "My brother and the patriarch and Balian have given their alms and I wish to give mine". And so he commanded that they let go without payment all the poor people who had not the wherewithal to redeem themselves. But if it happened that any were found to have money on them, it was taken from them and they were thrown into prison. When all this was done, there remained eleven thousand in prison. The married and the young women, too, relatives of knights or gentlemen who had been killed or captured with King Guy, came before Saladin. And when he knew what they asked, he commanded that their fathers and husbands, if they were found in his prisons, should be delivered, and to the others he gave generously from his own treasury.

And when the Christians thus came forth from Jerusalem, they were in very great number. So Saladin had them divided into three companies, with the Templars leading one, the Hospitallers another and the patriarch and Balian the third, and each set off fifteen days apart, so that they might find more provisions. Each company was allocated

SIEGE OF TYRE (1187). SALADIN SETTING FIRE TO HIS FLEET AND TO HIS SIEGE-MACHINES

"And Saladin himself was greatly afeared and lost all hope of taking Tyre. Therefore, he burned and destroyed all the galleys, camps and siege-machines and left ignominiously by night, heading for Damascus."

(FOL. 206A)

In 1187, Saladin laid siege to the city of Tyre. Jean Colombe depicts the fortified city by the sea. The galleys that Saladin has had sent from Acre to blockade the city are shown in the background. An extraordinary mêlée takes up the whole of the foreground of the principal picture. Prominent in the centre of the clashing troops, a knight in green armour, with two stag's horns on his helmet, spurs his white warhorse into a gallop. This is the celebrated Spanish knight, whose valour and exploits are related by Sébastien Mamerot. In the lower register, the artist depicts the departure of the Saracens. Once he had lost all hope of capturing the city of Tyre, Saladin burned and destroyed his galleys and siege-machines before retreating to Damascus. Once again, Colombe shows cannons similar to those in use in the fifteenth century.

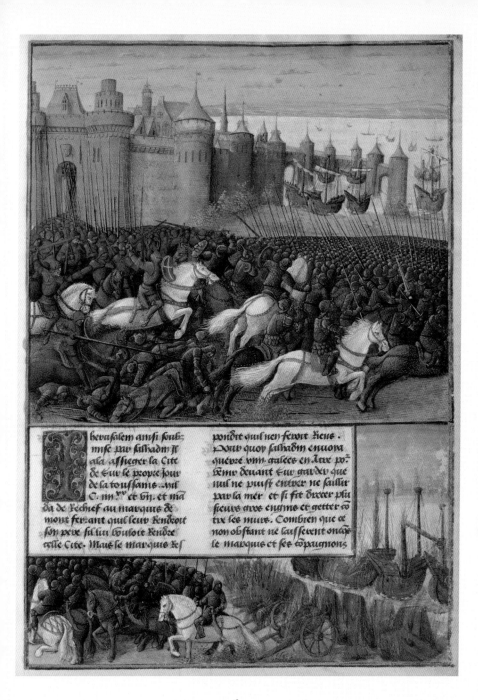

be Jerusalem ainsi soub-
mise par saladin il
ala assieger la Cite
de Sur le propre jour
de la toussains .mil
C. iiij.xx. et iiij. et man-
da de rechief au marquis de
mont ferrant quil leur rendroit
son pris sil lui couloit rendre
celle Cite. Mais le marquis res-

pondit quil nen feroit riens.
Pour quoy saladin envoya
querre vint galees en Aire po-
xine devant Sur garder que
nul ne puist entrer ne saillir
par la mer. et si fit dresser plu-
sieurs engins et getter con-
tre les murs. Combien que ce
non obstant ne laisserent onc es le
le marquis et ses compaignons

by Saladin fifty Turkish knights to escort them and they led them safely as far as the territory of Tripoli. But the count of Tripoli was unwilling to let them enter, instead sending many of his knights to capture the richest citizens and take from them whatever they had. A section of the poorer people went to the territory of Antioch and the other part remained in Tripoli and there did the best they could. But the other Christians, those who had come forth from Ascalon and the castles around it and whom Saladin was to bring into Christian territory, were luckier than the others. For when they were taken to Alexandria, the citizens there fed and looked after them and did much good for the love of God, till the time came when they must embark and cross the sea, and the commandant had them enclosed within palisades and made very sure that no harm came to them.

And so there came thirty-eight ships and other boats belonging to merchants of Pisa, Genoa, Venice and other places, who on their return wished to take on board the Christians who could pay their passage and refused to take the poor. And when the commandant found this out, he said: "Do you mean to leave your Christian brothers here as slaves and trample underfoot the promise and assurances of Saladin? I will not allow it. I shall force you to take them on board without payment, and I will give you enough bread and water for them as long as you are able to bring them to safety in Christendom." And he so compelled the merchants that they promised to take them freely over the sea to Christendom and thus the commandant handed them over, swearing by his own law, that if it turned out that they did not bring them to Christian lands without charge, that they or other merchants from their land would have accounts to settle with him. And they, therefore, obeyed him.[432] Now Saladin brought from Damascus four camels laden with rose-water and with this had the Temple of Our Lord washed, having first removed a great gilded cross that stood at the highest point of the temple and which was disrespectfully treated by certain Turks and Saracens, although it was not, in truth, known whether Saladin had ordered this. Then Saladin entered the Temple and worshipped God in the manner of the Turks and Saracens.[433]

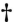

Chapter LXIII.
How Saladin besieged the city of Tyre. Of the valour of the marquis of Montferrat. Of the Green Knight. And the German emperor who drowned while bathing in a river. And how Tripoli was delivered by the Green Knight and Acre besieged by the king of Jerusalem.

Jerusalem thus became subject to Saladin, who went to besiege the city of Tyre on All Saints' Day of 1187[434] and immediately sent to the marquis to say that he would restore his father to him if he were willing to surrender the city. But the marquis replied that he would do nothing of the sort. Therefore, Saladin sent for thirteen galleys from Acre to come to Tyre to ensure that none could enter or leave by sea. And he had several large siege-machines built and loosed them against the walls. Despite this, the marquis and his companions, amongst whom was a young knight of Spain[435] bearing arms of green and two stag's antlers on his helm, a man of great reputation and admirable valour, never ceased making sorties, several times a day, in which they attacked Saladin's army. And whatever watch or ambush was arranged by the Turks, this Green Knight did such marvellous feats of arms in their midst that even the Turks, marvelling at his boldness and enterprise, would all come out of their tents and pavilions to see him whenever the rumour came that he was making a sortie, so renowned were the blows that he struck.

And at his advice, the marquis made boats covered in leather, called *bourbottes*, they being of a kind that can be brought closer to the coast than others, and in them put numbers of crossbowmen who did great execution on the Turks. Then the marquis sent to the count[436] to ask that they help him with men and provisions, and the count sent him ten well-armed and provisioned galleys. But as they approached Tyre, a great wind came up that drove them back to the port of Tripoli. During this siege, it happened that a young Turk, furious with his father, had himself baptised and came to the marquis in Tyre. Some days later, the marquis cunningly had him write letters to Saladin in which he informed him that he knew the entire disposition of the city of Tyre and that the Christians were due to flee that very night. And if he did not believe this, he should have people listen at the port and they would hear the noise. These letters once written were fired by arrow into the host and carried to Saladin, who rejoiced at the news. Therefore,

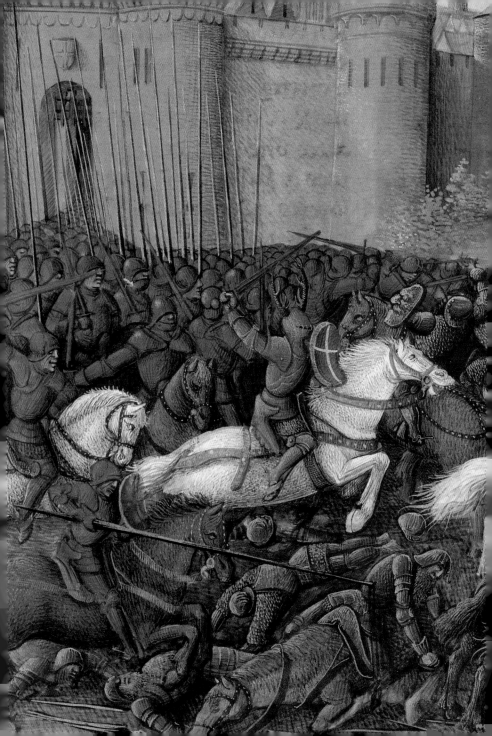

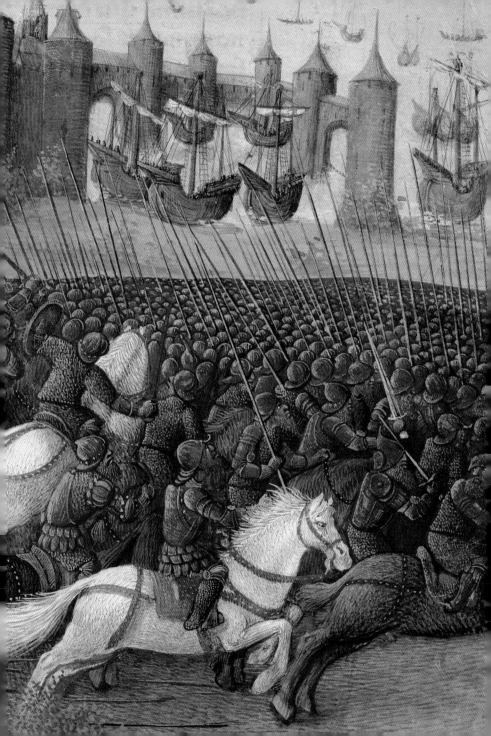

he had placed in the galleys his most valiant men so that they might surprise the fleeing Christians. Meanwhile, the marquis ordered that all who could carry arms should be on the bridge the following night. During this time, he had the towers and walls carefully guarded, then lowered the chain that guarded the harbour. The great noise that this made convinced the Turks that the letters were true.

And so when day came, Saladin sent five of his galleys into the port beyond the chain, whereupon it was suddenly raised by certain persons expressly set to this duty by the marquis, who thus took the five galleys and killed the Turks and Saracens in them and crewed them with Christians; they then went out to combat the other galleys, having also on their side the crossbowmen in the *bourbottes* who did great execution on Saladin's men. These galleys, not daring to encounter ours, steered some of them away towards Beirut and others towards their men on land. Now when Saladin's men saw the Christians attacking by sea, they rushed to assail the city and captured the moat. Moreover, they worked so hard in such a short time with mines and other machines that they came close to entering Tyre. But then our men, having defeated the galleys and heard of the Turkish attack on the walls of the landward side, opened the doors and sallied out so suddenly and with such vigour that most of those who were at the foot of the walls were killed and they chased the others towards their comrades the besiegers with such fierce impetus that the greatest amongst them were terrified.

And Saladin himself was greatly afeared and lost all hope of taking Tyre. Therefore, he burned and destroyed all the galleys, camps and siege-machines and left ignominiously by night, heading for Damascus, leaving part of his baggage, which the marquis and his friends plundered at leisure and with great rejoicing after so great a massacre inflicted on the Turks. Thus ended the siege of Tyre[437] by the aid of Our Lord and the ingenuity and valour of the marquis of Montferrat.

While things continued thus in Outremer, the very reverend archbishop of Tyre,[438] William, had visited the Pope and continued into France[439] and, because of his preaching, King Philip Augustus, the courageous, known as "Dieudonné", and King Henry of England made peace[440] and themselves both took the cross with the majority of their barons and a great number of people so that they might go to the aid of the Christians in Outremer, though this crusade had no immediate effect. For after a new quarrel between the two kings, King Henry died at Chinon-les-Tours in Touraine,[441] in part out of grief and displeasure with his own children, who had deserted him to fight against him with Philip. Moreover, Frederick Barbarossa, the emperor of Germany,[442] also took

the cross and, leading a very great army and accompanied by one of his sons,[443] but leaving two others in Germany, crossed the Danube and within a few days' march he came to Constantinople, where the Greek emperor[444] received him and feasted him. Then, leaving the city, he set out for Antioch, while the Greek emperor had merchants go before and behind him, selling provisions at excellent prices. But the Germans, ungrateful, forgot the courtesies and prices of these merchants and pillaged and robbed them of their wares when they arrived at the army. On this account the merchants stopped bringing provisions, with the result that the Germans spent three weeks without finding victuals, and consequently, there arose a great famine amongst them that carried off many of them. And to increase their ill fortune, it happened that, after their arrival in Armenia, when they encamped by a river, the emperor Frederick bathed in it and was drowned by accident, before he could be dragged out,[445] he having been emperor for thirty-six years. The barons and knights then, burying Frederick in their manner, raised to the imperial throne his son Henry, who was with them. He led them to the city and land of Antioch, where they afterwards stayed for a considerable time. Some, however, say that the three sons of the emperor were with him and that the people made the eldest emperor.[446]

Now Saladin, hearing of the arrival of the Germans and warned of the great army that the kings of France and England were assembling to come to Jerusalem, had the city of Acre well walled and reinforced and provisioned with men and victuals and equipment. He was certain that nowhere else in his lands was it so suitable for the arrival of such great and numerous armies and, therefore, ordered that no one of any rank should sally out of the city whatever advantage they foresaw from doing so, but that they should do no more than ensure their own safety behind the walls. Then, having provisioned and equipped and manned all the other coastal cities, he went with his whole army to lay siege to the city of Tripoli. In order to assist the city, the marquis sent the galleys that William of Sicily had sent to Outremer and with them the Green Knight, who, after he had been some while in Tripoli, made a sally with the men of the garrison and so boldly and forcefully attacked the Turks that he killed great numbers of them. Saladin, seeing his men thus vanquished and killed in more than one place by the Green Knight, sent to him to come under safe conduct to meet him.[447] This the Green Knight did and Saladin feasted him and offered him great wealth if he were willing to serve under him. But the Green Knight, replying that he had come to these marches in order to afflict the Turks, returned much honoured and esteemed by Saladin, who, acknowledging the valour of the garrison of Tripoli and the admirable conduct

*"Besides these ordinances, King Philip, before he departed, ordered
and commanded the burghers of Paris that this city that was so dear to him
should be completely encircled by high and strong ramparts, with towers placed
all around them well furnished with gates that could be defended."*

(FOL. 209A)

After the news of the fall of Jerusalem, Western Christendom prepared to retaliate. In 1188, the only possessions in the Holy Land that were still in the hands of the Franks were the fortress of Tyre, the county of Tripoli and the principality of Antioch. On 29 October 1187, Pope Gregory VIII issued the *Audita tremendi*, a papal bull calling for the Third Crusade. King William II of Sicily quickly responded by sending a fleet of fifty galleys to support Tripoli in the spring of 1188. France, England and Germany, however, were slower to react. It was May 1189 before Emperor Frederick Barbarossa set off for the East by the overland route with an army consisting mainly of Germans – the largest that had ever travelled to the Holy Land. The historiated letter "L" at the beginning of this chapter bears a portrait of the German emperor. In the lower register, Jean Colombe shows Frederick arriving at the camp of Guy of Lusignan, before the walls of Acre, which the latter had held under siege for over a year. The principal scene shows Philip II Augustus before the journey, dictating a series of royal ordinances that lay down the conditions of the regency during his absence. This event takes place in the royal palace in Paris in 1190. The king, seated on his throne, dictates his wishes to a clerk sitting before him. His mother, Adela of Champagne, and William of the White Hands, archbishop of Rheims, are present. The task of governing the kingdom will fall upon them since the king's son is still too young to assume such responsibility; the child is painted in the front row of the assembly, between the king and his mother. The tall windows that light the council chamber seem to confer extra length to it and allow a glimpse of the surrounding countryside.

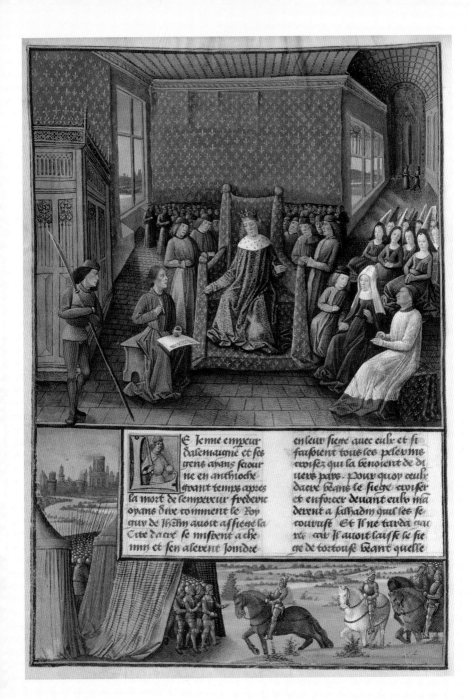

LE Ie me empeur
d'alemaigne et ses
gens eftans feiour
ne en anthioche
grant temps apres
la mort de l'empereur frederic
oyans dire comment le Roy
guy de Ih'rlm auoit assiege la
Cite d'acre se mirent a che
min et sen alerent ioindre

en leur siege auec eulx et fi
faisoient tous les pelerins
croisez qui la venoient de di
uers pars. Pour quoy ceulx
d'acre seans le siege croiser
et enforcer deuant eulx ma
derent a salhadin quil les se
courust Et Il ne tarda gua
re cur Il auoit laisse le sie
ge de tortouse leant quelle

of the Green Knight, raised his siege and went to invest the city of Tortosa. There the queen of Jerusalem sent to him asking that he should, as he had promised, deliver her husband from prison, along with the nine knights. Saladin sent to Damascus for them, made them swear that they would never take up arms against him again and then freed them. And he also freely restored the old marquis[448] to his son, who had twice defended the city of Tyre against him. King Guy spent some time at Tripoli, then went with his wife to Tyre, thinking to stay there. But the marquis[449] had the gates closed against him and when he demanded entry, had the reply sent that he could not enter and that the city was his, which greatly angered King Guy. But, hiding his feelings on the matter, he decided to lay siege to Acre in order to encourage the kings of France and England to come through Acre. And he sent to the knights of King William of Sicily that they should come to him before Acre and should bring their fleet. They immediately did as they were ordered. And Guy then left with all the troops that he could muster and, having had a great palisade erected around a little hillock, encamped there before the city walls.

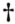

Chapter LXIV.
How King Philip II Augustus and King Richard, having taken the cross, undertook to go to the succour of the Holy Land. Of the will and testament of King Philip. Of how he set out from France and arrived at Messina, and King Richard likewise, one after the other.

The young emperor of Germany[450] and his men stayed long in Antioch after the death of the emperor Frederick Barbarossa, but when they heard men say that King Guy of Jerusalem had laid siege to the city of Acre,[451] they took the road and set off to join him at the siege, and all those pilgrims who had taken the cross, and had come there from divers lands, did likewise.[452] And for this reason, those within Acre, seeing that the siege before them was becoming greater and stronger, demanded of Saladin that he should come to their aid, and he took scarce any time to do so. For he had abandoned the siege of Tortosa, seeing that the city was well garrisoned, and he came up with all his great army hard by Acre and laid counter-siege to the Christians, and for every Christian he had ten Turks or other Saracens. Nevertheless, the Christians defended themselves so doughtily that they held the siege for two years, although,

despite their presence, those in the city and the army of Saladin did not cease to meet with each other, and thus those inside were furnished afresh with men and food.

During this siege both King Philip and King Richard of England[453] made solemn oath and promise, each to the other, that they would be true friends and companions on the journey to Outremer. And King Richard took the cross, that he might undertake and accomplish this journey, and so likewise did a most great number of his barons, knights, squires and others of divers estates, both from England and from France. And having done this, both kings went to assemble all things needful for the journey, and certain it is that they took their time to make ready, by reason of the great number of men that each king decided to take with him and did, indeed, take. And what pains and what care they took that they might order their affairs wisely, lest they incur any dishonour or harm! Now King Philip knew that the vow that he had made could not be accomplished unless he remained long away from his kingdom, and he feared also that he might die on this Holy Journey, without having given orders about his treasure and his lands to ensure that neither his soul nor the state of France should thereby be harmed.[454] And so he issued on all these matters ordinances, and likewise his will[455] and testament, in letters sealed with his great seal in which were inscribed these words:

"Philip, by the grace of God, king of France. The office of king is to take care in all possible ways of the well-being of his subjects, and to consider above all the common weal before his own. Inasmuch as it is our sovereign desire to accomplish our vow to go on pilgrimage to succour the Holy Land, we propose to order how the affairs of the realm should be administered and the realm governed when we have departed hence, and we also propose to make our will, whatever may happen to us.

We shall begin then at the beginning. Let our magistrates place in each provosty four men who shall be wise and loyal and of good character, and let no affair of the city be treated without their counsel or at least without the counsel of two of them. But we exclude from this ruling the city of Paris, in which we wish that there should be six men of standing, both wise and loyal. Then, in those places where we have appointed our magistrates in magistratures duly and severally named, we command that each magistrate assigns one day in his own magistrature that shall be called the day of assizes, and that all those who wish to make complaint should come thither and receive law and justice without delay from the magistrate of that place. But we wish that our law and our justice there delivered, for which we are responsible, should there be written down.

Thereafter, we desire and command that our dear lady[456] and William,[457] archbishop of Rheims, our uncle, should assign, every four months, one day in Paris when they shall hear accusations and complaints from our subjects, and shall deliver a verdict that shall be to the honour of Our Lord and to the weal of the realm of France. And we also command that those magistrates who hold the assizes throughout the towns of our realm should all, on that day, be there before them and that they should in their presence give account of all they have done.

Thereafter, we command that our mother and this same archbishop should hear and know each year the complaints that men make of our magistrates. And if any one of them should commit a fault, save for the four cases of murder, larceny, homicide or treason, then let them make known to us, three times a year by letter, which magistrate has transgressed and what the fault is. And should it befall that he takes a rent, a gift or a service, let them tell us what this is, from whom he has taken it and for what reason, that they may not lose that which is theirs according to justice nor we that which is ours. And let the magistrates make known to us the wrongdoings of the provosts.

Thereafter we desire that our dear lady and mother and the archbishop shall not remove our magistrates from their office, save in the case of homicide, murder, larceny or treason, nor shall the magistrates remove the provosts, save in these same four cases. For after our aforesaid mother and archbishop shall have made the truth known to us, then we have a mind to take such vengeance, with the aid of the Lord, that those who shall come after them shall be filled with terror. And we desire also that the queen and the archbishop shall make known to us for a certainty, three times in the year by letter, the affairs and the state of the realm. And thereafter, should it befall that certain churches, cathedrals or any royal abbeys are vacant or without pastor, we desire that the canons and the monks of those churches that are in such case shall come before the queen and the archbishop, and seek leave to celebrate their election in like fashion as they would do if we ourselves were there. And we desire that this shall be granted to them without contestation.

And we also command the canons and the monks to elect, in accordance with their powers, a person pleasing to God who shall be serviceable to the Church and to the realm. And also, let the queen and the archbishop hold the royal right in hand until he that is chosen is consecrated, and thereafter surrender it to him without hindrance.

And we also desire that, if a prebend or any other benefice should fall into reversion during the time that we hold the royal right in our own hand, then the queen and the archbishop shall present these same, in accordance with the counsel of brother

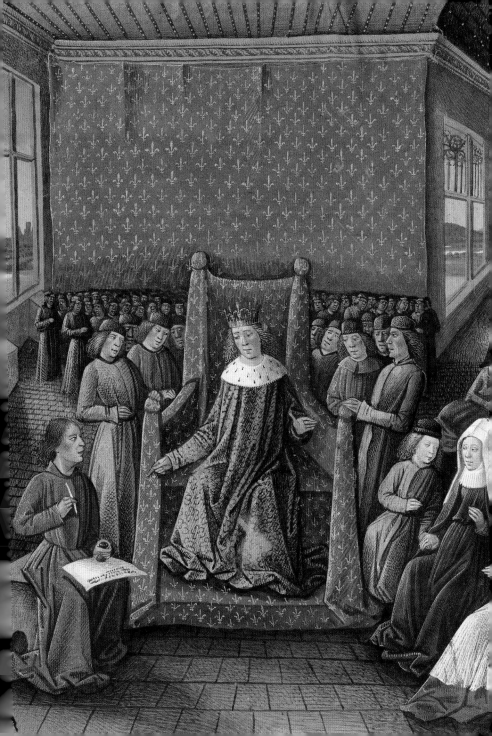

Bernard and as God wills and to the best of their powers, to honest and well-read men, save in the case of gifts that we have already made to certain men and that they can prove by our earlier letters.

And we also command all our prelates and servants that they levy neither great taxes nor taxes on the common people during that time when we shall be in the service of Our Lord. And if it should be God's will that we should die thereby, then we expressly forbid all the men of our realm, both clergy and laity, to pay either the great or the common tax until that moment when our son, whom God protect, shall be of an age when he is able and knows how to govern his realm.[458] And should there be any desirous of making war against him and his rents be insufficient, then shall all our subjects come to his aid, both with their body and their goods. And the churches shall give him that aid that they have been wont to give to us and to those who came before us.

And thereafter we forbid our magistrates and our provosts to take either a man's person or his goods as long as he wishes to give sure pledge and to pursue his rightful justice in our court, save in these four cases: murder, homicide, larceny and treason.

Thereafter we command that all our rents and all that is due to us shall be brought to Paris in three payments and three times a year: the first at the feast of Saint Remigius,[459] the second at the feast of the Candle and the third at Ascensiontide. And these monies shall be delivered to our burghers in Paris and to Peter the Marshal. And should it befall that one of those our burghers who have been appointed to receive these payments should die, then William of Garlande[460] shall designate another in his place to this office. Adam, our clerk, shall be present to receive the receipts of our treasure and shall set them down in writing, and this shall be put in the treasury in the Temple. And each one of them shall hold one key and the Temple shall hold another. And there shall be sent to us that sum of money that we shall demand by letter. Should it befall that God calls us unto him, we desire that the queen, the archbishop of Rheims, the bishop of Paris, the abbot of Saint-Victor, the abbot of Cernay and brother, Bernard, shall divide our treasure into two parts. And the one part they are to apportion, as seems fitting to them, for the rebuilding of those churches that shall have been destroyed by our wars, in such manner that the service of Our Lord may be accomplished there. And they shall also apportion some part of this same half to those who have been impoverished through our taxes on the common people. And of that which remains of this half, they are to give where it seems fitting to them and where they believe that it will be best employed for the salvation of our soul and the souls of our King Louis, our father, and our forefathers.

For the other half, we command all those who guard our treasury and our servants in Paris that it shall be kept for the needs of our realm and for Louis, our son, until that time when he reaches the age that he may, with the counsel of God, govern his realm. And should it befall that both we and our son die, we command that all that we possess be apportioned, for God and for the salvation of our soul and of the soul of our son, by the hand and by the judgement of the six persons whom we have already named.

We also command that, as soon as men know for a certainty of our death, our possessions shall be borne into the house of the bishop of Paris and shall there be well guarded, until that time when what we have ordered has been accomplished.

Thereafter, we command that the queen and the archbishop should retain in their hands all those honours that are vacant and that they can and should retain in honest wise, and in like manner, those concerning our abbey, with its deans and other dignitaries, until that time when we return from the service of Our Lord. Those that they may not retain, let them give them, according to God and by the counsel of brother Bernard, for the honour of God and the weal of the realm, to persons who shall be worthy and able. And that this testament may be sound and valid, we command that it be confirmed by the authority of our seal and by the inscription of the name of the realm.

This was done in Paris in the year of the Incarnation of Our Lord 1190, in the eleventh year of our reign, in our palace, in the presence of those whose names are here written and whose seals are inscribed: Count Tibald of Blois,[461] Matthew the Chamberlain, Ralph the Marshal, at that time when the chancellery was vacant."

Besides these ordinances, King Philip, before he departed, ordered and commanded the burghers of Paris that this city that was so dear to him should be completely encircled by high and strong ramparts, with towers placed all around them well furnished with gates that could be defended, and that all the castles and fortresses of his kingdom should likewise be well fortified. King Philip, having thus ordered all things needful to the affairs of himself and of his kingdom, determined to begin his journey, and so he went most devoutly to visit the church of monsignor Saint Denis. And after he had made his orisons, he took the oriflamme, in like manner as his predecessors had long been wont to do, as a standard most efficacious for obtaining victory for the kings of France; and this had been proved on divers occasions when a number of their enemies, seeing it, fled without daring to give combat, while others came to surrender themselves to the mercy of the kings of France. After he had entrusted it to one of his knights, he took the scarf and the pilgrim's staff from the hand of William, archbishop of Rheims, who was at that time legate in France and brother to the mother of the king,

DEPARTURE FOR THE THIRD CRUSADE.
A SHIP OF SALADIN BEING SCUTTLED

*"And recommending himself to the prayers of the convent and the people,
and receiving benediction in the name of the Holy Nail and the Holy Crown and
also of the right arm of Saint Symeon, he [King Philip] departed from the church of
Saint-Denis and took the road with his barons, King Richard being with him."*

(FOL. 209B)

King Philip set sail and arrived with his fleet at Acre in 1191. This provided Jean Colombe with an opportunity to demonstrate his skill at conceiving a scene entirely devoted to the sea and ships. The aesthetic effect is of the highest quality; a harmonious play of colours confers a poetic element to the picture. The white of the sails contrasts with the brown of the bulging hulls of the ships and the blue of the armour, highlighted with ochre. The king, standing, is identified by his crown and the *fleurs-de-lis* that adorn his mantle. The coat of arms of the king of France is readily discernible on the ships. A few sailors, simply clad in colourful clothes, are busily hoisting the sails up the masts. For his part, Richard of England headed first to Cyprus before moving on to Acre, where he arrived in June 1191. During the voyage there, his fleet succeeded in sinking a Saracen galley that was on its way to Acre with troops and ammunition, an episode illustrated by the artist in the lower register.

Quant le roy Phle cogneut le diffe rement du roy Richard et que le temps approuchier son hornage estoit convenable sentra liu et son armee en mer et laissant le roy Richard a meshmes fit tant quil hint aximier la heisle de pasques

deuant la cite dacre. pres de laquelle il trouua les xpiens du hremer qui la uoient longuement attendus et qui le receurent en sou ueraine ioye et menerent dedans leur ost et ou siege par eulx sa grant temps mantenu combien quil nauoient gaires proussite

and also from the hand of the most noble count of Champagne,[462] he who has a number of times already been mentioned as founder of the collegiate church of monsignor Saint Stephen in Troyes. And when he had done this, he took in his own hand two candles and two blood-stained standards that men had placed on the bodies of the martyrs, and these were marked with the Cross, to be his defence against the enemies of the Cross. And recommending himself to the prayers of the convent and the people, and receiving benediction in the name of the Holy Nail and the Holy Crown and also of the right arm of Saint Symeon, he departed from the church of Saint-Denis and took the road with his barons, King Richard being with him. And they went on in stages and so they came to Vézelay, and there, entrusting his son to the safeguarding of the queen, his mother, and the archbishop of Rheims, he then bade them turn back along with those of his barons who were not to go with him on the Holy Journey.

And that he might accomplish this, he departed from Vézelay on the Wednesday, the eighth day[463] after the feast of Saint John the Baptist, and journeyed until he came to Genoa, and there he set sail in the year of Our Lord 1190 and made such speed that, with the aid of Our Lord, he reached Messina, notwithstanding that he and his men had suffered great losses at sea from storms and tempest.

Now King Richard took another way, that their people might more easily find those things of which they had need, and he went through Provence and set sail from the port of the city of Marseilles and headed straight for Messina, as had before been agreed. And he, in like manner to King Philip, reached the port only after suffering and enduring many torments and most great dangers. King Tancred, who was king of Sicily[464] and held the greater part of it, received King Philip with great state and led him into his palace with all honours, and when he had entered he gave him an abundance of food and would likewise have given him a most great sum of gold and silver if he had consented to take as wife one of his daughters, or to give her in marriage to Louis, his son. But this thing King Philip, for love of the emperor Henry of Germany,[465] did not wish to do, for he knew that King Tancred was his enemy.

Moreover, there arose while they were there a great quarrel between King Richard and King Tancred, for King Richard demanded the dower of his sister.[466] But King Philip made peace between them and King Tancred gave to King Richard forty thousand ounces of gold, of which King Philip should have had half, but he would take only the third part of it for the benefit of peace. And then certain noblemen swore that King Richard would take one of the daughters of King Tancred for his nephew, Arthur of Brittany.

In that city of Messina, King Philip celebrated the feast of Christmas, and he gave great gifts to those princes, barons and knights of his men who had suffered great loss through the storms and the tempest at sea. And amongst others, he gave to the duke of Burgundy one thousand gold marks, to the count of Nevers and to William of Les Barres four hundred marks, to the bishop of Chartres four hundred ounces, to Matthew of Montmorency three hundred, to William of Mello two hundred and to many another whom I do not name for the sake of brevity. During that time when the two pilgrim kings were thus staying at Messina, all manner of food and other things became most dear there, for a setier[467] of wheat was worth twenty-four Angevin sous, a setier of barley eighteen sous, a setier of wine fifteen sous, and a hen twelve deniers. And for this reason, King Philip determined in his council that it would be better that he should go on and accomplish his journey, and he, therefore, sent his messengers before the king and the queen of Hungary, asking them if it would please them to help the army of the Lord by giving them food. And he also sent certain of his knights before the emperor of Constantinople and requested that, for the love of Our Lord, he should bring succour to the lands of Outremer. He asked him besides that, should it befall that he and his men had to pass through the lands of his empire, he would grant them passage, and he assured him, both for himself and for his men, that they would pass through peaceably and would cause him neither wrong nor harm. And King Philip, when he had thus dispatched his messengers, shortly thereafter called King Richard to council and asked and advised him that he should cause his army to be prepared, that he might be ready to set sail in mid-March, which time was approaching. But King Richard answered that he was not ready and that he could not set sail until the passage of mid-August.

When he had heard this answer, King Philip, after the council had dispersed, demanded and required of him as his liegeman that he should set sail and cross the sea with him as he had sworn to do. And with this request, King Philip made him two conditions: the first was that, if he would cross over with him as he was sworn to do by his solemn oath, then he should take the daughter of the king of Navarre,[468] whom his mother,[469] the queen of England, had brought thither, and should marry her in the city of Acre. The other was that, if he did not desire to cross over with him at that time, then he should marry his sister,[470] to whom he was affianced and to whom he was bound by that betrothal. But King Richard did not wish to accept either one or the other proposal. For this reason, King Philip summoned those barons and knights who were his liegemen and who held fiefs of King Richard and who had sworn and promised likewise to make the sea passage

in March with him, and he held them to their oath and required of them that they should keep the covenant that they had sworn to make that passage. And there answered then for all of them Guy of Rançon and the viscount of Châteaudun, saying that all were ready to make the sea passage whensoever it was demanded of them and that they would hold to all those covenants they had promised to King Philip, whereupon King Richard knew such great anger that he swore that he would disinherit them all. And so he did thereafter, and from that moment there began once again to multiply the bitterness, hatred and gestures of ill will between the two kings.

Chapter LXV.
How King Philip set sail once more and came before the city of Acre, and how he laid siege to it and battered it with divers machines. And how King Richard of England took Cyprus and arrived before Acre. Of the surrender of the city. Of the suspicions of King Philip and why it was that he returned to France.

When King Philip knew that King Richard would delay his departure and that the season was fit for the accomplishment of his voyage, he set sail himself with his army and, leaving King Richard at Messina,[471] he made such way that it was Easter Eve when he came before the city of Acre.[472] And hard by he found the Christians of Outremer, who had long awaited him and who received him with extreme joy, and led him into the midst of their army and to the siege that they had maintained for a great length of time already. And yet they had profited scarce anything by it, for Saladin had most abundantly garrisoned it with men and furnished the city with food and machines. And you may be sure that the Christians, knowing of the great valour, might and power of King Philip, shed many tears as they received him and rejoiced as much at his coming as if the angel of Our Lord had come down upon them, for they hoped and believed that, through him, this city should swiftly be taken. And so from that very moment when his foot touched the ground, he raised his tents and pavilions and had a house erected for himself so close to the walls of Acre that the Saracens within might loose arrows and hurl spears at it, and often they over-shot. And he straightway set up his stone throwers and his machines and shot, assaulted and hurled stones against the walls so constantly and with such force that a great part of them were so pierced and riddled

with holes in divers places that it seemed that the city could not but be taken at the second assault.

But they did not wish to take the city nor attack until such time as King Richard should arrive, and he was yet to come, for he did not wish to set sail until the August sea passage. And besides, when he had departed from Messina,[473] he came by sea to Cyprus and there he captured a tyrant who had made himself king and emperor of Cyprus by force.[474] And after he had pillaged and stripped him of his treasures, he took the daughter of the king and imprisoned her and then he placed defences in the strongholds and towns in his name and set sail once more. And as he was drawing towards Acre and was already very close, he met by chance with a ship that Saladin was sending to the men of Acre to succour them, and he sank it. And in this ship were many vials of glass filled with the Greek fire, and two hundred and fifty crossbowmen and other Saracens in great number, and there was also a most great abundance of bows and armour and other such manner of things for defence, and these things he used to kill the Saracens. And when the ship had thus been sunk at sea, he came into the port of Acre and betook himself to the siege with King Philip and the other barons who received him with great joy.

During this siege there died, with no heir of her body, the queen of Jerusalem,[475] who had been wife to King Guy, and so the kingdom came to Isabella, her sister, wife to the young Auffroi.[476] And he, being cowardly and faint-hearted, renounced his marriage with this same Isabella, so that the bishop of Beauvais, who was legate in the army for the Pope, gave her in marriage to the young marquis of Montferrat,[477] who had given a great sum of money for her to the young Auffroi, that he might renounce her. And this being done, the marquis took her to wife and led her into the city of Tyre.

Moreover, but shortly after the arrival of King Richard, King Philip told him, in his dwelling, that it would be good to attack the city of Acre[478] on the morrow, and King Richard answered that this contented him well and that he would send his men there. But when the time came on the morrow that King Philip brought up his men to the attack, he learned that King Richard would not suffer his men to leave their lodging places and so he led his men back. For this reason, on the day after there was convened a council, wherein were elected, with the accord of the kings, certain knights who should have the power to order the time when an assault should be mounted. At this siege there departed this life Tibald, count of Blois, seneschal and, I believe, constable of France; the count of Clermont[479]; and Philip, count of Flanders.

And to tell quickly of the end of this siege, those in Acre made known to Saladin

RICHARD THE LIONHEART ORDERING MUSLIM PRISONERS TO BE EXECUTED.
HUGH III OF BURGUNDY ORDERING A RETREAT

"And to be brief, King Richard made a number of fine conquests
against the Turks and the other Saracens of Outremer, and so high was his renown
and so great the fear of him that, when a child of the Turks was crying,
his mother said to him: 'Hush, or King Richard will come'!, and when a Turk
was riding his horse and it shied at some bush, he said to his horse:
'Do you believe that the king of England hides there'?"

(FOL. 214A)

On 12 July 1191, against the will of Saladin, the garrison of Acre capitulated after a siege that had lasted two years. They were promised freedom to withdraw as soon as the sultan had returned the True Cross, freed a great number of Christian prisoners and paid a large ransom of more than 200,000 bezants. Saladin was obviously unable to fulfil these demands at once. Since Richard was anxious to leave Acre and proceed to Jerusalem without delay, the more than 5,000 prisoners were a burden to him and he welcomed this as an excuse to have them executed. This episode, which Jean Colombe develops in the upper miniature into a most dramatic scene, in fact occupies only a few lines at the beginning of Chapter LXVI in Sébastien Mamerot's text. The artist shows the tragic procession of prisoners; wearing only shirts, their legs and feet bare and their hands tied behind their backs, they are conducted by armed men as far as a ladder by which they climb up onto a huge wooden scaffold. There, two executioners take charge: after they have blindfolded them, they cut off their heads with a sword, one after the other. The heads and bodies pile up at the foot of the scaffold. The executions take place under the eyes of the king of England, who can be identified by his arms on his standard with the three leopards. The lower picture shows the episode related by Mamerot when Duke Hugh III of Burgundy, to whom Philip Augustus had entrusted the command of more than 10,000 French soldiers before he himself returned to France, orders a retreat. He abandons the aim of capturing Jerusalem rather than let the English have the glory of taking the Holy City.

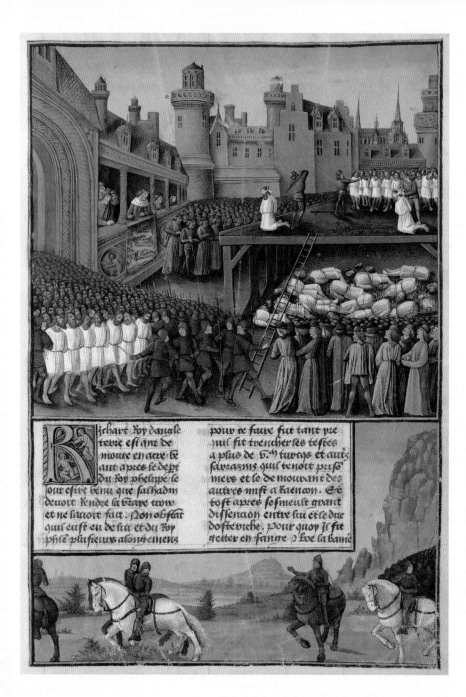

ichart roy dangle
tevre estant de
mouue en autre te
nant apres le dept
du roy phelippe le
iour estre venu que salhadin
deuoit rendre la braie crois
et ne lauoit fait. Non obstat
quil eust eu de lui et du roy
phie plusieurs alongemens

pour ce faire fut tant pre
quil fit trencher les testes
a plus de b.m turcys et autz
sarrazins quil tenoit pris
mers et le demouant des
autres mist a rancon. Et
tost apres se smeult grant
dissenaon entre lui et le duc
dostevriche. pour quoy il fut
retter en sange & voe la baniee

585

that they could not hold out for long, which grieved him greatly, and so he sent his messengers to the kings and begged that they should grant truces, and to this they acceded. And during these truces they made peace under these conditions: that the city of Acre should be surrendered to the Christians, and that Saladin should surrender the True Cross, which had been lost when King Guy was taken at the springs of Sephoria,[480] and that against each Saracen or Turk of Acre there should be surrendered one Christian. And they decided on a day when this should happen, however, the city of Acre was surrendered to the kings in the year 1191. And because those Christian citizens who had lost their inheritance by reason of Saladin's taking of the city asked it of them, it was agreed by the kings that those who through witnesses could show their right to their property should have their houses restored to them, notwithstanding that those pilgrims but newly arrived should dwell in them as long as they should remain there and no longer. And it was there likewise agreed that King Philip and King Richard should each one hold half of the prisoners. Moreover, when the day came that Saladin should surrender the True Cross, he obtained from the two kings a second and thereafter a third postponement of the agreed date.

And during this time it was made known to King Philip that King Richard sought his death, and that he received gifts from Saladin and sent him gifts secretly in return. And for this reason, King Philip had three galleys made ready, and leaving his lieutenant, the duke of Burgundy,[481] chief of all his men, and a great treasure likewise for the complete accomplishment of his vow, he set sail[482] and came to Rome, where he was absolved by the Pope of his vow and promises concerning the journey to Outremer. And thence he returned to France, where for long he knew great fear and caused himself to be closely guarded, since men said that, at the prompting of King Richard, certain Assassins[483] had made the sea passage after him with the desire of killing him. Nevertheless, he knew thereafter through messengers whom he sent to the Old Man of the Mountains[484] to enquire into it, that there was no such intent.

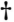

Chapter LXVI.

How King Richard had the prisoners of Acre cruelly put to death. How the duke of Burgundy caused those Frenchmen who were going to Jerusalem to return. Of Saladin and how King Richard surprised the Turks. And how King Richard, when he was returning from Outremer, was taken and long held prisoner. And of his return to England.

Richard, king of England, who had remained in Acre, observed after the departure of King Philip[485] that the day had come when Saladin should surrender the True Cross. Yet he had not done so, though he had been granted by himself and by King Philip a number of postponements, whereupon the king was so enraged that he had the heads cut off more than five thousand Turks and other Saracens whom he held prisoner, and for the rest he demanded ransoms. There soon arose a great dissension between himself and the duke of Austria,[486] and for this reason, he caused the banner of the duke to be cast down into the mire and mud, which the duke remembered long afterwards, to the great harm and dishonour of King Richard.

Moreover, Saladin had the walls of Ascalon destroyed, lest the Christians should lay siege to it, and it was also made known to King Richard that the Turks of Jerusalem had fled the city. And for this reason, the Christians held council, and it was there determined that they should load their ships with food and send them to Jaffa, and thence they continued until they were five miles from Jerusalem. There they divided up their forces, determined always to go on to the Holy City,[487] and King Richard led the vanguard and the duke of Burgundy the rearguard. But after King Richard had departed in the morning, the duke of Burgundy summoned the principal lords of France who were there and said to them: "You know well that the king of France, our sovereign lord, has departed and that the flower of his company of knights has remained here. And you know, too, that King Richard has but few men here as against our numbers. Now if we go up to Jerusalem and we take the city, men will say that the king of England has taken it and not us, and thus he will have the honour and the king of France the blame. For men will say that the king of France fled while the king of England remained to conquer the Holy Land, and for this reason, if you believe me, we should turn back." There were some who, despite the conclusion of the duke of Bur-

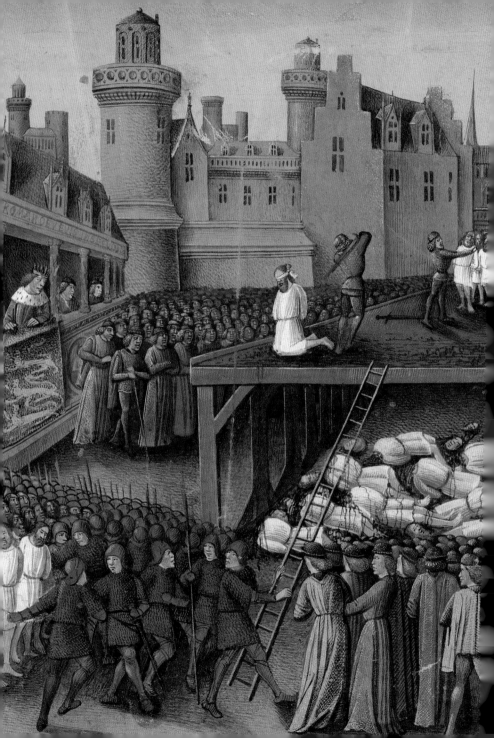

gundy, wished to go forward, but in the end they all turned back, which was made known to the king of England by a party of the lords who loved him and who advised him that he should advance no further, for he could not proceed in safety.

Now when King Richard received this news, and heard in his council that the best thing to do would be to turn back, he went to Acre, whither the duke of Burgundy was already returned, but the latter fell ill a few days later with a sickness from which he died. And when Saladin was informed of the discord amongst the Christians and of their return to Acre, he led his army before the city of Jaffa and ordered it to be heavily assaulted, whereupon King Richard, that he might succour this city and, at the entreaty of its citizens, led his own army and that of the French as swiftly as he might, both by day and by night, in that direction. Yet he could not go fast enough, and he found that the Turks had taken the city and had bound and slain the Christians. But the French and the English, with one accord, fell upon them with such force and boldness that they slew one part of them. Those of the other part fled back within their own army, accompanied and hotly pursued by the Christians, and then the latter retreated into the castle and town of Jaffa. Saladin from his lodging place heard the din and, being told how King Richard had driven off his men and was on foot on a small hillock, sent him a most fine horse, upon which King Richard mounted one of his squires; and he, spurring the horse, was borne whether he would or not into the army of Saladin, which filled him with shame. But Saladin straightway sent another horse to King Richard, who took it and mounted it and rode away into the castle with the other Christians.

And but a few days thereafter, Saladin went away to Damascus and King Richard led the army of Christians into the city of Ascalon, and strengthened it and defended it full well. And to be brief, King Richard made a number of fine conquests against the Turks and the other Saracens of Outremer, and so high was his renown and so great the fear of him that, when a child of the Turks was crying, his mother said to him: "Hush, or King Richard will come!", and when a Turk was riding his horse and it shied at some bush, he said to his horse: "Do you believe that the king of England hides there?"[488]

At about the same time, it befell that the marquis of Montferrat withheld in Tyre the greater part of the goods aboard a ship of the Assassins that had put into port. He wished neither to pay for them nor to surrender them to the merchants, who went to complain of this to their lord, the Old Man of the Mountains, who ordered the marquis to surrender them or else he would die, but he delayed in doing this. And for this reason, the Old Man sent to Tyre two of his men, who spied on him until they found, one day long after, that he was returning by a narrow way from the dwelling

of the archbishop, whereupon one of them presented him with letters. And, as the marquis bent down that he might take them, he struck him with a knife so that he died shortly thereafter, and so departed this world the most valiant marquis of Montferrat, leaving issue one daughter. And as soon as King Richard, who was in Acre, knew of the death of the marquis, he went there, taking with him his nephew Henry, count of Champagne, who was the son of his sister,[489] that he might cause Queen Isabella, widow of the marquis, to take in marriage this same Henry,[490] who had another brother called Tibald[491] and a sister[492] who was married to Count Baldwin of Flanders and Hainault.

As matters went thus in Syria, King Richard observed that the pilgrim crusaders in Outremer went back day after day into their own lands and countries, so that there remained but a small number. And he said to his nephew Count Henry that he should make truces with Saladin, for he must return to England, but he would return thence as soon as he might and would bring with him a great army. For this reason, Count Henry sent to request truces from Saladin, but these he was not ready to grant unless Ascalon, Gadara and Daron were slighted, which King Richard granted, for he did not wish to leave his nephew without truces. And he told him that he should have no fear and that he should have them rebuilt when he returned.

When the truces were confirmed and the three strongholds slighted, Saladin took pity on the great barons whom he had disinherited and he gave to the lord of Sidon one half of the citadel and the town of Safed, to Balian of Ibelin a town called Kaymon and he gave back to the lord of Haifa his own town and to Count Henry[493] he gave Jaffa. And then King Richard made ready his ships and set sail, taking with him his wife, his sister and the wife of the emperor of Cyprus, who had died in prison, and their daughter. But when they were far out to sea, there arose a tempest that did great harm, to him and to his people. And then, when he had with great difficulty escaped from the perils of the sea, he encountered yet other perils on land, for as he was going by land between Venice and Aquila,[494] the duke of that land caused a mounted force to pursue him, that he might take revenge on the king, because he had treacherously suffered those strongholds aforesaid to be slighted. And although he escaped yet again from this peril, eight of his knights were there taken and imprisoned and six others in another town called Friesach.[495] And finally he was overcome by the third peril, for the duke of Austria, ever mindful of the banner so shamefully cast down by the king at Acre, together with the emperor Henry of Germany (son of the emperor Frederick drowned in Armenia), who gave orders that all the ports, bridges and crossings should be guarded that the king might be taken, sought him with such diligence that he was

taken, poorly clothed, turning the spit in a poor hovel near Vienna in Germany.[496] And the duke of Austria delivered him up to the emperor,[497] on whose counsel he was held prisoner for one year and a half in a most secret place, and in this way he obtained two hundred thousand silver marks for him in ransom.

And after all these perilous adventures, King Richard returned to England, and there he was received with the most great rejoicing by all the kingdom. And Count Henry of Champagne, who was son to that most fortunate Count Henry who was the first count of Champagne and founder of the collegiate church of Saint Stephen in Troyes, as I have before acknowledged, preferred rather to follow the good example of his good father, who had twice gone to the aid of the Holy Land, and to remain there. And he put his body and his life in danger and suffered poverty and misfortune there for the love of Our Lord, rather than neglect to visit the Holy Sepulchre and leave unfulfilled his vows and his promises and instead return to his great lordships in France, where he could have lived most delightfully.

In consideration of which, the master of the Temple and all the barons of France and those of the lands of Outremer likewise had him married to the daughter of the king of Jerusalem aforesaid, the widow of the marquis of Montferrat,[498] and crowned him king of Jerusalem, giving thanks and praise to Our Lord God Jesus Christ who had sent them a leader and defender of such renown. And at the time when there begins the reign of this king of Jerusalem, Henry, count of Champagne, I bring to an end this account of the journey made to Outremer by King Philip of France and Richard, king of England, giving praise to Our Lord God Jesus Christ. Amen.

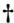

Chapter LXVII.
A brief account of certain expeditions to Outremer made by the emperor Henry and of his death. Of the crusade that was inititated in France and of which Tibald, count of Champagne, was the chief leader. Of his death and of the undertaking of the crusade and journey to Outremer.

At about that time, Henry, emperor of Germany, son to that emperor drowned in Armenia,[499] sent his chancellor with four thousand men on horseback and a great number of men on foot, together with much money, that they might remain a while in the land of Outremer for the succour and recovery of Jerusalem. Then there departed

*"Lest it should seem that, whether on purpose or through lassitude or,
indeed, through lack of having read sufficiently in the history of Outremer,
I have neglected to tell of the conquest of Constantinople made
by the French, I shall now write most briefly of it in this present account.
And yet this action does not strictly belong here, for it was committed
by Christians against Christians."*

(FOL. 217A–217B)

Although the crusaders had demonstrated in the course of the Third Crusade that they were capable of keeping Saladin in his place, the result was disappointing. In 1198, Pope Innocent III therefore proclaimed the Fourth Crusade. In spite of a certain reluctance, Sébastien Mamerot describes the conquest of Constantinople by the French and the Venetians. Although the original intention had been to go to Egypt, the Venetians would provide the crusaders with a fleet only in return for a promise of assistance in the capture of the town of Zara and the subsequent restoration of the deposed emperor Isaac II and his son Alexius IV Angelus to the throne of Constantinople. The picture in the upper register shows the arrival of the crusaders in Constantinople aboard splendid galleys heavily laden with men, horses and arms; on the shore, before the gates of the city, can be seen the camp of the usurper Alexius III Angelus, shortly to be overthrown.

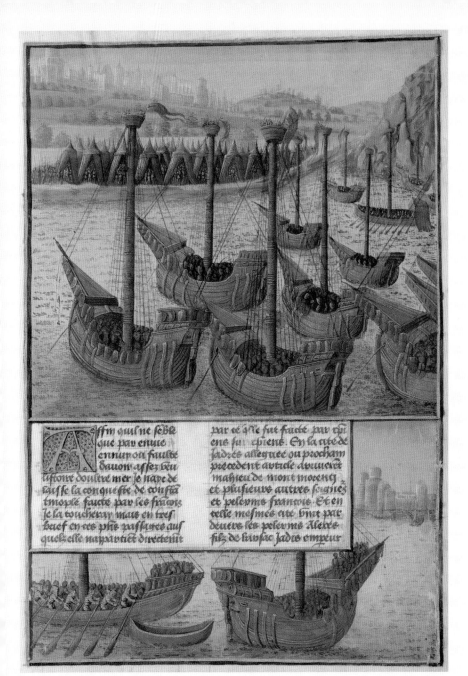

A ffin qu'il ne semble que par enuie ennuy ou faulse dauoir asses beu l'isse doultre mer Je n'aye de lausse la conqueste de constan tnople faicte par les françois Je la toucheray mais en tres brief en ces p'ns passuees aus quels elle n'apartiet directemt par ce q'le fut faicte par chi ens su' epiens. En la cite de sadres asseruee ou procham precedent article Arriuerer mathieu de mont morenci et plusieurs autres seignez et pelerins françois. Et en telle mesmes cite buet par deuers les pelerins Alexee fils de kisac iadis empeur

this world the king of Hungary without heir of his body, and the queen his wife, who was sister to King Philip and King Richard, sold her dower[500] and set off for Outremer, travelling with the Germans and bearing with her a most great treasure, for she wished to end her days in the Holy Land: but eight days after arriving in Tyre, she there departed this world. And so all her treasure came to her nephew Henry, king of Jerusalem and count of Champagne, who had received her with great state and caused her likewise to be buried in most honourable fashion.

And there died then also the great and mighty King Saladin, leaving twenty-two sons.[501] And to the eldest[502] he gave the kingdoms of Damascus and Jerusalem, to the second that of Egypt and to the third that of Aleppo, providing the others with a number of other lands that he had conquered, but none of his sons enjoyed for long that which their father had conquered. Now the oldest desired at the very beginning of his reign to make war against the Christians and to lay siege to Jaffa, and King Henry of Jerusalem led out against him the Germans and other knights. But as soon as he came to Haifa, wishing to stay there for the night and having sent the Germans on to Jaffa, he fell from high up in the castle, from a window by which he was washing his hands. And the squire who was holding his towel fell on purpose from the window after him, fearing lest he should be blamed for the death of the king, who was taken up dead while the squire broke his leg. So the king was buried with great lamentations in the church of the Holy Cross in the year 1195,[503] leaving two daughters of himself and the queen, his wife.

By reason of the death of this same King Henry, the Germans turned back into their own land and thus the son of Saladin took the city of Jaffa and garrisoned and defended it most strongly. In the year 1197, there departed this world the emperor Henry of Germany, having reigned over the empire for seven years. The empress had of him, as she said, one son, called Frederick, but so advanced was she in years that none believed her. Nevertheless, when she was on her deathbed, she affirmed that she bore him of the emperor Henry. The barons of Sicily crowned him king when he was still a small child, in the city of Messina.[504]

At about this time, too, there took the cross in France[505] Count Tibald of Champagne; Louis, count of Blois and Chartres; Nevelon, bishop of Soissons; Simon, count of Montfort; Reynald of Montmirail; Matthew of Montmorency; the châtelain of Coucy; Enguerrand of Boves; Baldwin, count of Flanders and Hainault with the countess, his wife; the count of Saint-Pol; the count of Le Perche; and a number of other great and mighty counts, barons, knights and squires from their lands, together with a most great

number of other men. And the counts of Champagne, Flanders and Blois sent certain of their knights to Venice, and there they found that the duke[506] and the men of Venice would take the pilgrims on the sea passage for a certain price. And the duke of Venice would furnish armed galleons at the expense of the Venetians, on condition that the latter should take their fair and just half of the towns, cities, castles and other lands that the whole army should conquer.

But alas! What grief! Before they departed, the good Count Tibald of Champagne was seized by a sickness from which he died,[507] leaving his wife, the countess, big with a boy-child who would be called Tibald,[508] and a daughter, too. Now the count had commanded that those knights whom he had chosen to journey to Outremer should be paid from his own treasure, and that when they were paid, they should swear an oath that they would set sail with the army of the Venetians. And for this reason, Matthew of Montmorency, and others named by him as executors of his will, went before the duke of Burgundy and thereafter before Baldwin, count of Bar, and they offered to each one in turn the treasure and the honour of being leader of the men of the late count. But because they would accept neither the honour nor the charge, they sent for the marquis of Montferrat[509] to come to the city of Soissons, and the marquis, who was a most valiant prince, accepted this charge in the garden of the abbey of the nuns that had been founded in that city in honour of Our Lady.

And there departed this life likewise, but shortly thereafter, the count of Le Perche, by whose orders his treasure and his men were entrusted to Stephen, his brother, to conduct them to Outremer. Finally, to tell this tale briefly, when Baldwin of Flanders and the other princes and barons[510] were arrived in Venice, there arose an altercation between them and the Venetians, for not all the pilgrims had money enough to pay their sea passage. But the duke of Venice, who had taken the cross likewise though he was of a great age, acted such that the Venetians were content to wait for the money that remained from the pilgrims until such time as they should have acquired it in the course of their journey. And so it was that they made the sea passage to Outremer, and there went with them likewise a number of bishops and great lords of Germany.

And they all came before the city of Zara[511] on Saint Martin's Eve in the year 1203. And they straightway seized the port by force, so that the terrified citizens made known to the duke of Venice that they would surrender on condition that their lives should be safe. But this the duke was not willing to accede to without the princes' consent, so he went before them and made known to them the wish of the men of Zara. But even as he went towards them, there were certain pilgrims who said to the

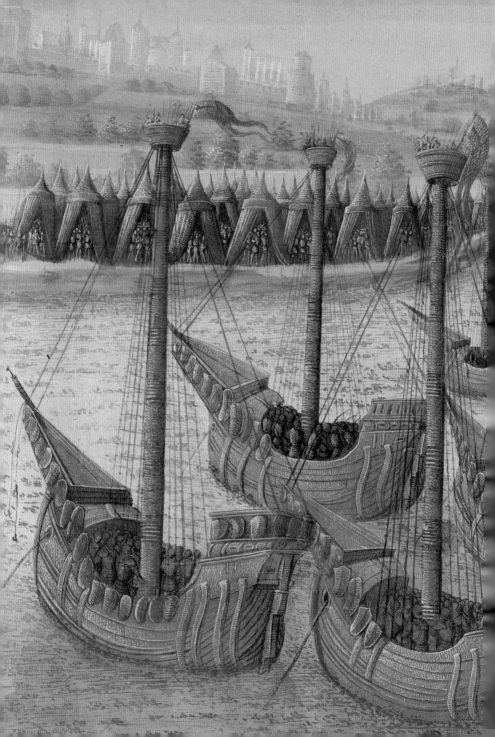

citizens that there was no need for them to surrender, and there came likewise an abbot of the Cistercian order who, as legate of the Pope, forbade the pilgrims, on pain of excommunication, to attack the city. Nevertheless, despite these prohibitions,[512] the barons were desirous of keeping the promises that they had made to the Venetians and so for five days they assaulted the city, so that they took it. And in that city there arose a great brawl between the French and the Venetians that the duke of Venice calmed, yet not before a most valiant knight called Giles of Landas had been killed.

Chapter LXVIII.

How the pilgrim crusaders renounced their chief intent through their desire to reinstate the son of the emperor Isaac in the empire of Constantinople. And how, after a number of great battles, Count Baldwin of Flanders was made emperor of Constantinople and his brother after him.

Lest it should seem that, whether on purpose or through lassitude or, indeed, through lack of having read sufficiently in the history of Outremer, I have neglected to tell of the conquest of Constantinople made by the French, I shall now write most briefly of it in this present account. And yet this action does not strictly belong here, for it was committed by Christians against Christians.

To the city of Zara, aforementioned in the preceding passage, there came Matthew of Montmorency and a number of other French lords and pilgrims, and to this same city there came also before the pilgrims Alexius,[513] the son of Isaac, who was formerly emperor of Constantinople, who had long been dwelling in Hungary with his uncle. And he offered, if the pilgrims[514] could reinstate him in the empire of his father, to make the city acknowledge obedience to Rome and, furthermore, to give them for their passage two thousand silver marks,[515] and the pilgrims agreed to this and promised to do so. And so he returned to Hungary, to gather together men and money against an appointed day. During this time, the princes sent Nevelon, bishop of Soissons, and a number of other men before the Pope, that they might be absolved from the excommunication of the papal legate, which the Pope acceded to and appointed bishop Nevelon as his legate, to undertake this matter and to go with them.

Moreover, the pilgrims, having battered down the walls of Zara, set sail once again and made such way that they landed at Corfu in Romania, and there the greater part

of the lesser knights of the army thought to break their word and to turn back. But the chief barons came before them, to the place where they were assembled, and besought them most humbly on their knees and refused to rise, until such time as they reverted to their first intent.

And this having been accomplished and all being of one mind, the pilgrims set sail and departed from the port of Corfu on the eve of Pentecost in the year 1204.[516] When Alexius, the son of Isaac, had joined forces with them at Bouche d'Avie,[517] they were advised that they should go by the strait of Saint George to Constantinople, and they went and cast anchor before the castle of Chalcedon, where they remained for one day and seized booty enough. Thence they sailed down the strait as far as a palace called Scutari.

And the emperor Alexius, the usurper in Constantinople,[518] came forth from the city at the head of his whole great army and encamped in tents and pavilions on the other side of the river to prevent them from approaching. They remained thus facing each other for nine days, during which time certain French knights went out on a great foray and brought great booty back to the army. At the end of these nine days, the emperor Alexius sent his messengers before the pilgrims and remonstrated with them, telling of his amazement that they should lay waste his land and also offering them food and money. But they made answer that this meant nothing to them, and that they need return to them no more unless their lord was prepared to give a large part of his lands to his nephew, the young Alexius.[519]

And shortly thereafter, the barons caused the young Alexius to be brought in a galley up to the walls of Constantinople, and those who accompanied him shouted aloud: "My lords, behold here your rightful sovereign!", but not one citizen dared to make show of respect to him. And so the barons made ready six corps of battle, and Count Baldwin of Flanders led out the first, Henry his brother the second, the count of Saint-Pol the third, the count of Blois the fourth, Matthew of Montmorency the fifth and the marquis of Montferrat the sixth. On the morrow they took the field to do combat with the Greeks, but the latter, not daring to await them, took flight to Constantinople. And the pilgrims went into the tents of the emperor and thence they moved into position before the tower of Galata, which they took, for those who were guarding it issued forth against our army but were most rapidly paid for their pains, for they were all killed or taken captive and the castle, port and tower were all captured. And to be brief, the emperor Alexius, when he knew that the pilgrims had taken all the fortified places around the city, took his treasure and went forth by night.

When the citizens knew of this, they went to the emperor Isaac, whose eyes had been put out, and they led him, dressed in his imperial robes, to the palace of Blachernae, whence they summoned his son the young Alexius to come out to speak with him. But the barons, fearing treachery, sent Matthew of Montmorency and Geoffrey of Villehardouin there, and they caused Isaac to swear to respect the covenants agreed to by his son, who also entrusted sealed letters to them. And for this reason, the princes and barons led his son into Constantinople and caused him to be crowned emperor, and they entrusted to him furthermore some part of their own men, and with their aid he issued forth from the city and reconquered a great part of the empire with none to oppose him. But once he had returned to Constantinople, he was so puffed up with pride that he took scarce any account of the pilgrims any more, nor did he wish to complete the payment he owed them. And they, therefore, sent to tell him, from that place where the army was encamped, that if he did not pay them as he had promised, then they would pay him back.

And so began the war between them and him, during which there rose in rebellion a Greek called Murzuphlus[520], who captured and imprisoned the young emperor,[521] which being made known to Isaac, he died of grief. Then Murzuphlus caused the young emperor to be strangled in his prison and, pretending that he had died a natural death, had himself made emperor,[522] but his crime was known to the Latins and the Greeks. For this reason, the prelates and the crusader barons determined that they might rightfully conquer the empire of Constantinople against this tyrant, and the papal legate conferred a plenary pardon upon all those who would help to banish the tyrant and to bring Greece back to obedience to Rome. And to be brief, the French and the Venetians considered and determined between themselves that, if they should take the city, they would divide the booty in fair and just fashion and that six Venetians and six pilgrims should choose that man amongst them who seemed, on their sworn oath, most fit to be made emperor.[523] He should have one quarter of all that they had won, both inside and outside the city, and likewise the two palaces of Blachernae and the Lion's Mouth. And of what was left, the pilgrims should have the one half and the Venetians the other. And then there should be chosen twelve Venetians and twelve men from the pilgrim army who should divide up the fiefs and the rents and should determine which service each man should perform for the emperor. This being done, the pilgrims attacked the city of Constantinople and many were slain and wounded on both sides, but in the end, the pilgrims, nevertheless, went into the city.[524] Now Murzuphlus, retreating into the castle of the Lion's Mouth and rallying his men to him, made pretence in the evening

that he would issue forth on the morrow to attack the pilgrims, but in truth, he came forth and fled during the night, as did likewise those of his men who could flee. Moreover, certain of our men, fearing lest the Greeks should attack them that night or on the morrow, set fire to some parts of the city and there were more houses burned there than there are houses in the three greatest cities of France together, according to the witness borne by certain of those consulted by myself, the chronicler of Soissons.[525] As for the gain that there was made, for all surrendered to save their lives only, it can scarce be believed! And notwithstanding that the booty, as it happened, was carelessly gathered in, nevertheless, the pilgrims had as their share more than five hundred thousand silver marks and ten thousand horses. The booty having been shared out, the twelve men chosen from the two sides began to elect the emperor, certain of them wishing for Baldwin of Flanders and the others for the marquis of Montferrat, and so it was determined that whichever of the two should be emperor should give to the other all the land beyond the strait of Saint George towards Turkey and the island of Crete, and for this he should do homage to the emperor. And matters being thus decided, Baldwin, count of Flanders, was elected, confirmed and crowned emperor of Constantinople amidst the most great rejoicing in the year 1205.[526]

Murzuphlus, having fled thence, went to join the emperor Alexius[527] but, though he gave him his daughter in marriage, a few days later he took him aside into a chamber as if to entertain him and there caused his eyes to be put out. Finally, Murzuphlus was taken and brought to Constantinople before the emperor Baldwin, who commanded him to mount up on a high column that was in the marketplace and had him cast down from the top to the ground, so that he died. And the marquis of Montferrat took the false emperor Alexius likewise, of whom I have already made mention in divers passages, and he sent his imperial robes to Constantinople to the emperor Baldwin, while as for Alexius, he sent him as prisoner to Montferrat.

Now finally, after a number of great hardships suffered by the emperor Baldwin in Greece by reason of the extreme contumacy of the Greeks towards him, and most particularly of a certain John who called himself king of Wallachia and who, even before the coronation of Baldwin, had waged war against the other emperors twenty years and more, Baldwin was taken by surprise in an ambush by this same John. And a part of his men died or were taken, while he himself vanished, so that there nevermore came news of him, save that he had been slain in this defeat. For this reason, the barons went shortly afterwards to Constantinople and there they crowned as the emperor Henry, brother to the emperor Baldwin, and he likewise suffered great hardships and was exposed to

many a great danger that he might maintain and guard the empire of Constantinople and take the place of his brother. And the Pope sent to him a cardinal legate called Peter of Cappes, and a number of small pilgrim journeys were made on divers occasions over a number of years from France to Outremer, in the course of which was performed many a fine feat of arms by the French and the Venetians. But in the cause of brevity, I make an end of these journeys here, giving praise to Our Lord God Jesus Christ.

Chapter LXIX.
How Damietta was captured by the king of Acre and the French pilgrims. And of the dispute that arose between the cardinal and the king of Acre. And how Damietta was surrendered thereafter to the sultan.

In the land of Champagne, there was a valiant knight who was called John, count of Brienne. And it happened that the barons of Acre and Syria sent to him to offer in marriage the only daughter of their king, who had died,[528] and the kingdom of Acre likewise. Now this thing John of Brienne[529] agreed to, in accordance with the counsel of King Philip, and he went to Acre and there he took the daughter of the king in marriage and the kingdom likewise. For the barons had him crowned king,[530] but shortly afterwards the Saracens and the Turks of thereabouts gathered together a great number of men that they might destroy Acre as soon as they heard that there was a new king. For this reason, King John made known to the Pope in Rome the intention of the pagans and requested succour from him and the other kings of Christendom. And because of this the Pope had the crusade preached, so that numbers of men took the cross and went to Outremer. And amongst them there went the king of Hungary, who came to Acre with a most great number of men, and there went likewise the kings of Cyprus and Armenia.[531] But shortly thereafter, the king of Hungary went back to his own land and the king of Armenia, too, whose daughter King John had taken to wife because his wife who was heiress to Acre and to Jerusalem had departed this world but shortly before, leaving one daughter she had borne of him.[532] And as for the king of Cyprus, he betook himself to Tripoli and there he took a sickness of which he died. These things notwithstanding, King John took those pilgrims who had remained to lend him aid and he fortified two castles, the one near Caesarea and the other, which he called Castle Pilgrim, in a defile seven miles distant from Acre. But before all was accomplished,

FREDERICK, EMPEROR OF GERMANY, ATTACKING THE PILGRIMS.
POPE GREGORY IX RECEIVING THE ENVOYS OF THE PILGRIMS,
WHO COMPLAIN OF THE EMPEROR

*"The Pope, being advised of the great need of succour in the lands
of Outremer, sent to the emperor Frederick declaring that he would excommunicate
him if he did not make his pilgrimage, and he answered him that he would go."*

(FOL. 222A)

Sébastien Mamerot does not waste much time on the unsuccessful Fifth and Sixth Crusades at Damietta, and presents Frederick II of Hohenstaufen as being a person without respect for God who was capable of dishonesty and cowardice but who was nonetheless effective. In the spring of 1228, after he had reached the Holy Land, he attacked and robbed a group of Christians who had made a raid into Muslim territory and forced them to return the booty. This is clearly the scene that Jean Colombe depicts in the upper register. In the illumination in the lower register, a delegation of crusaders complains of the conduct of Frederick before Pope Gregory IX. When Frederick arrived at Acre in September 1228, he at once opened negotiations with Sultan al-Kamil and, on 18 February 1229, he signed the treaty of Jaffa, by which Jerusalem and several other cities in the Holy Land were returned to the crusaders for a period of ten years. The emperor entered Jerusalem on 17 March 1229, having gained more by diplomacy than many of his predecessors had gained by the sword. Not surprisingly, the Pope did not approve of this arrangement and, as a faithful son of the Church, Mamerot was of the same opinion.

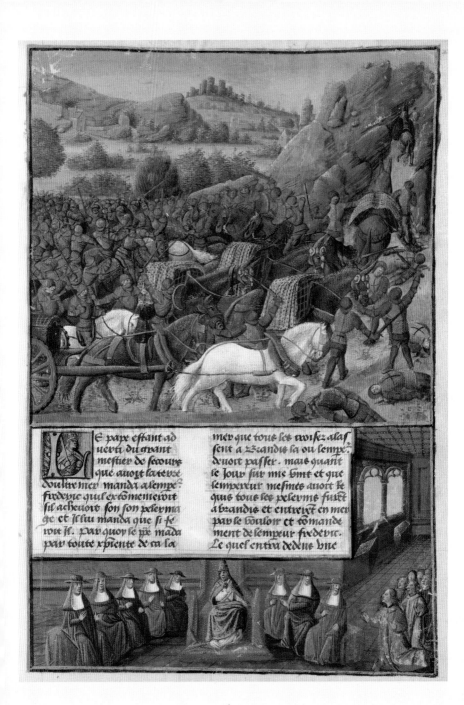

LE pape estant ad
uerti du grant
mestier de secours
que auoit laterre
doultre mer manda alempe
firderic quil excōmencoit
sil acheuoit son son pelerma
ge et Il sui manda que si fe
roit Il. Par quoy se pie manda
par toute xpiente de sa loi

mer que tous ses croisez alas
sent a brandis la ou lempe
doit passer. mais quant
le iour fut mis vint et que
lempereur mesmes auoit se
que tous ses pelerims fust
a brandis et entreist en mer
par le vouloir et comande
ment de lempeur frederic.
Le quel entra dedens vne

he bethought himself that, if he took Damietta or Alexandria, then he might readily regain the greater part of Syria.

For that reason, he went to lay siege to Damietta[533] and he maintained the siege a full year. Now when the Pope heard this, he sent to all quarters to urge men to take the cross and he sent as well two cardinals to the siege, of whom one, who was an Englishman, died very soon, while the other, who was a Portuguese, remained throughout the whole siege. When the sultan of Egypt[534] was told of the siege that the Christians meant to lay to Damietta, he caused the walls of Jerusalem and the castles round about, save for Krak,[535] to be slighted, thinking by this means to force the pilgrims in Egypt to turn back to Jerusalem, that they might complete their journey and then go back across the sea into their own lands. But they did nothing of the sort. And so he led a great army and came up hard by Damietta, and he encamped his men along the river and the Christians were on the bank of this same river on the other side. And shortly thereafter, he took a sickness of which he died, leaving one son, who became sultan and king of Egypt,[536] and he maintained the army of Turks and had the river Nile garrisoned and guarded, that the Christians might not go out to forage upstream. But when our men saw this, they armed their boats and sailed up to the palisades built by the Turks and tore them down.

The sultan, on the next night, ordered one of his emirs to go into Damietta with a garrison to safeguard it, but he made answer that he would by no means go, and that Saladin had in a like case sent his father into Acre and had let him be captured. The sultan was most greatly angered at this response and for this reason, the emir went back to his tents and departed that same night, taking his men with him, and when the men who were guarding the riverbank heard the din, they thought they were betrayed and so they took flight. When day broke, the Christians beheld the bank defenceless and so they crossed swiftly to the other side of the river and moved on in battle ranks towards Damietta, and the sultan likewise drew up his forces and issued forth from his encampments against them. But when he knew that the emir and a great part of his other men had departed, he dared not give combat, and so he abandoned his tents and the Christians took up quarters there and they found food there also in plenty. And they straightway built two bridges over the river: behind them they set up great and strong palisades and caused their siege-machines to batter Damietta most heavily, and the sultan, that he might succour the city, sent to al-Mu'azzam,[537] king of Damascus, demanding that he be pleased to come to his aid. And this latter had gathered together a great army and surprised and killed in ambush a number of knights from Acre.

Thence he went to lay siege before Castle Pilgrim. Nevertheless, he lifted that siege, that he might go to the aid of the sultan of Egypt, whose letters he received while he was there. Moreover, the pilgrims who were holding the siege before Damietta wished to do combat against the Turks. But these, as soon as they saw our men approaching, made pretence of fleeing, leaving behind their baggage, and when they saw our men coming back weighed down with their booty, they straightway turned back on them. They fell upon them with such force that all those on foot who had come forth from the main army were slain there, and the bishop of Beauvais and Walter, chamberlain to King Philip, who was a knight of great renown, were taken. And this defeat happened on the day of the beheading of Saint John the Baptist,[538] the self-same day when the Christians had been defeated before Acre a year before.

A great mortality struck Damietta, and when the citizens made this known to the sultan and begged for aid, he bade them keep a good watch and told them that when night fell he would rouse the Christian army, at which time he would send to them a new garrison of five hundred knights. And this he did, which occasioned much blame to the count of Nevers, for the five hundred knights entered Damietta from the side where he was encamped, and so he was banished from the army. Nevertheless, on a certain night when it fell to the cardinal's[539] men to keep watch, it happened that certain of his men went up close to the walls and, hearing no sound, climbed up on ladders and found the walls without defenders. They made this known to those in the army, who went straightway and entered the town, where they found in the streets and the houses many dead Saracens whom the king ordered to be thrown into the river. Those other Turks who were still alive retreated into a tower that they surrendered thereafter, and thus was Damietta taken and pillaged by the Christians in the year 1219.

The Christians having thus taken Damietta, there arose a dispute over the spoils between the cardinal and King John, so that the cardinal excommunicated all those who remained in that part of the city held by King John. And during this time, there departed this life the king of Armenia,[540] father to the wife of King John, at which he rejoiced greatly and made excuse thereof to leave the army and depart for Armenia. And lastly, inasmuch as men told him that his wife, the queen, sought to imprison his daughter in whose right he was king of Jerusalem, he beat her so savagely that she died of her wounds.[541]

Despite the departure of King John, the cardinal remained in Damietta and he excommunicated all those who sought to return thence to their own lands and likewise the ship-owners and sailors who gave them sea passage, save if they had letters

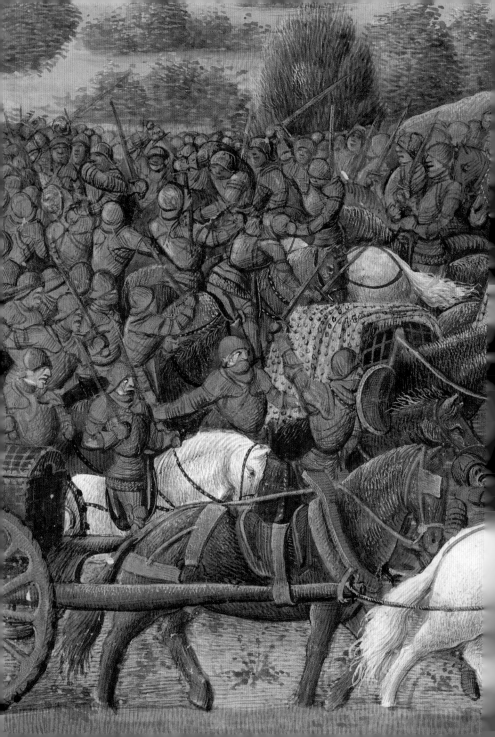

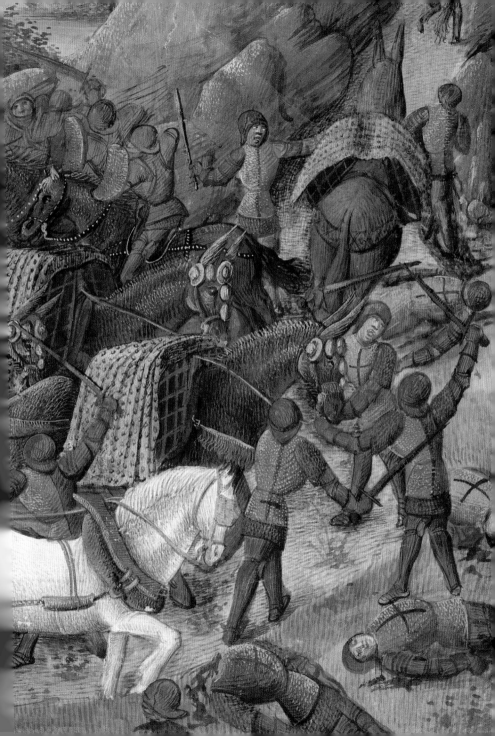

from him. The cardinal being thus ensconced in Damietta, the sultan armed twenty galleys that they might turn away those ship-borne pilgrims who were arriving day after day to bring aid to the Christians of Outremer. And although the cardinal was often warned of this, he would not believe a word of it, and would do nothing to remedy the matter until the Turks had killed and captured well-nigh thirteen thousand pilgrims. But a few days thereafter, the sultan sent to announce to the cardinal and the Christians that if they would surrender Damietta, he would surrender Jerusalem to them, together with as much land as their predecessors had held before them, save only Krak. But this they would not do, hoping that through Damietta they might in a short while take all of Egypt. Nevertheless, the cardinal made known the offer of the sultan to the Pope, and likewise that the barons of the land would not agree to this.

The Pope rejoiced greatly at this news and he sent to the emperor Frederick of Germany, who had taken the cross[542], saying to him that he should go to Outremer, and he had the crusade preached also a number of times throughout Christendom. The disloyal emperor Frederick, feigning to succour the Holy Land, was crowned in Rome by the Pope and recovered all the land of Sicily and Calabria. When the cardinal and the pilgrims of Damietta knew of this and that he was making great preparations that he might come to their aid, they garrisoned Damietta most strongly and took the road to lay siege to Cairo, which is the principal city of Egypt. And they sent to King John saying that he should follow them straightway, but he made answer to their messages that he would do no such thing, for he had to defend his land.

When the sultan of Egypt heard of the undertaking of the cardinal and the pilgrims, he sent to tell them that, if they would surrender Damietta, then he would surrender all the lands of Jerusalem, save only Krak, and that he would rebuild all the castles that had been slighted. And he would also give them thirty-year truces so that during that time they might people the land with Christians. Now the barons and the Templars and the Hospitallers would most readily have accepted these offers, but the cardinal did not wish it, and he sent to King John in Acre and besought him that he should for God's sake return to the army and then he might make peace, for the notion of peace was disquieting the army that was anxious for its share in the booty of Damietta, amounting to well-nigh a hundred thousand bezants. And then the king, fearing lest he be blamed, sent word to the cardinal that he would go, as indeed he did, yet it befell that this was to the great detriment of the Christians, though not through the king's doing.

For he and his men were, as it were, counter-attacked and besieged on their way by the sultan, who, when he heard that the emperor Frederick was sending one hundred

galleys against him, caused the sluices on the Nile to be broken by night and surrounded King John and his men on all sides in a place where they could not obtain food. King John offered battle to the sultan, but he would have none of it, knowing full well that he held the king like a prisoner since he could obtain no food. Yet, when the king sent to ask for safe conduct for himself and for the bishop of Acre likewise, he offered safety to the Christians but only if they would surrender Damietta. And so it was by this means surrendered to him with the consent of the cardinal, who preferred rather to lose the city than that King John and his men, coming to his aid and at his request, should be lost. And when the surrender was made, the sultan had to return all those prisoners whom al-Mu'azzam was holding, and all those Saracens held in Christian prisons had to be returned to the sultan, and they also made seven-year truces. The sultan ought likewise to have surrendered the True Cross, but he gave back another one and not that which was lost at the time when King Guy had been taken prisner by Saladin.

Chapter LXX.
The overseas journey taken by the disloyal emperor Frederick, who was excommunicated. And how he wore the crown in Jerusalem and of his return.

The Pope, being advised of the great need of succour in the lands of Outremer, sent to the emperor Frederick declaring that he would excommunicate him if he did not make his pilgrimage, and he answered him that he would go. For this reason, the Pope made it known throughout Christendom this side of the sea that all those who had taken the cross should go to Brindisi, whence the emperor should take the sea passage. And when the appointed day came that had been requested by the emperor himself, all the pilgrims were at Brindisi, and they set sail in accordance with the wish and the command of emperor Frederick. Now the latter went up into a galley and departed with them, but when night fell, he ordered his galley to turn back and he returned to land without the knowledge of the others and put in at Brindisi, while the others crossed over to Acre. And when the Pope knew of the trickery and wickedness of the emperor Frederick, he excommunicated him.[543]

But this notwithstanding, this same man, untrustworthy as he was and hardened to all evildoing, sent his marshal by sea to Egypt before the sultan, that he might give him leave to make his pilgrimage and go to Jerusalem, which the sultan granted him.

COUNCIL OF LYONS (1245). LOUIS IX TAKING THE CROSS

"And I believe that Our Lord heard the prayers of the devout people,
for the good Saint Louis, who by dint of this sickness had been held as if in
a trance and could neither move nor speak, suddenly regained his strength
and, against all the expectations of those who looked after him and who thought
that he was in the throes of death, opened his mouth and the first words
that he uttered were to demand the Cross."

(FOL. 225B–225VA)

The upper miniature shows Pope Innocent IV presiding over the ecumenical Council of Lyons, which was held in June 1245. He had been forced to flee to France because Emperor Frederick II had driven him out of Rome. At this council, Innocent IV announced the condemnation and excommunication of Frederick II, declaring him an enemy of the Church, and called once again for a crusade. During the month of August 1244, Jerusalem had been captured by the Muslims who, on 17 October, together with the Egyptian Ayyubids, soundly defeated the Frankish army at Gaza. Jerusalem was now finally lost for Christendom. It was above all the French king Louis IX (Saint Louis) who responded to the appeal for a Seventh Crusade, for while seriously ill in December 1244, he had vowed to go on crusade if he recovered. In the lower miniature, Jean Colombe shows Louis IX on his way to Aigues Mortes on the Mediterranean, where he embarked on his journey in August 1248.

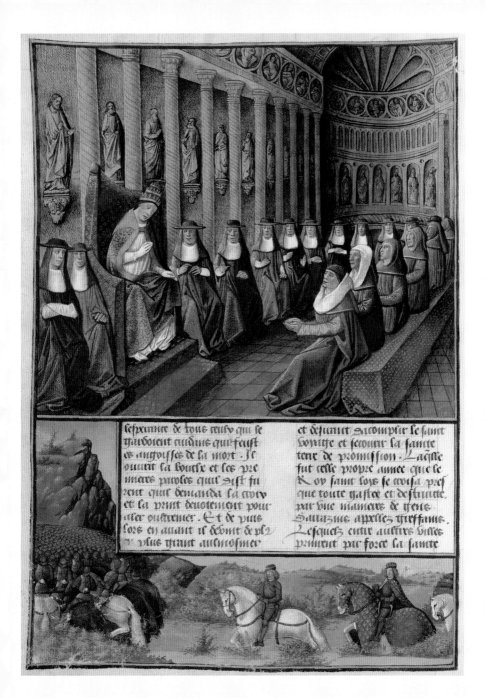

lefpurance de tous ceulx qui se tardoient andius qui feuft es angoisses de la mort. Il ouurit la bourse et ses premieres parolles quil dist furent qiul demanda la croix et la print deuotement pour aler oultremer. Et de puis lors en auant il donut de plus 𝔪 plus triant aulmosnier

et deuenit sacomplir le saint boyure et secourir sa sainte terre de promission. Laqlle fut celle propre annee que se Roy saint loys se croisa pres que toute gastee et destruite par vne maniere de gens Sarrazins appelles thessames. Lesquelz entre aultres bestes prinrent par force la sainte

611

And if the emperor Frederick was bad, his marshal was his equal, for this disloyal man, while returning from Egypt, robbed a number of Christian pilgrims whom he came upon near Sidon, bearing with them great booty that they had conquered from the Turks. He routed them with ease, for they did not mistrust him since he was a Christian, and he killed and wounded a number of them, which the pilgrims made known to the Pope, who forthwith anathematised the emperor Frederick with renewed force. But this notwithstanding, the latter, as soon as his marshal had sent him word from Acre that he might cross over safely, sent to the Pope to ask him to absolve him and to tell him that he would make the journey to Outremer and should not return thence until the time came that he had placed within the hands of the Christians all the lands that were there. But the Pope would do no such thing, and he sent messages to the patriarch and to the Templars and the Hospitallers, that they should not ally themselves with the emperor, nor should they take counsel with him.

However, the emperor Frederick crossed the sea and came to Acre[544] and thence he went to gaze upon Castle Pilgrim, which he was desirous of having, for it was most handsome. And when the Templars knew of this, they took up arms and drove him away, and he went back to Acre and reinforced his army in that part of the city where he thought to cast down the house of the Templars, which stood there. But the Templars and the French pilgrims opposed him and they resisted so fiercely that he could not accomplish his evil undertaking, so for this reason he abandoned his plan and sent to the sultan of Egypt, demanding that he keep his covenants with him. But the sultan, who knew of the discord there was between the Pope and the emperor, sent to tell him that al-Mu'azzam, king of Damascus, was dead and that for this reason he could not fulfil his covenants. When the emperor Frederick heard this, he sent again to the sultan declaring that if he did not keep his covenants, then he would never cease fighting in the lands of Outremer until he had despoiled him of them all. At last, the emperor and the sultan made a new pact,[545] whereby the sultan should surrender to the emperor all of the kingdom of Jerusalem that he held, save for Krak and Mount Royal and three castles in the land of Tyre and Sidon, for those who held them were not willing to surrender them to the sultan. And there was another condition: that three Saracens should have guard of the Temple of Jerusalem and that the Christians should have no lordship there, but the pilgrims, however, might go freely to the Sepulchre without payment of tribute. And it was agreed besides that the emperor might rebuild and refortify towns and fortresses, but that he might not build new ones, and also that the Saracens might not fortify their towns.

This same disloyal and untrustworthy emperor, having thus taken possession of the city of Jerusalem,[546] through vengeance and cruelty had Saracens dwell in the residence and manor of Solomon, which belonged to the Templars, the very one wherein they dwelt when Saladin took Jerusalem. And the disloyal emperor did this wicked thing because he did not wish the Templars to remain in Jerusalem. And when these conditions had been agreed upon, ten-year truces were made between the emperor and the sultan, but with the accord and the counsel neither of the patriarch nor of the Templars, for they did not wish to be present, nor to consent to these things because the Pope had forbidden them to do so. But this notwithstanding, the disloyal emperor promised to maintain them. And he wore the crown in the Holy City of Jerusalem on the Thursday of the third week of Lent, on which day he gave to the German Hospital[547] the king's manor that stands before the Tower of David.

This having been accomplished, he made known to the Pope how he had taken possession of the Holy Land, but the Pope and the cardinals rejoiced but little at this news, for they knew that he had made a bad peace, since the Turks held the Temple, and they knew also through what alliance he possessed it. They forthwith anathematised his disloyalty yet again, and the Pope would not, therefore, suffer that this news should be spread abroad in the name of the papacy, nor that the Holy Church should rejoice thereat, and so he made it known throughout Christendom that the emperor was excommunicated by reason of his untrustworthiness and lack of Christian belief. And besides this, he used the treasury of the Church to gather together a great number of men, and he entrusted them to King John of Acre and caused him to enter the land of the emperor, that he might safeguard the land of the patrimony of Saint Peter. This thing King John did, and in a very short time, he conquered a number of cities, towns and castles from the emperor. The latter, when he heard this news, put magistrates and other officers in his stead in the land of Jerusalem and returned to Sicily and Naples, and there he reconquered a number of towns and cities in a very short time and did great harm to men of divers estates. And to bring this account of his execrable life to a speedy conclusion, he was in his time the most perverse emperor there has ever been, for though he maintained he was a Christian and called himself such, he nevertheless declared most often and before a number of people worthy of belief that Moses had sullied the Jews, Our Lord and true God, the all-powerful Jesus Christ, the Christians and Mohammed the pagans, which made it plain that he held to no religion.

As for the chronicler of Soissons, he has written the name of this emperor with a heavy heart, but since he is constrained to continue with the journeys to Outremer, he

has set down this most brief account of which he here makes an end, giving praise to Our Lord God Jesus Christ. Amen.

<div style="text-align:center">✝</div>

Chapter LXXI.
A further crusade initiated in France, of which Tibald, count of Champagne and king of Navarre, was the leader. How the duke of Brittany went to plunder Outremer and gained abundant booty. Of other lords who sought to follow in his footsteps and were discomfited. The death of the count of Bar. And how fruitless this crusade was for the Holy Land.

Tibald, count of Champagne and crowned king of Navarre because his brother had died without direct issue,[548] was named the leader of a crusade initiated in France in the year 1200.[549] And with him to Ourtremer went the duke of Brittany, called Peter Mauclerc; the count of Bar; Amalric, count of Montfort; Richard of Chaumont; Anselm of L'Isle; and most of France. All these with many others of various estates crossed the sea[550] and arrived at the port of Acre.[551] And thence they took the field after only a few days' rest. Now it happened that the duke of Brittany[552] and a great number of barons, knights and others in his company departed from the army without the agreement of the other lords and more especially unbeknownst to the king of Navarre. Travelling by night, they went to a large and distant Saracen town, first sending spies to know the disposition of their enemies. The spies reported that the Saracens had set no guards and thus the duke and his men took and pillaged the town since there were no Turks within to defend it. Then, with their abundant plunder, they returned to the army and showed their booty to their companions, some of whom were envious and resented having thus been left behind; hoping to do what the duke had done, they set off in similar fashion without the permission of the king of Navarre or the advice of the other lords. Amongst them were the count of Bar, Amalric of Montfort, Richard of Chaumont and Anselm of L'Isle and many other barons, knights, squires and men of various estates. They galloped all night in their armour till, at daybreak, they came close to the city of Gaza, which lay on sandy soil, but there they were surprised. For the men of the city and its surroundings, having been apprised of the duke of Brittany's raid and, what was worse, knowing from their spies of the coming of the count of Bar and his friends and that they had galloped all night, armed themselves and came against them and they

were more numerous than the Christians, and fresher and stronger and consequently, those who had ridden all night and were weary and spent could not hold out against them. Therefore, many were killed or taken and the others began to flee the way that they had come, and few escaped.[553]

Indeed, they would all have remained dead on the field had not some carried the news to the king of Navarre, who sent ahead the best mounted and came behind them with the main corps of the army, the foot soldiers. There the kingdom of France suffered great losses and all the Christians of the army were in danger of death or capture. But the king of Navarre, mustering as many of the fugitives as he could, so rallied his men that the Turks dared not attack, but left the field having killed or taken the count of Bar, of whom nothing further was ever heard. And they removed to various prisons the count of Montfort and many other barons, knights, squires and men of divers estates. This defeat was roundly blamed on the count of Bar and Amalric of Montfort by most of the army, who said Our Lord had permitted this defeat on account of their sin, because they rather considered their honour as knights than the good of the Holy Land.

However, shortly after this defeat, there came in pilgrimage to Outremer with a great number of men Richard, earl of Cornwall, the brother of the English king.[554] And when he discovered that the host of pilgrims from the kingdom of France had been so discomfited by the rout and that so many barons and kings had been killed or captured, he was deeply affected and so harried and assailed the Turks and other Saracens that the prisoners were delivered and ransomed for gold and silver. Moreover, he succeeded in gaining a safe conduct from the Turks for the pilgrims to go Jerusalem and visit the Sepulchre of Our Lord Jesus Christ. And so on this occasion the princes and lords and other French pilgrims were of little service to Outremer.

Count Amalric of Montfort, having been delivered from his prison, wished to go to Rome and visit the Holy Places and there he died of dysentery. Therefore, he was buried with great honour in the church of the glorious apostles and those who were able returned to France as quickly as they could. And at this point the chronicler of Soissons, praise be to God, brings to an end his account of the expeditions in Outremer before that of Saint Louis, king of France. Amen.

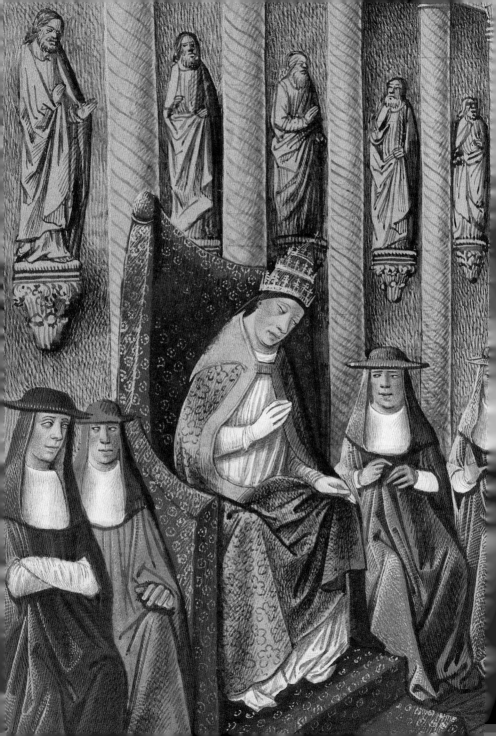

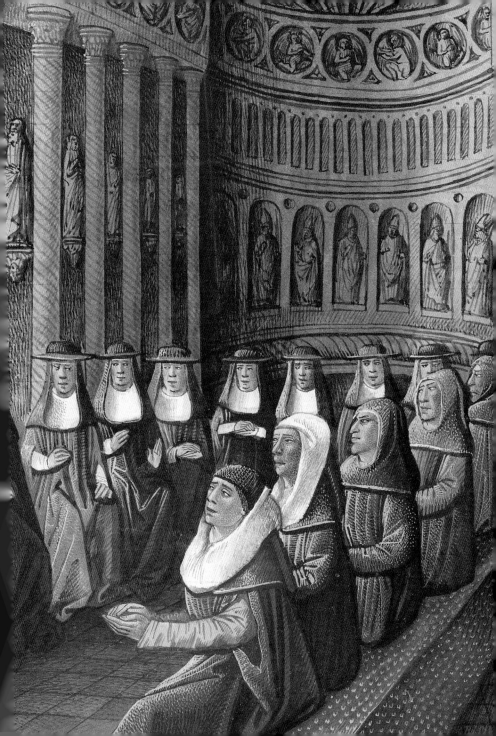

Chapter LXXII.

How Saint Louis, king of France, having been gravely ill, was suddenly cured and took the cross, vowing that he would go to Outremer. Of the council held by the Pope at Lyons against the emperor Frederick and for the succour of the Holy Land. Of the legate who preached the crusade. Of the barons and prelates who took the cross. How the king went to see the Pope at Cluny.

During the glorious reign of Saint Louis[555] in France, Frederick, emperor of Germany, did great harm to the Pope and to churchmen in general. Because of Frederick's tyranny, Pope Innocent IV was forced to leave Rome[556] and take refuge amongst the noble and courageous French as many of his successors had done and have done since, always finding the glorious French people very prompt and diligent in restoring the Popes to their seat in Rome, as is well known the world over.

Thus, it came about that the Pope, having arrived in Lyons, sent to Saint Louis saying that he would gladly speak to him and hear his counsel on church matters.[557] But when the king thus had news of the Pope and wished as a very Christian king to depart and hasten towards him, he was taken with a malady called dysentery[558] that so continuously afflicted him over so many successive days that his death was considered imminent. The prelates, princes, barons and churchmen and all the people of France, hearing of the king's illness and with the rumour abroad that he was already dead, were so disconsolate and so prayed and wept that no words can tell of it. Prayers and orisons abounded throughout France as if each saw his own father on his deathbed. And in truth, it was because he had been such a servant of justice and so generous in his alms and had so valiantly defended and so loyally safeguarded them from their enemies since his accession to the throne that he was thus openly mourned and lamented.

And I believe that Our Lord heard the prayers of the devout people, for the good Saint Louis, who by dint of this sickness had been held as if in a trance and could neither move nor speak, suddenly regained his strength and, against all the expectations of those who looked after him and who thought that he was in the throes of death, opened his mouth and the first words that he uttered were to demand the Cross, which he devoutly took in order to go to Outremer.

And thenceforth he was ever more generous in his alms and desired to accomplish the Holy Journey and go there to succour the Holy Promised Land. And that land was in this same year in which Saint Louis took the cross[559] almost entirely despoiled and destroyed by Saracens called Khwarismians, who captured, amongst other cities, the Holy City of Jerusalem and there killed the Christian population – man, woman and child – without exception and in such great multitude that the blood of the Christians massacred by them ran in streams in various places in the Holy City so that the Church of the Sepulchre was violated and sullied by it. And they did the same in the city of Gaza and other cities, where they killed all the Templars and Hospitallers that they found and also all the nobles and all the common people. And, in short, to make clear the insatiable nature of their cruelty, the massacres they committed were such as to threaten the ruin of the entire territory of Christian Outremer if they were long continued.

Therefore, Pope Innocent, seeing that the Church of God was thus tormented by various tyrants, in the year 1245[560] and on the last day of April summoned a Holy Council in the city of Lyons. There, amongst other things, it was decreed that the emperor Frederick was heretical, false and evil and, as such, by the Pope condemned and declared excommunicated and excluded from the entire community of faithful Christians and unworthy of the dignity and honour of the empire. And by this same condemnation the Pope declared the vassals of Frederick and his allies to be absolved of this sentence of excommunication on condition they should forthwith put an end to their obedience to the emperor, and all those who should continue to hold him their king and emperor would be excommunicated. And the Pope then gave permission to the electors of the empire to elect and make a new emperor. And, terrible as these verdicts were, none should doubt the Pope's integrity in the matter. For this very Frederick, as I find by chronicles of indubitable truth in various places, was crueller and worse than Nero and Julian the Apostate. And as to the evil that he did to the cardinals and other episcopal dignitaries, and even against priests and clerics, they are so manifold that they do not bear description. And to demonstrate his apostasy in brief, Frederick claimed that Moses had sullied the Jews, Our Lord and true God Jesus Christ the Christians and Mohammed the pagans.[561]

And before the Holy Council broke up, it sent the papal legate, cardinal Odo of Châteauroux, to France to preach a crusade. And thanks to his preaching,[562] the archbishops of Rheims and Bourges; the bishops of Laon, Beauveais and Orleans; the count of La Marche; the count of Montfort; Ralph, lord of Coucy; and many other princes and nobles and a great multitude of the common people took the cross. The Pope also sent another cardinal to the county of Hainault and to other parts of the

Holy Seat, so that those of these marches should take the cross and go to the assistance of the landgrave, the duke of Thuringia, who had recently been elected to the kingdom of Germany,[563] since the Pope was reluctant to see Conrad, the son of the very wicked Frederick, elected to the imperial throne.

Matters were at this point when King Louis and his three brothers, taking with him his mother, Queen Blanche, with a great multitude of princes, counts, barons, knights, squires and other men-of-arms, for he feared the action of his enemies, went to meet the Pope at the abbey of Cluny,[564] where they spent a fortnight together, arranging and ordering everything that was to be done to succour the Holy Land. And after the fortnight had passed, Saint Louis returned to the castle of Melun, where he held court and gave in marriage to his brother Charles the lady Beatrice, sister of his wife, the queen and countess of Provence, and bestowed on Charles the counties of Anjou and Maine. When the wedding was ended, the king commanded all his crusaders that they should prepare themselves and be ready to make the Holy Journey by the feast of Easter[565] in the year 1248, and each obeyed as best he might.

Chapter LXXIII.
How Saint Louis left France for the first time to cross the sea and visited the Pope. Of the vengeance that he took at Roche de Clin. And how he set sail and arrived in Cyprus. The death of many prelates and barons. And the letters sent to him by the king of Tartary.

In the year 1248, on the Friday after Pentecost,[566] Saint Louis left Paris with all his army on his way across the sea. And the people of Paris escorted him in great processions till the abbey of Saint Anthony[567] near Paris, where he stopped and made his prayers, and having made them and recommending himself to the prayers of the nuns and also of the clergy and all the assembled people, he mounted his horse and set off on his pilgrimage, not without innumerable lamentations, tears and regrets on the part of the people of Paris, who loved him for his admirable sense of justice, as if he had been the very father of each man amongst them. In his company and army went Robert, count of Artois, and Charles, count of Anjou, his brothers; and the cardinal and papal legate with many other prelates and a great number of princes, barons, knights, squires and French people of various estates. His other brother, Alfonso,[568] remained in the company of Queen

Blanche, his mother, to safeguard the kingdom, for though he had taken the cross, it was agreed by the king and barons that he would remain behind for one year.

Thus, King Louis, setting out upon his Holy Journey, went to Lyons, where he found Pope Innocent, who dared not go to Rome and face the persecution of the emperor Frederick. When the king and Pope had conferred at length, Saint Louis accepted the Pope's blessing and went on with his pilgrimage. But when he came to Roche de Clin,[569] he had the castle demolished and razed because certain members of the garrison had robbed officers of his who had gone before the army in order to supply part of the host. Thence the noble and holy king went to Aigues Mortes in Languedoc and set sail the Tuesday after the feast of Saint Bartholomew the apostle.[570] And by God's aid he had such favourable winds that he landed in Cyprus at the port of Limassol and thence went to the city of Nicosia, where he spent much time.

Indeed, his stay was so long that the sultan of Egypt,[571] who had assembled a great army to assail the Christians of Outremer and was already in Damascus, was there apprised of the true size of the great army of Saint Louis and how he had come to bring succour to the Holy Land, on which account he returned home posthaste to defend his kingdom of Egypt. Moreover, there died during the king's stay in Cyprus the bishop of Beauvais, the count of Montfort, the count of Vendôme, Archimbald of Bourbon, William of Les Barres, Drago of Mello and two hundred and eleven other good knights.

During the feast of Christmas, there came to King Louis in the city of Nicosia envoys from the great king of Tartary[572] who had – or so they said – recently had himself baptised along with many of his barons,[573] and sent friendship and greetings to the king, as they declared, and as it was written in the letters that they bore, which were translated in the following manner by Andrew of Longjumeau, confessor to the king:

"By the power of God in the Highest, His Excellency Guyuk, khan, king and prince of many provinces, noble adversary to the world, sword of Christianity and defender of the religion of the apostles, to the noble King of France, lord and master of the Christians, salutations. May Our Lord increase your lordship and kingdom as He sees fit, accomplishing your will in His law and in this world now and for ever! May God bestow upon you His divine virtue and safeguard your men by the prayers of the prophets and apostles! And I by these present letters send you a hundred thousand blessings and a hundred thousand salutations and beg that you willingly receive these salutations. For it is no small matter that so great a lord as I should send my greetings. It is our intention to work to the benefit of Christianity. I pray and beseech God that he bestow victory upon the Christian host and overwhelm and bring low all those who despise the Cross! True

God, exalt the king of France and raise him so high that all can see and admire him! We desire that, throughout our domains and powers, all Christians should be free and exempt from slavery and that they should be relieved of all tribute and tithes and all other customs and that they be honoured and safeguarded. We desire that churches that have been demolished should be rebuilt and bells rung and that all Christians should be able to come and go as they please within our kingdom. And because God has at this present time given us the honour of protecting Christianity, we have sent these present letters by our loyal envoys in whom we place our trust, David, Mark and Alpha, so that they may tell us from their own mouths how things stand with you. Take our letters and words to heart, for they are true. He who is King of Heaven, may He desire peace and concord between the Latins and the Greeks and between the victorious Armenians and the Jacobites and all those who adore the Cross. And we pray to God that he should make no dissent between ourselves and the Christians."[574]

Other letters were sent to the king of Cyprus by his brother-in-law[575] as follows:

"To my lord Henry, king of Cyprus, John of Balin, his brother, constable of Armenia, greetings! Know that, since my departure for Tartaria on behalf of his excellence the king of Armenia, Our Lord has conducted me safe and sound to a town called Sante. And I may tell you that on the way we have seen many a strange thing. We left India on our left and went by Baghdad and it took two months to cross the entire territory of the kingdom. We saw many cities that the Tartars had destroyed and despoiled, cities whose riches and greatness were beyond description. We also saw more than two hundred heaps of the corpses of local men killed by the Tartars. And if the grace of Our Lord had not brought the Tartars here to combat the Saracens, they would have destroyed all the territory held by the Christians and the kingdom of Syria. We crossed a great river that comes from the earthly paradise of Zion, which is a whole day's march wide from bank to bank. And we hereby inform you that the Tartars are here in such great numbers that no man could count them. They are ugly and various of feature; I can hardly tell you how they look. Concerning arms, they are good archers and of high courage. We have now been travelling incessantly for three months and we are not yet at the centre of the land of the khan. We have heard from certain persons that, after the death of the khan,[576] the great king of the Tartars, it took the Tartar barons and knights dispersed throughout various countries a whole year to assemble in order to crown the khan[577] who reigns now. And it was hardly possible to find a place where they could all meet together. Some were in India and the others in the territory of the khan and some in the territory of Sara[578] and in Insule, which is the land whence

came the three kings who went to adore Our Lord in Jerusalem and the people of this land are Christians. I have been in their churches and seen Our Lord painted with the three kings offering gold, myrrh and incense. And the Tartars first gained the Christian faith through these kings and by their ministry and, therefore, the great king of the Tartars and several of his princes are Christians. And before the noblemens' doors stand churches in which bells are rung as in the rite of the Latins. There, too, we find tables of the law in the manner of the Greeks. The Christian Tartars go to the churches in the morning to adore Our Lord Jesus Christ and then go to greet the king in his palace. And know that we have found many Christians scattered throughout the Orient and many beautiful churches, tall and ancient, which were destroyed by the Tartars before they became Christians. And so it has happened that some of the Christians of the Orient have again come before the khan now reigning, who received them with great honour and gave them their freedom to practise and had it announced by way of a ban that none should be so bold as to cause them ill by either word or deed.

In the land of India, which Saint Thomas converted to the Christian faith,[579] there was a Christian king that the Saracens had disinherited and deprived of most of his territory. He quickly saw that he would lose the rest if he received no help. Therefore, he sent to the king of the Tartars that if he were willing to safeguard and give succour to his land, he would gladly do him homage and would become his vassal. And as soon as the king of the Tartars knew the desire of the king of India, he sent for the most valiant men of his kingdom and commanded them to go to the aid of the king of India and of his land that the Saracens had despoiled, ordering them to do all in their power to aid the Christians and to love them like their own brothers. The leader thereupon elected set out at once with a great company of Tartars and came to India, where the king received them with great joy and went to greet them in their tents, and then returned to his own men and assembled his army jointly with the Tartars and together they went out against the Saracens, who awaited them on the battlefield, little suspecting that they now enjoyed the help of the Tartars. Thus, the Saracens were routed and almost anni- hilated and we saw how the king had more than forty thousand slaves sold. And know, very dear brother-in-law,[580] that we were present before the king of the Tartars when the messengers from the Pope reached him and asked whether he was a Christian. Afterwards they asked him why he had sent his men to kill Christians. And he replied that he had not done so since he had been made a Christian, but said that amongst the commandments of their laws followed by his predecessors was the requirement to kill all the evil men that they could find. And following that commandment they desired

that Christians should be killed, believing them to be evil people. May the Lord keep you safe and well! We hereby convey to you the appearance and the ways of the Tartars."

Saint Louis, having heard and understood these two letters, demanded of the messengers from Tartary[581] the name of the prince who had sent them and how he had known that the king of France was to make an expedition to Outremer. And they replied that the sultan of Egypt had sent letters to the sultan of Mosul, the city also known as More, in which it was said that the king of France was bearing down on the Saracens with a great host and navy and that the sultan had forcibly taken nine well-laden ships belonging to the king of France. And these things he had mendaciously conveyed to the sultan of Mosul in order to frighten him, for the king had suffered no losses at sea at this juncture. But he told him this so that he should not trust King Louis nor his men, and did so in the knowledge that the sultan of Mosul wished to become a Christian. "And you may be sure," said the messengers, "that as soon as the sultan of Mosul knew that you were attacking the Saracens, he passed this information on to the Great Khan,[582] our master. And on this account the prince Aljighidai has sent to you, so that you should know the intent of the Tartars, which is that they seek next summer to besiege the city of Baghdad and the caliph of the Saracens." They also said that their prince sent to ask him that he might attack Egypt so that the caliph of Baghdad could obtain no help from the Egyptians.

King Louis, having listened at length to the messengers of prince Aljighidai, asked how the Tartars had attained to lordship over such great domains. And they replied that it had been some forty years since the Tartars had poured forth from their lands and they were so great a multitude that there was no city or castle that could defend itself against them nor any place where they could remain; they lived in woodland and pasture, since all that they wanted was to pasture their herds. And that the land from which they came and where the Great Khan lived was named Tartar, for which reason they were called Tartars, and that it was twenty thousand miles square and that their king was so powerful that he had with him all the great princes of the earth and so great a multitude of men mounted and on foot and so great an abundance of herds that they were quite innumerable and they lived always in tents and pavilions and, therefore, could never be accommodated in any city. And that in respect of their horses and other animals, they kept them always at pasture because they had neither barley nor straw nor any other provender on which they could be fed. Therefore, it was the custom of their great princes to send their foragers in advance of their people to explore the lands and countries and the princes, then take whatever they found and make it part of their domains. And that

they sent a part of what they thus captured to the Great Khan and to the barons in his retinue and the other part they kept for their own sustenance. And that their custom when the Great Khan died was that the princes and captains had the power to assemble and elect a new king, but that it was proper that the new king was a son or nephew of the late king or a close relation, and that the king who had sent them was born of a Christian mother, who was the daughter of Prester John,[583] the king of India. And that by the advice of this good and saintly lady and of a bishop named Thalacias, this king and the Great Khan and eighteen of his princes had been baptised and that amongst them there were many great princes and others who wished to become Christians and that the prince who had sent them had long been a good Christian. And though he was not of the royal line, he was a great and powerful lord in the region of Persia.

The king asked why Duke Batu had not received the messages that he had previously sent to the Great Khan. They replied that Duke Batu was pagan and that he had in his lodging a number of Saracens who were members of his council and that he had not so great a rank of lordship as he wished; indeed, he had been deposed and placed under the lordship of prince Aljighidai. The king asked them further if the sultan of Mosul (which was, as I have previously said, the ancient Nineveh) was Christian. And they replied that he was the son of a Christian woman and that he loved Christians and observed the feasts of the apostles and martyrs as Christians did and did not obey the law of Mohammed and that his intent to become Christian awaited only the agreement and desires in this matter of the other barons of his land. Having heard these things, the king was counselled to send his own envoys with letters, gifts and jewels to the great king of Tartary and to the prince Aljighidai so that when those who should go on his behalf to prince Aljighidai had spoken to him and handed over the letters and presents, they would return and the others would go on to the Great Khan. And having heard from the envoys that the Great Khan would very much like a tent in which there was a chapel,[584] he had a very beautiful one made in scarlet cloth with gilded pommels and richly embroidered. And he had depicted within the way in which the three Tartar kings adored Our Lord and how He died for our redemption. And he also sent him a part of the wood of the True Cross. And these things he did in order to intensify the faith of prince Aljighidai, to whom he also sent another part of the True Cross, strongly recommending him in his letters that he should aid the Christian faith. The envoys of the king were two Franciscans, two Jacobites, two secular clerics and two lay brothers and the aforementioned brother Andrew of Longjumeau[585] was appointed as head of the embassy.

LOUIS IX LEAVING LIMASSOL. HIS ARRIVAL AT DAMIETTA

*"Thus, Saint Louis and those of his army left the port of Limassol
in Cyprus on the very day of the Holy Trinity and had such favourable
winds that the following Friday they could see the Egyptian coast. Choosing
the city of Damietta, they went to it as directly as they could and, there, hastening
to land, they maintained a close formation on the Nile, which flows
into the sea close by and whose source is said to lie in the earthly paradise."*

(FOL. 233VA–233VB)

Louis IX spent the winter at Limassol in Cyprus with his army, where he added further contingents to his strength. After drawing up a plan for the attack on Egypt, he set off on 30 May 1249. The upper miniature shows preparations being made for the king's departure. The galleys are moored close to the shore and the sailors are hoisting the sails. Louis IX himself, accompanied by a high-ranking nobleman, can be seen surveying the operations, while the armed men are waiting to board the ships. The walls of Limassol can be seen in the background. In June, Louis reached the coast of Egypt with his fleet. The landing of the crusaders on 5 June 1249 is depicted by Jean Colombe in the lower register; they disembark on an island and launch themselves into the midst of their enemies, who await them on the shore.

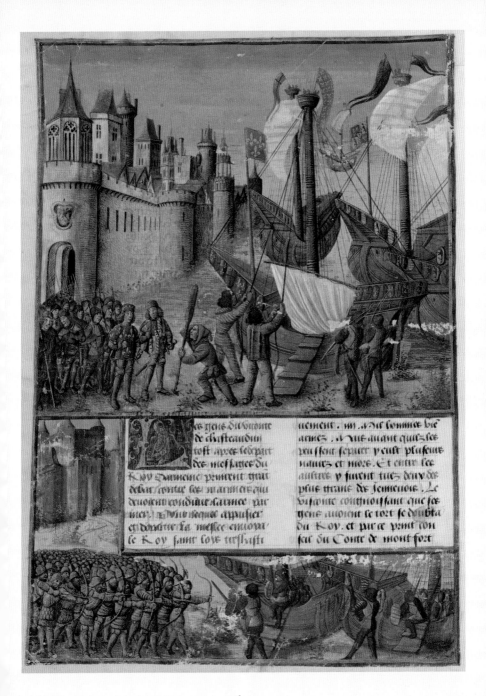

✝

Chapter LXXIV.
How the sultan of Egypt[586] fortified Jerusalem. Of the siege of the city of Homs.[587] And how the master of the Temple thought to make the king turn back at the request of the sultan of Egypt. And the peace made by Saint Louis between the king of Armenia and the prince of Antioch.

The sultan of Egypt, having heard of the renown of King Louis and learned that for the love that he bore the prelates, barons and knights, he was willing to come to Outremer, now grew more afraid than ever. And out of hatred for the sultan of Aleppo, whom he would willingly have made his vassal before the arrival of the French, if he had been able, he first went in great haste to Jerusalem and furnished the Holy City with soldiers, provisions and fortifications. And thence he sent to all the castellans of the region and commanded them that they garrison their castles and fortresses and told them that he strongly feared the coming of the king of France. And when he had arranged these matters, he came towards the region of Damascus because he wanted to make an alliance with the sultan of Aleppo and those whom he took to be his enemies in those parts so that he might have assistance against the Christians. And he told the caliph of Baghdad and the Old Man of the Mountains, the lord of the Assassins, how he was at loggerheads with the sultan of Aleppo and begged them to send petitions and envoys so that they might again be allied. But neither prayers nor anything that he could say would move the sultan of Aleppo to come to terms with him.

Therefore, the sultan of Egypt commanded two of his captains that they should go and lay siege to the city of Homs and they should hasten to assail and capture it because the winter was approaching, and that all those within it should be made prisoner if they did not immediately capitulate. His captains obeyed the command of their sultan and laid siege to the city of Homs, but during their siege there came from the mountains so great a torrent of water that it carried away most of the provisions and animals of the Egyptians, who fled the scene. The Bedouins being close by and seeing their flight and affliction attacked them and captured many, whom they placed in their prisons. However, when the great torrents of water ceased to flow, the two captains assembled and rallied their men and again came before the city. And the sultan of

Aleppo, who knew what was happening to the inhabitants of Homs, hastened to attack them with a great army and was only waiting for the great floodwaters to abate.

Before then, however, the envoy of the caliph, who was his lord and master, arrived and admonished him to make peace with the sultan, telling him great losses and harm would come to the Saracens if they did not come to terms. For the Christians were coming from the west to destroy the law of Mohammed and if the Saracens fought one another, they might fall into great confusion and incur great losses while the joy and profit would be for the Christians, their enemies.

But the sultan[588] dismissed these remonstrations and refused to consider a peace agreement and said that while the Egyptians were in his territory, he would not make terms; if they did not raise the siege of Homs, then he would do battle with them. When the caliph's envoy saw that he could not make peace, he took his leave and went to the army of Egypt and spoke to them, showing them the great peril to which they were exposed, for the sultan of Aleppo was about to attack them with a great multitude. When the two captains heard this news, they raised their siege and, having suffered great losses in both soldiers and equipment, they returned to Damascus.

The sultan[589] remained there afflicted with grave illness, but when he was a little recovered he sent to the master of the Temple, who was his very good friend, saying that he would be most grateful if he could arrange for the king of France to return to his own land and that there should be truces and treaties granted and sworn for many years. And the master of the Temple replied that he would do his utmost.

Thereupon he sent envoys and letters to Saint Louis showing him how great a thing it would be to make peace with the sultan of Egypt and thus incurred the severe displeasure of the king and the barons. For some said that the master of the Temple was more concerned with the profit and honour of the sultan than with their own. Therefore, the king ordered that he should not thereafter dare accept any request from the sultan of Egypt without the king's express permission and should hold no further parley with the Saracens about any matter regarding the French. And in truth, the master of the Temple and the sultan were so closely acquainted that, when they had themselves bled, they did so at the hands of the same surgeon, bleeding into the same recipient. Given these and other signs of their familiar relations, the Christians of Syria began to suspect that the master of the Temple was no longer of their party. The Templars for their part argued that the master showed such affection for the sultan and so honoured him and sought his company in order that he should keep the peace in the Christian lands, which would not, consequently, be constantly harassed and imperilled by the sultan and other Saracens.

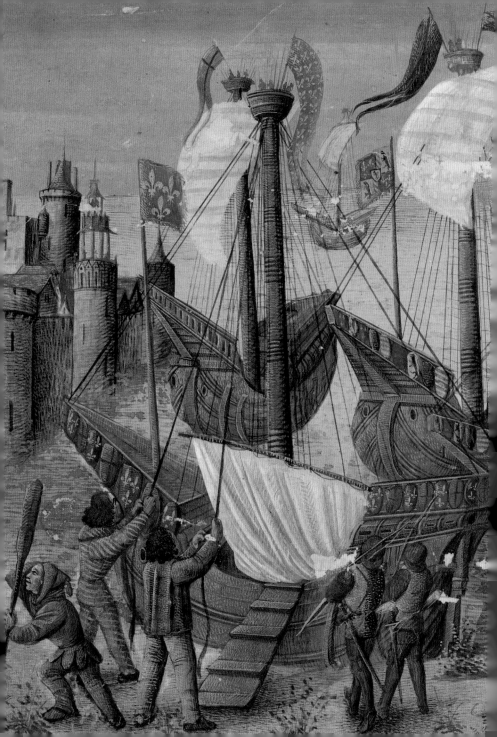

Meanwhile, the king of Armenia sent two bishops and two knights to Cyprus to King Louis, who was still on the island, and they brought him fine presents and letters, in which he said that he put his entire kingdom at the disposal of the king of France. And Saint Louis received his envoys with great honours. The king of Armenia asked that he should send to the prince of Antioch[590] to ask that he make peace with the king of Armenia; in respect of the dispute between them, he would put his faith in the king of France and was happy to except his verdict in the matter. Saint Louis wrote to the prince of Antioch, saying that it was a bad thing and dishonourable to allow dissension between Christian princes who should all be of one and the same will and wrote amongst other words the following: "We beg that you cease to make war against the king of Armenia, who is of our faith and belief, and, if he has caused damage in your territory, that will be compensated by ourselves and our advice." The prince of Antioch, for the reverence and love in which he held King Louis, agreed to make peace on condition that the king lent him five hundred crossbowmen to safeguard his territory against the Turks, who had so often attacked and afflicted it.

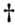

Chapter LXXV.
Of the quarrel that arose between the viscount of Châteaudun and his sailors. Of the spies who attempted to poison the king. How he set sail for Damietta and was forced back by the weather. How he returned and landed before Damietta and found it defenceless because it had been abandoned by its citizens out of fear of Saint Louis.

The men of the viscount of Châteaudun, soon after the departure of the envoys of the king of Armenia, quarrelled fiercely with the sailors who were to take the army over the sea, and Saint Louis was forced to send four thousand well-armed men in all haste to enforce the peace and separate the combatants. Before he could do this, there were many wounded and dead, and amongst the dead were the two chief Genoese. The viscount, knowing that his men were at fault, took counsel with the count of Montfort, thinking to cross to Outremer in haste with all his knights, but the count advised that he should not do this without the king's permission. And when the king heard of this, he commanded him that he should not be so bold as thus to cross over to Outremer and that if he did he might cause the disintegration of the army and thus

prevent the Holy Journey. On which account, he would himself settle the dispute and wished that both parties should refer the matter to the cardinals. The Genoese were content to do so for love of the king and promised on bail of two thousand marks to do whatever the king's court ordered. When they had reached an agreement, the king sent to Acre and other coastal cities in order to have ships in which he and his men and their equipment should cross to the further shore.

But his envoys could obtain nothing at this juncture because of the excessive enmity prevailing between the Genoese and the Pisans,[591] in the course of which the master of the Genoese had been killed with a spear. And there was also an open quarrel between the magistrates of Cyprus and the Venetians.[592]

Soon after the return of his envoys, the king sent new envoys, the patriarch of Jerusalem, the bishop of Soissons and the constable of France, and ordered them to make a lasting peace between the Genoese and the Pisans. And while they set out for Acre to seek shipping, the king had many small boats made so that they might easily land when they reached the Egyptian coast. On the very day when they began building these, two spies were captured who confessed that the sultan of Egypt had sent them to poison the king and all his army, their intent being to put the venom in the provisions that were to be loaded onto the ships. Within two months, the king's envoys had done their job so well that they found good and well-equipped ships, which they sent to the king. The king and the barons were overjoyed at this, for they were distressed at having to spend so long on the island of Cyprus. And therefore, the barons and other pilgrims assembled after over-wintering on the island and embarked on the ships and when the king and the army were abroad, he ordered the captains to steer their ships as directly as possible to Damietta in Egypt, and this they did. Thus, they set sail and recommending themselves one and all, Our Lord Jesus Christ, they left Cyprus in the year 1249. But when the ships were on the high seas, the wind turned against them and drove them back to Cyprus, off the city of Poisses. There they remained only some three hours because the winds declined and they again put out to sea, only to find that the wind again turned against them and drove them back to the port of Limassol, whence they had set out that same day.

Just then the prince of Morea[593] arrived in Limassol to come to the aid of the king and bring succour to the Holy Land and they all assembled together with the duke of Burgundy,[594] who had passed the winter in Rome. They were forced to spend the rest of the day waiting one for another as their ships had been scattered over the sea by the strength of the wind. And the following morning, with the winds now favourable, the captains and sailors unfurled their sails and put to sea. Thus, Saint Louis and

those of his army left the port of Limassol in Cyprus on the very day of the Holy Trinity[595] and had such favourable winds that the following Friday they could see the Egyptian coast. Choosing the city of Damietta, they went to it as directly as they could and, there, hastening to land, they maintained a close formation on the Nile, which flows into the sea close by and whose source is said to lie in the earthly paradise.

The Saracens in Damietta, seeing the Christian army close before them, quickly went aboard ships, galleys and other boats to attack them. For which reason Saint Louis, having taken counsel with his princes, barons, captains, knights and other men familiar with maritime battles, held his men at battle stations till the morrow. And as soon as dawn broke, they landed despite the Saracens, disembarking on an island close by, where the king of Jerusalem had also landed when he had laid siege to Damietta. And when the princes, barons, knights and other men-at-arms were all well armed, they went on board galleys and boats in order to capture the port more easily, and made as quickly as they could for land. Saint Louis was in a small galley and with him the cardinal, who held a piece of the Holy Cross and, in another little galley, which went before the king, was the flag of Saint Denis and the king's brothers surrounded many knights, sergeants-at-arms and crossbowmen.

As soon as they came close to land, all these with all speed and bravery flung themselves upon their enemies, who awaited them in multitudes on the bank and were firing arrows and throwing spears and darts of all kinds in great showers. And when the Christians came to the bank, they thrust and struck at them with spears and other arms. But despite all these defences, our men by the aid of Our Lord gathered and so massed together that they forced the Saracens to fall back and flee and very many of them were killed, with a number of their great lords amongst them, including the apostate of Damietta and two captains with a great number of foot soldiers. The sultan of Egypt was not present at this defeat; being ill, he remained a mile from Damietta with the part of his army that he had brought from the region of Damascus.

After this victory, our men blocked the Nile on the seaward side and thus captured those of the galleys and other boats of the Saracens that they could reach while the Saracens who fled did so upstream against the current of the river. Then the king and the princes, apprised of the flight of the Saracens, had their tents and pavilions erected on the bank and rested that night and all of Sunday, praising Our Lord. And it was ordered that the horses should be disembarked and join the army and that the equipment and provisions should be unloaded. The fact that our men were making camp so terrified the Saracens of Damietta that, when night came, they stealthily left their city, setting fire to

LOUIS IX LEAVING DAMIETTA.
CAMP OF LOUIS IX BEFORE MANSOURAH

*"To which the king replied with steady heart:
'You may kill my body but not my soul.'"*

(FOL. 240VA)

Although the Ayyubid rulers offered to return Jerusalem and Ascalon, Louis IX refused to negotiate with the Muslims. Instead, he decided to march on Cairo. The image in the upper register shows him leaving the fortress of Damietta with his troops in November 1249 and setting off for the interior. The foot soldiers, followed by the cavalry, are shown drawn up in serried ranks, moving forward in perfect order, while the king is on horseback in the centre of his troops. Before Mansourah, the hostile troops lay facing each other for six weeks on either side of the Bahr as-Saghir, a branch of the Nile. This is the situation depicted in the lower register, where the fortress of Mansourah can be seen in the background. Finally, in February, the crusaders succeeded in storming the Saracen camp on the other side of the river.

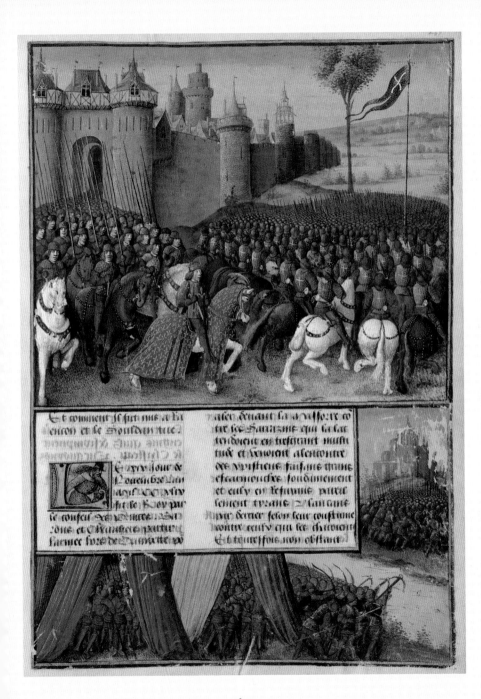

it as they went. When certain of the French saw this, they hastened towards Damietta and entered it by a pontoon bridge that the Saracens had not had time to destroy and scouting through the city made sure that the Saracens had, indeed, fled. They made this known to the king and he had all his provisions and equipment brought into the city and had the tents and pavilions brought up closer to the walls. And though the Saracens had taken with them many of their goods and equipment and the fire had damaged a great quantity of what was left, our men nevertheless found a good deal in the city.

Damietta was for almost all its circuit fortified with very strong walls and also by the Nile that flowed all around it. The king had the city emptied of all the corpses and cleaned. Then the papal legate, the patriarch of Jerusalem and the other bishops and prelates and all the clergy, barefoot, and the king, too, and the whole army, entered it in procession, singing the praise of Our Lord. The legate went first to the house of the Temple of Mohammed, throwing out of it all the graven images that he found there and rededicated it to Our Lady.

These things having been done, the king remained all summer in Damietta, waiting for the waters of the Nile to abate, for this was the season in which it was so high that it covered almost all the land. And while they were thus staying in Damietta, the Christian army left France and set sail on the feast of Saint John the Baptist of the year 1249.[596] One of Saint Louis's brothers, named Alfonso, count of Poitou, with his wife and many nobles and a great number of Frenchmen some days later landed at Damietta, where he was received with great joy by the king and all the prelates, barons of France and other Christians of various nations who were there, awaiting his arrival in order to advance further into the land usurped by the Saracens.

✝

Chapter LXXVI.
How Saint Louis led his army out of Damietta towards Mansourah. Of the count of Artois, who took part of the army across the Bahr as-Sagir river and, by disobeying the orders of his brother, was defeated and so perished. How Saint Louis was captured and his army defeated at Damietta. And how he was ransomed and the sultan killed.

The nineteenth day of November in the year 1249,[597] following the counsel of his princes, barons and knights, the king ordered the army to leave Damietta to lay siege

to Mansourah[598] in the teeth of the great multitude of Saracens who awaited the Christians making sudden attacks and as suddenly retreating, shooting arrows and throwing spears over their shoulders as was their custom when pursued. Yet despite this shower of arrows, the Christians killed great numbers of them and by dint of such skirmishes they came before Mansourah, which was then a small castle whose walls they could not reach because the Bahr as-Sagir river lay between them and the castle; it flows into the Nile close by. So they set up their tents and pavilions between the two rivers, taking up all the space between their banks.

There news came to them that the sultan of Egypt[599] who had set out to oppose them at Damietta was dead, but that while he still lived he had sent for his son from the eastern marches with a great host of men and, since he could not reach Egypt in time, his father had made his emirs and knights swear that on the arrival of his son, they would treat him as the true sultan and do him homage and fealty and obey him as their true lord.[600] And so that his army should not lack a commander, he had entrusted it to an emir called Fakhr ad-Din,[601] so that his son should find it whole and entire on his arrival.

Therefore, when King Louis was warned that the son of the sultan was close by with his host, he did all that he might to hasten the advance and the construction of siege-machines to take Mansourah before the son's arrival and the French, consequently, killed a great number of Saracens, but they could not take the stronghold because the Bahr as-Sagir river lay between them and it. The king, therefore, began building a road and pontoon bridge over the river so that his whole army could cross and reach the walls. To defend the labourers, he had a wooden castle built at the foot of the road. But when the Saracens saw this, they sallied out in such great numbers and hurled so many different projectiles that they broke up the castle. So our men could not cross over and were left in great perplexity.

Now it happened that in the Christian host there was a Saracen prisoner who told certain of the princes and the king that they could cross by a way that he showed them quite close to the roadway and pontoon bridge, which was being continuously broken up by the force of the current and the assault of the Saracens whenever it reached the middle of the river. And therefore, the king, on the advice of his princes, barons, knights and captains, ordered that his own brother, Robert of Artois, should cross over at the head of the vanguard, along with several others amongst the best mounted, as quickly as they could and, when they had reached the other side, should stay on the bank. And he commanded that they should on no account whatever leave the further bank till the king and all the rest of the Christian army had crossed over and joined them. This

Count Robert did as ordered and on the day of Lent on the year aforesaid, 1249,[602] he and the entire vanguard crossed over the river Tanis very secretly, via the ford that the Saracen had shown them, though they were still in danger of drowning, for the banks were soft and full of mud and slime and the river was very deep and wide and its current strong. The count of Artois, who was a man of great daring, seeing that he had the choicest part of the army, ordered that his men should march on and advance rapidly along the bank till they came to the Saracens guarding the road and the machines that they had constructed to oppose our own, these being the machines with which they had smashed the bridge of boats laid end to end across the river so that the Christian army could cross.

The master of the Temple had been appointed to go with Robert as his adviser and a man who knew the country and when he heard this, he argued against it as strongly as he might, showing amongst other things that the water that they had just crossed made a very perilous ford and that the king with the main army was still on the other side and had forbidden them to leave the bank till he and all his men had joined the vanguard. He also said that the countryside that they had reached was full of woods and valleys and they could not, therefore, estimate the strength and numbers of the Saracens, though they knew that the Saracens had sent out to countries near and far in quest of help. And it was, therefore, to be feared that the count and those that he led would come to harm if he conducted the rest of the vanguard away from the bank once they had crossed.

The count of Artois was a young knight and full of ardour, as is usual with the French, and hearing the reproaches of the master of the Temple, he was furious and followed the advice of certain men and especially the highest ranking, who wish only to hear what they like. And so they brought about their own loss, for they were like the proud sons of Israel, who once, when Moses he rebuked their obstinacy, were unwilling to hear good advice and replied: "Say things that are pleasing to our ears and we shall hear!" The prince replied with a terrible reproach: "There is always treachery in the Templars! Follow me, those who will!" And having spoken, he marched his army forward in all speed and against the will and desire of the master of the Temple, who had given him good advice. But he dared not issue a counter-order knowing that Count Robert had been made commander over him by the king and over the vanguard as a whole. So it came about that the count and his men made such speed that within a few hours they had reached the king's road, where the Saracens had constructed their machines to destroy the roadway, and surprised those who were there. For they were so terrified when they

saw Robert and his men descending upon them, never having heard that there was a ford in that place, that they abandoned their siege-machines. Indeed, Fakhr ad-Din and the other leaders, some of whom were still in bed, hearing the noise and seeing that our men had crossed the river and were unexpectedly bearing down on them, abandoned their tents and their riches and sought only to save their lives in flight. Our men, thinking that the enemy was routed, were so blinded by this that they began a headlong chase of the Saracens, breaking up into groups in disorder and without maintaining formation, some seeking plunder and others in pursuit of the enemy and widely dispersed.

Now the master of the Temple warned them that they had done enough and though it had all turned out better than he had expected, they should remain in close formation to face all possible dangers until the king should arrive. But they would not hear or believe him and thus went to their own destruction. For after they had wrought great execution on the Saracens and Fakhr ad-Din had been killed, the other Saracens, having retreated into Mansourah and there realised the disarray into which our men had fallen and seeing how they pursued the enemy madly, dispersed through the valleys of a region with which they were not familiar, they all assembled and with a single will began to advance on those who were pillaging the tents. The plunderers were almost all in short order killed or captured like men who were blind to the danger that threat-ened them, being in the midst of their enemies and far from their friends. Yet they raised their spirits a little and preferred to sell their lives dearly and avenge their own deaths. And they succeeded in linking up with those who were still pursuing the enemy, who, hearing the noise and cries, returned so that they could assist one another.

Nevertheless, they could not so well defend themselves, and the Saracens killed a great number and surrounded and pressed them and, in short, came close to killing them all, which they would certainly have done if the grace of Our Lord had not kept them safe and brought them help. For Saint Louis, who with the rest of the army formed the rearguard, had not hastened to cross, believing that the count of Artois, his brother, with the vanguard, was still on the further bank and awaiting him as he had ordered. And he was astonished when, having crossed, he found the vanguard was no longer there and was deeply alarmed, not knowing what had happened to it. Therefore, he had his army advance as quickly as it could. But he had not gone far before he was informed of the bad news by messengers sent by the count and barons when they were ambushed, who begged him to hasten forward with the rearguard in order to rescue them.

Ah, do not ask what pain he and the other Christians suffered and the grieving that they would have done had it not been for the great need in which their compan-

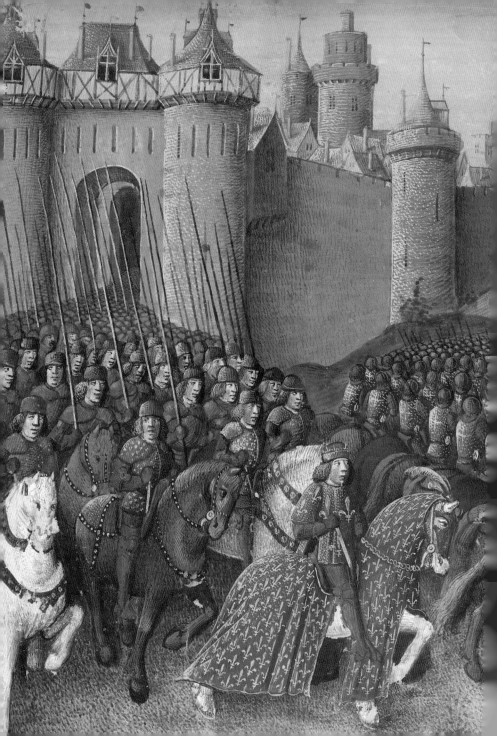

ions stood! Therefore, abandoning all other matters, the king ordered the cavalry to go forward with all speed and to contain the enemy till the foot soldiers could be brought up. But, in short, Count Robert was unable to join forces with those under his command who were, as we said, surrounded and hard-pressed by the Saracens. And he and a knight of the Temple sought to save their lives by retreating into the stronghold of Mansourah, as they had seen that the gates were open, but there he was immediately killed or captured and led away to a place whence nothing more was ever heard of him. And if the consequences of his presumption had fallen only on him, as he deserved, then mourning over his misfortune might have been short-lived. But alas, his pride was avenged not only on him, for it cost every pilgrim dear enough. And the vanguard in especial, for they were almost all captured or killed, with the exception of a small group, which, though still surrounded, after enduring and resisting many assaults and the showers of spears and arrows that fell on them as thick as rain from the Saracens, at last won the victory and, thanks to their crossbowmen, drove the Saracens from the field somewhat after nones.

Then they retreated and the king and the Christians spent the rest of the day and night that followed in their tents and pavilions near the Saracen equipment that they had captured. And when morning came, they made a wooden bridge so that they could bring across those who had remained on the far side of the Bahr as-Sagir river. When all these had crossed, they put up their tents around the king and from the Saracen siege-machines they made palisades and fences to ensure their safety.

Now the news spread throughout the land that the men of Mansourah were besieged by the Christians and from near and far great troops of Saracens began to come up. They assembled and charged, attacked and shot at the Christians, coming right up to the palisades of our men and screeching and making a terrifying noise with their drums. But the princes, barons and other knights and many others of various estates sallied out and charged into them so boldly that, having killed a great number of them and notably their greatest and most renowned lords, they forced the others to flee for their lives and in this way our men gained a little peace, though it was of short duration.

For soon after, there came to Mansourah a great multitude of Saracens with the son of the late sultan.[603] On his arrival, the men of Mansourah sounded horns and trumpets and drums and received him with great joy and honour as their lord. Alas, it grieves me to tell! The Saracen army having been thus increased by so great a number of men and still growing hourly as it was reinforced by new companies of pagans,

the strength and courage of our own men began to wane in equal measure. The death toll was so great not merely amongst men but also amongst horses and other animals that there were few who could still serve. And in addition to this grave pestilence, they experienced severe famine, to the point that many were dying of hunger since ships could not come up the river or carry anything to Damietta, because of the Saracens who sailed out to meet them; amongst the boats that they captured, two were bringing a great quantity of provisions and other goods. The Saracens killed everyone in the boats with the result that provisions for the men and provender for the animals were suddenly cut off. Now the king seeing that courage of many of his princes, barons and knights was failing and that they were afraid, held a secret council, after which he raised the siege of Mansourah[604] and began to return to Damietta, both in order to guard the city and to provide his army with greater security against the various pestilences[605] that were raging amongst the pilgrims.

But when the Saracens saw that the king was raising his siege and was already on the road to Damietta, they armed themselves, and all those who could bear arms sallied forth and attacked the Christians, ordering and bruiting through the land that everyone, great and small, should follow them and climb as quickly as possible to the mountains, passes and narrow places and from there shower spears and stones and arrows down on the Christians with all their might so that, closely pressed, they would fail to reach safety in Damietta. And shortly thereafter, all the mountains and passes by which our men were surrounded were covered in pagans and Saracens beating great drums and giving such terrible screams that it was terrifying to hear them and from the high ground firing down on the Christians in the valleys below innumerable darts, arrows, stones and javelins in such number that the Christians' shields were thick with them and the bodies and limbs of most of them pierced and wounded. Despite this the bold French defended themselves steadfastly and with great courage, forcing their way forward by force of arms till they came close to Damietta. Then, seeing that the French had little further before they were safe, the Saracens attacked the Christian army in so great a multitude and with such impetus that our men, who had till then kept close order, could bear it no longer, being for the most part ill and half dead from hunger, and were forced to disperse hither and thither in an attempt to save their lives and were, nevertheless, almost all captured and a great number of them killed; this despite all kinds of resistance, courage and boldness shown by the French that day.

One man in particular acquired a sovereign reputation for honour and valour. William of Le Bourg-La-Reine was the king's sergeant-at-arms and brandished a mace

with which he did such great execution on the Saracens attempting to approach the king that all the others were amazed. Yet he could not have escaped death unless by miracle because of the great multitude of the enemy. The king, seeing his courage and afraid that he might lose so renowned a man, cried out to him as loudly as ever he might (for he was very ill) that he should no longer defend himself but surrender and he would save his life. The capture of this man marked the end of this very painful and bitter defeat, which occurred almost without a battle having been fought, for the Christians were almost all killed or captured, having no space to set out their troops in defensive formations, but were captured as men surrounded and who had no hope of escape unless it were by crossing the river. And even those who did flee by river found little or no safety, for they were all taken by the Saracens, who killed all the sick men in the galleys, some of whom they dismembered while they were still alive, limb by limb.

Our Lord looking down with pity upon his people did not permit King Louis to be killed. But ill as he was, so ill that he could not stand, and his men taken or killed and all their wealth lost, he was carried in arms to Mansourah surrounded by a multitude of Saracens. Only the cardinal and his men escaped entirely unscathed since they had left a little in advance while all those who had been at Mansourah could find no place of refuge, but were captured or killed.[606]

When the hour of vespers came and the king asked for his prayer book to say vespers as was his custom, he could not find it for it had been lost with the rest of the equipment and he was very sad, but while he was thinking despondently that he would be unable to say his hours, the book was miraculously brought to him as can be read in the story of his glorious life.

Let me not long dwell on the baseness, spitting and trampling underfoot that the Christians (and the remains of the True Cross) had to suffer from the Saracens after this defeat and how those whom the Saracens made prisoners they flung into prison and treated with the utmost cruelty. It is enough to remember the many similar cases that I have described. However, Our Lord did not permit that the good King Louis be mistreated, on the contrary because he was so ill[607] that his men rather expected his death than his survival, he inspired such pity in the heart of the sultan[608] that he sent him his own doctors and had him guarded and cared for and generously supplied with anything that he wanted. And as soon as he knew him to be cured, he made him by threats and harsh words request peace or long truces. And this was agreed between them on condition that Damietta was restored to the sultan along with everything that

the Christians had found there and that the king would pay eight thousand bezants of Saracen[609] gold for the harm inflicted on the sultan and for the expenses that he and his men had incurred from the day when Damietta had been captured; also that the king would freely deliver all the Saracens that had been captured in Egypt since the time when the emperor Frederick had been there. And they would swear to observe the truce for ten years. And subject to these agreements, King Louis was to be delivered from prison, but was to hand over hostages for the ransom as soon as he had surrendered Damietta. And the sultan would do the same freely and without ransom for all the other Christians of whatsoever nation who had been captured and remained prisoners in Egypt since the emperor Frederick had come there, while the old sultan[610] was still reigning, the grandfather of the sultan by whom Saint Louis was captured.

Moreover, all the chattels that the king and all his princes, barons and other pilgrims had left in Damietta would be restored to them unharmed and they would be kept safe by the sultan till the king had the time and power to have them taken to security in Christian lands. And all the sick pilgrims and others who remained at Damietta to recover their goods or because of their illness could leave without impediment by land or sea whenever they chose, and the sultan would give them a safe conduct to Christian territory. And with this it was agreed and promised by the sultan that all the territories that the Christians held in the kingdom of Jerusalem, they should be allowed to retain in peace.

When these agreements were concluded and on the very day on which they were sworn, there came a number of leaders to the tent of the sultan around terce[611] who, by the counsel and consent of most of the other emirs of the army, killed him and cut him to pieces[612] out of anger that he had made peace and a treaty with Saint Louis without referring the matter to them. And, having done this deed, with their knives yet dripping with the blood of the sultan, they came at that same hour to the tent of the king and placed them against his throat and against his ribs and feigned and threatened to kill him and his princes and barons, too, if he did not surrender Damietta and if he did not promise to perform whatever he had promised to the sultan that they had just killed. Amongst them there was one named Julian, who came before the king with his sword drawn and demanded that he knight him. The king was happy to do this on condition that this man became a Christian and he offered to give him more land and wealth than he had in Egypt, but Julian refused to convert and so Saint Louis would not make him a knight.

Thus things went their course and the treaties were again agreed and, to make them still more irrevocable, the emirs wanted the king to put in writing that he would renounce God, the son of the Virgin, if he did not keep his promise and they would put in theirs that they would renounce Mohammed and all his power if they did anything in breach of their agreements. But whatever the emirs said and whatever threats they made, the king refused to make this promise, for which one of the emirs said to him in great anger: "We wonder that you, knowing that you are our slave and prisoner, dare speak so boldly! Know that, if you do not agree to this promise, I shall kill you forthwith!" To which the king replied with steady heart: "You may kill my body but not my soul". Faced with such constancy, the Saracens left him in peace and the treaties first made with the sultan were concluded and sworn and a day was fixed when the prisoners would be released and Damietta surrendered.

And the king was undoubtedly very reluctant to surrender Damietta, but it was demonstrated to him by those who knew that it could not long hold out. On the day specified, Damietta was surrendered[613] to the emirs, who freed the king and his brothers and the barons and knights and other men from France, Jerusalem, Cyprus and all the other nations only excepting a number that the Saracens continued to detain because they were in very distant prisons.

And a few days later, Saint Louis left Egypt, taking with him his brothers and the princes, barons, knights and as many pilgrims as he could. Nevertheless, there remained behind more than twelve thousand men because no ships could then be found or because of the illnesses by which many were afflicted. The king left certain of his men behind expressly to recover the remainder of the prisoners from distant prisons and to safeguard the goods that he could not then take with him. And when he reached Acre, he immediately sent a group of his men to bring back the prisoners still in the hands of the Saracens, but the emirs long procrastinated with honeyed words, saying that they had first to assemble a council. And finally, after the king's envoys had long been abused in Egypt, the emirs delivered to them a mere three thousand of the twelve thousand who had remained behind, while some of the nine thousand thus detained were given a cruel death and most of the remainder preferred to renounce their faith rather than suffer martyrdom.

When Saint Louis heard the truth of this matter, he was unspeakably distressed and though he had, believing that the Saracen emirs would keep their word, prepared his ship to return to France, he summoned a council of all his princes, barons and knights to find out what should be done. There it was concluded that he should certainly

The Master of Hungary speaking to the shepherds
before being received in Amiens by the religious authorities

*"The magician came to Picardy and there threw into the air a magic
powder and, making sacrifice to the Devil, went through the fields seeking out
the shepherds and cowherds and others and making them believe by his
honeyed words that he was a man of God and the shepherds must, according
to a prophetic vision that he said that he had had, recover the Holy Land."*

(FOL. 241VB–242A)

Sébastien Mamerot devotes an entire chapter to the story of the extraordinary adventure that took place after the crusade led by Louis IX suffered a serious defeat and when the king had remained in Egypt, although he had been freed. All these events aroused great emotion in France. A mass movement known as the "*pastoureaux*" grew up in northern France under the leadership of a monk, possibly a Cistercian, known as the "Master of Hungary": Mamerot portrays him as a Greek magician. He claimed that the Virgin Mary had appeared to him in a vision and commanded him to recapture Jerusalem. This movement, also known as the "Shepherds' Crusade" because it was mainly joined by humble folk, travelled about the country, holding assemblies at which the Pope and the clergy were accused of inaction, and vowing to rescue the king. In the lower register, Jean Colombe depicts James of Hungary with the features of a prophet, with a pale face and a long, grey beard; he is exhorting some shepherds sitting on the ground, with their sheep grazing peacefully alongside, to follow him in order to rescue Jerusalem. In the upper picture, the Master of Hungary can be seen at the head of his army of peasants before the gates of Amiens, being solemnly received by the religious authorities of the city who initially believed his words and in his mission.

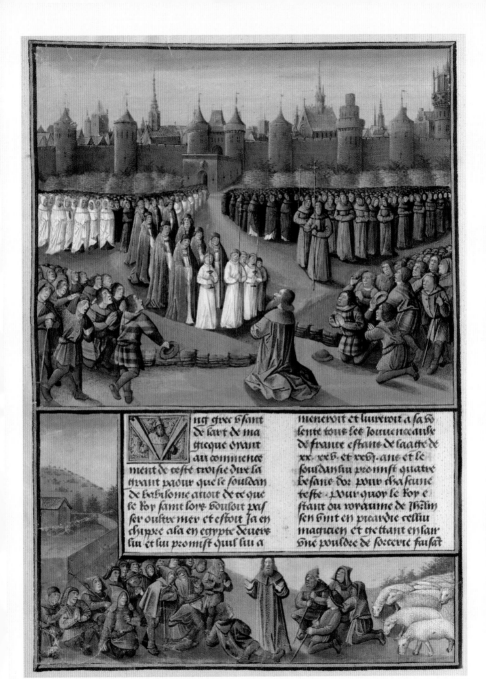

ung grec vsant
de lart de ma
gicque oyant
au commence
ment de ceste croise dire la
grant paour que le souldan
de babilone auoit de ce que
le roy saint loys vouloit pas
ser oultre mer et estoit ia en
chippre ala en egypte deuers
lui et lui promist quil lui a
meneroit et liureroit a sa vo
lente tous les ioueneceaulx
de france estans de laage de
xx. xxv. et xxvi. ans et le
souldan sin promist quatre
besans dor pour chascune
teste pour quoy le roy e
stant ou royaume de thilin
sen vint en picardie cestui
magicien et gettant en sar
ne pouldre de sorcerie faisat

not leave the Holy Land, which would be in greater peril if he left than it was before he arrived, while the prisoners would be deprived of their last hope and would all consider themselves lost. Whereas if he stayed, it might do great things for the Holy Land, more especially because of the discord between the Egyptians and the sultan of Aleppo,[614] who had already taken Damascus and several other castles that were formerly under the sovereignty of Egypt. And Saint Louis, the king, accepted this conclusion, preferring pains and travails for the profit of the Christians of Outremer rather than return to his kingdom, where he might live a life of leisure and ease. So he sent his brother, Count Alfonso, back to France to safeguard the kingdom, with Queen Blanche, their mother, and they, in their wisdom, kept it safe.[615]

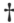

Chapter LXXVII.
Of the mad uprising of the shepherds and how it was suppressed. Of the cities that the king had fortified and strengthened in the Holy Land. How he visited the Holy Places. Of his great charity and his reasons for returning to France. And the great peril from which he and his men were saved at sea thanks to his prayers.

A Greek who practised magic[616] had, at the beginning of the crusade, heard that the sultan was very worried that Saint Louis sought to come to Outremer and was, indeed, already in Cyprus.[617] He went to the sultan and promised him that he would bring and deliver to him the young men of France aged twenty, twenty-five and twenty-six. And the sultan promised him four gold bezants for every head. While the king was in the kingdom of Jerusalem, the magician came to Picardy and there threw into the air a magic powder and, making sacrifice to the Devil, went through the fields seeking out the shepherds and cowherds and others and making them believe by his honeyed words that he was a man of God and the shepherds must, according to a prophetic vision that he said that he had had, recover the Holy Land. He so ardently and successfully yoked them to his own will that as soon as they heard his preaching and holy exhortations, believing him to be a holy man, they left their beasts in the fields and began to follow him wherever he went and to obey him as the envoy of Our Lord. And in less than eight days, he had more than thirty thousand followers, whom he led to the city of Amiens.

There the citizens, joyfully greeting this muster, went in procession to meet them and received the magician and his men with great honour and festivities and gave up to them their homes and goods. Because the magician was a thin man with a pale countenance and a large beard, they believed him to be a man of great austerity. From Amiens they set out again through the fields and, with the number of his men growing daily, the magician became so presumptuous, seeing himself thus accompanied, that he began to preach and declare that he had the power to absolve all sins and could undo and remake marriages as he liked. And because the priests and clerics contradicted his claim and his declarations, showing that they were untrue, he commanded his men to kill all the priests and clerics that they encountered. And it is not surprising that the people of Amiens and Picardy, who are people of little courage, though good Christians, were so easily deceived; for so were the Parisians, and even Queen Blanche, the mother of Saint Louis. She believed that they had thus assembled to go to the aid of her son and summoned the magician before her and, taken in by his words, did him great honour and bestowed gifts on him and ordered that he should be given free rein and not contradicted. And so, going from bad to worse, he became so proud that he donned pontifical robes and dressed like a bishop with crosier and mitre and in this guise preached and had himself accommodated in the church of Saint Eustace in Paris.

And, in short, the shepherds spread out through Paris and killed all the clerics they found so that it was necessary to close the gates of the Petit Pont for fear that they would kill the students.[618] And having thus stirred up Paris, he left the city with great treasures and because there was no town that could accommodate all his men, who were now more than nine thousand in number, he sent part of them to Bourges, ordering them to pillage and do there all the sinful things that they had done before, and then to set out for the port of Marseilles. He, meanwhile, set out with the other part of his shepherds, on the way practising all kinds of theft and acts of cruelty and deflowering virgins and raping married women. And when the clerics and priests of Bourges were apprised of the doings of the shepherds and that they would pass through their city, they informed the authorities of their crimes. Therefore, the magistrate and others secretly took precautions in fear of what the shepherds might do. And the latter, seeing that they were feasted and honoured in Bourges, went in search of priests and clerics. But when they saw that they could not attack them, they began to break into money chests and rape virgins and married women and impose their rule on the citizens. When the authorities learned of this, they brought forth their armed men, who captured the main masters and leaders of the shepherds; these confessed their crimes and were

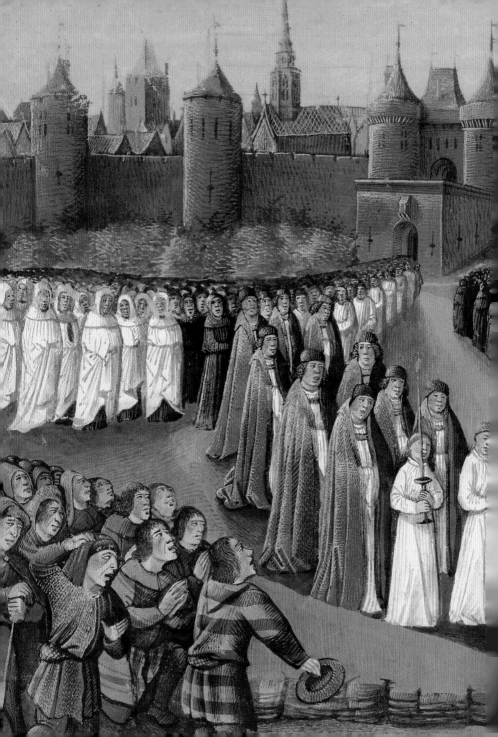

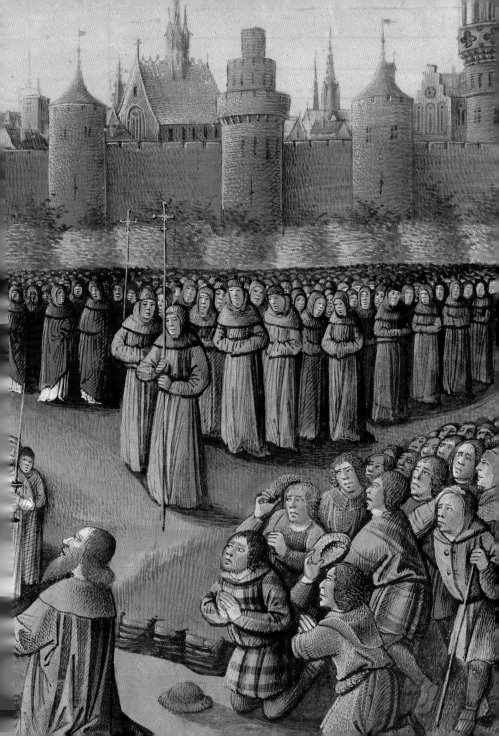

hanged for them while the remainder fled the city. And the magistrate of Bourges sent messengers with all speed to the magistrate Viguier of Marseilles, telling him of the shepherds' wrongdoing and Viguier captured the magician and, after he had confessed his treachery, had him hanged from a high gallows; and the remaining shepherds returned poor, naked and ashamed to their homes. And so this revolt of the shepherds was suppressed and brought to nothing in the year 1251.

The following year, 1252, saw the death of Queen Blanche, the mother of Saint Louis; he was still in the kingdom of Jerusalem, where he fortified and reinforced several cities, towns and castles at his own expense. The Saracens, knowing the great losses that he had suffered and that his country was far away from the kingdom of Jerusalem, were astonished that he was willing to undertake building works at such great expense, as was required to govern his army so far from his own land, and they began to love, praise and respect him and bear him honour, reverence and great signs of love.

And amongst the other buildings he had erected in Syria, he had the cities of Acre, Jaffa, Caesarea, Sidon and the castle of Haifa enclosed with good, high walls so that they could easily hold off the attacks of their enemies. These things done, he went to visit the Holy Land and arrived on the feast of Our Lady in March wearing a hair-shirt. He left from a castle in Galilee named Phere, where Our Lord changed the water into wine, then he came to Nazareth, where he was fed. And as soon as he could see the city, he dismounted and went on foot to the church of Our Lady and fasted, eating only bread and water all of that day, though he was greatly fatigued by the length of the journey. And thence, having had vespers sung and the following day matins and masses solemnly performed, he returned to the castle of Jaffa and stayed there for a short time while the queen, his wife, gave birth to a daughter who was named Blanche. And there he heard the news that his mother, Queen Blanche, had died, for which he long wept and made devout prayers for her soul and also had the divine service performed with great solemnity and caused masses and services to be said for her every day.

After these solemn commemorations, it happened that the Saracens from around Banyas made a sudden attack on the city of Sidon, where there were four hundred labourers that the king had set to work enclosing the city within walls and fortifying it; they were all killed and not one escaped, for they had never imagined that they were in danger. At this the king sent his entire army before the city of Banyas and had the territory around it burned and devastated. Then he returned to bury the Christians thus killed at Sidon and had the legate bless and dedicate the place where he had ordered that they should be buried. And because no one dared touch them, owing to the stench

that came from them, he took them in his hands and said: "Let us bury the bodies of these blessed martyrs who are worth more than we are and who deserve eternal life for the martyrdom that they have received". And he began to place them in the ground. At which his men were ashamed and did his bidding.

When the king returned from Sidon, there came envoys from France who announced that his people begged him in tears and lamentations that he might soon return to safeguard his kingdom, for the English were making great preparations, hoping to attack and capture Normandy. And on this account he took counsel with the wisest heads of his army, who all concluded as one man that the best thing for him was to return to France. And he agreed to do this, but before his departure, he left the cardinal legate with a great number of knights and other men-at-arms to keep and defend the territory of Outremer. And as his commander he appointed his lieutenant, a very valiant knight called Geoffrey of Sargines,[619] and ordered that he should be obeyed as though the king himself were present. And the valiant knight who accepted this charge was most energetic in the defence of the lands committed to him. And when the king had arranged all the needs of the country and his ship and galleys were all in readiness, he went aboard[620] accompanied by great processions and the tears of the inhabitants loudly calling out to him: "Oh, father of Christianity! Those amongst whom you leave us hate us even unto death! Alas, while you were still with us, we feared no evil! And even should we die, it was a comfort to us to die in your presence!" The king was filled with pity for them and, comforting them as best he could, he recommended them to the keeping of Our Lord and went on board his ship. And by a special dispensation from the cardinal legate, he had placed in the highest point of the boat in a very richly decorated place the precious body of Our Lord Jesus Christ, so that this excellent guardian might by his presence keep himself and his men safe and be seen by all who wished.

The sails were set and they had such favourable winds that they crossed over to Cyprus in less than three days. But they were in grave danger because the king's ship ran aground on a great sandbank with so great a noise that the mariners thought that it had split open and, in expectation of death, gave voice to great cries of lamentation, so that the king who heard them was greatly afraid. However, he again placed his hopes in God and, leaving the queen and the children all swooning, he went before the altar on which was the body of Our Lord and there, by his devout prayers, obtained what he needed. For the ship passed freely over the sandbank and the officers of the ship found that it had suffered no harm, for which they praised Our Lord, believing that

HENRY III OF ENGLAND PAYING HOMAGE TO LOUIS IX.
SIMON OF BRIE PREACHING THE EIGHTH CRUSADE

"Saint Louis, having thus returned to France, reformed his kingdom, restoring good customs and doing such justice that he was rightly called the father rather than the king of the French."

(FOL. 244VA)

After his return to France in 1254, Louis IX had to restore order to his kingdom and settle the conflict with the kings of England. The scene depicted by Jean Colombe shows King Henry III of England during a visit to the king of France, when he paid homage to King Louis on 4 December 1259. By this act, he acknowledged Louis as his suzerain in his French territories. The room in the palace is hung with tapestries covered in *fleurs-de-lis* and opens onto a smiling, verdant countryside. In the distance, on the far side of the river, can be seen the sprawling city of Paris surrounded by powerful defences. In the lower register, Cardinal Simon of Brie, the papal legate in France, is preaching the crusade before the king and an assembly of the faithful, and exhorting them to depart for Outremer to rescue the Holy Land.

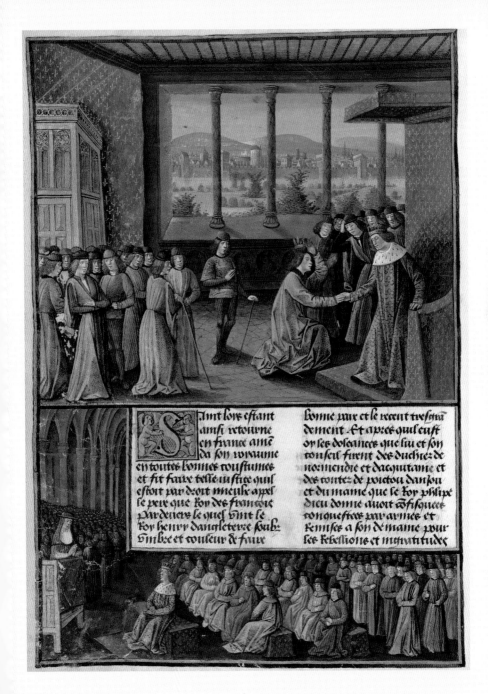

ant lors estant
ainsi retourne
en france amé
da son royaume
en toutes bonnes coustumes
et fit faire telle iustice quil
estoit par droit mieulx apel
le pere que les roy des francois
pardeuers le quel vint le
roy henry dangleterre souh
simbte et couleur de faire

bonne paix et le recent tresstu
dement Et apres quil euft
oy ses doleances que luy et son
conseil firent des duchies de
normendie et dacquitaine et
des contes de poitou danfou
et du mainne que le roy phlipe
dieu donne auoit coffisquees
conquestees par armee et
remises a son demainne pour
ses rebellions et ingratitude

he had saved them only out of respect for the good king Saint Louis, who gave humble thanks to God and had his ships steer directly for France. And, reaching France after eleven weeks at sea, he was welcomed with supreme joy and great celebrations, in the year 1264, six years after he had left.[621] And thus I, Sébastien Mamerot of Soissons, bring to an end the account of the expedition to Outremer made by the glorious king of France, Saint Louis.

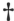

Chapter LXXVIII.
How Saint Louis undertook a second expedition to Outremer. Of those who took the cross with him. How he set sail and his fear that the captains of his vessels were disloyal. Their explanation, and how the king and his army landed in Africa before Carthage.

Saint Louis, having thus returned to France, reformed his kingdom, restoring good customs and doing such justice that he was rightly called the father rather than the king of the French. To him came King Henry of England[622] under colour of making peace and King Louis received him with great ceremony. And after he had heard the grievances that he and his council made concerning the duchies of Normandy and Aquitaine and the counties of Poitou, Anjou and Maine that King Philip Augustus had confiscated, conquered and added to the royal demesne because of the rebellions and ingratitude of the previous kings of England, it was clearly demonstrated by Saint Louis that the kings of England could never have any lawful claim to his territories. However, moved by pity, as a sign of pardon, he bestowed on King Henry Gascony and Agenais on condition that he and all subsequent kings of England became his vassals and did homage as liegemen to him and all the subsequent French kings as true subjects to them and the Crown of France and swore that they would always be good and loyal servants. And then King Henry made homage to Saint Louis for these two lands, which were recorded in the registers of France under the title of duchy of Aquitaine and peer of France; he promised and swore that he and his subjects would always be good and loyal subjects of King Louis and his successors as kings of France. And he renounced all right that he and his successors might have or demand in the duchies, counties and lands of Normandy, Aquitaine, Poitou, Anjou and Maine. And thus was a firm peace made between the two kings.[623]

After this peace had been made, Saint Louis founded many abbeys, hospitals and churches in various parts of France. Now his brother Charles, count of Anjou, attempted to conquer the kingdom of Sicily, which had been given to him by the Pope (it forms part of the inheritance of Saint Peter of Rome) and a number of fearful wars resulted, at the end of which peace reigned in the kingdom, though this did not quickly occur as the hostilities long continued.

Saint Louis had not forgotten his first vow and, aware that his first expedition had been of little assistance to the Christians in Outremer, he decided again to go to the help of the Holy Land by force of arms. The Pope, hearing of this holy intention, sent a legate to him in France, a cardinal of the order of Saint Cecilia.

On his arrival in France, the king held a general parliament in Paris to which came all the princes, barons, knights and most of the prelates of the kingdom. And when the cardinal had made a very notable sermon admonishing every good Christian of able body to take the cross and undertake the voyage to Outremer to bring succour to the Holy Land, the king first and foremost took the cross as did all his three sons, Philip, John and Peter, and after them a great number of barons, knights, squires and other nobles and persons of divers estates. Many other princes, barons and knights who were not present at the parliament also took the cross as soon as they heard that the king had done so. Amongst these were the king of Navarre (who was count of Champagne[624]) and Alfonso, count of Poitou (the king's brother), the count of Artois, the count of Flanders and the son of the duke of Brittany – all of whom agreed on a date when they would take ship together. But before the king left, he made his will and testament and entrusted the safeguard of his kingdom to Simon of Nesle and Matthew, abbot of Saint-Denis.

And in the month of May in the year 1269, the king went to the abbey of Saint-Denis and, having there made his orisons, he took the oriflamme, the scrip and the staff. Thence he went to the forest of Vincennes to visit the queen, his wife, from whom he there took his leave and set out for Outremer, passing through Cluny, where he spent four days before going directly to the port of Aigues Mortes. And because not all his men had yet assembled and Pentecost was approaching, he went to spend it at the abbey of Saint-Gilles, which many people mistakenly believe to be in Provence, whereas it is in Languedoc. While he was there, a great quarrel broke out at Aigues Mortes between the Catalans and the men of Provence. So great was the quarrel that, with the French helping the men of Provence, the Catalans were driven out to their ships after more than a hundred men had been killed, not to mention those who were

drowned, throwing themselves into the sea to seek refuge on board. When Saint Louis heard of this uprising, he went to Aigues Mortes on the very day of Pentecost, for the great lords had done very little to end the hostilities; there he ordered that the ringleaders be punished.

Shortly thereafter, the king set sail[625] with innumerable ships and vessels of all kinds loaded with men, provisions and armour. But the following Friday, a great storm blew up at sea around midnight and the king learned from the sailors that they were in what was known as the Lion Sea, which was so called for its indomitable spirit. When they had left this sea, they came to another part through which they sailed very peacefully till Sunday, when a terrible storm broke out during the day. The king, therefore, had four short masses performed: the mass of the Holy Spirit, that of Our Lady, that of the angels and that of the dead. And the storm ceased, but not before it had corrupted the water supplies of the ships and vessels to so great an extent that many men and horses died. Soon after, the king began to suspect the sailors because no port came in sight and they had said that they would reach the castle of Castre after so many days and he, therefore, had them assembled so that he could hear what they had to say. Some said that the son of William, one of the main captains, had taken leave of the others during the storm with a galley and had steered for Barbary.[626] But finally the king recognised that the captains and mariners were loyal.

After many pains and travails caused by the wind, which several times turned against them, the ships and galleys anchored close to the nearby the castle of Castre, having been unable to take refuge in the port. Now the king sent a boat to fetch new provisions, but the envoys of the king found the city so rebellious that they were barely willing to sell them water and wine and other provisions. It was later found out that the reason for this was their fear that the king sought to capture the city and pillage it and they had, consequently, removed to secret places most of their goods. In short, the king, realising that they were unhappy at his coming, sent one of his knights to beg the castellan that those of his army who were ill could be received and safeguarded in the town, which was not walled, and not in the citadel or castle, since they were reserved for the Pisans. And so the king had the sick carried onto land, many of whom died in the process, while the others, rich and poor alike, when they reached the gates of the town, were not allowed to enter even though there were fine houses to spare. On the contrary, they were confined to little shelters made of earth and mud in which were kept the goats and asses of the town. And there they were sold all kinds of provisions at ten times the price at which these were normally sold in the region and, indeed,

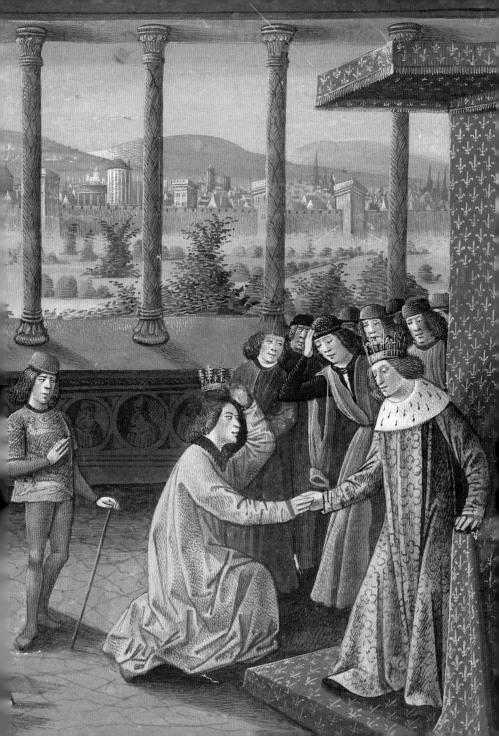

they were so expensive that they could barely afford any. What was more, the citizens refused to take the king's coin.

When the king was advised of their ill will, he sent his marshal to them to rebuke them and demand that they be more courteous to his men. They then replied rather out of fear than love that everything of theirs was at his disposal and that he should come to the castle and that they would receive him whenever he wished, but that he should bring no Genoese because they were at war with the Pisans. The marshal replied that their castle was of no interest whatever to the king and they should merely deal honourably with his men in their commerce and this would suffice. They promised to do this, but did nothing to honour their promises; some of the French were so angry at this that they begged the king to destroy the castle. But he refused; he had not, he said, left France in order to pit Christian against Christian.

Some days later, the other princes and Christian pilgrims who had left after him from the port of Aigues Mortes and that of Marseilles arrived and the king, seeing his men assembled around him, held council with his princes, barons, knights, ship-masters and captains to decide where he should lead his army. At last it was agreed that he would go to Tunis, which is a very great and rich city sited near or, indeed, on the territory where the renowned city of Carthage once stood. For the king of Tunis[627] had several times sent to the king saying that he would very gladly become a Christian, but must have the right occasion to do so, when the Saracens could not surprise him before he had put his plan into action. And now the inhabitants of Castre, seeing that the king wished to leave the port, presented him with twenty barrels of the best wine that they had, which he refused to take, having had it declared to them that they should be hospitable to the sick men of his army, which he would take as a great present in itself.

The king now leaving the port, he arrived on the feast of Saint Arnulf[628] near the port of Tunis, which lies below Carthage. There he sent his admiral to find out if anything in the port prevented them landing and to whom the ships in the port belonged. The admiral, entering the port, found two Saracen ships, both completely empty, while the rest belonged to Christian merchants. He captured all these ships and sent the master of the crossbowmen to tell the king and the barons this, but they did not dock their ships that night and were ill advised not to do so, for the Saracens, hearing of the Christians' arrival, assembled so quickly and in such a great multitude, both on foot and on horse, that the following morning the port was teeming with them. However, despite all the Saracens, the king's galley, in which there were men-at-arms in great

number, touched ground in the port and the men reached the shore. But they dared not advance further; once out of the port, they retreated to a little island some two miles long, where the mercenaries began to obtain fresh water. Some Saracens, hiding there and spying on them, observed this and charged down on them, killing ten men, and would have killed more had the mercenaries not been assisted by the French, who drove off the Saracens. When day came, our men perceived a tower close by and went to attack it, taking it by force and killing all whom they found there. It happened that certain Saracens who had been placed in the garrison of the tower and were now in flight came upon an emir who was hastening to their aid with a great number of men, whereupon they turned about and made a great charge with all the others against the French, who, seeing the multitude that they faced, themselves took refuge in the tower that they had just captured. There they were forthwith besieged by the Saracens, who would by means of fire have captured or burned them alive had it not been for the master of the crossbowmen, who, arriving with a great company, put the Saracens to flight.

The following day, the army came up to this tower and the Christians went to camp before Carthage, which was at this time nothing more than a small walled town. The captains and sailors, seeing the army encamped, came to the king and told him that they could hand Carthage to him if this would help them. And he entrusted them with five hundred foot soldiers and four companies of knights and horsemen. But it was not long after their departure that the Saracens came before the Christian host, skirmishing and attacking and showering them with missiles. When the marshal saw this, he ordered that all should be armed and take up battle formation, then sallied forth from one end of the army and rode so quickly that he was able to place himself between Carthage and the Saracens, who continued their skirmishing without, however, coming close to them. Meanwhile, the captains and sailors attacked the walls of Carthage with ladders and ropes and so constantly assailed it that they took it by storm at the cost of a single death, a man killed by a spear.

Once they had taken the city and had their fill of plunder, they placed their banners on the gates and towers. And the king and his men hastened to block the way of the Saracens escaping in flight from Carthage and followed so close on their heels that they killed a part of them and the others ran headlong into caves, hoping to save their lives in this way, but fire was set outside the caves and in this way they were all killed. And though at least three hundred Saracens were killed there, others escaped and carried off the riches of the city, which the French would willingly have recaptured, but they

"The following day, Saracens came up and skirmished so that the French had to leave their lunch and take up arms."

(FOL. 247VB)

On 1 July 1270, together with his brother Charles of Anjou, Louis IX, who was by now the king of Sicily, embarked on his Holy Journey once again from Aigues Mortes: this time, he headed for Tunis. After they had landed, the crusaders proceeded to capture Carthage. The lower miniature shows the arrival at the camp of three Saracens, who claim that they wish to convert to Christianity; they are seen entering the tent of John of Acre, followed by a group of a hundred Saracens who fall to their knees. The nocturnal scene is suggested by the vague, hazy blue chiaroscuro through which can be discerned the fortified city of Tunis. In the principal scene, the artist has depicted the two armies face to face. In the foreground appear the rumps of the cavalry's powerful warhorses. Mounted on one of them, the king can be identified by his crown and blue mantle, decorated with *fleurs-de-lis*. In the background, against a series of blues shading into each other, representing the sea and the sky, the skyline of Tunis can be made out. The exceptional harmony of the composition conveys an impression of the fate of the combatants hanging in the balance before the battle.

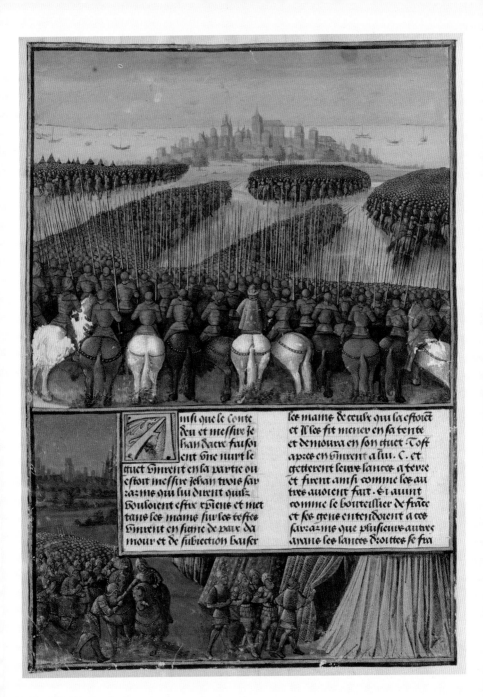

nsi que le Conte
du et messire Je
han dacre faisoi
ent une nuit le
stuct vinrent en sa partie ou
estoit messire jehan trois far
rasms qui lui dirent quilz
voulsoient estre rriens et met
tans ses mains sur les testes
vinrent en signe de paix da
mour et de subiection baiser

les mains de ceulx qui la estoict
et Il les fit mener en sa tente
et demoura en son estuct. Tost
apres en vinrent a lui. C. et
getterent leurs lances a terre
et firent ainsi comme les au
tres auoient fait. Et auint
comme le bouteillier de frace
et ses gens entendirent a ces
sarasms que plusieurs autres
auine ses lances droittes se fra

663

dared not give chase, because the marshal had forbidden every man to leave his formation. And thus the city of Carthage was taken by force of arms and pillaged. The following day, Saracens came up and skirmished so that the French had to leave their lunch and take up arms. But when the Saracens saw the French come forth to attack them, they fled. That very day, two Christian knights of Catalan birth came to the king, Saint Louis, and told him that the king of Tunis had sent them to say that, if King Louis had come to besiege the city of Tunis, he would have every Christian in his territory killed. And the king replied that the more harm he did to the Christians, the greater the grudge he would bear him.

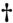

Chapter LXXIX.
Of the Saracen who came to surrender to the Christians. Of the fierce battle against the Saracens. And how, while King Louis awaited his brother, King Charles, several great lords died and he himself committed his soul to God in holy confession.

While the count of Eu and monsignor John of Acre were on nightwatch, there appeared to John three Saracens claiming that they wanted to be Christians and, placing their hands on their heads, they came with every sign of peace, love and subjection to kiss the hands of those who were present, and he had them led to his tent and remained on the watch. Shortly afterwards, there came to him one hundred more who threw down their lances as the others had done. Now it happened that the king's butler and his men were taking care of these Saracens when many others, their lances raised, made a sudden attack on the part of the army that he was guarding and forced the Christians to cede ground. At which they began to cry out so loudly that the whole army was alerted. But before the rest of the Christians could enter the fray, sixty of the Saracens were killed, foot soldiers and horsemen alike, and thus they were driven off. And when the butler had completed his watch, he returned to his tent, where he fiercely rebuked the Saracens. One amongst them, the master of the others, began to weep and excuse himself (according to a Jacobite who understood the Saracen language) and said: "Sire, I know that you suspect me, but I am not to blame, for a knight who hates me has done this to afflict me. You should know that he and I are amongst the two greatest mercenaries at the service of the king of Tunis and each of us

has under him one thousand five hundred horsemen. When my companion perceived that I wished to place myself and my men at your mercy, he ordered the assault that you have just fought off in order to prevent me accomplishing what I have undertaken to do – become a Christian. I know that one of my horsemen took part in this skirmish. And so that you have some assurance that I am speaking the truth, let my companions go to my men and they will bring you provisions and assist you as best they may."

The butler, having heard out the Saracen, told his story to the king, who replied that they should let the Saracens go and thus discover how trustworthy they were. And things being in this way, the king had moats dug around his army and had it thoroughly enclosed and fortified so that the Saracens who often came to skirmish and shower his men with missiles could not approach with impunity.

The king was unwilling to attack Tunis till his brother Charles I, king of Sicily, had joined him and Charles had lately sent that he would soon arrive with an immense army. Now when the Saracens heard that the French had dug moats around their army, they assembled from all sides in such numbers that they could scarcely be counted. And the king of Tunis let it be known that he would give battle. On the following day, therefore, the Saracens came forward on horseback in battle order and spread out along the coast, including the part of the shore where the Christian ships were, as if they sought to encircle the whole army and its ships. Then, by order of the king, the French quickly armed and sallied out of their tents into the fields, their formations in battle order and their banners unfurled. And the count of Nevers went with all his battalion, which was composed of a great many men, and succeeded in encircling one of the Saracen battalions. And the chamberlain went in the other direction with another company so that the king of Tunis could not come to the aid of his men.

Thus, the battle began on either side. But the Saracens, realising that they were in great peril, turned and fled, though the majority of them had already been killed. Amongst the king's men, too, there were deaths, including two very valiant men, the castellan of Beaucaire and John of Boussilières. After this defeat of the enemy, the king was advised to advance no further and, therefore, had his men return to their tents and pavilions and there they awaited the arrival of Charles of Sicily, the king's brother.

And on the second day after this battle, Oliver of Fives came to the king and gave him reliable news of his brother, the king of Sicily, who would arrive at the port of Tunis within three days. But alas! How it pains me to tell! So great a pestilence fell on them and so many and various illnesses because of the infected air and the corrup-

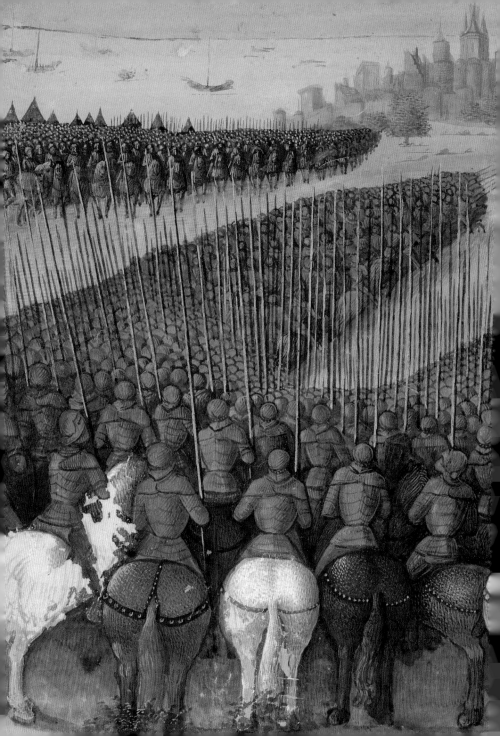

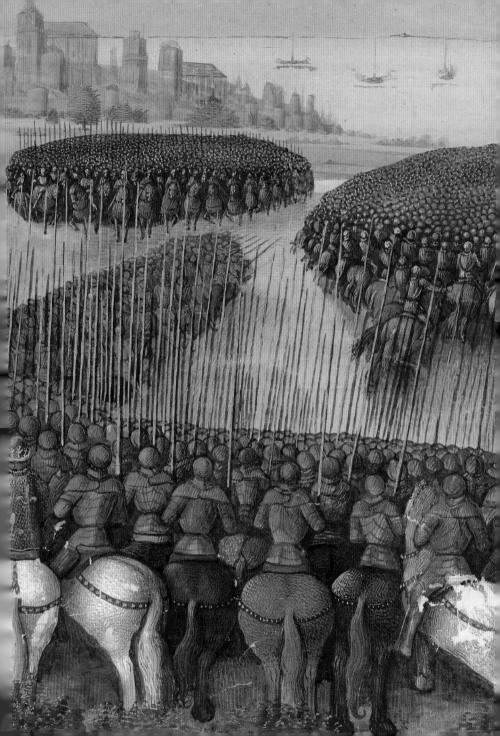

tion of the water that in very few days there died a great number of Christians, amongst them the papal legate and John Tristan, the count of Nevers.[629]

And the glorious king himself, Saint Louis, was afflicted with so great a flux of the belly and afterwards an acute fever that he took to his bed and was fully aware that he must commit his soul to God. Therefore, he summoned his eldest son, called Philip,[630] and in the presence of the other princes and barons, he handed him an epistle that he had written with his own hand. In this letter[631] he commanded Philip to strive to love God with all his heart and rather suffer the vilest torments than commit mortal sin. That he should thank God in adversity and think in his heart that he had deserved it and that he should praise Our Lord if He bestowed abundance on him. That he should often confess to a confessor, a man of unblemished life, who could teach him what he must do to please God. That he should devoutly hear the service of Our Lord. That pity and mercy for the poor should fill his heart. That he should maintain the good customs of his kingdom and abate the bad. That, if anything were weighing on his heart, he should discover it to his confessor or to some good and true man able to keep his secret.

Moreover, he told him that every prince must take especial care that the servants of his own household should be loyal men and true. That he should follow the Holy Scripture, which instructs one to love "men such as fear God, men of truth, hating unjust gain". And that he should not suffer that any ill thing be acted or spoken against God in his presence. And that he should be strict and faithful in giving and maintaining justice towards his people without falling into either excess. And if anyone should seek a quarrel with him for an injury or hurt that he believed himself to have suffered, that he should take pains to discover the truth of the matter. That if he had in his possession anything that did not belong to him, he should restore it immediately. That he should work to ensure that his subjects could live in peace and justice under his rule. In particular, that he should maintain the cities and towns of his kingdom in the condition and in the rights that his predecessors had administering and maintained, for even the powerful would hesitate to wrong him if his cities and towns of his kingdom were strong. And he adjured him to remember that the cities and good towns of his kingdom had often helped in the beginning when he was first crowned against a number of his princes and barons who rebelled and rose up against him. And it is certain that our good king called Louis XI (I would say Louis XII) now reigning and often considered the cynosure of the era subscribes to these words, having shown himself and still showing himself thus perfect.

Then the good King Louis ordered him that he should love and honour the Holy Church and that when there were benefices to be awarded by his hand, he should bestow them as advised by good men to those whose lives were reputable and unsullied. And that he should abstain from waging war against any Christian unless he himself had suffered a great wrong, but should then pardon the wrong-doer if he asked for mercy and should accept just reparation, such that God would look kindly on him. That he should be diligent in employing good officials and that he should often enquire into their deeds and how they performed their duties and that he should in particular enquire into those of his own household, whether they were too covetous or arrogant; it was natural for the parts of the body to resemble the head and when the head was wise, good and prudent, his servants would be the better for it and would follow his example. That he should strive to eliminate shameful oaths from his land. And most especially that he should hold in great contempt the Jews and all manner of people who denied the faith. That he should take care that the expenses of his household were moderate and reasonable. And lastly one might read in this letter: "My son, I beg you to bring succour to my soul with masses and orisons. I give you all the blessings that a good father should bestow on his son. And the blessing of God be upon you and may He give you the grace to do His will."

When the king had thus commended his son, he was more and more beset by his sickness. Therefore, he commanded that he be given the sacraments of the Holy Church, which was done. And when he felt that the hour of his death was nigh, after having by numerous prayers besought the aid of the saints that he particularly venerated, like Saint Denis and Saint James the apostle, he had himself laid in a bed of ashes and there, shortly afterwards, he gave up the ghost in his tents in the town of Carthage, on the day following the feast of Saint Bartholomew, in the year 1270, at the very hour at which Our Lord Jesus Christ received his death on the True Cross for the redemption of the elect to perpetual joy.[632]

When the army learned of his death, the sadness was universal and immense, for everyone loved him as they might love their own father. But they nevertheless concealed their grief so that the Saracens might not perceive it and showed themselves the more courageous on this account. At the very hour of the king's death, the ships of King Charles arrived and messengers were sent to him to inform him of what had occurred. And it is no wonder that he was profoundly grieved. Nevertheless, wise prince as he was, he disguised his grief so that the men of Tunis should not know of this disaster and, therefore, attack our men the more boldly. Thus, he went to see his brother, the

CHARLES OF ANJOU SUCCESSFULLY PURSUING THE SARACENS

"Soon after this, the French host was struck by virulent
pestilence in various forms, as were those within the city of Tunis,
and neither side could see how they might accomplish the goals
that they had intended, this being especially true of the king of Tunis."

(FOL. 252B)

The episode recounted by Sébastien Mamerot at the beginning of this chapter and illustrated by Jean Colombe took place immediately following the death of Louis IX. His brother, Charles of Anjou, took up the fight and pretended to flee with his troops. The image in the lower register shows the Saracens on horseback pursuing the king and his troops. The principal picture shows how Charles of Anjou, after ordering his cavalry to wheel round suddenly, joins battle with the vast numbers of Saracen troops: he forces them to flee and some even hurtle into the sea. The dead bodies and severed heads strewn about the ground bear witness to the violence of the battle. As in the preceding pictures, the city and the mountains descending to the sea can be discerned in the distance.

[H]uee de beaufoy et
ses compaignons
tous traillans to
batrans apparoi
uans les de frõs que faisoiet
souuent les sarrazine deuant
les tentes en sailluent bug io?
et les chacerent tant quilz
fuzent enclos en bng embuf
che et prins et si ne peurent
estre resconz combien que la

grant armee sailliff car il
se leua soubdainement tant
yrant vent qui esleua tant
espesse pouldaere quil couuint
quelle sen retournast. Et
retiree auant que bne autre
fois que les sarrazine retour
nerent en tant grant nõbre
quilz eussent bien peu enclose
les francoie lesquelz nen estaz
de riens espoantez saillerent

king, Saint Louis, there where he lay, his body still warm because he had only just died, as if he were going joyfully forth to a marriage. There he knelt down and weeping, commended Louis's soul to Our Lord. And when he had done this, wiping his eyes, he stood up without showing his affliction and ordered that the body of the king be prepared as custom required. And the following day, he and Philip, his nephew and now the king of France, had mass performed for the good king. King Charles had Louis's entrails[633] sent with great diligence to be buried in the abbey of Monreale of the Benedictine order near the city of Palermo in Sicily.

And when the mass was said, King Charles of Sicily had his tents and pavilions set up and his men accommodated on the shores of the sea just under a league from the French army. And between the French and the Tunisian armies there were four miles at least, but the Saracens nevertheless often came forward to shoot arrows and throw spears at them from every side. The French often sallied against them and the Saracens never awaited them if they saw that there were one or two hundred. For their custom is to harass their enemies in order to prevent them resting and then to lure them into disorderly pursuit, very often shooting or throwing projectiles behind them and so killing those who imprudently give chase.

$$\dagger$$

Chapter LXXX.
Of the defeat inflicted on the Saracens by King Charles of Sicily. How the king of Tunis assembled a great host, but dared not do battle with the French. Of various maladies. Why an agreement was made. Of Edward, son of the king of England, who, having arrived late, went on to Acre, and of his wounding and return home. And how King Philip returned to France and buried the body of his father at Saint-Denis, whence it has been raised up resplendent with miracles.

Seeing the disarray often wrought by the Saracens assailing the camp, Hugh of Beausoy and his companions, valiant combatants all, one day sallied forth to pursue them, but in doing so were ambushed, surrounded and captured. Nor could they be rescued, for, though the whole army made a sortie, a great wind suddenly came up, raising so thick a dust that they were forced to retire. And now the Saracens returned in such great numbers that they might easily have surrounded the French, who, not

daunted, came forth from their camp to give battle. Seeing the bold countenance they made, the Saracens dared not await them but fled.

When King Charles saw this from afar, he sallied forth from his tents and led his men in the same direction as the Saracens till he was very close to them; then, feigning flight for the space of a good league, he contrived to lure the Saracens after him; many horsemen gave chase. When the moment came, he suddenly turned his army back against them and assailed them with such temerity and force that he again drove them to flee. Four thousand Saracens remained dead on the field, not to mention those who threw themselves into the sea in the hope of saving themselves and were drowned. Moreover, our men having perceived that the Saracens of the army could obtain provisions and other such from Tunis only by boats navigating a great torrent from the mountains that flowed into the sea between the Saracen army and Tunis, they erected a strong wooden castle on the bank, heavily garrisoned within and without for its defence. Then they attacked the river in such numbers that they took all the vessels that were bringing provisions.

This so much dismayed the king of Tunis that, by the advice of his council, he assembled his entire army and came before the tents of the French, hoping that they would be frightened by his great host if he seemed willing to give battle. But he merely raised their spirits, for as soon as they saw them approach the king of France, the king of Sicily and King Tibald of Navarre, count of Champagne, had all their men arm themselves and form up handsomely in battle order, sallying forth from their tents, which now formed a single encampment. They left the count of Alençon, brother of King Philip and the master of the Hospital, with all their men within the camp to guard it. And when the king of Tunis and the other Saracens saw the Christians come before their army so fearlessly, they took flight and did not stop till the majority of them had taken refuge within Tunis. However, the French did not pursue them, for often when the enemy takes flight without so much as giving battle – or even at a later stage – pursuing them leads to disaster. And so the three kings and their men, still maintaining their formation, entered the camp of the Saracens and pursued them as far as the mountains, which were perilous. Some, intending to mount guard over the Saracen tents and later exploring them found great quantities of provisions, which they captured. They killed many sick Saracens who had been unable to flee before burning all the tents and pavilions, and thus returned to their accommodation greatly angered that they had been unable to make the enemy give battle.

Soon after this, the French host was struck by virulent pestilence in various forms,

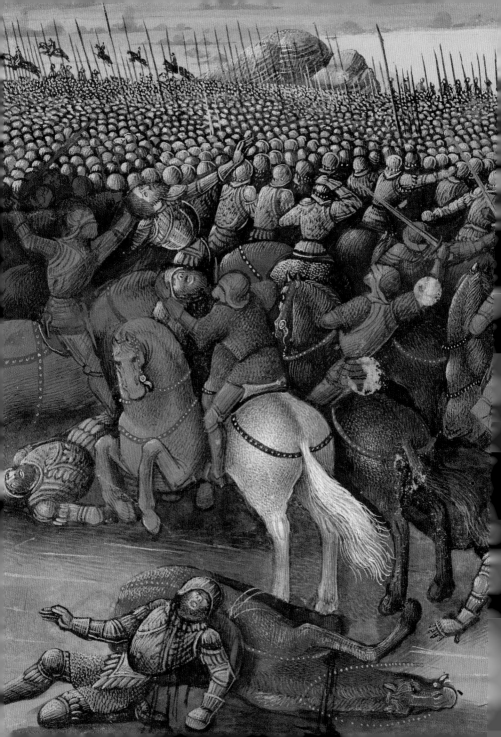

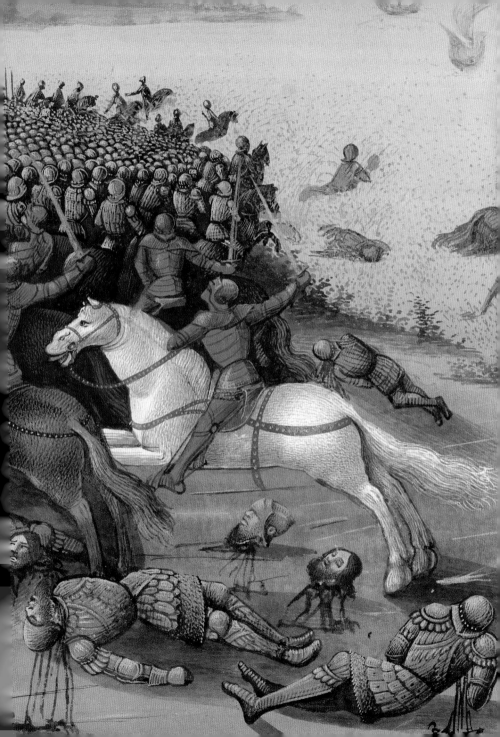

as were those within the city of Tunis, and neither side could see how they might accomplish the goals that they had intended, this being especially true of the king of Tunis. Therefore, following the counsel of his men, he sent envoys to King Philip, the son of Saint Louis, to ask for peace or a truce. The request of the king of Tunis was heard by the king in council and at last a truce of ten years between the Christians and the Saracens was made on condition that the king of Tunis should pay King Philip and his barons in gold and silver all the expenses that they had incurred from the day they had left their own lands to the day of the truce. And the king of Tunis further agreed and swore that all Christian merchants arriving in Tunis and bringing merchandise to his port, or driven there by storm or damage, should be free of all taxes and should pass through freely without payment, for the merchants had before been in a state of such servitude that they were forced to pay the tenth part of all that they brought to Tunis. It was further agreed by the king that he would thenceforth without dispute pay tribute to the king of Sicily as his predecessors had done. And he also agreed that he would deliver all the Christians who had come from various places to live in the kingdom of Tunis long before the war, whom the king had, out of spite for the French, imprisoned in various prisons, and that he would restore all the property that he and his men had confiscated. And he would further tolerate not only the reopening of the Christian churches within Tunis, whose closure he had ordered, but any further churches that the Christians might wish thereafter to build for celebrating the divine services, and that they would have bells as they do in any Christian country. When these things had been agreed and sworn on either hand and the gold and silver paid, the truces were forthwith cried and published in the Christian army and in the city of Tunis and those of either side went to visit the other, buying and selling in complete freedom.

Shortly before the truce was agreed, Edward, the eldest son of the king of England, arrived amidst the French host. Unwilling to return directly to his own country, he set sail and went to Acre; with him went some of the French. But while Edward was there, he was wounded most perilously by an Assassin who claimed to have news for him from his master, the Old Man of the Mountains; taking him aside in secret into a room, he stabbed him with a knife dipped in poison. When Edward felt this, with great effort he held onto the Assassin, who attempted flight, threw himself on top of him and killed him with the very knife with which he had just been wounded. However, some say that Edward's men captured him and made him confess that the Old Man of the Mountains had sent him. And in truth, Edward was gravely ill, however, the master of the Temple finally entrusted him with a stone that countered the venom and treated

him so that he was cured. And he returned to France, Gascony and then England, where he was crowned king[634] because his father, King Henry, son of King John Lackland, had died shortly before.[635]

Now Philip, king of France; Tibald, king of Navarre; Alfonso of Poitiers; Peter, count of Alençon; Robert, count of Artois; the bishop of Langres; and many other nobles put to sea from Carthage, which is the port of Tunis, and had favourable winds till they arrived a few days later without any difficulty at the port of Trapani in Sicily. And there they stayed for a fortnight while awaiting their companions.

The day after the departure of King Philip, a number of other princes and Christians set sail; a violent storm blew up and three thousand of them died and eighteen of their ships were wrecked, not to mention the smaller ships full of horses and other goods. After the storm, Tibald of Navarre, count of Champagne, died[636] in the city of Trapani, and his body was afterwards taken to be buried in the Franciscan convent of Provins. All the Christians in the army were deeply grieved by the death of the count, for he was the most powerful prince after King Philip and had shown himself wise, generous and affable to all who had dealings with him and particularly to the poor. And Queen Mary, his wife, the daughter of Saint Louis, grieving for her father and her husband at once, died on the return journey near Marseilles. By her own order, she was taken to be buried with the count, her husband.

When King Philip had assembled all those that he could of his army, he again put to sea and came via various cities in Sicily and Calabria to that of Cosenza, where his wife, Isabella, daughter of the king of Aragon, died. For, being with child, she had while going by land through another city received such a jolt from a horse that it caused her to give birth prematurely and so she died. Philip, her husband, had her body carried with him as he returned.

But a new grief was to follow. His uncle Alfonso, count of Poitiers, died at the castle of Corneto in Tuscany,[637] his wife the countess dying shortly after him; she was carried to the abbey of Jarcy near Melun. Despite these misfortunes, King Philip continued his return journey and, having passed through Rome and visited the Holy Places, finally reached France, where he with great reverence and honour arranged to bury the body of the king Saint Louis, his father, placing it in the abbey of Saint-Denis alongside King Louis, his father, son of the very powerful King Philip the Bold, known as Dieudonné. Thus, came to an end in the year 1271 the second expedition to Outremer undertaken by Saint Louis, king of France. In honour of Saint Louis, Our Lord has performed both in the abbey of Saint-Denis and in various other places innumerable

"To him in the eighth year of his reign, 1388, the Genoese sent
ambassadors from amongst the most renowned men of their city to inform
him and his council that the municipality of Genoa was concerned that the condition
of the Christians in their marches had greatly suffered from the raids
constantly made by the Moors, that is, the Saracens of Africa and Tunis."

(FOL. 254VA)

Here, Mamerot has leapt a hundred years forward, to a completely new situation. By now, the Turks had crossed the Hellespont and controlled the Balkans. The struggle against Islam was therefore no longer confined to Asia but had reached the West and, in particular, those countries surrounding the Mediterranean. However, the ideal of the crusade still survived, in the form of a war of defence against the threat posed to the West by advancing Islam. Thus, an expedition was undertaken in 1390 by Louis II, duke of Bourbon, at the urging of the Genoese, who were troubled by constant attacks by Saracens from North Africa and, in particular, from Tunis. In the lower register, Jean Colombe shows Genoese envoys travelling to the court of the French king in 1389, elegantly dressed as they ride across the countryside. It is their audience with King Charles VI that is depicted in the principal picture. The whole council chamber is hung with tapestries decorated with *fleurs-de-lis*; the king is seated in the midst of his councillors. The Genoese ambassadors are on their knees before him, explaining the purpose of their visit and emphasising their proposals by hand gestures.

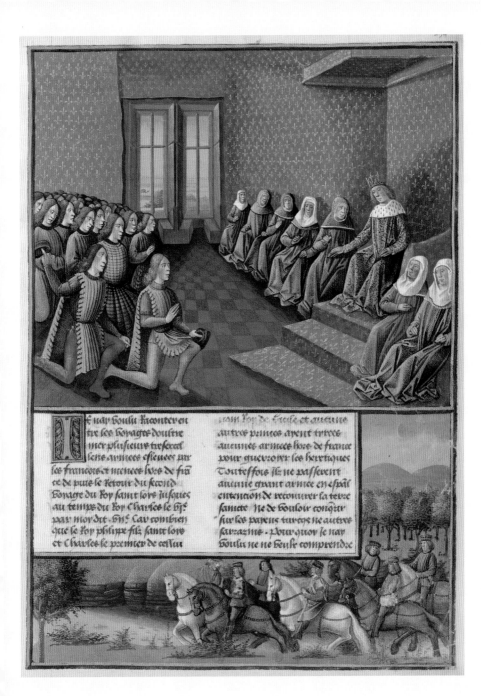

miracles, so that Louis has been canonised according to canon and holy law by Pope Boniface VIII.[638]

For reasons of brevity, I shall not describe any of his miracles and his holy canonisation, but bring to an end the narrative of the great expeditions to Outremer made by the French, compiled and composed by myself, Sébastien Mamerot of Soissons aforementioned, hoping that I may, with God's help, recall to memory certain smaller expeditions under the title *The Expeditions to Outremer Made by the French.*

<div align="center">✝</div>

Chapter LXXXI.
The overseas expedition made by Duke Louis of Bourbon, chief of the army raised by the French at the petition of the Genoese. Of the lords and nobles of this expedition and how they came to port in Africa.

Amongst the overseas expeditions made by the French, I was reluctant to recount the many excellent armies raised by the French and led out of France between the return of Saint Louis's second expedition and the time of King Charles VI (or as I insist, VII). For though King Philip, Saint Louis's son, and Charles I, king of Sicily, and a number of other princes have led armies out of France to combat heretics, they did not lead any great army overseas with the sole intention of recovering the Holy Land or attempting the conquest of pagans, Turks or other Saracens. Therefore, I was and am reluctant to include their deeds in the present work, but now jump from the expeditions of Saint Louis to those made under the reign of Charles VI.

To him in the eighth year of his reign, 1388, the Genoese sent ambassadors from amongst the most renowned men of their city to inform him and his council that the municipality of Genoa was concerned that the condition of the Christians in their marches had greatly suffered from the raids constantly made by the Moors, that is, the Saracens of Africa and Tunis. Therefore, the principal governors and leaders of Genoa had undertaken, if the king and the French were willing to assist them, to place on board their ships twelve thousand crossbowmen and eight thousand foot soldiers supplied with arms and provisions in abundance and further to equip and deliver ships, galleys and boats provisioned at their expense with oarsmen and ship's biscuit, water and vinegar to ferry across the sea without charge all Frenchmen, knights, squires and nobles able to bear arms. But they desired that the king should appoint to

be the chief of their army the duke of Touraine, his brother, subsequently the duke of Orleans, or one of the dukes who were uncle to the king.

Their embassy was heard at length in audience with the king and considered for a number of days by the council, at which it was concluded that, truces having been made for three years between France and England, the king for the honour and exaltation of the holy Christian faith should muster a small army of which the chief would be his maternal uncle, Louis, duke of Bourbon, and that the very valiant lord of Coucy and count of Soissons should be his companion in this voyage.

Whereupon the ambassadors returned joyously to Genoa and in the year 1389 made ready all that was needed to make the crossing. Moreover, when the news was known in France, there were many great lords and other nobles and men of various estates who undertook to be of the expedition. But not all those who would willingly have gone did in fact go, for they were required to travel at their own expense and there was no lord so great that he took with him at his own expense more men than those of his own household and also because it was ordered that no French citizen would take part without the permission of the king, for it was not desirable that the kingdom should be deprived of too many of its knights and squires. Nevertheless, there were in this expedition a great number of knights and squires because by permission of the king it was bruited abroad in the kingdoms and countries bordering France that if there were knights and other nobles who wished to be of this army and acknowledge the authority of the duke of Bourbon, that they would be very willingly received, for which they were wondrously grateful to the king. And on this occasion, many great knights and esquires from England and from other countries outside the kingdom of France equipped themselves for the expedition, and they and the French selected for the task were ready to cross the sea in the year 1389.

However, the duke of Bourbon could not be ready that year and postponed the crossing till the following year, which caused great harm to many knights, squires and many others who had sold or mortgaged their lands and other goods; they were all ready to leave and were obliged to double their expenses to live as their standing required for a further year. Nevertheless, when the year 1390[639] came round, the duke and those who wished to take part in the expedition arrived in Genoa, where they were received with great joy by the Genoese, who had carefully prepared all that they had promised, and so the army set sail from the port of Genoa and other ports nearby around the feast of Saint John the Baptist. And certainly it was a fine thing to see and hear their departure for the rich banners, pennants and other accoutrements and also

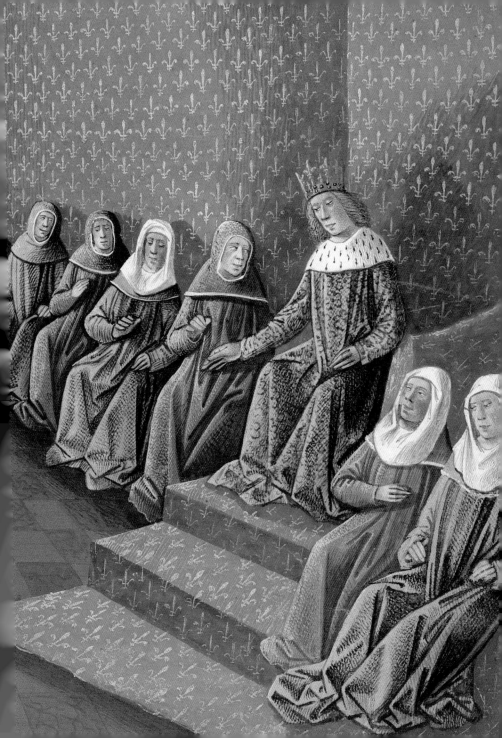

for the great multitude of instruments of different kinds playing and sounding in great melodies. The leaders and most renowned men amongst them were Louis, duke of Bourbon; Enguerrand of Coucy; the count of Soissons; Philip of Artois, count of Eu; the dauphin count of Auvergne; John of Vienne, admiral of France; Guy of La Trémouille; Philip of Bar; the lord of Harrecourt; Henry of Anthoing; the lord of Ligny and Havereth in Hainault; Beaufort, bastard son of Duke Lancaster in England; Ivan, bastard of Count Gaston of La Foix; and many other knights and squires from Burgundy, Brittany and other lands outside France.

The expedition had one hundred and twenty galleys, two hundred ships and one hundred other vessels bearing provisions and supplies, all well supplied with crossbowmen, oarsmen and good captains. The fourth day after leaving the port of Genoa, they anchored at Portofino and the following day at Portovenere. The following morning, recommending themselves to God, Our Lady and Saint George, they put out onto the high seas, arriving first at the island of Elbe and that of Corsica, those of Argentario and then that of Sardinia and crossed the gulf of Lion, for they could not avoid it though they knew that it was a very perilous passage and, indeed, they were in great danger there. For such a great tempest arose that no ship's master, however wise, had any advice other than to await the mercy of Our Lord, by whose grace they were delivered from this peril after a day and a night and came to the island of Commières, which is thirty miles from the city of Africa against which the army wished to attack first. It was chosen firstly because it is the greatest city of the kingdom of Tunis lying on the coast looking towards Genoa and the one from which their pirates made their raids and thievery, these pirates mustering there not only for safety but in order to divide their booty. And to advise those who would wish to make this or another such crossing hereafter, the captains and masters of the ships, galleys and other vessels had together concluded before they entered the gulf of Lion that if they had such divers fortunes that they needed to separate one from another, each should set the helm for this isle of Commières and there the first should await the coming of their companions, and this is what they did.

And when they had spent nine days there, the principal Genoese captain said to the duke of Bourbon and other great lords: "We are here in the territory that most nearly borders on the stronghold of Africa to which, with God's help, we shall lay siege. We must take council with one another how we shall enter the harbour, which you do not know as well as we do, though you are better acquainted with military matters than we. Wherefore we captains have considered amongst ourselves

that when we enter the harbour and land, in order to keep your men safe, we should first send our smaller armed vessels, the *brigantines*, further inshore and they will remain at the entrance to the harbour the day we advance and the following night, too; then, on the following morning, with God's aid, we shall disembark at leisure as close as we can to the city, though still out of range of their catapults. And we shall also disembark our Genoese crossbowmen, who will be ready to defend us and ward off skirmishers. We readily suppose that when we seek to disembark that a great number of squires amongst your men will, for the sake of advancement and honour, seek the order of knighthood and you can show us that you know how to act in these circumstances. For you may rely upon it that we are anxious to acquit ourselves of our debt to you and show you how we can do most harm to our enemies in order that the city of Africa known as Carthage can be captured, a city that has so often done us harm that it is in our view the key to the Barbary coast, the key to Africa, Tunis, Morocco and Bejaia. And if, by the grace of Our Lord, we succeed in taking it, all the Saracens will tremble as far as Nubia and Syria and we shall be praised and celebrated throughout the world. And with the aid of the Christian kingdoms and the islands in our possession off the African coast, we shall be able to maintain and renew its garrison daily with men and provisions. For it will be a common enterprise but if once we take the city we can constantly give battle to the enemies of God and so acquire new land from them."

These things having been thus argued by the Genoese captains and leaders, the lord of Coucy, in the presence of the duke of Bourbon and according to his will, replied that they would follow their words and advice and that the French lords would do as they had counselled. Therefore, having renewed their stocks of fresh water, they again put out to sea and came so close to the African coast that they saw the mighty city of Carthage and also the harbour and port quite bare of defenders, which astonished them given the great abundance of people who lived in these regions, for they were expecting to have found them assembled on the shore to prevent the Christians disembarking. But they arrived and touched ground in the harbour without encountering any opposition, even though the Saracens of Tunis and Carthage knew of their coming and had assembled in great numbers to attempt to beat off any landing. For they had followed the advice of a powerful emir named Madifer, who had argued that if our men were able to disembark in an undefended harbour, the courage of the Saracens would be the greater for it. But this advice was not accepted, for it was countered by the view of another emir named Behus, lord of the rich city of Maldages in Africa, who had part

of their archers sent to Carthage to fortify it while he and the others of the great army retreated into the woods and forests because of the great heat of the season, for it was now around the feast of Saint Magdalene.

He argued amongst other things that the French, who were bold and enterprising, would not have come to conquer this foreign land without a large army well supplied with crossbowmen, by whose arrows so many Saracens would be killed that the others would flee, leaving the harbour to the Christians; the latter would be so encouraged by this first victory that they would easily take the strong city of Carthage, in which terror would have been spread by the Saracens' flight. This would never happen if his advice were taken. For if the Christians were allowed to disembark and lay siege to the city of Carthage as they wished, they would soon suffer discomfort from the heat of Africa, to which they were not accustomed, and would be unable to find shade or comfort such as they were used to in their own countries. Meanwhile, they would be constantly harassed by the Moorish army: when they could be harmed, they would have no rest, and when they could not be harmed, they would be left in peace. And consequently, they would be so afflicted with various ills that they would fall ill before they could take the city by siege, for it was strong and well provisioned. And then they would agree that they should return home without having made any gains in Africa.

When our men had thus disembarked in Carthage harbour, they sallied forth onto land and made camp and besieged the city thus. The duke of Bourbon had before him his banner studded with *fleurs de lis* in the midst of which there was a white image of Our Lady, with a little Bourbon coat of arms at her feet. To the right of the duke of Bourbon, facing the city, were the tents of William of La Trémouille, the lord of Sully, bearing a banner; Guy of La Trémouille, his brother, bearing a pennant; the lord of Vodenay with a banner; Hélyon of Lignac; the lord of Surgières; the lord of Roux, a Breton; the lord of Tours; and John Harpedane with pennants. After them in order of battle, the men of Hainault, whose leader was William of Hainault, then count of Ostrevant; the eldest son of Duke Albert of Bavaria, the count of Hainault, Holland and Zeeland; the lord of Havereth; the lord of Ligny; and the lord of Matefelon, all bearing banners. Near them was Philip of Artois, count of Eu; beside him Boniface of Calain and the seneschal of Eu, both with pennants; the lord of Linières; the lord of Chin; the lord of Aumeval; and the lord of Liques with banner; Walter of Chatillon with pennant, John of Chasteaumorant with banner, the brother of the seneschal of Sancerre with pennant; John of Troyes with pennant; and the lord of Acourry with banner. There, too, with banner was the valiant Coucy, count of Soissons, and in more splendid array

than any other except the duke of Bourbon. And there, too, was the pennant of King Charles VI, with his coat of arms, next to which was John Le Barrois with pennant; William Merles with banner; the lord of Longueval with pennant; John of Roye with banner; the lord of Bours; the viscount of Aunay with banner; and John of Vienne, the admiral, bearing his banner. To the left of the duke of Bourbon were the lord of Auffremont; John Beaufort, the bastard of Lancaster, with banner; John le Boutellier, an Englishman, with pennant; John of Craina with banner; the Sourdit of L'Estrade with pennant; John of Harcourt; the lord of Garencières and Beraut, count of Clermont, the dauphin of Auvergne, bearing a banner; and, in rich array, Hugh the dauphin, his brother, the lord of Betencourt with his pennant; the lord of PierreBussière; the lord of Sainte-Sévère, with banner; Lonnart, marshal of the army; Borgne of Viausse with pennant; the lord of Loigny with banner; Gerard, his brother, with pennant; and the lord of Saint-Germain with banner. Then, with his pennant on a standard marked with his coat of arms, the duke of Burgundy; Philip of Bar with banner; Geoffrey of Charny with banner; Louis of Poitiers with pennant; Robert of Cabroles with pennant; viscount Duzes with banner; the lord of Montaigu with banner; the lord of Villenove with pennant; William of Le Moulin with pennant; Engorgié of Amboise with pennant; Alan of Champagne with pennant, all knights of great renown, not to mention thirteen other knights of great valour who were encamped with their men in the fields before the stronghold of Carthage.

Chapter LXXXII.
Of the great army of Moors that came to the aid of the city of Carthage. Of the ten Christians pitted against ten Saracens despite the advice of the lord of Coucy. Of the great harm that resulted. And how at last the Christians returned home without gain.

The fame of the siege of Carthage spreading far and wide, those of the neighbouring islands, such as the kingdoms of Naples, Sicily and, on the mainland, Puglia and Calabria, strove to bring all kinds of provisions and goods to the Christian army. They did not unload everything at once, but a small galley did nothing other than bring to land the provisions necessary for each successive day and in this way the Christians continued their siege but to little purpose. For from the kingdoms of Tunis, Morocco

FOL. 258

MIRACLE OF OUR LADY AT CARTHAGE. FRENCH
AND MOORISH ARMIES FACING EACH OTHER

*"But the Moors, when they heard this, merely laughed out
loud and said that they had not put Jesus Christ to death;
it was the Jews who had crucified Him."*

(FOL. 258VB)

On 1 July 1390, a fleet of sixty ships with 5,000 knights on board left Genoa for North Africa. It reached the coastal city of Carthage (in fact, Mahdia) on 22 July and immediately set about laying siege to it. The troops of this Franco-Genoese crusade, which is also known as the Barbary Crusade, were under the command of Louis II, duke of Bourbon, an uncle of the French king, Charles VI, and an experienced soldier and veteran of the Hundred Years' War. In this miniature, Jean Colombe illustrates two episodes from the time of the siege. In the lower register, the Saracens and the Christians are facing each other before moving onto the attack. In the principal picture, the artist depicts the miracle of Our Lady, which saved the Christians: when the Moors, whose faces here are black or dark-coloured, tried to attack the Franks by night, they found themselves facing a line of fair-haired maidens dressed in long, white robes. One of them, more beautiful than the others, is wearing a crown surmounted by a halo and she is holding a standard bearing the sign of the cross. Despite this miraculous support, the expedition quickly failed and Louis of Bourbon's troops were forced to retreat after a siege lasting only nine weeks.

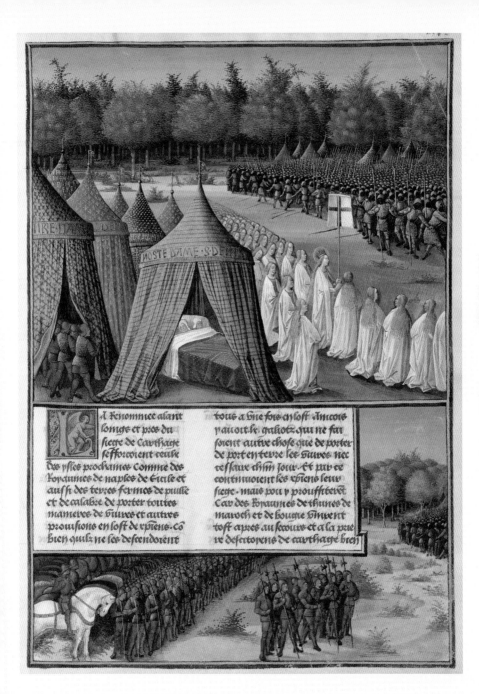

A Renommee alant
longe et pres du
siege de Carthage
sefforcoient ceulx
des ysles prochaines comme des
royaumes de naples de sicile et
aussi des terres fermes de puille
et de calabre de porter toutes
manieres de viures et autres
prouisions en lost de xpiens. Co
bien quilz ne les descendoient

tous a vne fois en lost. Ancois
y auoit le galiotz qui ne fai
soient autre chose que de porter
de port en terre les viures nec
ressaire chun jour. Et par ce
continuoient les xpiens leur
siege. mais pou y prousstteuvt
Car des royaumes de thunes de
maroch et de bougie vindrent
tost apres au secours et a la prie
re desertoyens de carthaye bien

and Bejaia shortly thereafter came great help and, at the petition of the citizens of Carthage, thirty thousand archers and ten thousand horsemen who encamped in the fields and on the sand opposite the Christians, taking advantage of the high wood that lay behind their camp so that they did not suffer sudden attacks from the Christians. And so the two armies remained for many days, one next to the other, without combat, though the Saracen archers often made a sally in fine battle order and came close to the Christians, firing arrows at them from a distance and killing them; their fire was returned by the Genoese crossbowmen. But neither army would attack in close combat. Finally, the Moors who had come to the rescue of Carthage and the Carthaginians themselves sent an intermediary to the French lords, who, when led before the duke of Bourbon and the lord of Coucy, said that the Moors were astonished and wondered what could move Christians from foreign lands to come and make war in their kingdoms when they were not aware of having done them any harm. And though they had been at war with the Genoese, their neighbours, the other Christians should not on that account make war on them.

The lords went into council and replied to the intermediary that the French and the other Christians who were there had come to avenge the death of Jesus Christ, their true redeemer, whom the Saracens' ancestors had put to death and that they also wished to destroy them because they were not baptised. But the Moors, when they heard this, merely laughed out loud and said that they had not put Jesus Christ to death; it was the Jews who had crucified Him. Nevertheless, they thought to deceive the Christians, for they rested eight days without skirmishing and then, on the ninth, they came silently by night towards the Christian army, which was then so profoundly asleep that they would have entered their camp unopposed had not Our Lord miraculously woken his knights. For as the Saracens advanced towards the camp, they saw before them a company of very beautiful ladies, all white, one of whom greatly exceeded the others in beauty and splendour and held before her a white standard bearing a scarlet cross. And the Moors were so terrified and appalled by this vision that they lost all strength and for a whole hour had neither the power nor the courage to realise their plan, which, therefore, did not hurt the Christians but instead made them the more careful in their watches. The great heat and the thickness of the air caused the spawning of several maladies, but the sick were well looked after by the special diligence of the lord of Coucy, who visited them and did them much courtesy. In short, as Froissart says, the lord of Coucy was so much loved and praised by all the nobles that many said that he should have sole charge of the army and that, had he been commander-in-chief,

they would have done greater and better things than they had and that the duke of Bourbon was too arrogant and unapproachable.

In the Christian army there came a plague of flies that greatly afflicted our men, but Our Lady, to whom they had all made their vows, helped them (as they believed); for a hailstorm killed all of them. Moreover, every day our men had willy-nilly to deal with new skirmishing by the Moors. And one day, at the end of one such skirmish, a great emir named Agadinquor – he was betrothed to Alsale, the daughter and sole heir of the king of Tunis – came on the advice of the other emirs with an interpreter and signalled to a very valiant Christian squire named Cisrenas that he wished to speak to him. And the squire, holding his men twenty paces from the Moor, went to speak to him and discovered that Agadinquor wished to demonstrate by a battle between ten Saracens (of whom he should be one) and ten Christian knights that their law was better than the Christian law. In short, Cisrenas agreed and said that he would return in four hours, he and nine others. And in fact he did this against the advice of the lord of Coucy, whose vassal he was.

However, when the lord of Coucy saw that the duke of Bourbon and the greatest lords wanted the battle to take place, he so urged the trickery inevitable in Turks that all the Christians made ready and moved out of the camp in battle order. But Cisrenas and his nine men, returning to the place where the Moor should be with his nine men, long awaited him there, but he never appeared. For when he and the other Moors saw the Christian battle order, they dared not approach even though they had three times as many men as the Christians. And when it came towards vespers, our men decided that, since they were ready and in arms, they would attack Carthage. And they did so with such success that they reached the moat and the outer walls of the city and forced the Saracens to retire to the inner walls, which they did without suffering many casualties; this could not be said of the Christians. For they suffered so greatly from the great heat they had endured throughout the day and from the missiles thrown by the Moors from their walls that some sixty knights and squires died, all men of great renown, not to mention others who were of less note.

Despite this, they persevered with their siege though not for long. For a rumour circulated amongst the French, a false rumour, that the Genoese had made an agreement with the Moors that they might depart freely and that the French and other nations who had accompanied them would be delivered to the enemy and betrayed. In short, the lord of Coucy, since the responsibility and hope of all the others rested on him, one day called a secret council of the barons and great lords before the duke

of Bourbon in his tent. There it was decided that the Christians would raise their siege for the moment and each would return to his country from which they would again come the following year and would again besiege the city of Carthage with many more men and much better equipment than they now had. And so they raised the siege on the sixty-first day of its having been set and set off on their return, some to their own countries and others to Cyprus, Rhodes, Constantinople and Jerusalem to their own great dishonour and with great prejudice to the Genoese. The latter, for all the petitions and promises that they might make, could not detain them any longer. And they, therefore, returned to their own city grief-stricken and extremely angry, as well they might be. For thereafter the Moors of Tunis had scant respect for them. Indeed, aware that they had exerted all their strength to destroy them and had not succeeded, they made terrible raids on them and raised their taxes on all merchandise and caused all kinds of difficulties for them, which I shall not enumerate, so that I may bring to an end this expedition by Louis of Bourbon, praising Our Lord Jesus Christ. Amen.

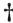

Chapter LXXXIII.
The expedition into Hungary made by the French to assist the Hungarians, whom the Great Turk Bayezid wished to conquer. How, after they had joined the king, he captured several cities and castles from his foes.

In the year 1395,[640] with King Charles VI (as many account him) reigning in France – it was the sixteenth year of his reign – the Great Turk Bayezid attempted the conquest of a large part of the territories obedient to the king of Hungary and, mustering a very great army of selected and experienced soldiers, left Turkey and advanced as directly as he could on Hungary. The Hungarians and their king in particular, for all their great valour, were much dismayed. Consequently, the king immediately had dictated and written many humble and pitiful letters and sent them to a number of Christian countries by his heralds and other envoys. More particularly, he addressed one of these letters to Philip of Artois, then count of Eu and constable of France, whom he had once met, having seen the count bearing arms most felicitously in the Hungarian borderlands with Admiral John of Vienne.

Now when the good count of Eu was apprised of the truth about the Turkish army – those enemies of the faith – and that they wished by force of arms to conquer

SIGISMUND OF LUXEMBURG, KING OF HUNGARY, RECEIVING THE ARMY OF
JOHN THE FEARLESS BEFORE BUDA. THE GREEK CHRISTIANS OF RAHOVA HANDING
OVER THE KEYS OF THE TOWN TO THE FRENCH AND THE HUNGARIANS

"There he [the king of Hungary] received them solemnly and with
great joy, above all others prizing the count of Nevers for his lofty French lineage,
the count of Eu, the lord of Coucy, the admiral of Vienne and Marshal Boucicaut,
for he had heard of and witnessed their renowned deeds of arms."

(FOL. 261A–261B)

In this chapter, Sébastien Mamerot tells of the expedition to Hungary to safeguard the populations and towns there that were threatened by the possibility of Turkish conquest. Count John of Nevers, the eldest son of Duke Philip the Bold, decided to set off and arrived in Hungary with his troops in July 1396. Here, Jean Colombe shows King Sigismund welcoming him with joy before the city of Buda, raising his crown as a sign of greeting and gratitude. The entourage of the king of Hungary is depicted in colourful fashion, as two men in white turbans mingle with the crowd. In the lower register, the artist depicts the scene in which the Greek Christians come out of the town of Rahova and offer to surrender.

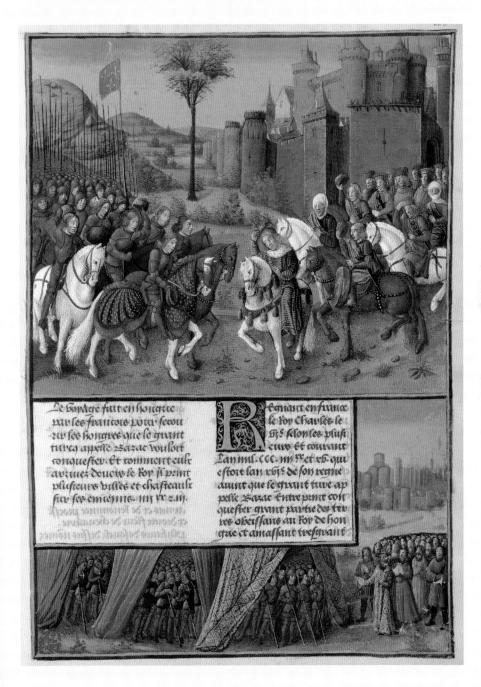

Le voyage fait en hongrie
par les francois pour secou
rir les hongres que le grant
turcq appellé Bazac voulort
conquester. Et comment eulx
arrivez devers le roy il print
plusieurs villes et chasteaulx
sur ses ennemis. iiij xx z iij.

Egnant en france
le roy Charles le
iiiȷᵉ selon les plus
seurs Et courant
Lan mil ccc iiijˣˣ et xvi. qui
estoit lan xvij de son regne
avant que le grant turc ap
pelle Bazac entreprint con
quester grant partie des ter
res obeissans au roy de hon
grie et amassant tresgrant

and destroy Hungary, which is, after France, England and Spain, one of the most powerful Christian countries, he was deeply grieved, and, therefore, laboured with all his might both in speech and letter to stir the courage and will of the excellent princes, knights, squires and people of France so that they might commit themselves to helping the king and people of Hungary.

And so John, then count of Nevers,[641] the eldest son of Duke Philip and subsequently himself duke of Burgundy, decided and promised with the permission and approval of Duke Philip, his father, that he would go with a great company of knights, squires and other men to bring succour to the Christians of Hungary against that great and long-standing enemy of the holy Christian name, Bayezid.[642] And thanks to the example and prayers of John of Nevers and to their faith in the very holy Catholic religion and their compassion for it, a very great number of noble and valiant Frenchmen vowed to undertake this expedition. And amongst them were the brothers Henry and Philip of Bar, the sons of the duke of Bar and relatives to the king; Philip of Artois, count of Eu and constable of France; and the count of La Marche, these latter both being cousins of the king. They were joined by lord of Coucy, who was count of Soissons and in all the world the man most renowned for feats of chivalry whether by land or sea; John of Vienne, admiral; and John of Boucicaut, marshal of France; the lord of La Trémouille; the lord of Hugueville; and many other knights and squires numbering one thousand of the flower of French chivalry, all very valiant in arms and renowned for their prowess.

A number of the above-named brought with them at their own expense many other noble knights and squires and men-at-arms, notably Marshal Boucicaut, who brought seventy gentlemen at his own expense, of whom fifteen were knights related to him, such as Le Barrois, and John and Godemart of Linières, Reynald of Chauvigny, Robert of Milly and John of Egreville. And when the count of Nevers and the other princes, barons, knights and squires who planned to depart with him were ready, they took their leave of King Charles, the dukes of Berry and Burgundy and other princes and set out as directly and hastily as they might on their way and thus, coming to Germany and passing through Austria and other lands, they soon arrived in Hungary and were received by the king, who came to meet them with a great company of noble knights and led them into his city of Buda.[643] There he received them solemnly and with great joy, above all others prizing the count of Nevers for his lofty French lineage, the count of Eu, the lord of Coucy, the admiral of Vienne and Marshal Boucicaut, for he had heard of and witnessed their renowned deeds of arms.

Some days after this handsome welcome, Sigismund, knowing that they longed for nothing so much as to essay their army against the enemies of the faith, mustered his entire army, in which there were some one hundred thousand horsemen, to move towards the Saracens, who were fast advancing, as he was told, and led his whole army across the great river Danube. On the far bank was a town called Vidin[644] held by the Turks, before which the king of Hungary encamped his army, expecting to assail and take it by storm, to which end the day after their arrival, the counts of Nevers and La Marche and a number of others were knighted. Thereupon the French and Hungarians began to attack the city from all sides and in fine formation to combat those who defended it, though they did not long defend it, for soon after the emperor of the region,[645] who was a Greek Christian and had been subjected by force to the Turks, came forth to surrender the city and, moreover, to hand over all the prisoners of the Turks that were held within the city.

Vidin having thus surrendered to the king of Hungary, he forthwith set out with all his Hungarians and a part of the French force to besiege another city, called Rahova.[646] No sooner had the count of Eu and Marshal Boucicaut discovered that the king was considering marching in that direction than they attempted to precede him and were accompanied by the Philip of Bar and the count of La Marche, the lord of Coucy, the constable of Eu and many other French barons, knights and squires. Since they were well mounted, they rode all night and by morning had reached the city of Rahova. At the sight of them, the inhabitants sallied out in great numbers to break down a fixed bridge over a deep moat that prevented any approach to the city walls. For this moat was so well made that only by the bridge could one reach the other side. But hasten as the Turks of the city might, they could not prevent the French arriving before the bridge could be demolished. Therefore, there began a fierce battle during which the Turks, with excellent discipline, committed a part of their troops to the destruction of the bridge, while the other part fought our men; but they fought in vain, for Marshal Boucicaut had asked the count of Eu, the head of the whole enterprise, to be given the task of guarding the bridge, and he took it and defended it though the great multitude of Turks made this very difficult.

Finally, the bridge was secured by Boucicaut and the other Turks were by the great valour of the count of Eu and the other Frenchmen driven back into their town before which that day came the king of Hungary and the count of Nevers with their men. The king and the count forthwith set out their men before the city in order to attack it. They had not completed this operation before Marshal Boucicaut, who had very

quickly had two ladders built, was amongst the very first at the walls of the city with his men. Their boldness encouraged the others, who followed and strove to mount the walls via the ladders but at last, after many had been killed or wounded in this assault, one of Boucicaut's ladders was smashed by a large stone and Hugh of Chevenon, the marshal's squire, who was carrying his standard, had it snatched from him at the summit of the wall and was thrown back with the other ladder, falling to the depths of the moat; it seemed his body was all broken into pieces, but he was rescued and carried to safety and later he recovered. And so this assault lasted all day and only at nightfall did the king of Hungary withdraw the assailants. And though Boucicaut and his men had begun and continued the attack, they were amongst the last to retreat. And despite their having performed marvellous deeds of valour and borne innumerable blows, they sought not rest but permission to guard the bridge and did, indeed, guard it all night lest the Turks and others of the city should make a sudden sortie and destroy it. They easily obtained this permission because no one else had any desire to undertake so dangerous a task.

When morning came and our men were expecting to continue their assault, certain of the principal Christians of the city, who were of the Greek denomination, realising that whatever the strength of the city they could not long hold out, came out of the city and offered its surrender to the king of Hungary. Considering that on the one hand so great a city would not be captured without great expense in blood and on the other that most of the inhabitants were Christian, he accepted their offer and sent Marshal Boucicaut within to ensure that no ill befell the Christian citizens, a task that he performed admirably. Thus, the Greek Christians surrendered the city and handed over to the king of Hungary all the Turks of the garrison, whom he put to death.

Now, he and his army set off to besiege the stronghold of Nicopolis. On this road, the count of Eu, Marshal Boucicaut and other French lords and their men took watches and undertook sorties, discovering the ambushes of the Turks, who were attempting to surprise the Christian host though in this they had little success, for the French killed so many of them and showed such audacity that the Hungarians became more bold and valiant than they had ever been and greatly praised the renowned strength and valour of the French. And with their assistance, the king of Hungary and his army besieged the mighty city of Nicopolis in the year 1397,[647] which they did for fifteen days,[648] during which he had two mines made that reached as far as the walls and were so wide that three men could fight in them side by side.

But alas! How it pains me to recount! While he and the French were intent on

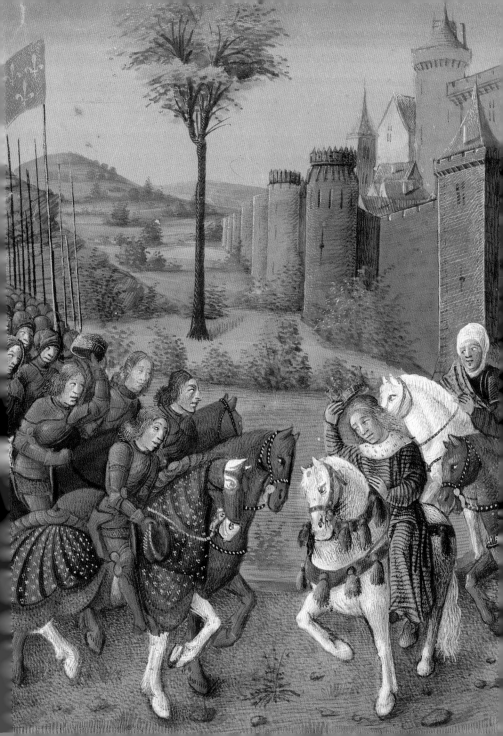

making various siege-machines to storm the city, the Great Turk called Bayezid and his allies were mustering in Turkey and the neighbouring vassal countries an innumerable army intended to raise the Christian siege and so secretly approaching that the king of Hungary had no news of them till this great army was very close to Nicopolis, despite the fact that he had sent and was sending spies continually to all parts of the surrounding country. And it is not known whether the spies betrayed him, for he knew nothing of the coming of Bayezid till the fifteenth day of his siege of Nicopolis and, therefore, was not on his guard against Bayezid or the other Turks. Nor were the French confident that, if anything should happen, they would learn of it in time from the Hungarians.

But when, on the sixteenth day,[649] around the time of the evening meal, there came in great haste a number of messengers to the king of Hungary telling him that Bayezid with his innumerable army was so close to them already that he and the French lords would scarcely have time to arm themselves, he was thunderstruck. And therefore, he had the order cried through all the tents that all should arm themselves and forthwith assume their formations and sally forth into the field to combat the Turks, and his own men obeyed him so quickly that each ran to arm himself as fast as he could, so that the king of Hungary and his men were already in the field all armed and in battle formation when one came to the count of Nevers to announce this to him and the other French lords, who had just cause for complaint that they had not sooner been informed. Yet they made such speed and diligence in arming, dressing and mounting that they were within a few hours ready to enter battle alongside the Hungarians and their king, whom they found already disposed in handsome battle order before the banners and standards of the Turks, who had now approached so near that they could see them with the greatest ease.

Now let me inform the reader of this present *Expeditions Overseas* – amongst which expeditions my aforementioned master, the lord of Châtillon, wanted me to give penultimate position to this Hungarian expedition, since it was undertaken against the Turks, the principal enemies of the Christians of Outremer – that it is my intention to follow as closely as possible the noble orator and author of the book known as the *Livre de Boucicaut*,[650] since the marshal, under whose eyes and in whose lifetime he composed this book, and who lived to see it completed, was one of the principal knights after the great French princes who accompanied, made and witnessed this expedition to Hungary and its upshot. And since he was so renowned for his deeds at arms, it is hard to believe that having seen and examined the book he would have allowed to remain within

it anything but the truth, whatever others have chosen to say or write about the griev-
ous battle of Hungary. Therefore, in following the said author, it is my intention to add
only some very few things that I know are not discordant with his account and that
he omitted only in order to avoid prolixity.

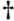

Chapter LXXXIV.
The disposition of the dreadful battle of Hungary. The cunning of the Turks. The boldness of the French. The contemptible flight of the Hungarians and the defeat inflicted on the Christians after the great numbers of Turks killed by the French, and the terrible martyrdom by which Bayezid put to death many true Christians.

The king of Hungary, having already set out his battle lines, called into separate
council the count of Nevers, the count of La Marche, the Bar brothers, the lord
of Coucy, the admiral of Vienne, Boucicaut, the lord of La Trémouille and the other
barons and argued that it would be best if he and his men formed the vanguard and
attacked the Turks first, both because the Hungarians had long since learned the best
way to combat the Turks and would, therefore, endure the onslaught the better and
because he knew that his men of Hungary were so lacking in courage that, should they
be placed in the rearguard and observe that the French in the vanguard seemed
in difficulties or had retreated a little because of the great multitude of Turks, they
would be so terrified that they would immediately take flight and leave the French
to be killed in the midst of their enemies. But if the Hungarians took the vanguard and
it then happened that they wished or attempted to flee the strength of the Turks, they
would be unable to do so, for the French who remained in the rearguard would force
them to turn back against the Turks, who would undoubtedly be defeated in this way
nor could they be defeated in any other way.

On hearing this, the count of Nevers asked the princes, counts, barons and knights
of his company to say what they thought of the argument and request of the king
of Hungary. Then, Philip of Artois, the count of Eu and constable of France, said that
the French would be for ever dishonoured if they accepted the request of the king and
that it was known that they were since time immemorial accustomed to be the first
in all the battles that they fought or ever would fight because of their widely famed

valour. The count of Eu having thus spoken, the count of Nevers asked the lord of Coucy what he thought; he replied that, saving the honour of the count of Eu, it was his view that they should accept the request of the king of Hungary, nor should they doubt that he said anything but the pure truth, for he was a most chivalrous king and well acquainted with the mettle of his people. But immediately the view of the lord of Coucy was contradicted by a knight of the company who said loud and clear that it seemed that this time the lord of Coucy was afraid, he who had always had the repute of valour to equal the most excellent knights then living in France or elsewhere in the world, and this the lord of Coucy found hard to bear and he replied (or so it is said) that they would see that day which of the two would be the bolder and that he would direct the head of his horse where the knight dared not maintain the tail of his.

At these words up rose the admiral of Vienne and Marshal Boucicaut, confirming the opinion of the lord of Coucy and seeking to argue by good reasons why it should be followed, but so many of the French there present took the side of the count of Artois that the count of Nevers sought to please them by concluding that the French should have the vanguard and said to the king of Hungary that he should not be offended and that with the help of Our Lord the Hungarians should have no occasion to take flight. At this the king of Hungary was greatly displeased, for he knew that the day was a perilous one for the Christians but he was nevertheless unwilling to reject the conclusion of the French both because of their great nobility and renown and because they had very generously come to the aid of Hungary from their very distant land.[651] And so the count of Nevers entrusted the standard and banner of Our Lady to John of Vienne, the admiral of France, who was one of the boldest and most valorous knights in the world and who was in many regions both this side of the sea and beyond highly renowned for his feats of arms. And it is the ancient custom of the French to have the banner of Our Lady in their great battles and have it borne by one of their most renowned knights.

And whatever others may have said or written, the French did not go into this battle by groups of ten or twelve or in any other form of disarray, but were extremely well ordered and in serried ranks before they marched against the Turks, who practised great cunning in order to deceive our men. For a multitude of Turks on horseback placed themselves in a great battalion directly before their foot soldiers. And behind these cavalrymen and between them and the foot soldiers they planted a great number of sharpened stakes prepared for this purpose; they were fixed in the ground at an angle, with their points turned towards our men at just the right height to reach the belly of

a horse. And when they had accomplished this – which did not take long because they had assigned many soldiers to place them – our men were already moving towards them at the trot in serried ranks and were very close. When the Turks saw that our men were sufficiently close, all those of the horse battalion turned in serried formation, like a cloud, placing themselves behind the stakes and behind their foot soldiers, amongst whom were as many as thirty thousand archers disposed in two fine battalions just far enough apart to accommodate a battalion of cavalry between them.

Now that our men were close and expecting to come to grips with them, the archers began to fire volleys of arrows at them with such violence that never did hail or raindrops ever fall so densely from the sky as did arrows fall on the French, killing great quantities of men and horses. And the Hungarians, who it is commonly said are not tenacious in combat and do not know how to inflict harm on their enemy unless it be on horseback and firing their bows and arrows forward and back as they flee, saw what was happening in this attack. A great number of them began to fall back for fear of the arrows and to retreat like the cowards that they were. But Marshal Boucicaut and the other French knights, not seeing the cowardice of the Hungarians at their backs (a thing for them unimaginable) nor seeing before them where the stakes had been planted with such great cunning by the Turks, were reluctant any longer to serve as targets for the Turks. Now up spoke Marshal Boucicaut: "My fine lords, what are we doing here? Shall we allow ourselves thus to be riddled with arrows, to be killed like cowards and do nothing about it? Let us come to grips with them in all haste! Let us boldly attack and so we shall have an end of their arrows!"

And then the count of Nevers, trusting in the opinion of Boucicaut, ordered the charge and that he and the other French should advance with all their strength and, consequently, when they came to the stakes, there were many men and horses wounded in the belly and thrown to the ground and killed by the stakes, which were strong and sharp. And though our men were greatly hindered by this obstacle, they nevertheless persevered in their advance. But alas! What a disaster and how different the event! The Hungarians had no sooner perceived that the French, undaunted by either the innumerable arrows of the Turks or their sharpened stakes, had passed beyond both and reached the great battalions of the enemy despite the harm that they had received, when they abandoned the French just as the apostles abandoned Our Lord Jesus Christ when they saw him in the hands of his enemies, and took to their heels in dismal flight when they saw the French plunging into the midst of the Turks. Such was their flight that with our men of France there remained of all the Hungar-

BATTLE OF NICOPOLIS (1396). BAYEZID I
MASSACRING CHRISTIAN PRISONERS

*"Alas! How pitiful! The noble and renowned French being
thus surrounded in the midst of a very great multitude of their enemy
with no help coming from anywhere had fallen into the maw of their enemies
and they were delivered up to their blows like the iron on the anvil."*

(FOL. 266A–266B)

The illustrations presented here by Jean Colombe show the crushing battle of Nicopolis and its disastrous consequences for the Christians. The two armies are drawn up facing each other: Turkish archers can be seen shooting flights of arrows at the Christians. Behind the archers, the Turkish cavalry await their moment to attack. On the Christian side, it is the cavalry that has charged forward, brandishing their swords and led by two knights in bright red armour who are possibly Boucicaut and the count of Nevers. In between the two armies, the artist shows the pointed stakes that have been stuck into the ground by the Turks to wound and kill the Christian knights and their horses. The artist faithfully fol-lows the detailed description of this inci-dent given by Sébastien Mamerot. In the lower miniature, Colombe shows the agony of the Christian prisoners after their defeat. The men's nakedness underlines their helplessness and humiliation as they are slaughtered before the eyes of Sultan Bayezid, seated in his tent; Mamerot com-pares this slaughter to Herod's Massacre of the Innocents. Some 3,000 prisoners were executed; only those members of the nobility for whom a high ransom could be obtained were spared. On the right, they are being sorted and led away. Among their number were the count of Nevers, the future John the Fearless and perhaps Marshal Boucicaut.

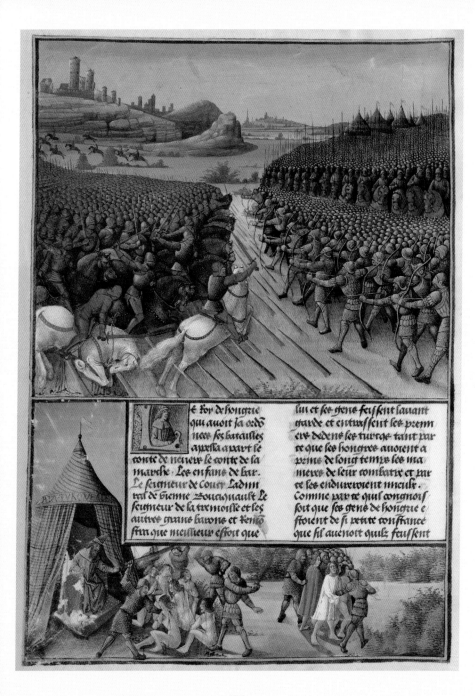

Le roy de hongrie
qui auoit sa oed
nee ses batailles
apella apart le
conte de neuers le conte de la
marche · Les enfans de bar ·
Le seigneur de Couci Ladmi
ral de bienne Boucquault Le
seigneur de la trimoille et les
autres grans barons et Reuo
strin que messieur estoit que

lui et ses gens feissent lauant
garde et entwassent ses prem
cers dedens les turcqs tant par
te que les hongres auoient a
prime de longt temps ses ma
nieres de leur combatir et par
te ses endureroient mieulx·
Comme par te quil congnois
soit que ses gens de hongrie e
stoient de si petite constance
que sil auenoit quilz feussent

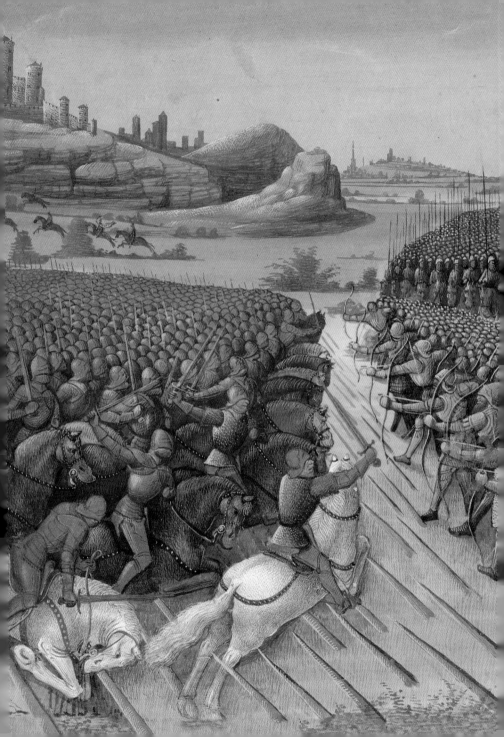

ians but a single lord of that country, a man called the great count of Hungary and his men, along with the foreigners who had come from other countries to take part in this battle, and all these together were very few when pitted against the great multitude of Turks there present.

Despite everything, the true champions of the Catholic faith gave no sign of retreating or of dismay at the flight of their disloyal allies. Rather, quickly passing the stakes, they charged with great impetus and marvellous valour into the heart of the very numerous Turks, showing as they have always shown from time immemorial – to which the glorious feats of arms recorded for their great excellence in the histories of all nations bear witness – that there is no people and there are no soldiers of such great strength, audacity and constancy in battle as the French have been and still are to this day. And it is rare that in any true chronicles they are said to have been defeated or conquered unless by base treachery on the part of their captains or those who should have led them. And it is true that they, when they are allowed excessive leisure and are not occupied with military matters, sometimes fail because of their captains' lack of sense or leadership, and great harm comes to their happy kingdom when this is so. For they are very often enriched, ennobled and decorated with the great wealth and riches from the great empires, kingdoms and regions that they have so admirably brought under their sway. You need hardly ask whether the memory of their renowned predecessors and the losses already inflicted on them that day urged them to redouble their strength and their courage at this very grievous battle. And at first they made such a terrible massacre of the Turks that they inspired wondrous fear in the rest. To be brief, there can be no doubt that if the Hungarians had followed them and taken heed of their splendid feats of arms and audacity, they would have entirely defeated the army of Bayezid that day.

He himself was in the rearguard and was dumbfounded on hearing that the French were no more than eight thousand and yet showed no sign of taking flight but were so bold, strong and courageous that they had already killed more than twenty thousand Turks and had put to flight his first battalion in which were three times as many Turks as there were Frenchmen in the French ranks. Indeed, he was so frightened by the great valour of the French that neither he nor his great cavalry battalion dared attack our men, but were, indeed, fleeing when messengers came to tell him that the French who thus fought so fiercely were few in numbers and they had no help from anyone and how the king of Hungary and all his men had fled and abandoned them and that his honour would be lost for ever if he did not turn and face them.

At this Bayezid took new heart and disposed his battalions in the shape of a shield with the wide side to the fore, so that when the French, who had done such execution in his vanguard, sought to attack the rearguard, where so many Turks remained, the two ends of his lines could open and embrace and enclose in their midst the small number of Frenchmen, and this they succeeded in doing. Indeed, they did it very easily, charging down on our men who must, in reason, have been much wearied and overburdened by the great feats of arms that they had done throughout the day. And they were so few that there were more than twenty Turks for every Frenchman and the Turks, man and beast, were rested and going fresh into battle.

Alas! How pitiful! The noble and renowned French being thus surrounded in the midst of a very great multitude of their enemy with no help coming from anywhere had fallen into the maw of their enemies and they were delivered up to their blows like the iron on the anvil. And yet they defended themselves by prodigious feats of arms though this day, which was the Monday before the feast of Saint Michael in 1396, was finally lost and the victorious Turks killed most of them, though they defended themselves valiantly to the death. However, some seeing that there was no other recourse took to their heels and escaped, but very few, and the others were captured and taken alive. Amongst those who were saved from death and taken prisoner were the count of Nevers, the count of Eu, the count of La Marche, the lord of Coucy, the lord of La Trémouille, Marshal Boucicaut, the two sons of Bar and some few other barons, knights and gentlemen, who had defended themselves beyond all counting, rather desiring to die at arms while fighting for the holy Catholic religion than to come into the hands of such inhuman enemies as were Bayezid and the Turks. And it is true that many shortly afterwards departed this life, undergoing a cruel martyrdom.

For when the morrow came and Bayezid had seen on the field where the battle took place that so few Christians, they being no more than eight thousand, had killed more than thirty thousand Turks who all lay dead where they had fallen, he was thoroughly enraged and out of baneful fury had erected there one of his pavilions. And when he had seated himself in a great and richly decorated throne, he had all the prisoners brought before him just as they were, in their doublets or partly naked, bound with cords, thinking to avenge the death of his men. And while he had them so brought, it is said that on the good lord of Coucy, who was all naked like the others, a cloak was thrown so suddenly that no one saw who had thrown it and it was believed that this tribute and honour had been divinely sent to him in remembrance of the glorious deeds undertaken by him overseas on several occasions to defend and enlarge the holy

Catholic faith. And when they were all before Bayezid and he discovered by his interpreters that the count of Nevers was the grandson of the king of France and second cousin to King Charles VI then reigning and that Philip, the duke of Burgundy, his father, was a prince of great power and wealth and also that the sons of Bar and the counts of Eu and La Marche were also close relatives of the king, he began to think that for their ransom he would earn a very considerable treasure. Therefore, he decided that they would not be killed, but that he would keep them prisoners and some other of the greatest barons amongst them.

So he made them sit down on the ground before the throne in which he was seated. And in just such manner as the cruel King Herod is described having the Innocents cut into pieces, thus were led before him, all naked, the very faithful Christians. And in the presence and under the eyes of the count of Nevers and the other counts and barons seated on the ground, each was led forward, their heads, necks, shoulders, waists, arms, thighs and legs being cut off by the inhuman Turkish eputxecutioners with axes and great knives wielded with insatiable cruelty. It is easy to imagine how pitiful and docile were their expressions as they were led forward in that piteous procession. For just as the butcher drags the lamb to the place of its death, so were the good and faithful martyrs led forward and put speechless to death before the arch-tyrant Bayezid.

And in this holy procession Marshal Boucicaut was led forward all naked but for his breeches so that he, too, might be martyred like the others. But God, who wished to save him so that he might avenge on the Saracens the deaths of this holy company – as he later did – moved the count of Nevers to look the marshal most piteously in the eye, and he the count, as he was about to be struck. And then, there came great pity over the count of Nevers that so excellent a knight should be thus cruelly put to death. Therefore, joining the two fingers of both hands together, he looked at Bayezid, signalling to him that this was his own brother and that he should spare him, and Bayezid, understanding the gesture, did so. And when all the Christians who had been taken in this dreadful defeat, with the exception of the count of Nevers and a few other great lords and noble knights and squires, had been thus hacked to pieces, their souls were as one may justifiably suppose translated by this triumphal martyrdom to Heaven. The inhuman arch-tyrant Bayezid then had his prisoners taken to various cities and led his army back to Turkey, where he entered one of the great and wealthy towns of the country, called Bursa.[652]

BAYEZID I RECEIVING THE RANSOMS OF THE CHRISTIAN PRISONERS (1397).
FLIGHT OF THE CRUSADER ARMY ACROSS THE DANUBE (1396)

*"When the duke of Burgundy knew for certain of the capture
of his eldest son, the count of Nevers, he immediately sent to Bayezid
with many rich and handsome presents and the other lords of France related
to the prisoners did the same, begging that he should quickly put the captives
to ransom and they should suffer no ill nor hurt through him."*

(FOL. 268B)

Sébastien Mamerot describes the fate of the Christian soldiers after the disaster of Nicopolis. Some attempted to cross the Danube to get away but were drowned in the broad, treacherous river: Jean Colombe depicts this episode in the lower register. In the principal picture, he shows how the Christians are forced to pay huge ransoms to Bayezid to free the prisoners. Certain details suggest the exotic character of the palace: the sheen of the vividly coloured, decorated columns that separate the room from the outer wall, the heads of wild beasts carved beneath the coffered ceiling, the pink pavement that echoes the colour of the vaulting. The Turks' costumes are outlandishly coloured: their long beards and pointed caps show the artist is striving for a realistic portrayal, as do the covetous looks they are casting on the riches being carried in by the Christians. In the middle of the picture, Sultan Bayezid, standing before a throne surmounted by a splendid canopy, is surveying the financial transactions.

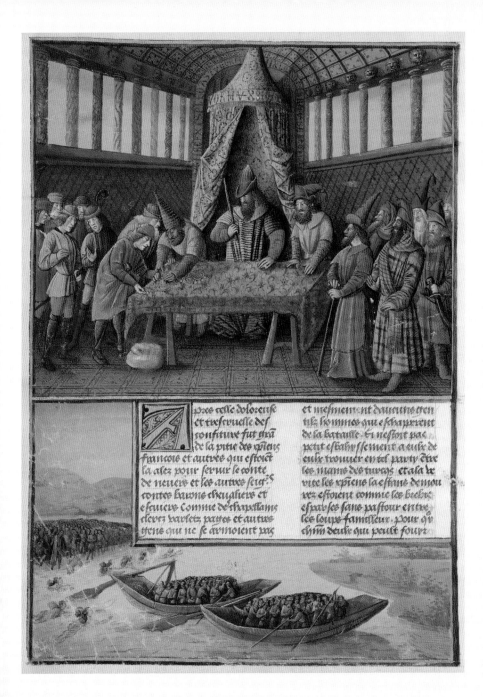

pres ceste doloreuse
et trescruelle des
confiture fut tra
de la pitie des xptens
francois et autres qui estoiet
la asez pour seruir le conte
de neuers et les autres seig̃[r]s
contes barons escuyaliers et
escuiers comme des mxpellans
clercz varletz paiges et autres
gens qui ne se armoient pas

et mesmemẽt dauctins cten
tilz homẽs qui eschapierent
de la bataille. et nestoit pas
petit esbahississemẽt a eulx de
eulx trouuer en tel party etre
les mains des turays. et a la le
uue les xptiens la estans demou
rez estoient comme les brebiz
esparses sans pastour entre
les loups familleur. pour qr̃
chun deulx qui peult fourz

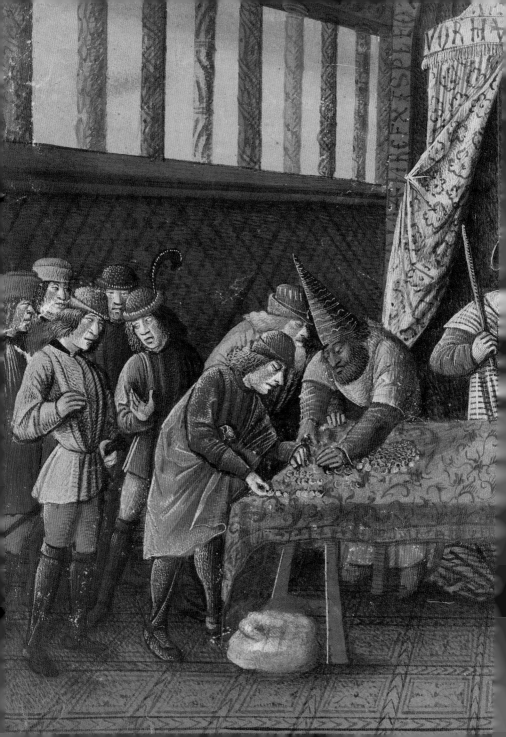

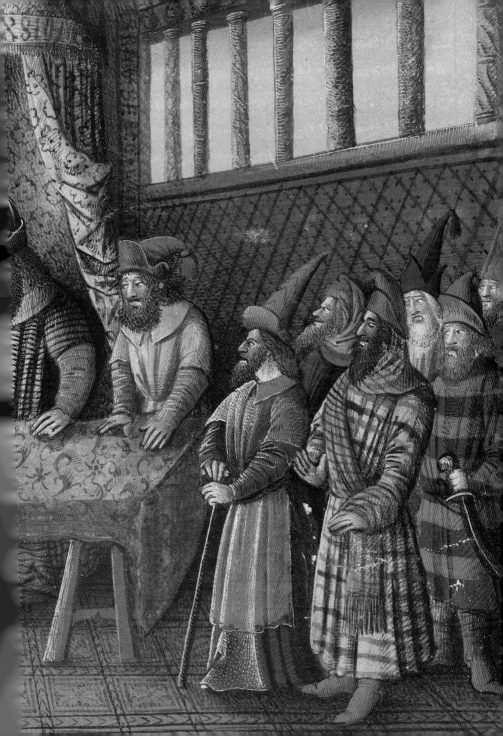

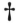

Chapter LXXXV.
How news of this dreadful defeat came to be known in France. The weeping and lamentations that were made. And how the count of Nevers and his companions were redeemed from prison. Of those who died on the return journey and elsewhere, and of those who returned.

After this cruel and painful defeat, there was great pity for the Christians, French and others, who had gone to serve the count of Nevers and the other lords, counts, barons, knights and squires, as, indeed, of the chaplains, clerks, varlets, pages and other men who did not bear arms, and even for the few gentlemen who had escaped from the battle. For they were not a little astounded to find themselves in such a situation and in the hands of the Turks; and in truth, the Christians who remained there were like stray sheep without a shepherd amongst famished wolves.

Therefore, all those who could took flight towards the Danube, fleeing there – mortal fear chases the endangered from one peril to another – as if it had been a genuine refuge in which they might seek salvation. Alas! How painful to recount! The first to arrive there plunged heedlessly into this very perilous river so that they could climb into the boats and so overburdened them that every one of them was close to capsizing during the crossing. And others who could find no place in the boats stripped off their clothes and began to swim, but most of them were drowned because their strength was not equal to the great breadth and power of the river. As to those who by these and similar recourses were able to escape, they included some gentlemen and others who brought the painful news to France, as did the messengers sent by the count of Nevers to the duke of Burgundy, his father, and by the other lords to their parents and relatives. Do not then ask of the lamentations, grief and weeping that were heard throughout the kingdom of France and not without cause. For in this dreadful defeat they had lost the greater part of their especial protectors and defenders and the very flower of their chivalry and, on grounds of length, I refrain from recounting the mourning, both private and general, that was felt by each and every citizen.

When the duke of Burgundy knew for certain of the capture of his eldest son, the count of Nevers, he immediately sent to Bayezid with many rich and handsome presents and the other lords of France related to the prisoners did the same, begging

that he should quickly put the captives to ransom and they should suffer no ill nor hurt through him.

While these messengers came to France and returned, within a few days of their cruel loss, Bayezid was at Bursa and had the prisoners with him. There the count of Nevers, Marshal Boucicaut and the lord of La Trémouille sent to him asking that he should put them to ransom, which he refused to do. However, when the messengers came to him a second time, he was content at the particular urging of the count of Nevers to deliver Boucicaut and La Trémouille and the lord of Helly[653] so that they could go to France and elsewhere to raise the ransom money for the others. But when Boucicaut and La Trémouille arrived in Rhodes, the latter contracted a severe illness of which he died and was there given honourable burial by Marshal Boucicaut, who went from there to the island of Mytilene,[654] whose lord accepted his bill and lent him eighty-six thousand francs for the other French lords. He returned with this sum to the count of Nevers and the other French lords, who were delighted by his sage conduct of the matter.

Shortly afterwards, Marshal Boucicaut went to Bayezid and paid him his entire ransom. Bayezid was pleased with him and gave him letters allowing him to leave freely whenever he wished, but Marshal Boucicaut was unwilling to return to France without the other lords, often speaking to Bayezid, trying to persuade him to have them ransomed. But the sultan would not be persuaded to do so; he wished to put them all to death, saying that if he delivered them for money or in any other fashion, they were such great lords and so courageous that they would stir the entire French kingdom to take up arms against him and would bring such a great army that they might destroy him to avenge the defeat that he had inflicted on them. Eventually, the lord of Hely, who spoke good Turkish, and was well known to Bayezid, together with Marshal Boucicaut so parleyed and argued with him that he agreed to their deliverance on payment of a million gold écus. And the reasons put forward by these two knights at last brought the sum down to one hundred and fifty francs, which the count of Nevers and the other lords agreed to pay and swore to Bayezid that for the rest of their lives, they would neither bear arms against him nor cause arms to be borne in their stead, for otherwise he would never have released them. And only because they swore this oath was he willing to come down to the sum of one hundred and fifty thousand francs. Of the French lords thus put to ransom, Philip, count of Eu, the constable of France, died in prison. His companions with great lamentations and regrets buried him in that country as honourably as they might, whence he was afterwards carried

BOUCICAUT BEFORE THE KING OF FRANCE.
NAVAL BATTLE BEFORE GALLIPOLI

"Shortly after the count of Nevers was sent back to France,
there came an ambassador named Kantakouzenos from the emperor
of Constantinople, whose name was Manuel II Palaeologus,
petitioning King Charles that he might, for the honour of the Christian
religion and the love of Our Lord Jesus Christ, bring him succour
and aid against the Turks, for otherwise the entire Greek empire
would soon be lost; he could no longer hold out against them."

(FOL. 269VA–269VB)

When Emperor Manuel III Paleolo-gus was threatened by the Turks, he sought help from the king of France to save the Greek empire. In the lower register, Charles VI is shown calling his council together to discuss ways in which they can go to the emperor's aid. It is at this moment that Marshal Boucicaut, who has returned from Guyenne, leads in a prisoner, the count of Pierregort, who has led a revolt against the king. Jean Colombe shows Boucicaut kneeling before the throne; he is indicating by a hand gesture that the prisoner is following him. The principal picture shows the French fleet sailing towards Constantinople. The heavy, wide-bodied galleys are laden with men, horses and shields. The sails swell in the wind. One of the ships is sinking – the main mast has broken. Here, Colombe undoubtedly intends to show one of the Turkish ambushes launched near the port of Gallipoli.

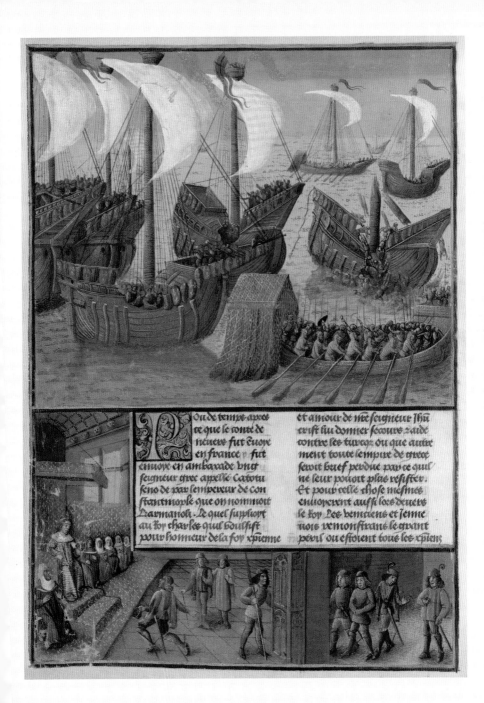

Ou de temps aprés
ce que le conte de
neuers fut enuoye
en france y fut
enuoye en ambaxade vng
seigneur grec appellé Cabou
seno de par lempereur de con
stantinople que on nommoit
L'armanoli. le quel supplioit
au roy charles quil touluist
pour honneur de la foy xpienne

et amour de me seigneur Jhu
crist lui donner secours et aide
contre les turcz: ou que autre
ment toute lempire de grece
seroit brief perdue par ce quil
ne leur pouoit plus resister.
Et pour celle chose mesmes
enuoierent aussi lors deuers
le roy les veniciens et senne
nois remonstrans le grant
peril ou estoient tous les xpiens

to France, where great sums of money were amassed to redeem the count of Nevers and his companions. These took an oath before Bayezid that they would never again make war on him. And the count of Nevers forthwith sent Boucicaut to Constantinople to find some way of obtaining the money for their ransom, a task that he accomplished admirably.

Meanwhile, there came envoys from France of whom the most prestigious were the lords of Châteaumorand and Vergy, who brought money and news, for which the lords received them with great joy and sent them afterwards to Bayezid, to whom they presented rich and beautiful gifts, jewels and presents on the part of King Charles and the other princes. Amongst these presents were the most beautiful goshawks imaginable, the gloves for carrying them being covered with pearls and precious stones that were worth a vast amount; there were also rich fabrics, fine sheets of wool and excellent cloth from Rheims, all of them such things as are not found in those parts without great pain or expense. And the king and his lords sent these presents to Bayezid so that he would be the more courteous and favourable to the prisoners. Moreover, the envoys paid the entire ransom. And so Bayezid freed the count of Nevers and all his companions and gave them leave to go with letters permitting them to pass his borders whenever they wished. They took their leave of him and came by sea to Mytilene, where the lord received them and fêted them; and they also thanked him for the great assistance he had given them and then set sail for Venice, near which city, in a town named Treviso, Henry of Bar died and was honourably buried, he who had as his wife one of the daughters of the lord of Coucy, with whom he had two daughters. After the burial, the lords went to Venice and there were held hostage for four months till money was sent from France, with which they acquitted their pledges and partly paid off their creditors. Then, they returned to France[655] and appeared before the king, who received them with great joy and feasted them at length as did the dukes of Berry and Burgundy and the other lords. And so ended the dolorous expedition to Hungary, which proved so prejudicial to the excellent kingdom of France.

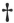

Chapter LXXXVI.
How the emperor Manuel II Palaeologus of Constantinople enlisted the help of the French. Of the voyage of Boucicaut. Of his victories at sea. And how he arrived in Constantinople.

Shortly after the count of Nevers was sent back to France, there came an ambassador named Kantakouzenos[656] from the emperor of Constantinople, whose name was Manuel II Palaeologus,[657] petitioning King Charles[658] that he might, for the honour of the Christian religion and the love of Our Lord Jesus Christ, bring him succour and aid against the Turks, for otherwise the entire Greek empire would soon be lost; he could no longer hold out against them. And for this same reason, the Venetians and Genoese also sent to the king, arguing the great peril in which all the Christians of Greece stood and offering assistance commensurate with their power if the king would undertake his part of the matter: each of the two cities would provide eight fully equipped galleys to supply this help. And they assured him that the people of Rhodes would also commission galleys to answer this need.

Now the king, who, following the custom of his predecessors, wished with all his might to maintain and defend and safeguard lands overseas that owned obedience to Christian princes, summoned his council. And while he was considering the nature of the aid that he could send and whom he should set at the head of it, there came before the king Marshal Boucicaut, who had returned from Guyenne, bringing with him his prisoner, the count of Pierregort, whom he had captured by force of arms, Pierregort having rebelled against the king. At this, it was agreed by the king and his council that Boucicaut would make the expedition to Constantinople and that the king would provide four hundred men-at-arms and four hundred varlets and a quantity of archers with money for their payment. Marshal Boucicaut was delighted to undertake this expedition as he desired above all things to go where he could obstruct Bayezid and the other Turks, to avenge not only the wars and devastation that they were striving to do and were, indeed, doing to Christians, but also the ill deeds that they had done in Hungary. And therefore, he did not rest till the men and money were delivered, indeed, he was so active that his galleons, galleys and other ships were ready and provisioned at Aigues Mortes to make this voyage by the summer feast of Saint John and

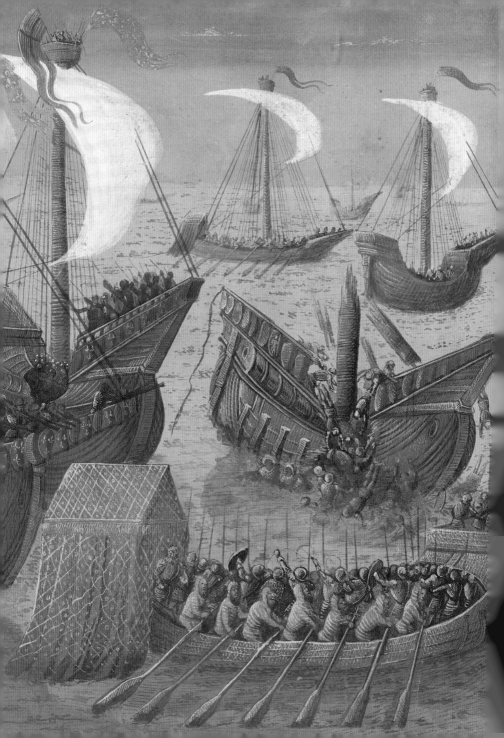

he himself arrived there two days later. And there, loading four ships and two galleys and accompanied by such noble and valiant men as the lord of Linières; John of Linières, his son; the lord of Châteaumorand; the hermit of La Faye; the lord of Montenay; Francis of Aubissecourt; Robin of Braquemont; John of Torsay; Louis of Culan; Robert of Milly; Louis of Cervillon; Renaud of Barbazan; and Louis of Ligny, all of them knights, and many other good and valiant knights and squires, he put to sea and reached Saonne, whence departing he went to a city of Sicily named Messina, staying there only briefly before going on to Chios, where he expected – this is what he had been told – to find the eight Venetian galleys that were to be sent to the aid of the emperor. He was told that he would find them at Euboea and so again set sail, passing through Mytilene, whose lord received him with great joy, though telling him that he had apprised the Turks of his coming in order that he should not seem to infringe the covenants and pacts that he had made with them. But Marshal Boucicaut courteously told him that he was not at all offended. In short, the lord of Mytilene, knowing the great sense, courage and courtesy of Boucicaut, said that he would leave with him despite the treaties that he had with the Turks.

Finally, the marshal, leaving Mytilene, led his army to Euboea but the Venetian galleys were not there. On which account, he decided to wait a little and in this time had two galleys commissioned, appointing captain of one of them the lord of Châteaumorand, who had with him amongst other nobles John of Ony, a very valiant man and esquire to the duke of Burgundy, and of the other the lord of Torsay, sending them to Constantinople to inform the emperor of his arrival so that he could prepare his men-at-arms for an attack on the Turks. And when the galleys left the port of Euboea, so that they should suffer no impediment, the marshal led them in convoy till they were within sight of Gallipoli and did not move from thence so that he might aid them if anything happened. And their need was great, for the Turks, who knew of his coming, had two ambushes of twelve galleys laid in hope of surprising him, one of them in the port of Gallipoli (where there were many other vessels) and the other laid above the city on the route to Constantinople. So it happened that as soon our two galleys went beyond Gallipoli,[659] the seven galleys in the first ambush were sent after them and immediately they saw coming towards them the other detachment in the which there were five galleys and so found themselves in the midst of their enemies, nor could they imagine any other recourse than to turn back towards the marshal. But to do this, they had to pass through their enemy's ships. And so they were no sooner in the midst of them than they were assailed on every side, but our men were full of courage and

set about their own defence vigorously and fought them off with such might that they could in no wise stop them. On the contrary, in the teeth of their attack they nevertheless extracted themselves, still fighting, though the Turks tried to halt them. But they were unable to do this, for our men, fighting as they came, reached a place so close to where the marshal was that he heard the sounds of the battle and, therefore, without delay he came forward in fine formation against the Turks to help our men, who were by now so weary that they could hardly defend themselves. For there were so great a number of Turks that the marshal was advised that he should not advance and that it was better to lose two galleys than his entire force. The marshal bitterly rebuked those who had given this counsel and replied that he would rather die than see by his own fault his own company die and perish, and he had rather that God ended his life before such villainy could be found in him. Having thus spoken, as quickly as he could, he threw his ships amidst the Turks with such countenance and boldness that they were terrified and left the two galleys in peace, thinking of nothing but flight in the hope of saving their lives, and fled so heedlessly that the largest of their galleys struck land and broke up so suddenly that the great numbers of Turks sailing in it were drowned or gravely wounded. And thus Marshal Boucicaut saved his two galleys and went to spend the night in the port of Bozcaada before Troy the Great.

The following day, there arrived the Venetian galleys with two from Rhodes and a galiot from the lord of Mytilene and shortly thereafter came the Genoese ships that were to go to the help of Constantinople. And the marshal was made chief and leader of this entire company by the goodwill and consent of one and all. There he set out his ships and entrusted the banner of Our Lady to Peter of Grassay, a knight renowned and valiant amongst all those of his company. And the following day, when mass had been sung, the marshal departed with all his company and did not stop till he had reached Constantinople, where he and all those of his army were received by emperor Manuel with great honour and rejoicing and were nobly feasted.

✝

Chapter LXXXVII.
How the army of Boucicaut together with the Greek army made great raids on the Turks. Of several towns and castles that the Christians took from the Turks by force of arms. And of the peace that the marshal made between the emperor and his nephew.

Well before the arrival of Boucicaut in Constantinople, the emperor Manuel had known that he must soon arrive with a great company of fine men-at-arms. And so the marshal found that the emperor had already prepared his army and mustered his men-at-arms so that there should be no delay for Boucicaut after his arrival. Therefore, on the fifth day after his arrival, the marshal assembled for inspection all the men in this army in a handsome fortress and found that they were in number six hundred men-at-arms, six hundred armed varlets and one thousand archers, not counting the assembled army of the emperor, in which there were many men, and there he instructed them on the formation in which they should advance and named his captains and gave them charge of men in accordance with his knowledge of their worth and their capacity to perform their task. The emperor set sail with this company in which there were twenty-one fully equipped galleys and three great *galées huissières* laden with some one hundred and twenty horses and in addition six smaller ships, galiots and *brigantines*, and they all landed in Turkey in a place called Pas de Narettes and went about two leagues inland, destroying, burning and razing the whole coastline – and there were many good villages and fine houses – and putting to the sword all the Turks they found. Shortly afterwards, they again crossed over into Turkey and went a good two leagues from the shore to destroy a big village lying on the gulf of Nicomedia,[660] called Daskily. But there they found a great number of local Turks who hoped to guard the village against our men; they were all in formation, mounted or on foot, assembled before it with such arms as they could find. Yet their defence counted for little, for they would all have been in short order killed and captured had they not fled, and, indeed, they could not so quickly flee so that a large portion of them were put to the sword. And in this village, there were many fine houses and a rich palace that had once belonged to Bayezid. But our men burned and razed and destroyed the entire village and others in the region and then retired and sailed all night. The next day, they sought to land

"Therefore, on the fifth day after his arrival, the marshal
assembled for inspection all the men in this army in a handsome fortress
and found that they were in number six hundred men-at-arms,
six hundred armed varlets and one thousand archers, not counting
the assembled army of the emperor."

(FOL. 272A)

This miniature is devoted entirely to Boucicaut, the renowned marshal of France. He is portrayed in the historiated letter "G" at the beginning of this chapter and is placed at the centre of the scene in the principal picture, reviewing the troops under his command. In the foreground, the blue of the massed foot soldiers contrasts with the brown, highlighted by glistening golden flecks, which distinguish the cavalry and their mounts. The composition is a pleasant blend of the armies, drawn up in open country near Constantinople and forming the essential element of the picture, and the roofs and large buildings in the distance, which suggest an imposing city. In the lower register, Boucicaut, now on foot, is appointing the captains of the army and entrusting their troops to them.

Comment l'armee de souu
quault sonite a celle de suer
fit tresgrans courses sur
les tures. De plusieurs
villes et chasteaulx que les
xptiens pruent par force
sur les tures. Et de la paix
que fit le mareschal souu
quault de sempereur et de
son nepueu. iiij xx z vij.

Vant temps auant
l'armement de
souuignault en
constantinople
auoit bien sceu sempereur ear
manoli quil y seron bref a
tout tresbelle et grant compa
gnie de gens darmes. Et par ce
trouua le mareschal quil auoit
la appreste toute son armee z
fait assembler ses gens darmes

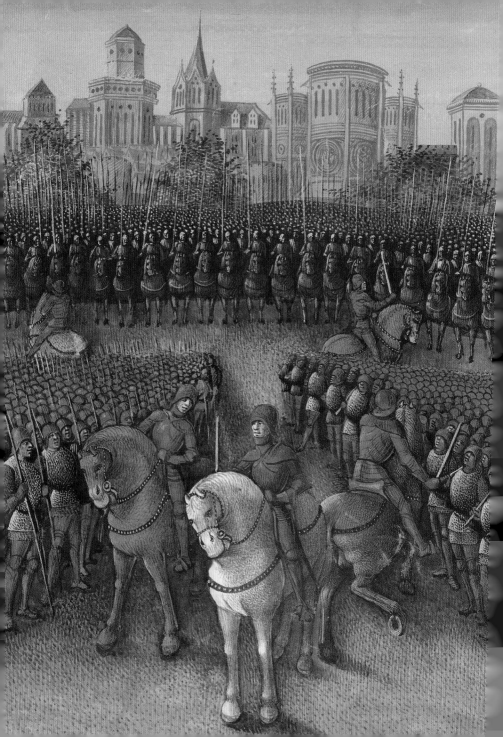

and disembark before the city of Nicomedia, but when they came to land, they met with a fierce attack from a strong force of Turks. Nevertheless, our men landed and valiantly drove the Turks back and went to assail the city in many separate attacks, setting fire to the city gates, which were covered with metal plates so that they could not burn. Therefore, they placed ladders against the walls, which were very handsome, thick and so high that the ladders were too short by more than three yards and so there was nothing that they could do. But they killed all the Turks they could find and set fire to the outskirts of the village and to all the villages in the region.

Then they returned to their ships and sailed all through the night. And when morning came, they landed as close as they could to a big country village called Harem, a good league inland. There all the Turks of the area assembled against us, hoping to prevent us reaching the city, but they could not do so and our men burned it entirely and killed the men they found there and in the whole region. And for this reason, Turks assembled hastily from all sides while our men were returning to their boats in strict formation as they were well advised to do. The Turks came so hard on their heels that several times they made the rearguard turn around as if to give battle, since they were trying by various skirmishes to force our men to defend themselves in disorder and yet they dared not launch an all-out attack. Moreover, darkness was falling and our men were unwilling to spend the night there and, therefore, went aboard their galleys and returned to Constantinople.

There Emperor Manuel and Marshal Boucicaut and the men-at-arms remained for six days and on the seventh day they again set sail and again landed in Turkey and by dawn were attacking a fine castle on the shore of the Black Sea, named Iriva. But the Turks, who had been partly informed of their intention by their spies at sea, quickly sallied forth into the field without seeking to prevent the landing and took up formation before the castle to give battle, for there were at least six or seven thousand Turks. Nevertheless, when they saw the fine and substantial company of our men, they further took all those who remained within to garrison the castle, leaving only a section of their best soldiers and thinking that these would be ample to guard it for a single day against all-comers, for it was in itself so high and strong that it was easy to guard. Then they all formed serried ranks and retreated a little above the castle so that when our men began their assault at the foot of the wall and spread out to attack the castle, they could come down on them so quickly that they would not have time to assemble into battle order, and, indeed, six or seven times that day they thought that they would be able to put their plan into practice. But Marshal Boucicaut had the emperor and the

knights of Rhodes remain in close battle formation before the castle with a consider-
able company of men-at-arms and crossbowmen to prevent the Turks who were close
by from breaking up the assault. And in this formation remained the banner of Our
Lady, firmly in place as it should be.

Having thus arrayed a part of his army, he took the rest of his men and went
to the castle, where he began the attack at dawn. The Turks had with great cunning
made other arrangements to prevent such an attack. For on the side where our men
were to attack, they had built scaffolding on the walls and moats covered with
straw and small branches soaked in water to make them smoke, and when they saw
our men approaching, they set fire to them. But none of this could help them. For the
marshal notwithstanding this led his men immediately to the foot of the wall and quickly
had two mines made there, which were so vigorously conducted that, despite
all impediments, the wall was pierced in two places, which were then the subject
of fierce fighting, for the Saracens defended the breaches with great strength so that
the French were forced to perform prodigies of valour.

Moreover, the marshal had several ladders raised by which the assailants climbed
to the top of the walls where they fought hand-to-hand with the Turks of the castle,
who threw so many large stones down on the ladders that they folded, broke and fell.
And when the marshal, who was always in the front line of the attack, saw that the
ladders could last no longer, he quickly had a very large and sturdy ladder made from
two galley main-yards and this was raised around sunset, and he himself wished
to be the guardian of the ladder. And this he did so well that a very valiant knight called
Guichard of La Jaille climbed it first and fought valiantly hand-to-hand for a consider-
able while against those who were within the castle. The defenders came against him
in such numbers that they tore his sword from his hands and he was forced to come
down, placing himself below a valiant squire, who was till then the second on the ladder,
named Hugh of Thologny; he fought so hard and with such great courage that he first
entered the castle and Guichard after him. And those undermining the walls performed
such feats of arms that they, too, entered the castle, John of Ony first, followed by Fulk
Viguier and then Renaud of Barbazan and the other knights and soldiers. They forth-
with went to the aid of their companions who had come over the castle walls by ladder
and were in dire need of help. For they were no more than ten or twelve fighting
on the wall and the ladder had broken under the great weight of all those who wished
to climb it. And thus, the castle, which had seemed impregnable, was taken and all the
Turks that they found within it were killed. The following morning, Marshal Boucicaut

had the whole stronghold demolished. One of its walls gave onto the sea and along two sides of it a river flowed, so that only one side was not defended by water.

Then the emperor and Boucicaut again set sail to return to Constantinople and, at sunset, arrived before a fine town named Le Girol, at the mouth of the Black Sea. And on the following morning, the marshal had the trumpets sounded so that his men would arm themselves to assail the town. The citizens and Turks within heard this and, having been approzed of the taking of the castle of Iriva and other feats recently performed by Boucicaut's army, they were so terrified that they very quickly started fires in more than one hundred places before fleeing into the mountains, which are very high. Shortly thereafter, the marshal perceived the fire over the walls and ordered that the army should not depart before the town had completely burned down, which it quickly did.

Meanwhile, there came news to the emperor that the Turks had come with twenty ships above the Pas de Narettes, whence they were doing great harm to the inhabitants of Constantinople and the city of Pere, surrounding the entire region and beginning to lay waste the whole land. Hearing this news, Emperor Manuel asked Boucicaut what should be done. He replied that the best thing was to go and meet them in battle, and to this end led his army and men in that direction. But when the Turks were apprised by their spies that the marshal was coming to attack them, they did not dare await him, but took flight and our men burned and destroyed all their vessels and returned thence to Constantinople, where they were received with great joy.

Moreover, Boucicaut never, at that time or previously, remained more than eight days in Constantinople till he had captured from the Turks all the neighbouring strongholds, towns and fortresses almost without exception. He further brought it about that the emperor's nephew, the son of his elder brother, named John Paleologus, who had been making war on the emperor for eight years, claiming the empire as his own by natural succession, came very humbly to ask his uncle's pardon; the latter at Boucicaut's prompting pardoned John his malevolence and restored him to favour. And there should be no doubt that the emperor and all the nobles and citizens of Constantinople loved and esteemed the marshal and all his men and often rendered them humble thanks for his aid. And the truth was that, if Our Lord had not sent them, Constantinople would have been in grave danger of being overcome by the Turks.[661]

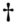

Chapter LXXXVIII.
How the emperor Manuel came to France and the return of Marshal Boucicaut. Of the lord of Châteaumorand and his valiant conduct in Constantinople. And how Bayezid died in the prison of Tamurlane of Tartary and the end of this work on the expeditions to Outremer.

The city of Constantinople was now much afflicted by lack of victuals; moreover, Marshal Boucicaut was running out of money, having been in that region for about a year. Therefore, he and the emperor with the other barons concluded that they should go to France with most of the army, both in order to convince King Charles VI of the great danger that the Christians of Greece were in and to request new help, both in men and in monetary aid.[662] And the emperor left his nephew John in Constaninople, ordering that he should remain there as emperor till his return. And since he was unwilling to remain without some portion of the marshal's men also remaining, he granted him as his lieutenant the lord of Châteaumorand, under whom he left behind one hundred men-at-arms and one hundred armed varlets from amongst his own men and a quantity of fully equipped crossbowmen with sufficient provisions for one year. And he further left money in the hands of rich merchants so that they should be paid monthly for the period of one year. And when the Genoese and Venetians saw what Marshal Boucicaut was doing and his very wise arrangements, they agreed between them that they would leave Châteaumorand eight fully equipped galleys, four from Genoa and four from Venice, so that he could defend the city. This garrison was of great comfort to the citizens of Constantinople, for they were otherwise in despair, having imagined that they would have to flee the city and leave it in the hands of the Turks. But they were sufficiently content with Boucicaut's arrangement that, with their consent, the emperor and Boucicaut recommended them to God's care and put to sea, arriving in Venice, where the emperor wished to stay for a while.

As to Boucicaut, he at his own desire left as quickly as he could for France to make clear what he would ask, and came forthwith before King Charles VI, who was overjoyed at his coming, as were all the princes, great lords and others who greatly honoured and fêted him. After him there came to Paris the emperor Manuel, whom the king received with high honours, making much of him. And he was certainly

a most wise and valiant emperor. Before the king and princes and barons of France, he demonstrated the great peril in which he and the entire empire of Constantinople now stood if it received no help from them and humbly petitioned them for their aid. Whereupon the king held several council meetings, at the end of which it was concluded that, for the good of Christianity and also because all good princes should help one another, especially against the infidel, the king would help him, and so indeed he did. For after he had paid all his expenses from the national purse and had given him great and expensive gifts, he promised to give him one thousand two hundred combatants paid for the duration of one year on condition that Marshal Boucicaut headed that company, as the emperor had himself requested, for he greatly loved Boucicaut. Then, taking leave of the king and the lords, the emperor departed very content with them and visited most of the Christian kings and princes, each of whom gave him great and rich presents, and most especially the Pope, who, opening the treasure chests of the Holy Church, issued a general pardon to any Christian who would aid the emperor with men or money. However, the emperor's pursuit of aid cost him nearly three years.

Throughout this time, the lord of Châteaumorand remained in Constantinople and its vicinity and showed himself an excellent and wise captain. For shortly after the emperor and Boucicaut had left the city, the price of the food rose so high that a great famine broke out and raging hunger forced the inhabitants to climb down cords hung from the walls of the city in order to go to the Turks and surrender. Therefore, Châteaumorand was very vigilant and diligent in keeping a watch so as to prevent the citizens of Constantinople leaving in this way, as, indeed, he was against the same citizens surrendering Constantinople to the Turks or against the Turks entering the city for lack of guards or a vigilant watch. Finally, he found an efficient remedy against this pestilence, for he frequently sent his men to forage amongst the Turks wherever he knew that they had very fertile lands and, whenever they did not adequately guard against him, he did great damage and his men captured good prisoners, whom they ransomed, some for money and some for provisions, and in this way he did so much that, with the aid of Our Lord, the city had its fill of all goods. And in all the time that he was there, no Turkish vessel dared pass close by, for it would be immediately seized by his galleys, which were always on the lookout. And thus, by his diligence, he was constantly winning things from the Turks, against whose power he safeguarded the city for three years, as we have already noted. In short, he and his company did so well, as say and report those who have written the truth about this, being themselves eyewit-

GENOESE AND VENETIAN GALLEYS GUARDING CONSTANTINOPLE.
REVOLT OF THE GENOESE (1461)

*"And in truth, the French have not made any general crusade
to Outremer since the year 1326, when Philip, count of Valois,
Anjou and Maine was made king of France."*

(FOL. 277A–277B)

Jean Colombe's last illustrated page in *Les Passages d'Outremer* indicates a carefully thought-out selection of subjects on the part of the painter. He depicts the situation in Constantinople when Boucicaut has gone back to France and left the city under the protection of the lord of Châteaumorand. Two of the eight galleys that the Genoese and the Venetians have put at the disposal of the governor to protect the city can be seen in the lower part of the page. In the foreground, French auxiliary troops are depicted, whose job was to prevent the starving residents of the city from fleeing and giving themselves up to the Turks. A few of them can be seen on the far left, climbing down the city wall on a ladder. In the upper miniature, Colombe shows a battle taking place before a European city, which is undoubtedly Genoa. In this final chapter, Sébastien Mamerot is in fact recalling the revolts of the Genoese when their city came under the control of the king of France. Louis de Laval, who commissioned Mamerot, had been governor of the city and Colombe shows him in the centre of the picture: mounted on a superb white charger and dominating the mêlée, he can be identified from the coat of arms painted on his armour. By this skilful touch, the artist gives added prominence to the figure of the work's patron while echoing the theme of the dedication scene that opens *Les Passages d'Outremer*.

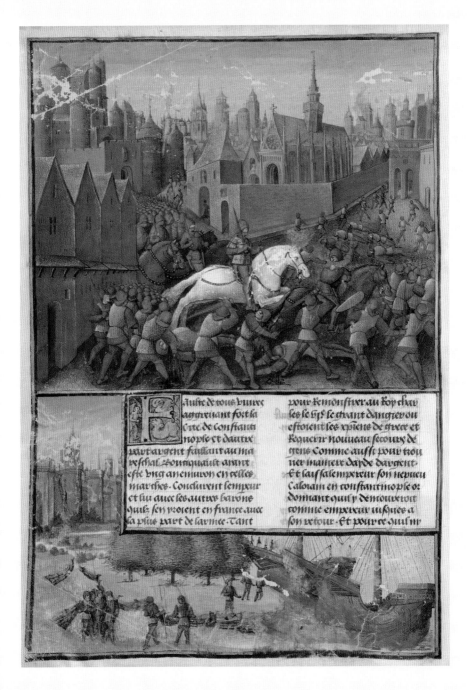

ausse de tous biurez
astreuant sort la
erte de constanti
nople et dautre
ruictargent faisant au ma
reschal. Soubzquaistz ainsi
este ung an enuiron en telles
marches. Conclurent semperur
et sui auec les autrus barons
quilz sen roient en france auec
la plus part de sarmee. Tant

pour le monstrer au roy char
les le hijs se estant danger ou
estoient les xpiens de grece et
requeru nouueau secours de
gens comme aussi pour trou
uer maniere dayde dargent
Et laissa semperur son nepueu
Caloiam en constantinople or
donnant quil y demourroit
comme empereur insques a
son retour. Et pour ce quil ny

733

nesses, that the city was, by the actions of the French, saved and guaranteed from destruction for that time.

Moreover, Our Lord now sent new help. For a great king of Tartary called Tamurlane[663] possessed of a seemingly innumerable army, abundant in men and provisions, which he had over the period of thirty years led through different provinces and regions of lands overseas, though he had not in this period ever slept in a town, city or castle or anywhere other than in tents and pavilions, and had in this way conquered the larger part of Asia Magna,[664] came into parts of Europe and so attacked the Great Turk Bayezid[665] in several battles that he at last captured him and put him in irons and bound him in his prisons, where he died an ignoble death. And thus, Our Lord, as I believe, brought his cruelty down on his own head and avenged the tyranny that he had done the Christian people both in Hungary[666] and elsewhere. And in the same way, a short time thereafter, died Tamurlane,[667] who had undertaken to conquer the entire world and more especially the very noble and ancient city of Constantinople.

To this city, there now returned the emperor Manuel, with a great military force having been escorted there by a number of Marshal Boucicaut's men. The latter had, during the three years in which the lord of Châteaumorand had been in Constantinople, been made by the aforementioned King Charles VI governor of the city of Genoa and of the Genoese, who had submitted themselves to the king because of the great seditions and dissensions that arose amongst them, which would otherwise have led to their destruction.

But Boucicaut, by his excellent conduct, had restored great prosperity to their lands and domains, which had, previous to his government, been ruinous and destroyed. And while he was governor, he undertook several great enterprises, raids and conquests against the Turks and Saracens by sea that earned great and deserved praise for him and the Genoese.[668] And despite this, certain dissidents of that city – where ingratitude is never lacking – rose up six or seven years later against Boucicaut, who was away waging war for the sake of the city and usurping it, established themselves in the place of Boucicaut and the king and threw his men out of the city.

Because of the grievous wars and dissensions then breaking out in France between the princes, partly for the murder of the duke of Orleans, the king's brother,[669] committed within the walls of Paris, and also out of rivalry for government of the kingdom, and also because of a grave malady with which the king was afflicted in the brain and memory[670] and which persisted intermittently throughout his life, starting in the eleventh year of his reign, the French did not at this stage concern themselves with taking revenge

on the Genoese. However, a long time afterwards, indeed, around the year 1466,[671] the inhabitants of Genoa made homage and submitted themselves to the orders of King Charles VII, son of King Charles VI. And as governors of the city of Genoa and the Genoese and their vassal states were appointed John of Calabria, the eldest son of Réné of Sicily, my aforesaid master, monseigneur Louis de Laval,[672] lord of Châtillon-en-Vendelais and Gaël, the count of Laval's younger brother. And against each of these two governors some few years afterwards still further partisans of Genoa rebelled, though they were defeated in battle at the first rebellion by duke John of Calabria and by Louis de Laval.

After the departure of the duke of Calabria, they thought they could surprise Louis de Laval because the king, who had for more than four years garrisoned a large number of men-at-arms there and paid their wages himself, sent there the knights John of Jambe and Henry of Merle with their counsellors so that the Genoese might find some way of affording between them the wages to be paid thereafter by the soldiers ordered by the king to guard their city and possessions. And so they rose up against him and the others who the king had sent there, and, in short, planned to put them to death. But the wise governor, forewarned of the dangers run by Boucicaut and other governors that they had in the past sought to kill, maintained the small castle within the walls well stocked with provisions and arms, and seeing their sudden fury he and his men retreated within this fortress and held it and the convent and church of the Franciscans for six months, during which he and his men performed innumerable feats of arms, sallying forth from their fortresses and by their strength and courage penetrating deeply into various parts of the city through its streets.

At the end of the six months, when the foolish conduct of those who were bringing French help led to their defeat outside the city, Louis de Laval sallied out from the city with great honour, saving all his men and goods. And by the following accommodation, on condition that the Genoese freely restored all the French prisoners taken by them a few days earlier in the defeat know as the battle of Godefa and discharged the king of Sicily, whose galleys were standing off the city and who was adviser in this accommodation, of the twenty thousand ducats owed by him and his son (the duke of Calabria) to certain Genoese merchants, Louis de Laval restored this little castle to them and went to Saonne, which he then safeguarded on behalf of the king. And so, because of the dissension in France, the first offence of the Genoese was never avenged and again, because of the death of Charles VI,[673] which occurred at around the time of this defeat, this second offence has not yet been avenged either. On the contrary,

the Genoese are currently under the duke of Milan, the son of Duke Francesco, who first usurped this duchy from the duke of Orleans, its rightful lord.

And in truth, the French have not made any general crusade to Outremer since the year 1326,[674] when Philip,[675] count of Valois, Anjou and Maine was made king of France. To him was restored the kingdom of France as if to its true king by the death of Charles the Fair without male heir and whose paternal first cousin this same Philip of Valois was, being also the nearest and aptest to succeed him according to the custom and constitution long made and instituted in the kingdom, and which was renewed by the peers, barons and three estates of France after the death of Charles the Fair[676] and before the coronation of Philip of Valois. He and all his successors as kings of France have been intermittently tormented by King Edward of England, son of the sister of Charles the Fair,[677] and his successors as kings of England, who, claiming to have the right to the kingdom, have waged so many wars against France and have made France so often wage war that it has not been possible for the noble French people to continue the great assistance that they so often brought to the Holy Land and other Christian kingdoms and regions by their crusades in Outremer.

I hereby bring to an end my account of the expeditions to Outremer, praising Our Lord Jesus Christ, by the grace of whom I, Sébastien Mamerot, a priest native of Soissons and cantor of Saint Stephen's in Troyes, completed this treatise at Vierzon this Tuesday, the nineteenth of April, 1474, shortly after Easter.

Here end the overseas crusades made by the noble French people.

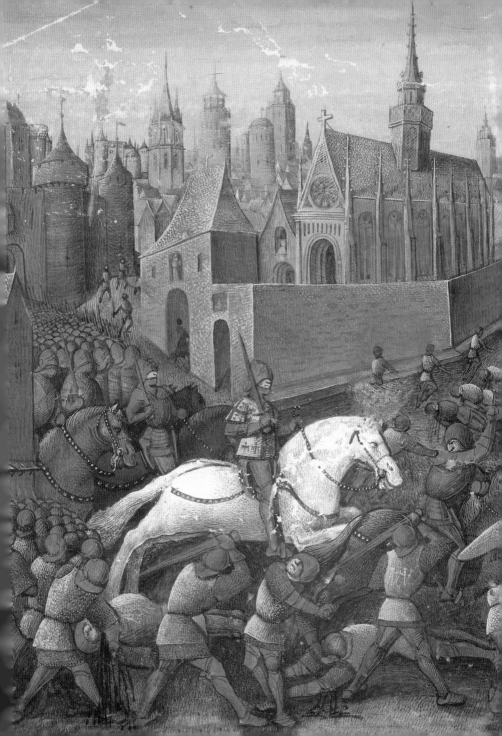

NOTES

1 Bayezid II, Ottoman sultan (r. 1481–1512).

2 Charles VIII of Valois (r. 1483–1498).

3 Mehmed II (r. 1423–1481) conquered Constantinople in 1453, the Byzantine Despotate of Morea in 1460 and the little Byzantine Empire of Trebizond (present-day Trabzon), on the Black Sea, in 1461.

4 The Byzantine emperor Heraclius I (610–641) retook Palestine and Syria from the Persian king Chosroes II, who had briefly gained control of these lands. Having reached the Persian capital, Ctesiphon, Heraclius demanded the return of the True Cross, which he reinstalled in Jerusalem in 630. These events were well known in the Middle Ages, particularly through William of Tyre's chronicle entitled *Eracles*, and through the *Roman d'Eracle*. The reconquest was of short duration. Exhausted and unable to resist the Arab armies, the Byzantine Empire finally lost control of Jerusalem in 638 – well before the imaginary events described here.

5 Constantine VI, son of Leo IV and Irene, was indeed blinded and imprisoned by his mother, who in 797 took the imperial title.

6 Nicephorus I, Irene's Minister of Finance, overthrew her. He reigned from 802 to 811. Constantine V (r. 741–775) never requested Charlemagne's (r. 768–814) assistance. The capture of Jerusalem by the Arabs in fact took place in 638. The chronology of the fantastical events recounted by Mamerot therefore has no historical validity.

7 The palace of Blachernae, near the wall in the northeast of the city, only later became the imperial residence, in the time of Alexius I Comnenus (r. 1081–1118). It was therefore this palace with which the chroniclers of the crusades were familiar and Vincent of Beauvais, who was Mamerot's principal source, followed their lead. At the time of Constantine V, the emperor actually lived in the Great Palace, near the Hagia Sophia and the hippodrome.

8 Charlemagne's alleged victories over the Arabs are, of course, imaginary.

9 Here Mamerot sets his narrative in the geopolitical map of his own time. The Bulgars had settled in this region as early as the seventh century, but the Hungarians reached the banks of the Danube only in the late ninth century. In Charlemagne's time, therefore, Hungary did not yet exist.

10 Mamerot's concern with realism is consistent even in his account of a miracle. Since the reign of Heraclius I, Greek had been the official language of the Byzantine Empire.

11 The cult of relics was a feature of medieval religiosity: Constantinople was famed for the innumerable relics preserved in its churches. Many of these were pillaged during the sack of the city in 1204, whereas the Latin emperor Baldwin II (r. 1228–1261), when his financial resources had been exhausted, sold others to Saint Louis. At the time of the crusades, the capital of the Byzantine Empire was also a centre for the production of vast numbers of fake relics for the pilgrims from the West.

12 In fact, the relics of Christ's Passion had been purchased by King Louis from the Latin emperor of Constantinople, Baldwin II. The abbey of Saint-Denis, made wealthy by the Merovingian king Dagobert I (r. 629–638), who had granted it many privileges, took great pride in the fact that it had enjoyed the protection of Charlemagne and his successors. The abbey was one of the great intellectual and artistic centres of the Carolingian Empire.

13 Philip I of France (r. 1060–1108).

14 In reality, the wearing of the cross as a distinctive sign did not become official until after the First Crusade, that is, when Saint Bernard was preaching the Second Crusade. The first crusaders did not wear a cross on their right shoulder.

15 Generally known as Adhemar of Monteil.

16 Usually referred to by historians as Hugh, count of Vermandois.

17 We know this king as William the Conqueror (1028–1087). Robert was in fact the oldest son of William, but his father preferred to pass the Crown of England to his younger son, William Rufus, rather than to Robert.

18 Called Raymond of Saint-Gilles.

19 He refused the title of king, not wanting to wear a crown in the place where Christ had worn the Crown of Thorns, and asked to be called the "Defender of the Holy Sepulchre".

20 Sébastien Mamerot was a canon of the collegiate church of Saint Stephen in Troyes.

21 In reality, Robert Guiscard was descended from a family of the minor Norman nobility that had settled at Hauteville. In the space of a few years, this adventurer had carved out for himself a vast principality in Apulia and subsequently in Calabria and Basilicata, finally conquering Naples. He had done this, firstly, by placing himself at the service of the Byzantines against the Pope and then by turning against his former protectors. By conquering the great port of Bari in 1071, he had driven the Byzantines out of southern Italy. Some years later, Bohemond was to attempt to invade the Byzantine Empire and was stopped only by the alliance of the Emperor Alexius I Comnenus and Venice (1081–1085). The Normans would subsequently conquer Sicily from the Arabs, thus forming a powerful kingdom with a highly advanced civilisation.

22 King of Hungary (r. 1095–1116).

23 In German Semlin, present-day Zimony, Serbia, near Belgrade.

24 The route through Denmark in order to go from Belgrade to Constantinople is clearly inaccurate. Serbia and Bulgaria were at that time integral parts of the Byzantine Empire, as was the whole Balkan Peninsula. There was no kingdom to pass through between Belgrade and Constantinople. "Stralice" refers to Sofia, which in Bulgarian is called "Triaditza".

25 Saracen king, sultan of Nicaea, capital of the Anatolian Seljuks. He died in 1086. The sultan at that time was in fact his young son Kilij Arslan (r. 1092–1107).

26 The castle of Xerigordon.

27 Vincent of Beauvais (d. 1265), author of one of the most celebrated encyclopaedias of the Middle Ages, the *Speculum majus* (completed *c.* 1258), of which the historical part enjoyed a very wide distribution throughout Europe, particularly in the French translation of Jean of Vignay (1333). This, in all likelihood, was Mamerot's principal source for this part of the narrative.

28 The fortress of Cibotus, on the southern shore of the gulf of Nicomedia (present-day Izmit), was at the time on the border between the Byzantine Empire and the Seljuk Sultanate.

29 This clearly shows how Mamerot endorsed the aristocratic ideology of his protector, Louis de Laval. The events described here are confirmed by the Latin chronicles and by the *Alexiad*, the account of the reign of Alexius Comnenus written by his daughter Anne.

30 Those who preached the People's Crusade were Gottschalk, Volkmar and Emich of Leisingen.

31 This is certainly the Leitha, a tributary of the Danube. The abuses of the People's Crusade against the Jews, who were often judged responsible for the misfortunes that

had beset Christ's tomb in Palestine, are well known. They bear witness to the spread of a type of violent anti-Semitism that had hitherto been almost unknown in the Christian West.

32 Dyrrhachium (Latin), Dyrrachion (Greek) or Durazzo (Italian) is present-day Durrës, Albania. The town was the coastal gateway of the Via Egnatia, which led to Constantinople by crossing the Balkans via Thessalonica. This was the route that one part of the crusaders had to follow.

33 Here, as in a number of other instances, Mamerot erroneously refers to a person called Bernard, count of Toul, in the original manuscript. At fol. 71va, he uses the correct name for the first time.

34 This is probably Henry's brother Godfrey, whom Mamerot mentions a little later.

35 This name may designate Ödenburg, the German name of the Hungarian city of Sopron, which Mamerot later refers to as "Ciperon".

36 The Leitha.

37 Present-day Sopron, Hungary.

38 This may be the same city as "Sur" mentioned near fol. 22vb.

39 The name, at the time, for the Bosphorus.

40 In the Middle Ages, the Mediterranean was thought to comprise a number of different seas.

41 This gate, constructed by Theodosius I in 388–391 to commemorate his triumph over Maximus, had been incorporated into the city walls by Theodosius II. It was reserved for the use of the emperors when they returned from military expeditions.

42 At Selymbria, on the sea of Marmara.

43 Present-day Edirna, Turkey.

44 Present-day Plovdiv, Bulgaria.

45 Mamerot leads us to believe that these events took place shortly after Christmas. In reality, although the crusaders were certainly not far from Constantinople by 23 December, it was not until the end of March, after many Latin raids into the city outskirts and when the arrival of Bohemond was announced, that Alexius decided to cut off their food supplies.

46 This account is, of course, far-fetched. At no time did Alexius Comnenus entrust his empire to Godfrey. On the contrary, the crusader leaders took an oath of loyalty to the emperor and swore that they would hand over to him those territories that they reconquered and that had previously been Byzantine. The ceremony of oath-swearing probably took place on Easter Saturday.

47 In fact, Alexius I had succeeded in repelling Robert Guiscard and Bohemond's offensive, after a lengthy fight, thanks in particular to the support of the Venetians (1081–1085).

48 The Vardar, whose course today lies mainly in Macedonia. Mamerot uses an alternative spelling in the following paragraph, "Bartade".

49 This common theme of the disloyalty of the Greeks appears as early as the chronicles of the First Crusade. In reality, the crusaders and the Byzantines were looking at things from a different perspective: Alexius Comnenus was hoping for assistance to reconquer those territories that had been lost by the empire in Asia, while the Franks were hoping for help from the Greeks to lead a Holy War against Islam, a long-time enemy of the Byzantines. Moreover, it was impossible for Alexius Comnenus not to feel defiant towards the Normans of Sicily, who had attempted to conquer the Byzantine Empire less than 20 years earlier.

50 Present-day Zadar, Split, Tara, Dubrovnik, Croatia.

51 Actually, a Latin language.

52 Scutari, present-day Shkodër, Albania.

53 Thessalonica, present-day Thessaloniki, Greece.

54 Rhaedestos, in fact a town on the sea of Marmara.

55 The truth is quite different: it was the crusaders who, after the departure of Raymond of Saint-Gilles for Constantinople, went on regular pillaging forays, as they had done on a number of occasions during the journey. The crusaders were severely defeated by the regular Byzantine troops and were forced to abandon their arms and their possessions.

56 Mamerot's narrative is once again tendentious. At no time did Alexius Comnenus make any apology to the count of Toulouse. Raymond, who considered himself as the natural leader of the crusade, was afraid of the privileged relationship that seemed to have been established between Alexius and Bohemond. He would therefore only agree to swear a modified oath, which acknowledged his allegiance to the papacy, although he subsequently proved to be the most reliable ally of the Byzantine emperor in the Latin camp.

57 This council defined, in the Nicene Creed, the symbol of the Christian faith, the Trinity of one God in three persons.

58 This council condemned iconoclasm and affirmed the orthodox doctrine of the cult of images.

59 Once again Mamerot interprets events in a manner unfavourable to the Byzantines. In reality, the inhabitants of Nicaea, informed that the final assault was imminent, surrendered to Alexius Comnenus and in the morning the crusaders discovered the imperial standards flying above the city walls.

60 Alexius knew the price of magnanimity towards a vanquished enemy in Eastern diplomacy.

61 This passage well illustrates the differences between the fast, mounted Turkish archers and the heavy French cavalry, supported by infantry that was relatively immobile.

62 The battle of Dorylaeum (near the modern Turkish town of Eskişehir), on 1 July 1097.

63 Antioch of Meander.

64 Mamerot uses the name that was current in medieval French, "Rohés" or "Rohays", for Edessa. The editors have opted for the latter, the modern name.

65 Present-day Konya, Turkey, principal town of the Seljuk Sultanate, which became its capital after the capture of Nicaea.

66 Present-day Ereğli, Turkey.

67 Mopsuesta, present-day Missis, Turkey.

68 Tancred arrived at Mamistra early October 1097.

69 Conquered by Baldwin in 1097, Edessa became the seat of a county. Its reconquest by the Turks in 1144 launched the Second Crusade.

70 Thoros, an Armenian of the Orthodox faith, a former Byzantine official.

71 Antioch was conquered from the Byzantines by Suleiman ibn Qutulmish in 1085 (only twelve years before the arrival of the crusaders beneath its walls). At his death, the town passed to Sultan Malik Shah and then to his son, Ridwan, emir of Aleppo: their lieutenant was Yaghi-Siyan. Nicaea was taken as early as 1081.

72 Kerbogha, *atabeg*, or regent, of Mosul.

73 Mamerot uses the name "Arthuse".

74 The Iron Bridge, over the river Orontes, where the crusaders actually arrived on 20 October 1097. Here, Mamerot is confusing the name of the bridge with that of the river.

75 Present-day Akşehir, Turkey.

76 After he had retaken possession of the western part of Asia Minor, which had been abandoned by the Turks, Alexius Comnenus marched to the relief of Antioch.

77 The Egyptian delegation was led by the all-powerful vizier of the caliph himself. But this move towards an alliance with the Turks, which was encouraged by Alexius Comnenus, led to no definitive result.

78 The caliph of Baghdad and the Turkish sultan followed the Sunni rule, whereas the Fatimid caliph of Egypt was a Shia.

79 The fortress of Harim.

80 The manuscript erroneously gives the year 1097.

81 Although Mamerot, like the majority of writers in his day, was fond of using repetition, the two terms of "knight" *(chevalier)* and "man on horseback" *(cavalier)* are not synonymous. The knight belonged to a social class within the nobility, which was placed at the service of the barons. Men on horseback could be simple peasants or bourgeois, who either possessed or had the use of a horse during combat.

82 In reality, Firouz, apparently a renegade Armenian who had converted to Islam but found himself at that particular time in conflict with Yaghi Siyan.

83 The siege of Edessa constituted a grave strategic error, for it weakened and delayed the emir of Mosul and was the main contributory factor preventing him from liberating Antioch from the crusaders.

84 Faithful to his oath to Alexius Comnenus (and considering himself the natural leader of the crusade), Raymond of Saint-Gilles wished to hand over Antioch to the Byzantines so that he could set off immediately to continue his journey to Jerusalem. He was thus the person who was most violently opposed to Bohemond's manoeuvres.

85 The tower of the Two Sisters.

86 On 5 June 1097.

87 On 10 June, Kerbogha completed the encirclement of Antioch.

88 Lambert, count of Clermont.

89 Here Mamerot insists on one of the traditional qualities of a nobleman: liberality, which consisted in giving generously to men, and particularly to the knights who were in one's service.

90 Alexandria in Lydia, present-day Iskenderun, Turkey.

91 In reality, the relieving army led by Alexius was exclusively composed of Greeks and of mercenaries.

92 Actually a half-brother of Bohemond. The preceding speech of Stephen of Blois does not entirely reflect what in fact happened. It appears that Stephen had informed the emperor that the crusader army had most probably been annihilated by the Turks. In addition, Peter of Aups arrived at the same time to announce that a Turkish army was moving against Alexius, and it was this that finally made the Byzantines decide to turn back, to protect the territories that they had just regained in Asia Minor.

93 The retreat of Alexius completed the breakdown of relations between the crusader leaders and the emperor, and rendered pointless any Byzantine claims on Antioch.

94 Mamerot again emphasises the role of the aristocracy in the face of the ignorant mass of the people.

95 In reality, Peter Bartholomew, a peasant (not a cleric) who had joined the crusade as valet to a pilgrim from Provence called William Pierre.

96 On 15 June. A different "Holy Lance" was worshipped in Constantinople and this possibly explains the scepticism of Adhemar of Monteil, who took several days before he decided to find the relic in the cathedral, something that Mamerot passes over in silence. In any case, this highly opportune discovery gave fresh heart to the exhausted crusaders.

97 A Frank called Herluin.

98 Greek fire was a preparation of tow and naptha, which continued to burn even on water. For a long time, the secret of its composition made it a formidable weapon that ensured the naval superiority of the Byzantines (Greeks) in the Mediterranean.

99 Several emirs, the emir of Damascus first and foremost, were afraid that a victory for Kerbogha would enhance his power and accordingly chose to desert during the battle, sowing disorder in the Turkish ranks.

100 Envious of Bohemond, the count of Toulouse was defending the rights of the Byzantine emperor; the crusaders had sworn to restore Antioch to Byzantium if they captured it.

101 Hugh reached Constantinople in the autumn, when it was too late to launch a military expedition through Anatolia. Alexius could therefore promise no assistance before the following spring. The crusaders interpreted this as a defection.

102 In Arabic, Tel Basheir castle, present-day Tilbeşar, Turkey.

103 Azaz was in the county of Edessa, north-west of Aleppo; its emir was Omar.

104 The bezant was a gold coin from Byzantium that was current throughout the Orient.

105 Balak ibn Bahram was the Ortoqid prince to whom the city of Saruj paid tribute till it was captured by the Franks. Mamerot here seems to confuse Balak and the emir Balduq. When Saruj revolted against him, Balak asked Baldwin of Edessa for help. On arriving at Saruj, Baldwin discovered that the revolt in Saruj was led by his ally, the former emir Balduq, who was nominally his vassal.

106 This was Emir Balduq.

107 A large-scale shield made of basketwork as a protection against projectiles.

108 Mamerot calls Homs "La Chamelle".

109 Hosn al-Akrad, a castle on the site subsequently occupied by the famous castle of Krak des Chevaliers. The crusaders attacked it on 29 January 1099.

110 The crusaders reached Arqa on 14 February 1099.

111 Present-day Trablus, or Tarabulus, Lebanon.

112 Present-day Tartus, Lebanon, a port between Lattakieh (Al Lathqiya) and Tripoli (Trablus).

113 Or Raymond Pilet, from the Limousin, who had come with the contingent of Raymond of Toulouse.

114 A port in Lebanon, known in ancient times as Byblos.

115 Al Marqa, south of Lattakieh.

116 The ordeal took place on Good Friday, 8 April 1099. Peter Bartholomew emerged horribly burned and died twelve (not three) days later. Only the Provençals continued to believe in his revelations. They claimed that he had emerged unscathed from the fire and had only been burned because he was pushed back in.

117 In fact, Shah an-Shah al-Afdal, vizier to Caliph al-Mustali, who was then a child.

118 The message of Alexius was, in fact, quite different: he promised the crusaders that he would join them in

Antioch in the spring and accompany them to Jerusalem with his army. But most of the barons and the common people refused to wait.

119 Present-day Yavne, Israel.

120 The Nahr el-Kelb river.

121 Present-day Saïda, Lebanon. The river is the Nahr al-Awali.

122 This refers to the pass known as the "Ladder of Tyre".

123 Present-day Akka, in the north of Israel. After the Franks had settled there, the city would often be called in French Saint Joan of Arc.

124 Mamerot calls the city "Japhès".

125 Present-day Lod, near Tel-Aviv. The village lay at that time in ruins.

126 Saint George, who was a native of Lydda, was martyred in Nicomedia under the emperor Diocletian. However, Justinian had raised a church in his honour not far from Ramleh.

127 While Sébastien Mamerot uses the form "Ramès", most chroniclers call this city Rama. They are referring to Ramleh, today called Ramallah, in present-day Palestine.

128 Amwas (Nicopolis), which was completely destroyed in the Six-Day War in 1967.

129 In Arabic, Ouadi Sitti Maryam.

130 Or Ge Hinnom.

131 The mosque of Omar, in east Jerusalem.

132 This refers to minarets, from which the muezzins ritually call the faithful to prayer.

133 Apart from the descriptions given by the chroniclers and later compilers, such as Vincent of Beauvais, Mamerot can not resist making use of his knowledge of the Bible. In this he remains faithful to the tradition of medieval erudition.

134 According to the chronicler Raymond of Aguilers, whose figures are certainly reliable, there were twelve thousand foot soldiers and twelve to thirteen hundred cavalry present on the side of the crusaders during the assault.

135 The siege began on 7 June 1099.

136 On 15 June 1099.

137 Tall wooden towers on wheels.

138 Sabran is today in the *département* of Gard.

139 This procession took place on Friday, 8 July 1099.

140 Arnulf Malecorne of Zokes, who was to be elected patriarch of Jerusalem after the conquest of the city.

141 Projectiles shot from a crossbow.

142 Liétuad or Létold in French.

143 Isoard of Gap.

144 This refers to the Fatimid governor of the city, Iftikhar ad-Daula, and his suite.

145 Arnulf, bishop of Marturano, in southern Italy (at that time under Norman domination).

146 Through humility and out of respect for Christ and the Pope, Godfrey took the title of Defender of the Holy Sepulchre. His successors did not have the same scruples and had themselves crowned kings of Jerusalem.

147 By ousting the count of Toulouse, the Frankish barons *de facto* rejected any Byzantine alliance and affirmed the independence of the young kingdom of Jerusalem. But they also got rid of a man of political skill who was a formidable soldier and who would certainly have wished to impose a strong royal power.

148 This undoubtedly refers to the vizier of Egypt, al-Afdal, who had led the Fatimid army in person.

149 On 9 August 1099.

150 On 12 August 1099.

151 Tabariyyah, called Tibériade by the Frankish chroniclers.

152 He had been sent as legate by Urban II shortly before his death, as replacement for the deceased Adhemar. He was an energetic bishop, who had been legate to the king of Castile in 1098, in order to organise the dioceses that had been reconquered from the Arabs. However, he had also displayed a regrettable taste for money and power, and was to prove particularly ambitious and dishonest when in office in the Holy Land.

153 On 21 December 1099.

154 Shortly after Christmas 1099.

155 Malatya, in eastern Cappadocia.

156 The Danishmend emir of Sivas, Malik Ghazi Gümüshtekin.

157 Bohemond was taken prisoner in August 1100, when he was marching to the relief of the Armenian commandant of Melitene, Gabriel, who was under attack by Malik Ghazi Gümüshtekin.

158 In French, *le chandeleur*, or the feast of the presentation of our Lord in the Temple and of the purification of the Virgin, on 2 February 1100.

159 On 1 April 1100.

160 Arabia around Petra, today in Jordan.

161 In fact, on Wednesday, 18 July 1100.

162 The Armenian princess Arda, whom he had married shortly after the conquest of Edessa.

163 Present-day Marakia, not far from Tortosa.

164 A small port to the north of Beirut.

165 City in the north of Israel. If Baldwin hesitated to enter this city, which was in the possession of his enemy, Tancred, it was in reality because he feared some treachery.

166 On 9 November 1100.

167 This expedition is nowadays not counted amongst the eight "great" crusades.

168 This episode is reported by the chronicler William of Tyre and here at fol. 110b.

169 In fact, this is Count Stephen I, known as "the Rash" (1065–1102). Mamerot's mistake no doubt arose because,

during his lifetime, the dukes of Burgundy also held the county of Burgundy (present-day Franche-Comté). In the Middle Ages, the duchy of Burgundy came under the king of France, while the county came under the Holy Roman Empire.

170 These allegations concerning the apparent treachery of Alexius Comnenus derive, via the *Miroir historial* of Vincent of Beauvais, from chroniclers favourable to Bohemond – and thus to the anti-Byzantine politics of the Normans. In reality, everything indicates that Alexius tried on a number of occasions to bring help to the crusaders, but that he was progressively put off doing this by their refusal to accept Byzantine sovereignty over Antioch. Subsequently, he advised the crusaders on a number of occasions not to undertake extremely dangerous ventures, such as that which would lead to the massacre of the expedition led by Raymond of Saint-Gilles in 1101: the Frankish and Lombard crusaders in fact had hoped to be able to free Bohemond, who was still in Turkish captivity. They went into action in the height of summer in the heart of the inhospitable mountains of Asia Minor and were almost all massacred shortly before Amasia.

171 The unnamed massacre inflicted on this crusade of 60,000 souls on 5 September 1101 took place to the east of Konya and left no one alive apart from a few knights. This came after the destruction of a Lombard-Frankish expedition led by Raymond of Saint-Gilles (July–August 1101) and that of 15,000 crusaders who were led by William of Nevers (August 1101).

172 After the capture of the town on 21 April 1102, Raymond of Saint-Gilles used Tortosa as the starting-point for his campaign to conquer what was to become the county of Tripoli, and also to ensure the continuity of Frankish domination between the principality of Antioch and the kingdom of Jerusalem.

173 Present-day Tel-Arshaf, north of Tel Aviv.

174 These victories took place in April–May 1101.

175 On 7 September 1101.

176 This fictional episode is recounted by William of Tyre.

177 Present-day Kaizarieh in Palestine.

178 The expedition took place in 1104. Baldwin of Le Bourg and Joscelin were taken prisoner on 7 May.

179 Philip I of France actually died in 1108, three years before Bohemond, who died in 1111.

180 Ridwan was a Seljuk emir.

181 This battle took place at Tizin, on 20 April 1105.

182 The battle took place at Ramleh on 27 August 1105; this victory gave the Franks control of almost all the Palestinian coastline.

183 Tancred had been reluctant to restore Edessa to Baldwin of Le Bourg in September 1108. The battle described here took place some months later. Tancred and the Turks of Aleppo fought Baldwin and his erstwhile gaoler Danishmend.

184 In February or March 1109.

185 King Baldwin imposed his decision, thus reaffirming his suzerainty over all the Frankish states: William-Jordan was to keep Tortosa and Arqa, while Bertrand inherited Jebeil, Mount Pilgrim and, after its conquest, Tripoli.

186 On 12 July 1109. Mamerot gets the order of events wrong: Tripoli was captured before William-Jordan's death.

187 In April–May 1110, the sultan of Persia sent a great army led by the emir of Mosul to reconquer Edessa. Baldwin's victory allowed Tancred to capture several strongholds previously held by the kingdom of Aleppo. A second Turkish expedition was then organised, but proved equally fruitless. Frankish resistance forced it to cross back over the Euphrates in autumn 1111.

188 This was a Byzantine coin bearing the image of Emperor Michael VII Ducas (r. 1071–1078), who was notorious for devaluing the Byzantine currency.

189 This amusing scene is described in detail by William of Tyre.

190 Mamerot's chronology is rather approximate here: the city of Sidon was actually conquered in 1110, before the events recounted at the end of the previous chapter.

191 In fact, this occurred in 1112. Gibelin of Sabran had been elected in 1108, when he succeeded Evremar of Thérouanne. The latter had been elected patriarch in 1105, replacing Daimbert of Pisa, who had been deposed by the pope for his inveterate peculation.

192 Today's Tel-Basheir. This was the second expedition sent by the sultan of Baghdad against the Franks. It was jointly led by the *atabegs* of Mosul and Damascus.

193 This was the Italo-Norman prince Roger of Salerno.

194 Also known in French as Poncet.

195 This was the *atabeg* of Mosul, who had led the previous expeditions under the authority of the sultan of Baghdad.

196 Actually, Pons, count of Tripoli.

197 The defeat of the Franks occurred on 28 June 1113.

198 In early August 1113.

199 Bursuq was the new *atabeg* of Mosul. He led his army towards Antioch in the summer of 1115, where he faced the coalition of Frankish princes, the king of Damascus and the *atabeg* of Aleppo, none of whom was willing to allow the sultan to restore control over the area.

200 Baldwin died on 2 April 1118.

201 Mamerot is not taken in by Joscelin's sudden conversion to Baldwin's candidature; Joscelin expected to profit by it and received the county of Edessa in reward for his support.

202 Alexius I Comnenus died in 1118. His son John II pursued the same strategy, imposing his suzerainty on the principality of Antioch.

203 The Temple of Solomon, now the al-Aqsa mosque.

204 Ilghazi was a Turkish leader of the Ortoqid clan. The battle in which Roger of Antioch lost his life took place on 28 June 1119 before Aleppo on a plain that the chroniclers dubbed "Ager sanguinis", or "Field of Blood".

205 The Turcomans were then nomadic tribesmen, unlike the Seljuk Turks who had settled in the Near East.

206 This was the Bedouin Dubais ibn Sadaqa, who helped Baldwin II besiege Aleppo in 1124.

207 Also known as Evremar.

208 In fact, it took place one day earlier, on 14 August, at Tel-Danith.

209 Waleran of Le Puiset, the nephew of Baldwin II.

210 In September 1122. Balak held them prisoner in his fortress of Kharpurt in the mountain fastnesses of Kurdistan.

211 Baldwin surrendered on 16 September 1123.

212 Joscelin, who could not swim, had taken with him two wineskins, which he used as floats. (Mamerot refers to barrels or casks.)

213 On 29 May 1123.

214 William of Bures, the regent, was lord of Tiberias.

215 The immense Venetian fleet, comprising more than 30 ships and 15,000 men and led by Doge Domenico Michiel, arrived in the Levant in May 1123. Mamerot is wrong in suggesting that the fleet was commissioned in order to liberate Baldwin II, who had only just been captured when it arrived.

216 The evidence strongly suggests that Balak was killed in battle against other Muslims and that Joscelin had nothing whatever to do with his death.

217 In fact, the royal banner was raised over the city on 7 July 1124.

218 Located in the north-east of the principality of Antioch. The battle took place in 1125.

219 Mamerot is mistaken once again: Baldwin II invaded Damascus in early 1126.

220 In fact, Baldwin II attacked Damascus early in 1126.

221 Bohemond landed at Saint Symeon and went straight to Antioch in October 1126. He was eighteen years old.

222 The marriage took place on 2 June 1129.

223 Bohemond II was killed in February 1130.

224 Imad ed-Din Zengi was the *atabeg* of Mosul, governor of Aleppo and father of Nur ed-Din.

225 In fact, Baldwin died on 21 August 1131, in the thirteenth year of his reign.

226 Mamerot is mistaken here: Cecilia married Pons of Tripoli, and Raymond was her son.

227 Henry II Plantagenet.

228 Louis VII of France. Mamerot's detailed survey here relates to his own times; he was writing shortly after the victory of Charles VII of France over the English at the end of the Hundred Years' War (1453), at a time when English claims to the throne of France and certain of its provinces had not been abandoned.

229 Geoffrey V, son of Count Fulk V of Anjou, bore the name of "Plantagenêt" before his son because of the yellow sprig of *genêt*, or broom blossom, he was said to wear in his hat.

230 Mamerot actually means Baldwin IV (r. 1174–1185), born in 1160.

231 Hugh of Le Puiset, lord of Jaffa and cousin of Baldwin II, was accused by Count Walter Garnier of Caesarea of plotting against the king. It was claimed that he was courting the favours of Queen Melisende. King Fulk allowed the execution of the Breton knight who had attempted to murder Hugh to demonstrate his impartiality.

232 Raymond of Poitiers, then thirty and living in France, had been chosen by Fulk to marry the heiress of the principality, Constance, and thus remove from power the dowager princess of Antioch, Alice, whose ambition and independence had endangered the Latin states of the Levant.

233 Zengi's siege of the castle of Montferrand ended on 20 August 1137.

234 John II Comnenus began his campaign in April 1138.

235 On 23 May 1138.

236 The treaty made between John II of Byzantium and Raymond of Antioch was, nevertheless, perfectly clear on this point: the prince had agreed to restore the city to the suzerainty of Byzantium in accordance with the oath made to Alexius I. But the manifest lack of enthusiasm shown by Raymond and Joscelin during the siege of Shaizar clearly demonstrates that the Franks could not bring themselves to honour their vow. The failure of John II meant the end of the Frankish-Byzantine alliance, which could only benefit their enemy Zengi.

237 In fact, the sole "predecessor" was Alexius I Comnenus. The scene in which John II, hoodwinked by the Franks, attempts to save face by ordering Raymond to safeguard Antioch as a loyal vassal of the Byzantine Empire, is recorded by William of Tyre in terms very close to those of Mamerot.

238 The count of Flanders actually married the king's daughter, not his sister, which Mamerot states correctly above.

239 On 4 May 1140. The siege of Damascus had begun in December. The capture of Banyas by the Franks allied to the Damascans took place in June.

240 In chroniclers contemporary with the crusades and in Mamerot, John II Comnenus is given a much more positive image than his father Alexius I. However, Mam-

erot's chronology is again inaccurate: John died in 1143 in the Taurus.

241 King Fulk died of the effects of this hunting injury in November 1143.

242 The events related here are not told in the correct order: Fulk of Anjou died in November 1143, whereas Baldwin III was crowed at Christmas of the same year at the age of 13; it wasn't until the following year, in 1144, that Zengi laid siege to Edessa.

243 On 23 December 1144. The impact of this event in the West was huge and resulted in the organisation of the Second Crusade.

244 The campaign against the Damascans was in fact a complete failure and endangered the traditional alliance between the Franks and the kingdom of Damascus at a time when, after the death of Zengi (1146), a new and formidable adversary had arisen in Syria, Zengi's son, Nur ed-Din.

245 The Armenians of Edessa opened the doors of the city of Edessa to Joscelin II on the night of 27 October 1146. The Muslims were massacred. But Nur ed-Din arrived immediately afterwards and besieged the city. An attempted sortie by Joscelin II on 3 November proved disastrous; the count escaped, but the entire Christian population of the city was massacred.

246 There is no doubt that Mamerot speaks of a Third Crusade here because he considers (see fol. 106b) that the Second Crusade was the one undertaken by the great French lords in 1101. According to the accepted chronology of the modern historian, this is in fact the Second Crusade.

247 Pope from 1145 to 1153

248 The messenger sent to the pope in the autumn of 1145 was Hugh, bishop of Djabala.

249 Contrary to what Mamerot suggests, the French lords showed no enthusiasm for the project of the crusade.

250 The assembly met at Vézelay, not at Versailles as Mamerot writes here and later, on 31 March 1146.

251 Conrad III of Hohenstaufen was king, and not emperor, of Germany as Mamerot writes. It was not until Christmas 1146 that he could be persuaded to set out.

252 Mamerot erroneously writes 1145 instead of 1146.

253 Mamerot erroneously writes 1146 instead of 1147.

254 Conrad set out around the end of May 1147.

255 The ruler in question is the young King Géza (r. **1141**–1161).

256 Today Izmit, Turkey.

257 It was not the Greeks but Stephen, the chief of his Varangian guard, whom the emperor Manuel sent to guide them.

258 This is Count Beranger of Sulzbach, whose daughter Gertrude had married Conrad; his other daughter, Bertha-Irene, had married the emperor Manuel.

259 Mamerot erroneously writes 1146 instead of 1147.

260 Today Antalya, Turkey. The city had once been called "Attalia" because it had been founded by the king of Pergamum, Attalus II, in the second century BC.

261 The allusion here is to Nur ed-Din.

262 Here Mamerot is repeating a rumour that claimed that Eleanor had a liaison with Raymond of Antioch.

263 Baldwin III of Jerusalem.

264 Alfonso-Jordan took the cross at Vézelay at the same time as the king of France.

265 Alfonso-Jordan died of a chronic illness, but there was talk that he had been poisoned at the instigation of his cousin Raymond of Tripoli, afraid that the count of Toulouse asserts his right to the county of Tripoli.

266 Also known as Maraqiya, located to the north of Tortosa.

267 This was 24 June 1148.

268 Caesarea Philippi corresponds to the town of Banyas. Mamerot is mistaken when he identifies it with Tabaria, present-day Tiberias.

269 On 25 May 1147.

270 Conrad left in February 1149.

271 Frederick Barbarossa, the nephew of Conrad III, became king in 1152 and emperor in 1155.

272 Mamerot does not specify which English king this was. It was Stephen of Blois,who reigned before Henry II; Henry was duke of Normandy until 1154 and, as such, had to swear allegiance to the king of France.

273 Mamerot considers this the Second Crusade, contrary to what he writes at the beginning of Chapter XLIII.

274 Philip II Augustus, known as Dieudonné, the "God-given", was king of France from 1180 to 1223.

275 Richard I, known as the Lionheart, was king of England from 1189 to 1199.

276 In fact, this happened on 29 June 1149.

277 Beatrice, countess of Edessa, resisted Nur ed-Din for as long as she could before finally yielding the city to the emperor Manuel and taking refuge in Jerusalem with her children.

278 When Baldwin had himself crowned on the following Tuesday in the church of the Holy Sepulchre, his mother had no idea that this was happening.

279 Here, Mamerot writes "Nautab".

280 The siege of Ascalon began on 25 January 1153.

281 Reynald of Châtillon was the youngest son of Geoffrey, lord of Gien and of Châtillon-sur-Loing.

282 In fact, Ascalon capitulated on 19 August 1153.

283 Here Mamerot follows the account of William of Tyre.

284 The reference here is to Aimery of Antioch.

285 The reference here is to Melisande.

286 Mamerot actually writes "Malse", although the reference is actually to the town of Amalfi in Italy.

287 Thoros II, known as the "Prince of the Mountains", held sway over Cilicia from 1140 to 1169.

288 Reynald of Antioch wished to take his revenge on Manuel, who had not been prepared to recompense him for the help he had given him in the struggle against Thoros. He therefore formed an alliance with his former enemy; he then disembarked in Cyprus, which in 1155 was under the control of the emperor, laid waste the island and, according to the eye-witness account in the *Estoire d'Eracles*, committed terrible atrocities.

289 It was then that King Baldwin III broke the truce that had been renewed in 1156.

290 This siege began on 21 May 1157.

291 Mamerot refers to this Palestinian town situated in the mountainous region of Upper Galilee as "Japhet".

292 The count of Flanders disembarked in Beirut in July 1158.

293 The reference here is to the princess Sibylla, daughter of Fulk V of Anjou.

294 Manuel suggested his niece Theodora. She arrived in Acre in September 1158.

295 William of Tyre calls this town Caesarea on the Orontes to distinguish it from Banyas, the ancient city of Caesarea Philippi.

296 Theodora, who was thirteen years old, arrived in Tyre and was then married in Jerusalem in September 1158.

297 The Taurus massif.

298 Mamerot calls the city "La Lice". The reference here is to Bishop Gerald of Nazareth, who went to intercede for Reynald with the emperor.

299 This refers to the robe of a penitent.

300 This was a great humiliation to inflict on Reynald of Antioch.

301 He remained a prisoner in Aleppo for fifteen years.

302 Manuel was left a widower in 1159, when the empress Irene died, leaving one daughter. Manuel sent an embassy to Jerusalem in 1160 to seek a new wife.

303 Melisende was the daughter of Raymond II of Tripoli and Hodierna.

304 Mary was the daughter of Raymond of Poitiers and Constance of Antioch.

305 Barac was a Syrian doctor.

306 Baldwin III, who was born in 1130 and became king in 1143, actually died on 10 February 1162.

307 He was buried in the church of the Holy Sepulchre.

308 Amalric, who was born in 1136, became king of Jerusalem on 18 February 1162. Mamerot, who has previously said that Baldwin III died on 6 February, here gives incorrect dates.

309 Alexander III was pope from 1159 to 1181.

310 William of Tyre's history of the Latin kingdom and the crusades, the *Historia rerum in partibus transmarinus*

gestarum, covers the period up to 1184. This was one of Mamerot's sources for *Les Passages d'Outremer*.

311 Agnes of Courtenay, a descendant of the counts of Edessa.

312 Mamerot here cites a name that was never used by any pope. This could refer to Pope Hadrian IV (r. 1154–1159) or to Alexander III (r. 1159–1181). Amalric's first marriage, with Agnes of Courtenay, took place in 1158. It was actually annulled and Amalric was crowned on 18 February 1162.

313 This defeat occurred on 10 August 1164.

314 Bohemond was freed during the summer of 1165.

315 Shirkuh was Saladin's uncle.

316 An ancient Egyptian city that was destroyed by the Arabs and that served as a quarry for the construction of Cairo.

317 He was accompanied by a Templar called Geoffrey, who spoke Arabic.

318 The custom in western Europe.

319 On 20 August 1167.

320 Shirkuh died on 23 March 1169.

321 This happened on 29 June 1170.

322 Thoros had died in 1168 and his brother, Mleh, was disputing the succession.

323 In December 1170.

324 He suggested to King Amalric an alliance against Nur ed-Din.

325 The ambush was set by Walter of Mesnil.

326 On 15 March 1174.

327 Mamerot refers to the city here as "Belinas".

328 Amalric actually died on 11 July 1174.

329 On 15 July 1174.

330 This was in fact on 25 July 1174.

331 Raymond III of Tripoli was in fact the closest relative of the king.

332 Miles of Plancy was removed from power and then assassinated in the streets of Acre.

333 The ancient Assyrian city of Nineveh on the Tigris was destroyed in the seventh century. It was replaced by Mosul, which is today in Iraq.

334 Mamerot here calls the principality of Homs "La Chamelle".

335 This is the castle of Homs in eastern Syria, on the Orontes, to the north of Krak des Chevaliers.

336 William was archbishop of Tyre from 1175 to 1184.

337 Baldwin IV's reign actually began in 1174.

338 Philip of Flanders disembarked at Acre.

339 This is Robert of Bethune.

340 He wished to marry his two cousins, Sibylla and Isabella, to the younger sons of Robert of Bethune, his favourite vassal, and met with the king's refusal.

341 The term "nones" used by Mamerot corresponds roughly to the ninth hour after sunrise.

342 Mamerot here uses the word "watchdog" (*mâtins* in the original) to denote a crude and unpleasant person.

343 This unlooked-for victory occurred near the castle of Montgisard to the south-east of Ramleh and saved the kingdom, at least for a while.

344 This castle was built to protect the kingdom's frontier on the upper Jordan, between lake Huleh and the sea of Galilee.

345 The biblical patriarch (Genesis, XX –XLIX) who crossed over the ford of Yaboq with his family to flee from his brother Esau.

346 Here Mamerot writes "Belinas" for Banyas.

347 The king was attacked by Faruk-Shah, the nephew of Saladin, in the forests of Banyas.

348 Mamerot refers to this "Valley of Springs" between the Litani and Jordan rivers as "Mergron".

349 Odo of Saint-Amand refused through pride to be exchanged for a Muslim prisoner and died in prison.

350 He was bishop of Beauvais.

351 The siege lasted five days, from 24 to 29 August. The castle was razed to the ground.

352 Hugh III of Burgundy was to marry the princess Sibylla, but he preferred to remain in France and Sibylla fell in love with Baldwin of Ibelin.

353 Bohemond III of Antioch reigned from 1163 to 1201.

354 The marriage took place on Easter Day 1180.

355 A two-year truce was signed by treaty between Baldwin and Saladin in May 1180.

356 This Aradin was a Canaanite (see Genesis 10, 18).

357 The patriarch Amalric of Nesle died on 6 October 1180 and Heraclius of Caesarea succeeded him on 16 October. He was patriarch from 1180 to 1191. According to William of Tyre, it appears to have been the king's mother, Agnes of Courtenay, who promoted his advancement.

358 The reference here is to Heraclius I, emperor of Byzantium, who regained the True Cross from the Persians and brought it back to Jerusalem in 630.

359 This is an illusion to William of Tyre's chronicle of the Latin kingdom of Jerusalem up to 1184 (*Historia rerum in partibus transmarinis gestarum*), a work that was completed by Ernoul. Mamerot appears to have used this text as a source.

360 Mamerot writes 1181, but Manuel actually died on 24 September 1180.

361 Alexius II (r. 1180–1183), son of the emperor Manuel I (r. 1143–1180), became emperor at the age of eleven; he was assassinated in 1183 by Andronicus.

362 A nephew of Manuel I and favourite of the Latin empress Maria, who held the regency of the empire, Alexius was extremely unpopular.

363 Andronicus Comnenus, cousin of the emperor Manuel I.

364 Since he lived in the region of Pontus, he crossed Anatolia in 1182 to reach Constantinople.

365 The empress was strangled.

366 Springs to the north of Nazareth.

367 This is the town of Saroudj.

368 The allusion here is to the death of as-Salih Ismail of Aleppo on 4 December 1181 as the result of dysentery, which was attributed to poisoning.

369 This was on 12 June 1183.

370 Also known as the lake of Genneseret or lake Tiberias.

371 At this time, the future Baldwin V, who was born in 1177, was only six years old.

372 In fact, the young Baldwin V was crowned at the beginning of 1185 in the church of the Holy Sepulchre and Baldwin IV died in March 1185.

373 Mamerot erroneously writes 1183 instead of 1185.

374 Mamerot erroneously writes 1184, but the Leper King in fact died in March 1185.

375 Baldwin V was actually the son of William of Montferrat and Sibylla, sister of King Baldwin IV.

376 He was, in fact, his grandson and not his nephew, as Mamerot states.

377 Actually, it was not King Baldwin V's uncle, Boniface, who journeyed to the Holy Land, but instead his grandfather, the marquis of Montferrat.

378 Andronicus I Comnenus, the grandson of Alexius I Comnenus, had his predecessor Alexius I strangled and seized the throne by force in November 1183.

379 Conrad was in fact the brother of Boniface of Montferrat and the son of William of Montferrat.

380 Isaac Angelus (r. 1185–95, 1203–04), who overthrew Andronicus I and succeeded him under the name of Isaac II Angelus (1185).

381 Mamerot draws on William of Tyre (XIV) for this and the following episodes.

382 There are a number of versions of this episode: one of these relates how the emperor was led on a camel and then tortured and torn to pieces by the people. Here Mamerot is faithful to William of Tyre's version.

383 Bela III.

384 He subsequently became emperor under the name of Alexius III (r. 1195–1203).

385 He became Alexius IV in 1203 and received help from the crusaders and the Venetians.

386 Mamerot refers to Alexius Branas as "Livernas".

387 Baldwin V, son of William of Montferrat and Sibylla, succeeded his uncle Baldwin IV under the guardianship of Joscelin III, count of Edessa. He died in August 1186.

388 The reference here is to Sibylla, daughter of King Amalric, sister of Baldwin IV and mother of Baldwin V. She had married Guy of Lusignan in 1180.

389 Reynald of Châtillon.

390 Although Mamerot does not name him, the master of the Hospital was Roger.
391 This was Gerald of Ridfort.
392 The royal insignia were kept in a chest with three locks, to which the patriarch and the two grand masters of the Hospital and the Temple each held a key.
393 Around 3 o'clock in the afternoon.
394 Another version relates that he threw the keys out of the window.
395 Mamerot means Baldwin of Ibelin here.
396 The allusion is to the defeat at Hattin, which occurred on 4 July 1187.
397 Raymond III of Tripoli.
398 Isabella, born in 1172, was the daughter of King Amalric I and Maria Comnena. She had married Humphrey of Toron in 1183, and subsequently two more times.
399 Humphrey of Toron was indeed terrified at the prospect of being king.
400 The count of Tripoli returned to his wife's lands in Galilee.
401 Thomas of Ibelin.
402 Bohemond of Antioch gave him a very large fief by way of thanks.
403 Archbishop Josias of Tyre.
404 They left Jerusalem on 29 April 1187.
405 Nur ed-Din al-Afdal.
406 This defeat actually took place on 30 April 1187.
407 On 2 July 1187.
408 The countess Eschiva held out as best she could with her small garrison, who were forced to retreat into the town's citadel.
409 A proverbial expression that is also found in William of Tyre's text and which meant that the count was in fact still in a position to fight.
410 This incident is recounted by William of Tyre.
411 William of Tyre states clearly that she went to Saladin to receive the recompense for the service she had rendered him in attempting to bewitch the Christians.
412 Around 3 o'clock in the afternoon.
413 They set up camp in a place called the Horns of Hattin.
414 The defeat of Hattin, which led to the fall of the kingdom of Jerusalem, did not take place in 1188 but on 4 July 1187.
415 The Saracen troops were here commanded by Taki ed-Din.
416 William, not Boniface. The same mistake occurs in William of Tyre's account.
417 On 5 July 1187.
418 On 10 July 1187. The town was defended by Joscelin III of Courtenay.
419 This was Queen Maria.

420 Mamerot erroneously refers to him as "Gerard de Rochefort".
421 He died at the end of 1187.
422 He had no children and therefore bequeathed his county to Raymond, son of Bohemond III of Antioch.
423 Conrad, son of the marquis of Montferrat, had been implicated in an affair of murder and wished to absent himself from Constantinople.
424 On 14 July 1187.
425 Again, this is William of Montferrat.
426 Saladin spared the life of the old man.
427 It was on 5 September 1187 that Saladin allowed the inhabitants of Ascalon to leave the city with their families and their possessions.
428 Saladin set up his siege-machines on 20 September 1187.
429 The Christians were relying on the sacred nature of the city of Jerusalem to protect them.
430 This agreement was signed on 2 October 1187.
431 Historians of the crusades agree upon a different date, that of 2 October 1187.
432 The story of this incident is frequently told; it underlines the contrast between the generosity of the Saracens and the selfishness of the Europeans.
433 Within a few months, all the churches and convents of Jerusalem had been re-converted into Muslim buildings.
434 He arrived in Tyre on 2 November 1187.
435 He was one of a group of knights who had been sent by William of Sicily in 1188. The Christian name of this knight is no longer known; all that is known is his surname.
436 The reference here is to Raymond, count of Tripoli.
437 On 1 January 1188.
438 Mamerot is mistaken here, for the reference is in fact to archbishop Josias, who set out from Rtyr at the end of the summer of 1187.
439 In 1187.
440 Josias met the two kings at Gisors on the frontier between Normandy and the French royal estates.
441 Henry II died on 6 July 1189. In that same year, his son Richard had formed an alliance against him with the king of France.
442 Frederick Barbarossa was at that time seventy years old. He took the cross at Mayence on 27 March 1188.
443 He took with him his younger son, Frederick of Swabia.
444 This is Alexius III Angelus.
445 This accident happened in Seleucia, in the river Calycadnus, on 10 June 1190.
446 It was the emperor's younger son, Frederick of Swabia, who took over the command of the troops.
447 Saladin met the Green Knight near Tripoli during the summer of 1188.

448 William of Montferrat.

449 Conrad of Montferrat.

450 Mamerot is mistaken here; when these events took place, the emperor Frederick Barbarossa was not yet dead.

451 The king set up camp on the hill of Tron on 28 August 1188.

452 The reinforcements (Danes, Flemish, French, Germans, etc.) arrived from western Europe in September 1188.

453 King Richard of England, who was known as Richard the Lionheart, reigned from 1189 to 1199.

454 The king of France had very strong views on the political government of the kingdom; he also believed that the kingdom incurred great risks in his absence.

455 Mamerot incorrectly calls this document a "will". It was in fact an ordinance, in other words, an act generally establishing how the kingdom should be governed in the king's absence.

456 Adela of Champagne, the second wife of King Louis VII, who gave birth to the future Philip II Augustus on 21 August 1165.

457 The reference here is to William of Champagne, known as William of the White Hands, the fourth son of Tibald II the Great, count of Champagne. William was archbishop of Rheims from 1175 to 1202.

458 This son, who was born in 1187, was the future Louis VIII, who reigned from 1223 to 1226.

459 That is, on 1 October.

460 William I of Garlande took the cross in 1190–91.

461 Tibald of Blois was seneschal to Philip II Augustus.

462 Henry I the Liberal, count of Champagne from 1152 to 1181.

463 In other words, eight days after 24 June 1190, on 4 July.

464 Tancred succeeded William II of Sicily, who died in November 1189. He was a cousin of the king and count of Lecce.

465 Henry VI (r. 1191–1197), son of Frederick I Barbarossa.

466 The sister of King Richard the Lionheart, Joan of England, had been married to Tancred's predecessor, William II of Sicily. Her daughter was Constance, wife of Henry VI of Hohenstaufen.

467 The setier was a measure of volume for grains and liquids.

468 Berengaria of Navarre.

469 Eleanor of Aquitaine, who had married Henry II Plantagenet.

470 Alice of France, sister of King Philip II Augustus.

471 Philip II Augustus set sail from Messina on 30 March 1191.

472 On 30 April 1191.

473 Richard finally left Messina on 10 April 1191.

474 For the previous five years, Cyprus had been under the control of the emperor Isaac Ducas Comnenus, who had driven out Isaac Angelus. He agreed to negotiate with King Richard the Lionheart. The king married Berengaria in Limassol, and then seized Nicosia. By the end of May 1191, the island of Cyprus belonged to King Richard.

475 Sibylla died in 1190.

476 Alternative spelling of Honfroi.

477 Marquis Conrad of Montferrat.

478 Twenty-five galleys belonging to King Richard arrived in Acre on 8 June.

479 The reference here is to Rudolph I, count of Claremont.

480 During the battle of Hattin.

481 Count Hugh III of Burgundy, cousin of King Philip II Augustus of France.

482 Philip set sail for Brindisi early August.

483 An Ismaili sect, which was established in the twelfth century in the mountains to the east of Tortosa. Driven by a fanatical zeal, they had no hesitation in killing their enemies.

484 Sinan, chief of the Assassins.

485 Richard then took complete command of the Christian armies.

486 Leopold V, duke of Austria, chief of the German army, claimed equal rights over Acre to those of the kings of France and England and had planted his banner beside that of King Richard.

487 Richard ordered the crusader army out of Acre on 23 August.

488 All the English chroniclers tell such tales, which give a very positive image of Richard the Lionheart.

489 The half-sister of Richard was Mary of Champagne.

490 Henry, son of Mary of Champagne and of Henry I the Liberal, was married to Isabella of Jerusalem in 1192. He died in 1197.

491 Tibald III, count of Champagne from 1197 to 1201.

492 Mary married Baldwin IX of Flanders.

493 On 29 September 1192. It appears that this is an allusion to the five-year peace treaty signed by Saladin in September 1192.

494 Here Mamerot gives a brief summary of this episode: Richard was shipwrecked near Aquilea and had to set out overland through Carinthia and Austria.

495 Friesach is in Carinthia.

496 As the story goes, Richard had disguised himself as a cook.

497 Leopold handed over Richard to the emperor Henry VI, who kept him in prison and freed him only only in March 1194.

498 Mamerot is incorrect here. He refers to Isabella as Conrad of Montferrat's daughter, not as his widow. The

text has been corrected here. In 1183, Isabella, daughter of Almaric I of Jerusalem, married Humphrey IV of Toron. In 1190, she became the wife of Marquis Conrad of Montferrat. Two years later, following Conrad's death, she married Henry of Champagne.

499 This was Frederick Barbarossa.

500 Marguerite of France, the widow of King Bela III, was the sister of Philip II Augustus and sister-in-law of King Richard.

501 Saladin died on 3 March 1193.

502 The oldest son was al-Afdal.

503 Henry of Champagne died on 10 September 1197, not 1195.

504 Henry VI died on 28 September 1197. His wife Constance of Sicily had had a son on 26 December 1194 when she was forty years old. Frederick was two years old when he was crowned at Palermo, not, as Mamerot states, at Messina.

505 These lords took the cross during the tournament of Ecry in l'Aisne, after hearing the preaching of Fulk of Neuilly.

506 Enrico Dandolo, born in 1107, was at that time doge of Venice.

507 Count Tibald died in March 1201.

508 The future Tibald IV, count of Champagne and king of Navarre.

509 The election of Bonface I of Montferrat was ratified at Soissons.

510 Amongst them was a great lord of Champagne, Geoffrey of Villehardouin, who has left a chronicle of this crusade, called *On the Conquest of Constantinople*.

511 Zara was at that time in the hands of the Hungarians. The crusaders arrived there on 10 November 1202, not in 1203.

512 Although the Pope disapproved of what had happened at Zara, in fact he did no more than publish a bull forbidding attacks on any other Christians.

513 The reference here is to the future Alexius IV, known as the Young, the son of Isaac II Angelus, whom Mamerot calls Kirsac and who was the nephew of Alexius III.

514 Mamerot uses the term pilgrims to denote both the Venetians and the French who set out from Venice on what historians now call the Fourth Crusade (1203–04).

515 Other sources give 200,000 silver marks.

516 In fact in 1203.

517 Abydos, a port situated on the strait of the Dardanelles. Mamerot uses the name Bouleredane.

518 Alexius III deposed his brother Isaac II in 1195. He blinded him and put him in prison.

519 The future Alexius IV.

520 Murzuphlus organised an uprising in January 1204.

521 Alexius IV.

522 Under the name of Alexius V Murzuphlus.

523 The crusaders' dream was to instal a western European as emperor of Constantinople.

524 The crusaders entered the city in April 1204.

525 This is how Mamerot refers to himself throughout the mansuscript.

526 Baldwin IX was solemnly crowned at the Hagia Sophia on 16 May 1204.

527 Alexius III.

528 From 1205 to 1210, the daughter of the king of Jerusalem, Maria of Montferrat, was queen, with John of Ibelin acting as regent. Now aged seventeen, she had to be married.

529 John of Brienne was poor and already sixty years old, but he had a great deal of political experience. He arrived in Acre on 13 September 1210.

530 The coronation took place in Tyre on 3 October 1210.

531 The kings referred to here are Andrew II of Hungary, Hugh I of Cyprus and Leo II of Armenia.

532 The young queen died in 1212 giving birth to a daughter, Isabella. John of Brienne married again in 1214, to the princess Stephanie of Armenia.

533 The crusader army set sail from Acre on 24 May 1218 on Ascension Day and reached Damietta on 27 May.

534 The brother of Saladin, al-Adil Saif ad-Din.

535 Krak des Chevaliers is a fortress built by the Hospitallers, which is today in Syria.

536 This was Malik al-Kamil.

537 Al-Mu'azzam was the brother of al-Kamil.

538 On 29 August 1219.

539 The reference is to Cardinal Pelagius of Albano.

540 Leo II of Armenia died in 1219.

541 This happened in 1219. It was also said that the queen wished to poison the little girl.

542 Frederick II had taken the cross at Aix-la-Chapelle in 1215, but he delayed in setting out.

543 On 29 November 1227.

544 He arrived on 7 September 1228 and had himself acknowledged as regent of the kingdom.

545 The treaty of Jaffa of 18 February 1229 allowed the Christians to regain the territory they had lost after the battle of Hattin.

546 He installed himself in Jerusalem on 17 September 1229 in spite of the hostlility of the patriarch and of the military orders.

547 This refers to the Order of the Blessed Virgin Mary, which was dependent on the German Hospital.

548 Tibald IV (r. 1201–1253), count of Champagne and of Brie, nephew of Henry of Champagne, became king of Navarre in 1234 after the death of Sancho VII, known as "the Strong".

549 There is a gap in the manuscript here; the date is incomplete. Other manuscripts give 1245.

550 They embarked at Aigues-Mortes and at Marseilles.
551 Tibald landed at Acre on 1 September 1239.
552 Here Mamerot confuses two episodes. The first concerns Peter of Brittany, who was tipped off by a spy that a caravan laden with merchandise was close by and pillaged it; his booty aroused much envy in the army. The second concerns an attack on the town of Gaza, which took place in spite of the fact that the king of Navarre defended it.
553 The Christian army was surrounded and the battle swiftly came to an end. This was a disaster for the crusaders.
554 Richard was the brother of Henry III of England and his sister was the wife of the emperor Frederick. He stayed in Palestine until May 1241.
555 By calling him Saint Louis, Mamerot anticipates the canonisation of the king.
556 In June 1245, the Pope was driven out of Italy by the forces of the emperor Frederick II.
557 In 1244, after the disaster of Gaza, Galeran, the bishop of Beirut, was sent by the patriarch Robert of Jerusalem and came to the West to inform the Pope of the situation and to ask for military reinforcements.
558 He fell ill in December 1244.
559 In 1248.
560 The Council took place in Lyons from 24 June to 7 July 1245.
561 Mamerot already insisted on this point in fol. 223va.
562 On 9 October 1245, the king called together in Paris an assembly of barons and prelates, during which large numbers of people took the cross.
563 Henry Raspe was the anti-king appointed by the Pope in place of Frederick II and the latter's son Conrad IV.
564 This meeting took place in November 1245.
565 Mamerot is mistaken; this happened during the month of August.
566 In fact, the king left Paris on 12 August 1248.
567 Saint-Denis.
568 Alfonso of France, count of Poitiers.
569 La Roche de Clin is in the Drôme, near Valence. Its lord maintained that he could exact a toll from the pilgrims and was punished by the king for doing so.
570 He embarked on 25 August and arrived in Limassol on 17 September 1245.
571 The reference is to the sultan as-Salih Ayub.
572 Tarsus, a town in Turkey. In May 1248, two Nestorian messengers, called Mark and David, sent by the Grand Khan, presented themselves before the king in Nicosia. The Tartars, of Mongol origin, had conquered territory in Anatolia and their presence so close to the Latin kingdom alarmed the Franks.
573 They were Nestorians, or heresiarch Christians, disciples of Nestorius, who was a patriarch of Constantinople in the fifth century.

574 This letter, like the following one, stresses the strong interest in that the Mongols had in Christianity. The Christians hoped that the Mongols would prove to be allies against the Saracens.
575 This letter was sent to Henry I, king of Cyprus, by King Heitrum of Armenia.
576 Mamerot writes "Chain" instead of "Khan".
577 From 1251 to 1259, the great Khan was Mongka.
578 Sara was a town in Persia (Iran), from which the three Wise Men set out to find the Christ Child.
579 According to legend, Saint Thomas brought Christianity to India.
580 Mamerot writes, incorrectly, "dear sire", which has been corrected according to the sense.
581 These messengers came to represent the Great Khan of Mosul, whom Mamerot calls Escarthay.
582 This was undoubtedly Hulagu Khan (r. 1251–1265).
583 Prester John was an imaginary monarch; he was portrayed as a Christian from the East and, in the Middle Ages, it was thought that he might come to the aid of the Holy Land.
584 This is a portable chapel.
585 Andrew of Longjumeau, who spoke Arabic, had been the principal emissary of the Pope during the preceding years. The king's envoys left Cyprus for Mongolia in January 1249 and went as far as Karakorum, where they learned that the khan Guyuk was dead.
586 In the original text, Mamerot speaks of the king of Egypt, and then later speaks of the sultan of Babylon. In both cases this was as-Salih-Ayub.
587 Both here and later Mamerot refers to this town as "La Chamelle"; this was in fact Homs.
588 This refers to an-Nasir Yusuf of Aleppo.
589 This refers to as-Salih Ayyub.
590 Bohemond V.
591 All along the Syrian coast, open warfare was waged between the Genoese, who were allies of King Louis, and the Pisans.
592 The Venetians did not in fact approve of this plan.
593 William II of Villehardouin was prince of Morea and of Achaea.
594 Hugh IV, duke of Burgundy.
595 The king's fleet made ready to sail for Egypt in May 1249 and came in sight of Damietta on 4 June.
596 On 24 August 1249.
597 On 20 November 1249.
598 The town of Mansourah, whose name means "the Victorious One", had been built by the sultan al-Kamil.
599 Although he was ill, the sultan Ayub had had himself carried along to organise his troops. He died on 23 November 1249.
600 His only son, Turanshah, was far away and so it was the king's widow and the general el-Fakr ad-Din who

took power, falsifying a document in which the sultan appointed his son as his heir and successor.

601 This is the name of the general who was viceroy during the king's illness and who wished to govern in place of Turanshah.

602 Mamerot is mistaken. This happened on 8 February 1250.

603 Turanshah arrived on 28 February 1250.

604 He set up camp on 5 April 1250 with the intention of taking refuge in Damietta.

605 They were suffering from dysentery and from typhoid.

606 The Egyptians were overwhelmed by the great numbers of prisoners they took, and executed the weakest.

607 The king was lodged, in chains, in a house in Mansourah where he was cared for.

608 Sultan Touramshah.

609 The king had to pay 500,000 pounds (Livres tournois), about a million bezants.

610 Sultan al-Kamil.

611 At about nine o'clock in the morning.

612 Turanshah was killed by the Mameluks, possibly at the instigation of his own mother, on 2 May 1250.

613 Geoffrey of Sargines surrendered the town on 6 May 1250.

614 This refers to an-Nasir Yusuf.

615 The king's brothers left around the middle of July.

616 This character remains shrouded in mystery; he is called the "Master of Hungary".

617 In fact, this episode took place after the disaster of Mansourah. When the news of this defeat reached the west, there was a spontaneous popular uprising amongst the peasants and the labourers, who called each other "shepherds". They wished to denounce the Pope and his clergy and to come to the help of King Louis.

618 The university students were actually on the Left Bank of the Seine.

619 Geoffrey of Sargines was a knight from the region of Sens; a number of authors, in particular John of Joinville, stress his exceptional bravery.

620 On 24 April 1254.

621 He disembarked at Hyères in July 1254.

622 Henry III of England (r. 1216–1272).

623 The treaty was signed in Paris in 1259.

624 Tibald V of Champagne.

625 On 1 July 1269.

626 That is, in north Africa.

627 The emir of Tunis was al-Mustansir.

628 On 18 July 1270.

629 Tristan, who was born at Damietta, was the son of King Louis IX.

630 Philip, the heir to the throne, was also seriously ill.

631 A number of versions of this text, which is known as the "Enseignements" (Instructions), exist in various French and Latin manuscripts, in particular the *Vie de Saint Louis* of William of Saint-Pathus, the *Grandes Chroniques de France* and the *Vie de Saint Louis* of Joinville. Mamerot condenses the text considerably here.

632 Louis IX died on 25 August 1270.

633 The entrails and the flesh were buried in Sicily in the cathedral of Monreale. Only the heart and the bones were taken back to Saint-Denis.

634 Edward I reigned from 1272 to 1307.

635 Henry III reigned from 1216 to 1272.

636 Tibald V of Navarre died in 1270.

637 He died on 21 August 1270. William of Nangis says that this was at Corneto in Tuscany; other sources maintain that Alfonso died at Sampierdarena near Genoa.

638 The king was canonised twenty-seven years after his death, on 11 August 1297 by Boniface VIII.

639 The manuscript has 1310 here, a mistake that has been corrected to 1390.

640 Actually, the sultan Bayezid I was attempting to seize territory from Hungary from 1390 onwards.

641 Count John of Nevers, son of Duke Philip II of Burgundy, called "the Bold", became duke after him and was known as John the Fearless. He was twenty-four years old at the time of the expedition to Hungary.

642 Bayezid I "the Thunderbolt" (r. 1389–1402).

643 Buda, a city in Hungary, was fortified in 1247, when Bela IV (r. 1235–1270) built a castle there to resist the Mongols.

644 Mamerot uses the spelling "Saudin" to denote this town of Vidin, in northern Bulgaria.

645 The lord of Vidin was a Bulgarian prince, Ivan Sratsimir, who did not bear the title of emperor.

646 Rahova was a strong fortress where there was a large Turkish garrison.

647 The siege took place in September 1396 and not in 1397.

648 The Turkish governor, Dogan Bey, refused to surrender.

649 On Monday, 25 September 1396.

650 The reference here is to the *Livre des faits de Jean le Meingre dit Boucicaut,* which was written between 1406 and 1409 and which recounts the story of the marshal's life. The author's name is not given in the text and it is unlikely to have been the work of the marshal himself.

651 The army was thus divided into four corps: the Hungarians were in the centre, the Walloons on the left and the Transylvanians on the right, while the western Europeans formed the vanguard.

652 A Turkish city near the sea of Marmara, which was formerly called Bursa.

653 James of Helly, a French knight, spoke Turkish.

654 Mytilene is the principal port of the Greek island of Lesbos, in the Aegean Sea.

655 They returned at the end of 1397.

656 The Cantacuzenus family was Greek and had provided Constantinople with two emperors during the fourteenth century.

657 Manuel II Palaeologus, born in 1350, was emperor of Constantinople from 1391 to 1425.

658 Charles VI of France.

659 Gallipoli is a Turkish city situated on the European shore of the strait of the Dardanelles.

660 Present-day Izmit, Turkey.

661 Marshal Boucicaut is here portrayed as the saviour of the city of Constantinople.

662 Manuel II went to France and stayed there for three years, from 1399 to 1402.

663 Tamurlane, Turco-Mongol chief (r. 1370–1405).

664 He conquered vast territories in Asia – Transoxania, Persia, northern India – and was preparing to invade China when he died.

665 Tamurlane inflicted a serious defeat on Bayezid on 20 July 1402 near Ankara.

666 An allusion to the defeat at Nicopolis in 1396.

667 Tamurlane died in 1405.

668 There was a Genoese colony at Pera, opposite Constantinople. Boucicaut arrived in the Bosphorus in 1399 and prevented the Turks from completely destroying Constantinople.

669 Louis of Orleans, brother of Charles VI, was assassinated in Paris in 1407 by men of John the Fearless, duke of Burgundy.

670 Charles VI (r. 1380–1422) suffered from dementia.

671 Mamerot is mistaken here, it was in 1458.

672 Louis de Laval was appointed governor of Genoa in 1461 by King Charles VI.

673 He died in 1422.

674 Mamerot is incorrect; it was in 1328.

675 Philip VI of Valois (r. 1328–1350) became king in 1328, when he succeeded Charles IV. He was chosen by the great barons of France, who preferred him to the two other relatives of the king, Philip of Evreux and King Edward of England.

676 Charles IV the Fair (r. 1322–1328) was the son of Philip IV the Fair.

677 Edward III of England (r. 1327–1377) was the son of Edward II and of Isabella of France, and therefore the grandson of King Philip IV of France (the Fair), to whose crown he laid claim. It was this which triggered the Hundred Years' War between the French and the English.

BIBLIOGRAPHY

Reproductions of manuscripts illuminated by Jean Colombe

Fac-similé du Livre d'heures de Louis d'Orléans (St Petersburg, National Library of Russia, ms. lat. Q. V. I. 126), Barcelona, 2001.

Raymond Cazelles, *Les Très Riches Heures du duc de Berry*, Paris, 2003.

Marcel Thomas (preface and commentary), *Histoire de la Destruction de Troye la Grant: Reproduction du manuscrit Bibliothèque nationale, Nouvelles Acquisitions Françaises 24 920*, Paris, 1973.

Studies of Jean Colombe and his œuvre

J. J. G. Alexander, J. H. Marrow, L. Freeman Sandler, *The Splendor of the Word: Medieval and Renaissance illuminated manuscripts at the New York Public Library*, London, 2006, nos. 48, 61, 97.

François Avril, Nicole Reynaud, *Les manuscrits à peintures en France, 1440–1520*, Paris, 1993, esp. pp. 324–347 (Ms. BnF Fr. 5594 is described on p. 332; no. 180).

François Avril, "Un chef d'œuvre retrouvé de l'enlumineur Jean Colombe: les heures de Guyot Le Peley, marchand troyen", *L'Art de l'enluminure*, no. 21 (2007).

François Avril, Maxence Hermant, Françoise Bibolet, *Très riches heures de Champagne*, Paris, Hazan, Châlons-en-Champagne, 2007.

Janet Backhouse, note on ms. Harley 4335–4339, British Library, in *Renaissance painting in Manuscripts: Treasures from the British Library*, New York, London, 1983, pp. 157–162, n. 20.

Paul Chenu, "Le livre des offices pontificaux de Jean Cœur, archevêque de Bourges", in *Mémoires des Antiquaires du Centre*, vol. XLVIII, 1941, pp. 2–32 and pls. I–IX.

Thierry Delcourt, "Un livre d'heures à l'usage de Troyes peint par Jean Colombe: Une acquisition récente de la médiathèque de Troyes", *Bulletin du Bibliophile*, no. 2 (2006): pp. 221–244.

Paul Durrieu, *Les Très Riches Heures de Jean de France, duc de Berry*, Paris, 1904, pp. 104–112.

L.-F. Flutre, "Un autre manuscrit des *Faits des Romains*", Neophilologus, 21, no. 1 (1936): pp. 243–249.

Katharina Georgi, "La Bethsabée des Heures Le Peley et le traitement du thème dans l'œuvre de Jean Colombe", *L'Art de l'enluminure*, no. 21 (2007): pp. 56–61.

Katharina Georgi, "Bethsabée, la belle séductrice: À propos d'une miniature de Jean Colombe retrouvée", *Bulletin monumental* (2007).

Marie Jacob, "Jean Colombe, un pittore di Bourges familier e miniator del duca Carlo I di Savoia", *Corte et Città: Arte nel Quattrocento nelle Alpi occidentale*, Turin, 2006, pp. 463–466.

Marie Jacob, "Les Faits des Romains, un autre manuscrit aux armes Le Peley enluminé par Jean Colombe", *L'Art de l'enluminure*, no. 21 (2007): pp. 62–67.

Jean Murard, "Un mécène de la Renaissance, Simon Liboron", *La Vie en Champagne*, no. 21 (Feb.–March 2007): pp. 3–15 (erroneous attribution of the Livre d'heures de Simon Liboron to Jean Colombe).

Otto Pächt, Dagmar Thoss, *Die illuminierten Handschriften und Inkunabeln der Oesterreichischen Nationalbibliothek. Französische Schule I*, Vienna, 1974, pp. 68–79 (Vienna manuscript, BN 2577–2578).

Jean Porcher, *Les Manuscrits à peinture en France du XIIIe au XVIe siècle*, Paris, Bibliothèque nationale, 1955, pp. 151–59 (nos. 323–334).

John Plummer, Gregory Clark, *The Last Flowering: French Painting in Manuscripts, 1420–1530*, New York, 1982 (nos. 54, 68, 69, 70).

Laurence Rivière Ciavaldini, *Imaginaires de l'Apocalypse: Pouvoir et spiritualité dans l'art gothique européen*, Paris, 2007 (manuscript 'e' of the *Apocalypse* in the collection of El Escorial library).

G. Saroni, *La biblioteca di Amedeo VIII di Savoia (1391–1451)*, Turin, 2004, pp. 49–52.

Claude Schaefer, "Un livre d'heures enluminé par Jean Colombe à la Bibliothèque Laurentienne à Florence", *Gazette des Beaux-Arts* (Nov. 1973): pp. 287–296.

Claude Schaefer, "Nouvelles observations au sujet des Heures de Louis de Laval", *Annales de l'Ouest* (1980): pp. 33–68.

Claude Schaefer, "Die *Romuleon* Handschrift des Berliner Kupferstichkabinetts", *Jahrbuch der Berliner Museen* (1981): vol. XXIII, pp. 142–143.

Claude Schaefer, "Autour des Heures de Laval: les activités de l'atelier Colombe après 1470", in *Medieval Codicology, Iconography, Literature and Translation: Studies for Keith Val Sinclair*, ed. R. Monks and D. D. R. Owen, Leiden, 1994, pp. 157–169.

Claude Schaefer, "Die Werkstatt des Jean Colombe", in *Fouquet: An der Schwelle zur Renaissance*, Dresden, Basle, 1994, pp. 283–286.

Patricia Stirnemann, "Combien de copistes et d'artistes ont contribué aux Très Riches Heures du duc de Berry", in *La création artistique en France autour de 1400. Actes du colloque international. École du Louvre-Musée des Beaux-Arts de Dijon-Université de Bourgogne, 7–10 juillet 2004*, ed. Élisabeth Taburet-Delahaye, Paris, 2006, pp. 370, 374, 378.

J. Stratford, "Un livre d'heures inconnu et le rayonnement de Jean Fouquet", *Revue de l'Art*, no. 135 (2002): pp. 93–105.

Kay Sutton, Description of Lot 31 in Christie's sale catalogue, London, 8 June 2005 *(the Livre d'heures de Guyot II Le Peley acquired by the Médiathèque de l'Agglomération troyenne).*

Louis Thuasne, "Note sur Jean Colombe, enlumineur", *Revue des bibliothèques* (Jan.–April 1904).

Roger Wieck, *Painted Prayers: The Book of Hours in Medieval and Renaissance Art*, New York, 1998.

Publications on Louis de Laval

A. Bertrand de Broussillon, *La maison de Laval, 1020–1605, étude historique accompagnée du cartulaire de Laval et de Vitré*, Paris, 1900, vol. III, pp. 13–15.

A. Sorbelli, *Francesco Sforza a Genova (1458–1466): Saggio sulla politica italiana di Luigi XI*, Bologna, 1901, pp. 42–53.

Publications on Sébastien Mamerot and his works

Le Romuleon en françois: Traduction de Sébastien Mamerot. Critical edition, introduced and annoted by Frédéric Duval, Geneva, 1991.

Pierre Champion, *Chronique martiniane, édition critique d'une interpolation originale… restituée à Jean Le Clerc*, Paris, 1907.

Frédéric Duval, "Sébastien Mamerot", in *Romania*, 1998, vol. CXVI, pp. 461–491.

Frédéric Duval, *La traduction du Romuleon par Sébastien Mamerot*, Geneva, 2001.

L.-F. Flutre, *Li* Fet des Romains *dans la littérature française et italienne*, Paris, 1932, p. 178.

Abbé Lebeuf, "Mémoire sur les Chroniques martiniennes", in *Mémoires de l'Académie des Inscriptions et Belles-Lettres*, 1753, vol. XX, pp. 224–266.

M. Lecourt, "Notice sur *l'Histoire des neuf preux et des neuf preuses* de Sébastien Mamerot", in *Romania*, 1908, vol. XXXVII, pp. 529–537.

D. J. A. Ross, "Les Trois Grands: A humanist historical tract of the 15th century", *Classica et Medievalia*, 27 (1966): pp. 375–396.

D. J. A. Ross, "Les Trois Grands: A New Ms and the identity of the Author", in *Medium Aevum*, 55 (1986): pp. 261–265.

H. Schroeder, *Der Topos der Nine Worthies in Literatur und bildender Kunst*, Göttingen, 1971.

Antoine Thomas, "Notes biographiques et bibliographiques sur Sébastien Mamerot", in *Romania*, 1908, vol. XXXVII, pp. 537–539.

Richard Trachsler, "Le seigneur et le clerc: Sébastien Mamerot et la naissance du dixième preux", in *Le clerc au Moyen Âge: Senefiance*, 1995, no. 37, pp. 539–555.

The crusades: medieval sources in French and Latin

Pierre Aubry, Joseph Bédier, *Les chansons de croisade*, Paris, 1909.

Robert de Clari, *La conquête de Constantinople*, ed. Philippe Lauer, Paris, Champion, 1924.

Collection des Mémoires relatifs à l'histoire de France, published by François Guizot, Paris, 1823–1835 (partly reprinted, from 2000; can be consulted on the BNF *Gallica* site, http://gallica.bnf.fr/).

Roland Delachenal, *Les Grandes Chroniques de France: Chronique des règnes de Jean II et de Charles V*, Paris, 1910–1920.

Histoire anonyme de la Première croisade, ed. Louis Bréhier, Paris, 1924 (reprinted 1964).

Jean de Joinville, *Histoire de saint Louis*, ed. Jacques Monfrin, Paris, 1995.

Livre des faits de Jean le Meingre, dit Boucicaut, ed. Denis Lalande, Geneva, 1985.

Though somewhat dated, the *Recueil des historiens des croisades*, published by l'Académie des Inscriptions et Belles Lettres, Paris, 1841–1906, remains indispensable for many texts.

Danièle Régnier-Bohler (ed.), *Croisades et pèlerinages: Récits, chroniques et voyages en Terre Sainte, XIIe–XVIe siècle*, Paris, Robert Laffont, 1997.

Jean Viard (ed.), *Les Grandes Chroniques de France*, Paris, Société de l'Histoire de France, 1920–1953 (10 vols., up to 1350).

Geoffroi de Villehardouin, *La conquête de Constantinople*, ed. Edmond Faral, Paris, 1961 (with numerous subsequent editions).
NB: A modern edition of Vincent of Beauvais's *Miroir historial* does not exist.

The crusades: Byzantine sources (unknown to Mamerot)
Nicétas Choniate, *Annales*, ed. and trans. Harry J. Magoulias, Detroit, 1984.
Anne Comnène, *Alexiade*, ed. Bernard Lieb, Paris, 1937–1945.
Jean Kinnamos, *Chronique*, trans. J. Rosenblum, Paris 1972.

The crusades: modern studies
Pierre Alphandéry, Alphonse Dupront, *La chrétienté et l'esprit de croisade*, Paris, 1995 (reprint).
Pierre Aubé, *Baudouin IV de Jérusalem, le roi lépreux*, Paris, 1981.
Pierre Aubé, *Godefroy de Bouillon*, Paris, 1985.
Pierre Aubé, *Saint Bernard de Clairvaux*, Paris, 2003.
Michel Balard, *Croisades et Orient latin (XIe–XIVe siècle)*, Paris, 2001.
Claude Cahen, *Orient et Occident au temps des croisades*, Paris, 1983.
P. J. Cole, *The Preaching of the Crusades to the Holy Land, 1095–1270*, Cambridge, MA, 1991.
Thierry Delcourt, *Les Croisades, la plus grande aventure du Moyen Âge*, Paris, 2007.
Alain Demurger, *Vie et mort de l'ordre du Temple*, Paris, 1994 (3rd ed.).
Alain Demurger, *Chevaliers du Christ: les ordres religieux militaires au Moyen Age, XIe–XVIe siècles*, Paris, 2002.
Alphonse Dupront, *Le Mythe de la croisade*, Paris, 1997.
Alphonse Dupront, *La Guerre sainte, la formation de l'idée de croisade dans l'Occident chrétien*, Paris, 2001.
Anne-Marie Eddé, Françoise Micheau, *L'Orient au temps des croisades*, Paris, 2002.
Anne-Marie Eddé, *Saladin*, Paris, 2008.
Jean Flori, *Pierre l'Ermite et la première croisade*, Paris, 1999.
René Grousset, *Histoire des croisades et du royaume franc de Jérusalem*, Paris, 1934–1936.
René Grousset, *L'Épopée des croisades*, Paris, 1957 (with numerous subsequent editions).
N. J. Housley, *The Later Crusades, 1274–1580: From Lyons to Alcazar*, Oxford, 1992.
Amin Maalouf, *Les croisades vues par les Arabes*, Paris, 1983.

Jean-François Michaud, *Histoire des croisades*, Paris, 1966–67 (6th ed.).
Cécile Morrisson, *Les croisades*, Paris, 1969.
Zoé Oldenbourg, *Les croisades*, Paris, 1965.
Marcel Pacaud, *Frédéric Barberousse*, Paris, 1990 (2nd ed.).
Joshua Prawer, *Histoire du royaume latin de Jérusalem*, Paris, 1969.
M. Rey-Delqué (ed.), *Les croisades: l'Orient et l'Occident d'Urbain II à saint Louis, 1096–1270*, Milan, Toulouse, 1997.
Jean Richard, *Le royaume latin de Jérusalem*, Paris, 1953.
Jean Richard, *Saint Louis*, Paris, 1985.
Jean Richard, *Saint Louis et son siècle*, Paris, 1985.
Jean Richard, *L'esprit de la croisade*, Paris, 2000.
Paul Rousset, *Histoire des croisades*, Paris, 1978.
Paul Rousset, *Histoire d'une idéologie: la croisade*, Lausanne, 1983.
Jonathan Riley-Smith, *The Atlas of the Crusades*, London and New York, 1991.
Jonathan Riley-Smith (ed.), *The Oxford Illustrated History of the Crusades*, Oxford, 1997.
Steven Runciman, *A History of the Crusades*, 3 vols., Cambridge, 1951–54 (with numerous subsequent editions).
F. H. Russell, *The Just War in the Middle Ages*, Cambridge, 1975.
Georges Tate, *L'Orient des Croisades*, Paris, 1991.
Les croisades, with an introduction by Robert Delort, Paris, 1988 (collection of articles from the journal *L'Histoire*).

ACKNOWLEDGEMENTS

The reprint of the illuminations of Sébastien Mamerot's *Passages d'Outremer* is based on a copy from the Bibliothèque nationale de France, Paris. We owe special thanks to the authors Danielle Quéruel and Thierry Delcourt, who passed away in 2011, for their extensive and first transcription and transfer of the original manuscript. Without their efforts and detailed text analysis it would not have been possible to realize the present edition. We thank Fabrice Masanès for his scholarly examination of the miniatures and his support during the completion of the project. We would also like to extend our thanks to the employees of the Bibliothèque nationale de France for their friendly cooperation, especially Marie-Pierre Laffitte and Philippe Salinson, who was responsible for the digital reproduction.

The facsimile edition (which was published by TASCHEN in 2009 and serves as a basis for the present volume) was born in late 2007 of a meeting between the Manuscript and Reproduction Departments of the Bibliothèque nationale de France and TASCHEN's editorial team, convened around some of the greatest masterpieces of French illumination. Throughout this long and exacting process, we have been most grateful for the ready and constant cooperation of Petra Lamers-Schütze and Mahros Allamezade, whose unflagging enthusiasm was combined with patience and understanding about the delays made inevitable by a project whose complexity and scale we had not originally grasped. Their collaborators, translators and editors have in many instances helped us to improve the quality and accuracy of our adaptation of Sébastien Mamerot's long, intricate and fascinating text.

We should also like to thank François Avril for his invaluable advice and to acknowledge the huge debt we owe to the works of Frédéric Duval on Sébastien Mamerot and Louis de Laval and to those of Marie Jacob on Jean Colombe, on both of which we have relied heavily in the introduction and commentary of this magnificent volume.

Thierry Delcourt and Danielle Quéruel, 2009

As the huge task of amending and commenting on the text of *Les Passages d'Outremer* draws to a close, I should like to offer a special vote of thanks to Petra Lamers-Schütze and Mahros Allamezade for their extensive and energetic support during the entire production period.

Finally, my sincere thanks go to Thierry Delcourt, the former chief librarian and director of the Department of Manuscripts at the Bibliothèque nationale de France, and to Danielle Quéruel, professor at the University of Reims Champagne-Ardenne, for valuable suggestions and helpful discussions and to Marie-Pierre Laffitte, chief librarian of the Department of Manuscripts, who kindly made available to me Louis de Laval's exemplar of *Les Passages*. Last but not least, I should like to thank to Johannes Althoff for his scrupulous attention to the captions as the work neared completion; I am most grateful to him for his erudition and willingness to help.

Fabrice Masanès, 2009

1000 Chairs

1000 Lights

Decorative Art 50s

Decorative Art 60s

Decorative Art 70s

Design of the
20th Century

domus 1950s

Logo Design

Scandinavian Design

100 All-Time
Favorite Movies

The Stanley Kubrick
Archives

Bookworm's delight:
never bore, always excite!

TASCHEN
Bibliotheca Universalis

20th Century
Photography

A History of
Photography

Stieglitz.
Camera Work

Curtis. The North
American Indian

Eadweard Muybridge

Karl Blossfeldt

Norman Mailer.
MoonFire

Photographers A–Z

Dalí. The Paintings

Hiroshige

Leonardo.
The Graphic Work

Modern Art

Monet

Alchemy & Mysticism

Braun/Hogenberg.
Cities of the World

Bourgery. Atlas of
Anatomy & Surgery

D'Hancarville.
Antiquities

Encyclopaedia
Anatomica

Martius.
The Book of Palms

Seba. Cabinet of
Natural Curiosities

The World
of Ornament

Fashion. A History from
18th–20th Century

100 Contemporary
Fashion Designers

Architectural Theory

The Grand Tour

20th Century
Classic Cars

1000 Record Covers

1000 Tattoos

Funk & Soul Covers

Jazz Covers

Mid-Century Ads

Mailer/Stern.
Marilyn Monroe

Erotica Universalis

Tom of Finland.
Complete Kake Comics

1000 Nudes

Stanton.
Dominant Wives

IMPRINT

EACH AND EVERY TASCHEN BOOK PLANTS A SEED! TASCHEN is a carbon neutral publisher. Each year, we offset our annual carbon emissions with carbon credits at the Instituto Terra, a reforestation program in Minas Gerais, Brazil, founded by Lélia and Sebastião Salgado. To find out more about this ecological partnership, please check: www.taschen.com/zerocarbon **Inspiration: unlimited. Carbon footprint: zero.**

To stay informed about TASCHEN and our upcoming titles, please subscribe to our free magazine at www.taschen.com/magazine, follow us on Twitter, Instagram, and Facebook, or e-mail your questions to contact@taschen.com.

Photo credits
The manuscript and all illuminations of the *Passages d'Outremer* by Sébastien Mamerot: © 2009 Bibliothèque nationale de France, Paris. Bibliothèque nationale de France, Paris: pp. 9, 11, 14, 18, 23, 31, 34–46, 55, 56, 69; Bibliothèque Sainte-Geneviève, Paris: p. 33; © Médiathèque de l'Agglomération troyenne – Photo Pascal Jacquinot, Troyes: p. 59; Österreichische Nationalbibliothek, Vienna: pp. 17, 26; © The Pierpont Morgan Library – Photo Joseph Zehavi 2005, New York: p. 60, 62; © RMN – Photo René-Gabriel Ojéda, Paris: pp. 49, 50.

© 2016 TASCHEN GmbH
Hohenzollernring 53, D–50672 Köln
www.taschen.com

Original edition: © 2009 TASCHEN GmbH
Transcription and translation of the original Middle French text into modern French:
Thierry Delcourt, Paris; Danielle Quéruel, Paris

Project management: Mahros Allamezade, Cologne; Petra Lamers-Schütze, Cologne
Editing: Michele Tilgner, Gröbenzell
English translation: Mary Lawson, Ashford (commentary on the illuminations; MS text: fol. 14–73, 84–112, 137–157, 169–193, 206–223); Chris Miller, Oxford (introduction; MS text: fol. 1–14, 73–84, 112–137, 157–169, 193–206, 223–277)
Scientific editing: Johannes Althoff, Berlin (transl. by Ruth Schubert, Munich)
Design: Birgit Eichwede, Cologne
Production: Horst Neuzner, Cologne

Printed in China
ISBN 978-3-8365-5445-9